The Art of the Picts

SCULPTURE AND METALWORK IN
EARLY MEDIEVAL SCOTLAND

Thames & Hudson

GEORGE HENDERSON ISABEL HENDERSON

The Art of the Picts

SCULPTURE AND METALWORK IN
EARLY MEDIEVAL SCOTLAND

with 326 duotone illustrations and 6 maps

Frontispiece: 1 *Detail of front of cross-slab, Nigg, Ross & Cromarty*

First published in hardcover in the United States of America in 2004 by
Thames & Hudson Inc., 500 Fifth Avenue, New York, New York 10110

thamesandhudsonusa.com

Library of Congress Catalog Card Number 2003101330
ISBN 0-500-23807-3

Printed and bound in Singapore by CS Graphics

For Rosemary Cramp

Quoniam placuerunt servis tuis lapides ejus
Psalm 101

Acknowledgments

The authors wish to record, with a deep sense of obligation, the contribution of Tom E. Gray to the illustrations in this book, both in specially commissioned photographs and in his having granted ready access to the Tom and Sybil Gray Collection of negatives, which now forms part of the National Monuments Record of Scotland. They also wish to thank Ian G. Scott, formerly of the Royal Commission on the Ancient and Historical Monuments of Scotland, for the use of his drawings of sculpture. His drawings of items from the St Ninian's Isle Treasure were commissioned for this book. All his drawings reveal personal insights and interpretative skill. The authors are also very much indebted to David Henry, of The Pinkfoot Press, for his enthusiastic and ingenious realization of their wish to have informative mapping of the art of the Picts. Delia Pluckrose has been the authors' constant support in the preparation of the typescript of this book.

The authors also wish to thank the following friends and colleagues for information and practical assistance: Paul Adair, Norman Atkinson, Susan Bennett, Nan and George Bethune, Tim Blackie, Martin Carver, Joanna Close-Brooks, Barbara Crawford, Lesley Ferguson, Ian Fisher, Sally Foster, Mark Hall, Catherine Hills, Kristina Johansson, Alan Lane, Alastair Mack, Janet and Calum Mackenzie, Ellen Macnamara, Bernard Meehan, Helen Nicoll, Niall Robertson, Susan Seright, Ian Shepherd, Alison Sheridan, Simon Taylor, Ross Trench-Jellicoe, Susan Youngs, George Watson, Patricia Weeks, and Niamh Whitfield.

This book also makes use of the creative studies of other people, to which reference is regularly made in the footnotes; but the authors would especially single out the work of Charles Thomas, Richard Bailey, David Wilson, James Graham-Campbell, Michael Ryan, and of the late Robert Stevenson. The publications of the International Conferences on Insular Art have been invaluable, and without the expertise of the contributors to the 'Work of Angels' exhibition catalogue, the chapter on metalwork could not have been written. The authors of course accept full responsibility for the opinions stated and the interpretations offered.

The authors are conscious of the benefit to their subject of having this book produced by Thames & Hudson, a publisher notable for strikingly sensitive combination of words and images; that sensitivity has been fully embodied in the editor, Christopher Dell, and the designer Alexandra Coe, whose initiatives have contributed significantly to the coherent and attractive presentation of complex material. To them and everybody else at Thames & Hudson they offer their sincere thanks.

In dedicating their book to Rosemary Cramp, the authors wish to express their affectionate appreciation of her long-standing friendship, as well as their admiration for the rigorous thinking and integrity of this truly interdisciplinary scholar.

G. H. & I. H., Nigg, Ross & Cromarty, June, 2002

Contents

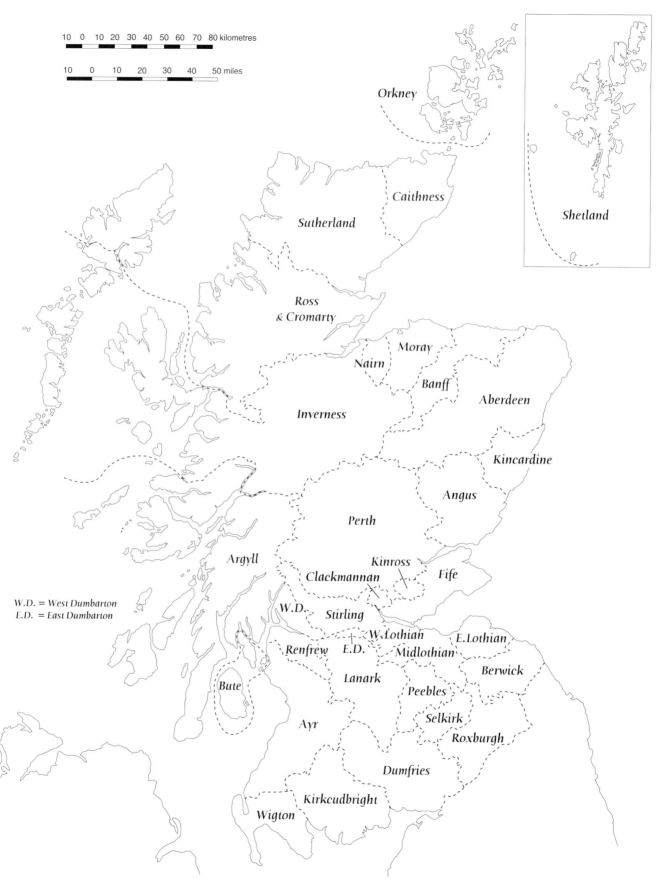

Scale:
10 0 10 20 30 40 50 60 70 80 kilometres

10 0 10 20 30 40 50 miles

Orkney

Shetland

Caithness

Sutherland

Ross & Cromarty

Moray

Nairn

Banff

Aberdeen

Inverness

Kincardine

Angus

Perth

Argyll

Kinross

Clackmannan

Fife

W.D. = West Dumbarton
E.D. = East Dumbarton

W.D.

Stirling

W.Lothian

E.Lothian

E.D.

Midlothian

Renfrew

Berwick

Lanark

Peebles

Bute

Selkirk

Roxburgh

Ayr

Dumfries

Kirkcudbright

Wigton

Map 1

Regional names used in the text

Introduction
The Criticism of Pictish Art: from 'insular' to Insular

In the early medieval period, which in this book means the 7th to the 9th centuries, all the regions of what is today called Scotland were producing striking and original art. Some of this art, in the form of sculpture, can still be seen close to where it was made: the great cross at Ruthwell, Dumfriesshire, raised by the Northumbrian English; the slabs and high crosses of the Irish monastery on Iona in the Western Isles;[2] the sculpture of the Britons, at Govan, near their stronghold on Dumbarton Rock;[3] and the elegant, expressive sculpture of the Picts of northern and eastern Scotland whose monuments are widely dispersed from the Firth of Forth in the south to the Shetland Isles in the north. This book is about the art of the Picts, in metalwork and stone sculpture. It is concerned primarily with the technique, style and content of the works of art themselves, and with their art-historical context within Britain and Ireland.[4]

The Picts are less familiar to the general reader than are their contemporary neighbours, the English, the Irish, and the Britons. For the purposes of this study the reader needs to know that the name 'Picts' is an English translation of *Picti*, the name used by a handful of late Classical writers to describe some of the peoples whom the Romans confronted during their campaigns in North Britain in the early centuries AD. The status of the name, whether it is an attempt to reflect accurately one particular native name, or is merely a nickname, is uncertain, but it provided a convenient form for early medieval authors to adopt, when writing in Latin.[5] The Britons, who spoke a language cognate to that of the Picts, called 'Picts' *Prydyn*. The related Irish name for them is *Cruithni*.[6]

The Picts were for the most part an indigenous people. The view that the common Roman threat produced a precocious unity, represented in medieval times in the surviving native list of consecutively reigning kings of the Picts, is no doubt an oversimplification. Abbots of Irish Iona, and English Northumbria, were thoroughly familiar with the Picts, and the names of individual regions found in sources emanating from these abbots' scriptoria will reflect, to some degree, the political geography of the Picts. Perhaps the geography of Scotland itself, the defining mountain chains, the fertile straths and the penetrating river valleys are the surest guide we have to controllable divisions.[7] Up until very recently natural features defined the administrative regions of Scotland and for this reason we have maintained their names here (Map 1).

The loss of contemporary native sources means that commentators often give too much weight to the sporadic evidence in foreign sources which, inevitably, are not overly concerned with exact, embracing, terminology. The disappearance of the label 'Picts' in such sources, from about AD 900, is now thought to reflect just that, no more and no less. At that period there was a conscious adoption of a new label, 'Alba', which was applied to the peoples of North Britain, the Irish and the Picts.[8] Under this guise, aspects of Pictish social structure were carried forward as elements in the social transformation which eventually led to the creation of Scotland as we know it.

Recent advances in Pictish studies have come about through intensive specialist studies by historians, linguists and archaeologists. In a field where all the disciplines are struggling with sparse and intractable data, the value of an interdisciplinary approach is obvious. The pitfalls are equally obvious. Understanding how to use the findings of another discipline is not easy. Research is not always fruitful for the same geographical areas or within the same time-frame.[9] Bringing it all together by accepting as 'facts' the legitimate interpretations of other disciplines may ultimately be more distorting than keeping them apart. It is unusual for the art of the Picts to be altogether ignored by other disciplines, but often it is brought into play simply as an assurance of a Pictish presence, or as a phenomenon justifying hypotheses requiring a context of a high level of culture.[10] Deployment of the evidence present or implicit in the content of the art is restricted to its distinctively Pictish qualities, its display of the unique symbols, and of what is regarded as secular iconography.[11] This book will give equal weight to those aspects of Pictish art that show it to be part of contemporary art in the common cultural area of Britain and Ireland, known as Insular art.

The overemphasis on the distinctiveness of Pictish art has understandably had a detrimental effect on its inclusion in studies of mainstream Insular art. Those elements in it not seen as distinctive are attributed to outside 'influences', or in extreme cases to the importation of craftsmen from Ireland or England.[12] Proposals of priority of invention or the production of pre-eminent work by Pictish artists are met with respectful scepticism because of the lack of other cultural indicators. The existence of the art itself is not regarded as sufficient evidence for a church or aristocracy served by an intellectual, text-producing class. This study will demonstrate that the evidence of the art can support the assumption that the Picts were socially organized so as to make their own dispositions, and that a similarly enabled, independent Pictish church emerged in the 7th century. Pictish society, like other societies in Britain and Ireland, will have been influenced by the transformation under way in the rest of Europe, but to no greater or lesser degree than its neighbours.

The largely art-historical approach of this study will, it is hoped, strengthen the evidence available for the nature of Pictish society and enhance understanding of the mechanisms behind the rapidly evolving synthesis that produced the Insular style.

Studies of Pictish art in all media have benefited enormously from the still indispensable systematic work of Joseph Anderson and J. Romilly Allen, published as *The Early Christian Monuments of Scotland* in 1903, and now available in reprint.[13] Both men concerned themselves with the assembly and analysis of factual information. Anderson provided a wide-ranging introduction, demonstrating his view that to understand Scottish sculpture one must compare it with the art of the other parts of Christendom. He was particularly interested in metalwork, so that this aspect of Pictish art was given expert coverage in a study otherwise centred on stone sculpture.[14]

A long-lasting legacy of the work was the division of the sculpture into three classes.[15] The classification was based on the form of the monument, the presence or absence of symbols, or of 'Celtic' designs 'similar to those found in the illuminated pages of the Hiberno-Saxon manuscripts between 700–1100 AD'. Class I comprised undressed boulders incised with symbols. Class II had symbols and 'Celtic' ornament carved in relief on regularly cut cross-bearing slabs. Class III had 'Celtic' ornament but no symbols. The classification scheme remains very popular for reasons of convenience of reference, and because its very simplicity makes for easy quantitative and topographical analyses. Although the evolution of aspects of the classes is undeniably significant, the classification will not be used in this study because its advantages are greatly outweighed by its disadvantages.

The arrangement of Allen's descriptive catalogue into the occurrence of the three classes within the county divisions obscures the significance of individual sites. The sculpture is presented as it were in horizontal layers of classes rather than as centres of sculptural production. Another of the common perceptions of Pictish sculpture arising from the classification scheme is that it is a 'national', even ethnic, phenomenon. This is broadly justifiable, but the sculpture is best understood as a response to local conditions and local resources, not as part of a pervasive representation, or non-representation, of the 'classes'.

The description 'symbol stone' is acceptable for Class I, but the transference of the notion of a 'stone' to Class II subtly demotes the Pictish relief cross-slabs, setting them apart from the sophisticated productions of Insular art. The usage, not uncommon, of 'Pictish standing stone' for both 'classes' is unacceptable.[16]

More serious difficulties arise with Class III. Allen and Anderson's work included monuments throughout modern Scotland, so that, for example, St Martin's Cross on Irish Iona (now in modern Scotland) and the celebrated Anglian cross at Ruthwell are described under the heading 'Class III'. Class III is therefore linked by association with non-Pictish sculpture. Allen pointed out that Class III included, besides cross-slabs, much

sculpture in northern and eastern Scotland in other formats, such as solid recumbent grave markers, monuments of box construction and architectural sculpture.[17] To the list should be added free-standing crosses. All such sculpture, because of the lack of symbols, comes under suspicion of having been carved under Irish or Northumbrian 'influence'.[18] That Pictish sculptors restricted themselves to carving symbol-bearing monuments is improbable to the point of being indefensible. It is equally likely that from time to time non-Picts carved symbols.

Although Allen and Anderson regarded the classification as a sequence of types rather than a chronological development this sort of development was implied, particularly in Anderson's part of the work. Pictish sculpture is therefore widely used to chart Pictish political and ecclesiastical history in preference to the patchy obscurities of the documentary and archaeological evidence. Class I, with its 'pagan' symbolism, is regarded as belonging to the pre-conversion period (something Anderson had serious reservations about). Class II, with its display of the cross, is seen as a consequence of the conversion (postponed to the early 8th century because of the generally acknowledged date-bracket for the art of the cross-slabs). A broad political division at the Grampians between northern and southern Picts is supported by late Classical texts. In the past, writers have seen the supposed numerical predominance of Class I in the north, and of Class II in the south as a reflection of this prehistoric division, but also as a tangible sign of a shift of power from north to south during the 7th century.[19] The disappearance of the symbols in Class III serves both for the triumph of Christianity or the cultural disappearance of the Picts under the overlordship of the Irish colony in Argyll (Dál Riata) sometime in the 9th century. This oversimplified account of Pictish history is readily grasped by the visitor to a Heritage Centre but less excusably it still serves to flesh out the early medieval period in academic general histories of Scotland.[20] This set of half-truths neutralizes the contribution Pictish art can make to interdisciplinary study. If perceptions of Pictish art continue to be filtered through a typological classification scheme devised at the end of the 19th century, then it cannot contribute in any serious way to either current work in Insular art, or Scottish archaeology. To impose an artificial evolutionary classification on the sculpture will not help understanding of what Pictish society wanted of its monuments or what intellectual resources it was able to apply to them.

One further deficiency of the scheme needs to be noted. In appendices to the counties Allen occasionally lists monuments with crosses, incised or in relief, bearing no other ornament.[21] To include this group in the three-class system would have been problematic. Often carved in incision on undressed stones, they share aspects of Class I. Displaying a cross they belonged with Class II. Having no symbols they belonged firmly with Class III, but they failed to meet the other requirement of Class III, the presence of Celtic ornament. Anderson had written perceptively elsewhere about these cross-marked stones, but he dropped them

entirely from the introduction to *The Early Christian Monuments of Scotland*.[22] Allen must have known that there were many more than he had recorded. He made no attempt to build them into his statistics. With the virtual suppression of this group it was not surprising that in terms of conventional monumental tradition the symbol stones are frequently taken as representing the outlandish Pictish substitute for the simple cross-marked stones in Ireland and Britain. This study, for the first time, will incorporate the cross-marked stones of the Picts into an analysis of their art. The history of the art of this period was profoundly influenced by the Church, and to use the sculpture as an indicator of the progress of Christianity without taking the cross-marked stones into consideration (however difficult they may be to date) gives a wholly misleading picture.[23]

As a critic of art, Joseph Anderson was comparatively indifferent to the artistry of what he and his co-author assigned to their 'Class I'. He was on more comfortable ground with regard to relief-carved monuments, in which he saw the scope of Pictish art much enlarged, with rules applied in the preparation and shaping up of the slabs and their framed and panelled compositions. His account of the variety of decorative motifs used in the cross-slabs is thorough and workmanlike,[24] with a good word here and there for a 'really effective' piece of designing by a Pictish sculptor. He rightly associated this phase of sculpture with the art displayed in illuminated manuscripts such as the Gospel Books of Durrow, Lindisfarne and Kells. Indeed he perceptively goes back to the incised sculptures, comparing the convention of sweeping spiral curves 'marking the junctions of the limbs' of the Burghead bulls [25] with that 'characteristic of the early group of Irish manuscripts'. He is similarly first-hand in assuming the former existence of Pictish manuscripts, and he cites, just as we do in a later chapter, the lost examples at St Andrews and Banchory Ternan.[25] But he does not pursue his observation of 'the firm precision and excellence of the animals' in Pictish incised sculptures forward to a recognition of the self-same skill and artistry in the illuminated initials in his 'Irish' books. In Anderson's Rhind Lectures of 1892 (incorporated in the 1903 publication), and long afterwards, the straitjacket of those 'illuminated MSS of the Celtic Church' was firmly in place. During the second half of the 20th century the problem of the origin and development of the Insular, not solely the Irish, style, has been painstakingly unravelled. In this book we reject Anderson's interpretation of Pictish cross-slabs as giving 'the feeling of copying from manuscripts', as if somehow the idiom was foreign to their sculptors, or that the various media did not naturally overlap. We will argue that the Picts were ever-present past masters of Insular art.

Anderson was the founder of the science of reading the Christian images displayed on the Pictish relief sculptures.[26] In all the intervening century his survey has not been improved upon. He brings to bear the late 19th-century insider's view, referring to Adam and Eve as 'our First Parents', and presses his visual and formal analogies too far, as when more than once he connects the

Pictish 'beast head' symbol [69, 75] with the bust of an ass in pictures of Christ's Nativity,[27] or is hopeful of being able to discern a reference to the journey of the Magi in the Pictish processions of horsemen.[28] Of the two principal models which he applies, the world of Romanesque imagery, and the art of the Catacombs, the former was seriously anachronistic, notably in his wholesale interpretation of mature Pictish animal art by the standards of the *Physiologus* and the Bestiary,[29] while the latter (Catacombs) rightly directed him straight to the Pictish core images of David [191], Daniel [194] and Jonah [101], and the possibility of other typological allusions. He gropes his way to recognizing the 'bovine animal placed on a pedestal' on the cross-slab at St Vigean's, No. 7 [205], as the golden calf of Exodus 32,[30] but is perhaps deliberately disingenuous in interpreting the knife in the kneeling figure's hand as a rod, and his curled protruding tongue as a scroll, and so misses the powerful antithesis presented in the sculpture between pagan and Christian sacrifice. He looks too literally for scriptural narrative illustration, in a culture preceding that in which narrative illustration was developed as a devotional aid.[31] The Insular mind in its specifically Christian iconography preferred the iconic to the narrative mode.

Allen was not much interested in dates, while Anderson's dating scheme depended on historical explanations most of which are now regarded as simplistic, and are being substantially revised. Intensive work on Insular art has not led to dating schemes neatly packaged for use by other disciplines. The catch-all term 'traditionally dated to', sometimes used by other disciplines, is meaningless. A measure of consensus (not the dates proposed in the 19th century) is to be hoped for, and if this is not forthcoming the options have to be acknowledged and assessed. Dating the sculpture on a single issue, such as the occurrence of a particular decorative motif or a type of artefact has obvious attractions, but the entire work of art on which they occur must be taken into consideration and if other characteristics have to be explained away in order to accommodate a single 'factual' issue, such as the date of a type of weapon or musical instrument, then the method, given the degree of losses, must be suspect.[32]

Dating the productions of Insular art is not easy, and of all the media stone sculpture is the most difficult. A recent survey of the current methods of dating English sculpture admits that in spite of some progress a fifty-year date-bracket may be all that can be expected.[33] The general editor of the *Corpus of Anglo-Saxon Stone Sculpture* is equally honest and equally pessimistic. Even resorting to comparison with other, book-dated media, the end result, she feels, can only provide 'a very imperfect account of the original picture'.[34] Nor at present, in spite of some Herculean work on the High Crosses, is there a consensus for the dating of Irish sculpture.[35] On the other hand, understanding of the nature of art of early medieval Ireland has been dramatically changed by the spectacular new finds of de luxe metalwork datable to the 8th and 9th centuries. Only a small corpus of Pictish metalwork has survived, but if claims are made for the Picts being players in the

interactions that produced the Insular style, then this new knowledge must be taken into account. Significant for making the case for the early involvement of the Picts in the formation of the Insular art style are the new finds at Dunadd [148], a power centre of the Irish colony, Dál Riata, which shows conclusively that Celtic and Anglo-Saxon connections, of a kind associated with the Sutton Hoo ship burial in East Anglia [6, 7], were under way in the fine metalwork being produced in Dunadd's 7th-century workshops.[36] Dál Riata borders on Pictland and Iona was influential in both areas. The implications for the involvement of the Picts in the earliest phase of the style are obvious.

Pictish art includes a small quantity of sculpture, and a single piece of metalwork, bearing Latin inscriptions. The letter forms are an aid to dating for they can be related, in one instance, quite closely, to hands used in Insular manuscripts. One inscription contains the name of a known historical figure [278].[37] The current state of uncertainty in the study of the inscriptions in the Irish ogham script carved on both symbol stones and cross-slabs makes these less helpful both for dating and for cultural context.[38] Only the relationship between the inscriptions – Roman and ogham – and the layout, design and technique of the associated art will be discussed here.

There is some help available for dating from archaeological contexts. A primitive symbol stone can be associated with a stratification in a structure in Orkney datable to the late 5th or early 6th century.[39] Pictish carvings are found within two strongholds both broadly datable to the 7th century, and a number of symbol stones have been found in the vicinity of datable graves [71, 246].[40] The excavations at Tarbat in Ross & Cromarty provide a sealed and datable archaeological layer for sculpture in a fragmented but seemingly recently carved state. These excavations also provide the first evidence for the production of sculpture at a major Pictish monastery of the 7th to 9th centuries.[41]

Recent systematic excavation of documented Pictish secular power centres has contributed substantially to knowledge of Pictish society.[42] One of the sites excavated, Forteviot, in Perthshire, has associated with it a diverse collection of non-symbol-bearing sculpture [103] that will be assessed here for the first time. Forteviot, and other less thoroughly investigated sites such as Burghead in Moray [299, 300], provide a model for Christian sculpture functioning within an apparently dominantly secular environment. It used to be thought that sculpture in this period was exclusively part of monastic culture. The mixed nature of the forms of Pictish sculpture is well suited to new perceptions of church organization which after the missionary phase embraced a range of ecclesiastical establishments including monasteries, local pastoral churches and the private chapels of seculars.

Place names with Pictish elements have always been related chronologically to Pictish sculpture, but usually in terms of the Allen and Anderson classification scheme that may be misleading. The evidence for Christianity embedded in some place names ought to be relatable to the presence of cross-marked stones and cross-slabs, but the relationship is complex. Certainly place names such as those with the British element *eccles* or the Gaelic element *cill* can indicate specific periods within Pictish ecclesiastical history to which Pictish sculpture could be related.[43] Place names and sculpture represent between them the largest body of evidence for the Picts, but the questions they can answer are very different. To see a missionary or a cult behind every coincidence of sculpture and a place name involving the name of a saint is over-optimistic.

The study of Pictish sculpture can scarcely be said to be 'text aided' and only one native text has ever been used for this purpose. Known until recently as the Old Scottish Chronicle, it purports to give an account of events in the reigns of kings of the 9th and 10th centuries. The exact nature and value of this text has been under scrutiny, as part of a reassessment of the period when the Irish from the west and the Picts cease to have separate histories.[44] Developments in the intellectual and material culture of the Picts are at least hinted at in a non-native text, Bede's *Ecclesiastical History*, in his isolated but concentrated record of contacts between the Picts and the community of Wearmouth-Jarrow early in the 8th century.[45] The Irish annal collections include many entries about Pictish affairs.[46] When looking for patrons of art, those recorded as being effective in the politics of North Britain are understandably selected as significant for cultural developments. The candidates are as follows: the 6th-century Bridei, associated with Columba and the north; the 7th-century Bridei who by a notable victory in the field freed southern Pictland from the occupying Northumbrians; Naiton, the King who sent the delegation to Bede's monastery; and Oengus, who conquered the Irish colony (Dál Riata) in the west in the second half of the 8th century. All four had external contacts that could provide for the interactions at a high level that are necessary for full participation in the Insular art style. One would not want to discard the potential of these leaders for ambitious art patronage. Nonetheless it has to be remembered that the records are partial and possibly deliberately selective. Exclusive reliance on them can distract from the art-historical evidence available for comparatively undocumented areas such as Aberdeenshire and Scotland north of the Moray Firth. Developments within the Pictish regions are unlikely to have been simultaneous. What the general editor of the *Corpus of Anglo-Saxon Stone Sculpture* says of the English regions can apply to the Picts: '...there is not a steady development...inception and changes in ornament occur at different times from area to area...there are sudden bursts of activity and equally unaccountable periods of stagnation'.[47] One might want to substitute a less pejorative word than stagnation, for areas where there is little discernible change, but this kind of sporadic creativity needs interpretation within local regional studies.

We have outlined the problem of how to relate the limited written records to the art, and the difficulties, as we perceive them,

of 'art aided' history, which seeks to wrest quick responses out of the art while viewing it through various forms of stereotype spectacles.[48] Pictish art deserves to be approached objectively and to be seen as a whole. The first essential is to recognize that it works naturally within the idioms of Insular art. In the two following chapters of this book we set out in some detail the characteristics of Insular art, and then survey the remarkable exploitation of these style features by the Picts. Chapter 3 focuses on those aspects of Pictish art that are critically distinct and indeed unique. Returning in Chapter 4 to the core principles of Insular art design, we shall attempt to define the canon of Pictish metalwork. In Chapter 5, the amazing diversity and hitherto wholly underestimated intellectual depth of Pictish iconography will be described. Then follow Chapters 6 and 7, methodically surveying the various shapes of the monuments and their possible function, offered as an antidote to the superficial view that the Picts were exclusively committed to 'stones', or 'slabs'. What is known or may be surmised to have been lost from among the monuments of Pictish art is discussed in Chapter 8. In our text and its illustrations we hope to present valid, art-historical, evidence of lively original human communication passing back and forward between creative artists, deeply integrated into the social and spiritual needs of their time, and an audience unusually susceptible to visual displays featuring line, pattern, texture, and, above all, pictorial imagery which evidently swayed and guided them. Historians and archaeologists must now, in their 'models', allow for a political maturity and economic infrastructure adequate for the production of this art.

Note All measurements are given in metric; imperial measurements of works discussed are additionally given in the List of Illustrations on p. 249.

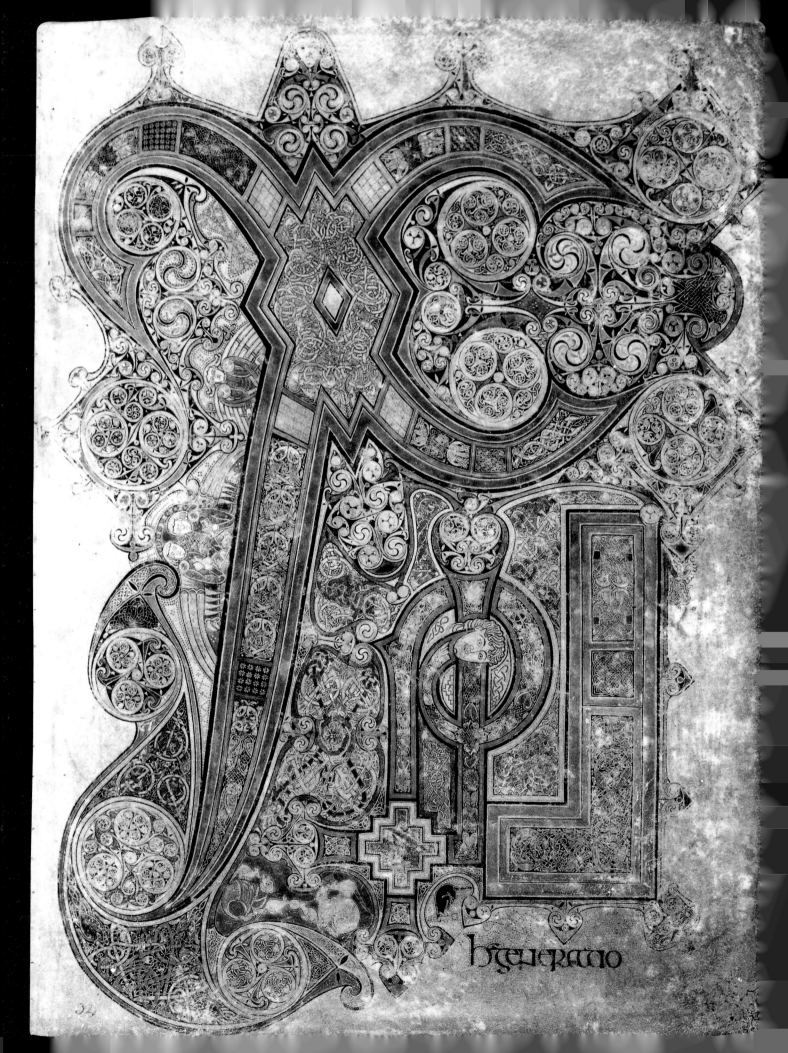

ħᵹᴇɴᴇᴦᴀᴛɪo

The Diagnostic Features of Insular Art: A General Review

Origins

The Insular style is the first comprehensive professionally planned and executed mode of artistic expression to appear in Europe in the post-Classical period. It flourished between roughly AD 600 and 900. In spite of its symbiotic relationship to the faith and discipline of the Christian Church – which, in various parts of Britain, was still at a very early and vigorous stage in its history – the Insular style is essentially abstract and decorative, consisting of a set series of linear rhythmic motifs and patterns, many of them originating in the visual traditions of separate ethnic groups – spirals and trumpet-shaped scrolls, knotted and interwoven strap- and cord-work, tightly meshed long-bodied stylized animals with and without limbs, and various zigzag motifs, formed into regular step, key, and fret patterns. At first, and throughout the development of the style, these different motifs and patterns, although closely juxtaposed, are strictly segregated by narrow frames and tightly packed within separate geometric compartments, a diagnostic feature of the style being the elaborate stacking-up of its compositional building-blocks. At the same time, notwithstanding this fundamental rule of the segregation of one category of pattern from another, within the handling of the individual motifs we can discern the effects of cross-fertilization, and in the most mature and sophisticated works of art visually striking examples of conflation and merger. An often remarked on characteristic of the style is the minute scale on which its practitioners worked, within the limited compass of precious objects of personal adornment, such as pins and brooches [5, 137], and on the parchment pages of Gospel Books [8, 16], Psalters and other books, cut to a practical handleable size. Thanks to the primitive strength of the basic motifs, and to the best Insular artists' innate sense of form, exploring and controlling the liveliest of running flickering patterns, even in small things the style can achieve a monumental effect, and with no impairment of the idiom can expand with seeming ease to literal monumentality, where the medium is high-relief stone sculpture [39, 41].

The original creative stimulus, whether by artist or patron, responsible for the emergence of a great art style is frequently a matter of dispute. The critical literature on the Insular style has many of the characteristics which mark discussion of contentious issues in the history of art,[1] so natural is the urge to pin-point the specific location or environment where the salient principles of a style were first laid down. It is perfectly healthy to take a leaf out of Arius's book and affirm that there was a time when the Insular style 'was not',[2] since no single motif, but rather the scrupulous and measured combination of a number of previously unconnected motifs is the hallmark of the style. This, however, is not to deny continuity of traditional skills or, perhaps, conscious imitation of a past style in the antecedents of at least one essential element of Insular design, namely compass-based curvilinear patterns of circles, scrolls and spirals. The *ad hoc* structure of crescents, peltas and curved trumpet-like segments, bounded by a circle – like apple peelings on a plate – with some elements raised and some recessed, and textured with hatched lines, on tinned bronze sheets from a minute Christian portable shrine from Clonmore, County Armagh [3],[3] is aesthetically akin to Iron Age productions such as the Birdlip and Desborough mirrors, of the early 1st century.[4] A similar lopsided infill to circles with keeled trumpet and spiral motifs is seen in the ornamental epigraphy of the Psalter known as the *Cathach*,[5] of about the same time as the Clonmore shrine, *c.* AD 600.

Earlier ideas and models, Romano-British ones, are clearly reflected in the open-work escutcheons, the ornamental suspension attachments of bronze bowls [121], of uncertain purpose but highly prized by aristocratic patrons of diverse ethnic groups, also dating to around 600. Hanging-bowl manufacture,

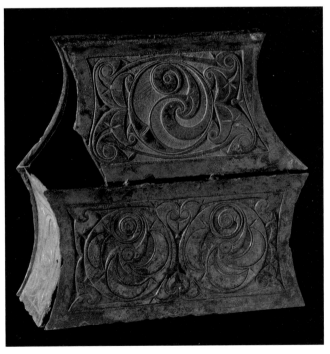

3 *Back view of house-shaped shrine, Clonmore, County Armagh. Tinned bronze*

2 Christi autem *initial, the Book of Kells, Dublin, Trinity College MS 58, f. 34,*

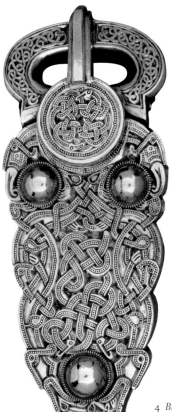

4 *Buckle, Sutton Hoo Ship Burial. Gold with niello inlay*

his shoulders, waist and thighs, and who in his state appearances must have been visually positioned halfway between the canonical imperial costume of Justinian in the mosaic in San Vitale, Ravenna, and the weird enamelled solemnity of St Matthew's symbol on *f.* 21v of the Gospel Book of Durrow.[9] Buried with him was an unusually large and splendid hanging-bowl, with fine line scrolls and peltas set off by enamel and boldly coloured millefiori insets, though not yet showing the developed trumpet spiral designs. His own immediate entourage of Anglo-Saxon craftsmen had renewed and repaired some worn or lost fittings of the bowl in a clearly different, Germanic, style,[10] but in their own most sumptuous products they made lavish use of brightly coloured chequerboard millefiori glass, evidently obtained from the same artistic milieu as the original hanging-bowl itself. British, Irish and Saxon workmanship is in the process of combining. Outside the Sutton Hoo complex, the very same process of amalgamation is witnessed by the circular base-disc of a hanging-bowl excavated at Hadleigh Road, Ipswich, which displays a broad spiral pattern filled with red enamel, encasing a gilded disc of tightly interlacing grooved ribbons, typical of Anglo-Saxon taste.[11] The great master goldsmith of the Sutton Hoo regalia miraculously contrives a fluent two-strand twisted ribbon pattern out of cut garnet plates and gold cloisonné cells in two of the rectangular mounts from the royal sword harness.[12] On a vastly larger scale, Germanic feeling for strands, loops, and meshes is displayed in the elaborate iron gear designed to suspend an enormous cauldron of a kind also found in the Sutton Hoo burial chamber.[13] More traditional in style than the other regalia, the great gold buckle [4] exhibits three different thicknesses of strandwork: a comparatively slender ribbon ending in a snake's head and tail, used twice on the buckle loop; a circular plate at the base of the buckle tongue is packed with two thick wormy snakes, their interwoven coils outlined and textured; and two similar snakes, on a larger scale, thrash and tangle down the length of the buckle to the large boss at its base.[14] At the upper centre of his purse cover the great goldsmith designed four stylized quadrupeds in profile, two hunched, two stretched out, which face each other in pairs and whose upper and lower jaws and hooked paws interweave in a delicate linear pattern.[15] These amorphous creatures look like an elegantly cool redrafting of the fierce archaic stylized horses in repoussé, cramped into the flange of the Sutton Hoo shield boss, which confront one another and wrestle in a small but zestful design whose spirit was much later recaptured in George Stubbs's *Fighting Stallions.*[16] As becomes an instrument of war, even if designed for ritual show, the Sutton Hoo shield is fitted with strips of gilded metal in the shape of monstrous beasts and birds, their brows shaded with drooping horns or lappets, their beaks coiled up like a party 'blower' and their partly-open jaws armed with huge shark's teeth. The grip extension on the back of the shield ends in a dragon's head seen flat on, from above, while four other necks and fierce profile heads stick out sideways, as if they were the legs of the principal dragon.[17] Even in its mature phase, the

wherever the responsible 'Beseleels' and 'Hirams'[6] actually worked, was one of the most potent design preliminaries to the invention of the Insular style. New patterns and brilliant colour effects were being introduced, hair-line scrolls set off against red enamel and tiny flower-like patterns made from multi-coloured millefiori glass rods, drawn out, cut, and grafted in. The major achievement of the hanging-bowl escutcheon workshops was the reorganization of the inert segments, disposed inchoately within a circle, on for example the Clonmore Shrine, into a dynamic curvilinear design basically of three separate spirals from each of which one of the small spiral whorls runs off, and expands, its broad end hooked over and marked by a triplet of leaf-shaped vents before it ricochets in the reverse direction, to be caught up into another of the spirals, resolving and unifying the entire design. Hanging-bowls, with ever more skilful and articulate bronze and enamel escutcheons are a prime factor in cultural exchange, in the period around 600, whether this exchange was calculated and deliberate, as diplomatic gifts, or in the forced exigencies of war, as tribute or loot.[7]

It is a curious fact that the first proven hothouse for the incubation of the Insular style should be the furnishings and treasures laid out for the 'shipping' of a dead Anglo-Saxon king and buried under an earth mound on the southern edge of Suffolk;[8] but the creative adventure, both by opportunism and by the exercise of critical taste was, of course, in the lifetime of that three-quarters pagan king whose incredible wealth was concentrated, like sunshine through a magnifying glass, on to

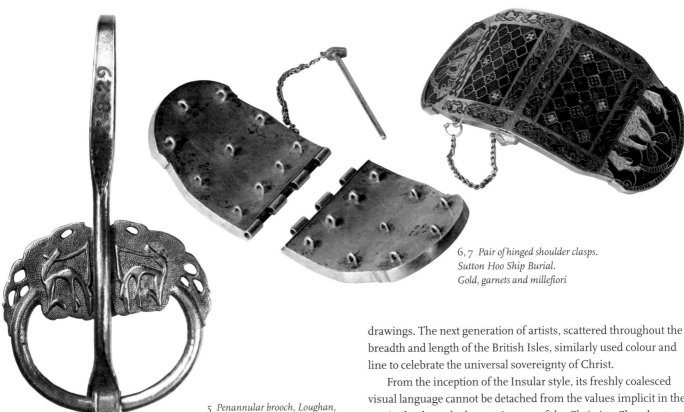

5 *Penannular brooch, Loughan,*
County Derry. Gold

6, 7 *Pair of hinged shoulder clasps.*
Sutton Hoo Ship Burial.
Gold, garnets and millefiori

Insular visual imagination continued to relish such staccato forms. The reverse of the terminals of a 9th-century gold brooch from Loughan, County Derry [5, 175], is decorated with a pair of animals cast in relief whose lean jerky silhouettes are a cross between a stick insect and a Swiss Army knife.[18] The same quality of vehemence, barely constrained, is found in manuscript illumination, accompanying the most decorous of subject matter. The text on the opening page of an early 8th-century copy of ecclesiastical Canons, now in Cologne Cathedral Library, is split by two horizontal bars, off-shoots of the frame, the one going left ending in a bovine head seen flat on, from above, the one going right ending in the profile head of a grinning sharp-toothed wolf.[19]

The Art of the Book

A totally different aspect of the Sutton Hoo burial – the elegant neatness of the royal shoulder clasps, their smooth rectangular surface scintillating with the minute patterns cut out by crisp gold cells filled with mosaic glass and gold-backed garnets [6, 7][20] – opens up another avenue to the future achievements of Insular artists, in the framed all-over patterned pages of 7th- and 8th-century Gospel Books. The stable, limited, four square format of the newly fashionable codex provided the perfect alternative outlet for the artistic experiments begun and then put into cold storage in the ship burial at Sutton Hoo. At the planning stage, the king's servant, the Sutton Hoo goldsmith, must have made coloured

drawings. The next generation of artists, scattered throughout the breadth and length of the British Isles, similarly used colour and line to celebrate the universal sovereignty of Christ.

From the inception of the Insular style, its freshly coalesced visual language cannot be detached from the values implicit in the service books and other equipment of the Christian Church, at a zealous proselytizing stage throughout Britain. What a book could and should be like had first to be learned from continental imports and literary sources.[21] Cassiodorus, the wealthy Italian 6th-century patron of church learning, laid down that it was proper that books had on their outsides the equivalents of their beautiful lettering, and these covers he likened to the nuptial garments of those invited to the Lord's supper in the Gospel parable.[22] Meditation on the furnishings prescribed in the Books of the Old Testament for the Jewish Tabernacle and Temple, notably the woven multi-coloured veils hung before the Holy of Holies,[23] was a further stimulus towards the honourable presentation of the sacred words of the Gospels. The first full statement of such a purposeful symbolic feature of the Insular Gospel Books comes with the first complete surviving manuscript, Trinity College Dublin MS 57, the Book of Durrow, which has seven decorated pages, appropriately nowadays termed 'carpet pages', one before each Gospel and others at the beginning and end.[24] The carpet page opposite the opening of St Mark's Gospel [8] consists of brightly coloured knot-work organized into circular units, in five rows of three, the cords within the circles coiled closely together but where the linking cords pass beyond the circle they criss-cross in a sharp jagging action. A basic rule of Insular strap-work is here stated, that the cords consistently pass over and under, over and under, the transitions emphasized by the different colours which the cords take on. Plaited cords of various thickness, in the tradition of the Sutton Hoo gold buckle [4], but without zoomorphic terminals, are displayed also on the first surviving folio, framing an inset panel, and within the panel packing the background of a double-armed cross, the square

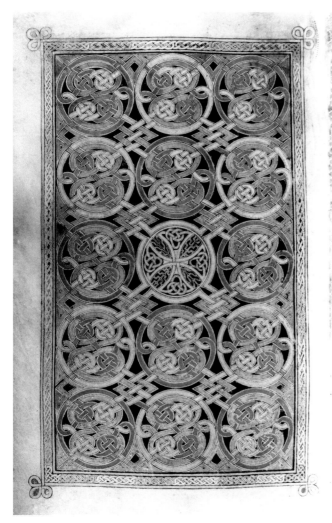

8 *Carpet page, the Book of Durrow, Dublin, Trinity College MS 57, f. 85v*

terminals and stem of which are decorated with painted imitation millefiori glass. On *f.* 3v the frame of the carpet page is again of contrasting loose and tightly knotted strapwork in the Germanic tradition, but the main body of the page is boldly different, consisting of big and little circles and spinning spirals, from which long, lopsided trumpet-shaped members shoot off, hook over, and fall back into the fast revolutions of the spirals. This picture of galvanized energy is a perfect evocation of the 'wheels within wheels' of Ezechiel's vision,[25] the Old Testament counterpart to St John's vision of the four Evangelists in the Book of Revelation.[26] But its artistic source is the ongoing metalwork tradition of hanging-bowl escutcheons, lent or robbed at Sutton Hoo but now smoothly accommodated into the exhilarating repertoire of the established Insular style.

Whether much time needs to have elapsed between the designing of the trim four-legged crustaceans on the Sutton Hoo purse cover and the creeping undulating creatures that confront the opening of St John's Gospel in the Book of Durrow is a matter

of speculation [9]. As they passed from gold and garnet appliqués into parchment and paint these stylized animals have changed a little. Their eyes are no longer clapped to the top of their heads and they now have laid-back prick ears, but many of them still have elongated upper and lower jaws that coil wirily around their legs or bodies, and their pliable legs still end in weak tufts or toes. In the illuminators' hands, the animals are larger, and make bolder patterns by means of their many changes of colour. The opening of St John's Gospel itself, the *In principio* initials,[27] is comprised of rigid upright painted braids with 'V'-bases like bookmarks, tightly packed with interlacing cords, differentiated solid or wiry like the suspension gear at Sutton Hoo. Flowing between these uprights, and swelling and dribbling like melted wax around their base and apex are delicate and elaborate trumpet spirals, the design at the core of each spiral again varied with conscious art. The logical next step in Insular design appears in the opening page of St John's Gospel in the now fragmentary Gospel Book, MS A.II.17 in Durham Cathedral Library [10].[28] The masterly display of trumpet spirals is here confined to the base of the great double vertical which sets the splendid *In principio* initials in motion, and the three principal discs are given a thick edge made of infinitely fine threads, within which, as if in a bird's nest, the rhythm of the spiral is taken up by a triplet of long-beaked birds' heads, set against a tangle of interlace. The witty convergence of motifs is well under way. Balanced on top of the vertical stems of *In* and *principio* are more large discs, but this time they do not contain even modified trumpet spirals but instead tangles of yellow or brown cords, which run out into the margins and are sealed off in the form of pairs of passive dragons' heads, lying nose to nose, with manes or lappets of fine hair trailing off behind their heads. The infill of the great initial letters themselves is not strapwork but the lineal descendants of Durrow's crustaceans [9], queuing up as in Durrow with long weak pliable legs but now with double-coloured bodies, and firm straight jaws like alligators, some armed with a huge single fang. One band of these creatures do not droop their heads down in line with their bodies but toss their heads back up with a twisted writhing movement. Filled to the brim with these seething animal forms, the great letters look for all the world like the laboratory apparatus of the divine alchemist.

In spite of a zoomorphic, even ornithological, tendency in the jointed, crooked and bird-eye treatment of the cores of the spirals in early hanging-bowl escutcheon design,[29] the overt display of birds' heads grouped within the spiral discs in Durham MS A.II.17 marks a development in the repertoire anticipating or more probably paralleling the decision of the artist calligrapher of the Lindisfarne Gospels, London, BL Cotton MS Nero D.iv,[30] to add flocks of fully fledged birds, in profile, to the traditional animal line-ups. These birds are passively attached to one another's tails and hind claws by their long hooked beaks. Their folded wings are dappled with feathers like bright enamelled scales. By the same token, the old amorphous animals are replaced by creatures with muzzled dog-like heads and padded

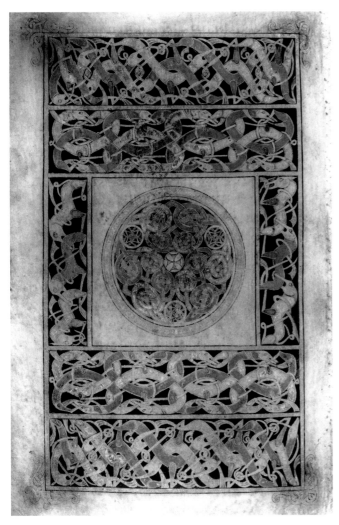

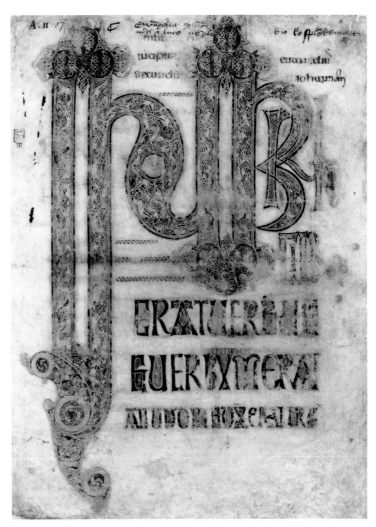

9 *The Book of Durrow, Dublin, Trinity College MS 57, f. 192v*

10 In principio *initial, Durham Gospels, Durham Cathedral Library MS A.11.17, f. 2*

clawed feet, as well as very occasionally by long nosed, fanged, dragons. In the Lindisfarne Gospels the tangled-animal motif is further revolutionized by the full implementation of interlace and spiral principles, so that all the creatures are more tightly locked together, criss-crossing one another and packaged in broad carpets of interwoven forms. Four birds belonging to this particular phase of manuscript design, bundled together to form a richly textured symmetrical pattern, were reproduced in stone sculpture in the north Northumbrian cross-shaft from Aberlady.[31] In the Lindisfarne Gospels the hindquarters of the quadrupeds are now spun round with their legs kicking out diagonally across the wheel-form of their own bodies.[32] The designer sets no limits to his elastic treatment of animal forms, which sit oddly with the greater naturalism of their detailed features. On the outer rim of the remarkably calm and balanced carpet page design before St Mark's Gospel on *f.* 94v, instead of the bulbous mamillation of trumpet spirals favoured by other artists, he projects into his margins the paired heads of birds and hounds, open-mouthed,

screaming, one might suppose, or gasping for air, after the compression to which their members have been submitted to form the straight frame of the carpet page.

Developments in Metalwork

The range of choice now available to Insular artists is seen in a work often closely associated with the Lindisfarne Gospels, the 'Tara' brooch.[33] The broad panel closing the gap between the two wedge-shaped terminals of the brooch displays two confronted quadrupeds whose hind quarters cartwheel as in Lindisfarne, but significantly the creatures are not domesticated as in Lindisfarne but are long necked, long jowled dragons, and a different menagerie too is represented in the round rim of the brooch, whereas on *f.* 94v of Lindisfarne heads and extremities lift up off the silhouette, but in Tara they are bird and fanged dragons' heads and linked fishtails, a metalwork tradition of limbless creatures,

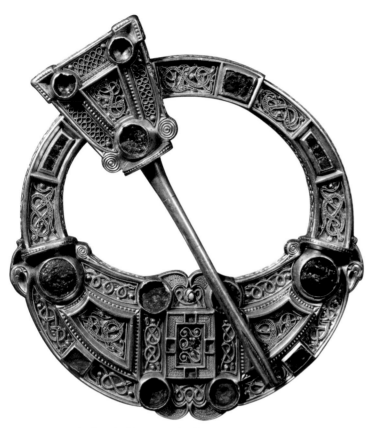

11 *Annular brooch, Hunterston, Ayrshire.*
Silver, gold, amber

favoured also by the slightly earlier Hunterston brooch [11].[34] The careful overall balance of discrete motifs, however, is very similar to that in, for example, the *Christi autem* page of the Lindisfarne Gospels; the front of the brooch is neatly partitioned with bands and segments displaying filigree wire interlaced in various patterns, while the back alternates profile bird processions with bands of trumpet spirals. The metalworker adds interest to this motif by varying the scale of the discs, altering his technique from cast to engraved metal, and his colours from silver to gold. Like Lindisfarne, he sticks faithfully to the early canon of spiral ornament laid down in the hanging-bowl escutcheons, notably the crooked trumpet scrolls and round pseudo eye, suggesting a bird's head. The colleague and *alter ego* of the master of Durham MS A.II.17, the designer of Corpus MS 197B's initial to St John's Gospel,[35] was more ready to explore the design potential of the trumpet spiral motif, cheerfully filling in trefoils, half-moons, and bold contrasts of dark and light, and at the top of the two left verticals of 'IN', two gaping-mouthed dragons' heads.

Heavy-headed, long-nosed dragons with closed mouths and thick lappets curling behind their heads, patently the kindred of the dragons' heads set nose to nose at the top of the Durham Gospels *In principio* [10], are engraved on the inner zone of the backplate of the door or shrine handle from Donore, County Meath, while the outer zone consists of discs containing thick swirls of trumpet scrolls and the old escutcheon pseudo birds' heads, given unusual solidity and presence.[36] Another hatched and engraved bronze disc from Donore sends a storm of trumpet spirals out in all directions from a circular hole at the centre. The biggest of the trumpet scrolls beat against the outer rim like waves against a cliff. The roundels scattered across the surface are filled alternately with busy little spiral ornaments and with restful patterns like sea urchins or marigolds.[37] The same delight in the decorative effect of trumpet spiral roundels filled with contrasting patterns is seen in the painted arch over the scene of David and his companions praising God with words and music in the Canterbury Psalter, Cotton MS Vespasian A.I.[38] A quite different approach to trumpet spiral design, but equally authentic, is found in the *Christi autem* initial in the Barberini Gospels in Rome.[39] Here the formula of Durham MS A.II.17, the centre of the spirals taking the form of birds' heads, is exuberantly exploited, and not only the spirals but the trumpet shapes radiating from them become a ring of birds' heads, with beaks like macaws, and various other creatures deftly fill every chink and crevice, like a child's picture puzzle. Several of the large scrolls grow fantastically into full-length cat-faced dragons, licking delicate fruit stems with their extended curling tongues. The transfiguration of trumpet spirals into other forms of decoration is a feature also of the *Christi autem* page in the Book of Kells [2].[40] Its designer controls his ebullient ornament by means of the powerful boundaries of his grand display letters, in the tradition founded by the master epigrapher of the Durham Gospels, but the energy of his patterns goes out beyond the letter forms themselves, with the same wonderful exhalation of lobes and circles used by his contemporary, the engraver of the Shanmullagh, County Armagh, fragmentary book shrine.[41] Exquisitely, at the top right of the page between the out-reaching prongs of the 'Chi', the surging spinning discs and trumpet forms straighten and turn first to slender threads which criss-cross to form a delicate web which at its top and bottom becomes the

12 *Detail of surviving roof finial from lost house-shaped shrine,*
St Germain-en-Laye, Musée des Antiquités Nationales. Gilt bronze

outline of the neck of a profile bird's head. Another interpretation of the trumpet-spiral motif which keeps within its spirit and yet breaks the conventional barriers is the raised cast decoration of the roof finials of a great metal shrine now in the French National Museum at St Germain [12], worthy of St Columba and of Iona at the height of its pre-Viking prestige.[42] At the centre of six loosely disposed roundels are flickering leaf-like motifs. The roundels themselves have deep wide rims, built of matted concentric cords which after six revolutions sprawl out into the thick bodies of snakes, the trumpets of trumpet-spirals transmogrified. As a final lesson in the variety revelled in by the Insular style, the snakes, which either bite one another or are bitten, have heads viewed from above, or in profile, or full face, and among these heads are those of short billed birds like parrots or puffins, a prick-eared wolf, men as if asleep or entranced, and monstrous dragons with gaping jaws. The effect of the design of the St Germain plaques is of bubbling mud and crawling reptiles, the very epitome of the horrid; in the contemporary Book of Kells, however, eared serpents abound in much less sinister contexts. As well as using the bird-beast tangles of Lindisfarne, Kells devised a new kind of animal ornament [2], consisting of swathes of long limbless creatures, their heads seen from above with their two eyes fixed on ear-like flanges and their bodies ending in a broad spiky fishtail. These coiling heaps of snakes are very formally arranged on the model and grid of interlace medallions, and where they form the base and cap of the great initials, as on *f. 130*, they function as large accumulations of spirals formerly did on the terminals of initials in the Gospel Books of Durrow and Lindisfarne.[43]

Decorative Experiments

While the compass provided the basic structure of interlace and spirals, the ruler and set-square also were employed in Insular design to lay out grids for chequer, key- and fret-patterns, which from small and mysterious beginnings became the dominant component of several Insular works of art. The dazzling miniature carpet patterns on the Sutton Hoo shoulder clasps [6, 7] are based on cloisonné cells, step-sided, and running on from one to the next, covering the field with alternating coloured infills which can be read vertically or diagonally.[44] Step-patterns of this kind are taken up by the Insular book painters, in panels of ornament on the cross-carpet page opposite St Luke's Gospel in the Book of Durrow[45] and later forming the borders of a picture of David as saint and warrior, in a copy of Cassiodorus's commentary on the Psalms in Durham Cathedral Library [13]. Step patterns are also among the repertoire of motifs in great initial letters of the Echternach Gospels (Paris, BN MS. lat. 9389).[46] The grandest of the imported Roman silver in the Sutton Hoo burial, the Anastasius dish, displays in one section of a band of ornament, a running pattern based on a repeated swastika.[47] The same type of decoration occurs frequently in the borders of Roman mosaic

13 *Cassiodorus*, Commentary on the Psalms, 'David as Warrior', *Durham Cathedral Library MS B.11.30, f. 172v*

floors, and differently organized can straddle out across an entire floor.[48] On *f. 2* of the Book of Durrow, the wide border framing the four Evangelist symbols grouped around an interlace cross has the cubic look of floor tiles, but the border of all these cubes consists of a narrow continuous band, folded in and out as it makes its steady maze-like journey diagonally up the page.[49] A similar narrow band makes an angular extension, like folded linen, around the projecting terminals of the two armed cross on *f. 1v* of Durrow, the turns of the outer band repeating but enlarging the tiny 'T'-shaped motifs, borrowed from enamel work, at the junction of the cross-arms.[50] The device of a ribbon, folded over and laid parallel to itself as it sets off in yet another direction is raised to penitential solemnity in the horizontally and diagonally projecting green crosses which lock into place the boldly coloured Eagle symbol of St John in the Gospel fragment, Corpus MS.197B, *f. 1* [14]. The rectangular space of the carpet page on *f. 138v* of the Lindisfarne Gospels is similarly penetrated and segmented by turning angular forms, the lesser motifs overlaying a steady repeat pattern of tesserae, each containing a bent key-pattern like those on *f. 2* of Durrow but multiplied and elaborated with vivid changes

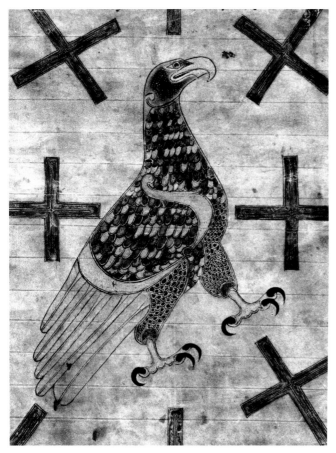

14 Imago aquilae (detail), *Corpus Gospels, Cambridge, Corpus Christi College MS 197B*, f. 1

Passion in St Matthew's Gospel.[56] Curiously, the Barberini and St Petersburg Gospels, which take infinite pains with their varied panels of fine interlace, ignore the developed fret motif altogether.[57]

While dragons and snakes more than keep their place in the repertoire, in the 8th century the Insular menagerie, already modified by the more detailed naturalistic treatment given by the Lindisfarne artist to the feet and heads of his interwoven animals, opened itself up to embrace many other animals, derived from many different sources. Even in the fine drawn gold filigree threads of the Derrynaflan paten [17, 18] we get a real sense of the natural form and proportions of dogs, lions, a stag, and the mythological griffin.[58] Dogs with puppy-like vitality bound across panels in the margin of the David as musician miniature in the Durham Cassiodorus.[59] The confronted puppies at the base of the left column in the equivalent page of the Vespasian Psalter lift their paws in mutual salute but are wholly naturalistic in outline, as also are the hare and stag housed among the initial letters of Psalm 68.[60] With the development of the historiated initial – a purely Insular invention whereby pictorial matter illustrative of or at least relevant to the adjacent text is employed to fill the space within a large initial letter – some of the naturalistic animals

of colour.[51] The dynamic patterns produced when such squat key-pattern blocks are, as it were, lifted from the background into the foreground of the design, forced to occupy new spaces, either curved or bounded by strong vertical lines, are splendidly displayed in the cross-slab inscribed with the name of Berechtuine at Tullylease, County Cork, a cross-carpet page in stone [15].[52] Another effective new design, less key than fret, featuring a triangular zigzag format suspended on either side of a strong continuous vertical or horizontal line, like cascading bundles of short chopped sticks, or barbed wire, is the *Leitmotif* of the borders of the Lichfield Gospels.[53] There, the light strands are set off vividly by a darker background, and the full potential of the design can be seen in the great cross-carpet page on *f.* 126v of the Gospel Book from Echternach, now in Augsburg [16].[54] The elegant sophistication of this design makes Tullylease look almost Durrowesque, by comparison. The same motif makes another rare appearance in stone sculpture, in one of the architectural friezes at Breedon-on-the-Hill.[55] In the Book of Kells fret is regularly employed, from *f.* 1 onwards, in, for example, architectural contexts; the square and circular capitals of the canon-tables, the arch over the 'Arrest of Christ' miniature [22], and notably the frames around the texts relating to Christ's

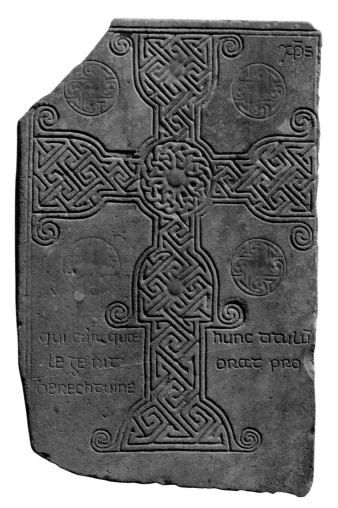

15 *Cross-slab, Tullylease, County Cork. Stone*

16 *Cross-carpet page, Augsburg Gospels, Augsburg Universitätsbibliothek Cod. 1.2.4.2, f. 126v*

representation appears, oddly enough, in the Lindisfarne Gospels where a profile head is poised on the curved lower terminal of the 'C' of *In principio* on *f.* 211, as an alternative to little spiral discs or beaked birds' heads.[65] On the Derrynaflan chalice large oval human faces, placed sideways at either end of a filigree panel, might conceivably carry a Jonah connotation since their chins rest against the open mouths of dragons, as if being swallowed or disgorged.[66] A human head suspended between dragons, or birds' jaws is a familiar motif in Insular metalwork, as in the pin from Grousehall, County Donegal, where the dragons have embossed amber eyes.[67] A more significant development found on the Derrynaflan paten is the panel featuring two full-length figures, placed back to back in a bed of interlace like their animal counterparts, the interlace in this case being the men's pigtails and beards [17]. The men's function is probably decorative even

17 *Filigree panels, detail of rim of paten, Derrynaflan, County Tipperary. Silver, gilt bronze, gold wire, enamel*

which are introduced to Insular book illustration have that intellectual content and justification, as for example the wolf and crane in the initial to Psalm 101 in the Salaberga Psalter or the fly, alluding to Beelzebub, Lord of Flies, in an initial to Matthew 12, 24, in the Book of Kells.[61] But the margins of the Book of Kells bring to a climax the trend towards representing, for purely decorative purposes, separate, well-realized animals, mostly domestic or otherwise accessible, though naturalism does not inhibit their brilliant metallic colouring.[62]

Alongside the multiplication of decorative animals in the filigree ornament of the Derrynaflan paten and the margins of the Book of Kells, another sign of the widening scope of Insular ornament is the introduction of the human figure into the decorative repertoire. The human figure had of course appeared much earlier in overtly decorative contexts, as in the frontal man between wolves or lions appliqués on the Sutton Hoo purse cover, and in the repeat pattern of pairs of dancing warriors on the helmet,[63] but there, as in the hanging-bowl mount from Myklebostad, where a boldly featured male head projects above a small stylized body decorated with 'L'-shaped enamel cells,[64] the figures probably served a more substantial, iconic, purpose. The first hint of a throwaway, decorative, intention in a human

18 *Paten, Derrynaflan, County Tipperary*

though their crouching pose rather suggests bound prisoners or gaunt ascetics.[68] The visual analogy of paired, confronted, entangled animals drew Insular designers at a comparatively late stage in the development of the style to construct fantastic whirligigs, knots, and tangles of human figures, as for example in an open-work disc brooch from Togherstown, County Westmeath, and similarly replacing spiral ornament in the roundels at the top and base of the curved joint of the *Initium* initial in the Book of Kells, *f.* 130.[69] Confronted men entangle with one another's extremities at the top of the *Quoniam* initial, *f.* 188, where a larger reading of the iconography of the initial suggests sinister implications, as also with the naked man who squats halfway down the finely threaded animal tangle in the central column of the first canon-table in the Barberini Gospels.[70] The evolving conventions of the style, however, are simply displayed in the integrated profile men-and-bird pattern which fills the columns of the canon-tables on *ff.* 1v and 2 of Kells, where in the days of Lindisfarne a queue of birds only was thought appropriate.[71]

The Tree of Life

In the drawn and coloured framing panels of the Durham Cassiodorus, as in the strips of filigree ornament on the Derrynaflan paten, the single or paired animal figures are bedded down on an amazing fine swathe of their own extended tongues and ears. In its mature phase Insular tangled-animal ornament shows two opposite developments. In the one the animals put on more substance and naturalistic detail, such as the shaggy fur attached to the flanks of the interwoven beasts on the base of the Rothbury Cross;[72] in the other, the whole structure of the interlace lightens, the animals' attenuated tongues and extremities blending into a frail cobweb across the decorative surface, as in the Witham pins.[73] A new mannerism appears in the Durham Cassiodorus, namely one of the slender lines extending from tongue or ear actually penetrates the animal's body like thread drawn by a needle through cloth. Although the 8th-century southern English gospel-book known as the *Codex Aureus* (and now in Stockholm) shares this trick of penetration, the tendrils which encompass the limbs and bodies of the many trim mammals in the *Christi autem* page of the *Codex Aureus* are more like the natural thicket amongst which they feed.[74] This move to give a natural habitation to the beasts is linked to the wholesale invasion of Insular art proper by the Late Antique motif of the 'inhabited vine scroll' symbol of the scriptural 'Tree of Life', first adopted in classicizing monumental stone sculpture such as the Ruthwell Cross.[75] In the canon-tables of the Cutbercht Gospels the birds no longer queue up and worry one another as they do in the old biting beast tradition still active in the Lindisfarne Gospels and the 'Tara' brooch, but perch one above the other on an undulating vine scroll, turning their heads to feed on its fruits.[76] Birds similarly feed on the vine in the left margin of the *Christi autem*

19 *Front cover of the Stonyhurst Gospel. Leather, moulded over string*

page in the Barberini Gospels. Leaves and berries spring out at the terminals of neat panels of interlace in the Barberini Gospels, even where the strands are really the tails of a beast or bird. Foliate tendrils also straggle over the bands of display letters, giving the Barberini Gospels' pages a touch of romantic desolation.[77] Insular foliage takes many forms. The formal plant design embossed on the red leather cover of the copy of St John's Gospel found in St Cuthbert's coffin shows two wiry 'S'-shaped branches springing from a short stem and ending with large penny-like discs [19].[78] The budding branch held by the hieratic figure of St Luke on p. 218 of the Lichfield Gospels is more a blacksmith's idea of foliage than a botanist's.[79] A plant design much favoured in Insular sculpture and metalwork, and subsequently in book painting, has long leaves, broad at the base and coming to a sharp point, with two discs or round fruits attached to the stem, just below the leaf. An elegant example of this plant fills the upper part of the 'B' of *Britannia* prefacing the St Petersburg copy of Bede's *Ecclesiastical History*.[80] A gracefully flowing vinescroll is fitted in adjacent to the muzzles of the two flat gold beast-head terminals of 'Chi' in the *Codex Aureus*'s *Christi autem* initial. Fantastic foliage with wiry interwoven stems and orchid-like flower heads is experimented with by the sculptors of the Hexham and Bewcastle crosses[81] and the painter of the Barberini Gospels. In the Gospels the stems of

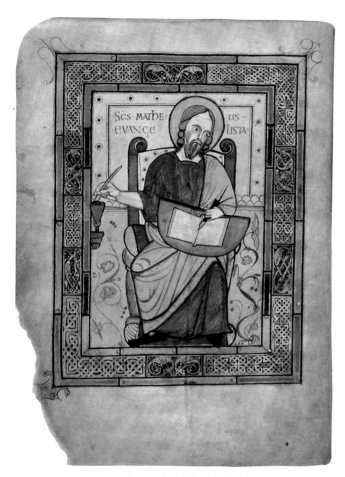

20 *The Evangelist St Matthew, Barberini Gospels, Vatican,*
Biblioteca Apostolica MS Barberini Lat. 570, f. 11v

the exotic shrub at the left of the St Matthew portrait page, *f.* 11v
[*20*], lurch stiffly to and fro as they progress upwards, and a
similarly artificial, chevron-like pattern is formed by the plant
stem on the side panels of the Abercorn cross-shaft.[82] Stiff zigzag
plant stems occur also in the Book of Kells, projecting from the
chalice at the bottom right panel of the *Christi autem* page [*2*].[83]
Many of Kells's plants swell up out of chalices or jars, and display
the familiar pointed leaf with berry appendages and the big blank
penny like discs [*22, 217*]. However, Kells invents its own fantastic
foliage form, hard to parallel, bunches of short fat sprawling
leaves which fan out, each with a rounded tip, like a balloon. The
hand-like spread of chestnut leaves might have suggested the
general form, but not the stocky solid effect.[84] Throughout Insular
art plant forms are calculated and manipulated, art building on
art, never on nature.

Frames

In the Sutton Hoo shoulder clasps [*6, 7*] the continuous rectilinear
ornament of the main field is admirably cut off by the more
scattered fluent animal tangles set in a broad frame on all four
sides. In Sutton Hoo also the vigorous concentric patterns of the

hanging-bowl escutcheons are completed and sealed in by a wide
hatched and textured frame. Inherent native tendencies,
therefore, do not contradict the design principles which the
remains of Roman mosaics with their wide strap-work or key-
patterned borders will have presented to their 7th-century
observers.[85] Books with pictures in them imported from the
Continent seem likely to have underscored the importance of
the frame, judging from the attention paid to frames in such
representative early books as the Vienna *Dioscorides* and the
Rabbula Gospels.[86] The Evangelist symbol and carpet pages in
the Book of Durrow might appear at first glance to require no
explanation other than the directly inherited values of the Sutton
Hoo goldsmith, but the outside line of the frame of the eagle, the
calf and the lion [*24*] does not turn at a right angle at the top and
bottom corners but extends into a little thorn-like barb, and the
carpet pages have more extensive corner pieces, as if they were
brocades needing loops for suspension [*8, 9*].[87] The pictorial
models of the great Bible from Wearmouth-Jarrow, the *Codex
Amiatinus*, whatever precise form they took, provided their
copyists with many opportunities to consider the discipline
inherent in frames. It is controversial to what extent the prefatory
diagrams in *Amiatinus* displaying the different authorities'
ordering of the books of the Bible reflect the specific format of
imported models.[88] The precocious iconography and the grandeur
of the *tabulae ansatae* and other forms might seem convincingly
continental and metropolitan. A notable feature, however, of the
Septuagint (Hilary) diagram [*21*] is the tiny bud-like excretions at
the corners of the cross-shaped contents lists, and their strict
silhouettes are further softened by plant sprays. Heart and leaf-
shaped motifs are likewise attached to the flat or pointed bases
of St Jerome's and St Augustine's divisions of the Bible.[89]
Consequently we might see in the inability of the Lindisfarne
Gospels artist simply to turn the corner in the frames which he
designs around his Evangelist portraits[90] a response to an
impressive Antique reservoir of forms available for study at
Wearmouth-Jarrow. The book painter might on the other hand
be thought of as following the decorative ideas of the metalworker.
In sumptuous objects like the 'Tara' brooch the silhouette of the
jewel is broken by erupting body parts, linked heads and linked
tails, and the same release of energy at points where the design
changes direction is typical of the outline of Insular metal
shrines.[91] The Lindisfarne Gospels artist is a committed framer.
It is he who begins the process of hemming in his lines of display
letters with strips of ornament, though not yet joined up, in effect
turning his text pages into carpet pages.[92] Significantly the
designers of the Durham Gospels and the Corpus Gospels are
not yet at that stage of design layout, or reject it, but the custom
becomes universal, reaching its climax in the Book of Kells, and
subsequent Irish Gospel Books.[93] In Kells the projecting corner
pieces of the carpet pages and Evangelist portrait pages are like
great extra platforms or plinths to support the weighty structure
within the frame. Significantly again, the designer of the

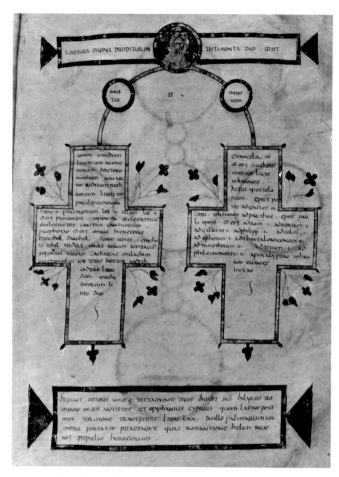

21 *Framed lists of books of the Bible, the* Codex Amiatinus, *Florence, Biblioteca Medicea Laurenziana MS Amiatinus 1*, f. VII

Barberini Gospels, Kells's contemporary, appears to be reacting against the evolved Insular tradition of massive frames and corner pieces, and after his first portrait, that of St Matthew [20], he reverts at the corners of his comparatively simple frames to tiny flower heads, in the spirit of the *Amiatinus* diagrams.[94]

Conventions of Depicting the Human Figure

The designer of the Barberini Gospels perhaps rather more widely exercised his selectivity than his fellow artists, but all of them make choices in their handling of the human figure within pictorial representations, and the flexibility of the Insular idiom in this respect is one of its most impressive achievements. From an early interpretation of the human figure in terms exclusively of the gold and millefiori appliqués and engraved gold foils of Sutton Hoo, exhibited in the St Matthew symbol of the Book of Durrow, freer draughtsmanship and genuine painting style, with a vastly extended palette, emerges in the Evangelist portraits of the Lindisfarne Gospels. Crisp hard lines and vivid changes of colour help create figures that are both fully humane and consort

naturally with the epigraphic showpieces that follow them. The challenge of matching figural representation and script has never been better met than in the Insular style, witness the minute gold and niello plaque, part of a lost book cover, from Brandon, Suffolk, which combines with perfect economy the head and shoulders of St John along with his inscribed name and qualifications.[95] The figure of the warrior David in the Durham Cassiodorus [13] has the same direct readability. Its designer borrows the figure's dignified pose and authoritative gesture from a Late Antique ivory relief,[96] but sensitively translates the draped human figure into the same flat colours and linear patterns as the wide panelled frames which enclose him. His form is simply laid out on a wider grid than theirs. The artist of the Barberini Gospels evidently had access to impressive models, probably panel paintings of saintly authors, seated in a landscape closed behind the figure by a boundary wall. He retains from his model the texture and drag of the drapery, the calm meditative expressions and to a remarkable degree the plasticity of shoulders, arms, wrists and hands.[97] This artist shows what Insular painting outwith the limits of the codex may have looked like. He may himself have been a traveller and have seen examples of continental mural art.[98] Panel painting suggests itself as the source of inspiration of the artist of the Book of Kells, for example in the miniature of the Virgin and Child enthroned with angels,[99] and in the figures of Christ and the Evangelists seen in sumptuously shafted niches. These pictures have an intense iconic quality, markedly different from the casual naturalism that the Barberini Gospels artist was pursuing. It seems certain that a wide variety of artistic propositions will have been placed before Insular artists by the contents of church or secular treasuries throughout Britain and Ireland.

There is a fixed convention, as seen in about half the surviving Insular Gospel Books, to represent the Evangelists prefatory to their Gospels in an hieratic frontal pose, with the body other than its extremities, head, hands, and feet, draped or covered in a highly schematized fashion. That this rejection of naturalism is deliberately intended to enhance the sacred status of the person represented is suggested by its application to, and perhaps origin in, Insular images of Christ crucified, for example in the Durham Gospels[100] where the mystic wraith-like figure of Christ wears a billowing *colobium* (robe). His arms and shoulders are striped as if tightly swathed in differently coloured bandages, while under his chin a pair of stole-like bands cascade downwards and loop over, their rhythm taken up by a series of layered segments whose repeat pattern reaches almost to the hem of Christ's tunic, which is itself striped vertically. The tendency to veil the sacred figure and aggrandize it by pattern does not carry with it uniformity of treatment. The artist who designed the Durham Gospels also designed the *Imago hominis* in the Echternach Gospels, with a totally different abstract formula, an inverted heart-shaped panel for the shoulders and arms, below which are two pairs of lobed motifs, one pair shaped like horseshoes, and the lower pair like mussel shells, either of which might have served to suggest the

bent knees of a seated figure, seen frontally, but which combined build the pose of the figure up too high to give much function to the throne-like structure which frames the figure.[101] Ambiguity as to whether an Evangelist stands or sits remains a factor in the Gospel Books which favour the hieratic non-naturalistic Evangelist 'portrait'. Like the Echternach/Durham artist, the artist of the Lichfield Gospels used two entirely different, but equally non-naturalistic, systems to describe the bodily presence of the enthroned Evangelists Mark and Luke. The Lichfield Mark started life as a standing figure, classically robed, with the presence of a Late Antique saint, but into the fall of the classical draperies is infiltrated hard bandage-like segments, and also a spiral, and a panel of key-pattern.[102] Luke, on the other hand, between the levels of his hands and feet, consists of two pairs of thick coiled bands and a central seam of arcs and vertical bars, fastening his legs together as if with a padlock.[103] Durham, Echternach, and Lichfield have their later devotees. The bundled up and bandaged appearance of the Durham crucified Christ is hardened by the Crucifixion page in St Gall, Stiftsbibliothek Cod.51[104] into an anthropomorphic version of the Sutton Hoo gold buckle, while the keyhole treatment of drapery in Lichfield's Luke has a queue of followers, in the Evangelist pages in St Gall Cod.51[105] and the Macdurnan Gospels.[106] The 'reversed horseshoe' motif in the midriff of Echternach's *Imago hominis* helps to explain the shorthand formula used to represent seated figures in the Book of Deer, an Irish abbreviated Gospel later owned by the community at Deer in Buchan, Scotland.[107] A marked feature of Insular formal figure composition is the connecting links made between figure and frame. From the Echternach *Imago hominis* onwards, the central enthroned figurative motif is tethered to the frame by various means, either a transverse bar at elbow level, or the crown of the head pressed against the upper frame. The Book of Kells, despite the sumptuousness of the settings in which it places figures, textile-laden thrones, curved apses, chalices and peacocks, is faithful to the tradition of the adhesion of figure and frame, bending its architectural construction to lock the contained figure on to the external frame.[108]

The poses of the Insular figures noted so far are frontal or three quarters, but Lindisfarne's trumpet blowing half-length angel of St Matthew is set sideways, his eye, however, large and almond-shaped, as if seen from in front.[109] The Book of Kells multiplies examples of this pose, with strongly featured men in profile, bust length, grouped in panels attached to the frame, and others full length, crouching like the filigree figures on the Derrynaflan paten [17], and others again standing, in the role of companions or captors of Christ in the 'Arrest' miniature [22].[110] In this picture the idiosyncratic Kells style of drapery is displayed to maximum effect, the mantles thick and baggy, with many of the 'lurks' rightly dreaded by later Scottish tailors or their clients, the legs as if trousered in the Scythian or Sassanian manner,[111] the hemline gyrating with a life of its own. Heavily draped figures within a richly decorated interior appear in the David with his

22 *'The Arrest of Christ', the Book of Kells, Dublin, Trinity College MS 58, f. 114*

musicians miniature in the Vespasian Psalter,[112] and point to possible antecedents of the Kells style, but none of the Psalter figures have profile heads. Men in profile, with strong features, take a dramatic part in the exotic, and the mysterious native, narratives on the Franks Casket [23],[113] and it may be that in Kells the profile figures who crowd together as witnesses of events or themselves play active roles are symptoms of a tradition of narrative illustration of which little remains in the canon of the Insular style, as conventionally presented.

Insular Sculpture

In describing the general character of the Insular style it is inevitable that most examples have been selected from metalwork and manuscript illumination. The synthesis came about through the interaction of these arts and students of sculpture, particularly in its earliest phase, find their comparanda there. Later the relationships between the media changed and sculpture took on its own role in the developing repertoire. The term 'Insular sculpture' has never had general currency and indeed it has been

23 *Romulus and Remus panel, left side of the Franks Casket. Whalebone*

said that what strikes one most about the sculptural traditions of early medieval England, Ireland and Scotland is how different they are.[114] This view can be sustained at a superficial level on the basis of the discrepancy of the regionally predominant formats. The ringless free-standing cross is favoured by the English, the ringed free-standing cross by the Irish, and the cross-slab by the Picts [49]. The nature of the figurative styles has also been regarded as discrepant. Nevertheless all three traditions used the repertoire of Insular ornament as described above, and all shared the format of the small scale cross-marked pillar-stone or slab, manufactured side by side with the more ambitious monuments.

Whatever the chosen format, the principal function for Insular sculpture was to display the cross publicly. The comparatively intractable medium and the scale of the enterprise inevitably led to some adaptation of motifs, but as remarked earlier, Insular designs were readily expandable. Small-scale cross-slabs could display the simplest of linear crosses but even these appear with terminal embellishments drawn from the curvilinear or geometric repertoire. Slabs at Glencolumbkille, County Donegal, repeat in stone motifs that are used in the glass and enamel studs set in contemporary de luxe liturgical metalwork.[115] Others, for example the slab at Killorglin, County Kerry, display incised crosses within frames readily relatable in layout to the carpet pages of manuscripts, even to the inclusion of corner elaboration.[116] The widely used 'outline' type of cross, where the height and breadth of the cross are delineated, may have a connection with similar Mediterranean slabs. Often the cross is left undecorated, although it may have terminals softened with curves or key-patterns, and an inscription, for the majority of such slabs are funerary or supplicatory; the Northumbrian name-stones are of that kind, some so small that they give the appearance of stone books, each as it were a *Liber vitae* inscribed with the name of the

person to be remembered.[117] Some of the large-scale free-standing crosses and cross-bearing slabs are also left comparatively plain. A recent study has drawn attention to the extent of this genre in Ireland, and there are notable examples of the type at Wearmouth-Jarrow in Northumbria and Whitby in Yorkshire.[118]

The 'outline cross', like its counterpart in the display initials of the manuscripts, which often increase their decorative potential by splitting their structure into separate strands and panels, offers discrete areas for decoration, whether within the body of the cross on a slab or on the surface of a free-standing cross. The cross-head, divided into the upper and lower arm, the horizontal arms, the crossing and the shaft, were all available for filling with various abstract ornaments. Trumpet spiral ornament is displayed with great bravura on the ringed cross at Ahenny, County Tipperary, on the cross-head of the north Cross and on the shaft of the south Cross, and there are brilliant panels of spirals on the St John's Cross on Iona.[119] Such spiral-work is rare in Anglo-Saxon sculpture but the panel at South Kyme, Lincolnshire, only recently fully published, shows that spirals were making their way into the repertoire of architectural sculpture and sculptured church furnishings in the Midlands, and the more staccato pelta patterns on friezes at Breedon-on-the-Hill are examples of the same taste. The designs at Ahenny are carved in a technique modelled on metalwork chip-carving, and the spirals recall the discs of spiral-work on the hanging-bowl escutcheons described earlier. Whether the purity of the Ahenny designs represents an early, Durrowesque, phase in the production of sculpture, or a later masterly revival in response, say, to some revered metalwork model, is much disputed.[120]

The earliest stone-carved interlace surviving in Britain, unless one accepts a very early date for the round shaft at Reculver in Kent, is probably the fragment of fine-strand circular interlace on

the closure screen at Wearmouth (founded 674). The cross-slab at Fahan Mura, County Donegal, with a cross on both its east and west faces, has thick-strand interlace, with grooved rims to the strand, giving a marked resemblance to the simple matted interlace of the carpet pages of Durrow, although again a late return to the Durrow manner, as in the decoration of the 9th-century Macdurnan Gospels, is arguable. The north Cross at Ahenny covers the cross-head with fine ribbon interlace, and the same rippling and undulating cords and knots clothe the shafts of the sculptured crosses from Easby and Rothbury. As the contrasting ground-work for raised interlace and spiral bosses the sculptor of the south Cross at Clonmacnois uses the angular rhythms of key-pattern. The sensitive use of this motif on the slab at Tullylease, County Cork [15], has already been mentioned. In Northumbrian sculpture, on the other hand, it rarely appears – a curious fact, since it is freely used in the Lindisfarne and Lichfield Gospels and is not difficult to carve, lending itself to mass-production, as in the limited repertoire of Welsh sculpture of this period.[121]

Durrowesque animal ornament expressed in stone survives at Wearmouth in Northumbria and Hackness in Yorkshire.[122] More specifically Germanic animal ornament, comparable to the dragons' heads on the Sutton Hoo purse cover decorates the 7th-century fabric of Wearmouth. Lindisfarne-style animals feature on the Bealin cross, County Westmeath, and in a developed form on Lindisfarne itself.[123] As noted above, the fragment of a cross-shaft from Aberlady is well known as a close parallel to the bird ornament used in this phase of book painting. Later the favoured animal type in Insular art, naturalistic confronted pairs of dog-like animals, and later again single or confronted bipeds whose hindquarters merge into interlace, appear in ivory carving on the Gandersheim Casket [44] and in large scale stone sculpture on a cross-shaft fragment at Elstow, Bedfordshire.[124]

Imported, and possibly even surviving Romano-British sculpture encouraged the development of the vinescroll motif, first in Northumbria whose earliest plastic art is dominated by it. These decorative foliate forms were from the start charged with symbolic meaning, the vinescroll as it climbed up shafts and borders being inhabited by beasts and birds feeding on its grape bunches, signifying the nourishment of the Christian soul by the Eucharist. Within Northumbrian sculpture the inhabited, and the uninhabited vinescroll as at Hexham, developed in separate ways and in the rest of the Insular world different modes of depiction evolved. To share a theme but to vary it is typical of Insular sculpture and of Insular art generally.[125]

At the initial planning stage all the visual media depended on two-dimensional design. Thereafter the various forms of art went their separate ways. An important device in stone sculpture, already achieved in metalwork through casting or appliqué settings, came about by an increase in practical skills. Varying height of relief became the means, *par excellence*, of articulating surfaces and structuring designs. The sculptor was able to plan for raised bosses at points he wished to emphasize, the crossing, the arms, or elsewhere. Bosses could be conical, hemispherical, or wreath-like, and were themselves prime locations for the display of ornament, spiral sworls, heaped interlace, and in late spectacular examples in Ireland and Iona interlace was 'animalized' by treating the mesh as the bodies of snakes. Because bosses were by nature prominent, standing out on a flat bed of ornament, as we see them at Ahenny, they were particularly suitable for expressing the ubiquitous Christian number symbolism. Arranged in a group of five as at Irton, Cumberland, they could stand for the five wounds of Christ.[126] Groups of seven would bring to mind the seven gifts of the Holy Spirit or alternatively the seven loaves of the Gospel miracle of loaves and fishes. There were endless opportunities for enriching the visual imagery by such implicit numerical references.[127]

We have already considered the question of figurative representation in the manuscript art of this period and have emphasized the ability of Insular artists to move freely within a wide range of options, depending on the response they were inclined to make to their immediate model and the character and function of the work of art they were creating. The 20th century's recovery, through the sensitive eyes of its own artists, of conventions of depicting the human figure drawn from other traditions than that of western 'naturalism', has broken that boxed-in opinion, taken for granted by 19th-century critics, that Insular artists were fluent decorators but were embarrassingly weak at figures. In addition, the serious study of the deep psychic changes at work in representational art in the Late Antique/early medieval period, traced for example by Kitzinger in *Byzantine Art in the Making*, has opened minds to the expressive intention of various different modes of depiction. Certainly various different modes of depiction are displayed among the surviving monuments of Insular stone sculpture, the stately classicizing figures on the Ruthwell Cross, the chunky cut-outs on St Martin's Cross, Iona, the figures with ovoid heads, drilled eyes and angular ribbed drapery on the Rothbury Cross.[128] Genre affects style, and the muscular realism of the arm of Christ crucified on the same Rothbury Cross is different again. The typical Irish formula of frontal groups of two or three persons carved in a hard, precise manner on rounded forms has a kind of ritual integrity, but Irish sculpture finds other methods, softer portrayals in profile, such as the touching depiction of a 'refugee' family on a panel on the north face of the High Cross at Durrow, where the mother has her baby strapped to her back, and is ushered along by an apprehensive father.[129] The visual means serves the artistic purpose. In the matter of figurative art, in all the media, Rosemary Cramp is undoubtedly correct in maintaining that Insular art is not 'monolithic'.[130] When we turn to the work of Pictish sculptors, we will see that it is not only the easy authority and abundance of their handling of the canon of ornament, but also their peculiar agility in utilizing the human figure in a multitude of situations, that puts them at the heart of the Insular achievement.

Map 2

An Insular network: a selection of sites in Ireland and Britain associated with works of art which share specific aspects of the Insular repertoire

Papil
St Ninian's Isle

Knowe of Burrian

Skinnet
Ulbster
Ballachly
Golspie
Kincardine
Portmahomack, Tarbat
Shandwick
Hilton
Burghead
Sittenham
Nigg
Kinneddar
Raasay
Applecross
Forres
Elgin
Old Deer
Grantown
Dyce
Canna

Kirriemuir
Meigle
Aberlemno
Lethendy
Brechin
Dunfallandy
Cossans
Logierait
Rossie
St Vigeans
Iona
Dunkeld
Wester
St Madoes
St Andrews
Fowlis Wester
Gask
Dupplin
Dunadd
Forteviot

Govan
Hunterston
Lindisfarne

Carndonagh
Kildalton
Whitecleugh
Rothbury

Glencolumbkille
Fahan Mura
Camus
Loughan
Anwoth
Ruthwell
Bewcastle
Jarrow
Hexham
Monkwearmouth
Grousehall
Clonmore
Ormside
Easby
Whitby
Shanmullagh
Hackness

Togherstown
Donore
Castletown
Bettystown
Flixborough
Kells
Clonmacnois
Ballinderry
Bawtry
Banagher
Bealin
Durrow
South Kyme
Kilmainham
Repton
Breedon-on-the-Hill
Moone
Peterborough
Derrynaflan
Lichfield
Fletton
Brandon
Ardagh
Ahenny
Tullylease
Sutton Hoo
Killorglin
Ipswich

Gloucester
Beckley

Windsor
Canterbury

0 100 kilometres

0 60 miles

2
Pictish Participation in Insular Art

Shared Values and Relative Chronologies

The level of Pictish participation in early Christian art in Britain was made controversial by the former Director of the Scottish National Museum of Antiquities, R. B. K. Stevenson, who regarded the manuscript art of the Book of Durrow [24], itself independently founded on metalwork precedents, as the specific source of modes of design and representation in a number of successive Northumbrian-Irish Gospel Books, pushing on into the 8th century. Only when this manuscript art and its conventions were fully formed did the animals incised on Pictish field monuments make their appearance, in direct response to manuscript models.[1]

Stevenson was not prepared to consider that, unilaterally, the Picts had achieved representation of animals, even though the Irish, in the fish in the *Cathach* (Dublin, Royal Irish Academy MS.s.n.), and the Anglo-Saxons, on the Sutton Hoo purse cover, had done so. The Sutton Hoo hanging-bowl minnow, and the stylized stag from the top of the whetstone sceptre, are animals not from the Anglo-Saxon menagerie and are at least of debatable origin, so the question of North British animal art is deeper than Stevenson allowed.[2] He considered that the calf (*f.* 124v) and lion (*f.* 191v) of Durrow were 'quite possibly by the same artist', and he closely connected their designs chronologically, seeing the tilted upright scroll on the lion's shoulder and the framing panel on its chest and throat as a loose interpretation of the 'trumpet' vents on the shoulder of the calf. Whereas the calf's 'trumpets' fit neatly together, they have broadened and been slung across the lion's chest, and a little curl within the shoulder is all that remains of the calf's large spiral motif. Turning to the extant Pictish animal designs incised on field monuments, Stevenson regarded the curl on the shoulders of the Burghead bulls [25] and the Dores boar [26] as belonging to the same drift away from the compact trumpet-spiral construction of the Durrow calf, a process of atrophy signalled first by the Durrow lion, and established in what he asserted was its canonical form, in the calf symbol in the Echternach Gospels [27]. The scrolls which mark the bodies of the Pictish animals and of the various Evangelist symbols in the manuscripts were for Stevenson a 'period mannerism' truly belonging to the vocabulary of the scriptorium, not to be differentiated from the decorative scrolled forms of animal and human hair in Gospel Book illustration, including the hair of the man looking from behind the curtain in the St Matthew portrait page of the Lindisfarne Gospels! So the Pictish animals, the Burghead bulls, the Grantown stag [28], the boar of Dores and the

wolf of Stittenham, Ardross [29], post-date the Echternach Gospels calf and take their formal vocabulary directly from it, but with 'an increased naturalism' supplied by 'an exceptionally observant artist'.[3] This sudden, unaccounted for, spurt of talent on the part of a Pictish artist, presumably of the first half of the 8th century, seems no less gratuitous than to allow such artists to have existed at the pre-manuscript stage.

Stevenson's analysis of the shoulder scroll of the Durrow lion in terms of the trumpet spirals on the calf is inadequate; it pays no

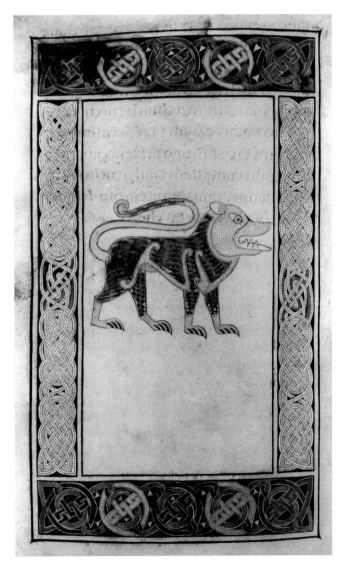

24 *Lion symbol, the Book of Durrow, Dublin, Trinity College MS 57, f. 191v*

25 *Incised sculpture of bull from Burghead, Moray. Sandstone*

26 *Incised symbol of boar (fragment) from Dores, Inverness. Diorite*

regard to the sprawling coat-hanger-like motif which marks the groin, belly, and the left side of the lion's foreleg and shoulder. A comparison with the Dores boar or the Stittenham wolf shows that the purpose of these scrolls, equally with the one at the front of the shoulder, was to convey, by expressive stylization, the thrust and dimension of the animal's body. The curl on the shoulder of the lion of Durrow drifts towards a merely applied trumpet spiral pattern, failing to describe the muscularity of the shoulder. The lion's foreleg has withered, and the scroll at the right, instead of framing the shoulder, has slid forward on the nape of the neck, like a harness. The Durrow design, conceived as interlocked flat slats of enamelled metal, has its own validity, but the original elements of the design are seen in their authentic relationship in the springy upright shoulder scroll and separate curved dewlap of the Stittenham wolf. The curved cheek, scroll ear, open mouth and lolling tongue of the wolf are copied in the manuscript, but given a different proportion to the body as becomes the notion of a great-headed lion. Mistakes as well as choice are evident in the Durrow design. The genitals of the beast are oddly nipped by the framing line of its belly, and the corner of its elbow, instead of being outlined, dimensionally, against the hinder shoulder scroll and chest panel, merely exists as the area beyond the curve of the scroll. The calf of Echternach similarly drops its elbow below the corner of the body marking [27]. The other elements of the design are more correct by Pictish standards – the furrow or scroll beyond the cheek, under the ear, and the relationship of the throat panel to the upward scroll in front of the shoulder. The outline of the back, lifting over the bones of shoulder and haunch, is true to the sensitive draftsmanship of the Pictish sculpture. The several big spaces shaped on the page below the animal's head, belly, and

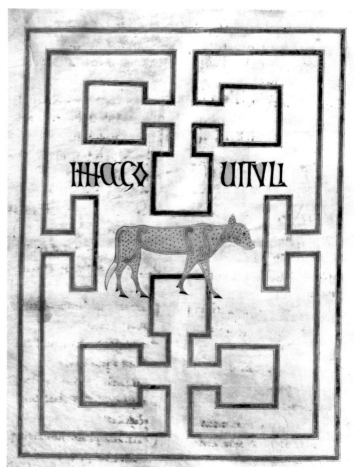

27 *Calf symbol of St Luke, Echternach Gospels, Paris, Bibliothèque nationale MS lat. 9389, f. 115v*

legs, agree perfectly with those cut out by the incised bodies of the Pictish animals. In the manuscript, the ink lines constructing the calf are uniform, like a methodical tracing, whereas in the sculptures, notably in the wolf, varied pressure gives an extraordinary dash and grace to the design. The decorative conventions of the scriptorium, too, rob the body markings of their naturalistic function and animation. The Echternach calf is merely segmented, each section outlined with dots and filled with an all-over pattern of triple dots, like those beside the 'N' of *Quoniam* on *f.* 139 of the Lindisfarne Gospels.[4] The proposition that the Pictish animals, from the Burghead bulls onwards, derive from the Evangelist symbols at the Echternach Gospels stage is like saying that lost profiles and tilted foreshortened heads in the Egerton Genesis or the M. R. James Psalter are the sources of these features in Italian trecento painting.[5] The coherence of the design, the measure of creative intelligence behind it, the necessary quality of spontaneity and intention, indicate where it originated.

In this discussion of priorities, an essential document ignored by Stevenson is the symbol of the Evangelist St John on *f.* 1 of the fragmentary Gospels in Cambridge, Corpus Christi College MS.197B [14].[6] Exactly the same artistic principles hold good in the layout of the eagle page as for the Echternach calf. The figure of the animal is held at bay, as it were, by crosses which stretch out

28 *Incised sculpture of stag and 'rectangle' symbol from Grantown, Moray. Mica schist*

29 *Incised sculpture of wolf from Stittenham, Ross & Cromarty. Sandstone*

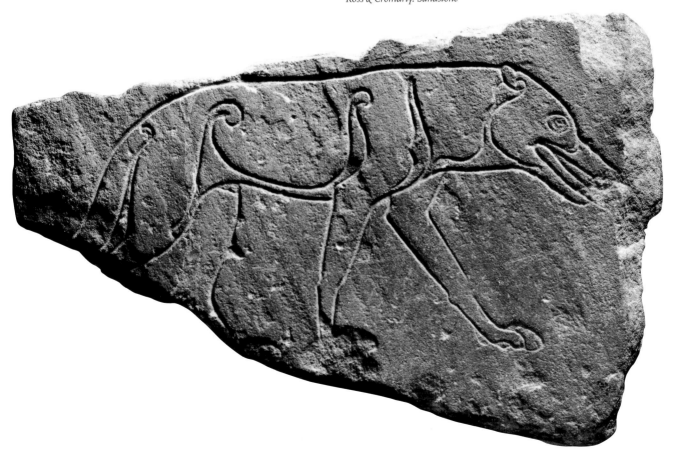

towards it from the plain open border frame. Whereas the calf is small and meek, not larger than its caption, *imago vituli*, the eagle, set diagonally on the page, is large and fierce, dappled with the 'primitive' green, red and yellow (verdigris, red lead, and orpiment) of Durrow.[7] Read as linear design rather than miniature painting, it is recognizably the same depiction of a raptor as that which was cut by a Pictish sculptor on a slab from the Knowe of Burrian, Birsay, Orkney [30].[8] The legs set widely apart, the outspread claws with their hooked talons, the mushroom-shaped cap where the leg enters the baggy *tibia* – these features are identical in the miniature and the Pictish sculpture. The great shoulder scroll, diagnostic of this series of Pictish animals, occurs in both eagles, but with a significant difference. In the Birsay eagle the scroll describes the projecting breast of the bird, and also divides the breast from the mantle and wing. In the miniature the scroll is shifted, so that it represents only the folded wing. Various divisions are introduced on the body – one part repeating the small lizard-skin treatment of the *tibia*, another part, between the legs, carrying the large scale-like feathers of the neck and wings. A button-like motif breaks into two the broad decorative scrolled

30 *Incised sculpture of eagle, Knowe of Burrian, Birsay, Orkney. Sandstone*

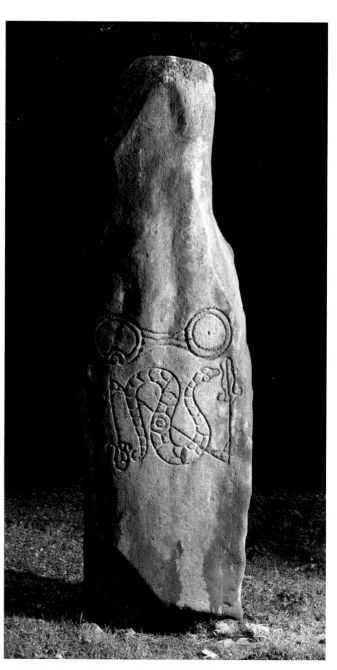

31 *Incised sculpture of serpent and 'notched double-disc symbol', Newton, Aberdeenshire. Gneiss*

frame of the main plumage, undivided in the Pictish example. In the Pictish eagle three great wing feathers sweep back, interlocked, and the scrolled rump of the bird holds them in place. In the miniature the rump is oddly omitted, replaced merely by another delicately hatched quill, broader but otherwise identical to the four wing feathers above. Just as the wolf of Stittenham makes more anatomical sense than the lion of Durrow and the calf of Echternach [29, 24, 27], so the eagle of Birsay looks artistically coherent and economical, in a way that the eagle in Corpus MS.197B does not, while eminently sharing all its elements of 'naturalism'. In the process of transmission, from the symbol stone to the Gospel Book, errors and over-elaboration have been introduced.

It was not part of Stevenson's methodology to explain or even hint at the cultural circumstances in which the linear conventions of manuscript illumination, from Durrow (which he dated, conventionally, to c. 675) onwards, were made accessible to, and found advantageous by, the sculptors of the early Pictish field monuments, notably those of the Ross & Cromarty and Moray areas. Stevenson's derivation of the Pictish incised animals from the comparatively mature stage of Insular illumination represented by the Echternach Gospels either makes some, at least, of the incised sculptures with their comparatively limited repertoire and total lack of interest in framing motifs, contemporary with the more elaborate sculptures in relief, which emphasize the Christian cross and the frame; or else delays the

emergence of elaborate relief sculpture in Scotland, opening a chronological gap between Northern Britain and the rest of the British Isles. A time-span starting earlier, accommodating Pictish art into the full gamut of Insular art from the origins of the Durrow style onwards, might seem preferable.

The incised symbol stones, everywhere from the extreme north of Pictland to the south, show that Pictish sculptors, by training and temperament, possessed the requisite calligraphic skill to exploit all the components of the Insular art repertoire. The serpent with 'sleek enameled neck'[9] in the serpent and Z-rod symbol at Newton in the Garioch, Aberdeenshire, writhes on the centre of the stone, leaving long lobed spaces, one open upwards, one downwards, between the turn and twist of its body [31]. The same feeling for linear rhythms and the value of the voids as well as the solids in a design is displayed by the artist who drew the In principio initial in the Durham Gospels [10].[10] This visible stylistic connection overrides the difference in the statement being made by the two works of art. The statement of the manuscript illuminator and of the Pictish sculptor draw close in the phenomenon of the cross-slab. Like the cross-carpet pages placed before the Gospel texts in Durrow and Lindisfarne, the Pictish cross-slabs do not simply outline a heavy moulded cross like the memorial, and iconic furnishing, slabs at the joint monastery of Wearmouth-Jarrow,[11] but fill the cross with complex variegated patterns drawn to a remarkable degree, in what we may suppose are the earliest slabs, from a repertoire of interlace designs. The circle and the spiral, purely curvilinear patterns such as comprise the incised symbols themselves and consistently enter their interior spaces, in the case of the 'crescent' symbol [30],[12] are indeed employed in the incised symbols placed on the back, and, experimentally, on the front of the cross-slab Glamis No. 2 [32, 33].[13] But the emblem of the cross itself absorbs the circle into the ground-work of great wreaths or medallions of interlace, the linear equivalent, perhaps, of the endless intercessions, the 'mantras', of the faithful.

Interlace

A possible hint that the Glamis sculptor was not yet fully in control of the reproduction of interlace in stone is the circular centre of the cross where an ambitious design involving four quadrants filled with pairs of symmetrical loops and asymmetrical loops, itself gives the appearance of a cross with curved arms, the outline of St Cuthbert's pectoral, but at Glamis this is tilted to the left. The design was evidently recorded in some handbook of motifs, since it is used again, this time vertically aligned, at the centre of the cross on the front of the cross-slab at Rossie Priory [102], and at the centre of the cross at St Vigean's, No. 7 [48], where it is turned so that the cross is 'X'-shaped.[14] It is presumably too early for the slight inclination of the cross at Glamis to refer symbolically to Christ's turning to console the good thief, at his

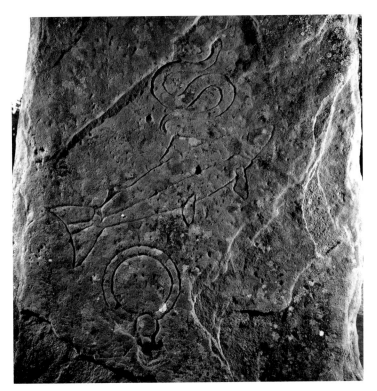

32 Incised symbols on back of cross-slab, Glamis, Angus, No. 2. Sandstone

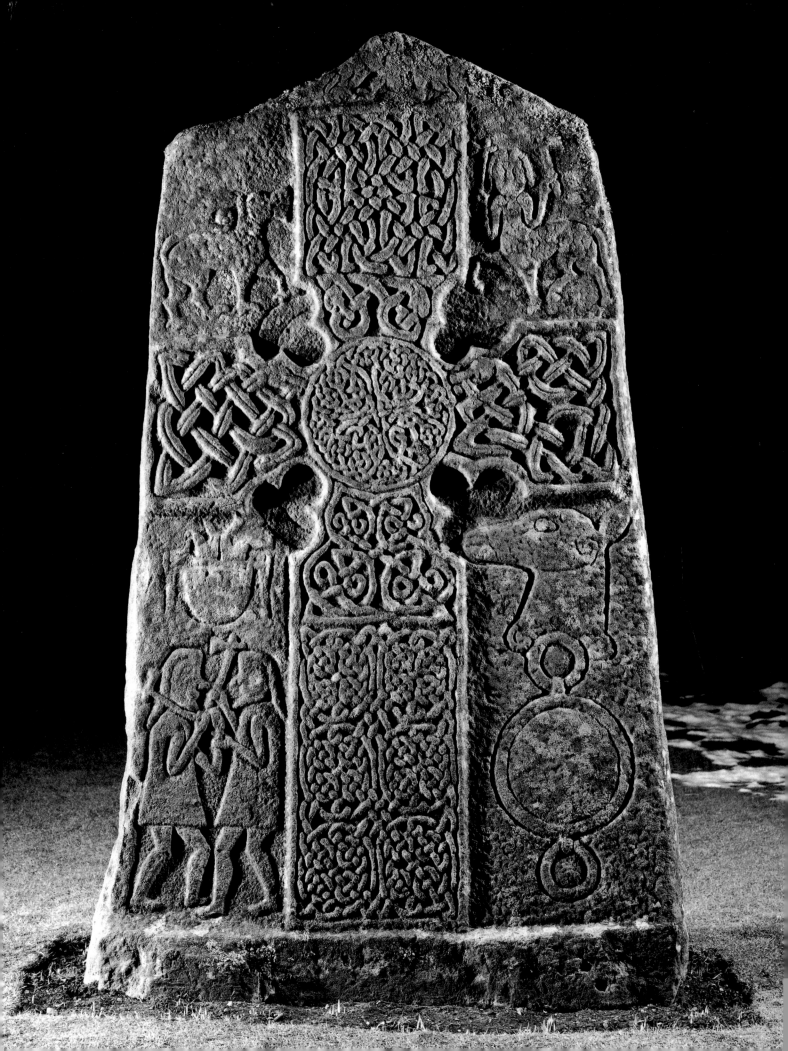

right on the Cross, or the drooping inclined head of the dead Christ, a regular feature of 10th- and 11th-century Anglo-Saxon crucifixes.[15] So inexperience will be the answer, but the zest with which the sculptor has planned the cross-head and stem, with brilliant variations in the thickness and complexity of the strands, is reminiscent of the carpet pages in the Book of Durrow [8].[16] The more delicate thread-like interlaces and the uniform scale of the motif in the Lindisfarne Gospels is not yet attempted.[17] The projection and texturing of the sculptured strands has of course no parallel in the manuscripts and has a craggy strength that suggests analogies in large scale cast metalwork (not filigree), hard to come by, except back at Sutton Hoo in the great gold buckle with its strands and knots of three different thickness [4].[18] The parallel of the Sutton Hoo buckle is reasonable also in as much as beast heads terminate the strands in the two cross-arms and the top arm of the cross at Glamis.

If we have enough surviving to judge by, the trend of Pictish sculptured interlace appears to be immediately away from the Glamis programme of variegated width of strand and zoomorphic features, with only a partial recollection in the lower arm of the cross at Eassie.[19] The various strap-work patterns used on the arms of the cross and on the cross-stem, many of them identical or similar, at Eassie, Glamis No. 1 [34], St Vigean's No. 7 [48], Rossie Priory [102], Meigle No. 4 [104], and Aberlemno churchyard [36],[20] are regular in width and gain their picturesqueness not from animal features or width changes but from the complexity of the knotwork and the basic divisions or turns of the ornament, paralleling by the regular turning of the motif back to front, or upside down, the alteration by changes of colour displayed in the blocks of interlace in the manuscripts, for example on *f.* 94v of the Lindisfarne Gospels. The manuscript analogy stands scrupulous testing. Allen numbered all the vast variety of circular and interlacing knots and noted where a Pictish design is constructed on the same principles as one in Lindisfarne or Kells, the Durham Cassiodorus or the Stockholm *Codex Aureus*.[21] In some cases the interlace pattern is so specific and so uncommon that communication between, say, the makers of the Vespasian Psalter on the one hand, and artists working in Caithness and Ross & Cromarty on the other, seems certain, presumably basically in the form of shared compilations of motifs. It is compilations of motifs in their raw form rather than as selected and laid out, digested, on the pages of manuscripts that appear to have inspired the sculptors, in the period between, theoretically, Glamis and Aberlemno churchyard. The sculptors give themselves over to an explosion of interest in interlace patterns, just as indeed the makers of the Gospel Books do from Durrow onwards, but we do not find in the sculpture equal thought and effort being put at this stage into the development of other parts of the Insular repertoire. The basic square key-pattern which fills the background of *f.* 138v of the Lindisfarne Gospels is employed as a variant for interlace to fill the circle at the centre of the cross at Eassie, at Glamis No. 1 [34], and on the reverse of Rossie Priory [86], while the cross on the front of Rossie Priory puts the square key-pattern on the arms of the cross.[22] A very modest spiral pattern, consisting of six triplets and a central spiral of six converging lines, is placed in the central ring of the cross at Aberlemno [36] and of Meigle No. 1. This form of spiral does not go much beyond the double spiral on the two horseshoe-shaped panels which help to make up the body of *Imago hominis* in the Echternach Gospels, and which has an Antique parallel on the apron of Juno Regina at Chesters.[23] The level of such spirals is that of the *Cathach*,[24] rather than of the Book of Durrow. Of the 'developed trumpet spiral' of the escutcheons and of the manuscripts from Durrow onwards, there is not yet a hint. The other marked absentee, were Gospel Books the reference works directly consulted by Pictish sculptors, is the tangled-animal ornament which flails up and down the cross-carpet pages of Lindisfarne.[25] Yet interestingly enough Pictish sculpture is not ignorant of strictly Insular animal ornament; it simply declines to apply such ornament to the body of the cross. The Picts are quite likely to have had fairly definite ideas about the use of zoomorphic forms as ornament.

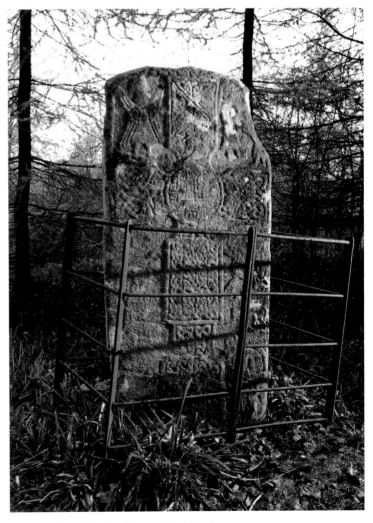

34 *Front of cross-slab, Glamis, Angus, No. 1. Sandstone*

Zoomorphic Ornament

After Glamis, and perhaps Eassie, the tangled knot pattern, ending in animal heads, is shifted out of the cross-arms and placed among other ornaments and motifs on the back of the cross-slab Meigle No. 4 [35], while alongside the cross-shaft at the bottom of the front are the remains of two panels of interwoven serpents bodies, ending in fishtails at the right [104], the knot patterns employed being paralleled, according to Allen, in the *Codex Aureus*, the Vespasian Psalter and the Book of Kells.[26] The most remarkable early display of animal ornament is on either side of the cross-shaft on the front of the Aberlemno churchyard

cross-slab [36]. Here items from the artists' book of single motifs are laid out before us in an almost pedantic spirit, but with wonderful clarity of cutting. In the gently tapering space at the left of the cross-shaft the sculptor has placed three identical quadrupeds, one above the other, their bodies arranged in a reverse 'S-curve', bringing the body through between its own legs and juxtaposing the heads of each of the two lower creatures with the criss-crossed hind legs of its neighbour. The repeated upward coil and swing of this animal ornament is reminiscent of the all-over birds and beasts on the cross-carpet page on *f.* 26v of the Lindisfarne Gospels, but all the forms employed are less specifically descriptive of foot and muzzle, less fanciful and florid.

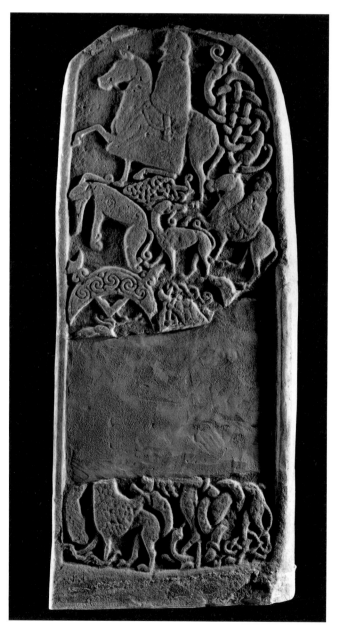

35 *Back of cross-slab, Meigle, Perthshire, No. 4. Sandstone*

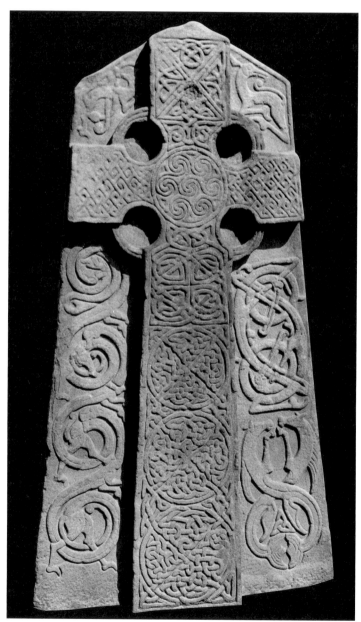

36 *Front of churchyard cross-slab, Aberlemno, Angus. Sandstone*

Lindisfarne, and its metal counterpart, the 'Tara' brooch, look forward to the jangle of forms in the cross-carpet page in the Lichfield Gospels.[27] In the much more limited space at his disposal, the Aberlemno sculptor does not give his animals that second spurt of the body, at the joint of the forearm, which the 'Tara' brooch, Lindisfarne and Lichfield all display, but the design of the heads of the Aberlemno creatures, biting their neighbours' bodies with short snouts or duck-like beaks can be compared to the heads ending the letters 'Chi' and 'I' in Lichfield's *Christi autem* initial.[28] Scroll-bodied animals whose legs straddle the curve of the body occur in the Westness brooch [149] and on a bowl and a conical mount from St Ninian's Isle [159, 165],[29] so there are parallels for the Aberlemno animals in the north as well as the south; a single luxury Gospel Book is certainly not the source of the Aberlemno sculptor's design. The range of the material available to him is highlighted by the very different kind of animal ornament which he selects for display at the top right of the cross-shaft [37]. Two lanky insect-like beasts, each with only a front and hind leg, are coiled and folded in on one another. Their limbs are bent at sharp angles and their beaks are of elongated blanket-pin construction. Such abstract treatment of animals is paralleled in the St John prefatory page in the Book of Durrow [9], but the soft worm or shrimp-like undulations of Durrow are replaced by stiffer forms.[30] Part of a similar animal design survives in a fragment of a closure screen or altar frontal at Wearmouth, dating to anytime from 674 onwards.[31] At Aberlemno it is notable that the insects' ridged bodies, claw feet, and the circular spin of their necks and bodies agree precisely with the treatment of the later-type animals opposite. In the Aberlemno relief panels we appear to have a record of Insular zoomorphic ornament in a state of transition, and of an editing process, based on materials being passed around, in the period between Durrow and Lichfield.

The third 'sample' which the Aberlemno sculptor selects, at the bottom right of his cross-shaft, is unusual by Insular standards in the character of the animals, but not in their confrontation and figure-of-eight disposition. Two serpentine creatures with fishtails confront one another on the door jambs at Wearmouth,[32] and as we have seen fishtails terminate elongated eel-bodied dragons on the rim of the 'Tara' brooch. At Aberlemno the fishtails belong to two short firm-bodied hippocamps, their manes arranged as dorsal fins. They each lift a foreleg, as if to smite hoofs, and their slim horse faces, in opposed profile, are close together. The elegance of their silhouette, and the breeding evident in heads and legs, recall that of the hippocamps which career on the black and white mosaic floors of the Baths of Neptune at Ostia.[33] The Aberlemno sculpture, or perhaps some exotic model which it reproduced, had lasting appeal among Pictish designers. A tantalizing fragment of relief sculpture, recently excavated at Tarbat, consists of the back-to-back heads of two stylized beasts and under them a stiffly erect pair of hoofs, the flat of the hoof placed together [38].[34] But horses were very much in the Aberlemno sculptor's mind, as witnessed by the battle scene on

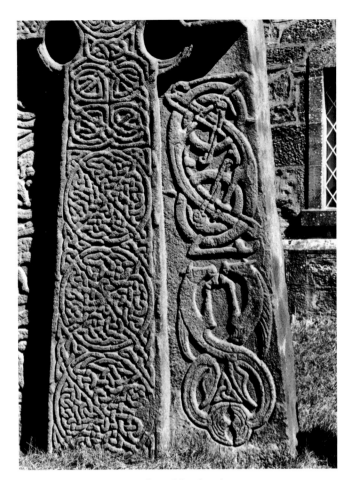

37 *Detail of animal ornament, front of churchyard cross-slab, Aberlemno, Angus. Sandstone*

38 *Fragment of relief sculpture from Tarbat, Ross & Cromarty. Sandstone*

the back of the slab [*82*], and the extent to which a Classical model needs to be called upon is uncertain. A later sculptor, at St Andrews, placed recognizable deers' heads on typically long, drawn-out and enmeshed Insular animal bodies, because deer were represented in a narrative-type panel alongside.[35] The Aberlemno hippocamps' pose is similar to that of the pair of dogs with raised paws at the bottom of the left column framing David and his musicians in the miniature in the Vespasian Psalter. The hippocamps at Aberlemno seem to belong to that same stage in Insular animal ornament – the stage of the Salaberga Psalter, the *Codex Aureus* and the Durham Cassiodorus – when a solid naturalism and clear demarcation of bodies makes its way against more abstract attenuated forms.[36]

Demonstrably Insular-type animals, confronted or otherwise woven together, make erratic appearances outside the emblem of the cross in Pictish cross-slabs, for example, on the front of the Elgin cross-slab [*216*] in the space below the cross-stem and base, and on the front of the great Aberlemno roadside cross-slab [*218*], below the ringed cross-head. At Kirriemuir [*183*] a pair of confronted beasts occupy the stem of the cross itself, and at Fowlis Wester a longer cross-stem shows traces of interlaced bodies of birds and beasts [*270*]. The weathered and damaged condition of all these examples makes reading of the ornament difficult.[37] Animal ornament of an idiomatic but as yet unparalleled character decorates the sides of the great Rosemarkie cross-slab [*39*]. Small panels have lengths of loose-ended interlace,

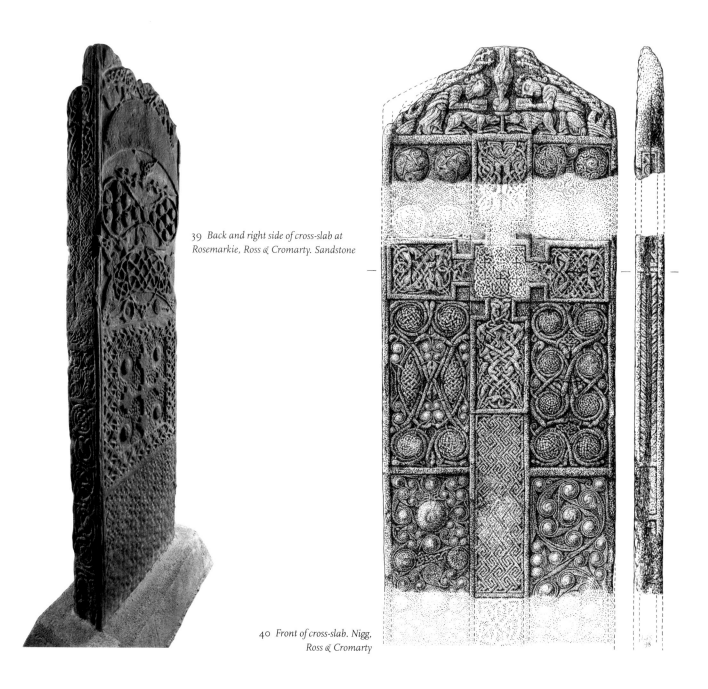

39 *Back and right side of cross-slab at Rosemarkie, Ross & Cromarty. Sandstone*

40 *Front of cross-slab. Nigg, Ross & Cromarty*

animalized with goat-like heads or simply by a mere swelling
of one end of the strand. A long panel, on the left side, has an
all-over pattern consisting of attenuated finned creatures whose
otherwise featureless 'limbs' are indicated by bifurcation.
Their heads are barely discernible. The snaky mass creates a
framework comparable to 'medallion vinescroll', with each
medallion containing a rivet-like pellet which itself has four
bead-like attachments.[38]

The full entry of Insular zoomorphic ornament into the
decoration of the cross itself occurs at a comparatively mature
stage technically and artistically, at Nigg, Ross & Cromarty [40,
202], where a classic balance of the entire Insular canon of motifs,
interlace, spirals, fret, and zoomorphic ornament is achieved, and
where the resemblance of a Pictish cross-slab to a manuscript
carpet page is at its most convincing.[39] The cross represented at
Nigg is long and narrow, with a moulded edge. The shape of the
cross-head is rectangular, with square indents, like that of the
cross on f. 2v of the Lindisfarne Gospels. The lower part of the
stem carries a complex diagonal key-pattern, and the square
centre of the cross contains a panel of nine circular knots, in three
rows of three, with subtly alternating patterns. The four arms of
the cross carry the sort of slender interlocked beasts which fill the
background of the cross on f. 26v of the Lindisfarne Gospels, but
the busy cartwheel effect of the hind limbs in Lindisfarne is
quietened, the rhythm of the composition being produced by the
curve of the necks and bodies as well as haunches of three or four
pairs of identical animals, not the mixed race of beasts and birds
used in Lindisfarne [41]. The medallion and the large 'X' patterns
created in the earlier Pictish interlace-filled cross-heads are here
stated entirely by the delicate interplay of the animal bodies. The
thread-like fineness of the zoomorphic ornament is reminiscent
of that of the Witham pins,[40] though not like in the detailed
description of the animals. The Nigg animals, with the exception
of the fiercer more dog-like creatures in the top arm, all have wide
open-mouthed little cat-like faces, in profile, similar to the cat
faces of the animals inset in narrow panels decorating the canon-
tables in BL Royal MS I.E.vi and terminating the interwoven
letters of the display script of the Gospel *incipits* in the Barberini
Gospels.[41] The great relief-carved cross at Nigg appears like a
sumptuous woven fabric, its elegant cohesion and fine finish
accentuated by the huge interlace bosses placed on either side of
the cross-stem, like racks of textile raw material, silk thread spun
onto lozenge-shaped reels, and stout round balls of wool.

A series of lithe animals very similar to those at Nigg, but
pressed more closely together, and intruded deeper into
sculptured space, are displayed on the two outer panels on the
front of the St Andrews Sarcophagus [42].[42] They knot and writhe
against a background mesh of infinitely fine interlace, and they
themselves are textured, as the smooth Nigg animals are not,
having matted hair in little coils on their shoulders, as if the lion
of Echternach was mixed into their ancestry. The sprouting of hair
by Insular animals can be witnessed in the tufted tails of the

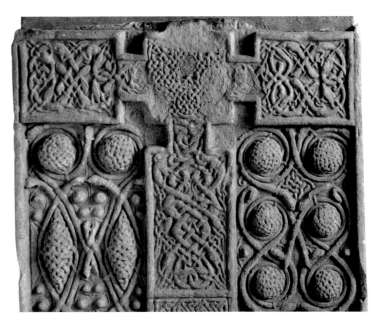

41 *Detail of front of cross-slab, Nigg, Ross & Cromarty. Sandstone.*

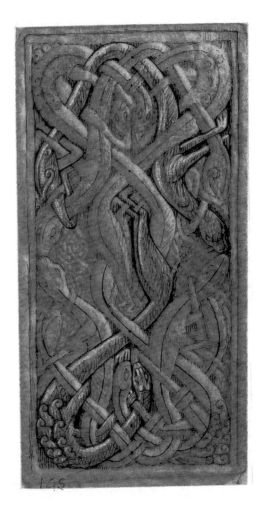

42 *Corner slab of St Andrews Sarcophagus, Fife*

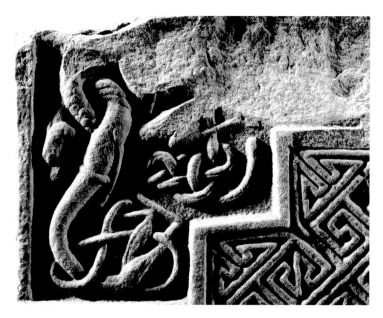

43 *Detail of animal ornament, front of lower portion of cross-slab at Hilton of Cadboll, Ross & Cromarty. Sandstone*

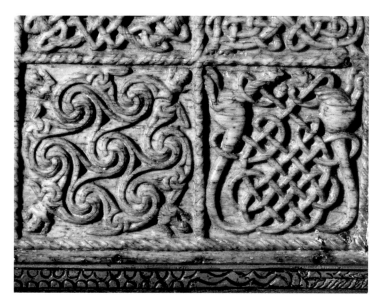

44 *Detail of the back of the Gandersheim Casket, Herzog Anton Ulrich-Museum, Brunswick. Walrus ivory*

confronted beasts straddled across nests of fine interlace in the borders of the Durham Cassiodorus, by the capes of hair displayed by the tangled animals in the 'torment of Hell' scene on the base of the Rothbury cross-stem, by the long, grooved neck of the dragon at South Kyme, and by the bedraggled half-moulted animals in a sculptured panel at Breedon-on-the-Hill.[43] Among the recently recovered fragments from the front of the Hilton of Cadboll cross-slab, a dog-faced animal, the head viewed from above, with unusual curved ears flopped forward like the ears of a sow, stretches out its straight neck exactly like the creatures on the

Southumbrian Gandersheim Casket [44],[44] giving the immediate impression of the head and thick neck of a serpent. But the texture of the neck is mottled, lumpy, with the effect of fur, and the large, firm, but graceful thighs of the animal, seen sideways, are etched with shaggy hanks of fur, the striated surface giving also the appearance of taut muscles. This ridged sinewy treatment of the body is paralleled in the markedly gaunt beasts crouching in the pediment of the Nigg cross-slab [203]. The hind limbs of the animals on the side panels of the St Andrews Sarcophagus are similar in shape and proportion to those of the Hilton animal but at St Andrews the hairy texturing is kept as manes on the shoulders, not on the smooth hind legs. The background of the Hilton animal is empty, not matted with interlace like St Andrews. On either side of the double-stepped base of the recently recovered lower section of the cross-face of the Hilton of Cadboll slab, a pair of very large quadrupeds with elongated bodies move freely in space, linking sinuous necks and nipping each other's bodies with spindly legs emerging from thickened foreshoulders [43]. Extended tongues and tails intertwine to form loose asymmetrical knots quite unlike the symmetrically-woven mats which they create at Nigg and St Andrews. Different also at Hilton are the fierce dragons' heads with beaked gaping jaws. The neck of one of the animals at the left is shaggy and screwed round dimensionally as it passes over and under another animal's body. This marked twist of the textured neck again signals a connection with the design of the Gandersheim Casket [44]. At Hilton, the animals' long bodies do not provide mirror-image structures. They loop and tangle in a way more suggestive of a narrative than of a decorative intention.

Zoomorphic ornament of a rather different design fills the very broad stem of the huge wheel cross of the cross-slab, Meigle No. 2 [45, 199]. The sculpture is worn, but at least two out of the three panels contain a pair of large confronted animals, with other smaller animals cocooned in amongst them. The large animals in the upper compartment crouch on their haunches, their hind legs sharply bent, but they rear stiffly upright on their long thin forelegs, in a guarding, sphinx-like pose. Their chests meet in a straight line, and their heads are held erect on elegantly curved necks. The confronted animals in the second compartment are more thickset, and place their square jowls, like those of bears, close together, continuing the line descending vertically from between the chests and legs of the upper pair of animals. The curious mixture of the animals' elegant stance with hefty physique, and the rigid symmetry of the design, are reminiscent of the details and layout on the animal ornament on the silver objects from St Ninian's Isle (see Chapter 4). One of the chip-carved and engraved silver-gilt conical mounts displays animals which, though back-to-back, meet together with a single vertical line between them, like the animals in the top panel of the cross-stem at Meigle. On the silver pommel from St Ninian's Isle animals crouch and bend their hind legs sharply. The second of the silver bowls is decorated with a floppy slouching version of the

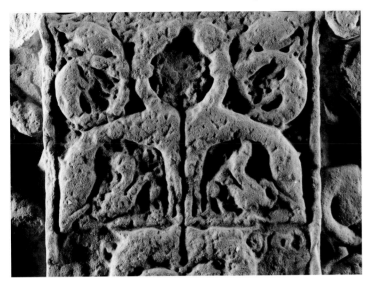

45 *Detail of animal ornament, front of cross-slab at Meigle, Perthshire, No. 2. Sandstone*

spinning-thigh, criss-cross legs animal motif, familiar from Lindisfarne and the 'Tara' brooch, and fastidiously depicted at Aberlemno.[45] The very same heavy sluggish treatment of the motif, perhaps befitting an ugly denizen of Hell making his way upwards, is seen at Meigle No. 2 [199], at the top of the narrow space at the right between the cross-stem and the border moulding.

Spiral Ornament and the Raised Boss

The St Ninian's Isle treasure contains two objects on which impressive spiral patterns occur. One is another of the conical mounts, over whose entire surface spirals are engraved [165]. The centres of the spirals are varied, with triplets of lively patterns, reminiscent of the picturesque quality of the spiral medallions mounted on the capitals in the St John portrait miniature of the *Codex Aureus*.[46] What is markedly lacking from the St Ninian's Isle cone are the pairs of trumpet-shaped members, hooked together, which occur on the rim of the *Codex Aureus*'s medallions. In the silver conical mount all the conjoint forms are spirals, none are the hooked juncture of extra loose-flung trumpet forms, the essential element of the 'developed trumpet spiral'.[47] Even the worn top of the silver cone makes the three trumpet forms link in spiral mode, not the hooking of two trumpets without spiral implications. The crucial moment, as it were of 'hook up' is omitted. However, the St Ninian's Isle hanging-bowl has an impressed disc on its base [161] which displays a true 'developed trumpet spiral' pattern, the wide spaces between the spirals having the hooked thrust and spray of leaf-shaped vents, such as we see in the escutcheon on the Winchester hanging-bowl[48] and in the classic manuscript example, *f*. 3v of the Book of Durrow,[49] and on the panel on the Moylough belt-shrine, which shares with the

St Ninian's Isle hanging-bowl disc the *pressblech* technique.[50] The 'developed trumpet spiral' appears to have been a latecomer to the Pictish sculpture repertoire, despite its vigorous representation on the Brough of Birsay lead disc [133], an essay in hanging-bowl escutcheon design.[51] The red-enamelled, engraved silver plaques from Norrie's Law [112] display spirals inside the discs of the 'double disc and Z-rod' symbols. The motif joining the spirals is lobed, not hooked. It goes back the way it came. Exactly the same spirals with side loops, not hooked trumpets, are displayed on the 'double disc and Z-rod' symbol copied from the lost Monifieth plaque [322], suggesting that the 18th-century drawing is an accurate record of the original.[52] Developed trumpet spirals, picked out with enamel, decorate a disc found in the excavations at Dunadd. This 7th-century production at a centre in close touch with the Columban monastery on Iona confirms that the type was available in North Britain,[53] as indeed does the St Ninian's Isle hanging-bowl described above, which has importance as a 'transmission' piece for the Insular style.

As we have seen, the place of spirals in the repertoire of the Pictish cross-slabs is modest in extent (to start with) and certainly not manuscript directed, as we might suppose the vastly sophisticated anthology of interlace patterns to have been. The Aberlemno churchyard cross-slab's [36] spiral centrepiece is not

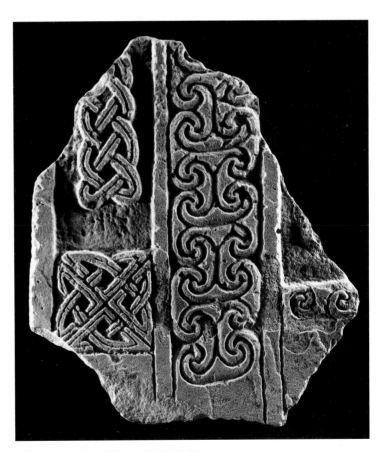

46 *Fragment of cross-slab at Meigle, Perthshire, No. 27. Sandstone*

essentially different from the simple spiral scrolls on the Baginton Bowl escutcheon.[54] The monuments at Glamis (Nos 1 and 2) [34, 33] and at Eassie and Rossie Priory [102], do not employ spiral patterns at all. Closely meshed peltas, like macaroni, rather than round spirals, fill the lower cross-arm of the cross-slab, Meigle No. 4 [104] [55] and the stem of the fragmentary cross-slab, Meigle No. 27 [46]. Golspie No. 1, on the front, uses the basic peltas in reverse of one another, sideways, upright, as in Meigle No. 4, but using only

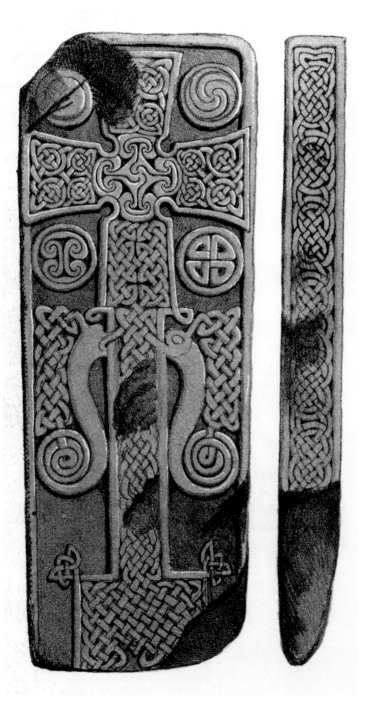

47 *Cross-slab from Skinnet, Caithness. Sandstone*

a few peltas and on a large scale,[56] and the same large simple form of the motif is used at Farr [268], and at Lethnott, in both of which it runs directly into interlace, that merging of motifs which argues a mature stage in the handling of the Insular repertoire.[57] The breastplate of Christ at the top of the back of the Elgin cross-slab [188] has the same pattern of two upright, two horizontal peltas as at Farr, and the crescent symbol below is crowded with 'macaroni' peltas.[58] The cross-slab at Skinnet uses two upright and two horizontal peltas at the base of the cross on the back, and designs the core of the interlace cross-head as a four-cord spiral [47].[59] The same small wormy pelta form is used as a divider for the large panel of spiral ornament on the cross-stem of the cross-slab at St Vigean's, No. 7 [48], which moves the spiral motif forward in an important way. In this it is paralleled only at Birnie, Moray and Applecross, Ross & Cromarty,[60] where the lobed triplets are modified after one use, first into spirals of birds' heads, as in the Durham Gospels [10],[61] but shorter billed, then beaked, dragons' heads, exactly repeating the shape of the two uppermost heads on the interlocked animal ornament at the left of the cross-stem at Aberlemno churchyard. In the fourth spiral the group of lobes are made into the bearded heads of men, analogous to the decorative thinking of the designers of the Book of Kells.[62]

The front of the cross-slab at Dunfallandy [49] gives another new emphasis to the spiral motif, by using in the top and bottom arms of the cross a series of spirals which are still essentially the conservative pelta pattern with scrolls at either end, linked around the edge of the panel by straight, tube-like motifs, hardly deserving Allen's description as 'C-shaped', on top of which five spirals are allowed to swell up in high relief. What is more, three raised spirals on each of the side arms of the cross are allowed to sit on, and rise out of, a simple square key-pattern, again a sign of the sophisticated coalescing of motifs. The design of Dunfallandy is elaborated on the recently disinterred bottom of the cross-slab at Hilton of Cadboll, where the stepped base of the cross is covered by a wide network of diagonal fret, interspersed with simple raised spirals, like worm casts on the shore, forming a curiously formal pattern of three, two, and five, with speculatively the same pattern in mirror image (for symmetry), now lost with the loss of the lowest section of the slab [273].

The back of the Hilton of Cadboll cross-slab [50] is decorated below the hunting, or narrative, scene, with a huge panel containing large triplets of spirals, linked by long strands, trumpets only in atrophy or more probably with their roots in Iron Age metalwork pelta and scroll patterns.[63] The spirals and their linking lines are set out diagonally, in opposite directions, not just up and down. The scale and the expanse is large, and the spirals are austerely uniform, showing a mature and presumably indigenous taste, quite different from the explosive quality of Irish spiral ornament such as the door furniture from Donore.[64] Shandwick, just three kilometres west of Hilton, also displays an enormous panel of peltas and spirals, set around a central core forming three rings, a different composition from Hilton but

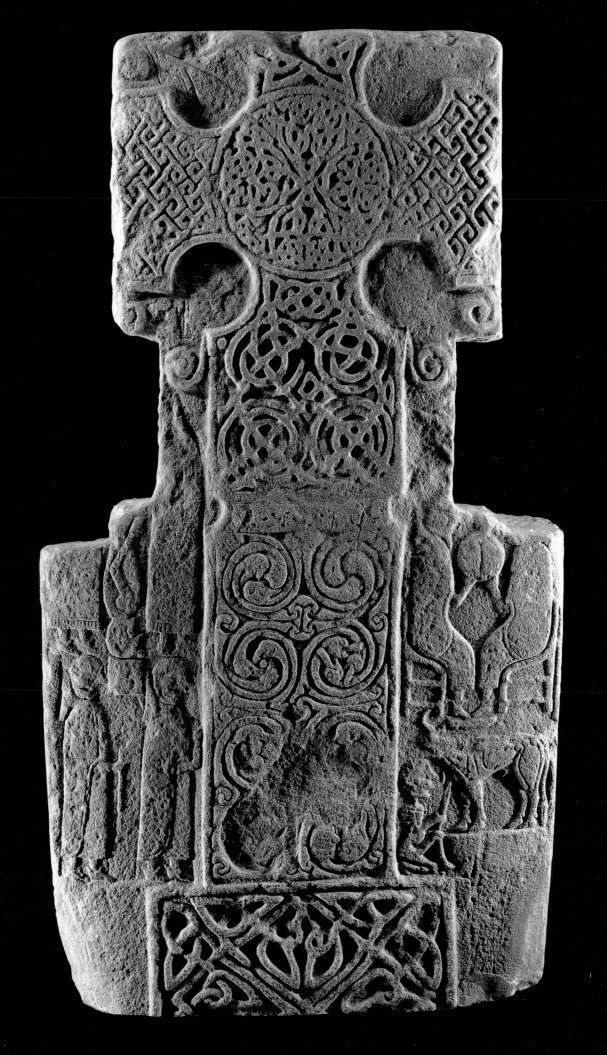

similarly stately and austere [51]. One might suppose that most Pictish sculptors regarded spirals as effective wallpapering, but not as expressive or iconic. However, Shandwick also follows the lead of Dunfallandy in raising spirals into boss-like protruberances. The cross-stem and cross-head [200] are thickly studded with spiral bosses, giving the cross its striking *crux gemmata* appearance, but the basic design programme is of simple peltas with scroll ends, placed at right angles to one another through the whole sequence, very like Farr, but of course raised into high relief.[65] On the back of the Shandwick cross-slab the 'double disc' symbol nods to the full vocabulary of a 'developed

trumpet spiral', in that the hook and reverse direction of trumpets is drily stated at the outer edge of the panel, in the form of a regular triangular motif.[66]

In regard of spirals, a different world of artistic expression from that of Shandwick and Hilton of Cadboll opens up, curiously enough in the near vicinity, first at Nigg, at the southern end of the Tarbat peninsula, and then at Tarbat itself, at the northern tip. Superbly large and superbly idiomatic as they are, making vivid visual contrasts to the adjacent interlace bosses and the zoomorphic ornament of the cross-head, the two raised spiral bosses at the top left of the obverse of the Nigg Cross are conceived

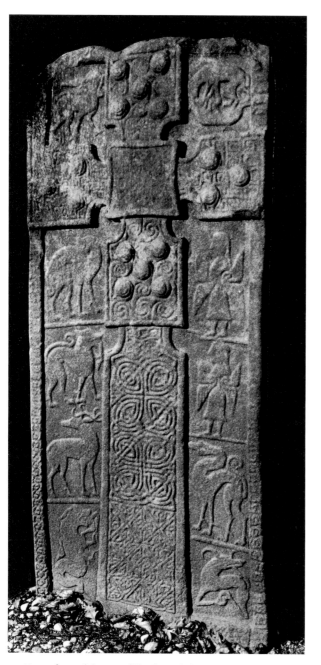

49 *Front of cross-slab at Dunfallandy, Perthshire. Sandstone*

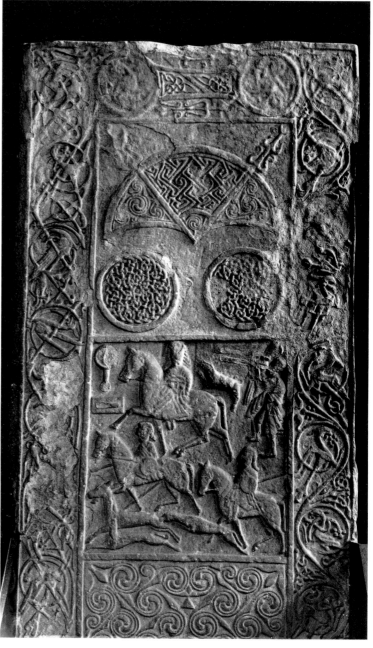

50 *Back of cross-slab from Hilton of Cadboll, Ross & Cromarty. Sandstone*

51 *Back of cross-slab, Shandwick, Ross & Cromarty. Sandstone*

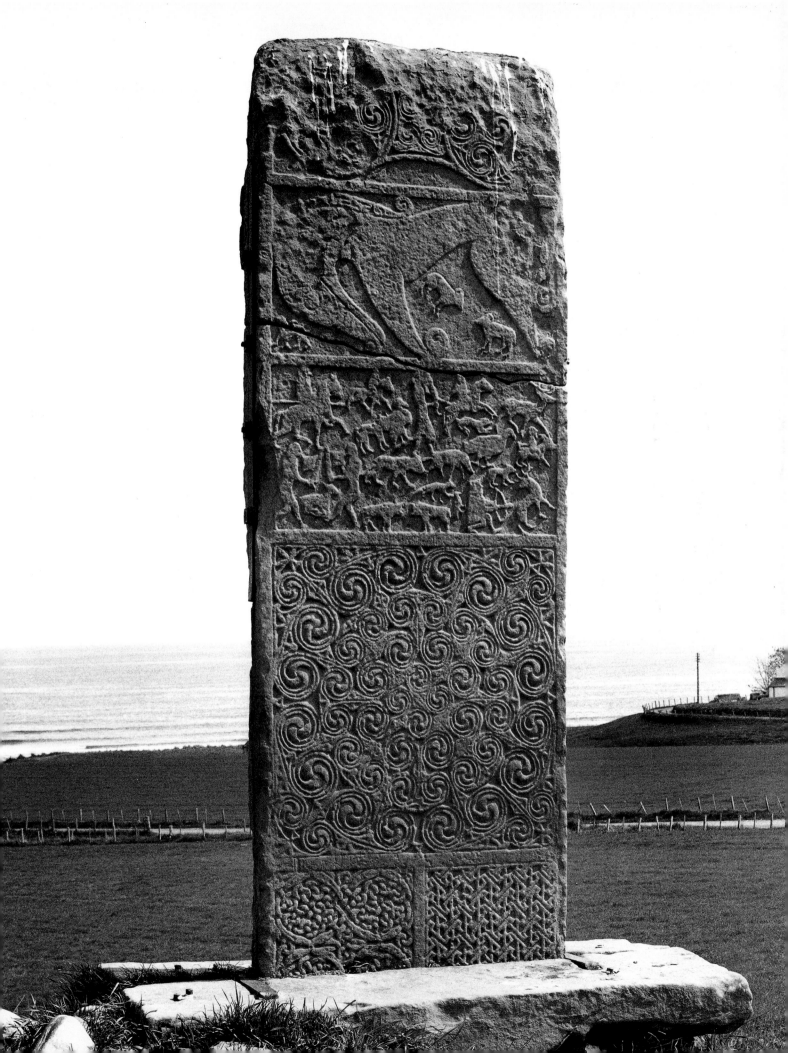

irregularly aligned than at Shandwick, giving the effect of a spontaneous field of energy, and in the extreme corners of the design giving a closer approximation to the erratic hook motif of the true developed trumpet spiral. The composition of the ring of bosses, set well apart and bounded by the thin rim of the main medallion, to a surprising degree, with new vocabulary, shares the aesthetic of the spacious patterns of the Iron Age Battersea shield, while the Nigg sculptor's sensibility to surface texture and graduations of relief, is worthy of comparison with that of Donatello.[68] The panel at the left-hand corner of the front [52] much enlarges the scale of the principal raised boss, and surrounds it with irregularly sized bosses, bonded by sharply etched trumpet strands going off in many directions, so that the ground-work of the design is disturbed and restless, compared with the calm drift of the right-hand panel [52]. Conspicuous among the ruffled texture of the left-hand panel is a brief mat of interlace, the most dramatic of all Insular examples of the barriers being thrown down between the discrete decorative motifs of the repertoire. The monumental 'Chi Rho' initial in the Book of Kells [2], with its use of irregular sizes of spiral medallions and its direct run-off from spirals into interlace, at the top right of the initial is a close linear parallel to the Nigg design, although of course lacking the eloquence of the sculpture's plasticity.

A series of fragments probably from more than one magnificent cross-slab at Tarbat shows the exhilarating effects of close juxtaposition of contrasting motifs. In one of these, fragment No. 6 [53], a raised ring or wreath of plastically realized

52 *Panels from front of cross-slab, Nigg, Ross & Cromarty. Sandstone*

– exactly like the silver cone from St Ninian's Isle – as continuous spiral pattern, the linking strands going right across from one spiral to the next, a direct passage, with no lingering on the way as seen in 'developed trumpet spirals'.[67] The great novelty at Nigg lies at the base of the front of the cross-slab [40], first in the panel at the right, which like Shandwick places a circular composition of spirals within a square (or rather at Nigg a rectangular frame). However, it handles the spiral motif quite otherwise than at Shandwick. High spiral bosses of different dimensions, are used, one large one at the centre, surrounded by six lesser spirals, with a smaller spiral again used in each of the four corners outside the main medallion. This composition was mirrored in the damaged lower portion of the panel, with an intervening zone of a looser construction of small bosses. The ground-work from which the bosses rise is kept uniformly flat, and is beautifully etched in subtly shallow relief, with the cords forming the bases of the raised bosses and the long grooves of the linking members, more

53 *Fragment with wreath boss, Tarbat, Ross & Cromarty, No. 6. Sandstone*

54 *Fragment of trumpet spiral ornament, Tarbat, Ross & Cromarty, No. 7. Sandstone*

55 *'Double disc' symbol in relief, from fragment of cross-slab, St Vigean's, Angus, No. 6. Sandstone*

zigzag key-pattern is set on a surface grooved with the curved link-lines of small spiral bosses. In fragment No. 5 a bubbling panful of spiral bosses are hemmed round by a wreath of interlace. Fragment No. 7 [54] celebrates the full acknowledgment of the potency of the 'developed trumpet spiral', as we have seen by no means universally employed in Pictland heretofore, and adds to its potency by carving deeply the lobes of the spirals and the hooks and vents of the trumpet motifs, which chase one another across the surface like waves.[69] With his exact eye for the quality and variety of Pictish sculpture, Allen wrote of Tarbat No. 7, 'A most exquisitely finished piece of spiral ornament, more nearly resembling that in the best Irish MSS than that on any other stone in Great Britain'.[70] It has a rival in the accurate description of spirals and their roaming trumpet offshoots, and in the extraordinary depth and vitality of the carving, in a similarly small shattered fragment[71] of a lost cross-slab or panel from Kinneddar, Drainie, on the southern shore of the Moray Firth, the site from

which comes the David and the Lion fragment which is related to the design of the St Andrews Sarcophagus, Fife, and which shares with Tarbat the unusual extent to which its authoritative sculptured monuments suffered demolition, in unknown circumstances. These grand, developed trumpet-spiral designs were part of the decoration of the broad surface of a cross-slab, but in two striking instances developed trumpet-spirals are represented within the twin medallions of 'double disc and Z-rod' symbols. On the reverse of the fragmentary cross slab at St Vigean's, No. 6 [55], two sets of four irregularly placed raised spiral bosses are accompanied on a lower plane by three splendid generously relaxed hooked trumpets, with leaf-shaped vents scattered across them, like the design seen on *f.* 3v of the Book of Durrow.[72] The 'double disc and Z-rod' symbol on the obverse of the great Rosemarkie cross-slab [81] has unusually integrated pear shaped discs, each carrying seven identical spiral bosses skirted around the edge by three proper trumpet hooks, placed between

each alternate boss. In both these sculptures, the exterior of the symbol's discs is conceived as a firm rim or moulding, like a cast metal construction, again reminiscent of the firm raised rings that articulate the Battersea shield. As so often with Pictish sculpture, a metalwork dimension to the stone-carver's craft seems probable, and it is particularly suggestive that exactly the same elaboration and display is lavished upon the Pictish symbols as upon the cross.

From the time of the earliest incised symbols, the interior of the crescent symbol was ornamented with curvilinear patterns. The huge crescent immediately under Rosemarkie's handsome embossed 'double disc and Z-rod' symbol [81] is a striking example of the infiltration into the interior of the crescent symbol of an interlace knot, a knot incidentally recognized by Allen as of a

design several times used in the decoration of the Vespasian Psalter, but at Rosemarkie terminating in giant biting-beast heads, as if taste for zoomorphic strands was still at the stage of Glamis No. 2 [33].[73] At St Vigean's No. 1 [83] both discs of the 'double disc' symbol are divided into four quadrants, each ornamented with an open design of a spiral loop. By way of contrast, the pair of separate discs on the back of Hilton of Cadboll [50], edged by a broad moulding similar to that of St Vigean's No. 6 [55], are filled to the brim by a concentric arrangement, first of six, then of twelve loops, giving even more denseness to the packing of the strands than in the centre of the cross-head at Glamis [33] or on the shaft of the cross at Aberlemno churchyard [36].

The custom of decking out the cross on cross-slabs with interlace, so dominant at the start of the series, is never abandoned. Indeed, on the back of the slab at Ulbster, Caithness, [56] an equal-armed stemless cross is formed of five squares, each divided into triangles, which in turn each contain triangular knots, rotated at right angles, a design of great rarity only paralleled in the Vespasian Psalter and exported later to Aachen and the Harley Gospels.[74] But generally experiments with interlace are moved into other portions of the cross-slab. The grand sequence of medallions which featured on the cross-stem at Glamis and Aberlemno churchyard, are transferred at Nigg to the back of the cross-slab [184], into the unusually wide borders of the monument, giving it, like the cross-carpet page appearance of the front [40], a striking resemblance to an illuminated page, specifically the portrait of David as warrior on *f.* 172v of the Durham Cassiodorus [13] which sets panels of ornament in a sequence of clearly marked rectangular frames around the edge of the miniature. The unusual use of incised technique for two of the spiral knot patterns at Nigg, one on the left, one on the right, starting at the level of the head of the damaged figure of David, adds to the calligraphic quality of the work.

The most remarkable development of interlace decoration parallels that of the raised spiral boss. At Nigg [40, 41], great nodules formed of plait-work project from the background of the relief on both sides of the cross-stem, their resemblance to a textile worker's store cupboard having already been remarked on. Complex interlace on the surface of the round or lozenge-shaped bosses is daringly conceived, as a sublimation of zoomorphic ornament, as the infinitely extended matted necks and tails of snakes which coil and stir, meet and part across the broad rectangular format of the embossed panels, a design strikingly like that of the St Germain finials [12],[75] but with much more buoyancy both in the bosses and in the serpents' bodies, giving full scope to the lyrical play of light and shade and the strong asymmetry of the two panels, with no sense of the sluggish sinister iconography of the St Germain finials. If the same artist designed the finials and the cross at Nigg, as might well be the case, his mood and medium, not his artistry, had changed.

Loosely looped and winding interlace effects are made out of serpents' or fishtailed eels' bodies at the top and bottom of the

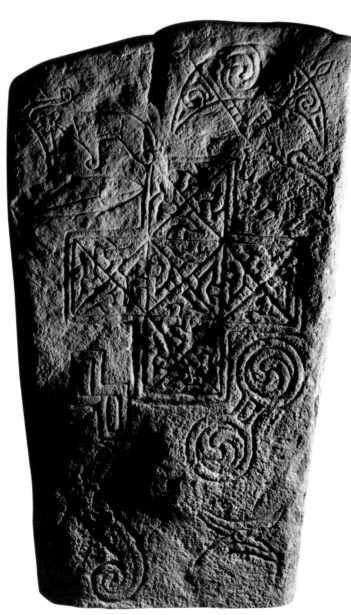

56 Back of cross-slab, Ulbster, Caithness. Sandstone

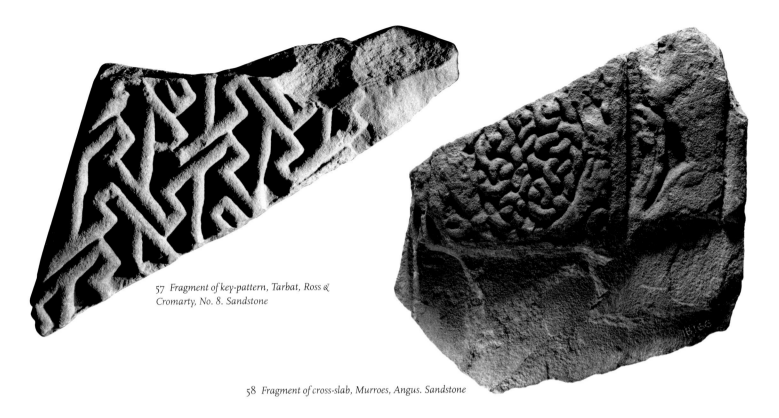

57 *Fragment of key-pattern, Tarbat, Ross &
Cromarty, No. 8. Sandstone*

58 *Fragment of cross-slab, Murroes, Angus. Sandstone*

Initium initial on *f.* 130 of the Book of Kells, but the patterns are
quite different from those at Nigg, and different also from the
serpent bosses at Shandwick [*200*], which place a pair of thick-
bodied serpents firmly round each of four large raised bosses
filled with interlace knots, made up of their bodies, like guardians
of heaped treasures.[76] The animals there place their square profile
jowls together and their ears extend into the corners of the design
in an interlace network. Such ear-trails are exactly paralleled on
f.130 of Kells. A medallion formed of the looped interlaced bodies
of two pairs of fishtailed serpentine creatures with dogs' heads,
confronting each other on the perimeter, like those at Shandwick,
survives on a small fragment of a cross-slab from Murroes [*58*],
a unique occurrence of this motif in southern Pictland.[77] At
Shandwick, smaller hanks or knots of interlace on the back of the
cross-slab are also given animal heads, long and narrow-jawed,
and an essay in archaism was made at the extreme bottom right
where the zoomorphic strands are markedly thick and grooved,
giving the effect of a heavy double-strand, as displayed in the early
days at Glamis [*33*], and in the carpet pages of the Book of Durrow
[*8*]. Indeed above the serpent bosses at Shandwick, on either side
of the cross-stem, the pairs of entangled animals are smooth and
neatly folded in on themselves, not so very far from the queues of
loose-limbed shrimp creatures in the St John's page of Durrow [*9*].
The packaging of all these interlace bundles in square or small
rectangular compartments, with wide flat frames, has very much
the same flavour as the heavy stacked and layered decoration of
the Book of Durrow. Again one wonders if lost metalwork forms
the intermediary for this particular resemblance.

Key-and Fret-Patterns

The square composition, half the width of the slab, at the bottom
right of the back of the Shandwick cross-slab [*51*] is decorated with
an all-over fret-pattern set diagonally in regard of the margin, with
the effect of boxed-in, repeated, scrambled lettering, an angular 'P'
or 'R'. The rectangular quality of this design, with the steady
downbeat of its verticals, is in beautiful contrast to the swathed
rounded knots of interlace in the adjacent compartments. At Farr
the same design is spread across the whole breadth of the cross-
slab [*268*], like the frontal of an altar supporting the wide-based
relief-carved ringed cross in the upper part of the monument.[78]
It plays exactly the same role on the back of the great Rosemarkie
cross-slab [*39*], as a decorous preface to the stronger relief and
larger scale of the fret-bordered book or shrine cover design
immediately above. The same pattern is one of a number of
contrasting fret-patterns used on the upper panels in the frame on
the back of the Nigg cross-slab [*184*]. Exactly the same emphatic,
jabbing, geometric pattern gives extraordinary presence to a 25 x
12.7 centimetre fragment of a smashed cross-slab or panel from
Tarbat [*57*], and to another such fragment measuring 17.8 x 15.2
centimetres, from Burghead.[79] On the front of the Rosemarkie
cross-slab [*59*] the deeply recessed square panels – which
ingeniously outline a plain equal-armed cross with rounded
armpits – are decorated with two key-patterns repeated in reverse,
one with the setting-out lines placed diagonally to the margin, the
other paralleling the margin, this variety and contrast in the
handling of the same motif being characteristic of the use of key-

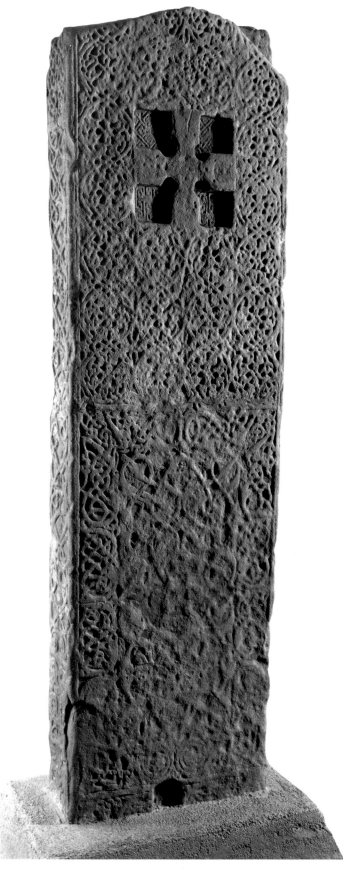

and fret-patterns in manuscripts such as the Gospels now in Augsburg University Library [16] which spreads key- and fret-patterns within the cross of its cross-carpet page and in the background to the cross, achieving by this contrast the definition of the cross's shape very much as Rosemarkie does.[80] The stepped fret-patterns on the corners of the Durham Cassiodorus standing David page [13] are sharply outlined against their background reserved in black, giving them the same decorative boldness as the sculptor's deeply indented surface. The particular form of fret pattern displayed in the square panel at Shandwick and the cross in the carpet page of Augsburg is deeply entrenched in Insular manuscripts, in Lichfield and Kells and the 9th-century Macdurnan Gospels,[81] though it is neglected in the Barberini and St Petersburg Gospels, along with the spiral. The Macdurnan Gospels, for example in the St Matthew portrait on *f.* 4v, tends to add small decorative pellets in the small rectangular spaces among the fret, and the very same device occurs in the fragment of a cross-stem at Kinneddar and on the broad panels of closure-screens or box shrines at Kinneddar [298] and Rosemarkie [304].[82] Key- and fret-patterns are comparative rarities in ambitious Insular stone sculpture, outside the Pictish province, though they are part of the repertoire of the architectural sculptors at Breedon-on-the-Hill, handled with the same simple clarity as round knots of interlace and curious 'hook and eye' spirals.[83] A fret pattern with the same strong vertical stroke of Augsburg and Shandwick forms the decoration of the engraved chased panel on both sides of Christ's robe on the Athlone plaque, while interlace forms the central panel and trumpet spirals the hem.[84]

Plant Forms

The extensive vocabulary of Insular vinescroll ornament, uninhabited and inhabited, which is skilfully employed by Pictish sculptors at a mature stage in their output, has interesting antecedents and parallels in other Pictish representations suggestive of the growth of plant forms. The so-called 'flower symbol' which like the 'beast head' symbol may originate in the design for a pole top, in its artistically finest version, at Dunnichen [68],[85] looks like a cross between a thick-stemmed, heavy-sheathed Arum lily, and the sculptured forms decorating the greaves of a Thracian prince.[86] In other versions of the symbol, the interior tensions of the design disappear, leaving only the silhouette, the 'flower heads' drooping to the left, not to the right as at Dunnichen and the kindred version at Pabbay.[87] The version on the Ulbster cross-slab [207] has three mushroom-like flower heads. At Fowlis Wester [222] an elaborately robed cleric sits enthroned in profile, looking right, with a plant stalk growing straight up at his feet, with nine short stems projecting one above the other to the left, each ending in a round leaf. It is uncertain if the shape of this tree has been infected by the Ulbster 'flower' symbol, or the Ulbster 'flower' symbol by this tree. Another schematized but vigorous

60 *Detail of tree inhabited by animals, from long panel, St Andrews Sarcophagus, Fife*

plant-like form among the Pictish symbols is the 'Z-rod' that accompanies, and in some way glosses, the 'double disc' symbol. In the version at Dunnichen, and curiously in a reversed position on the Norrie's Law plaques [112], the upper bar of the 'Z-rod' sends out alternate wiry stems, like a natural vegetable or arboreal growth. A tree rising vertically behind a walking figure on the back of the cross-slab at Eassie [208][88] has branches syncopated in just this way, again suggesting literally, cross-fertilization between the province of the symbols and that of narrative relief sculpture. It is, however, salutary to note that it is not the laws of nature but those of the blacksmith which dictate the paired backwards-hooked 'branches' of the 'Z-rod' sculptured in relief on the back of the great cross-slab at Aberlemno roadside [186]. The tree carried over his shoulder by the centaur at the base of the Aberlemno slab is an equally artificial metallic structure, with three pairs of branches forming scrolls on either side of a rigid bar. As if by way of a deliberate contrast, the centaur on the great cross-slab, Meigle No. 2 [194], supports under his right arm and trailing out behind him an irregular mass of branches and leaves, which belongs to the same naturalistic tradition as the grove of saplings through which the hunters run towards the wolf's den on the left side of the Franks Casket [23].[89] The master work in this style is the front panel of the St Andrews Sarcophagus [60], where a thick-boled tree grows up and throws out its leafy boughs in all directions. Six hefty animals squat, scurry, or break out from its branches. The composition is decorative and densely populated not like an inhabited vinescroll but more like a late medieval pastoral tapestry. The branches and leaves on the Sarcophagus form pretty knots, in the Insular interlace tradition, but the controlling purpose is picturesque naturalism, and the model for such an irregular burgeoning tree must be the same kind of Late Antique

work of art which brought the heroic David and the lions and griffin into Pictish Scotland.[90] Equally remarkable in putting the conventions of the Insular style to the service of picturesque narrative are the three-strand plait of the palm trees which enclose the figures of SS Paul and Antony at the top of the Nigg cross-slab [203]. The effect is naturalistic, as if the pediment was clad in free-growing ivy. The sculptor uses his foliate strands as a scene-setter more in the spirit of the landscapes of the Antwerp Sedulius[91] than of the claustrophobic regimented potted-plants of Kells [22].[92]

Critical agile minds, therefore, were ready to work at the adoption and adaptation of formal vinescroll as seen in early Anglo-Saxon sculpture such as the Ruthwell and Bewcastle crosses and the Jedburgh shrine panel.[93] Vinescroll inhabited by birds and slim winged quadrupeds was used as a frame around the picture space on the back of the Hilton of Cadboll cross-slab [50]. Just as the V-rod on the 'crescent' symbol at Cadboll looks like a huge pair of tongs or a bent spit, armed with flamboyant, smith-crafted, terminals, so the scrawny birds, hovering with half-opened wings among the undulations and knots of the vine resemble an open-work metal grill. The elegantly curving lines of the design are similar in mood to the zoomorphic and foliated display letters in the *In principio* page of the Barberini Gospels.[94] The sprawling pair of petals crowning a berry-bearing stem behind the backs of the Hilton of Cadboll trumpeters has something of the look of the wide bat-winged flower heads on the weird plants that grow in St Matthew's garden on *f.* 11v of the Barberini Gospels [20], and the sudden zigzag lurch of the stems in the miniature hints at the bold chevron layout of the vinescroll at the left of the Hilton of Cadboll slab.[95] Hilton of Cadboll [50, 61] is the Pictish masterpiece in the vinescroll tradition, with typically Pictish visual contrasts from one side of the composition to the

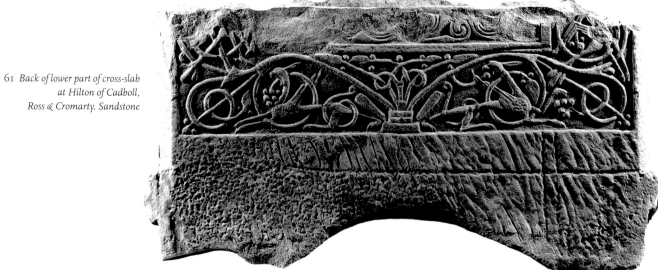

61 *Back of lower part of cross-slab at Hilton of Cadboll, Ross & Cromarty. Sandstone*

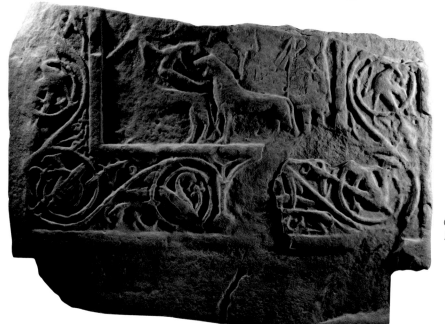

62 *Lower part of cross-slab, Tarbat, Ross & Cromarty, No. 1. Sandstone*

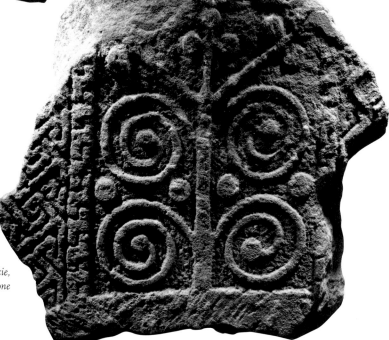

63 *Fragment of grooved panel, Rosemarkie, Ross & Cromarty. Sandstone*

other, similar to the contrast between lozenges and round bosses alongside the cross-stem at Nigg. The same sculptor carved what remains of a vinescroll bordered cross-slab from Tarbat, with long swooping scrolls, inhabited by birds and beasts as thin as dragonflies [62].[96] Clearly related to Hilton and Tarbat, and moving the motif forward into even more fragile stylized forms, is the right flank of 'Sueno's Stone' at Forres [64],[97] where the vinescroll is inhabited by men in the upper panel, and in the lower the vine loses its leaves and its pliable scroll, and becomes like dry brushwood, lodged up against the side of the cross-slab, like matting. Such quirky individual treatments of the vinescroll motif cannot have developed overnight, but nothing survives to prepare us for the polish and sophistication of these performances. There are other examples of vinescroll ornament in Pictland, but on the whole they follow conventional lines. St Vigean's No. 1, an unusually idiosyncratic Pictish cross-slab called the 'Drosten Stone' after the personal name inscribed on its right flank [250], has a meander vinescroll (on its left flank) [65] with pellet berries at the centre of the scrolls, the spaces between the scrolls being filled by a single spear-bladed leaf on a stem which springs from the inner scroll and lies across the outer scroll in a characteristically Insular manner [65]. The upper section of the vinescroll is handled somewhat differently, with looser and more varied placing of stems and leaves. In the second 'scroll' from the top a small beast is perched, biting the berries, like a miniature version of one of the inhabitants of the Rothbury vinescroll.[98]

Fragments of cross-slabs at St Andrews (Nos 30 and 32), have plant stems coiling apparently at random, with in the first case berries at the end of the stems, all placed outside the scrolls, and in the second case no berries, only leaves on short stems or at the end of the strands.[99] On the free-standing Dupplin Cross [196], one spear-shaped leaf and stem is treated in the same fashion as at St Vigean's No. 1, lying across a coiled up stem, but all the other leaves are trefoils, and the plants that bear them grow from two rectangular bases at the bottom of the cross-head and lie over one another to wind round the central boss and coil into the arms of the cross, so that the whole cross-head is foliated, a pleasing device.[100] The cross on the front of the Crieff cross-slab [279] is clothed in part with similar trefoil leaves and strands, and a frothily foliated pair of meandering bands, ending in savage animal heads, fills the left flank of the slab.[101]

A panel at Rosemarkie [63], which may be from the end of a box shrine, is carved in relief with a little tree with three spreading stems at the top, each bearing a stylized trefoil leaf, while the main trunk sends out two pairs of scrolls ending in a disc-shaped fruit . This late sculpture describes the little tree and vinescroll motif in very much the same archaic simplicity as the little tree on the cover of the Stonyhurst Gospel of St John [19].[102] The panel belongs resolutely with the tree carried by the centaur at Aberlemno, not with the real rugged tree carried by the centaur on Meigle No. 2.

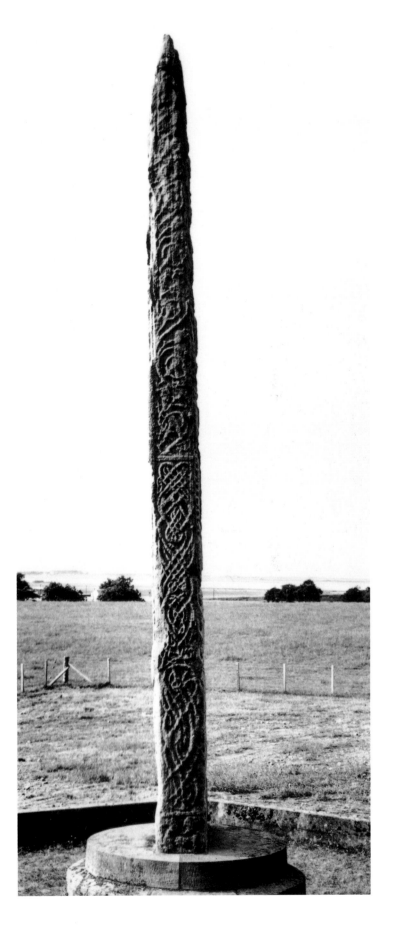

64 'Sueno's Stone', Forres, Moray. Sandstone

Ornament Involving the Human Figure

Pictish sculptors represent the human figure in a number of different contexts, as indicated in the survey of iconographic programmes (Chapter 5). Overall, Pictish figure sculpture widens the scope of the Insular idiom in this respect, and sets a standard equally for creative adoption and adaptation of external models and for continuous authentic vigour of 'native' production. There are some categories of figure sculpture in the Pictish area, however, which draw closer to conventional figural representations as seen elsewhere in the Insular world. A number of decorative motifs involving the human figure have direct parallels in the Book of Kells. The lithe tensely scrolled-up body of the man on the wreck of a fine cross-slab from Monifieth, and seen again on a Meigle recumbent, No. 9 [290], might have been transposed directly from or into Kells, above the start of Canon 7 on f. 5.[103] At the middle of the left side of Meigle recumbent, No. 26, four naked men bend to form the four sides of a square decoration, each with his profile head adjoining the buttocks of the man in front, who in turn grasps his neighbour's toes [66]. Variations of this motif occur in the Book of Kells, for example in wrist-holding triplets above and under the central scroll of the *Initium* initial on f. 130, and also in Irish stone sculpture and metalwork.[104] In the upper panel on the right flank of the front of 'Sueno's Stone' [64], at least four thin profile figures of men are placed one above the other, facing alternately right and left, and

65 *Vinescroll ornament on side of cross-slab at St Vigean's, Angus, No. 1. Sandstone*

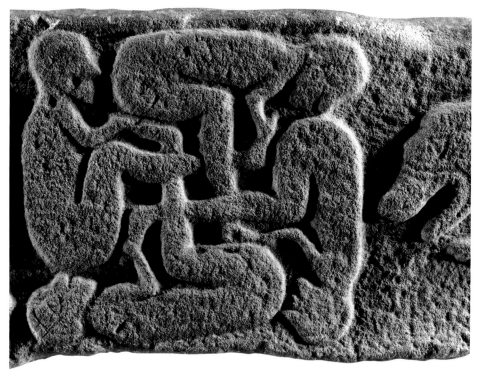

66 *Panel of figurative ornament on recumbent monument, Meigle, Perthshire, No. 26. Sandstone*

striding purposefully like the pedestrian hunter at Eassie [179] but confined now within the narrow space of the panel, and enmeshed by slender encircling strands of a vinescroll meandering up the edge of the monument. At Jarrow a stalwart figure of a shield-carrying man, in ribbed clothing, is encased in thick foliate strands, exactly as in another panel birds sit among framing branches;[105] but the Jarrow man is engaged in a horizontal narrative scene and not truly one of the inhabitants of a vertical vinescroll. A nearer, but not close parallel for the Pictish vinescroll inhabited by human figures is at Breedon-on-the-Hill, where equal-sized men and birds and armed horsemen are set within circular foliate strands in horizontal decorative architectural panels.[106] Thin crouching men, one above the other, all facing in the same direction, are packed into the narrow columns or pilasters of the canon-tables on ff. IV and 2 of the Book of Kells, accompanied occasionally by predatory birds and with an undertow of thin interlaced strands, extensions of the men's beards and hair, but foliage strands, of the vinescroll tradition, are kept apart in Kells, on f. 2 filling the arch over the entire canon-table.[107] On f. 3v three men are test-tubed in the two central columns of the canon table, facing towards one another across the gap, while the same two central columns on f. 4 contain a small plump chestnut leaf-like pattern of vinescroll.[108] The two adjuncts do not come together as vinescroll inhabited by men, whereas this particular syncopation, typical of the visual agility of the Picts and using a traditional type of freely moving figure, is achieved at Forres. More in line with Kells' own particular congested style is the panel of ornament at the top right corner of a fragmentary recumbent, recently discovered at Rosemarkie, where human ankles and feet appear below a large spiral scroll, exactly the design, only in reverse, of the anthropomorphic letter 'B' of Kells' beatitudes on f. 40v. Oddly enough, at Rosemarkie the essential Insular feature, preserved in Kells, of one leg over and one leg under the scroll, is discarded.[109]

Where Pictish figural sculpture is most obviously related to standard practice in mature Insular book illumination is in the incidence of frontal figures of sacred persons, angels, and ecclesiastics, on monuments in Perthshire and Angus which do not carry the Pictish symbols or representations of riders. Enthroned figures on the cross-slab at Kirriemuir No. 1 [314], with heavy moon faces, one seated on a throne with beast-head terminals, and others with a single arm projecting from below their robes, have a family likeness to the formidable foursquare presence of the figure of Abraham opposite the *Christi autem* page of the Book of Deer.[110] Rugged simplicity of outline and texture is the hallmark of this series of relief-carved frontal figures. Three standing figures at Invergowrie [67] wear grooved mantles and robes, and have large heads on stunted bodies. Whether the two outer figures are angels with stylized wings, or clerics with shoulder disc brooches, is uncertain.[111] The central figure appears to hold a seal matrix suspended from a short stick, or some such sign of his authority. The similar pair of frontal figures at

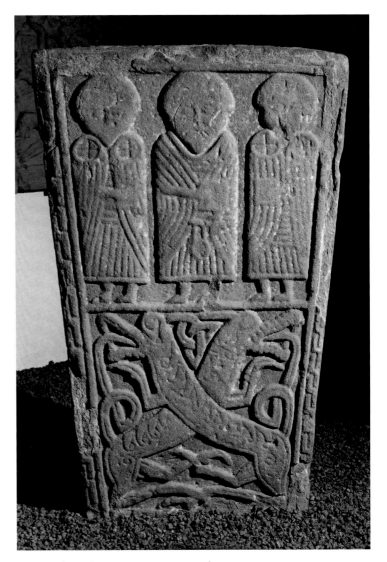

67 *Back of cross-slab, Invergowrie, Angus. Sandstone*

Lethendy [210] and Meigle No. 29 have button eyes and noses on round flat faces.[112] These sculptures look simply like weak imitations of the more expressive, rationally proportional figures seated on beast-headed thrones at Aldbar [193] and St Vigean's 11 [209]. Significantly the horizontal struts on the backs of their thrones do not continue outwards to touch and make a pattern with the frame, as they do in the Gospel Books of Deer and Macdurnan, nor in the major monuments in the frontal style is there any hint of the extreme stylization and convolution of body and drapery seen in the latest Irish Gospels and Psalters.[113] The source of, or parallel to, Pictish frontality is not so much the abstract style of the Echternach *Imago hominis* as the classically derived and sober standing or seated figure of David in the Durham Cassiodorus.[114] Thus in Pictish figure sculpture there is no equivalent of the lobed, tent-like structures used to represent the figures seated in the Book of Deer, an indication that 'Deer' signifies provenance, not origin.[115]

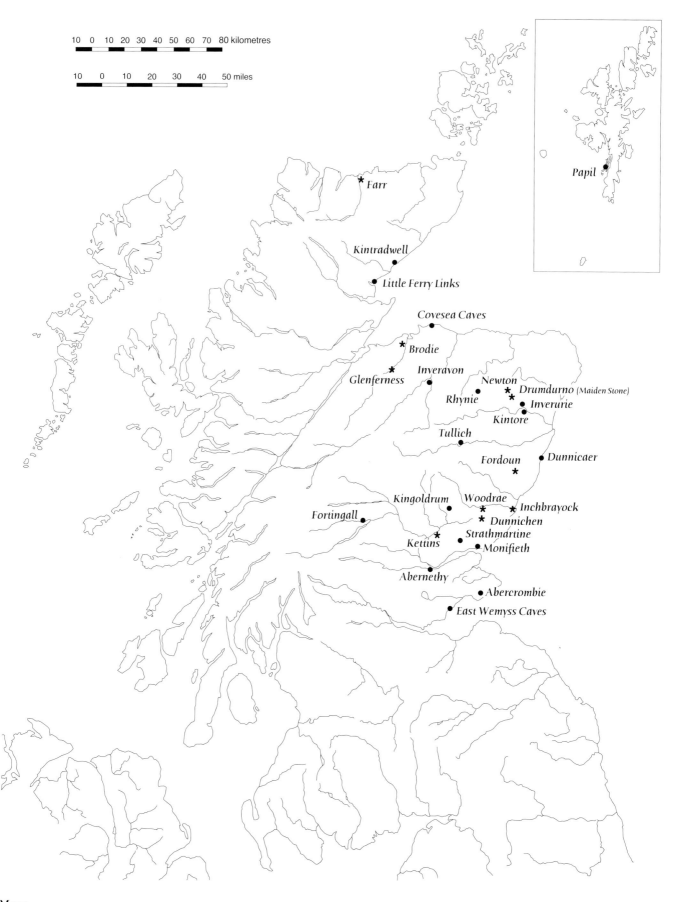

Map 3

Sustained activity and ambitious commissions: locations of major collections of Pictish sculpture (for which also see Map 2), and findspots(*) of apparently single monuments of particular art-historical significance

3
The Pictishness of Pictish Art

The Pictish Symbols and their Exploitation in Art

It is reasonable that a study of the Pictishness of Pictish art should begin with some consideration of a tantalizing component of that art, the symbols. A great deal has been written about them and a select bibliography on the subject is included at the end of this book. While from an anthropologist's point of view 'symbols are not art objects',[1] it is specifically as formal artistic creations and an element in larger decorative and pictorial compositions that they will be discussed here.

The Pictish symbols consist of a few figures of animals and a larger series of abstract firmly-contoured designs, the majority easily distinguishable from one another and indeed as if a calculation of difference was the basis of their designers' thinking. Two symbols that are evidently twins, sharing at their base a firm cone, beautifully nodulated and grooved, are clearly differentiated

as they rise, one splitting into two curved stems, the other carrying a graceful animal's head [*68, 69*]. Ambiguity occurs only in the symbols using circles, for example the right half of the 'double disc' symbol at Bourtie might be taken to be the 'rosette' symbol of Kinellar or Rothie Brisbane.[2] The erect 'mirror case' symbol [*70*] is only distinguishable from one half of the 'double disc' symbol by the latter normally being placed horizontally. There are symbols that fail to maintain their shape, and in the long run seem not to be found useful. A symbol of good appearance, vigorously executed, the flared thunderbolt design on Dunrobin, Sutherland, No. 2 [*71*] survives only in a looser more curvilinear form, like a vertebra, from Newton of Lewesk, Rayne, and much modified as two narrow crescents, pressed back-to-back, at Ulbster [*56*] and Kintore.[3] The 'triple oval' symbol barely appears outside Caithness [*73*].[4] A symbol shaped like manacles, at Mortlach, and a helmet-like symbol at Congash have no duplicates.[5] This catalogue of

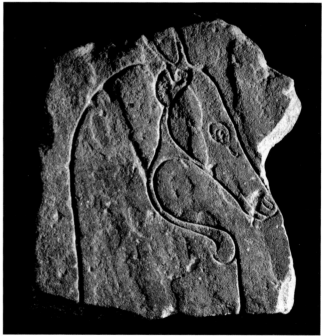

69 Incised 'beast head' symbol, Stittenham, Ross & Cromarty. Sandstone

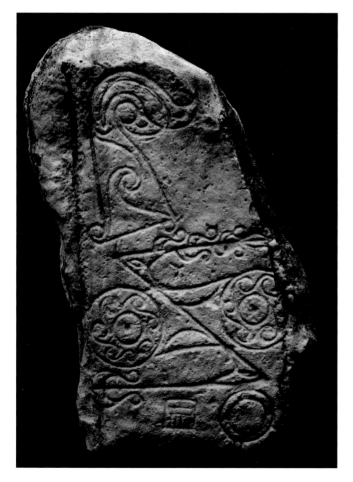

68 Incised 'flower symbol', Dunnichen, Angus. Sandstone

deviants or failures, if so they be, cannot alter the impression given by the symbols as a whole that they are essentially as fixed and settled in shape from the start as are 'A', 'B', 'C'. Each symbol in its incised form comprises a bold coherent unit, the design principles of which are entirely congruent with the flowing decorative infill of some of them, in particular the 'crescent' symbol, where the various curvilinear patterns, lobes and peltas, common to them all (whether the tiny crescent scratched on a phalangial bone from the Broch of Burrian [251] or the generously long crescent from Greens, Orkney,[6] and from Golspie [72]) suggest that the designers thought within the conventions of Iron Age metalwork. Among the symbols representing animals, the sustained beauty of line which gathered in, on one small stone surface, the tranquil 'beast head' symbol from Stittenham [69], and the flick of the wrist that checked, just short of completion,

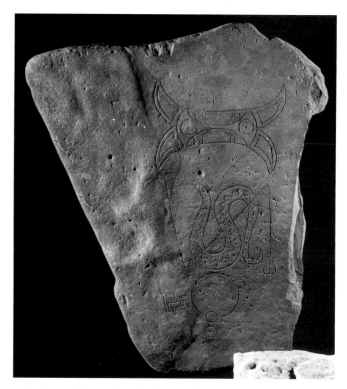

71 *Incised symbol stone, Dairy Park, Dunrobin, Sutherland No. 2. Sandstone*

the tip of the slim volute which defines the shoulder of the Stittenham wolf – these are signs of that sureness of touch that characterizes Pictish art from the start. The languorous silhouette of the 'Pictish beast' symbol on Golspie No. 1 [72] is scored with extraordinary tentative sensibility on the flinty surface of a flagstone. Looking at its curved heron-like neck and head, its long calf-like body, its short thick thigh and narrow foreleg, both dropping down and scrolled at the ends like flayed hide, one would say: this was drawn from the life; the form must be thus, and no other.

With one notable exception, the Craigton symbol stone in the grounds of Dunrobin Castle, which has a huge 'crescent and V-rod' symbol in the unusual vertical position and pushes little 'flower' and 'tuning-fork' symbols into the confined space at either end of it [74],[7] the symbols incised on pillars and slabs are all given equal emphasis, placed in an orderly manner one below the other, with a clear field around them. Many of the original symbol-bearing monuments have been broken in pieces or reshaped for later different use, but a classic presentation of symbols can be seen on one face of an irregular slab at the Old Churchyard, Rhynie No. 5 [75], and on a rectangular slab in a nearby field [76].[8] The linear motifs are cut with verve and clarity into the rough surface of these monuments and they very agreeably sit within the available space and shape of the stone. Routinely only two symbols appear, although often the motifs shaped like, and no doubt representing, a 'mirror and comb' are added for good value, always at the bottom. The rule that symbols occur in pairs holds good for the remarkable leaf-shaped engraved silver plaques from

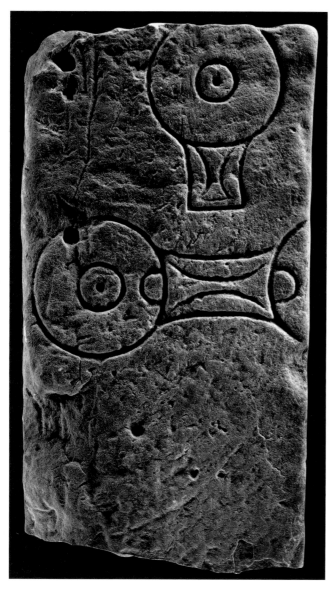

70 *Incised symbol stone, Westfield, Fife, No. 1. Sandstone*

72 *Lightly incised symbol stone, Golspie, Sutherland. Thin bedded micaceous sandstone*

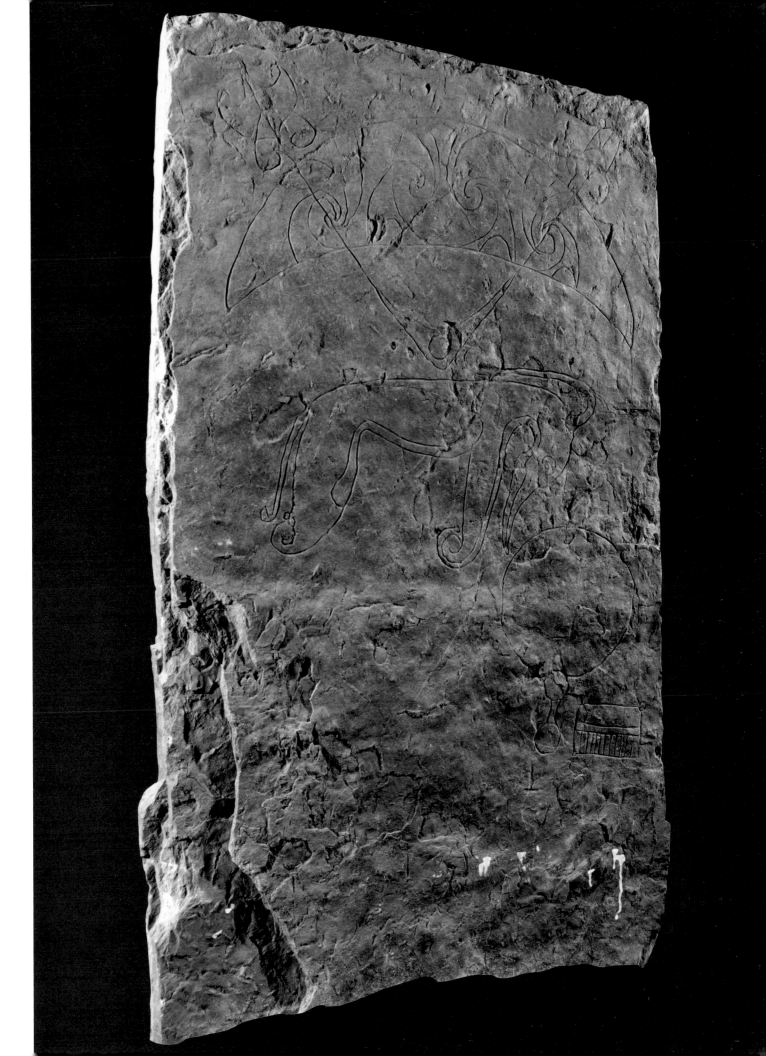

Norrie's Law [112] and for a number of terminal rings of heavy silver chains [109, 111]. In the case of two sculptured monuments, Kintore and Easterton of Roseisle (where two pairs of symbols appear, one pair each on the front and the back), one set of symbols is upside down, indicating a change of plan. But Kintore also has a slab carved with two pairs of symbols, different ones, correctly viewed, sprawling across its opposite sides.[9]

In what looks like an early stage in the encounter of cross and symbols, on an upright slab at Raasay, Skye [253], the incised cross is of a type paralleled in both the *Cathach* and the Book of Durrow,

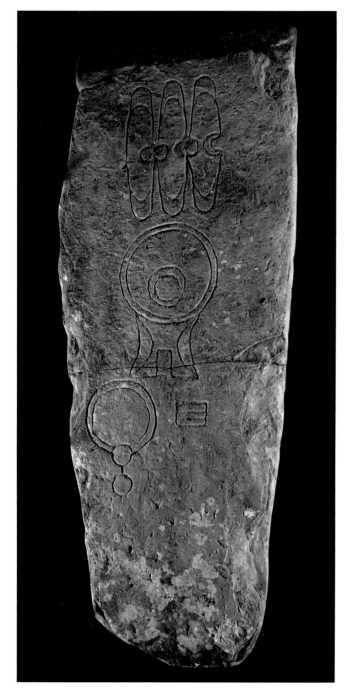

where it is used to flag up conspicuous sacred places in the text.[10] Perched on top of a narrow stem like a metal portable cross, it is of solid square format, its deeply splayed curved arms separated by petal-shaped openings. Its upper arm is marked at the right by the curl signifying the initial 'Rho', making the whole image the monogram of Christ, the Christogram. Incised in the same style below the cross are two symbols laid out across the lower section of the slab, one above the other. The introduction of the cross drawn out large as if on a cross-carpet page, demanding plenty of vertical space, and worked in relief, caused a basic change in the presentation of the symbols, both individually and in association with each other. All monuments are shaped up, with straight sides and flat rectangular fields of relief decoration on both front and back, the symbols being consistently confined to the latter, while the cross takes over the former. Two exceptions to this rule, Glamis Nos 1 and 2 [34, 32, 33], may be significant in the chronology of Pictish style and design. In both cases the slabs have fine incised symbols on the otherwise empty rough surface on one side, while on the other a flattened surface (in itself nothing new, since monuments bearing incised symbols in the finest style from Dunrobin [71, 72] and its neighbourhood are most sensitively prepared) displays a handsome relief cross decorated with interlace and other Insular motifs.[11] A second pair of symbols, not reproducing those cut on what would now be deemed the back, are fitted in on Glamis No. 2 at the right of the stem of the cross, one above the other, in the traditional manner. The option of simply adding to the symbols on the back has not been entertained. Technically the new symbols are not much different from their predecessors. They are firmly incised, but the Pictish style of relief, which often consists of cutting away the background of the motif, is in play under the deep carved right arm of the cross, and gives the effect of raised relief sculpture to the 'beast head' symbol.

At Eassie the front of the slab carries a design of cross closely related to those at Glamis. The symbols, however, are now placed on the back [208]. There are again two, tiered one above the other, but their position, crowded into the top left corner and juxtaposed with figures and other pictorial elements which may perhaps represent a biblical narrative, has a perfunctory look.[12] The presentation of the symbols, once they ceased to be the only images which sculptors were called upon to carve, has a purely aesthetic aspect as well as the more opaque one of why they are on the monuments at all. A regular pair of symbols, the stylized 'Pictish beast' and the 'crescent and V-rod' are displayed on the back of the cross slab, No. 4, at Meigle [35]. They have been placed halfway down and at the left-hand side of the picture space, otherwise occupied by the profile figures of riders, a slim hound-like beast and two patches of interlace, nicely contrasted in the

73 Incised symbol stone, Sandside House, Caithness. Sandstone

thickness of their strands. All these variegated forms are clearly delineated, with rounded edges and surface detail, but all sharing the same frontal plane, with a flat recessed background behind. The same effect could be achieved in wood carving, say, on the front panel of a chest. The relief technique of the whalebone Franks Casket [23], though minute by comparison, is very similar. On Meigle No. 4 the style, both representational and decorative, is totally integrated, so the symbols are effortlessly part of this buoyant visual fabric. They were evidently 'second nature' to the sculptor and the integrity of their design is wholly unimpaired by

their being slotted in with simply decorative motifs. When one thinks of the shape-changing of Evangelist symbols in Insular manuscripts – for example, the lion symbol in the Gospel Book of Durrow [24], Echternach, Lindisfarne, Kells[13] – the forms of the Pictish symbols are rocklike by comparison. What we are meantime investigating is not any alteration to the symbols, but rather the visual emphasis they are apparently being given in any one monument.

The approach of the Meigle sculptor contrasts strikingly with that of the sculptor of the cross-slab at Dunfallandy [77]. The

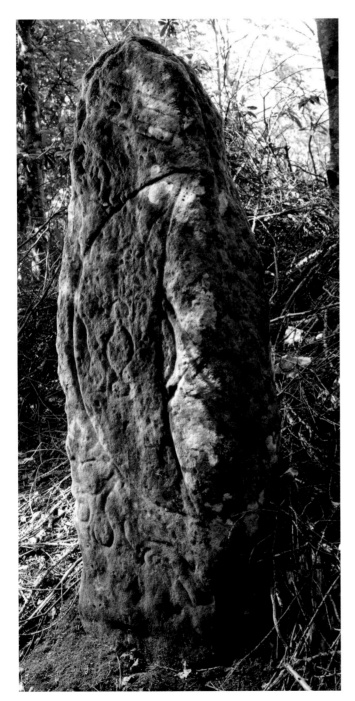

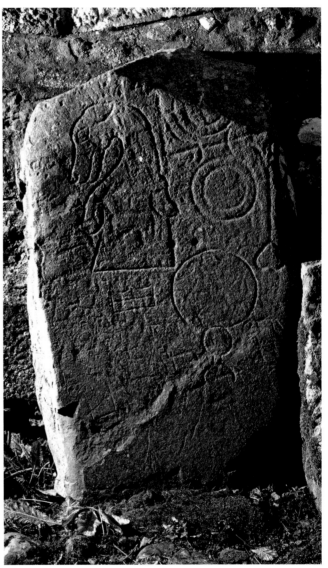

75 *Incised symbol stone with 'beast head' symbol, Rhynie, Aberdeenshire. Whinstone*

74 *Incised symbol stone, Craigton, Sutherland. Sandstone*

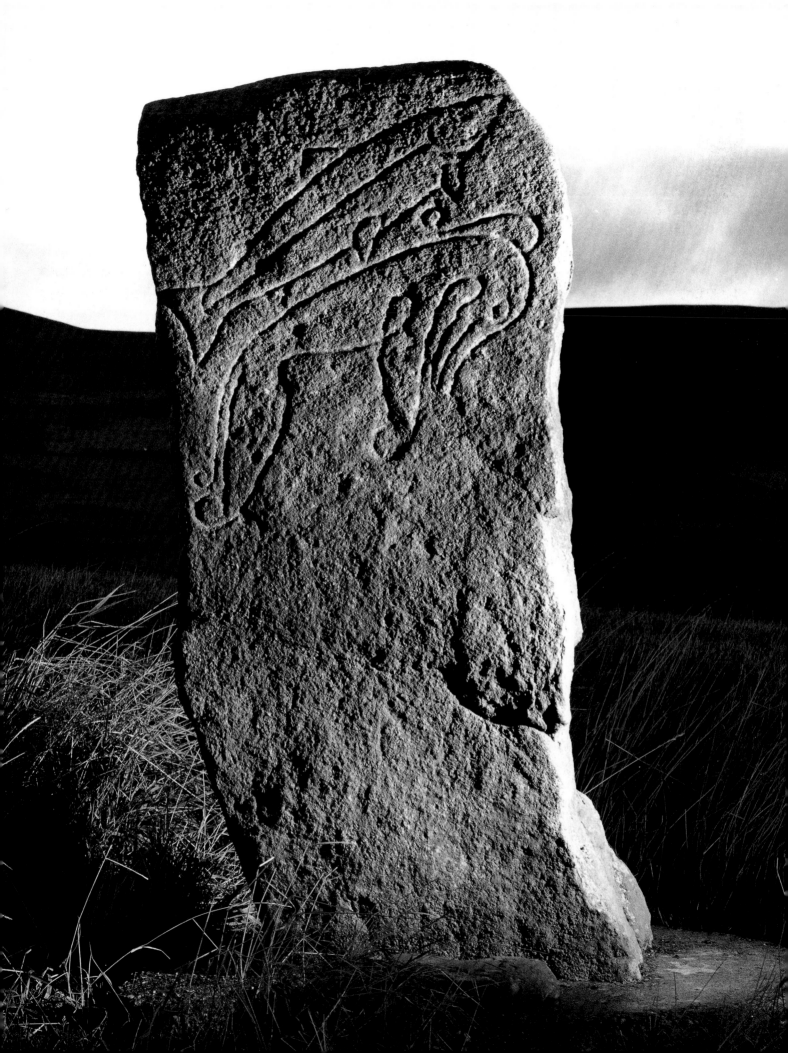

symbols are again confined to the back, but they share the picture space in what seems a deliberately restrained manner with nothing more than three human figures, two seated and one riding. One of the pairs of symbols is repeated.[14] In any ordinary Latin codex of the period, such attendant motifs, fluttering around the figures, could only be captions or attributes. Crudely cut symbols fill the space below a single seated figure on the back of the cross-slab from Kingoldrum.[15] In the top framed panel on the back of the Woodrae cross-slab [274] a pair of symbols share the

space with a single horseman.[16] As it survives, the vigorous relief sculpture on the back of the cross-slab at Logierait consists solely of a horseman and a single symbol, as large as himself, a snake and rod, on which he appears to trample.[17] The back of the cross-slab at Kirriemuir [263] shows two horsemen, one with hounds at the climax of a deer hunt, the other, in the upper part of the monument, making stately progress to the right with a single symbol floating in the top left corner behind his back. On a slab from Birsay [78], in what looks technically like a tentative early

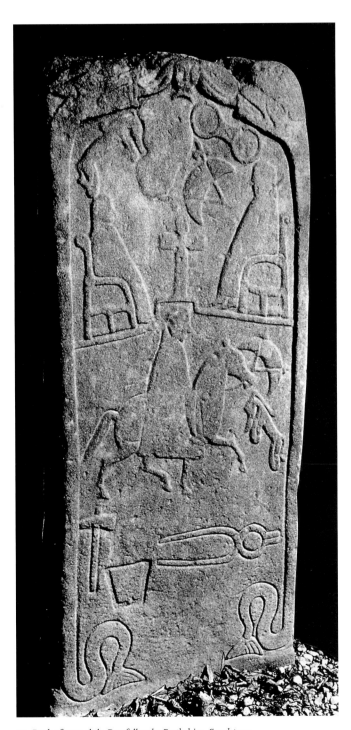

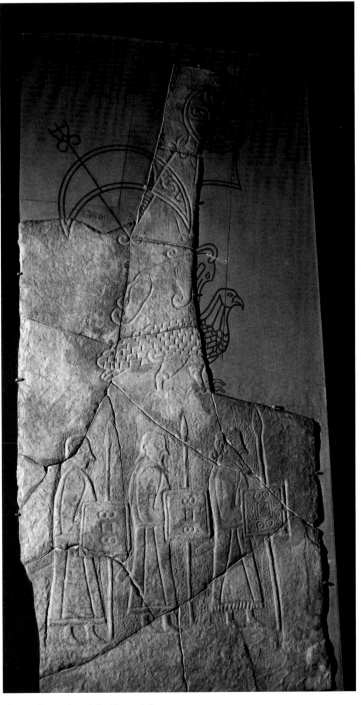

77 *Back of cross-slab, Dunfallandy, Perthshire. Sandstone*

78 *Warriors and symbols, Birsay, Orkney*

exercise in relief sculpture, the wide space above the procession of three warriors is occupied by four, tiered, symbols, the effect of the whole making the warriors look like symbols themselves, rather than that the symbols gloss the warriors.[18] In much the same way, though in a later bolder style, the back of the cross-slab from St Madoes [79] seems to fling the data at the modern spectator, without any more certainty resulting. Three horsemen, arranged vertically with each in a separate framed compartment, occupy the upper half of the slab, and three symbols (each separately framed, two side by side and one below) occupy the lower half.

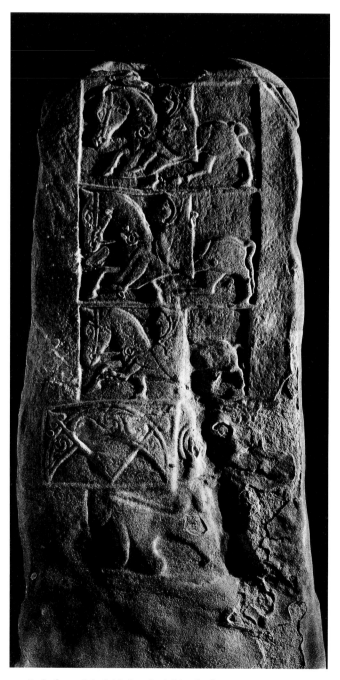

79 *Back of cross-slab, St Madoes, Perthshire. Sandstone*

Setting a square frame round a symbol, giving it the ostentation of a placard or titulus, recaptures the extraordinary impact and visual clarity of early incised symbols, such as those from Clynemilton [247] or Dunnichen [68], by a wholly different artistic means. The individually framed, relief-carved symbols laid out across the 'Maiden Stone' [80] at Chapel of Garioch have a kind of archaic simplicity. The full effect of framing, taken in conjunction with increased ornamentation within the body of the symbol itself, is seen on the back of the cross-slab from Hilton of Cadboll [50] where the uppermost square section of the monument, within a broad decorative border that encases the entire picture space, is filled from corner to corner by a magnificent rigid version of the 'crescent and V-rod' symbol and by two huge discs packed with knitting-wool interlace. The same framed treatment is given to the hunting scene in the next square section of the monument, proportioned exactly like the symbol square. Sealed off from the other symbols, as if it somehow belonged to another category, a 'double disc and Z-rod' symbol occupies the top border, visually accommodated by the lacy circular bird-and-vinescroll ornament of the adjacent border strips. At Shandwick [51] two symbols – a 'double disc', and a 'Pictish beast' benign and god-like in its bulk and expression – are each placed in a long rectangular panel which they entirely fill, one above the other at the top of the back of the giant cross-slab. The next rectangular panel, of exactly the same proportions, contains the frieze of men, horsemen, animals and birds. Lower down again is a square panel containing a methodically regular trumpet-spiral pattern like a colossal sunburst or maelstrom. The rigid division of the upright cross-slab into horizontal panels each bounded by a plain narrow frame is strikingly reminiscent, on a vastly increased scale, of the panelled carpet page on *f.* 192v of the Book of Durrow [9].[19] The weight and grandeur of the symbols is out of all proportion to the rambling disjointed (though beautifully carved) inhabitants of the figurative frieze immediately below them, and more in harmony with the big spiral panel on the middle region of the monument or with the high-relief cross on the obverse [200], the cross-arm of which lies directly behind the 'Pictish beast'.

The apogee of this approach to the presentation of the symbols (which in its very nature takes us further away than ever from understanding the message the designer was really conveying) is the back of the cross-slab at Rosemarkie [39, 316]. There, the middle region of the slab is filled with a square cross-carpet page design, in itself one of the great works of Insular Christian art, and which again looks surprisingly like a magnified page from the Book of Durrow, the cross-carpet page on *f.* 1v.[20] Piled up above this square ornamental block and filling the height and breadth of the slab are four enormous symbols [81], three 'crescents and V-rods' and one 'double disc and Z-rod' represented as if sumptuous examples of the goldsmith's art, their membrane formed of open-work interlace and cast or repoussé spiral bosses. This amazing storehouse of crescents looks for all the world like the top trophies

won three years running by St Curitan's men[21] in a pan-Pictish competition for horse racing or choral singing or whatever. It is at least food for thought that these spectacular symbols are indissolubly united on the same side of the monument with the likeness of a venerable Gospel page, or Gospel Book cover, or the cover of a precious shrine.

That the centrality and ostentation of these symbols at Hilton of Cadboll, Shandwick and Rosemarkie were a matter of decision and choice is confirmed by the comparative reticence in respect of its symbol input of the Nigg cross-slab, a work of art of equal technical excellence from the same territorial area, indeed only six kilometres from Shandwick. At Nigg the analogy of the manuscript page is even more palpable than at Shandwick or Rosemarkie. The entire back [184] has a wide margin, divided into panels, along the lines of the frame around the picture of David as saint and warrior in the Durham Cassiodorus [13]. Consequently the picture space is especially tall and narrow, and at the top of this a pair of symbols one above the other, unframed, are placed with no particular other emphasis; indeed, they are positively compressed by the number of other impressive motifs, men and animals, which provide discrete units of action down the whole length of the monument. On the Aberlemno churchyard cross-slab, the front of which belongs to the early elegant decorative tradition of Glamis [33] and Eassie [179], the system later perfected in the North-East is already in place on the back [82]. The pair of symbols are presented on a large scale, dominating the pediment-shaped upper part of the slab and kept clear by a framing line from the battle composition which fills the rest of the space. On the formal analogy of a consular diptych, the symbols take the role of the official in his box, and the battle is the circus or games in the arena below.[22] In the subsequent Aberlemno masterpiece, on the roadside [186], the pair of symbols are still in their own separate compartment at the top of the slab, but have grown in size and complexity of surface ornament, matching the appearance of the Hilton of Cadboll symbols [50] as only two works by the same team of sculptors can. Cossans, also in the south, places a decorative frame around the edge of the back of the cross-slab [315], in width and choice of ornamental motifs more directly related to southern monuments such as the recumbent at Meigle, No. 26 [292, 293], than to the wide borders favoured in the North-East, but the large-scale presentation of the symbols in the upper part of the monument and the neat horizontal ground lines that divide the rest of the picture space into narrow rectangles show awareness, similar to that of the Aberlemno roadside cross-slab, of North-East trends.

On the other hand, St Vigean's No. 1, the 'Drosten Stone' [83], a sophisticated southern monument with mature features such as its decorated flanks, reverts to the essentially decorative casual approach of Meigle No. 4 [35], and allows the symbols, the 'double

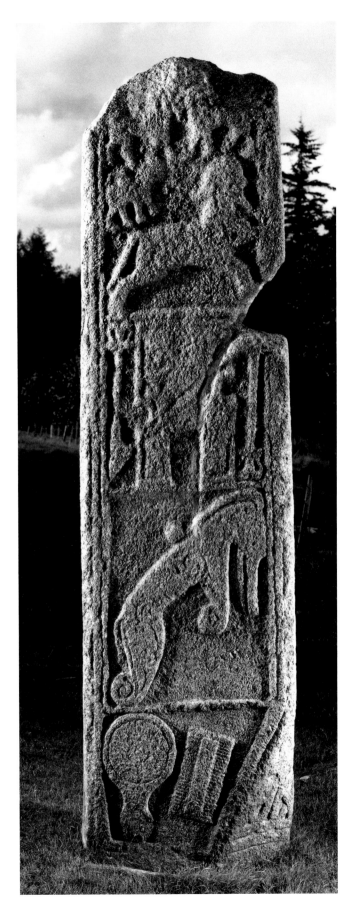

80 Back of cross-slab, 'The Maiden Stone', Drumdurno, Aberdeenshire. Granite

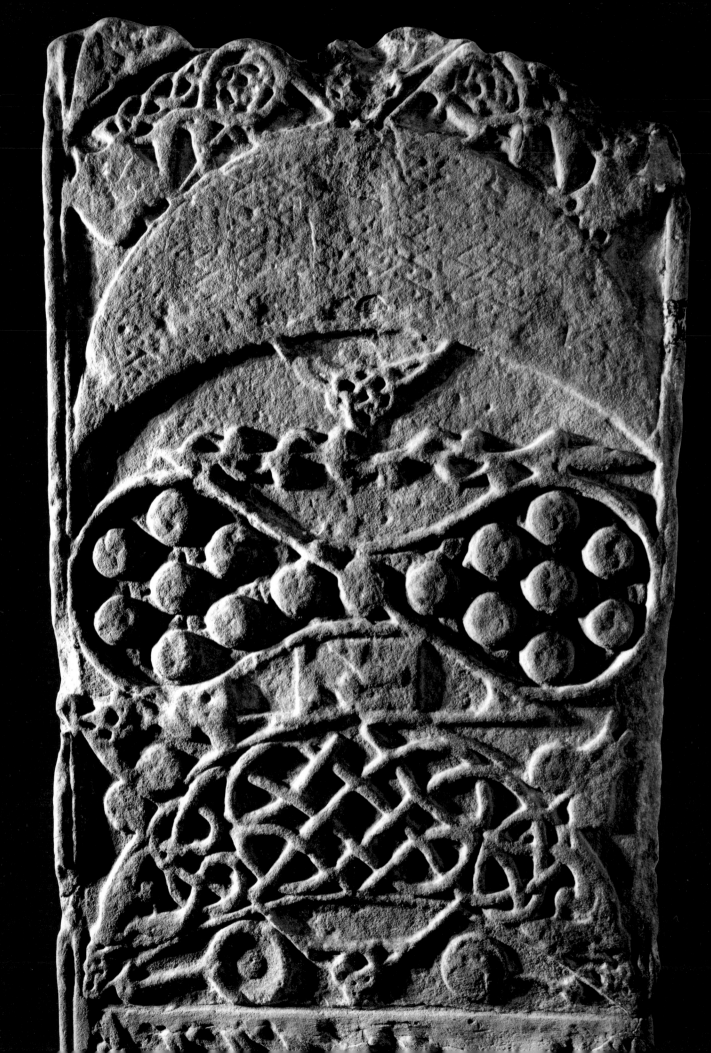

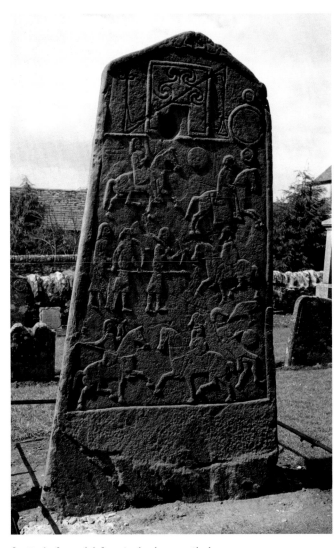

82 *Back of cross-slab featuring battle-scene, Aberlemno churchyard, Angus. Sandstone*

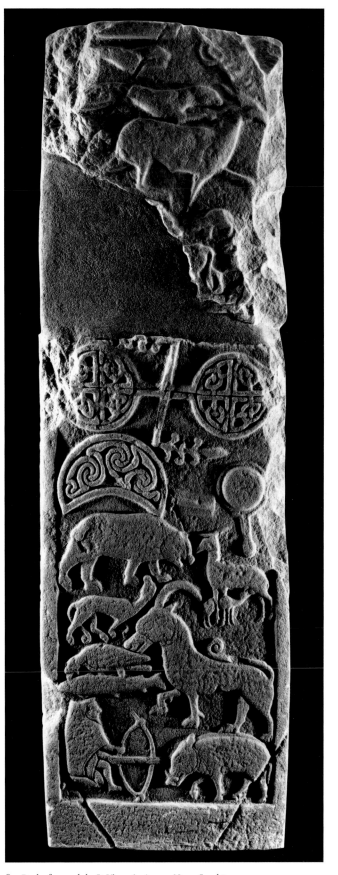

83 *Back of cross-slab, St Vigean's, Angus, No. 1. Sandstone*

disc' and 'crescent', large and showy as they are, to slide down into a middle zone between a fast-moving pursuit of a deer by hounds at the top, and a beautiful quiet pastorale at the bottom. At Fowlis Wester [198] these same two symbols so often chiming in together on the monuments, are uncoupled, the 'double disc' being set right at the top, above the figure of a single horseman placed conspicuously on the level of the projecting arms of the cross carved in the front. In tiers below him is the figure of an animal, then a pair of horsemen carrying a hawk as at St Andrews [190] and Elgin [188], then the unique scene of a company of foot soldiers following the belled cow and its keeper; under the feet of the keeper, far down the monument near its left side, is a 'crescent and V-rod' symbol with, on the right, possibly an eagle symbol; and at the very bottom a damned soul is trapped in Hell mouth.[23] What looks now like disassociation of ideas, carrying the symbols along with it, cannot be assumed to have been so at the time of manufacture. Throughout the development of Pictish art, perhaps

81 *Upper half of back of cross-slab, Rosemarkie, Ross & Cromarty. Sandstone*

Pictishness of Pictish Art 69

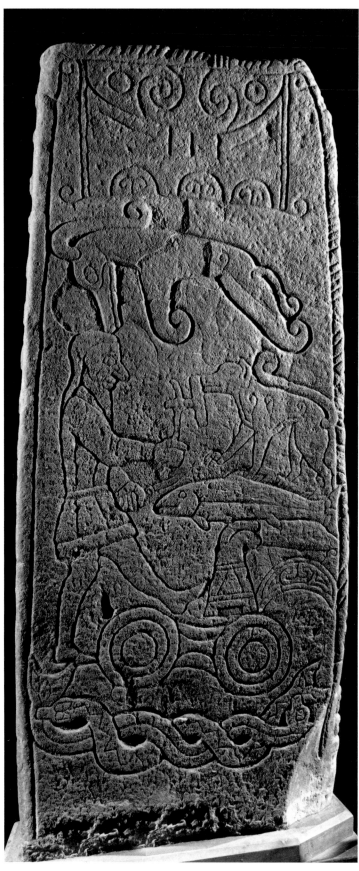

84 *Back of cross-slab, Golspie, Sutherland. Sandstone*

the ground kept on shifting around the symbols. It is impossible to say whether the disposition of the symbols on the 'Drosten Stone' and the Fowlis Wester cross-slab represents a positive preference or a loss of direction.

The trend we have noted towards orderliness in the positioning of the symbols and selectivity in their choice – along with a tendency to make them large and magnificent, to blow fanfares around them as it were, in keeping with the trumpeters at the hunts at Hilton of Cadboll [50] and Aberlemno roadside [186] – was reasonable on aesthetic grounds alone because the alternative, of which we have some examples, involves untidiness and clutter. The back of the cross-slab from Largo[24] may originally have indicated a significant relationship between the pair of large symbols, one halfway down at the left, and one near the base, and the three small horsemen who with hounds and their quarry pace across the picture space at different levels, but in compositional terms the symbols and the riders are quite uncoordinated. All or most extraneous material is rejected by the sculptor of the Golspie cross-slab, in what looks like conscious archaism. Despite the maturity of the design of the relief cross itself and the elaborate working of decorative scrolls on the flanks of the slab,[25] the back [84] appears no more advanced in its carving technique than the symbols on the front of Glamis No. 2 [33], the symbols at Golspie being incised with some small areas of background removed to give an occasional effect of relief. The symbols are tiered but their proportions are irregular, the 'purse cover' symbol at the top, a symbol with an early and northern distribution never met with in relief sculpture, and below it the 'Pictish beast', both large, but the 'flower' symbol and the 'crescent and V-rod' near the bottom right, very small. The fact that the sculptor has to accommodate six certain symbols and two other images, along with the axe-wielding man, which may at that stage themselves amount to symbols, could have resulted in the marked gradation in scale, without implying variations in their value. The most inchoate of all the cross-slabs, Meigle No. 1,[26] does nothing very out of the ordinary in placing three large-scale symbols one below the other in the upper section of the slab [85], but the horsemen (and one horsewoman riding side saddle), who proceed diagonally up the surface of the lower section look literally like a hunting party of the 'Little People', and the two or three other symbols which infiltrate the space among the three big ones appear similarly negligible.

The cross-slab from Ulbster, whose back carries not less than six symbols [56],[27] is much more disciplined than Meigle No. 1. It looks like a charter, with equal spaces for all the signatories or seals. The function of this portmanteau-type symbol-bearing slab is clearly different from monuments which display a single pair of giant symbols. Ulbster is, however, a special case, because it displays the emblem of the cross on the back as well as the front, the two crosses being nicely diversified, and makes another break with convention in that it places at least two additional symbols alongside the stem of the cross on the front, reverting to the system which prevailed at an early and experimental period at

Glamis [33]. While its layout and restrained carving technique are untypical, Ulbster introduces us to an important category of cross-slabs: those which display large-scale cross designs on both sides of the monument. The cross-slab from Gask [273] makes a formal unit of its two faces by cutting right through the hollows under the arms of its wheel-headed cross, giving the impression of a free-standing cross.[28] The pair of symbols are halfway down the right-hand side on the back, above two horsemen, and vie for attention with droves of bizarre animals pacing sideways on both sides of the cross as if to demonstrate the Scythian origin of the Picts. The cross-slab at Rossie Priory differentiates its two crosses by the higher projection and the wheeled shape of the cross on the front. The stem of the cross on the back [86] is made transparent to accommodate the regular hunting party, the principal horseman having the lower arm of the cross all to himself. The pair of symbols, their essential shape clearly stated without elaborate infill, space being limited, are placed in front of the riders, in the narrow gully at the left between the frame and the cross-stem. The cross-slab at Balluderon, where only one side is carved, thus necessitating conflation of the repertoire, inserts the principal horseman in the stem or lower arm of the cross, while another smaller horseman collides with two symbols in the lower section

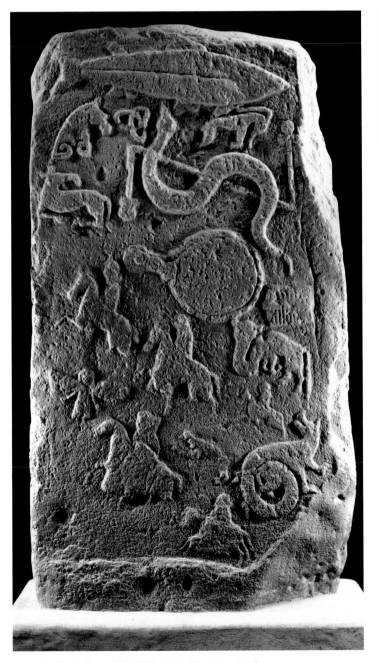

85 *Back of cross-slab, Meigle, Perthshire, No. 1. Sandstone*

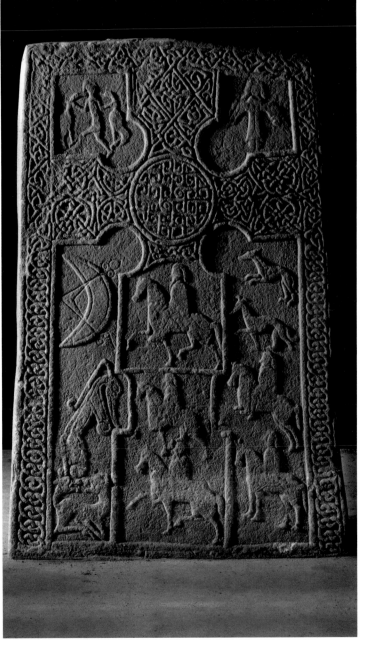

86 *Back of cross-slab, Rossie Priory, Perthshire. Sandstone*

of the slab.[29] At Fordoun, similarly carved on one side only [87], the procession of horsemen, themselves incised, pass like ghosts through the undecorated stem of the cross, and a symbol is placed below, for want of an alternative position.[30] How, and what, symbols were displayed on the back of St Vigean's No. 7 [88], a monument with fine sculpture and an important programme of imagery, we cannot know because the area below the cross-head on the back, evidently as large a cross as the one on the obverse, has been erased.[31] On the cross-slab from Skinnet [47][32] the cross on the back has a shorter stem than the one on the front and a pair of symbols, one above the other, the 'three ovals' characteristic of Caithness [73] and the 'crescent and V-rod' symbol fill the space at the foot of the cross, taking us back to that sense of offering and commitment which we have in the early incised cross-slab at Raasay [253], and which is missing in the more 'hit or miss' designing of Balluderon and Fordoun.

The tenaciousness of the symbols under pressure for space is demonstrated by the small cross-slab, Meigle No. 3 [89], which fills the pediment shaped top of the back of the slab with a single horseman with sword and spear and striped or pleated saddle cloth, facing left.[33] The same space on the front [90] is filled with a decorated cross-head. Driven out by the rider on the back, the 'double disc' symbol has taken refuge on the front, under the left arm of the cross. Exactly the same exhibition space for a single horseman, with the same striped saddlecloth, is provided on the back of Meigle No. 5 [91],[34] except that the plinth on which he rides has survived and below it a further flat panel, on both or either of which an inscription could have been painted. The front [321] is occupied by an equal-armed cross set up on a short curved stem, its base corners finished like a shrine with two projecting animal heads, and with decorative animals set in the background above and below the cross-arms. The attractive vigour

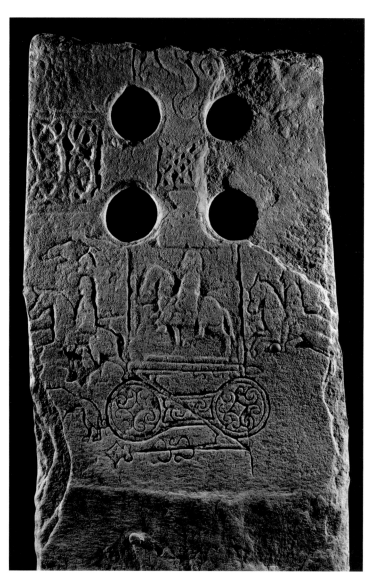

87 *Cross-slab, Fordoun, Kincardine. Sandstone*

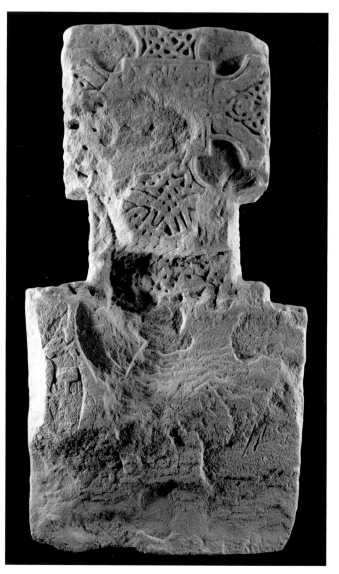

88 *Back of cross-slab, St Vigean's, Angus, No. 7. Sandstone*

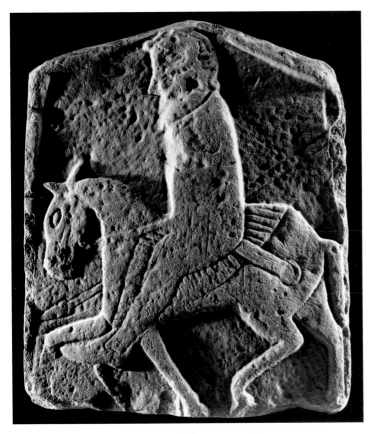

89 *Back of cross-slab, Meigle, Perthshire, No. 3. Sandstone*

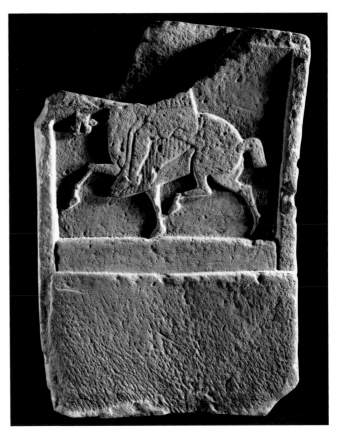

91 *Back of cross-slab, Meigle, Perthshire, No. 5. Sandstone*

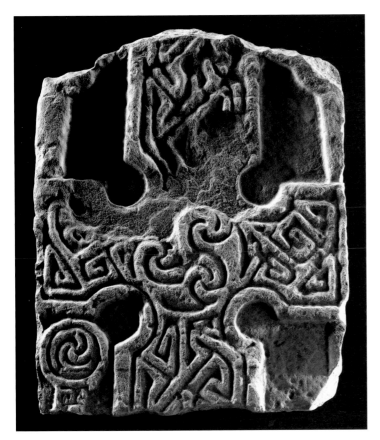

90 *Front of cross-slab, Meigle, Perthshire, No. 3. Sandstone*

of this design and of the equestrian statue on the back, leave no room for symbols, but these remained part of the sculptors' brief, and he has placed them on the left flank of the cross-slab [*92*], behind the horseman, as at Kirriemuir [*263*]. In a sense the symbols are better integrated into the whole fabric of the cross-slab and their importance better emphasized than when they were crowded in somewhere beside the horseman on the back. Some such design consideration, which we cannot now even guess at, caused the sculptor of the fragmentary slab, Tarbat No. 1 [*62*],[35] the *alter ego* of the sculptor of the Hilton of Cadboll cross-slab, to insert his symbols at the bottom of the right flank of his slab.

It is difficult to think of this phenomenon as the marginalization of the symbols. It is rather as if by hook or by crook they had to be there. On the other hand, the cross-slab at Edderton [*93*] carved with beautiful, austerely simple crosses of different design on both front and back, marks quietly, for its own reasons, the twilight of the symbols. There are three horsemen on the back, two, as at Fordoun [*87*], incised, at the very bottom of the slab, and the principal rider in relief, above. He does not invade the cross-stem itself, as at Fordoun and Rossie [*86*], but rides within an arch or hillock, as if it was his funeral mound, topped by the cross. Of symbols on back or front or on the sides of the slab there is now no sign, unless the horsemen, so long associated with the mysterious propaganda of the symbols, have over time become symbols themselves.

In the period up to the late 7th century, before elaborate cross-slabs were desired for Christian observance, and during the subsequent period, from the 7th century to the 9th, artificers skilled in stone carving had an important role in Pictish society, not least in affirming the Pictish presence in the landscape. The symbol-bearing slabs vouch for aesthetic sensibility, technical dexterity, and a social organization efficient in deciding where to put them. The cross-slabs give a vivid impression of the exercise of exhilarating freedom of choice of repertoire as well as of remarkable continuity of outlook, and also of purely artistic initiatives being boldly taken. Meantime, the persistent display of the symbols, shuffled and reshuffled with easy familiarity, and increasingly decorative in their handling, like beribboned

mascots, might perhaps suggest that they were the perquisites of the very artificers to whom we owe our knowledge of them, metalworkers as well as stone sculptors, as some kind of traditional trade marks, part and parcel of the entire professional operation, both intellectual and practical, of designing and making the monuments. It is certainly no less speculative to detach the symbols from their material existence on the sculptures and the precious metalwork, and attach them instead to the values of some other social controllers about whom we know nothing.

Pictish sculpture divides technically into three different modes, incised, shallow relief, and high relief, but it is characteristic of the art of the Picts that these different techniques,

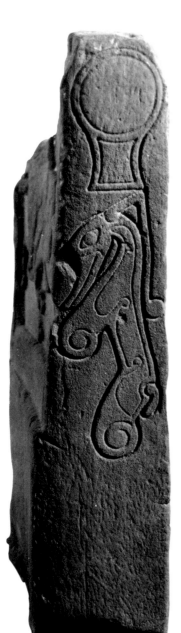

92 *Symbols incised on left side of cross-slab, Meigle, Perthshire, No. 5*

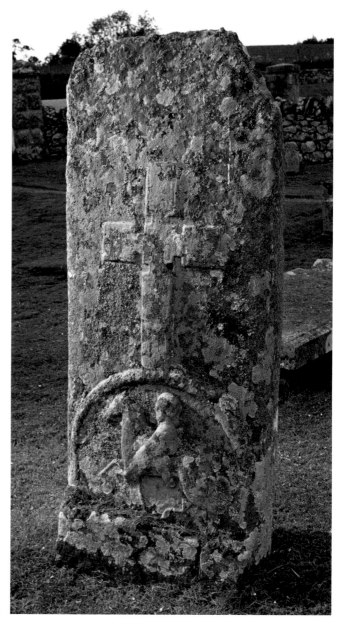

93 *Back of cross-slab, Edderton, Sutherland. Sandstone*

which sound in theory like a learning curve from primitive to sophisticated, have no implications for artistic quality. Although the use of these different techniques is probably a rough indication of chronology, factors such as location and purpose, and the stimulus of lost models have got to be kept critically in mind. High-relief sculpture is comparatively rare, though major works of art survive in this technique and often have more than merely technique in common. Speaking generally, Pictish sculpture typically consists of limpid drawing on stone surfaces. The sculptors' first preoccupation, the symbols, are usually carved by a pecking technique executed with punch and hammer and afterwards smoothed, to produce clean continuous lines, deep enough to fill with shadow at points of emphasis, giving animation and a bold graceful presence to the various designs. A challenge which the sculptors of the symbol stones frequently sought and exploited was to carve their crisp and pungent designs on large upright boulders of irregular outline and unequal surface levels, so that the designs are stamped on the stone as if to control and discipline it, but ride buoyantly with its primitive contours [76].

Pictish Animal Art: Naturalism and Fantasy

Sensibility to line and surface texture only increases when sculptors begin to work in relief. The essential linear quality of the designs continues on the cross-slabs, but the drawn outline gains impact by being a silhouette, standing proud of the smooth level background plane [33]. In the majority of cases, the decorative strategy of the sculptors is conditioned by the motif of the ornamental cross which dominates at least one side of the slab, and conditioned also by a new engagement with the semi-narrative subject of horsemen and the chase. But to a remarkable degree, the traditional fashion of lining up the symbols, each one fully realized and given its due, can still be perceived in the way that Pictish sculptors handle their vastly expanded repertoire of forms and motifs, indeed a bewildering number, which on the cross-slabs are set down one below the other in the narrow spaces alongside the cross-stem, each with such emphasis and conviction that one hesitates to think of them as simply decorative [49]. They have the air of agenda. Although these new motifs by no means displace the traditional symbols, which are indeed the regular third ingredient of the design layout of the cross-slabs, they multiply phenomenally, as if visual art had suddenly been given a new official license to explore its own imaginative kingdom and make public show of the result [102]. To an extent paralleled only by the older art of Scythia, this imaginative kingdom is inhabited by animals, naturalistic or composite and invented, solitary and self-sufficient or locked in combat.

The famous naturalism of the Pictish incised symbol-stone animals – snake, salmon, goose, eagle, bull, horse, stag, boar, wolf (and now bear: see Appendix) – has been compared to prehistoric cave art,[36] as if it must be instinctive and hand-to-mouth, part of the ritual of the hunt. A more sober view would take into account the calculated artistry of the designs, how they cleverly portray the shape or bulk and movement of the different animals [25, 28], employing where appropriate a subtly varied system of body scrolls on shoulder and thigh. An inner core of the surviving monuments have such obvious distinction and authority that they may be attributed to a single mind and hand, that of a man 'filled with wisdom and understanding'.[37] The original and authentic canon of animal designs, which includes the Burrian eagle [30] and the Stittenham wolf [29], extends to the formal 'beast head' symbol from Stittenham [69] and to the exquisite fragment of the 'Pictish beast' symbol at Inveravon [324]. Derivatives from the canon are found throughout the Pictish area and the quality of design can fall off very steeply. The Inverness bulls[38] as opposed to those of Burghead are clearly apprentice work. An elegantly fluid version of the 'Pictish beast' symbol at Tillytarmont [252] is accompanied by an oddly compressed and stodgy copy of the Burrian eagle.[39] Incidentally, the study of the Pictish symbols has been dogged by a numerical approach, and as a concomitant, the habit of representing each symbol by a visual stereotype, so that the masterpiece and the hackwork are flung in together, the actual quality of the design counting for little.[40] The discipline of art history, with its much maligned element of connoisseurship, offers a useful antidote to this cavalier blurring of the visual evidence. What matters for our present purpose is that a deep foundation for future developments is laid by an influential sculptor and his immediate followers by the striking depiction in outline of native animals, together with that of a formalized compound animal, the 'Pictish beast' symbol. Both principles of animal design, the real and the hybrid, are stated at this early stage in an art form, stone sculpture, which evidently had a secure and growing place in Pictish society.[41]

The naturalistic element in Pictish sculpture has a special status and function, appearing only seldom in single items on cross slabs, but is usually accommodated on cross-slabs in wider semi-narrative panels, and occurs on recumbent monuments and in friezes intended as architectural sculpture. The space on either side of the relief-carved cross on the cross-slab at Dunfallandy [49] is divided into five compartments. In the second from the bottom, at the left, is a stag as lifelike as the classic stag incised on the narrow slab from Grantown [28], but here carved in shallow relief, not walking but pausing, attentively looking back over its shoulder, in a compact design like that of the incised goose from Easterton of Roseisle. A stag with the same backwards-looking pose of its slim head was placed in the upper corner of the reverse of a fragmentary cross-slab, St Vigean's No. 19 [94]. Here the stag is crouching with its four thin legs folded up below it, in linear grace and delicacy of mood the Pictish equivalent of the panel with the white hart in the Wilton Diptych over six hundred years later.[42] The pose of an animal down on its knees is not found among the incised animal symbols, but the St Vigean's sculptor is fully aware of the tradition of body markings to articulate the animal's thigh

and shoulder. The jagged rhythm of the deeply shaded trenches between the bent legs is gently led across the flank of the animal by three long incised scrolls, following the direction of its backwards gaze. Pictish stag hunts convey vividly the frantic flight of the stag and the fluid career of the pursuing hounds, memorably realistic at the top of the back of the 'Drosten' cross-slab [83], also at St Vigean's, but the pathos of the vulnerability of animals is concentrated on static images of fallen animals.

A foal sunk down on its folded-up legs and with drooping head is a useful space-filler on the narrow tapering end of the side of Meigle recumbent No. 26 [95], the foal's reason for collapsing perhaps the heavy snuffling bear which walks away from it towards the left, equipped with body scrolls worthy of the Burghead bulls themselves. A naive-looking small animal, on its knees, is the victim of an attack from behind by a beaked hybrid quadruped at the top of a relief panel, evidently architectural sculpture, at Tarbat [303]. All the animals in this elaborate scenic panel pay the most fulsome tribute to the tradition of body scrolls. A deliberate contrast is made on the panel between animals crouching in intimidation[43] and animals' guardianship of their own kind. A cow and a bull close in protectively over a tiny calf [96] which the massive bull is licking with its extended curved tongue, a nice piece of naturalistic observation. A more conventional image of parental care is represented on the 'Drosten' cross-slab. Separated from the thrust of the deer hunt at the top by the symbols straddled across the middle of the slab, a quietly standing doe is giving suck to a little fawn, interwoven, in honour of the Insular style, between the doe's forelegs. This section of the slab achieves an extraordinary pastoral effect, through the juxtaposition of several self-absorbed animals or animal groups together with a hooded crouching bowman. The same sense of a landscape, but much more busily populated, is created by the sculptor of the panel below the giant version of the 'Pictish beast' symbol at Shandwick [97]. Although this 'Pictish beast' has discarded its pristine body scrolls and adopted instead a key-pattern texture, it is nonetheless a worthy successor of the best incised examples, with a serenity of shape and line that makes one

94 *Stag couchant on back of fragmentary cross-slab,*
St Vigean's, Angus, No. 19. Sandstone

95 *Bear and fallen foal on left side of recumbent,*
Meigle, Perthshire, No. 26. Sandstone

remember Job's Leviathan, 'In his neck strength shall dwell'.[44]
Like the pair of bovines at Tarbat protecting their young, the
mighty 'Pictish beast' at Shandwick shelters between his limbs
the field where two rams are grazing, and with his forehead he
nudges away a lion. Under him the picture of a whole world of
animals spreads out, birds and beasts all wholesomely naturalistic
in shape and proportion. A fine stag paces away from horsemen
and hounds at the top right, while another turns to look behind it,
fixed in the Dunfallandy pose [49], but now with the same
crouching hooded bowman to look at. This bowman might well
have had a name and a context in some traditional narrative, now
lost, and so also the tall figure astride two beasts at the top centre
of the composition. Another human figure who is recognizable
by his frequent appearances, the pedestrian hunter carrying spear
and shield, pursues or shepherds ahead of him a fine upstanding
stag with clear curling body scrolls on the front of the cross-slab at
Eassie [179]. The body of the deer in flight from the pedestrian
hunter on the back of the Nigg cross-slab [184] is marked with
body scrolls, running closely parallel as in the crouching deer at
St Vigean's but with the scrolls unusually hooked round towards
the rear of the beast. Beyond the bowman at Shandwick two bulls
stand in opposed profile, head to head, a theme again learned
from natural observation, and repeated as the decoration of the
narrow side of another Meigle recumbent, No. 12 [291]. These
bulls lack body scrolls, but scrolls are firmly inserted to give
dignity to the sacrificial bull whose blood is being licked by the
extended tongue of the evil manikin at the base of St Vigean's
cross-slab No. 7 [205]. Body scrolls are a regular and characteristic
feature of naturalistic animals carved in shallow relief, but Pictish
naturalistic animal sculpture is not confined to one technical
mode. An architectural frieze at Meigle [307] has as its centrepiece
a frontal semi-human figure clutching his horns or hair, his legs
knotted and ending in fishtails. At the left of him a thickset bear
walks to the left, carved in high relief, its jowl and forehead
sticking up from the background and its thick rounded legs
ending in three huge claws indented into each of its fleshy feet.
Round its cheek and throat it has a band or ruff of fur, which, with

97 *Upper half of the back of cross-slab,*
Shandwick, Ross & Cromarty. Sandstone

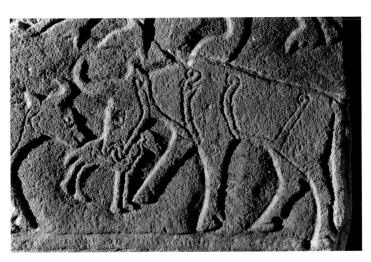

96 *Bull licking calf, detail from relief panel,*
Tarbat, Ross & Cromarty. Sandstone

the straight bar of its tongue glimpsed behind its bared teeth,
gives it a dangerous muzzled appearance. At the right of the fish-
man is a panther or wolf [98], as relaxed and immobile as the other
is tense and on the rampage. This panther is lying down, but not
in defeat. It sleeps with its tail comfortably coiled between its hind
legs and with its head, projecting high from the rear plane of the
sculpture, slumped forward on its drooping forepaws. All four
legs carry the same big spiky claws, realized in depth. The apogee
of this high-relief style, which allows the spectator to confront the
animal forms not merely laid out lengthways but also nearly full
face, looking at the frieze end on, is the central panel of the St
Andrews Sarcophagus [189]. Here the Meigle panther's pose,
stretched out sideways and drooping its head forward over its
forepaws, is echoed and excelled in the fierce hybrid figure of a
griffin with closed wings, standing four-square on the collapsed

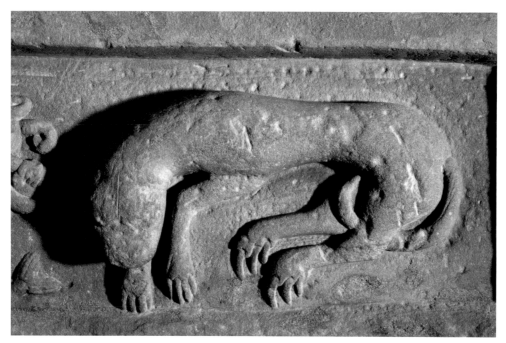

98 *Relief-sculptured panther, detail of architectural frieze, Meigle, Perthshire, No. 22. Sandstone*

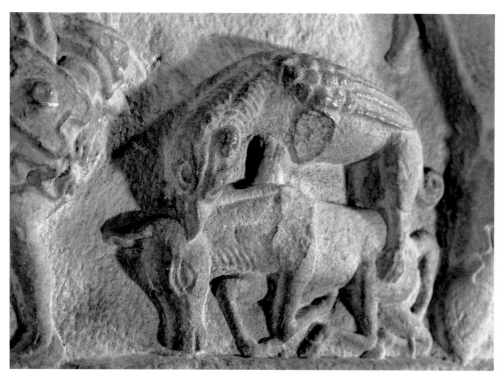

99 *Griffin and fallen mule, detail of long panel of St Andrews Sarcophagus*

body of a foal, whose throat it pecks with its strong stooping eagle's head [99]. The raven or dove descending with folded wings in the Nigg pediment [203] droops its smooth feathered head in exactly the same position. Above and to the left of the St Andrews griffin, full-chested lions rear and dogs and timid deer run and trot among the forest trees. At the extreme left a grisly wolf-hound or wolf [100], with thick legs carrying the same potent claws as the Meigle beasts, springs forward with gaping jaws, the perfect fulfilment in three dimensions of the Stittenham wolf [29].

The compartment below the shallow relief-carved naturalistic deer at Dunfallandy [49] is occupied by the *Ketos* and Jonah image referred to in a subsequent chapter, and there also mention is made of the two stationary seraphs at the right of the cross-stem. There are six other compartments on the front of the Dunfallandy cross-slab and they are each filled by a non-naturalistic animal, set sideways to display the curious construction of their bodies. The most radically artificial of these animals is in the bottom right compartment, crouching on two thin folded-up legs, the fallen

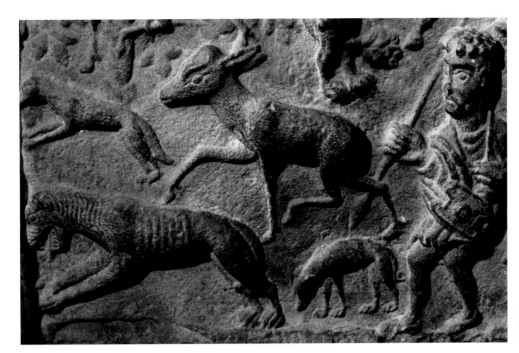

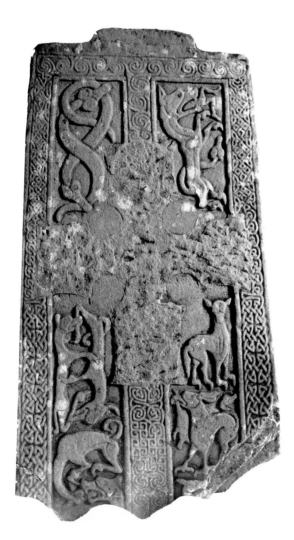

foal pose, but here the creature hooks its clawed feet together and abruptly turns its horned pointed head to draw back the upraised bar of its tail, a zoomorphic ornament as much as an animal. The other creatures make rather more show of consonance with the naturalistic stag, their bodies held high on strong thin legs, one coiling its neck like a snake, one heraldically pacing with a snake dribbling from its mouth. In the top left corner a squatter creature turns its human face frontally. In the top right a hound stands over another, the inverted image of the first, perhaps being deluded by its own shadow, as in the fable. In the top corner of the front of the Aberlemno cross-slab [36] are animals similar to those at Dunfallandy, one with a long snake lolling from its mouth and lying across its body, the other a compact creature folded in on itself looking back over its scrolled tail, with an elegant deer's head modified by a hooked lower jaw and stylized feet with a rounded 'heel' and one solid curved toe or claw, the same 'ball and claw' feet on which the thoroughly Insular scrolled animals are walking at the left of the Aberlemno cross-stem. On the front of the cross-slab from Woodrae [101] the Insular affiliation of the non-naturalistic animal repertoire can be seen in the two long-bodied, hook-legged creatures set opposed, end to end, and in a conventional mutually biting pose, and perhaps also in the goggle-eyed snakes forming a fluid figure-of-eight design. But the other creatures seem to preen themselves in their autonomy and individuality, while the *Ketos* and Jonah design at the top right avows its Pictishness by adding a goggle-eyed snake's head to the end of Ketos's tail. (A tail terminating with a head is another of the intriguing coincidences between Pictish and Scythian/nomadic animal designs.)[45] A hoofed beast pacing along at the bottom left of the cross-slab at Gask [272] has a huge beast's head raised over its back on the end of its tail.[46] Above it a horned beast stares out with human features, and further up again two beasts walk on a

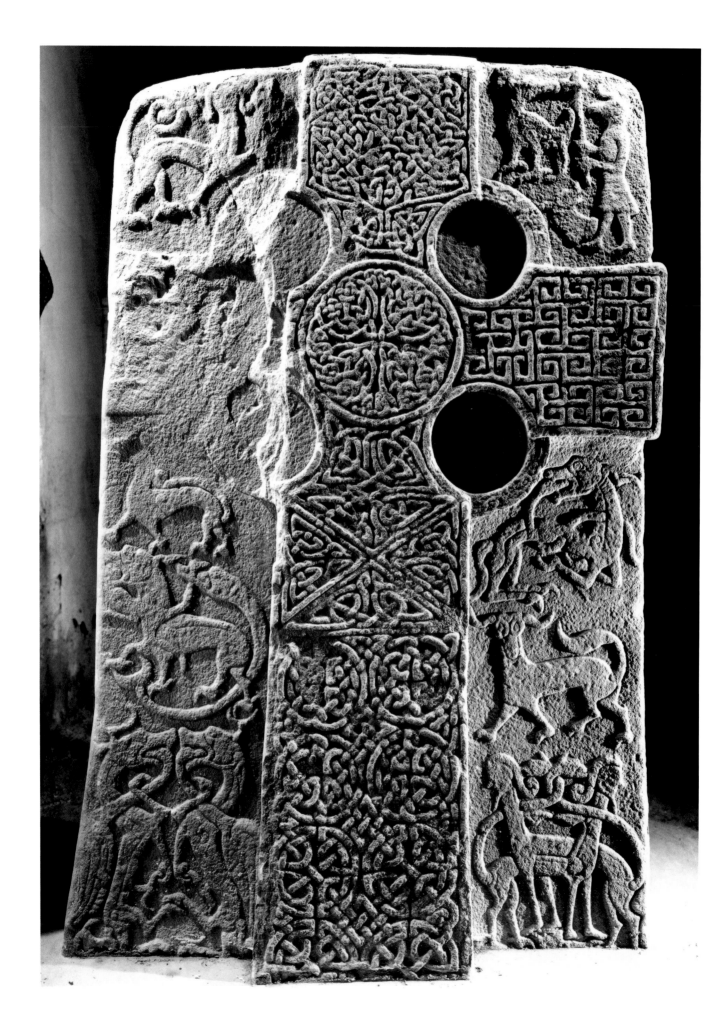

mixed footage of claws and trotters. Both turn their round human faces outwards, beguilingly crested with huge scrolls of hair. In the equivalent space on the other side of the cross-stem a predator is swallowing a snake and two fantastic boars with long coiled tails and 'ball and claw' feet display along their backs a series of conical spikes or spines, their bristles turned Triassic by their designer's ingenious search for picturesque variety.

The fullest expression of this strain of Pictish inventiveness is on the cross-slab at Rossie Priory [102], where some strutting animals continue the same strict autonomy but others link up in remarkable poised ornamental tableaux. In the top left corner, substantially the same human-headed quadruped as at Dunfallandy [49], and Gask, stares out at the spectator with the same huge curled-up tail over its haunches as in one of the Gask examples. In the top corner a clear indication of the time-warp in which the carved monuments of Pictland stand is given by the figure which we have identified as a symbol, the animal-headed axe-wielding man, here in the pose of a Roman *victimarius*.[47] He threatens a bird, and what looks like the Pictish 'beast head' symbol lies at his feet. Normal decoration begins again below the right arm of the cross. A long-bodied beast lies stretched out towards the right, with its forelegs bent awkwardly under it. It turns its heavy wolf's head backwards to the left, and holds the head of a snake in its mouth. The snake takes advantage of a groove running the full length of the beast's body to enter and exit through this crack, an ostentatious essay in the device of penetrating bodies that we noted in the Durham Cassiodorus. The range of animal types concurrently available is seen in another version of the 'beast *versus* snake' motif, carved in similarly shallow relief on the base of the back of a cross-slab at Forteviot [103]. A neat but swarthy beast stands sideways facing right, with hoofed hind legs, heavy humped shoulders, a tail swinging up across its body, and conspicuous scrolled body markings, all in the tradition of the Burghead bulls [25]. But this is no naturalistic animal, because its front legs are of 'ball and claw' design and its savage wolf head has a curved horn jutting from its forehead, all proclaiming its hybrid nature. It grips the neck of a goggle-eyed snake, this time with spiky ears above the eyes, which in turn bites the horn of its enemy. This snake's head and snake is in fact the end of the tail of a flattened, elongated, 'ball and claw' footed animal which forms, with its shorter tailed counterpart at the left, the border, now broken off, of the whole obverse design. So one animal leads into another by various forms of juncture, a favourite Pictish device for relating frames to content, as at Meigle No. 4 [104] where two unusually symmetrical quadrupeds twist their snake necks and heads back and up, to bite the throats of the long framing dragons curving round to meet nose to nose at the top of the cross.

The linking of animal bodies into single grandiloquent decorative panels is displayed most strikingly at the base of the front of the Rossie Priory cross-slab [102]. At the right two tall upstanding slender quadrupeds with human forelegs and feet slot

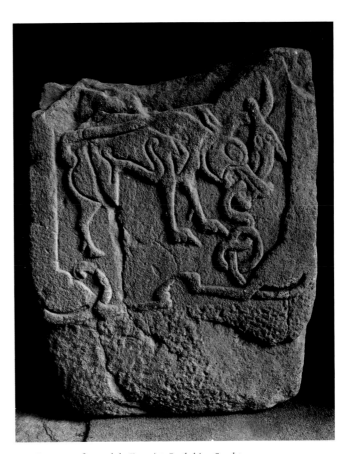

103 *Fragment of cross-slab, Forteviot, Perthshire. Sandstone*

over one anothers' bodies so that they stand looking to left and to right with equal vigilance. Their long necks which have fins jutting out behind them are crowned by bearded human heads with a long roll of hair on the nape of the neck, which makes a resting place for the chins of two watchful beast heads which twine together and settle in reverse of one another in the space between the reversed human heads. These beast heads are the terminals of the very stout raised tails of the two quadrupeds. If ever there was a beast Janus, this is it. At the left of the cross-stem are two symmetrically juxtaposed rampant beasts whose heavy dogs' heads have thin antlers. These beasts appear to be a fantasy on the theme of the fox carrying off the goose. They have long-necked birds slung over their backs. But they also look as if they had ambitions to fly, and have donned the totally passive feathered carcasses to give themselves the effect of wings. They support the birds' clawed feet in one of their own 'ball and claw' forefeet, and support the birds' necks with their other forefeet, heraldically raised. They have the birds' heads in their jaws, but with no sense of devouring, rather in a formal conjunction that might be for eternity. This artist could have given yeoman service to the minor initials controller of the Book of Kells or to the designer of the Carolingian Corbie Psalter.[48] He has the necessary unreasonableness, but on the sculptured slab he has no letter forms to aim at that would further strain his ingenuity, and so he

102 *Front of cross-slab, Rossie Priory, Perthshire. Sandstone*

Pictishness of Pictish Art 81

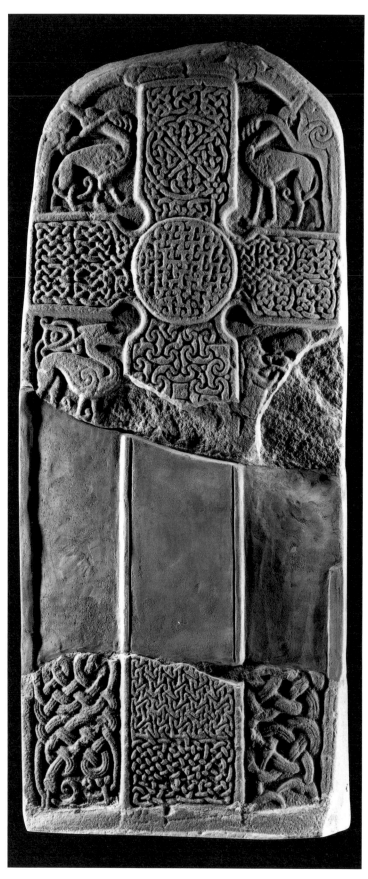

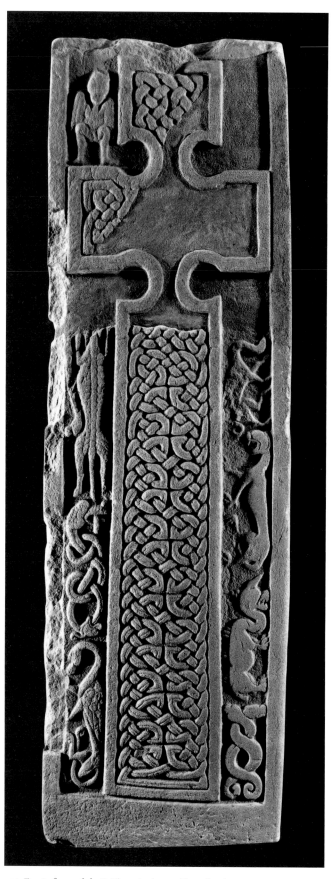

104 *Front of cross-slab, Meigle, Perthshire, No. 4. Sandstone*

105 *Front of cross-slab, St Vigean's, Angus, No. 1. Sandstone*

achieves designs both whimsical and stately. Perhaps his most remarkable calligraphic concept is placed above the pair of goose-sucking dragons on the left of the cross-stem. A big headed wolf monster with slim body and short legs, ending in 'ball and claw' feet, holds the back of a man's head in its mouth. The man is not passive like the geese. His head is being dragged in, and he hangs in an agonized pose, borne along under the jaws of the wolf, with his arm tensed up and his legs kicking wildly on the level of the wolf's shoulder, his left leg trapped in the pointed muzzle of a serpent which is curved round the rear of the wolf, under its off hind leg and with its crescent-shaped fishtail fitted in between the forelegs of the wolf. Whether they are allied in attacking the man, or the snake is attempting a rearguard rescue, is not clear. Flailing, neat calved, human legs are a favourite Pictish device. We see them in the cauldron at the left of the cross-stem at Glamis [33], and in the jaws of *Ketos* at Woodrae [101]. In the Book of Kells the human body, including legs, tends to be more decoratively manipulated and interwoven.

The Aims and Principles of Pictish Artists

The plethora of Pictish figurative designs, men and animals, were devised essentially for use in shallow-relief sculpture, and their natural context is the cross-slab. They uniquely solve the problem of formulating a visual language that could reach out beyond abstract interdependent decorative motifs, interlace, spirals, key-pattern, and pure zoomorphic ornament, to include also the world of representation, without that sense of unease and misalliance which one sometimes feels in works of the period from other parts of the British Isles which attempt to coordinate naturalistic subjects and models with the intensely idiomatic Insular decorative style. The shape-changing, the shifts of direction, the linear loops and scrolls and the various cavortions of the bodies of 'Pictish beasts' nicely balance the world of natural forms with the strong rhythms and ornamental textures applied to the stem and arms of the relief-carved cross. The exigencies of the artistic situation are themselves the reason why Pictish artists opened their very own *Liber monstrorum*.

The conscious choice that Pictish artists make among the types of animals they represent is clearly illustrated by the extraordinary assortment of animals that are placed on different parts of the 'Drosten Stone' at St Vigean's [83]. As an exception, to prove the rule, a creature like a yale[49] (only questionably naturalistic, with a horned dog-like head and padded toes) walks among the wholly naturalistic animals on the broad spaces on the back, while a particularly mongrel and fantastic series of beasts crawl and coil on the narrow edge of the front alongside the heavily braided cross-stem [105]. Two totally different animal types are juxtaposed at the foot of the back of the cross-slab at Cossans [106]. One of the flauntingly high-thighed quadrupeds, featured also at Dunfallandy, with spikes on its heels and an arched tail,

thrusts its head over that of a horned but docile naturalistic cow or bull. Under the feet of the axe-carrying centaur on the back of Meigle No. 2 [194], a naturalistic bull has had its head caught and twisted sideways in the monstrous jaws of an amorphous coiled dragon. It is only in such associations that fantastic animals can enter a natural inhabitable space.

As we have seen, Pictish creativity in the field of naturalistic representation of animals is not curtailed by their alternative line of fantasy. Pictish naturalism responds effectively to stimulus from the Mediterranean world, without any loss of control, the most notable example being the St Andrews Sarcophagus [189, 190]. The horseman lifting his sword against a lion, like a Sassanian king, is mounted on a characteristically mincing Pictish horse.[50] The foreground group of the fallen foal and its griffin attacker, clearly directly copied, like the stalwart classically draped lion taming figure of David, from some orientalizing Late Antique imported treasure, tell us about distant Pictish contacts which simply added to the superlative range of Pictish art. At this stage in the history of medieval art, only a Pictish artist could have provided the pairs of monkeys, originally waiting for a purchaser in a Roman shop window, with a new setting congruent both spatially and decoratively [107].[51] It is a striking fact that the early, experimental Glamis cross-slab [33] includes in the top right corner of the front the figure of a centaur, native of the classical

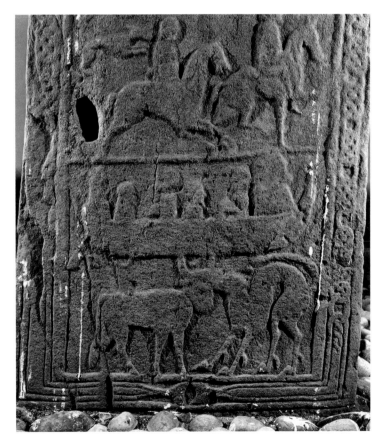

106 *Lowest part of back of cross-slab, Cossans, Angus. Sandstone*

world, his head and torso turned frontally, his horse body stepping sideways like any native Pictish profile horse. The centaur was adopted as a standard part of Pictish imagery precisely because he was a confection, a hybrid.[52] He received the accolade of being given the axes wielded by the native monstrous or beast-headed man symbol. Similarly the classical griffin, picked up from imported models, was welcomed for its being part lion, part eagle, and is reproduced in full naturalistic classical terms at St Andrews, and in low relief at the foot of the back of the cross slab, Meigle No. 4 [35], where its hybrid character is emphasized, huge eagle claws on its forelegs, paws on its hind legs, a splendid feathered wing on its shoulder, its predatory nature shown by the pig swinging from its (lost) mouth, and an extra touch of fantasy in the huge beast-head terminal to its tail, pushing its ultimate model back to the distant steppes. The third beast of Classical origin that is accommodated in Pictland is the hippocamp, part horse part fish. The ground-work for its ready reception was laid by the unique incised symbol at Upper Manbeen,[53] conflating salmon's body with wolf's head, and in fact the hippocamp, after its first authentic appearance at Aberlemno [36, 37], gradually drifts in Pictish usage into a more generalized, limbless, fish-wolf combination, though on occasion, as at Ulbster [56] and Brodie [108],[54] it appears almost to gain the status of a symbol.

The animals carved on Pictish cross-slabs could, one suspects, have had textile equivalents, since in both form and content they bear some resemblance to the teeming animal life in the borders of the Bayeux Tapestry.[55] In their variety, and in their location on the monuments, Pictish animals also have something of the character of the marginalia which became fashionable as an art form at the turn of the 13th into the 14th century. In their prepackaged/transferable look, they also resemble the sketchbook of Villard de Honnecourt of the 1230s and the Pepysian Sketchbook of around 1400,[56] where the pages are loaded with motifs, figurative or decorative, thrown in together, drafted and stored in preparation for selective use in some other more formal context. However, Pictish sculptors purveyed their accumulation of motifs in the finished works of art, though the discrete motifs, some used more than once, must have been passed around in some previously drafted form, as must also have been the case with the original symbols. The star item in this particular category of Pictish art is probably the cross-slab at Rossie Priory which, as we have seen, places on either side of the cross-stem an assembly of richly fantastic, exquisitely contrived and finished animal bodies, reminiscent of the boldly zoomorphic decorations in the Book of Kells and the Corbie Psalter. The loss of Pictish manuscripts means that we cannot know to what degree they also were showpieces of the Pictishness of Pictish art.

In the characterization given above of the content and disposition of Pictish sculpture some generalizations emerge. Of these the most striking are the continuities of the artistic tradition. The sculptors of the elaborate relief-carved monuments continued to find relevant locations for the Pictish symbols, happily giving them a new look with interior decoration taken from the decorative repertoire of Insular art. Similarly, their naturalistic animal art, which assimilated well with new themes available in Mediterranean art, continued to rely on their stereotypical profile

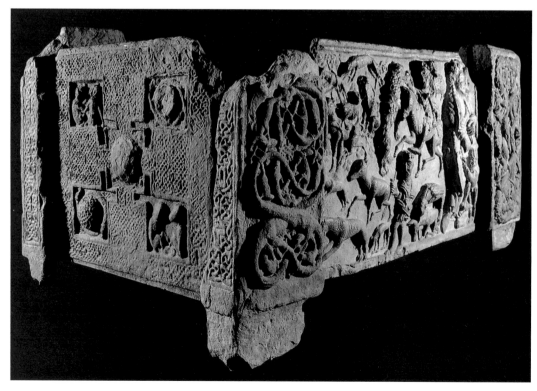

107 *End panel of St Andrews Sarcophagus. Sandstone*

pose, and to a surprising degree the device of body scrolls was maintained even in the most pastoral naturalistic contexts. Moreover, the key to much that is peculiarly Pictish in later Pictish sculpture lies in that most Pictish of all symbols, the 'Pictish beast'. If, as has been argued by other writers, it is an extract from the ornamental repertoire of Insular art, then the Picts' capacity to imbue a design with universal symbolism is not only unique, but suggests an unlikely incapacity to contrive a design to express a pressing social need. The 'Pictish beast' [72, 97] is one of the commonest symbols in both incised and relief monumental art. Much more probable is the view that the symbol is an imaginative construct, made up of parts of animals including horned

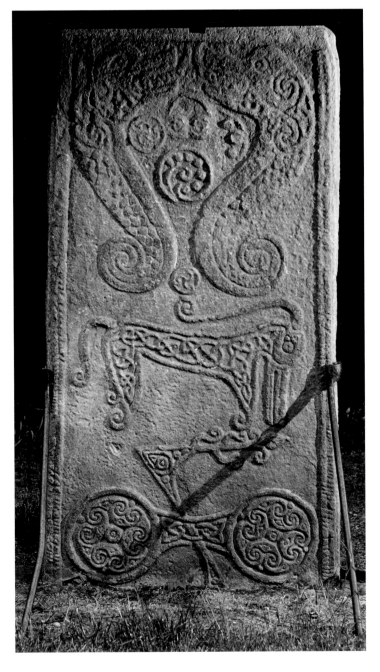

quadrupeds and marine creatures, a pure hybrid based on no core species, a concept of the animal world beyond Nature. As demonstrated above, hybridization pervades animal motifs in relief sculpture. Animals have human heads, humans wear animal masks. The responsiveness of Pictish sculptors to the great classical hybrids, the centaur, the griffin and the hippocamp, can therefore be readily explained. There is nothing comparable to the fully realized Pictish classical griffins and their victims elsewhere in Insular art, although such imagery in Northumbrian and Irish sculpture, in less explicit forms, confirms that models were in wide circulation. That Pictish artists uniquely added a serpent's head to the tails of their griffins, and indeed to other quadrupeds, to endow them with the multiple strength of the hybrid proves the conscious preoccupation of the Picts with this concept. This trait is not even discernible in the multifarious menagerie of the Book of Kells. Its closest parallel, as we have remarked, lies in the art of ancient societies similarly stimulated by the imagery of animal force.

We have seen that a moving theme in Pictish animal is the depiction of distressed animals, the victims of predators, real or imaginary [95, 99]. Other images show more equally matched combats between naturalistic animals, monstrous animals, birds and snakes. Some of these, such as the quadruped entrapped by a thick-bodied snake in the back of Meigle No. 4 [35] has an air of displaying virtuosic design and execution. Others, such as the monster swinging round its powerful neck to twist and pull the head of a cow whose legs are braced in an effort to hold its ground [194] is a physical expression of animal combat quite unrelated to zoomorphic ornament. These displays of animal violence may echo classical expressions of the destructive power of death. This theme is certainly in mind when men, the hunters of animals, are in turn, overpowered by animals and brutally torn apart.

It can be shown that the Picts were also responsive to the multiple and complex meanings attributed to the natural world in the text known as *Physiologus*.[57] The animal themes of this text are overtly Christian, and in the early medieval period it had not been reduced to the simplicities of the later Bestiary texts. Its elucidation of the innately Christian character of the natures, for example, of the snake, the lion and the stag, lies behind the presence of these animal themes in all media in Insular and Carolingian art. Pictish appreciation of those themes is an index of Pictish ecclesiastical culture, but the range of animal art of which it forms a part is Pictish and coherent. This creative response to exotic animal imagery stems from the same impulse that produced the naturalism of the incised animals and ensured the enduring relevance of the 'Pictish beast' symbol. The vigour and economy of the incised animal designs and the fleeting grace of the scenes of the chase in relief are widely acknowledged and admired, but the depiction of animal aggression, with its latent symbolism, characterizes some of the Picts' most memorable works.

108 *Back of cross-slab, Brodie, Moray. Sandstone*

Map 4

Insular metalwork and moulds found at Pictish sites.

Sites associated with metalwork now wholly lost are within square brackets

10 0 10 20 30 40 50 60 70 80 kilometres

10 0 10 20 30 40 50 miles

Pierowall
Westness
[Broch of Burgar]
Brough of Birsay
Stromness
Monker Green

St Ninian's Isle

Jarlshof

Freswick

Achayrole, Dunbeath

Carn Liath
Rogart
Golspie

Portmahomack, Tarbat

Gaulcross
[Forglen]

Croy
Craig Phadrig
Caledonian Canal
Urquhart Castle

Parkhill, New Machar
Monymusk
Banchory Devenick

Aldclune
Tummel Bridge

Castle Tioram

Clunie
Monifieth
Crieff
Forteviot
St Andrews
Clatchard Craig
Norrie's Law

Machrins

Aberdour

4
Reassessing Pictish Metalwork

Silver Chains and Symbol-bearing Plaques

The earliest phase of Pictish metalwork is traditionally characterized as made of high-quality silver, cast and engraved with designs picked out in red enamel. A group of massive double-link silver chains are assigned to this phase, for two have single terminal closure rings engraved with Pictish symbols highlighted in red enamel [109]. Since the 19th century, when many of them were found, these chains have been regarded as quintessentially Pictish, fittingly primitive neck ornaments for bearing the enigmatic symbols. Only recently has it been acknowledged that a difficulty lies behind this heroic evocation. Of the eleven known locations of chains or fragments of chains, only four are in the Pictish regions; the rest come from south of the Pictish border, in East Lothian, Berwickshire and Lanarkshire.[1]

One of the symbol-bearing chains comes from deepest Pictland, at Parkhill, Aberdeenshire, the other is from Whitecleugh in Lanarkshire. Any number of explanations can be found to account for the presence of Pictish artefacts south of the Firth of Forth or for British artefacts finding their way north.

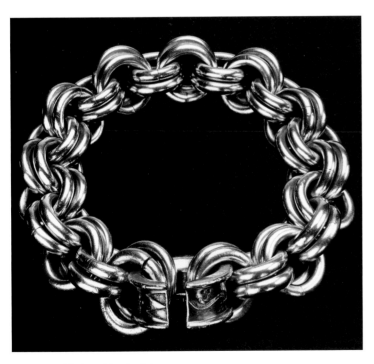

109 *Chain and terminal ring,*
Parkhill, Aberdeenshire. Silver, enamel

However, from the point of view of the art it can be confidently asserted that the symbol-bearing terminal rings were engraved by Picts for Picts. The deftness of the layout of the symbols between the rims of the rings is the result of long experience of the symbol designs. That the Britons in the south used symbols of this type and could carve them in this way cannot be sustained on present evidence. The Aberdeenshire ring displays the rare 'S-curve' symbol only found in sculpture north of the Grampians, for example, at Drimmies, Aberdeenshire [110], but present in virtually identical form on the walls of the caves at East Wemyss in Fife, a location associated with the production of Pictish silver.[2] This ancient symbol, the origin of which is apparent in its median keel-line typical of repoussé Caledonian metalwork, is rooted in the art of the Pictish symbols. The same could be said of the exactitude of the representation of the 'notched rectangle' symbol on the Whitecleugh ring. The engraver of this ring had the difficult task of adapting the 'double disc and Z-rod' symbol for portrayal within a narrow band [111]. He could have simply miniaturized it, but instead the 'double disc' is inclined within the whole width available and the middle section of the 'Z-rod' passes at right angles between the discs. This is the standard solution to fitting this symbol into a narrow composition on the symbol stones, as for example, on Rhynie No. 5 [75] in Aberdeenshire and Edderton [245] in Ross & Cromarty. We can still, therefore, imagine Pictish chieftains enjoying the ostentation of these formidable chains even if they were manufactured elsewhere, the display of an exotic artefact indeed adding to their effectiveness. That the symbols could have been engraved by a non-Pictish hand is another matter.

Assistance in locating and dating the engraving of the symbol-bearing terminal rings is to be found among the surviving pieces of silverware in the hoard found in the tumulus known as Norrie's Law in Fife [112].[3] The well-known pair of leaf-shaped silver plaques are engraved with a version of the 'double disc and Z-rod' symbol picked out with red enamel and very similar in design to the version on the Whitecleugh ring. Here the classic design of the bridge between the discs is adapted so that the rod passes between two crescentic shapes placed horizontally, tangential to the discs. This is a superior design to the crossing of the rod at right angles as described on the ring. The infilling of the discs is of finer quality also, but many details, particularly the form of the rods, their tips and floriations, are identical. On the plaques the symbol associated with the 'double disc and Z-rod' is the 'beast head', presumably (like the 'S-curve') a depiction of some ancient piece of ritual impedimenta, in this case, a pole-top. Couped heads

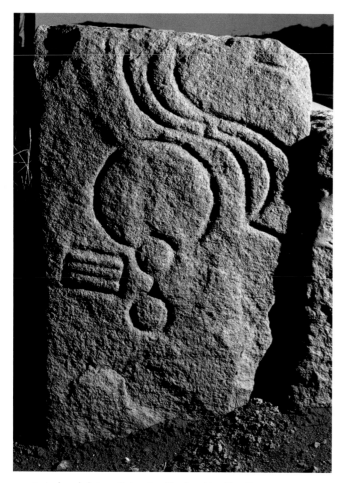

110 *Incised symbol stone, Drimmies, Aberdeenshire. Granite*

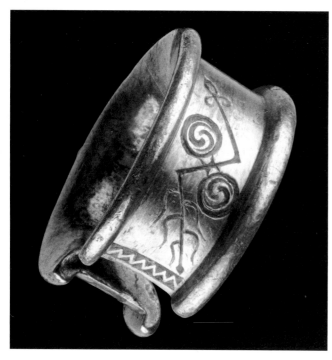

111 *Terminal ring, Whitecleugh, Lanarkshire. Silver, enamel*

are represented on both the symbol stones and the cross-slabs, with a broad distinction between those with heads lowered, as on the plaques, and, for example, on Rhynie No. 5 [75], and those with a stag-like muzzle held, nobly, at right angles to the neck. The fine carving of a beast's head from Stittenham, Ross & Cromarty [69], deploys a sensitively responsive lobed scroll from behind the ear to the rise of the chest, linking the symbol stylistically with the animal designs. None of the examples on the sculpture has the internal, essentially decorative, fleur-de-lys shape of the design on the Norrie's Law plaques, suggesting that they belong to a mature phase when the classic lobed scrolls were no longer being strictly observed.

The function of the plaques is unclear and no satisfactory explanation has been offered for the boss at the top, which may be skeuomorphic. The possibility that they are survivors of a larger number of plaques engraved with symbols, some of them 'coin like' is explored in Chapter 8.[4] The examples of stone discs engraved with symbols might be surviving versions in another medium of these lost circular symbol-bearing plaquettes. One disc from Dunrossness, Lerwick, is incised with random-seeming 'S-scrolls' on one side and a zigzag pattern in a circular panel on the other, possibly related to the rectangular panel of zigzag ornament on the Whitecleugh ring. A disc from Jarlshof, Shetland [113], has zigzag within a horseshoe shape on one side and an S-scroll adjacent to a couped serpent's head on the other. Another stone disc from Jarlshof is incised on one side only with a plain 'double disc and Z-rod' symbol [114]. These discs are around 6 centimetres in diameter: that can be compared to the 8 centimetres length of the leaf-shaped plaques. All these objects are indicative of a role for the symbols on portable artefacts outwith sculpture.[5]

The 'beast head' symbol on the Norrie's Law plaques, with its naturalistic dog head has been used to support a date-horizon for the hoard. The broad similarity with the innovatory dog heads in the art of the Lindisfarne Gospels suggests a date for the plaques of around 700. An even closer analogy to the manuscript dogs is the 'beast head' symbol on Rhynie No. 5 [75], where the chisel of the sculptor shows better control of line than the engraver's tool. That the rich naturalistic animal art of the neighbouring Picts influenced ornament in a Northumbrian Gospel Book is in line with the more specific relationship between Pictish animals and the Evangelist symbols in the Book of Durrow. The plaque dogs and the manuscript dogs may indeed reflect each other but the somewhat coarser heads on the plaques (coarser that is than other representations in Pictish sculpture), together with the other decorative deviation mentioned earlier, may be the result of knowledge of another brand of naturalism coming from outside the native tradition.

Without at all wishing to endorse as a general method, the principle of a deteriorating series, the repetition, a curious fact in itself, of the pair of symbols, the 'double disc and Z-rod' and the 'beast head', on the lost but accurately recorded [322, 323], crescentic bronze plaque from the Laws, Monifieth, Angus, does

112 *Selection of objects from Norrie's Law hoard, Fife, including leaf-shaped plaques. Silver, enamel*

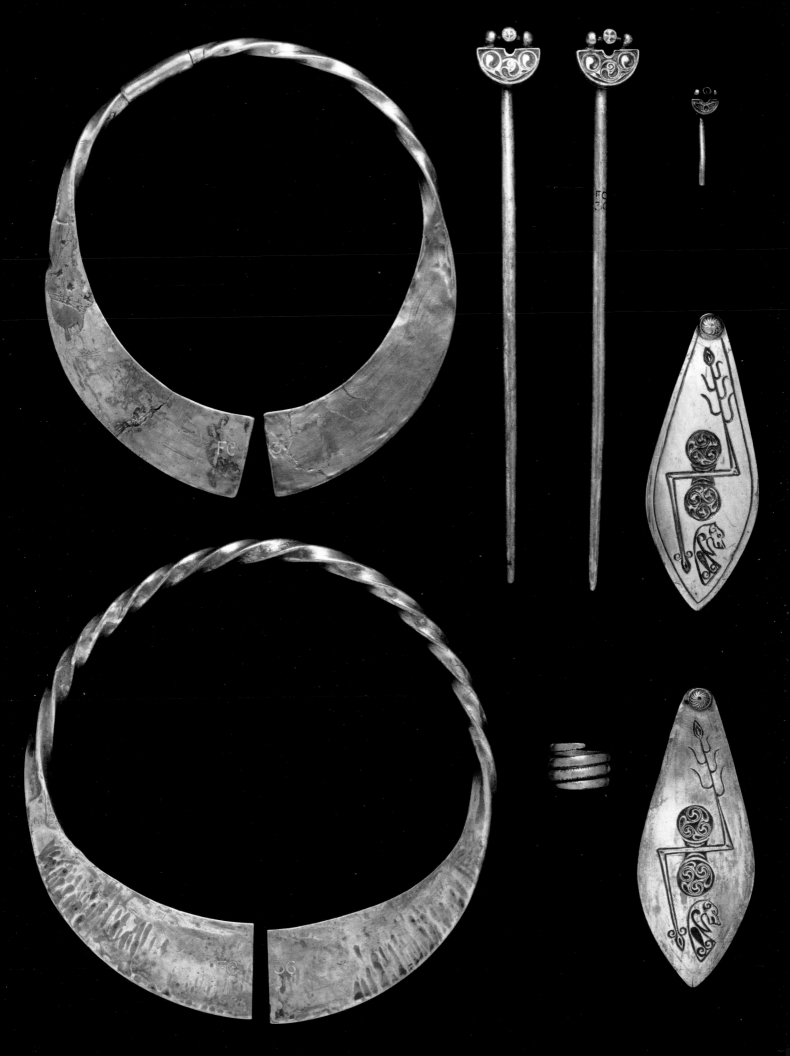

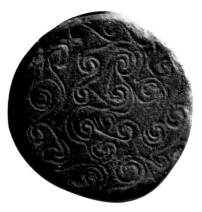

113–116 *Pictish incised discs. Sandstone. Jarlshof, Shetland*

seem to support the possibility of native stylistic loss. Here all aspects of the symbols seem uninhibited by standard forms as defined by the symbol stones. The floriations of the rods of both the crescent, engraved on one side, and the 'double disc' on the other, do not conform to the 'correct' versions of these features on the Whitecleugh ring and Norrie's Law plaques. The naturalism of the 'beast head' symbol has given way to an almost geometric formula with the eye-socket reduced to a diamond shape.[6] The crescent has lost entirely its curvilinear interior decoration. Its all-over diaper pattern is exactly comparable to the treatment of the symbols in mature Pictish sculpture. We can compare it, for example, with the crescent filled with key-pattern on Rosemarkie No. 1 [*81*]. Interestingly there are still some connections with the stone discs, the Jarlshof 'S-scroll' referred to above appears oddly positioned on the horns of the crescentic plaque, and on the border of the crescent side a section of curvilinear 'T-fret' pattern is paralleled exactly on a disc [*117*], from Ness of Burgi, also in Shetland. A later Shetland parallel has also been noticed on the flange of the silver chape, No. 16, in the St Ninian's Isle treasure [*163*].[7]

As well as being engraved on both sides, the Monifieth plaque [*322, 323*] differs from the other portable bearers of symbols in its scale, being 12 centimetres wide. It is possible that it was suspended in some way and worn on the chest. It has been suggested that bronze repoussé mounts taking the form of conjoined discs, found in a Viking grave at Ballinaby, Islay, might

be appliqué 'double disc' symbols.[8] It has been argued that such shield appliqués could lie behind a number of the symbol designs but there is no satisfactory diagnostic trait on the Islay, mounts to support a relationship to the 'double disc' symbol. Stevenson's belief that aspects of the curvilinear designs of the early crescents could best be explained by the copying of patterns cut out of metal sheeting is, however, convincing, and provides further evidence for symbols expressed in metalwork.[9]

It has often been remarked that the same pair of symbols, the 'double disc and Z-rod' and the 'beast head', positioned close to each other, appears on the symbol stone Rhynie No. 5 and on the Norrie's Law and Monifieth plaques. The pair is also found in the extensive cave art at East Wemyss in Fife, where, as we have seen, the 'S-curve' of the Aberdeenshire ring is also well represented. Cave art in the form of crosses is common in the Insular world but the appearance in caves of designs found in other media is unusual. Symbols and other designs are also found on the walls of caves at Covesea, near Elgin, Moray [*119*].[10] There are fine renderings of the 'flower' symbol in Fife caves. There are only eight examples of this symbol, equally divided between the symbol stones and the cross-slabs, and between north and south. There are also 'arch' symbols and salmon, along with seemingly more embryonic forms of symbols [*118*]. A recent survey of the cave art concludes that many of the motifs could possibly be the result of the temporary or seasonal encampment of metalworkers in silver on this southern boundary of Pictland.[11] The location of a silverworking site in Fife is of obvious importance, particularly for the understanding of symbol-bearing silver from Norrie's Law, and related pieces. The range of the cave art is, however, of more general importance. The designs on the walls, which are in the nature of motif pieces for planning designs, take us very close to the symbol cutters and to the period of the evolution of such predominant symbols as the 'Pictish beast', in a district not normally associated with the symbol stone phase. It may be, therefore, that in southern Pictland, the symbols were functioning in a portable form before and during the period when symbol stones were beginning to be raised in greater numbers in other districts.

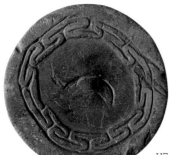

117 *Pictish incised disc, Ness of Burgi, Scat Ness, Shetland. Sandstone*

118 *Carvings on walls of Court Cave, East Wemyss, Fife*

119 *'Salmon' and 'crescent and V-rod' symbols on east side of entrance. Covesea Cave, Moray*

Bronze Hanging-Bowls and Silver Personal Possessions

The series of bronze bowls, belonging in the main to the 7th century, with hooked mounts (escutcheons) for supporting suspension rings presents a far more significant problem of disjunction between find-spot and place of origin than do the massive silver chains. As is well known, the majority of the hundred or so surviving hanging-bowls are found as grave goods throughout Anglo-Saxon England whereas the decorative components of the mounts are paralleled most closely in Irish metalwork. It is one of the great ironies of the chance nature of finds that the only evidence so far for the manufacture of hanging-bowl mounts comes not from Ireland or from the British kingdoms proximate to Anglo-Saxon England but from the Pictish heartland. In 1971 the front half of a mould for an open-work mount [120] was found in excavations on the hill-fort on Craig Phadrig two miles north-west of the Caledonian Canal and the city of Inverness, overlooking the Moray Firth. Not far to the south at Castle Tioram, Moidart, Argyll, an actual mount of this type was found [121], still attached to the remains of a bowl, so similar to the Craig Phadrig mould that it has been suggested that it may even

120 *Escutcheon mould, Craig Phadrig, Inverness. Baked clay*

mount very similar to that represented by the Inverness mould, although larger and more elegantly decorated, near the site of a monastery in County Derry associated with Comgall, the friend of St Columba of Iona, opens up the possibility of an Ionan dimension to artistic interaction at this early period, for St Columba is also associated with the northern stretch of the River Ness.[15] These slender connections are now strengthened by the finds from Dunadd, Argyll [148], also part of the Columban sphere of influence.[16] We cannot judge the significance of the art of the Craig Phadrig workshops on the basis of half a mould, but taken with the other evidence for hanging-bowls and related mounts in the far north, Perthshire, and possibly Fife, the Picts should not be marginalized in the general discussion.[17] At the very least they are seen to be producing a genre of metalwork which was to play a crucial part in the transmission of forms and techniques which contributed to the evolution of the Insular art style.

As artefacts, pins – encompassing many types, and with a wide distribution – have a long history. Here only the silver pins, and their analogues will be discussed. In the 1989 exhibition mentioned earlier a formidable silver disc-headed pin, some 32 centimetres long, was described as 'Irish or Pictish, probably 6th century' [122]. The pin, of unknown origin, is part of the Londesborough Collection in the British Museum. It has not appeared in discussions of the Pictish corpus of silver metalwork, or indeed in any publication after the 1920s.[18]

The pin is one of a group of disc-headed pins found on both sides of the Irish sea, not all of silver and not all decorated. An example very similar to the London pin, now in the National Museum of Ireland, has been attributed to possibly the same 'Irish or Pictish' workshop.[19] The function of such very large pins is not obvious. The diameter of the disc-head at just under 2 centimetres seems disproportionately small for the length of the shank. The panelled decoration on the shank is confined to the

have been made there. This bowl along with examples from Tummel Bridge, Perthshire used to be thought of as having been looted or traded from the Roman province. Now they can be regarded 'as perhaps produced in independent Pictish workshops', but, surprisingly, 'not necessarily by Picts'.[12] Such automatic cultural discrimination seems perverse. There is, however, radical disagreement about the date of the Craig Phadrig mould. One authority on the bowls insists on a 5th-century date and another, more expert in the Scottish material, a date in the 7th century.[13] In the catalogue of the 1989 'Work of Angels' exhibition of Celtic metalwork the mould is described as Pictish, and the date attributed to the 6th–7th century.[14] More positively, the find of a

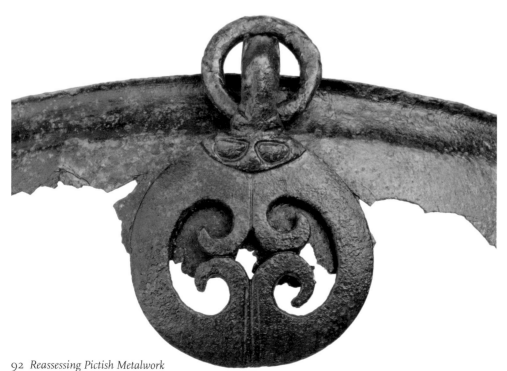

121 *Rim and escutcheon of hanging-bowl. Castle Tioram, Argyll. Bronze*

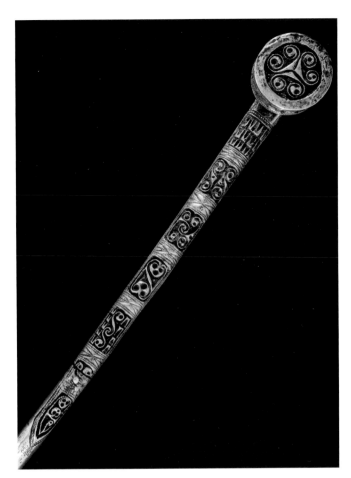

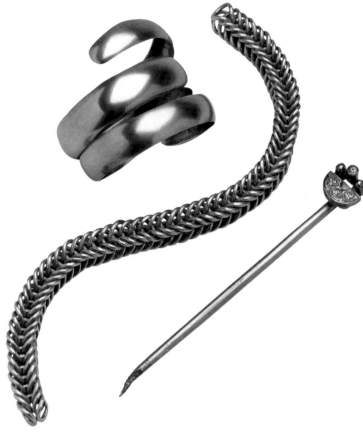

122 *Upper half of 'Londesborough Pin'. Silver, enamel*

123 *Objects from the Gaulcross hoard, Ley, Banffshire. Silver, enamel*

outward-facing surface. It extends on both pins to almost halfway down its length to end in a nib-like point, suggesting that only the decoration was visible in use, the pointed terminal panel indicating the depth of penetration into a heavy textile, an elaborate head-dress, or possibly, a large joint of meat. The sturdy disc-head juts out at right angles to the shank in the manner of the semi-circular 'palm' which forms the head of the better-known 'handpins'. The decoration on the shanks of the London and Dublin pins is remarkable for its density and fine detail. It consists of panels of subtly differentiated curvilinear ornament and gouged tooth-like forms reserved against red enamel, still present in the London pin. The enamelled panels are set off by broad borders of lightly incised or punched geometric patterns that include saltires.

One justification for introducing the possibility of Pictish manufacture, in spite of the fact that no example has been found in the north, is the lavish use of silver necessary for such a large pin, combined with red enamel decoration, which we have seen characterizes the symbol-bearing silver, particularly if one subscribes to the still defensible view that the equally lavish silver chains are Pictish in origin.[20]

Of more significance however, are the similarities of repertoire between the disc-headed pins and the very fine 'handpin' from the Pictish hoard from Gaulcross, Ley, Banffshire [*123*]. Here, the finely spun trio of triple spirals ending in lobes punctuated with a single dot fills the head of the pin with delicate accuracy. The same type of ornament but with single lobed ends decorates the circular field of the London pin. On the shank the curvilinear ornament is tendril-like and trailing, with a degree of somewhat mechanical symmetry. However, some of the panels, particularly the third from the top, and the pointed terminal panel, have a wandered delicacy which suggests a style, fugitive, but perhaps diagnostic. The simplicity of the triple-pelta motif on the London pin is replaced on the Dublin head by a more sophisticated arrangement of interlocking scrolls with counterpoised, varied centres. The treatment of the end panel is firmer, and more suited to its skeuomorphic function. A first impression, even to the most Pictophile eyes, is that the style of these large pins is not at all Pictish, the gouged ornament seems particularly alien, but the possibility of expanding the Pictish corpus, or of expanding the possibility of Pictish participation in contemporary artistic development will never be achieved if the

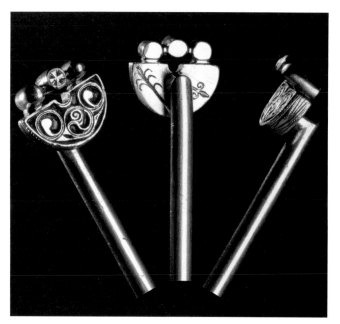
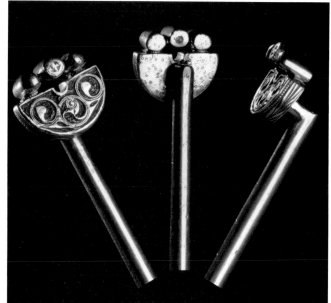

124, 125 *Front, back and side views of the heads of the two pins from Norrie's Law, Fife. Silver, enamel*

material for comparison is limited to the familiar range of artefacts. These disc-headed pins are presumably somewhat earlier than the Gaulcross 'handpin' and the apparent stylistic difference may be no more than a difference of form, quality and a degree of evolution.[21]

When it was discovered around 1840, the Gaulcross hoard contained many more objects, including brooches, than the three pieces that survive; the 'handpin' described above, a chain and a bracelet [123]. All of these are of uniformly high quality. The elegance and finish of the bracelet, a spiralling band of plain beaten silver, and the delicacy and complexity of the chain matches the craftsmanship of the 'handpin' and bonds it to them. The three items when worn together (presumably by a woman, as the diameter of the bracelet is 6.4 centimetres) would have created a splendid but restrained effect of status, and the pieces testify to a high level of sophistication in northern Pictland around the time of the conversion. It is just possible that the 'eight-pointed star' with the central piercing on the middle 'finger' of the pin relates to the zigzag ornament on the sandstone discs and on both the symbol-bearing chain closure rings.

Among the surviving pieces from the Norrie's Law hoard is a spiral finger ring of the same construction as the Gaulcross bracelet and two 'handpins' [124, 125].[22] In design and size the pins are a pair, both with three roundels of spiral decoration on the 'palm' and reserved crosses on the middle 'finger'. The decoration of one [124] has been shown to be inferior in execution, so it may

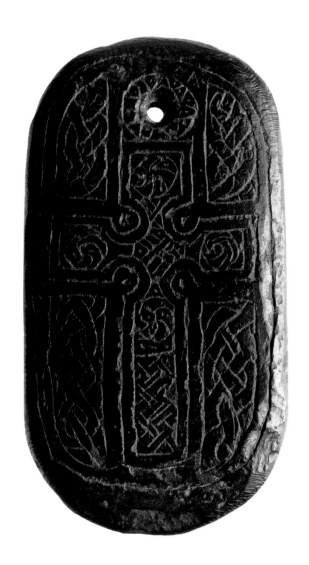

126, 127 *Front and back of the 'Erchless Pendant', Breakachy, by Beauly, Inverness-shire. Shale*

be a copy. This coarser version has the additional feature of what Anderson correctly described as an incomplete 'double disc and Z-rod' symbol, incised on the reverse of the head.[23] Only the 'Z-rod' is depicted so we must assume that this modifying element (it is never used alone on the sculpture) could affect some aspect of the function of the pin. It might be that the circular backs of the three 'fingers' were taken to represent the double disc and its juncture and that the complete symbol design is, as it were, disintegrated. The 'Z-rod' on the pin is pointed at both ends in the manner of the depictions on the Norrie's Law leaf-shaped plaques, the Monifieth plaque and the closure ring of the Whitecleugh chain. Its floriations are aberrant in that they point downwards, but there are plenty of examples of such variation on the 'double disc and Z-rod' symbol on the sculpture, and those on the Monifieth plaque as we have seen are equally non-standard. It has been suggested that the placing of the symbol (where the part is representing the whole) on the back of the head, while an equal-armed cross within a circle features on the front, belongs to the conventions of slab sculpture.[24] The same could be argued for the layout of the neatly

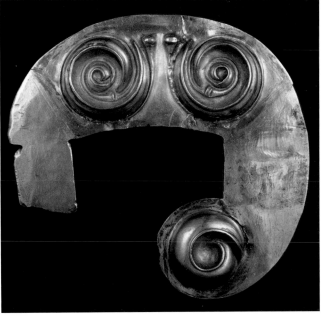

128 *Sheet of repoussé bosses, Norrie's Law, Fife. Silver*

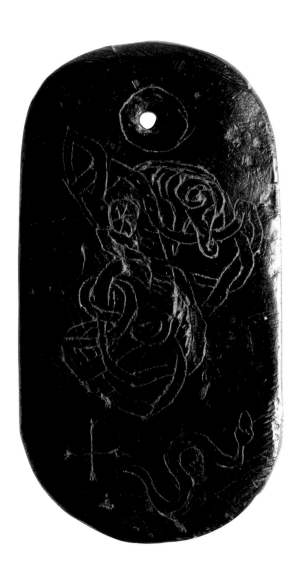

carved shale pendant [*126, 127*] from Erchless, Breakachy, now in the Museum of Inverness. The pendant is rectangular, 6.5 centimetres high by 3.5 centimetres wide, rounded at the corners and smoothed so that it fits comfortably into the palm of the hand. A double-contoured Latin cross with hollowed armpits runs its full length. The decoration observes the slab convention of differentiating the cross-head from the shaft, here with roundels of zoomorphic ornament on the arms and diagonally-set key-pattern on the shaft. The background is filled with panels of zoomorphic interlace. On the back is an animal entangled with a snake, a single snake in the style of the symbol stones, and a small linear cross. The whole is strongly reminiscent of a miniature cross-slab. That the carver of the pin also knew the slab conventions is certainly possible, the cross on the front producing a natural reflex on the part of the metalworker, one which one would dearly like to understand.[25]

It is important, however, to recognize that the surviving *disjecta membra* of the Norrie's Law hoard provide evidence for high-quality, non-symbol-bearing metalworking in silver. They also include an impressive sheet of repoussé bosses [*128*] comparable to the terminals in bronze of the probably 7th-century bow-brooch from Ardakillen Lough, County Roscommon.[26] This analogy has led to the suggestion that the Norrie's Law embossed sheet is an import from Ireland, but there seems no reason why the Picts could not have participated in the revival of this conservative style, particularly since repoussé Iron Age heirlooms, or humbler descendants of the style, may have informed aspects of the Pictish symbol designs. The style was apparently one of the latent components of the Insular synthesis also present on hanging-bowl or related mounts.[27]

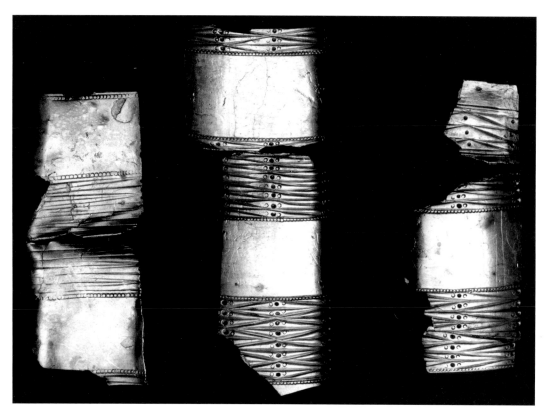

129 *Fragments of binding strips, Norrie's Law, Fife. Silver*

Two other fragments of objects likely to date to the 6th or 7th century can be identified in the hoard [129]. Fragments of silver bands with lightly expressed linear ornament comparable to the treatment of the edge of the 'handpins' are paralleled on the rims of the mounts on the large hanging-bowl deposited in the ship burial at Sutton Hoo, Suffolk, now considered to be of Irish workmanship. The same ornament appears on the celebrated brooch from Ballinderry, County Westmeath, the art of which provides the best background for the great bowl. The strips were identified as suitable for knife-handles but another Irish analogue suggests that they might be sections of strips for binding saddlery.[28] A recently confirmed identification of silver bracelet terminals in the hoard has followed from the recognition of Irish examples in bronze.[29] A complete Irish bracelet is coiled in a fashion reminiscent of the Gaulcross bracelet, but it is of stronger construction and larger diameter. The identification is significant for, with the finger ring, it creates another link between the two Pictish hoards.

The Norrie's Law hoard also contains two silver penannular circlets long considered as unusually large brooches with twisted hoops and flattened terminals [112]. It is now thought that they may have been worn on the chest in imitation of Roman military insignia.[30] This need not altogether disturb their relationship with the plain silver penannular brooches, damaged, but complete with their pins, in the hoard from Tummel Bridge in Perthshire [130]. As we have seen, the hoard also contained fragments of at least two hanging-bowls themselves reminiscent of Roman provincial productions. Both the circlets and the plain penannular brooch

type – dated by some to the 7th century, but by others as early as the 5th – can therefore remain part of a native continuum in the use of penannular forms and a taste for plain silver.

The date and nature of the surviving and lost contents of the Norrie's Law hoard remain disputed and there is a danger that the dating of related pieces becomes part of a circular argument. On balance a date of deposition of the hoard in the 7th century seems the most probable but all are agreed that the hoard contains items of different dates. The art of the symbols as displayed in the hoard can contribute to the debate only in so far as it appears to be closer to the art of the slabs than to that of the symbol stones. For Pictish art the hoard is important for giving a degree of coherence to the widely dispersed silverware, to the engraved terminal rings of the chains, and to the Gaulcross hoard. It also affords unique evidence to the function of the symbol designs outside the sculpture and hints at methods of transmission of the designs over time and space.

Penannular Brooches: Design, Provenance and Origin

In any account of the Pictishness of Pictish metalwork the enduring taste of patrons for penannular brooches must take precedence even over the symbol-bearing pieces. Although some modification of previously held views of the evolution of the typically Pictish penannular is now in order because of new finds of related moulds in the 7th-century workshops of the Dalriadic stronghold of Dunadd, David Wilson's definition of the type

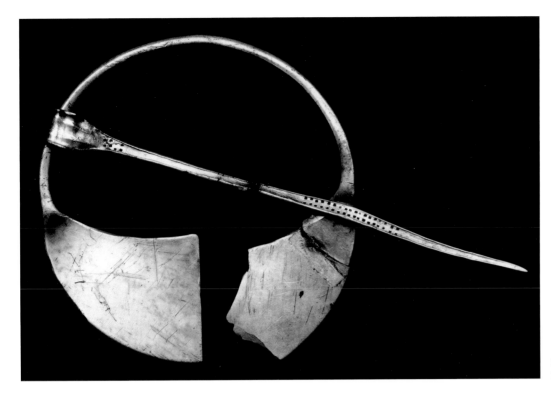

130 *Penannular brooch,*
Tummel Bridge, Perthshire

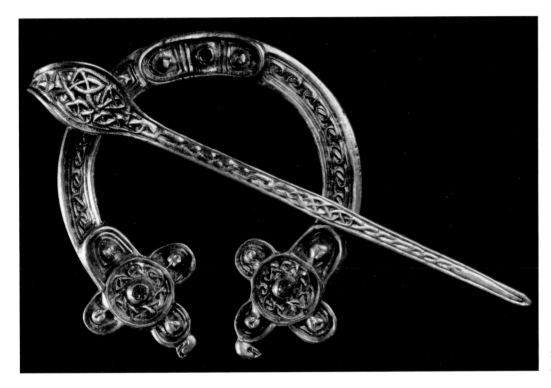

131 *Penannular brooch,*
St Ninian's Isle, Shetland, No. 20

stands.[31] A Pictish penannular brooch typically has a ribbed hoop with a centrally placed oval cartouche [131]. A well-defined cusp marks the juncture of the hoop and the terminals. The pin is formed by a simple fold-over, with a head of lentoid shape.[32] The type contrasts with Irish brooches [142] which are annular and have more elaborate pin-heads, often decorated so as to match ornament on the ring. The recognition of the distinction between the types is not to deny that some brooches have features taken from both. Indeed, such hybrids are to be expected within the synthetic processes of Insular art. That the Insular synthesis brings with it difficulties of determining origin is well known in manuscript studies but has been less of an issue in metalwork studies, in spite of difficulties implicit in the portability and diplomatic value, through exchange, of fine metalwork.

132 *Brooch moulds, the Brough of Birsay, Orkney. Baked clay*

133 *Decorated disc, the Brough of Birsay, Orkney. Lead*

Wilson's definition was based on a painstaking examination of the formal and stylistic traits of the brooches in the St Ninian's Isle, Shetland treasure.[33] The treasure, found in the floor of the nave of the medieval church enclosed in a box and covered with a slab, consists of twenty-eight silver objects. Its discovery in controlled, if incomplete, excavations in the 1950s ensured its safekeeping as an entity. Had it been found in the 19th century its fate would have been very different. The treasure included twelve penannular brooches which although variously decorated had formal consistency. Wilson's conclusion – offered with some reservations – that they were examples of a larger class of Pictish brooches came just before the realization that evidence for the manufacture of the type was amply present in the moulds discovered in excavations on the Brough of Birsay, a tidal island lying off the north-west top of Mainland, Orkney [132]. Birsay gives unique insight into a major Pictish craft centre. Its production of pins and combs, the latter directly relatable to the types carved on Pictish sculpture, and its own relief monument [78] of a distinctive and impressive kind shows that the manufacturing enterprise was part of mainstream Pictish culture. The quantities of artefactual finds, which included moulds for sixteen penannular brooches, is unfortunately not matched by surviving structural remains. The latest excavations did, however, detect one structural unit devoted to smithing and radio-carbon dating confirms the art-historical dating derived from the parallels with the brooches from St Ninian's Isle: Pictish penannulars were being made or worn on both these islets from the 7th century and throughout the 8th. The one surviving brooch on Birsay is described by the excavator as 'the very pattern of a St Ninian's Isle brooch'.[34]

One of the Birsay moulds was for a brooch with terminals consisting of an animal head with gaping jaws, its protruding tongue held between its fangs. The design immediately recalls the terminals of the smaller of the two decorated scabbard chapes,

artefacts unique to the Shetland treasure [163]. That the fashioning of scabbard chapes drew on the repertoire of brooch terminals is more likely than the reverse, and such interchangeability of motifs is characteristic of Insular metalwork productions.[35] The Birsay moulds include well-articulated fierce birds' heads for individual casting in the round. Birds' heads, as we shall see, are a feature of Pictish brooches, but as the excavator rightly observes, such high-relief heads could have been attached to a variety of objects. A good, but entirely unpredictable, example is the dog's head riveted to the juncture of the handle and the bowl of a spoon in the St Ninian's Isle treasure. Its tongue is extended to 'lick' the contents of the bowl. Conveniently proximate to the moulds was a collection of glass and garnet objects for use as settings, some from vessels datable to the 8th century, or possibly slightly earlier. These will have been acquired presumably on the initiative of the craft workers through familiar contacts with seaborne traders.[36] The collection includes a garnet prepared for mounting in a cloison. Such collections need not be regarded as simply a magpie-like activity. For a skilled craftsman the nature of each fragment would have been of professional interest adding in some measure to technical and artistic possibilities. A lead disc filled with a somewhat sketchy but properly constructed arrangement, in negative form, of developed spiral ornament is probably a die [133]. Such an object is a standard resource of Insular decorative art, and confirms the impression that the workshops in Birsay had ongoing contact with craft centres in the other regions.[37]

The brooches in the St Ninian's Isle treasure, with one exception, were in working order, presumably being worn by members of a Shetland family up to the time of their concealment for safety below the earlier church floor. All are silver gilt, the majority being of comparatively low silver content. Brooch No. 25, otherwise unremarkable, has a silver content of 82 per cent, much

nearer to the quality of the earlier Pictish silver, but no doubt a chance circumstance of the recycled material on hand.[38]

The largest brooch, No. 17 [134], some 11 centimetres in diameter at the widest point, has a broad hoop and triangular terminals that rise to create a kidney-shaped void paralleled in some of the Birsay moulds.[39] Superficially it appears to be decorated with neatly tailored, variously shaped, panels of interlace. Closer examination reveals the presence of microscopic animal heads which betray an ultimate origin in Germanic zoomorphic interlace, but which, with their prominent eyes and pointed ears seen from above, remind one vividly of similarly poking heads ranged around discs in the cruciform capitals of the columns in the 'Arrest of Christ' miniature on *f.* 114v of the Book of Kells [22]. Similar curiously minute heads finish off a section of the interlace which frames a cross on the slab at Rossie Priory, Perthshire [86]. Here the heads are in profile but these understated zoomorphs hidden in a dense array of ornament is in tune with the design of brooch No. 17.[40] Such heads, often in bolder forms with their sometimes upturned snouts pointing ambiguously towards the centres or the edges of terminals, are a distinctive trait of the St Ninian's Isle brooch repertoire. The terminals of brooch No. 19 have three of the breed but they are encroached upon by a much larger profile creature, the cusp being developed into a round head with a sharp beak entering the terminal. This arrangement recalls the basic Anglo-Saxon bird-headed brooch being made at Dunadd in the 7th century, long before the more developed St Ninian's Isle type of a century later.[41]

The ornament on the pin-head of brooch No. 19 is remarkably complex. Wilson describes it thus: 'In the centre of the head is a repoussé boss, which is divided into quadrants. The boss is much worn, but may originally have been decorated with a series of knots. On either side of the boss two animal heads face outwards. Each has a well-defined cheek line and a curled lower lip: from the mouth emerges a tongue which extends downwards to interlace with the first loop of the interlace pattern on the shaft of the pin. The neck falls away to a front hip, from which emerge two formalized legs which form a symmetrical interlace with the legs of the opposing animal'.[42] This kind of animal ornament although concentrated in a small field can be exactly paralleled on the cross-face of the symbol bearing slab at Nigg, Ross & Cromarty [40, 41], where, for example, tongues emerging from the mouths of confronted snakes extend into spirals which then connect up with the interlace on bossed forms.

A common design within the group has lobed terminals containing animal masks, often flanked by S-coils that soften the ill-assorted geometry of the hooped cusp and the triple-lobed terminal. One brooch of this type, No. 20, varies the outline by projecting a head from the lobe opposite the cusp. Wilson maintains that such a feature is unparalleled in the corpus of Celtic penannular brooches.[43] Of even more interest is the design of the head with its curved cheek-line, dot-eye, and snub-nosed reptile-like snout. As Wilson points out, the form is similar to

that of the animal-head frieze on the crest of one of the chapes and is related to heads in the interlace of brooch No. 17 and the internal mount of brooch No. 6. This detail has important implications therefore for the coherence of the treasure as a product of local manufacture.[44]

The flatter more linear profile terminal heads of brooch No. 28 [135] have jaws curled out, ears pricked, and a coiled head crest. These features create an interesting contour marred by the clamped teeth with paper-dragon zigzag teeth and an ineffective interlace pattern on the muzzle. The terminals are very similar to those on a brooch fragment from Freswick, Caithness [136], although there the design is more naturalistic, the jaws gape, the eye is lentoid and the muzzle more appropriately filled with herringbone pattern. This parallel is significant for it is evidence of contacts between the north-eastern tip of mainland Scotland, the Northern isles, and, as we shall see, even further afield.

The eastern seaboard, from Caithness southwards to the Tarbat peninsula, is rich in Pictish archaeology and metalwork. The fragment of a brooch from Achavrole, Dunbeath, Caithness [137], widens the discussion of brooches with a Pictish provenance.[45] Enough of it has survived to show that it was an elegant silver gilt penannular, but there the comparison with the northern brooches ends. There is no cusp at the juncture of the hoop and the terminal; instead, the transition is marked by a circular setting of amber and a cast bird's head on the external edge.

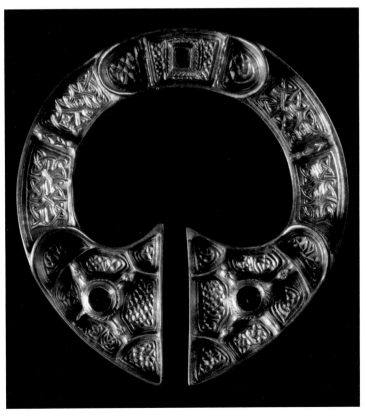

134 *Penannular brooch, St Ninian's Isle, Shetland, No. 17. Silver-gilt*

135 *Terminal of brooch, St Ninian's Isle, Shetland, No. 28. Silver*

137 *Fragment of penannular brooch, Achavrole, Dunbeath, Caithness. Silver, gilt, gold filigree, amber*

136 *Fragment of penannular brooch, Freswick, Caithness. Bronze*

There are three smaller amber settings on the terminal. Apart from the settings the decoration is entirely composed of panels of filigree. The filigree is mounted on gold trays that are themselves mounted on a back plate. This 'hollow platform' technique is used on the finest Insular metalwork such as the brooch from Hunterston, West Kilbride, Ayrshire [11], and the technically outstanding paten from Derrynaflan, County Tipperary [17, 18]. The maker of the Dunbeath brooch produced what has been rated as a 'crude copy' of this mounting device: Certainly the filigree work appears less controlled than that on the Hunterston brooch and infinitely less varied and complex than that achieved by the maker of the classic example of this group, the 'Tara' brooch, Bettystown, County Meath.[46] The surviving section of the Dunbeath hoop is filled with a beast-headed snake with a fishtail. Its jaws are wide open, the tongue extended and held between its fangs. Beast-headed snakes are among the motifs used in the Derrynaflan paten, although there they are arranged in symmetrical pairs and have indications of joints. The animal in the panel of the surviving Dunbeath terminal has the same head as the snake, but its extended tongue unhampered by fangs loops round to penetrate the body in the manner of the snake that pierces the body of a fierce beast on the cross-slab at Rossie Priory, Perthshire [102]. The treatment of the feet of the Dunbeath beast, two pads and a claw, is closer to the 'Tara' animals than to the archaic 'ball and claw' feet of Hunterston. The exuberance of the gaping jaws of the Dunbeath heads contrasts with the firmly closed jaws of the Hunterston animals. The Dunbeath beast is less attenuated, has joint spirals and moves forward on four visible

138 *Penannular brooch, the Rogart hoard, Sutherland. Silver, gilt, glass*

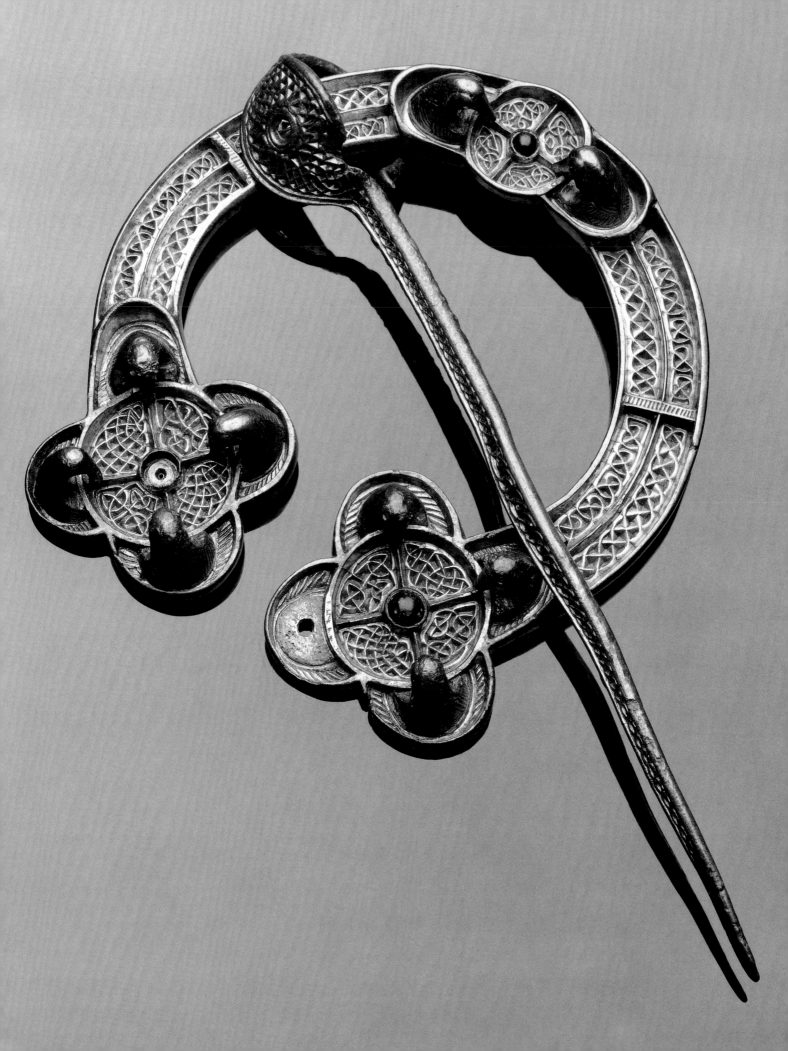

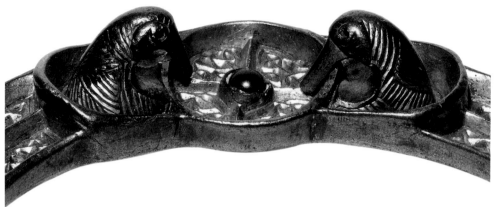

139 *Detail of ornament on hoop of Rogart brooch*

legs: all features not found in the animal designs on the 'Tara' and Hunterston brooches. It has been noted, however, that some of these features are paralleled in the animals on the reverse of the later larger brooch from Ardagh, County Limerick [*142*].[47]

The difficulty of reconciling the find-spots with the probable place of manufacture of metalwork is exemplified by the Dunbeath brooch fragment. A recent assessment considers it to be 'Irish style, 8th century' but because it is penannular, 'presumably manufactured in Scotland', a compromise between ornament and form such as would have been achieved by 'travelling craftsmen attempting to satisfy local variations in taste in what was otherwise a fairly homogeneous material culture'.[48] The reality behind such a conclusion is difficult to imagine. One wonders why the shared cultural traits excluded the ability to share skills and materials. The logic, of course, is that there is an insufficient base of localized comparison to account for the nature of the ornament. But that deficit will remain if the possibility of a yet to be discovered skill base, hinted at by isolated finds, is simply not entertained.

The case for full Pictish participation in the production of brooches of the Hunterston/'Tara' type may well be strengthened when the nature of the early Christian site at nearby Ballachly [*232*] is fully investigated. The work of its sculptors, presumably accepted as Pictish, has recently come to light, so a context for fine metalworking is in position.[49] The skill base may indeed already be identified in the evidence for fine metalworking coming from the excavations at Tarbat, not far south. Meanwhile the animal motifs on the Dunbeath brooch, the beast of three species on the hoop and the explicitly quadrupedal backward-turning linear beast can be readily paralleled in the animal art of Pictland.[50]

Moving southwards, a hoard of the valuables of a household in Rogart, Sutherland was discovered in 1868 while constructing the central stretch of the North Line railway from Inverness to Wick. Rogart lies about seven miles from Golspie, in the neighbourhood of which is a rich array of Pictish archaeology, including monuments remarkable in both form and content.[51] Eleven brooches were recorded as being in the hoard. They were rapidly dispersed. Two complete silver brooches survive and possible

fragments of another four have been traced. The smaller of the two conforms closely to the St Ninian's Isle type, with a cartouche at the top of the hoop, cusps at the juncture of the hoop and terminals, resting on circular terminals with two adjacent semicircular lobes. The pin, too, is the simple fold-over type. The decoration is almost entirely of cast interlace, some of it with the minute insect-like heads that characterize so much of the St Ninian's Isle repertoire. The larger brooch [*138*] is a major masterpiece of Insular art which has to be viewed from the side in three dimensions to be fully appreciated. It too has lobed terminals, and wiry, interestingly varied, cast interlace on the terminals. Attached to the cusp and the three lobes are gilt birds' heads with green glass eyes, whose arched, feathered necks curve down to dip their spatulate beaks into the circular panel. The beaks meet the arms of a cruciform framework that creates quadrants of differing panels of interlace to meet at a setting of red glass at the crossing. Similar high-relief birds' heads dip their beaks into a matching circular 'pool' within the hoop cartouche [*139*]. Though the arrangement of the birds is markedly rigid, the pose inevitably recalls the image of the Fountain of Life where deer, birds and other creatures refresh themselves, just as mankind yearns for the reviving Water of Salvation.[52] The species of bird on the Rogart brooch is different from the fierce eagle of the Birsay moulds but the birds clearly belong to the same artistic tradition. The diameter of the hoop is 12 centimetres, which is similar to the dimensions of the Hunterston brooch, though entirely different in its techniques. The slightly larger annular brooch from Ardagh, County Limerick [*142*], mentioned above, has the same imagery, with three very beautiful winged birds resting their beaks within a cruciform panel at the centre of the plate.[53]

Unlike the hoards on St Ninian's Isle and at Rogart, the hoard from Croy, to the east of Inverness is probably the stock-in-trade of a jeweller, who, judging from the Anglo-Saxon coins in his collection, cached his materials around the middle of the 9th century.[54] They were found in a field in the 1870s but some items were, subsequently, inadvertently, scattered by the plough. Among the surviving items were three silver penannular brooches, one complete but for the pin, and the other two, fragments, but with

sufficient remaining to show that all three were formerly Pictish penannulars. One of the fragments has a lobed terminal with small triquetras in the lobes surrounding a square panel that contains interlocking oval rings. The smaller fragment is of particular interest, for its cusp frames a triquetra, but here in gold filigree [140]. The terminal has the flared triangular shape of the large brooch in the St Ninian's Isle treasure. A central sub-triangular setting consists of garnets in a network of gold cloisons, deeply framed with three panels of filigree containing S-coils of the type used in the panels on the curved edge of the Dunbeath fragment. In form this Croy fragment stands closer to the St Ninian's Isle norm than does Dunbeath, but they share some of its materials and techniques. It is improbable that the find-spot of this gold and garnet brooch fragment is related to its place of manufacture but its form shows knowledge of the Pictish type of brooch and the duplication of the cast triquetra motif on the other Croy fragment, which is certainly Pictish, sets up the possibility of a Pictish workshop producing garnet and gold jewelry. Of great interest is the existence in the collections of the British Museum of an unprovenanced fragment that Françoise Henry regarded as 'identical' to the Croy cloisonné fragment but 'in reverse' [141]. It is tempting to see this right terminal as part of the missing partner of the Croy penannular but the two have never been examined together.[55]

South of the Grampian mountain range moulds for penannulars are found on Clatchard Craig, a fortified site in Fife. The Clunie hoard in Perthshire contained at least two silver brooches, with a further three from Perthshire, two of which, Aldclune and an unpublished fragment, were found after the publication of the St Ninian's Isle treasure. The brooch in the British Museum from the Breadalbane Collection has a saleroom

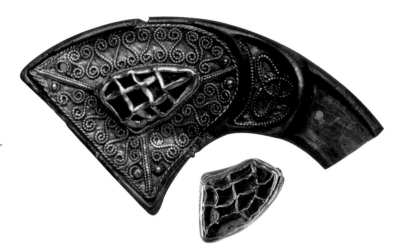

140 Left terminal of a penannular brooch, Croy hoard, Inverness-shire. Silver-gilt, gold filigree, garnet

141 Right terminal fragment of penannular brooch, gift of Max Rosenheim, The British Museum. Silver-gilt, gold wire, garnet

history that suggests it originated in Perthshire [143]. It has been described as 'Irish and Pictish', although within the design is a recognizably 'fossilized' Pictish penannular that appears to have been made originally as an annular brooch. Its Pictish pin is thought to be secondary, the work of the Pictish smith who cut away a section between the terminals in order to make it penannular. The cartouche on the hoop has a panel of gold foil framed with filigree that contains two entwined snakes, with round heads, made of gold wire. The fusion of forms, techniques and repertoire have rightly been said to 'reflect the development of

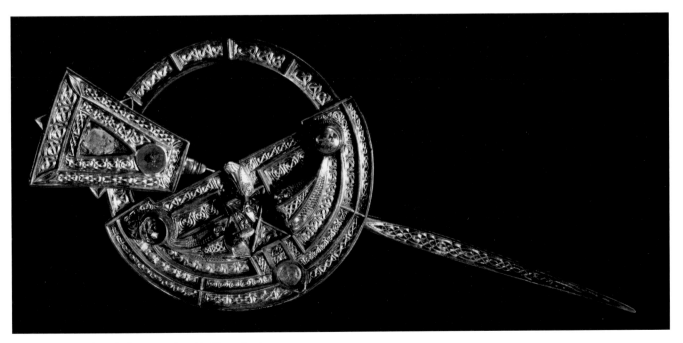

142 Annular brooch, Ardagh, County Limerick. Silver, gilt, glass

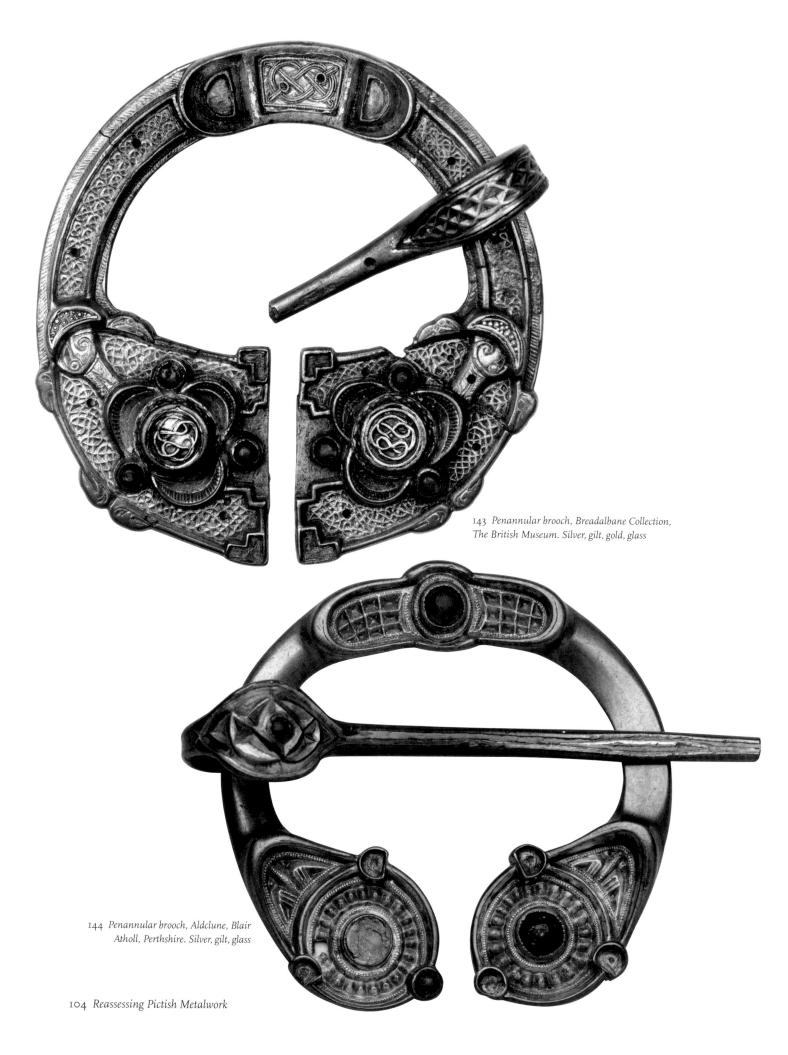

143 *Penannular brooch, Breadalbane Collection, The British Museum. Silver, gilt, gold, glass*

144 *Penannular brooch, Aldclune, Blair Atholl, Perthshire. Silver, gilt, glass*

/ A.D.M. Barrell.

M. (Andrew D. M.)

10041199639hil0

Due: **06-03-22**

Title: **A history of Scotland / Allan I. Macinnes.**
Author: Macinnes, Allan I., author.
Barcode: 30660913177205
Due: **06-10-22**

Title: **Five euphemias : women in medieval**
Author: Sutherland, Elizabeth.
Barcode: 3 2210 00190 5428
Due: **06-03-22**

Title: **Get talking Mandarin Chinese [sound**
Author: Scurfield, Elizabeth.
Barcode: 30605003744521
Due: **06-10-22**

Title: **Elementary Mandarin Chinese : the**
Author: Kubler, Cornelius C., author.
Barcode: 062791007698229
Due: **06-10-22**

Title: **Art of the Picts : sculpture and metalwork**
Author: Henderson, George, 1931-
Barcode: 064791001951200
Due: **06-03-22**

Total items checked out: 6

Northport
151 Laurel Avenue
Northport, NY 11768
631-261-6930

East Northport
185 Larkfield Road
East Northport, NY 11731
(631) 261-2313

www.nenpl.org

an insular ornamental style'.[56] If the brooch was manufactured in Perthshire then the annular format has to be accounted for. One has to wonder if metalsmiths on either side of the Irish sea were indeed so fixated with the annular/penannular differentiation, or whether a craft option is being given too rigid an ethnic significance. The suggestion that the loss of an 'en suite' pin of the Irish type led to the opening up of the brooch so that a simple pin could restore its usefulness is a reasonable one, although an alternative might be that a short cut was taken when the disadvantages inherent in securing the annular brooch were appreciated. The Pictish brooch from Aldclune, Blair Atholl, Perthshire [144] has a circular setting on the cartouche flanked by passages of grid pattern suggestive of cloisons. The cusps frame a pair of confronted birds possibly pecking at a branch, an image, perhaps, of the Tree of Life. The brooch is also of interest for its double rows of punch-dot decoration edging the main fields. Such dotting, as we shall see, is characteristic of other Pictish metalwork.[57] The smaller of the brooches from Clunie, Dunkeld, Perthshire [145, *right*], recalls the Rogart bird brooch, for here three relief animal heads attach themselves to the circular frames within the terminals.[58] Only one of the cusps retains its filigree decoration, which consists of intertwining serpents with the protuberant eyes of the snakes in the decorative repertoire of the Book of Kells. The terminals are edged with a border of S-scrolls. The pin-head was showy, with a similarly frilled edge framing a panel of gold filigree now much worn away. One feels that the maker of this brooch, who had access to gold, was aware of the en suite pins of the grandest brooches.

The larger of the Clunie brooches is a contrast and an interesting one. Wilson considered it 'strange and unique' and did not include it in his list of penannular brooches of the St Ninian's Isle type. Stevenson described it as 'typologically odd but genuine'.[59] The terminals are triangular but with a straight inner contour emphasized by a rim of interlace. There are the standard cusps at the junction of the hoop and terminal but it is 'animalized', not as the neck of a beast-head terminal such as brooch No. 28 in the St Ninian's Isle series, but in, as it were, reverse direction, treated as the fishtails of long-bodied serpents that ascend the hoop. Marginal fishtailed creatures with elongated bodies are common in Insular art of all media in all regions. In metalwork it is used most elegantly on the edge of the 'Tara' brooch. In Pictish sculpture the reverse of the cross-slab at Dunfallandy, Perthshire [77], is one of a number of examples.[60] These Clunie heads, like many of the heads on St Ninian's Isle brooches, are seen from above with well-defined dots for eyes and poking snouts. The eyes are set in lozenge shapes very reminiscent of those that produce the fine mesh of interlace, the 'eye-trails', of the aforementioned fishtailed snakes in the Book of Kells. A direct relation of the Kells snake's head, without the trails, is carved on the relief cross-slab at Logierait, Perthshire.[61]

Returning to the brooch, it appears that lizard-like limbs emerge from behind the first head. Flippers appear in this position on one of the Kells snakes, within the bravura tangle of animals on *f.* 250v,[62] but the lizard-like limbs belong with a whole range of animal ornament where serpentine creatures seen from above stretch out stick-like fore-limbs, as for example, in the

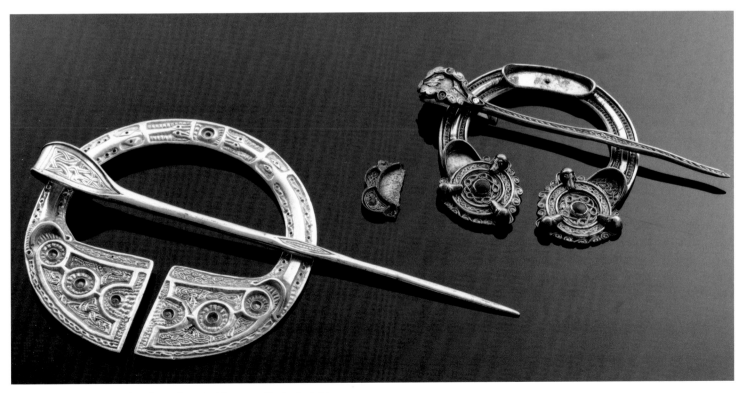

145 *Two penannular brooches and terminal fragment, Clunie, Perthshire.*
Left-hand brooch *cast silver;* right-hand brooch *silver, gold filigree, glass*

146 *Loch of Clunie, Perthshire, island site*

possibly Northumbrian St Petersburg Gospels, on the Northumbrian Rothbury Cross, on St John's Cross on Iona, on the Southumbrian Gandersheim Casket, and the section of an Insular mount from Romfohjellen, Møre, Norway.[63] In Pictish sculpture the animal seen from above is common. The Murthly shrine panel in Perthshire [182] has a good example of the type, where the body is that of a fish, and the head somewhat crocodile-like with long jaws and prominent round eyes.

The Clunie designer stopped the creatures with fishtails at a point influenced by the classic cartouche space at the top of the hoop. The pseudo-cartouche is further separated off by a background of hatching, contrasting with the S-scrolls that form a background for the main animals. These S-scrolls echo the carefully turned 'frill' edge of the smaller Clunie brooch. In this larger brooch the punching out of the turn of the scrolls may be a crude shortcut, but it links them with the punched eyes of the creatures and gives an impression of a frieze of snouted animal heads. The creatures within the cartouche, that flank the square panel with its bossed empty setting, relate to the edge of the hoop in a way that creates lizard forequarters. They are nudged along by the main creatures, their bodies lying beneath them or consumed by them. Their heads, seen from above, have blunt muzzles, segmented with concave curves in the manner of snakes in the Book of Kells.[64]

The disposition of these four serpents is the work of a designer who was determined to do something different with the hoop. One imagines his concept began with using the cusps as fishtails. Thereafter familiarity with marginal fishtailed animals in other media, including the 'Tara' device, drew the serpents up the hoop towards the traditional central space, in which further, guardian serpents were introduced. This particular aspect of the larger Clunie brooch shows a Pictish smith participating in an Insular convention, but the fact that he introduced creatures of this type into the hoop is a measure of the extent to which Pictish artists were committed to animal art and its symbolism. In this, therefore, it rates as characteristically Pictish. The find-spot of the brooches is documented as 'near Clunie Castle'. Clunie Castle stands near an island in a small loch fed by the River Lunan [146]. The brooches may have been part of a hoard, for a recent find – a terminal fragment of a silver brooch with filigree decoration – adds to the number of brooches from Clunie.[65] The lizard-like reptiles on the hoop of the larger brooch have parallels, as we have seen, on sculpture from nearby sites in Perthshire, providing an artistic context that strengthens the possibility of its manufacture here. The island site, in Loch of Clunie, would have been ideal for precious metalworking.

Although there has been no discussion of the zoomorphic ornament on the hoop of this brooch, the resemblance of the cast decoration on its terminals to moulds for brooches among metalworking debris at Pictish Clatchard Craig in Fife, and in the workshops of Irish Dunadd (Argyll), has given the larger Clunie brooch a central place in new evaluations of the great heavily decorated brooches of the 'Tara' type. Three fragments of a mould for a single brooch are evidence for the manufacture on Clatchard Craig of a large brooch around 13 centimetres wide [147]. The hoop was convex and there appears to have been a cusp at the juncture

with the terminal. The brooch was penannular and it shares with the Clunie brooch the layout of the decoration on the terminals made up of linked circular and semi-circular panels.[66] The important difference is that the Clunie brooch is an integral casting in silver whereas the Clatchard Craig layout is of a framework of empty cells to be decorated presumably with filigree, comparable to those in the smaller of the Clunie brooches. The Fife excavation report dated the brooch made from the mould fragments to the 8th century, indeed all the metalworking on the fort is assigned to this period. The find of a silver ingot in the same context allows for the possibility that this and other penannulars made on the site were of silver.[67]

The Dunadd mould [148] consists of the conjoined fragments of the terminals of a large penannular brooch. There is a small gap between the terminals that could have been joined to form a 'pseudo-penannular'. It has been reconstructed, for study, in a diagram and in a mould, in both forms.[68] There has been a typical cusp at the junction with the hoop. The geometric layout of the surviving terminal is markedly similar to both the Fife mould and the Perthshire brooch. However, the Dunadd mould, like the mould from Clatchard Craig, was cast for empty cells. The excavators at Dunadd date their mould, on deductions based on stratigraphy and radiocarbon dating, to the 7th century and suggest that a date as early as this could be argued on

148 *Schematic reconstruction of casting of large brooch, Dunadd, Argyll, mould No. 1636*

archaeological grounds for the Clatchard Craig mould given an uncertain stratification and the evidence for activity on the site in the 7th century. The larger Clunie brooch it is argued, with its 'attempt to imitate filigree or cable interlace' could be interpreted as 'a not very successful, and early, attempt to copy Anglo-Saxon metalwork'.[69] It seems more probable that the integral casting and its crudeness is the result of debasement or corner-cutting. From the point of view of its design, the decoration of the terminals, whatever its technical incompetence, is typical of the art, represented by the lizard-like creatures on the hoop – in simple terms, the art of much of the zoomorphic ornament in the Book of Kells. The iconography of the creatures is paralleled in Irish brooches of the 9th century, for example, the showy but also somewhat crudely executed brooch said to be from Roscrea, County Tipperary, where animals with prominent eyes and beaky jaws flank circular settings at the top and bottom of the design gap between the panels of filigree on the pseudo-terminals.[70] Unless an early analogy for the animal ornament on the larger Clunie brooch can be found then its date on art-historical grounds must remain 8th to 9th century and it would be better removed from arguments about the starting point of the large brooches. Its atypical nature in itself makes it an unsatisfactory underpinning. A distant prototype must lie behind the relationship of these pieces. The importance of the moulds found at Clatchard Craig lies in the evidence they provide for the manufacture of brooches in southern Pictland. This cannot have been the only production site. As Stevenson has pointed out, 'The distribution pattern of Pictish brooches...is no doubt unrepresentative of the original area of their use and manufacture, because archaeological excavation hitherto, and the pressures of Norse raiding, have been peripheral to the agricultural heartlands of the Picts'.[71]

147 *Fragments of mould for a penannular brooch, Clatchard Craig, Fife. Baked clay*

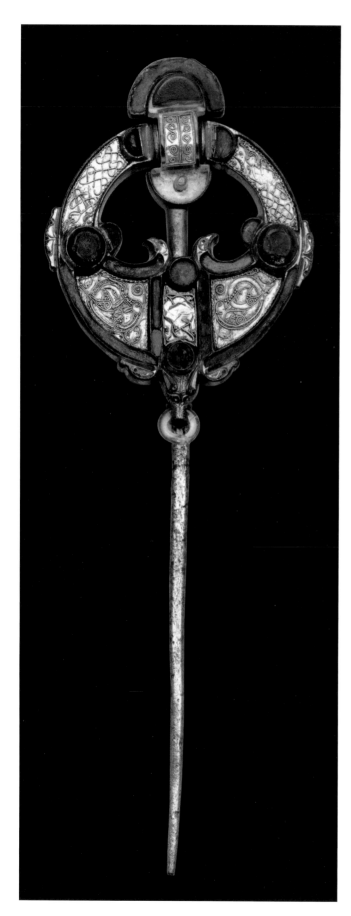

A Northern Brooch-pin

One of the 8th-century brooches, or more correctly, brooch-pins, that has cast animals on its edge was found in a Viking grave on Westness, Rousay, Orkney [149]. As on the 'Tara' brooch they are cast in profile, but they do not have the fishtails found there and on the marginal animals in Pictish sculpture.[72] In quality, the brooch-pin is equal to the 'Tara', Hunterston [11], and Dunbeath [137] brooches. As a brooch-pin it is remarkable for the wolf's head, cast in full relief, which held a ring in its jaws in the manner of a miniature door knocker, an arrangement described by Stevenson as a 'novel conceit' of Mediterranean inspiration. A cord will have passed through the ring to wind round the shaft to keep the brooch securely attached.[73]

The Westness brooch is considered to be of Irish manufacture on the grounds of technical similarities with the 'Tara' and Hunterston brooches, which include the setting of filigree on trays of gold foil. However, in addition to the animal head, the brooch has a number of idiosyncrasies. The most obvious is the positioning of the filigree animals on the terminals so that they are to be seen the right way up from the point of view of the spectator. Like Dunbeath, the animals have four legs visible, but with archaizing 'ball and claw' feet, and have wide-open jaws. The bowed pin-head is regarded as an innovation, as is the position of buffers on the hoop to prevent the pin from sliding down. The use of settings of red glass has been attributed to possible imitation of garnet inlays. The brooch was studied with characteristic thoroughness by Stevenson. He demonstrated that it has many imperfections in execution, but his analysis, using his favoured methodology of establishing a degenerating series, put it at the head of the development of the brooch-pin. Stevenson accepted the 'peculiar position' of the Westness brooch but one would hesitate to promote a claim for its Pictishness on that score alone. However, in a recent review of filigree animal ornament from Ireland and Scotland, Niamh Whitfield, the acknowledged expert in Insular filigree, while recognizing some similarities with 'Tara' and Hunterston, points out significant differences. In general she finds closer analogues 'in feel' on a bowl from the St Ninian's Isle treasure [158], the Monymusk reliquary [167] (both to be discussed later) and on the cross-face of the Aberlemno churchyard symbol-bearing slab [36].[74] This assessment, taken with the expressive naturalism of the wolf's head and the idiosyncrasies mentioned above might support the view that the Westness brooch-pin was, like Dunbeath, the production of a peripheral workshop, peripheral that is to the centres that produced 'Tara' and Hunterston, and showing discernible, independent traits reflecting the artistic taste of the Picts.

149 *Brooch-pin, Westness, Rousay, Orkney. Silver, gilt, amber, glass*

Ceremonial Silver Tableware

In addition to their twelve penannular brooches the owners of the valuable possessions hidden on St Ninian's Isle had an interesting collection of eight silver bowls, which from their similar size, around 14 centimetres in diameter at the rim, can be regarded as a set in use, if not in manufacture. A similar set of ten slightly larger silver bowls was included among the grave-goods in the 7th-century ship-burial at Sutton Hoo. The Sutton Hoo bowls are decorated on the inside with cruciform motifs. They originated in the eastern Mediterranean. It has been suggested that one of the St Ninian's Isle bowls (Wilson's No. 1) could also have been a Mediterranean import as, like the Sutton Hoo bowls, it lacks the recession in the base that gives all the others much greater stability in use.[75]

The bases of the bowls Nos 2–6 [150–155], are decorated with a seemingly consciously varied selection of cruciform patterns all of which would go unremarked on Insular cross-marked stones in incision or relief. Not surprisingly they are all equal-armed crosses within a circular frame. One is a hexafoil with sub-triangular forms in the interstices (bowl No. 3). Others are based on a division of the circle into four quadrants (bowls Nos 2, 4 and 5) or segments of a saltire (bowl No. 6). The four fields are filled either with interlace or simple straight-line spirals. The spiral whorl design (bowl No. 7) is also paralleled in the circular panels at the centre of sculptured crosses. The design that spreads over the whole of the exterior of bowl No. 1 is multi-cruciform [156]. A framework made up of interlinked circles produces a series of cruciform shapes, their presence indicated by 'coded' punched dots. Triplets of dots lie on the arms of a central Maltese cross. Groups of five decorate a four-petal cross and groups of four belong to a larger Maltese cross with a loop at the outer edges forming circular 'studs' also marked with groups of five dots which lie away from, but in symmetrical relation to, the four-petal cross carrying the same code. The innermost Maltese cross has a circular frame arranged so that it links the larger circles together, circles which in turn produce a quatrefoil. This ingenious design recalls the page with Pentateuch texts in the Northumbrian Bible, the *Codex Amiatinus*.[76] The parallel is not exact but it may be another indication of Mediterranean influence, for the design in

156 *Multiple cruciform design on spherical silver bowl, St Ninian's Isle, Shetland, No. 1*

150–155 *Designs on bases of six silver bowls, St Ninian's Isle, Shetland*

the book is itself based on Italian *opus sectile*. The execution of the design on bowl No. 1 falls short of the quality of the design, but this essay in laying out patterns over bossed forms belongs naturally, as we shall see, with the ambition displayed in the rest of the hoard, and on Pictish sculpture in eastern Scotland. The simple geometric treatment of bowls Nos 4 to 6 look like early attempts to gain experience in the punched technique. The advantage of dividing the surface into bands, is visually successful when the bowls are seen from the side, shelved perhaps, when not in use.[77] Bowl No. 1, in contrast, looks much less effective in profile. It has to be everted to be appreciated [156]. The choice of pattern in these 'geometric' bowls is varied in a way that is typical of Pictish sculpture. We can compare, for example, the juxtaposition of incised interlace with broad-band interlace on a fragment most probably of an altar slab at Rosemarkie [310] with the design on bowls Nos 4 [157] and 7.

The arched, petal-like, forms on bowl No. 5, contrasting with the heavy step-pattern used nearer the rim, are interesting because of their rare appearance in Pictish sculpture.[78] Either they echo the shape of the central field of the sword-pommel in the

treasure, or they are an imitation of fluting such as might be known from Late Antique silver. In general, however, nothing mentioned so far is out of place in Insular art and this is certainly true of the animal ornament on bowls Nos 2 and 3 [158, 159].[79]

The geometric designs described above are made up of lines of punched dots. Bowl No. 1 alone has the design first incised on the bowl, then flanked by dots. This is an unparalleled trait but rather than being a cultural marker it may simply be the result of first using a guideline to achieve the complicated layout and then, to achieve emphasis, enhancing it with double-contour punching in the manner of the Aldclune brooch [144]. The punched work, *pointillé*, becomes a major artistic device in bowls Nos 2 and 3. It would have been possible to 'draw' the animal motifs with punched lines, but instead, the background is stippled and the animals left plain giving an illusion of low relief. On bowl No. 2, four quadrupeds process, or rather gallop, round the bowl. They have well-rounded hind- and forequarters, a tubular high-groined body, ear-less heads and toothless duck-like jaws. Each is a single motif but extended tails and tongues give the impression of a continuous frieze. Animals with or without coiled hindquarters

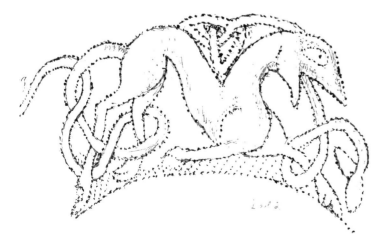

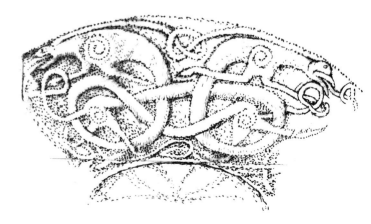

158, 159 *Animal ornament on bowls Nos 2 and 3, St Ninian's Isle, Shetland*

alternate. One animal with coiled hindquarters knots its neck round its own foreleg. Another has a lappet arranged more or less as a triquetra. One has a tail ending in a trefoil; another has a leafy shoot at the end of its tongue. The whole effect is lively and inventive. The single motifs, in their vigour, bear clear resemblance to the animal with four legs at full stretch on the terminal of the Dunbeath fragment [137].

The ornament of bowl No. 3 is more ambitious. The observation that the simple geometric ornament immediately under the rim is of Mediterranean origin – present in, for example, the Cambridge Corpus 'St Augustine's Gospels', an Italian manuscript which came to England at the time of the conversion – was considered a little far fetched by Wilson.[80] But the accurate transmission of even such a simple decorative motif is not impossible if the Insular synthesis is accepted as a reality, and it has already been noted that bowl No. 1 may betray knowledge of geometric designs, ultimately Mediterranean, but present in Northumbria. The cross of arcs on the base of bowl No. 3 is given the same stippled background as the animals on its sides, instead of the simple linear work used on the other bases, the kind of matching detail that reinforces the view that bowl No. 3 is more sophisticated in design than bowl No. 2.

On bowl No. 3, the animals are linked together either by interlacing, or conjoined extremities, or by the looping together of their bodies [159]. Both tails and tongues have leafy terminations. This particular feature is found in the teeming menagerie of the Book of Kells, and the general swing of the linked animal bodies is paralleled closely in the border to the Virgin and Child miniature in that manuscript.[81] Such a similarity testifies to the general participation of Pictish artists in motif development within the Insular art style, although the number of links with the art of the Book of Kells in Pictish sculpture makes the connection something characteristically Pictish within the style. The animal frieze on bowl No. 3 is made up of pairs of animals of two configurations, one having rolled hindquarters and the other having hindquarters far removed from its looped forequarters. The significance of this feature for the art of the treasure will be returned to later.

The elaboration of bowl No. 6 [160], which is otherwise geometric, is concentrated on the addition of an elaborate internal mount. Evidently, it was a bowl to be looked into. Recent opinion accepts the mount as of local manufacture, on the grounds that 'its technical and artistic construction is in keeping with that of other items in the hoard'.[82] The external upper zone of the bowl is decorated with a punched triangular pattern. The mount is triangular also but its heavy frame has convex sides. At each corner is a modelled undifferentiated human head. The edge holds firm two plates, one plain, the other a gilt mount divided into three fields by spines attaching the heads to the points of the centrally placed triangular field filled with red enamel. This device recalls the way that the modelled birds on the Rogart brooch [138] relate to the circular field on its terminals, seen in a reductive

form on St Ninian's Isle brooch No. 23. One of the interlace fields in the internal mount is zoomorphic, with minute heads, here with open jaws, typical of the repertoire of the treasure. The inclusion of small human heads at points in the design is typical of Insular brooch art. Three heads, within a precious bowl, set in train thoughts of a liturgical vessel with imagery of the Trinity, although this would be unprecedented iconography. The three heads revealed to the drinker may simply convey corporate conviviality, or more respectfully, bring to mind a group of ancestors.

The eighth bowl may not be part of the set [161]. Like the rest it is made of silver but it is a hanging-bowl with the three ring attachments represented as boars seen in plan. Their heads peer over the rim to hold the suspension rings. The bowl has a rim profile of the type that includes two other heavily zoomorphic bowls, the Lullingstone bowl, and the lost Witham bowl, the latter made of silver.[83]

When the St Ninian's Isle treasure was being prepared for publication in 1973 it was not known for certain whether hanging-bowls were produced in the Pictish area. This was a possibility, which 'for the moment' had to be set aside. As we have seen, such evidence is now available. The St Ninian's Isle bowl is rather grander than the evidence in mainland Pictland allows, but the artefact as such was in production at a geographically mid-point in Pictland suited to contacts with both the north and south.

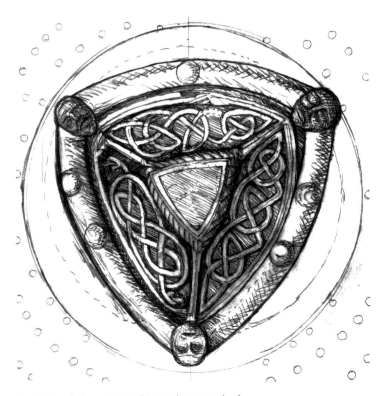

160 *Silver, gilt, bronze, enamel, internal mount on bowl No. 6, St Ninian's Isle, Shetland*

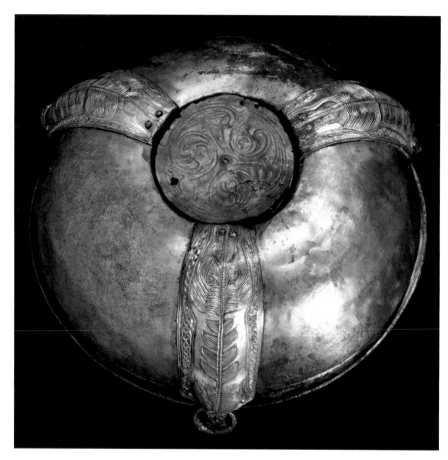

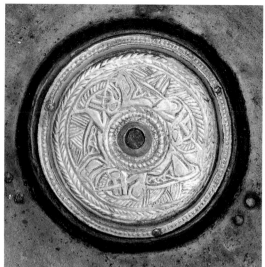

162 *Interior view of hanging-bowl, St Ninian's Isle, Shetland*

161 *Exterior view of hanging-bowl, St Ninian's Isle, Shetland. Silver*

The external mount attached to the base of the hanging-bowl is of silver foil stamped with trumpet spirals which can be compared in a general way with the design on the lead disc from Birsay [133], although it is superior work. It could certainly be of local manufacture. The internal mount comprises a procession of three animals round a central field [162]. Their bodies are angular, but their necks roll round to bite their own forelegs with their long jaws. The bodies are filled with 'basket' hatching and their haunches and shoulders are pear-shaped. The general impression is of Germanic animals such as one sees in the Book of Durrow on *f.* 192v [9], although they lack fringed feet and their interlaced tails are anomalous.[84] An archaic looking motif of interlocked animals with necks rolled round to engage with stick-like limbs and jaws is carved as a discrete motif to the top right of the cross-shaft on the slab in Aberlemno churchyard [36, 37]. The motif has been compared to a similar ribbon-bodied animal with a sling beak and a pear-shaped haunch on a relief panel at Wearmouth dated to the late 7th or early 8th century.[85] The feet of the Wearmouth animal have not survived but the Aberlemno creatures have archaizing 'ball and claw' feet. Two, single, rolled-neck animals, biting their own hind legs and with their tails forming interlace, are carved between crescent symbols on the Rosemarkie cross-slab [81]. Archaic animals lie behind the Aberlemno and Wearmouth creatures but the compact crouching angularity of the animals in procession on the St Ninian's Isle mount seems older again. Certainly the hunched back-line of the beast biting its own foreleg

on the tip of the gold buckle from Sutton Hoo [2] dating early in the 7th century is a close parallel. Such an animal is most likely to have entered the motif repertoire of the Aberlemno sculptor ultimately via Northumbria but it is perfectly possible that it had already been assimilated by Pictish metalworkers.[86]

The boar attachment 'ribs' are unique. They have been compared to the four very stylized lions that rise up the sides of the boss from Steeple Bumpstead, Essex, a decorative fitting of great technical complexity thought to have been made in Ireland in the first half of the 8th century.[87] The lions are applied to a dome, on to which they crouch, seen from above, with their forelegs stretched out and their tails lying along their backs. Their manes are arranged in stylized hanks along their spines. In many ways, however, this is an unsatisfactory parallel. The hanging-bowl boars have naturalistic body contours and elegant, naturalistically conceived, limbs and trotters readily paralleled in Pictish representations of boars [26]. The scrolls defining the juncture of the limbs with the body are not those of the Pictish animal designs but the hip scrolls take the form of leaf-shapes familiar in many Pictish symbols. Animals seen from above are common in Pictish sculpture [105, 276]. The arrangement of what is probably a wolf on St Vigean's No. 1, with all its limbs stretched out and its tail extended is a much closer parallel to the boars than are the limbs on the Irish boss. The arranging of crest hair and manes in hanks is also common. There is no difficulty in accepting these St Ninian's Isle boars as part of Pictish naturalistic

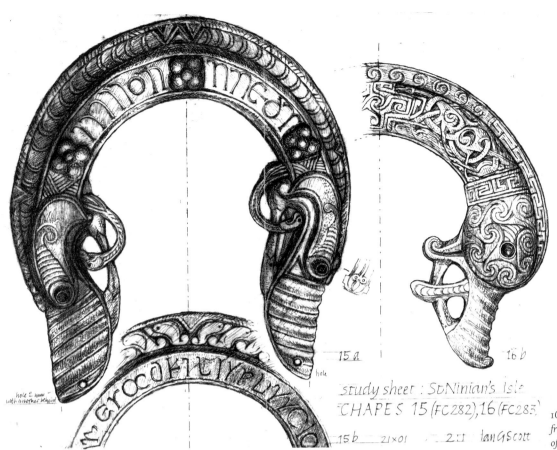

study sheet : St Ninian's Isle
CHAPES 15 (FC282), 16 (FC285)

15b 21×01 2:1 Ian G Scott

163 Chapes, St Ninian's Isle: No. 15, front and detail of back; No. 16 detail of the front. Silver-gilt

animal art, and a case can be made for the bowl being either of native workmanship, or, on the strength of the animal style of the inner mount, a Northumbrian import, itself made under the influence of the rich range of animal art north of the Forth.

Silver Fittings for Parade Weaponry

It has recently been suggested that three other objects in the hoard, the two chapes [163] and the sword-pommel [164] show such strong Anglo-Saxon influence that they too might be imports.[88] The argument is based on similarities with the animal art of a group of unconnected pieces found in southern England, most notably a finger ring found in the Thames at Chelsea, a key-handle from Gloucester and a sword-pommel from Windsor.[89] Parallels with Southumbrian metalwork were noted and fully discussed by Wilson. He concluded that the resemblances were specious, and that a common source must account for them, there being too many differences in detail.[90] There is no doubt that the 'shovel-shaped snouts, lobed jaws and trumpet-scrolled eyes' which characterize the animal art on these south English objects appear also on the chapes and pommel. One must also agree that 'spiral convolution' of hindquarters is not a trait restricted to animal ornament in Pictland.[91] On the other hand, such arguments ignore the decorative cohesion of the treasure where the blunt-nosed animal type is found not only on the chapes and

pommel but on brooches Nos 17 and 20 and the internal mount of bowl No. 6.[92] On the matter of head-types the juxtaposition of blunt-nosed beasts and minute frontal heads of the mask type, found on a number of the brooches, suggest that the maker of the pommel, who also uses both, was party to the brooch repertoire. Nor can the convolution of the hindquarters of the beasts on the pommel be compared simply with this feature in the art of the 'Tara' brooch, the Lindisfarne Gospels, or indeed the Aberlemno cross-slab [36]. The exploitation of this particular animal device, which brings with it ever greater separation of forequarters and hindquarters, finds its counterpart in the zoomorphs on the cross-head of the Nigg slab [41] and the corner-slabs of the St Andrews Sarcophagus [42]. This exaggerated form is integral to the treasure, occurring on the uninscribed chape, the pommel, conical mount No. 12 [165, 166], and bowls Nos 2 and 3. It is a hallmark of the Shetland workshop.[93] That Pictish art indeed had a connection with Southumbria, particularly Mercia, is well known, and the recent find of animal art at Hilton of Cadboll, near Nigg, reinforces the connection. On the now disinterred lower portion of the Hilton slab [43] there are what could be described as extracts from the art of the Gandersheim casket [44], if one chose to express the relationship that way. Rather, what is demonstrable, is not evidence for the importation, or copying, or even just a 'facility in adaptation' of some other region's art. Such a rich corpus of distinctive decorative animal art should be thought of as finally *sui generis*, a Pictish expression of a particular stage in Insular art.

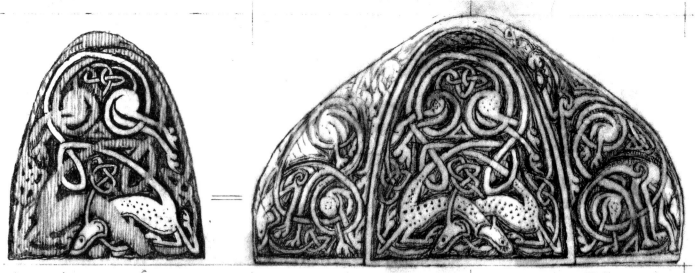

164 *Analytical drawing of central panel and front view of pommel, St Ninian's Isle, Shetland, No. 11. Silver-gilt*

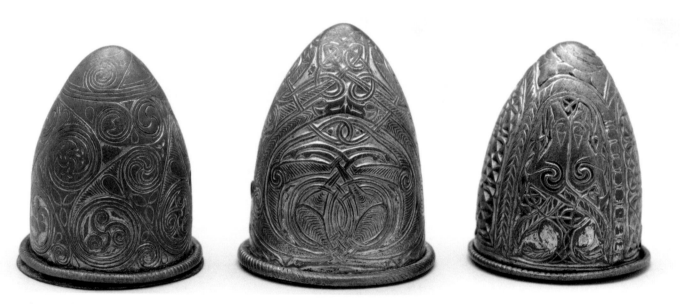

165 *Conical mounts from St Ninian's Isle, Shetland, Nos 14, 12, 13. Silver-gilt*

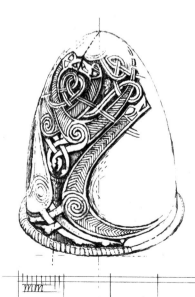

166 *Analytical drawing of animal ornament on conical mount, St Ninian's Isle, Shetland, No. 12*

House-shaped Reliquaries

In characterizing Pictish metalwork the use of the technique of *pointillé* is regarded as an identifiable preference. Dotting as a decorative device is present in Insular manuscript art from the earliest period. It is used a great deal by the artist of the Lindisfarne Gospels. Dotted interlace between the letters which open the Gospel of St Mark produces loops of rounded forms very similar to the interlace patterns on the St Ninian's Isle bowls. Between the stems of the decorated letters are two interlocking quadrupeds, drawn in dotted lines, one of which has its neck knotted round its foreleg, a position closely paralleled in one of the animals in bowl No. 2. As a means of texturing a surface *pointillé* has an obvious role in metalwork. It certainly cannot be claimed as an indicator in itself of Pictish manufacture.[94] Nevertheless, one reason why the miniature house-shaped box known as the Monymusk reliquary [167] stands apart from the Irish shrines of this type is the use of *pointillé* on the silver plates which clad the wooden core, to express a background for zoomorphic ornament comparable to that on bowls Nos 2 and 3 in the St Ninian's Isle treasure [158, 159].[95] The lightly dotted animals on the shrine are very worn, presumably as a result of its being handled through the centuries. Nonetheless a few characteristics can be discerned.[96] All the animals are of the familiar long-bodied type, entangled in interlace made up of head-crests and tails. Some look backwards, others face forwards. A row of four, paired rump to rump, at the bottom of the back-plate have rolled necks. There is no clear example of the 'rolled haunch' device. Like the animals on the bowls, the feet are merely indicated, the limbs tapering to an elegant point. On the roof ridge the sub-circular finials are decorated with long-billed birds' heads whose bodies dissolve into interlace, which terminates in a claw. This is an exact parallel with the motifs on the hoop of the Westness brooch-pin discussed earlier [149], one which helps to secure that brooch for the Pictish corpus of metalwork.

The more recent attribution of two other house-shaped reliquaries to Pictish workshops has not been wholeheartedly endorsed. The stronger case is that for an unusually massive example, now in the Museo Civico Medievale, Bologna [320].[97] It shares with the Monymusk reliquary a notable commitment to animal ornament. On the back, between the pair of circular mounts is a motif of confronted animals with rolled haunches. They have short 'weak' forearms markedly similar to the animals on bowl No. 3 from St Ninian's Isle. Their tails and head-crest interlace into triquetra shapes, an arrangement paralleled on bowl No. 2, and in a reduced form on the Dunbeath brooch-terminal [137]. The selection of this type of animal, particularly in such a sinuous form, supports a connection with the Monymusk designs. The coincidence in cross design between that on the base of bowl No. 5 from St Ninian's Isle and the cross on the back of the house-shrine shape at the centre of the Bologna roof ridge is unlikely to be significant. More telling is the prominence given to

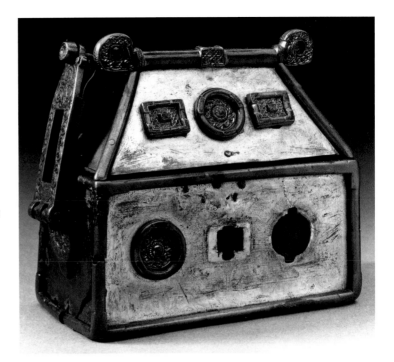

167 *The Monymusk reliquary. Silver, enamel, bronze, wood*

animals in the design of the roof-ridge and of the carrying-hinge. The dragon on the latter is unique among the shrines but the neatly packaged creatures on the finials with a small animal under its body has parallels in single animals on the Aberlemno churchyard slab, to the right of the upper arm [36], and on the Dunfallandy slab, at the bottom right of the cross-face [49]. These are not direct parallels but the Pictish designs with their interlocked limbs and 'ball and claw' feet have a background in metalwork. The motif of a small animal within the framework of the body of a larger one is a device found on Pictish sculpture at Nigg, St Andrews and Meigle. There is a similar arrangement on the circular back-plate from Donore, County Meath, a circumstance that yet again demonstrates the degree of interdependence in the art of this period.[98] The heaviness of the rectangular mouldings for the settings on the front of the Bologna shrine provides a very adequate model for the rectangular mouldings in high relief on the cross-head of the Aberlemno roadside slab [218]. Much of the decoration on that slab and on the great Meigle No. 2 slab [199] is skeuomorphic, inspired by lost metalwork.[99]

A shrine now in Copenhagen shares with the Bologna Shrine the decoration of the back with an all-over pattern of incised ribbon interlace which forms a bed for three similarly disposed circular mounts.[100] The front of the Copenhagen Shrine has an abstract design of gridded 'T' and 'L' shapes. Such sunken geometric forms were part of Pictish taste, seen, for example, on one of the corner-slabs of the St Andrews Sarcophagus and on stepped cross-shapes at Rosemarkie and Tarbat [168]. Although the Copenhagen shrine stands apart from the other shrines in

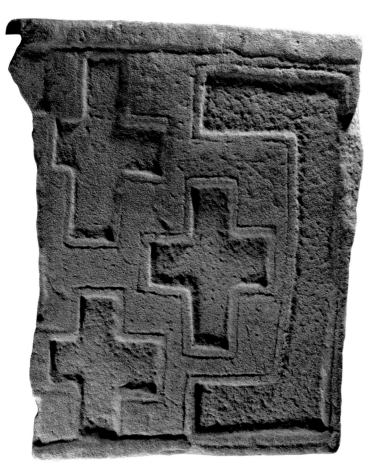

168 *Carved fragment with recessed crosses,*
Tarbat, Ross & Cromarty. Sandstone

having no animal ornament, a rare deficit for a Pictish object, the possibility remains that both it and the Bologna Shrine were made somewhere in Scotland, the possibilities being further extended by the fact that technical analysis reveals that distinct workshop practices can be detected in their methods of construction.

The portability of metalwork does not allow overemphasis on geographical location as a guide to origin, although it would be expected that a hoard would be hidden in a location familiar to the owner and convenient for retrieval. The movement of house-shaped shrines would be of a different character. Initially closely guarded by those who had commissioned them, unanticipated changes of circumstances would lead to their destruction or movement to safe havens further afield. Nonetheless the fact that the Monymusk shrine and a fair proportion of Pictish metalwork, has a provenance, if not a certain origin, north of the Grampian mountains is of significance. These artefacts are not in the Perthshire corridor, so are less likely to be acquired Irish artefacts. They are also in regions not so celebrated for elaborate sculpture, and help to redress the cultural imbalance between north and south of the Grampian mountains. It is true that the metalwork was found in what are now regarded as remote parts of the country. Unfortunately this very remoteness seems to have mitigated against its survival once found.

Miscellaneous Isolated Finds

The most substantial of finds without context, other than brooches, are the mounts sold in Crieff, Perthshire, in the 19th century [169, 170]. The cultural richness of Perthshire could well have supported commissions for these highly designed mounts with their voluted contours, use of rare rock crystal, and on the larger of the two, confidently expressed iconography of a serene head set between birds. The contours of the mounts bear comparison with the novel voluted outlines of the free-standing cross at Dupplin, Perthshire [196, 278], and in metalwork this 'architecture' has been compared to a recent find in Cumberland, a metalwork plaque which was made in 'an Anglo-Saxon cultural milieu albeit with strong Irish influence'. That these Perthshire mounts were originally part of a precious item of church metalwork is surely correct, even though, as has been suggested, they may have been reused for saddlery.[101] The mount with the head between birds has been compared with a silver-gilt brooch fragment from a grave at Skjeggenes, Nordland, Norway, which displays prominently a similar clean-shaven head between birds. The Norwegian fragment has been identified as a composite pin-head of a pseudo-penannular brooch comparable to that on the Westness brooch-pin discussed earlier [149]. The fragment has a surviving inset of a stone identified most probably as garnet. The Westness brooch-pin as we have seen has insets of red glass, a rarity, explained as imitative of Anglo-Saxon garnet jewelry. The Kilmainham, County Dublin, penannular brooch [171] described in the '*Work of Angels*' catalogue as 'probably Irish', also has settings of red glass. Because of its penannular form, cartouche on the hoop, diminutive cusps and lobed terminals the Kilmainham brooch has been said to be 'clearly heavily influenced by contemporary fashions in Pictland'. These chains of connections hint, albeit indirectly, at Pictish participation in Insular metalwork and certainly do not justify the Crieff mounts being moved into the corpus of Irish metalwork, or even into that cultural catch-all, the 'Irish style', a no doubt useful and defensible label, but one which does nothing for the perception and identification of Pictish productions.[102]

In reviewing the small corpus of potentially Pictish metalwork due weight has to be given to isolated finds, however small. The fragment of a gilt-bronze mount embossed with a fierce, bounding lion whose curved teeth faintly echo the Donore lion's head door handle, a masterpiece of Irish metalwork, was found in the same Viking grave as the Westness brooch. This battered fragment is all that remains of some precious item of church metalwork.[103] A pin with a neatly carved human head from Golspie, Sutherland [172], is all that survives in metalworking to match the abundant sculpture of this district, as is the unique bone pin with amber settings from Courthill, Rosemarkie [173], described by Stevenson as 'a minor masterpiece'.[104] Into this category also comes the fragment of a small enamelled disc replete with decoration from Aberdour in Fife [174]. Here a central

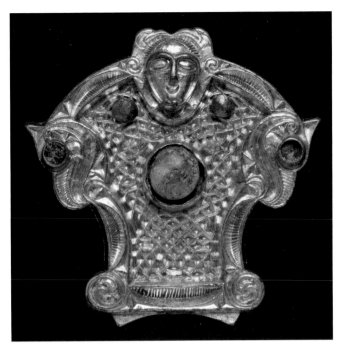

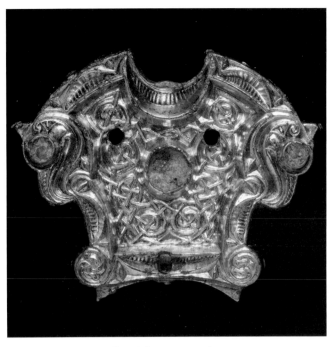

169 *Larger mount, Crieff, Perthshire. Bronze, gilt, rock crystal, glass*

170 *Smaller mount, Crieff, Perthshire. Bronze, gilt*

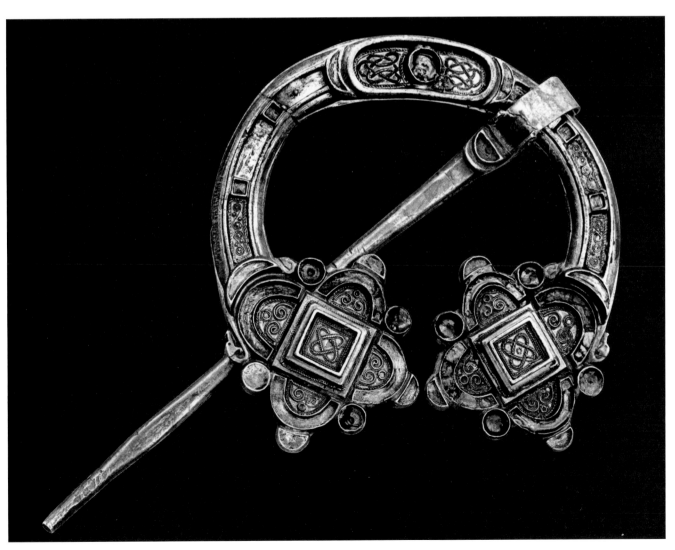

171 *Penannular brooch, Kilmainham, County Dublin. Silver, gold, glass*

zone contains a Greek hollow-armpit cross, with silver wire insets creating a snaky effect. Its outer zone was divided presumably into four compartments. The two surviving frame a quadruped with convoluted hindquarters, and ribbon interlace of a type recently identified in metalwork.[105] All that survives of the fine metalwork of early medieval St Andrews is an enamelled stud probably part of a harness fitting [174]. A similar stud was found in Freswick, Caithness [174], from where the miniature brooch with the beast-head terminals also comes.[106] Across the Forth estuary at Cramond, not far from the find-spot of the gold and garnet pyramid from Dalmeny, West Lothian [174], a circular mount [174], a chance find in the churchyard, is decorated with a Greek cross made up of rectangles of millefiori.[107] These finds on the borders of the Pictish area show a surprising range of techniques and design extending the possibilities for assimilation during the 8th century. The current excavations at Tarbat have produced substantial traces of an 8th-century monastery with evidence in the form of crucibles, of a fine metalworking area. The hard-won

finds include a single stud suitable for the decoration of a liturgical vessel and a fragment of sheet bronze embossed with what appears to be part of a wing.[108]

Returning to Fife, the excavations at Clatchard Craig so rich in moulds, produced the ingot of silver mentioned earlier, probably belonging to the period when brooches were being made. The one surviving component of fine metalworking at Clatchard Craig is a tiny disc, about 22 millimetres in diameter which is decorated with pelta designs, probably enamelled, which although smaller in scale, has been compared to designs on the hanging-bowl escutcheons of the later 6th to the mid-7th century. It could, however, have decorated other precious objects, either secular or ecclesiastic, of a later date.[109]

The Role of Pictish Metalworkers and the Dispersal of their Productions

Such tantalizing *disjecta membra*, interesting as they are, throw the assessment of Pictish fine metalworking back on the evidence of the St Ninian's Isle treasure and the Pictish-type penannulars and even there, as major new discoveries are made, the claim to ethnic exclusivity is hard to sustain. Arguments to this end may help to sharpen observation and can provide a framework for discussion, but the accumulation of small degrees of difference and similarity necessary for rigorous scholarly study, can dissipate recognition of the nature of Insular metalwork. It is salutary to conclude a review of Insular penannulars with contemplation of that most beautiful Irish brooch from Loughan, County Derry [5, 175]. It is made entirely of gold and in the words of a master in the field of Irish art it 'is a work of great delicacy and refinement'.[110] It is penannular and gives its motifs the benefit of being set in a fine *pointillé* background remarkable for its evenness. Its animal motifs have a supple grace and ambiguity of anatomy that is characteristic of many animal studies in low relief in Pictish sculpture. Another Irish expert has declared that it was produced 'under heavy Pictish influence'.[111] If that is so it would be appropriate to accept this view as meaning something more than a mere itemizing of preferred Pictish forms, techniques and repertoires. If Pictish metalworkers had indeed any influence in the production of such a work of art as the Loughan brooch, then it is much to their credit and sufficient in itself as witness to the uniquely beneficial interplay of traditions that characterize Insular art.

The fundamental question here is whether for metalwork the term 'Irish style', so ubiquitous in the *'Work of Angels'* exhibition catalogue is a more accurate description than the umbrella term 'Insular'. For one writer Insular ornament is defined as 'the product of an area of Irish cultural influence extending far beyond Ireland'.[112] Such a view is accurate and historically defensible but as we have seen it removes the possibility of defining the native cultural component in Pictland, and indeed in Wales, represented by response, participation and invention. Ireland does not have

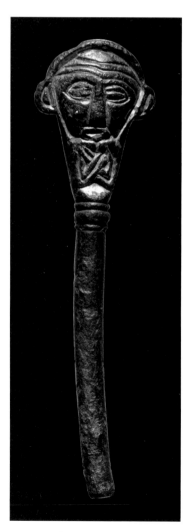

172 *Pin, Golspie, Sutherland. Bronze-gilt*

173 *Pin, Rosemarkie, Ross & Cromarty. Bone, amber*

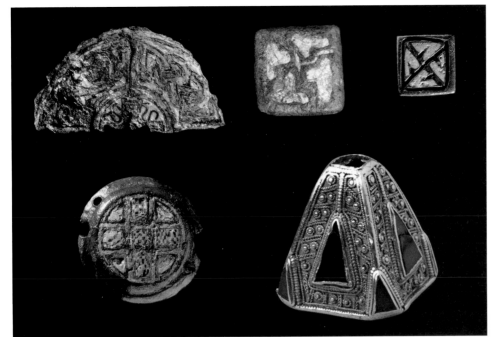

174 Top left *Fragment of disc, Aberdour, Fife. Bronze, enamel, silver wire, millefiori*; top centre *Stud, St Andrews, Fife. Copper, enamel*; top right *Stud, Freswick Links, Caithness. Copper, enamel*; bottom left *Circular mount, Cramond, Midlothian. Bronze, enamel, millefiori*; bottom right *Pyramidal mount, Dalmeny, West Lothian. Gold, garnet* [not to scale]

'identity problems' in respect of metalwork but the Picts do, and in a theoretical desire to be objective, glimmerings of Pictishness, manifest in the sculpture, and detectable in metalwork, should not be dazzled out of existence by the superlative, surviving, Irish productions. Clearly the new finds at Dunadd bring a new understanding of the way that the production of Irish and English metalwork were present on one site and could spark off the Insular synthesis, but it is surely correct that the fact that the Pictish type of brooch existed in embryo in Dunadd in the 7th century need not invalidate the labelling as 'Pictish' the developed and elaborate forms made in Pictish workshops in the 8th century. That 'Pictish-Irish' hybrid versions were produced, is, as has been said, to be expected. While the realities behind their production are largely undefined, one would not want to lose the specificity of this label, with its acknowledgment of a Pictish involvement, in a desire to avoid unfashionable ethnic terminology. In spite of portability, the operation of gift exchange, and the possibility of itinerant craftsmanship, a degree of technical and artistic distinctiveness attributable to a particular workshop and centre of patronage must betray ethnic, or if one prefers, regional propensities in a medium so charged with personal and institutional significance.[113]

The complexities of the ethnic mix can be no better displayed than in the relationships between Insular and Scandinavian metalwork, and in particular in the interaction between imports and manufacture of brooches. The connections of the Birsay mould No. 300 is a case in point. The mould is for the smallest of the Birsay brooches but as Mrs Curle pointed out, the better preserved terminal provides an exact parallel for the heads of the terminals of the uninscribed chape in the St Ninian's Isle treasure, with their wide-open jaws and long teeth transfixing the protruding tongue. As we have seen it is a head-type used on the

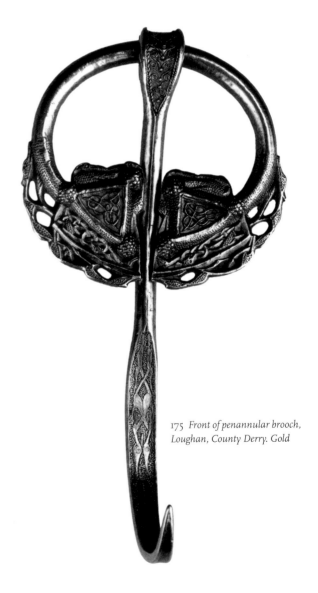

175 *Front of penannular brooch, Loughan, County Derry. Gold*

small penannular from Freswick, Caithness [136], and it appears again in bronze in four Norwegian copies. Most remarkable of all it forms the juncture between the hoop and terminal on a penannular brooch from Hatteberg which has both Norwegian and Irish features.[114]

There must be a possibility that some of the Insular artefacts in Scandinavian graves come from Pictland. Even Stevenson who was free of any hint of Pictomania, allowed the possibility that the richly decorated harness mounts from Gausel, Norway, could have been Pictish.[115] Wilson, immersed as he was in the St Ninian's Isle material and a master of the Scandinavian scene was markedly ready to look for Pictish traits in pieces which under the influence of Scandinavian scholars, were attributed if not to the Irish, to the Northumbrians.

The recent publication of an example of an attractive artefact, the decorated bucket from Skei, now in Trondheim Museum [176], has brought to mind Wilson's floating of the view that the famous bucket from the great 'chieftain centre' of Birka in Uppland, Sweden might be Pictish.[116] The Swedish bucket has more recently been firmly claimed for Northumbria, another part of the Insular world which has a deficit of fine metalwork. Here the attribution is based, broadly, on the presence of inhabited vinescroll, almost as important to the Northumbrian artistic identity as the symbols are to the Picts.[117] The Hexham bucket, cited as a comparable bucket in the north of England, is different in shape, and very different in repertoire with its handle attachments in the form of two naked

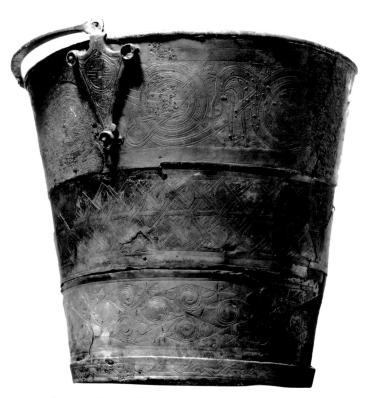

176 *Bucket, Skei, Steinkjer, Nord-Trøndelag, Norway. Bronze, wood*

female figurines cast in explicit relief.[118] There is a series of comparable buckets in Irish contexts. The bucket from Clonard, County Meath is particularly handsome in general effect, with its open-work bands of ornament. The possibly Pictish origin of the Birka bucket was not discounted in the discussion of this Irish bucket in the catalogue of the *'Work of Angels'* exhibition.[119] Such open-mindedness acts as a spur to consider the case for a Pictish origin for the newly published bucket from Skei, Norway.[120]

First it must be said that the Picts have a lively and innovative range of vinescroll on their sculpture [61–64]. This exotic theme, without doubt, came to the Picts from Northumbria, but once introduced into the repertoire it was fully assimilated.[121] This is true also of the inhabited vinescrolls in the Book of Kells, which abound, in miniaturized, easily overlooked versions used as border ornament. The presence of inhabited vinescroll in itself cannot establish the origin of an artefact. The round-bodied, beaky birds in tightly organized vinescrolls have their closest parallels in the Book of Kells and in the embossed fragment from Monker Green, Stromness, Orkney [177].[122] The more attenuated, elegant birds on the Skei bucket are closer to those Ross & Cromarty vinescrolls which combine animals and birds in a finely delineated linear style. Graham-Campbell rightly remarks on a detail of the Skei design where there is 'a particular elegance to the line of the single elongated bird's leg as it interweaves with the spiral which terminates the plant-scroll'.[123] A very close parallel in this respect is the top of the complex trelliswork vinescroll on the left border of the back of the Hilton of Cadboll cross-slab [187] where the bird's offside leg intertwines with two scrolls and a jutting shoot. The animals on the Norwegian bucket have not the sinuousness of the Pictish creatures but their 'S'-shaped bodies with arching hindquarters and open jaws with lolling tongues belong with the style of the remarkable animal ornament on the recently recovered portion of the cross-face of the Hilton slab [43, 273]. Even the comparative rigidity of the hindquarters is paralleled, although this is more marked on the bucket. The decoration of the central and lowest zone consists of diagonal fret and trumpet scroll both well represented in Ross & Cromarty. Of relevance also is the fragment of bronze sheeting with engraved ornament showing the hindquarters of two animals set on a background of oblique hatching from Machrins, Colonsay [178]. Of great interest is its relationship with a cast bronze boss apparently riveted through the decoration. The boss as recovered, cuts through the decoration but it appears that boss and sheet came originally from the same object, most probably part of a pail-binding and handle fitment. The form of the ornament has obvious parallels in the St Ninian's Isle treasure, for example, the conical mount No. 12 [165, centre]. The excavator, Graham Ritchie, assembled all the links with the then-known Insular bronze pails.[124]

A fragment of a decorative pail-binding has been identified among the rich store of artefacts found in the undocumented Anglo-Saxon site of Flixborough, South Humberside. It had been

177 *Fragment of mount, Stromness, Orkney. Bronze-gilt*

reused as a strap-end. The close similarities of its fine incised curvilinear ornament to the lowest zone or ornament on the Birka bucket has been convincingly demonstrated in its recent publication. The hatching of the meeting point of double spirals creates a distinctive 'twisted ribbon' effect in both designs. The pail from which it came is attributed to Northumbria or Ireland, the vinescroll on the Insular buckets that ended up in Scandinavia being regarded as a powerful argument for their Northumbrian origin. The existence of Pictish vinescroll is recognized, and the context of the piece is accepted as broadly 'Insular', a context 'defined by tradition, wealth and politics as much as by geography or ethnicity'.[125]

The consistent layout of the decoration of the buckets in zones recalls the decoration of the sides of the St Ninian's Isle bowls Nos 4, 5, and 6, but more particularly, that of a superlative Pictish object, conical mount No. 14 [*165, left*], one of the three domed mounts unique to the treasure. The complexity of the decoration of the mount has been described definitively by Wilson.[126] Although it is engraved with continuous interlocking spiral designs with varying centres, he shows how it is organized in three zones: the lowermost consists of tightly spun large spirals; the zone above, of alternating large and small spirals; and the uppermost row, of pairs of spirals. The top of the dome is decorated with simple spirals that run out of the main body of ornament. The ingenuity and variety of other aspects of the design is brought out in Wilson's detailed description. We are certainly in the same world as the decoration of the cross-face of the Nigg slab [*52*]. On the mount, hatching, such a feature of the spiral ornament of the Birka and Flixborough ornament, is used for the expansion of the trumpets of the spirals and for the interstices of the top row. In spite of the difference in materials and artefact type the quality of the engraving and the resources employed seem very close to the art of the buckets. Hatchings of various kinds permeate the St Ninian's Isle treasure. Compare, for example, the passage of hatching consisting of triangles of parallel lines set at right angles to each other on the front of chape No. 15 [*163*], with a

similar arrangement on the Flixborough fragment. (Hatching was, of course, a regular method of enhancing the curvilinear ornament used for the interior decoration of the Pictish crescent symbol.) Wilson's speculation that a bucket, such as the one from Birka, could have been made by Pictish craftsmen is sustainable and the ornament on the recently published pieces does nothing to weaken it.

A case for the expansion of the corpus of Pictish metalwork cannot be built on 'possibilities', however kindly meant. All the metalwork found in Pictland should be reassessed as a group, by an expert in the fine metalwork of this period, with the specific aim of testing the natural assumption that it belongs there. The first Insular manuscripts depended heavily for their decoration on metalwork styles. All agree that some Irish sculpture drew on, or even intended to replicate, precious metalwork. A relationship between Pictish slab sculpture and manuscript art is acknowledged. As we shall see in a later chapter it is Pictish sculpture that can give us the confidence to believe that it is possible to retrieve at least the appearance of some of the lost fine metalwork of Pictland. Intricacy was a significant component of the Pictish artistic genius. Evidence for the opportunities that fine metalwork afforded the Picts to display this talent is amply present in the St Ninian's Isle treasure and no doubt featured abundantly in the objects lost in the meltdown of the 19th and earlier centuries.

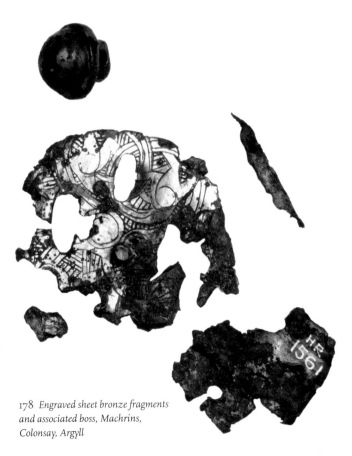

178 *Engraved sheet bronze fragments and associated boss, Machrins, Colonsay, Argyll*

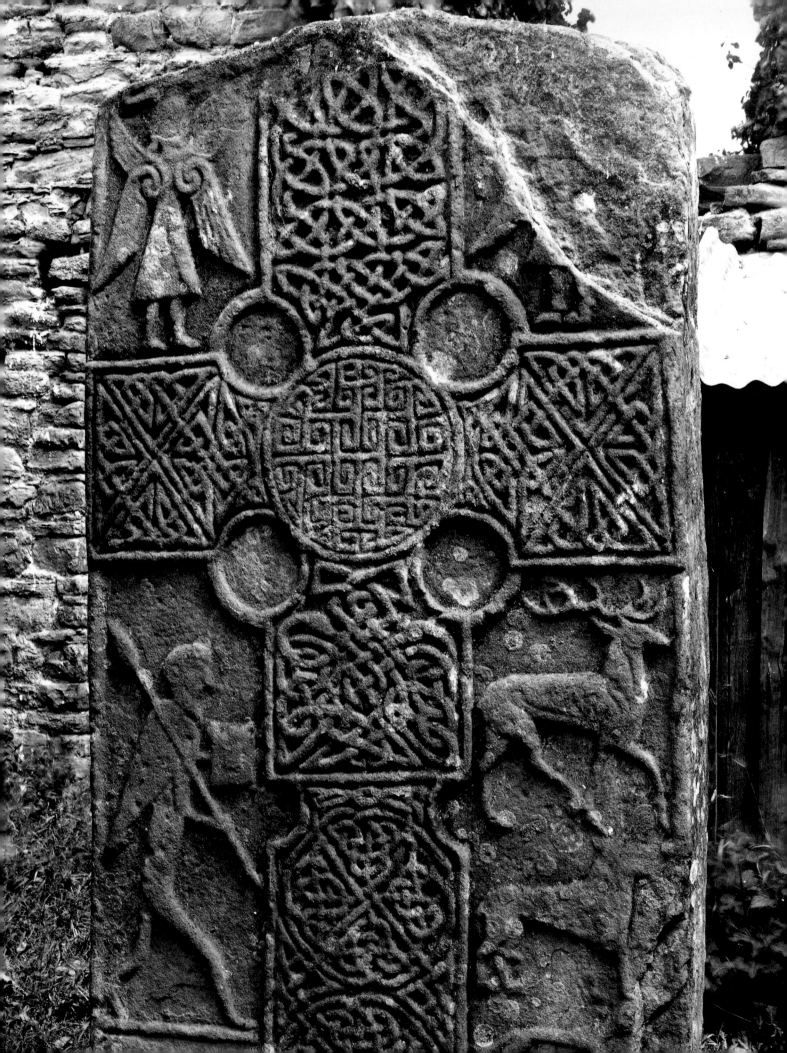

5
Pictish Figurative Art: Themes and Programmes

The Pictish symbol stones comprise a programme: a readily recognizable set of visual devices, ideograms, formal images, incised on large stone slabs from one end of the country to the other. The nature or function of the symbol programme is considered in the next chapter.[1] One of the hierarchy of images is more or less a human figure. He can evidently stand alone, sharing this autonomous validity with some of the incised animal symbols. His original significance, like theirs, is unknown, but just because he is a man, more or less, with attributes, he provides a starting point for discussion of the figurative art of the Picts and of the themes and programmes which they tackled.

A narrow kite-shaped boulder from Barflat, Rhynie, Aberdeenshire, is incised with the figure of a man, just over 1 metre high, in profile facing right – the direction faced by all the incised animal symbols [180]. He wears a belted tunic that reaches to just above his knees. His legs are shapely but his feet are narrow and flat, with a curved wedge shape at the end of the toes, and the lack of a division at the ankle suggests that he is wearing fairly stout leggings up to the thigh. His hands are represented gripping, quite tensely, the slender stem of an axe-hammer, which rests on his right shoulder. His head is out of proportion to his body and his rugged profile has the bold 'foreign' look of an Assyrian or Hittite. His grinning open mouth contains huge pointed teeth. His hair is smooth and deliberately shaped, like a wig or headdress, bald on the brow, trailing down the nape of the neck and shoulders and then cut off straight. Critics of the 'Celtic tonsure' seem to describe an arrangement of the hair much like this.[2] His bared teeth recall words of St Gregory, quoted by Bede near the start of Book II of the *Ecclesiastical History*, 'Behold the tongue of Britain, which knew only how to grind out barbarous speech'[3] 'Bristling jaws' are an attribute of the inarticulate hippocentaur interviewed in the wilderness by St Antony, in St Jerome's *Life of St Paul the Hermit*.[4] The Rhynie man is not likely to have taken shape in response to literary animadversions such as these. His sculptor was probably fully positive towards him, and his intimidating appearance will be his function, a ritual prophylactic one in which his tool or weapon plays some part.

When Queen Aethelthryth's steward renounced the world and presented himself at the door of the monastery at Lastingham he was dressed only in a plain garment and carried an axe and an adze in his hands.[5] This Christian-rooted humility is not the one displayed at Rhynie. How far off we are from the religion of Chad, let alone of Wilfrid, is apparent in the image from Mail, Shetland, delicately incised on a flat compact sandstone or mudstone slab, half the height of the Rhynie one [181]. The figure is again in

profile, facing right, again with a tunic belted at the waist and cut short above the knees, but the proportions of the figure are different, the legs, again in stockings or boots, relatively small, and the arms thin and weak. The most eye-catching feature is again the head, not big like that of the Rhynie man but in its own way more repulsive, having the high rounded brow and projecting dog-like muzzle of a baboon. A wisp of a beard hangs out from under the shallow lower jaw and the slightly open mouth is armed

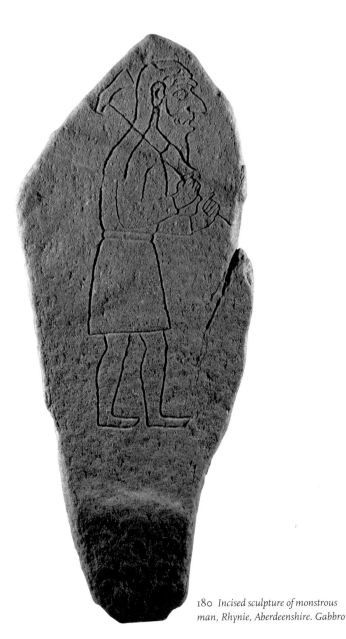

180 *Incised sculpture of monstrous man, Rhynie, Aberdeenshire. Gabbro*

179 *Front of cross-slab, Eassie, Angus. Sandstone*

Pictish Figurative Art 123

181 *Incised sculpture of animal-headed figure, Mail,*
Cunningsburgh, Shetland. Sandstone

with a long row of pointed teeth. The figure has an artificial obese and bolstered appearance as if flimsily constructed, a stuffed straw man fit for burning, but the hands hold a long narrow handled club, and up against the shoulder an axe-hammer, the head of which is much more sharply incised than all the rest of the image, except perhaps the tent-like pattern on the skirt of its tunic.

Three other examples of this incised solitary image, a profile figure wearing a tunic and carrying tools or weapons, two with the head of an animal, are recorded at Kilmorack, west of Inverness, Strathmartine in Angus, and another from Rhynie.[6] Recognizably the same figure reappears on a carved monument of a different kind, a tall sandstone cross-slab carved in high relief on the front and sides, formerly at Kirkton, north of Loch Fleet, and now in the Dunrobin Museum, Golspie [84].[7] The back of the slab carries firmly incised symbols and other motifs, with some small portions among them cut away, to give the effect of relief sculpture. The Golspie man has the strong 'Hittite' profile, and grimaces with closed lips. He wears the usual belted tunic with wide hem and side panels, and boots or leggings, like the Mail man, but his proportions are the most normal of all these figures. His left leg is raised, perhaps simply to make room for another of

the incised symbols crowded together on the monument, but the effect is of a vigorous kicking pose. He grips the hilt of a short knife in his left hand close to his side, and holds out in front of him an axe with a very long narrow blade. In later art this is a builder's or a carpenter's tool. The builders of the Tower of Babel use it in Bodleian MS Junius 11,[8] and Noah constructs the Ark with it from late Anglo-Saxon times onwards.[9] The Golspie man appears to menace or ward off a wolf or lion with his axe, just as he appears to kick the 'flower' symbol, but given his independent symbol status, it is unlikely that he is here being woven into a narrative situation. The accumulation of symbols at Golspie, as in the similarly incised cross-slab from Ulbster [56], might have come about as some kind of 'second edition' of older, separate symbol stones. As we have seen, a fairly large number of very early style symbol stones, each with two or three symbols only, not the six of Golspie, have come to light from the south-eastern tip of Loch Fleet, and the format of the Golspie cross-slab could represent a later conflation of their function. The formidable man symbol evidently remained acceptable and relevant to the generation that required the splendid relief cross on the front of the Golspie slab.

The same figure may perhaps be recognized occupying the central position in the upper part of the panel filled with men and animals on the back of the great Shandwick cross-slab [51, 97]. He stands sideways, facing right, with a tunic-length garment and well shaped legs one in front of the other, as if walking. One of his feet appears to rest on the head of a lion or leopard padding to the right, while the other is over the rump of a boar moving vigorously ahead of the leopard. The figure gains great solemnity from this apparent pose, standing on the backs of beasts, like the Hittite deities carved in the rock shrine at Yazilikaya, Turkey,[10] or Juno Regina at Chesters on the Roman Wall,[11] but the relation of man to beasts may simply be the result of congestion, as at Golspie. The figure, however, is tall and centre stage, and has a large head or head-dress and carries something in his outstretched hand, that reaches his face and may go back over his shoulder. He is part of a composition filled with men on horseback and a remarkable variety of animals and birds, a real 'Caucus-race' including the Dodo, all streaming towards the right as if united in their flight like the animals in Piero di Cosimo's *Forest Fire*.[12] At Shandwick the motif of the single, weapon-holding, man is duplicated and diversified in the bottom left corner by two men facing one another in profile, holding swords and shields, the man on the right kicking out his leg like the Golspie man symbol.

A similar diversification of the original image is found in a relief sculptured frieze, part of a box shrine, from Murthly, Perthshire [182], where two figures are shown fighting, the one on the left standing, with a bird's head, the one on the right, in a crouching pose, with a beast's head.[13] Another form of diversification from the solitary incised figure is seen on a sculptured frieze from Birsay representing a row of profile warriors, a commander with more ornamented weapons and

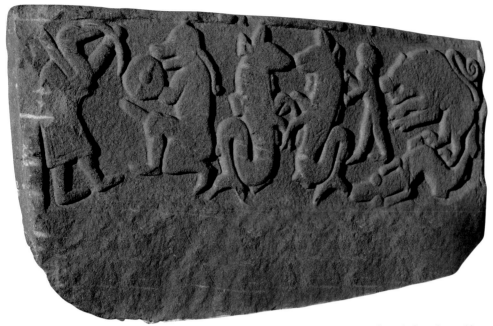

182 *Relief panel, Murthly, Perthshire. Sandstone*

coiffure, and two identical adjutants in his rear [78].[14] They all wear full-length coats, but the pepper-pot shape of their torsos, the belts at their waists and the flared panels on their skirts closely resemble these features of the Mail and Golspie men. The three Birsay warriors each have a large eye, as if seen from in front, in their profile heads, sharp pointed noses and small pointed beards, but lack any hint of the grotesquery of the Rhynie and Mail figures. The composition – with figures moving sideways holding decorated square shields evidently held on the back of their right hands, with a spear bolt upright transecting the shield, beyond it, so either held in the invisible left hands or coupled with the operation of holding the shield – draws into the connected circle of motifs a figure who occurs three times on grand elaborately carved cross-slabs. This is a pedestrian herdsman or hunter. At Eassie he strides to the right [179]. He has a wing-like mantle jutting out from his right shoulder but is otherwise gaunt in silhouette, with close fitting trews. He carries a spear resting on his right shoulder and a rectangular shield held up beyond his chest in his left hand. He walks on a relief ground line and though his progress is interrupted by the intricately decorated stem of the cross which occupies most of the front of the slab, he is clearly related compositionally to the stag, the large beast, and the running hound, the latter on a ground line like the man's, which fill the space at the right of the slab beyond the stem of the cross. A similar striding figure, as big as a St Christopher[15] in relation to the game he pursues, fills the space at the left of the cross-stem at Kirriemuir [183]. As at Eassie he carries a small square shield. His cloak is wrapped round him, its folds plaited like the drapery of the figures in the Forteviot arch [211]. He is in profile to the waist but swings his body round, partially exposing his back, as he vigorously lifts his right leg to stride forward.[16] On the back of the great cross-slab at Nigg [184], above the area dominated by the

figure of David and his associated imagery, a man walks in at the left of the slab, evidently related to animals (now partly illegible) running ahead of him. He also walks vigorously, moving the haunch of his right leg out and forward. He appears to be carrying an animal, a fox or pig, or its pelt, slouched on his right arm. He has a short sword suspended from a baldric round his neck and outlined against his chest. He holds a spear upright in his left hand and also a squarish, wing-shaped, shield, of which we see the inside, with his gripping hand, the pose perhaps also implied but not seen in the Birsay warriors relief. In the few cases examined, where a wider visual context has opened up, the protaganist might perhaps be interpreted as a 'master of animals' and patron of the chase.[17]

Images of the Hunt

Another kind of travelling processing figure is at the centre of the Pictish pictorial achievement, namely the figure riding on a horse. This motif is so often represented, and with such assertion, that it may be regarded, like the archaic incised tool-carrying man, as a stereotype hero image, open to variations and to wider or narrower contexts. Unlike the incised man symbol who faces right, the horseman in many major monuments moves across the field from right to left, differing in this respect from the normal medieval narrative impulse from left to right, based on the Antique tradition exhibited, for example, in the illustrated Terence Comedies and the Joshua Roll.[18] After many centuries of reading Latin texts from left to right, the designer of the Bayeux Tapestry naturally makes Harold set off on his journey from Westminster to Bosham from left to right,[19] but no such conditioning dominated Pictish sculptural design. The basic horseman motif is

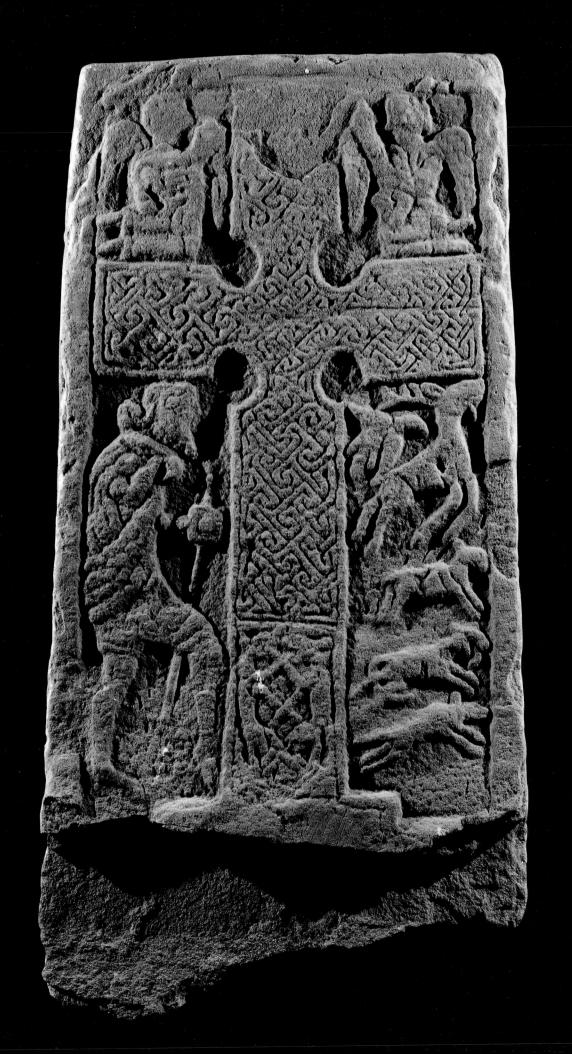

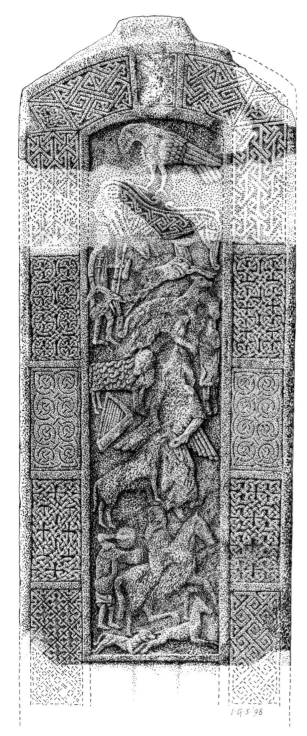

184 *Back of cross-slab, Nigg, Ross & Cromarty. Sandstone*

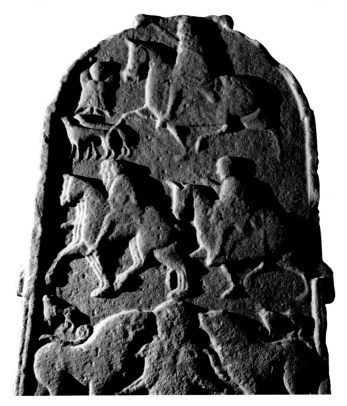

185 *Upper part of back of cross-slab, Meigle, Perthshire, No. 2. Sandstone.*

pleated saddle-cloth. His horse lifts its right foreleg and left hind leg high off the ground. Its tail is elegantly arched and chopped. Two horsemen are represented on the back of another cross-slab at Meigle, No. 4 [35], the principal, larger, one being placed at the top of the picture space with his head, with jutting nose and beard, touching the upper curved rim of the slab. His saddle-cloth hangs below him with a straight edge, almost giving his strutting horse the heavy caparisoned look familiar in 13th-century illustrated Histories and Apocalypses.[22] The same priority of image is clearly intended in the huge round-headed cross-slab at Meigle, No. 2 [185; see 194 for full work], where the deeply framed top of the back of the slab is occupied by a single rider, his horse again heavily draped along its flank. His stately progress is in this monument greatly enhanced by the group of horsemen who accompany him, immediately below him as at Edderton, but (unlike Edderton) in superb high relief, the sculptor revelling in the series of planes which he cuts away from the surface of his 2.4 metre high monument, revealing, as in a cameo, three horses superimposed, tramping forward with the verve one associates with Attic vase painting.[23] The top rider has two hounds standing just ahead of him, and below the lower riders two smaller dogs also stand guard. The Meigle recumbent, No. 11 [287], in its different format places the three horses in procession, again lifting their legs very high. A small dog accompanies the leading rider. The iconography is not yet fully that of the hunt, but parallels the ride of Harold to Bosham, equipped for future field sports with a pack of hounds that run ahead of him along the road.

seen on the back of the Edderton churchyard cross-slab [93].[20] The unarmed principal rider, in relief, is accompanied on a lower section of the monument by two incised warriors, riding, armed with spears and round shields. In a high-relief cross-slab at Meigle, No. 5 [91], a single horseman in a framed compartment occupies the bulk of the space on the back of the monument, though there is room for a painted caption or inscription below him.[21] He wears a shoe, and his left leg is outlined against a

The hunt itself, with the hounds in full career, leaping up to worry and drag down the running deer is represented in a large rectangular framed panel on the back of the Aberlemno roadside cross-slab [186]. Four horsemen are shown, their hierarchy and scale less clearly differentiated, although the claims of the central uppermost rider to hero status is supported by the unusual motif of two men, with wing-like drapery rather flatly carved one behind the other, blowing long trumpets, a striking triumphant image which recurs in the stately equestrian procession on *f.* 55v of Matthew Paris's *Life of St Alban*.[24] The handsomely framed square scene of a hunt on the giant cross-slab from Hilton of Cadboll [187] also uses the two trumpeters motif, more interestingly placed in depth, one beyond the other, not simply in a row as at Aberlemno and pointing to the artistic priority of the Hilton version. There are again four horsemen, but only one hind, running with a spear lodged in its flank and harried by two slim but powerful hounds. Two of the riders are given the cameo treatment, one superimposed on the other as at Meigle, but unlike the vigorous trudge of the Meigle horses, the horses at Hilton prance along more daintily. A hound leaps up behind the main rider, under the long tubes of the trumpets, again giving an impressive spatial quality to the panel. The main rider sits side-saddle, and is therefore a woman, with long hair on either side of her oval face and with pleated garments, her skirt spreading out, the first frontal figure we have encountered. The male rider beyond her is reduced only to an emphatic profile nose. The uncommon gender of the rider here is perhaps being signalled by the relief-carved comb and mirror floating in front of her horse, the gifts thought by Pope Boniface I to be fit for a queen, as reported by Bede in the *Ecclesiastical History*, Book II, chapter II.[25]

In the very coarse grained grey and yellow Banffshire granite cross-slab at Elgin [188] four horsemen are again depicted, their

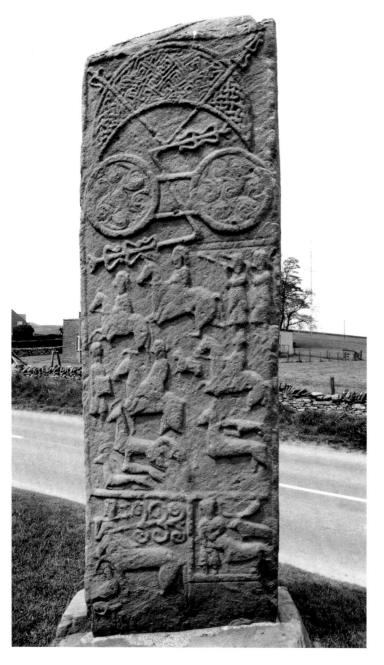

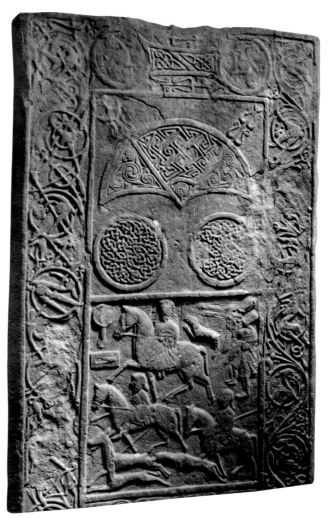

187 *Upper portion of back of cross-slab, Hilton of Cadboll, Ross & Cromarty. Sandstone*

186 *Back of cross-slab, Aberlemno roadside, Angus. Sandstone*

quarry a fine antlered stag such as appears also in the more diffuse scene on the back of the Shandwick cross-slab [51]. One hound, away from the main chase, leaps up behind the principal rider, as it does at Hilton of Cadboll, and his prime status in the scene is indicated by another new motif, the hawk, as large as an eagle, perched on the wrist of his left arm held out behind him. A second bird, standing ahead of him, will presumably be its intended prey. The Elgin rider's big slightly inclined head, notwithstanding the dappled blur of the medium, has something of the solemnity of the head of the rider on the front panel of the St Andrews Sarcophagus [189], a head preternaturally large in proportion to his own body, as if it had its own sacred significance, like the bogeyman head of the Rhynie man, or like the Scandinavian bracteates where the huge Roman emperor's head, disembodied, presses down on the back of his undersized mount.[26] As at Elgin the St Andrews rider carries a hawk, but it is

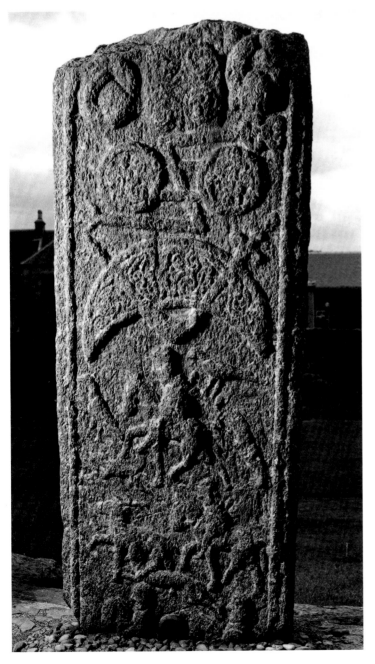

small, framed against his chest, not held out behind. The novelty of the St Andrews programme lies in the fighting pose of the rider, and in his quarry [190]. His right hand is raised, holding a sword, with which he threatens a rampant lion whose claws are about the throat of the rider's little trotting horse and its wide-open mouth close to his raised hand. This particular Pictish huntsman has had granted to him the prayer of young Ascanius in Book IV of Virgil's *Aeneid* that instead of the timid fleeing deer he might confront a tawny lion 'come down from the mountain'.[27] The designer of the St Andrews Sarcophagus was evidently stimulated to modify and extend the normal Pictish iconography of the hunt, whatever the social function of that traditional iconography may have been, because of the particular demands of the Sarcophagus commission itself, but also because he had had access to a specific visual model, itself reflecting the great Sassanian tradition of representations of royal lion hunts featuring rampant lions and sword-wielding kings.[28] At St Andrews the exotic elements have been fused with the Pictish conventions with remarkable panache. The familiar figure of the herdsman, the pedestrian hunter, walking with the same firm swing of the leg as at Nigg [184], drives a steady stream of animals ahead of him [80]. They move across the surface of the panel in recognizably the same way as the animals at Shandwick [97], even if they are going in the opposite direction. What is new in the programme is the rich elaboration, in the hands of a master, of the relief sculpture style. Elements of the design jut much further out from the surface than at Aberlemno or Meigle, even to the extent of standing free, by undercutting. The animals plunge in among the naturalistic foliage, their bodies scored across by a pattern of branches and leaves [60] exactly as the letters of the Gospel *incipits* of the Barberini Gospels are smothered by foliage.[29]

King David the Psalmist and other Heroic Images

The polish and sophistication of the St Andrews style suggests a deep cultural experience on the part of its sculptor, which enables him to make an organic whole of his sculptured panel as few other Pictish sculptors were able to do. So the group of the griffin pecking the flesh of a dying mule at the bottom centre of the Sarcophagus frieze [99] is a discrete decorative unit, a space filler, dropped in exactly like the tangle of biting snakes behind the back of the principal rider on Meigle No. 4 [35], or the crouching archer with the bow at the bottom corner of the figure panel at Shandwick [97], but St Andrews attains a quality of unified landscape only hinted at in Hilton of Cadboll. There is also an evident unity of inspiration, the orientalizing classical lion hunt and the griffin hinting at what becomes explicit in the massive

188 *Back of cross-slab, Elgin, Moray. Granite with heavy crystals of felspar*

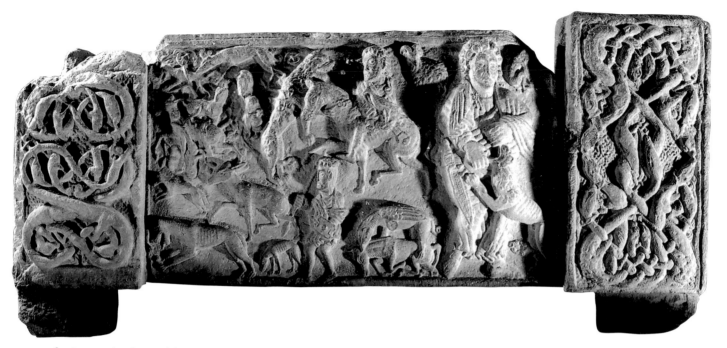

189 *Long panel and corner slabs,*
St Andrews Sarcophagus, Fife. Sandstone

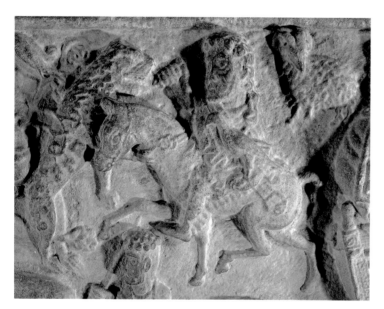

190 *Detail of lion hunt from long panel,*
St Andrews Sarcophagus, Fife

robed figure at the right end of the panel, tearing open the jaws of a rampant lion half his height. His broad face, crowned by rolling locks of hair and his humped rounded shoulders, canopied with drapery hanging thickly in parallel folds, are those of the portrait of St John in the Lindisfarne Gospels, and the David enthroned in the Durham Cassiodorus,[30] but realized here in full plasticity, so giving us a uniquely accurate view of a high-relief model of metal

or ivory, presumably showing a number of scenes and full of interesting details of dress and equipment, imported from Rome, or Constantinople, or from somewhere in between, dare one say Patras, in the heyday of the Pictish church and state. The senatorial figure on the Sarcophagus, pivoting on his foot, with a splendid hunting knife buckled to his side, is recognized by the sculptor as the Psalmist David, slaying the lion according to his boast in I Kings, 17, the rescued ram of his flock standing above his right shoulder.[31]

Through international contacts, the programme of Pictish sculpture now lay open to Late Antique art objects and to overt Christian iconography. The fragment of a closely similar representation from Kinneddar, Drainie, near Elgin [191], consisting of a good part of the lion but only the hands, sleeves, dagger fitments and dress fastening of David, indicates that a prestigious model could have impact, directly or indirectly, in widely different parts of the country. The remains of the lion and man are disposed differently on the block, perhaps suggesting that in the finished work they no longer shared a common ground line. The solidity of the block from Kinneddar looks more like a cross-slab than a sarcophagus panel.[32] At Kinneddar, though remarkable details such as the hangers of the dagger on David's thigh are retained, the rendering of the forms appears thinner, more spiky. A further modification of the same image may be seen on the back of the Nigg cross-slab [184] where the figure of David shares the picture space with other figures and motifs.[33] The lion hangs out sideways, away from David, as at Kinneddar, though it is now on the left, not on the right. David's controposto

pose, so far as it can be read, appears not to have been altered. The fall of drapery over his left arm is now markedly flat, the same diminution of detail and substance that we noted in the drapery of the trumpeters at Aberlemno [186], as compared with those at Hilton of Cadboll [187]. The passivity of the Nigg lion, evidently no longer clawing up at its assailant, might suggest the hand of a weaker artist, but the mutilation of his work makes this an unfair judgment, and it is, besides, contradicted by two remarkable features elsewhere on the back of the Nigg cross-slab. David is identified not only by his sheep, as at St Andrews, but by a large triangular harp, laid out flat below the feet of the sheep, as if seen from above, the same abrupt change of viewpoint which we see much later in the scene of David slaying the lion in the Tiberius Psalter where the sheep graze on an ordinary ground line but David's cloak and club are stretched out vertically.[34] The artistic convention followed by the Nigg artist is the same as that of the sculptor of Hilton of Cadboll when he places a comb and mirror in front of the advancing horsewoman, and the analogy of the Hilton comb and mirror is relevant also since the representation of the harp as a free-standing attribute of the Psalmist is a novelty, and presumably derives from the mental set of a sculptor accustomed to depicting, where relevant, the Pictish symbols, pictograms of fixed form, fully realized in relief sculpture, whose meaning was known to his audience.

If one sign of the Nigg artist's originality is his ability to extend a native tradition, another is his apparent familiarity with a quite different tradition, that of Late Antiquity, the same startling artistic reserve on which the great sculptor of the St Andrews Sarcophagus was able to draw. At the bottom left of the reverse of the Nigg cross-slab a small figure with a huge head and slim body is represented balancing or swinging two discs, one up, one down [192]. He may be about to clash together two cymbals, to frighten out of their lairs the forest animals, which a horseman and hound, adjacent to him, are pursuing, the rationale of the trumpeters in the Hilton of Cadboll and Aberlemno hunting scenes. Or he may be a strayed member of the Psalmist's band of musicians, the sort of figure who claps, dances, or blows horns in the pictorial preface to the Vespasian Psalter, or who sit accompanying the Psalmist with various musical instruments in the preface to the Psalms in the Carolingian Vivian Bible.[35] In that book the semi-naked figure of the Psalmist, isolated, in strutting or dancing pose against a dark blue background is directly related to the Carolingian copies of Aratus's treatise on the constellations, in which the tremendous figures of Aquarius, Perseus and the like are caught in action, running, turning, stooping, or bearing weights, like stills from a sequence of motion pictures.[36] As we look at him, the credentials of the Nigg figure seem clear enough. He turns his buttocks, and the back of his legs, towards us. His great head, lowered in profile, though sadly wasted, has the *gravitas* of an emperor's portrait on a coin. His stooping pose and the easy swing up and down of his arms suggest, even if now in pygmy guise, Myron's famous discus thrower,[37] and some ultimately Classical model has flickered

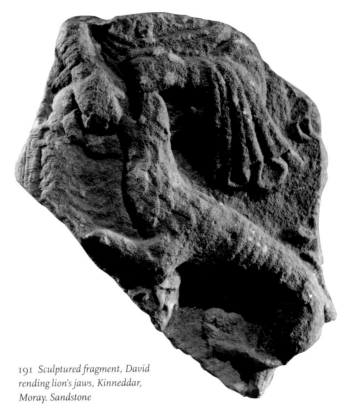

191 *Sculptured fragment, David rending lion's jaws, Kinneddar, Moray. Sandstone*

before the sculptor's eyes, just as was the case with the consular-diptych-style statuesque David in the Durham Cassiodorus [13], who lifts up his name in a disc as if raising a napkin to signal the start of the games.

In its unusually tall, narrow format, like a half-open door, and its haphazard yet close-packed placing of discrete motifs, giving an all-over picture of restless action but on no common ground-line, the picture space on the back of the Nigg cross-slab [184] resembles a Late Antique consular-type diptych such as the lion combat diptych now in the Hermitage.[38] Late Antique mosaic floors also favour this 'modular' approach to composition, but the scintillating quality of relief at Nigg makes a sculptural model more likely. The breadth of the frame, clearly divided into separate rectangular panels of contrasting ornament must be directly related to the ideas current in the scriptorium responsible for the Durham Cassiodorus (with its own connection, remarked upon above, to a consular diptych), but the segmental arch that frames the top of the Nigg scene has no parallel in manuscript decoration of the period. This striking feature, unique in Insular art, especially suggests understanding of classical models, consciously contrasting the triangular pediment on the front of the cross-slab [203] with a low curved pediment on the back.[39]

On the back of the cross-slab at Aldbar, David retains his ram and his harp, gains a staff or javelin, but is otherwise reduced to the ranks of a profile figure wearing the familiar belted tunic with wide bordered hem [193].[40] On the Aberlemno roadside cross-slab [186] he retains his frontal pose and some of the strength of his

gesture from the original St Andrews scheme. Horizontal harp, sheep and lion are laid out one above the other beside him. However, the enormously inflated hunting scene at Aberlemno has reduced David to a subsidiary framed compartment, a postage stamp only on the long rectangular shape of the slab. Adjacent to David is another compartment, filled with the figure of a centaur with an axe over his shoulder and a long branch with formal scroll foliage under his arm. A centaur armed for the hunt is, of course, another classical allusion, to the constellation *Centaurus*. He might have entered the Pictish repertoire from an illustrated Aratus. On the other hand, the branch under the centaur's arm might suggest that he is the centaur skilled in drugs, Chiron, and might ultimately depend on a medical or herbal treatise.[41] A much larger relief sculpture of a centaur fills one level of the back of Meigle No. 2 [194], holding up two long bladed axes like trophies and with long scraggy branches spread beyond his body, like a misunderstanding of the centaur's ragged mantle or mane of hair trailing behind him in the Carolingian Harley MS 647.[42] The Meigle centaur opens another line of speculation as to his own significance and derivation, as well as having bearing on the scope and coherence of the programmes of Pictish sculpture.

In its middle section Meigle No. 2 presents a heroic figure of a different kind from the riders above, not on the move or concerned with the chase, but himself stationary and, as it seems, trapped by animals. The figure is completely frontal, only our second after the mounted huntress of Hilton of Cadboll. Like her, it wears a long pleated robe, with wide flared skirt. However, only a late romantic fiction reads this figure as that of a woman.[43] Long skirted figures of Evangelists and of Christ occur in the Book of Kells, although it is true that their robes are less waisted and their skirts less flared.[44] The Meigle figure's head is large, and probably bearded. Its arms are close to its pear-shaped body to the elbow, and then the tapering forearms extend out and down filling the space between the foreheads and chests of two pairs of lions with scrolled tails and lifted paws which hem in the figure on both sides. The image goes back before the birth of the Insular style. The Sutton Hoo purse cover carries two appliqué panels showing a frontal man on the point of being partitioned between them by two wolves or lions.[45] Equally uncertain is the control being exercised over encroaching lions by the frontal figure in the repeat pattern on the 6th-century textile, the shroud of St Victor at Sens.[46] A naked figure between lions is painted in the Catacombs, identifiable as Daniel in the Lions' Den, one of a series of redemption images, including also Jonah's resurrection from the belly of the whale and Noah's delivery from the Flood.[47] The monument at Meigle is popularly called the 'Daniel Stone', and this identification may well be correct; certainly in the general sense that the figure seems to be a heroic survivor rather than a mere victim. The calm acquiescent pose is close to that of the glorified robed Christ on the Cross in Durham MS.A.II.17.[48] Powerful and large as the image is, it is not easily apparent how, as a subject, it relates to the horsemen facing from right to left

193 *Back of cross-slab, Aldbar, Angus. Sandstone*

192 *Detail of man with cymbals, back of cross-slab, Nigg, Ross & Cromarty. Sandstone*

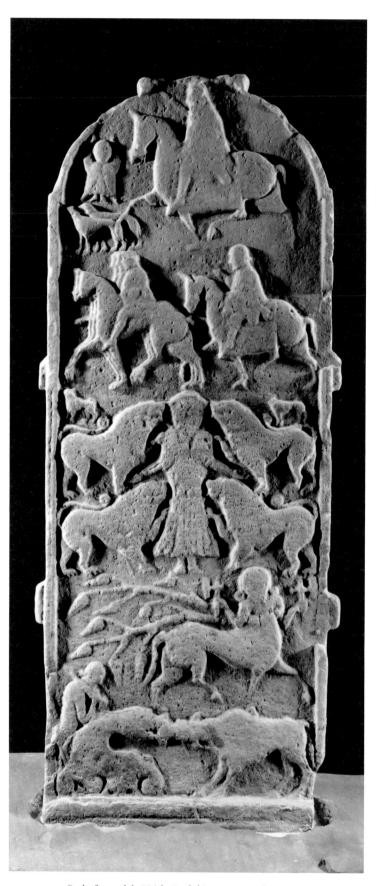

194 *Back of cross-slab, Meigle, Perthshire, No. 2. Sandstone*

immediately above and to the centaur below, moving with equal determination from left to right, although we might conceive that all these real and mythical equestrians were in process of circling around the group of man and lions, as if in the centre of a wide arena. A pointer towards a more unified programme is perhaps the small figure of the multi-winged angel or seraph who stands in the top left corner of the whole composition. This sort of angel accompanies Christ on the Cross in Durham MS.A.II.17, and on the open-work Athlone book cover.[49] In its position at Meigle, it relates more obviously to the leading horseman whom it confronts than to the redemptive image further down the slab. In the Barberini Gospels the *Initium* initial of St Mark is decorated with two impressive human faces and with a bust-length angel, illustrating the opening lines of the Gospel, quoting the Prophet Isaiah, 'Behold I send my angel before thy face, who will prepare your way before you. A voice crying in the Wilderness: prepare the way of the Lord, make his paths straight'.[50] Such an angel might reasonably intrude at Meigle as a moral didactic directive, into imagery concerned overtly with journeys overland on horseback. The Evangel is now 'set before the face' of an important representative of secular society, as psychopomp if he has died, as mentor and guardian if he still lives. Having focused on St Mark's Gospel, I, we read at verse 13, in St Mark's account of the Temptation of Christ, that Christ was 'in deserto' with the beasts, 'cum bestiis'. There is nothing in the formal appearance of the man among the lions to prevent him representing Christ as well as Daniel, or instead of Daniel. In a text certainly known to Pictish clergy of this period, St Jerome tells the story of St Antony's journey through the wilderness in search of St Paul, where he meets and seeks directions from a hippocentaur.[51] The Meigle sculpture may not only have a literary programme drawn from Scripture, but also from hagiography, the image of St Antony's centaur evoking the desert and its bewildering paths where Christ, having fasted forty days, confronted and conquered Satan.

It seems feasible that the subject matter of Meigle No. 2 is held together by a new narrative intent, drawing on literary sources. As well as devotional literature, historical writing flourished in both Anglo-Saxon England and Ireland in the period when the Pictish high-relief sculptures were erected.[52] A portrait of an event, if not of a historical narrative, appears on the back of the Aberlemno churchyard cross-slab [82]. The figures are arranged in three rows, but since rows of figures at different levels is a commonplace in the representation of hunts and horsemen, with no probability of sequential significance, it seems more likely that a single battlefield is intended, with concurrent skirmishes scattered across it, rather than an unwinding series of confrontations, implying cause and effect.[53] At the bottom right corner a warrior, in a mail shirt and still helmeted, lies upright, full length, dead, like Goliath in the Muiredach Psalter, Cotton MS.Vitellius F.xi.[54] His being dead is vividly signalled by the big carrion bird that lunges at him with its beak. Other weapons than his lie discarded on the ground; at the top centre a shield in relief and an incised

sword, seen flat, frontal, in contrast to the strictly profile representation of men and horses. The contestants are probably differentiated by helmets and lack of helmets but the unhelmeted figures fight on horseback as well as on foot. The two riders at the top give a left-to-right impulse unusual in Pictish sculpture, but the other contestants move in to meet one another from both sides. The rarity now, in Pictish art, of a battle scene involving many warriors is typical of the Insular world as a whole. It is notorious that the only extant parallel of similar date to the Aberlemno battle scene is the panels depicting the siege of Egil's stronghold and the capture of Jerusalem in the 8th-century Anglo-Saxon Franks Casket. It is salutary to recall that the scenes on the Casket draw in the one case on a traditional epic not necessarily yet committed to writing, and in the other on a very sophisticated ancient literary source, Josephus's *Bellum Iudaicum*.[55] We cannot know now whether anyone had the status or the acumen to turn reporting of near contemporary events into art. The only Anglo-Saxon sculpture which we might cite is the fine round-headed cross-slab at Lindisfarne, whose reverse is jammed with a row of soldiers with midriffs striped like wasps and all waving swords or battle axes in the air. But these are much less likely to be a reminiscence or anticipation of the dreaded Northmen who sacked Lindisfarne in 793 than an illustration of Christ's prophecies in Matthew 24 concerning 'Wars and rumours of wars' or of Psalm 67, 'the nations who delight in wars' whom the Lord God will scatter.[56] The Carolingian monarchy, as aware as anyone of the value of propaganda, favoured an allegorical approach, drawing its battle iconography from The Book of Kings.[57] In the post-Insular period, we begin to hear of art as newspaper reports, the Battle of Maldon hangings at Ely[58] and the one survivor, the Bayeux Tapestry, the very fact of whose survival, in church hands, underlines the wholesale loss of secular art and subject matter from the early medieval period. Pictish art is exceptional in many ways, but whether it turns contemporary chronicle material into art at Aberlemno churchyard can only be speculative, since the function of the cross-slabs, other than as focuses of devotion to the Cross of Christ, is speculative too.

A later Pictish parallel for Aberlemno is the 6-metre-high cross-slab at Forres [195], popularly called 'Sueno's Stone', as a result of the same historical disconnection that leads Hugh Miller to vouch for the Danish origin of the 'obelisks' of Ross & Cromarty.[59] The Forres monument rams home its military iconography, rejecting the imagery of the hunt which still fully satisfied the designer of the comparable tall pillar at Mugdrum.[60] The Dupplin Cross in Perthshire [196], inscribed with the name of the Pictish king Constantin, son of Fergus, and dating to the first quarter of the 9th century, makes a similar shift of emphasis, confining the racing hounds to a narrow compartment at the base of the shaft and clearly identifying the horseman at the top of the shaft as a military commander by means of the four heavily armed foot-soldiers who form a sort of plinth for him to ride on.[61] 'Sueno's Stone' is on an unusually ambitious scale. In this respect

195 *Back of cross-slab, 'Sueno's Stone', Forres, Moray. Sandstone*

196 *Front of free-standing cross, Dupplin, Perthshire. Sandstone*

squashed together, rather than the gradually ascending spiralling of the scenes on the Roman columns, but the layout on the flat surface of the cross-slab would account for that different effect.

The attraction of the Classical world as a model for conduct and display is vividly present in the imperial pretensions implicit in the gold and garnet jewelry of the Sutton Hoo [4] – the threshold of the Insular style.[65] Classical literature was honoured in one half of Cassiodorus's library at Vivarium,[66] and his English beneficiaries were ready to fashion their thoughts and style on whatever their money could buy. The text of Virgil's *Aeneid*, which had been illustrated and quoted on wall paintings and mosaics in Roman Britain,[67] returned to this country in the Insular period, either in whole or in part. Those who wish to see in the Aberlemno churchyard battle scene a memorial to the Pictish victory over Ecfrith, King of the Northumbrians, in that locality in 685, can at least point to the evidence of Bede that the battle had wide repercussions. When Bede writes about Ecfrith's defeat, he borrows a phrase about the hopes of the English 'ebbing and falling away' from Virgil's account of the siege of Troy in Book II of the *Aeneid*.[68] Bede is given to expressing himself in Virgil's vocabulary. He applies to an earlier English king, Edwin, in exile and troubled in spirit, Virgil's words from the *Aeneid*, Book IV, about the lovelorn Dido, Queen of Carthage, 'wasted with hidden fire'.[69] When Bede and Abbot Ceolfrith wrote their helpful letter about the correct calculation of Easter to King Naiton around 710 they assumed that they would be understood by that 'philosopher king'[70] when they likened various errors in church practice to the rocks of shipwrecking Scylla and the whirlpool of Charybdis, dangers which bulk large in Aeneas's sea adventures described in the *Aeneid*, Book III. The Hilton of Cadboll hunting scene [50], where trumpeters signal the ceremonial importance of the event and the principal rider is a woman, wearing a conspicuous brooch on her breast, might have picked up a hint or two from a picture – or at least from the text, of the great hunt in the *Aeneid*, Book IV, where the Queen of Carthage rides out with horsemen and hounds, her purple cloak clasped by a gold fibula.[71] That hunt and the circumstances surrounding it are significant events in Virgil's presentation of the historic destiny of Rome, the theme of two out of the five panels on the Franks Casket [23], a Northumbrian production often associated with a splendid illustrated Late Antique manuscript, a topographical historical treatise called by Bede 'the Cosmographers', which belonged to the learned Northumbrian King Aldfrith, Ecfrith's successor.[72] Such models existed in the 8th century, and artists naturally had access to them. As we have seen, Pictish sculpture contains some striking quotations from Late Antique art, and the woman at Hilton of Cadboll might be another.

The example of the Franks Casket provides a useful parallel for another aspect of the programme of Pictish relief sculpture. The right panel of the casket, although like the others it carries a carved caption, shows characters enacting parts of a story that is no longer known.[73] Under the shadow of the Pictish symbols,

it is as likely to be a conscious cultural gesture – especially in view of the good evidence that there were originally two 'curiously carved pillars' on the site[62] – by a 9th-century patron fresh from a visit to Rome, who wanted the equivalents of the Columns of Trajan and Marcus Aurelius[63] on his doorstep, as that we should regard the camp scenes, parades and massacres as an intelligible act of local reportage. The disposition of the sculptures resembles rectangular illustrations in a codex such as the Vatican Virgil[64]

197 *Hooded archer, back of cross-slab, St Vigean's, Angus, No. 1. Sandstone*

198 *Detail of back of cross-slab, Fowlis Wester, Perthshire, No. 1. Sandstone*

especially when writ large, many Pictish sculptured scenes, even the standard hunts, have an inscrutable air. But in addition many specific and circumstantial subjects are represented, the key to the iconography of which was lost with the destruction of literary records and the failure of traditional story telling. Did the hooded archer with the rustic bow and bolt crouching at the bottom left of cross-slab No. 1 at St Vigean's [197], at the bottom right of the figure panel at Shandwick [97], crowded in among the symbols in a panel on the back of the Glenferness cross-slab, and on a lost monument at Meigle [318], once have a name?[74] Where are the six passengers sailing to in the boat at the base of the Cossans 'St Orland's' cross [106]?[75] What is the meaning of the procession of soldiers, following a man leading an ox or cow with a conspicuous cowbell on its neck on the back of the Fowlis Wester cross-slab [198]?[76] Such problems are not confined to the Pictish province of the Insular tradition. We do not know the stories which lie behind the relief sculpture at Jarrow where a man lies supine on the ground of a wood,[77] or the scene on the base of the North Cross at Ahenny where a headless corpse is borne in procession on the back of a horse.[78] But an undoubted characteristic of Pictish sculpture is the casual dropping in of allusions to topics we cannot recognize, often in close proximity to the image of the Cross. In 797 Alcuin complained to the then Bishop of Lindisfarne that his priests were letting their attention wander from the words of scripture to the hero ballads of harpists: 'What has Ingeld to do with Christ?'[79] The Picts as we know them from their art enjoyed a pre-Alcuin civilization. Their equivalents of Ingeld, even less known than he, were admitted openly.

The Cross and Related Themes

That these lively aspects of Pictish verbal and visual lore had indeed 'to do with Christ' is of course made clear by the basic structure of the relief-carved monuments. These consist, as frequently rehearsed above, of cross-slabs, two-sided upright monuments, one side of which is largely filled by an elaborately ornamented cross. Before the practice of relief sculpture but no doubt also concurrent with it, boulders, pillars and slabs were incised with the sign of the Cross, technically akin to the stones carved with symbols, but it is only in the relief sculpture phase that the Cross becomes an element in and a condition of the iconographic programme.

The level of artistry displayed in the format and ornamentation of the relief cross-slabs such as Eassie, Aberlemno, or Meigle, has been discussed from various points of view in other chapters of this book. What concerns us here is the Cross as image, a phenomenon which manifested itself from the very beginning of the Insular tradition. The only surviving decoration in the early Irish copy of the Gospels, *Codex Usserianus Primus*, is an upright cross with splayed terminals, the top extended at the right with a hook which identifies the whole as the abbreviated name of Christ, the Christogram.[80] The Christogram hangs in the middle of a rectangular space, circumscribed by three frames made of scratchy dots and loops. Unrefined though the artistic means are, the symbolism of the design, where it is placed, appears weighty. Arculf's and Adomnán's very basic plans of the layout and furnishings of the Holy Places, drafted with a stylus on

wax, will have looked like this.[81] So the Christogram, within its enclosure, may evoke the prophet's words: 'his train filled the Temple...the Lord shall suddenly come to his Temple.'[82] Immediately above the framed Christogram are the last lines of St Luke's Gospel, celebrating the establishment of Christ's worship in the Temple, that is the beginnings of the Christian Church. In later manuscripts the cross-carpet pages [16] have the connotation of the veil of the Temple covering the Ark of the Covenant,[83] but

also, like the elaborate *Christi autem* initials [2], represent the person of Christ himself and his saving death and resurrection in a non-pictorial, or rather non-figurative, manner. The Insular cult of the Cross as the vehicle of salvation reaches its verbal climax in the Old English *The Dream of the Rood* where the poet sees the Cross, having shared the humiliation and wounds of Christ, glorified, raised up, covered with gold instead of blood, fair jewels instead of wounds, a sign of healing and immortality.[84] The prototype of this visionary cross was the precious effigy of the Cross erected on the Hill of Golgatha itself, represented in the apse mosaic in Sta Pudenziana, Rome.[85] In Meigle No. 2 [199] the equal-armed cross-head, bonded by a great disc, is studded with thirty-three projecting bosses, representing jewels, perhaps once polychromed. At Shandwick the whole length of the cross-shaft as well as the head of the cross is carved with a regular series of fifty-six high-relief spiral bosses [200], giving even from a distance the sumptuous appearance of a cross encrusted with pearls or great cabochon gems. Viewed from the side, this cascade of spiral bosses takes on the appearance of clusters of ripe fruit, redolent of the Eucharist. The imagery of the Cross displayed here is as confident and splendid as anything in Europe in this period. The metropolitan level at which Christian art is being transacted both at Meigle and at Shandwick must be taken into account in any overall consideration of the function and message of these cross-slabs. Thirteen kilometres from Shandwick, the remains of a cross-slab from Tarbat carries along one flank eight short horizontal lines of handsome relief lettering invoking Christ and his Cross, and commemorating an individual whose name is now partly illegible [201].[86] It is evident from this *in commemoratione* formula that the great equestrian figures placed in prominent positions on Pictish relief sculptures were likewise to be remembered before God. The rare invocation *In nomine Iesu Christi* is paralleled in The Acts of the Apostles, in relation to the exercise of the miraculous powers with which the Apostles were endowed, while *Crux Christi* is a phrase used by the Apostle Paul in various epistles to epitomize the Christian faith.[87] The choice of these words is peculiarly appropriate at Tarbat, since they are carved on the flank of a cross-slab itself bearing a representation of the Apostles. But inscribing a stone cross with the words *Crux Christi* brings the sacred concept and the material work of art into a mystical union, and seems to imply a liturgical role for the High Crosses of Pictland.

On the front of the Nigg cross-slab [202] the massive sculptured bosses, not as at Meigle and Shandwick decorating the image of the Cross itself but set alongside it, emphasize the soaring outline of the Cross and the delicate patterns within it [40, 41] . The original arrangement of ten bosses, including the diamond shaped ones, at the left and the twelve at the right, might signify the Old and the New Testaments, the Decalogue at the left and the New Law preached throughout the world by the twelve Apostles at the right. Bede recognized the value of number symbolism, following the lead of writers like St Augustine in *The*

199 *Front of cross-slab, Meigle, Perthshire, No. 2*

City of God.[88] A carpet page in the Book of Kells, f.33, dominated by eight great medallions, packed like Nigg with ornament, is widely accepted as referring to the eight days of Passion week.[89] At Nigg the top of the decorative cross is not kept within the frame, as the cross-arms are, but rises up on a level with the frame, thus visually forming the decorated frontal of an altar on which a chalice is standing. The top of the Nigg cross-slab is treated as a pediment [203],[90] containing on one level the story of the 4th-century desert

Fathers SS Antony and Paul, sharing a meal of bread brought miraculously by a raven. The source of the story and of details of the imagery seen here, such as the woven branches which enclose the scene, is the Latin *Life* of St Paul the Hermit, written by St Jerome. The saints do not hold or break the bread, as they do in the version of this subject on the Ruthwell Cross, but bow over the space where the bread is being delivered, holding open books in their hands. By a remarkable artistic and iconographic invention

200 *Front of cross-slab, Shandwick, Ross & Cromarty. Sandstone*

201 *Fragment of cross-slab, with relief-sculpted inscription on right side, Tarbat, Ross & Cromarty. Sandstone*

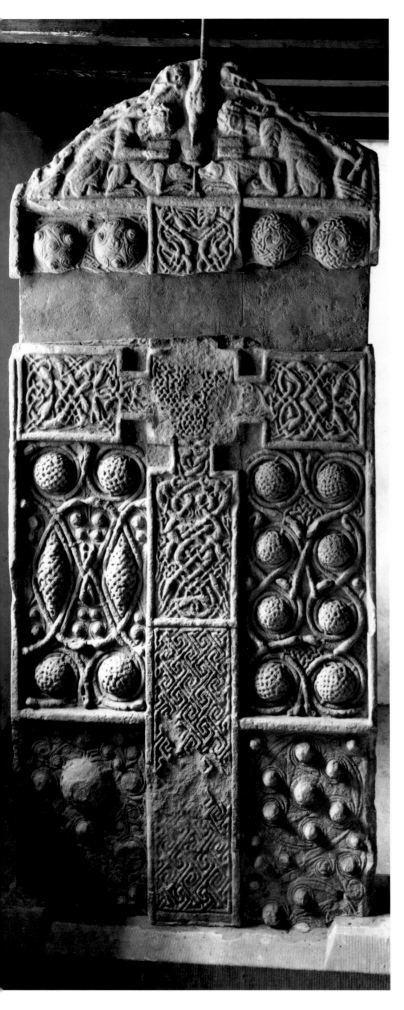

the raven no longer carries a mere loaf to nourish the hermits in the desert but the consecrated host, held above the chalice and already broken, indented in its lower left quarter, in accordance with the rite set out in the early Irish tract on the Mass copied into the 11th-century Stowe Missal. Where the sculptor of the Elgin cross-slab placed an image of Christ himself, in archaic hero pose, fending off serpents [188],[91] the Nigg sculptor represents the body of Christ broken in the Eucharist, and places on either side the lions which roam the desert in St Jerome's narrative but here transformed into the two beasts between whom Christ appears, 'in medio duorum animalium', according to the Old Testament Canticle of Habacuc, used in the Roman Liturgy of the Mass from at least the 4th century. The plummeting raven with the host in its beak recalls the descent of the dove of the Holy Spirit bearing the ampulla down on the head of Christ in the Baptism miniature in the Benedictional of St Aethelwold.[92] The composition formed at Nigg by the two saints and the raven happily anticipates one of the great images of late Anglo-Saxon art, the first two Persons of the Trinity seated with the Holy Spirit flying down between them, for example on the handle of Godwine's seal.[93] It is much to the credit of the Nigg sculptor that his visualization of the central event of the Mass is difficult to parallel in the period. There may have been something similar in the lost 5th-century mosaic portrait of St Peter Chrysologus at Ravenna.[94] Carolingian representations of the Mass are more matter of fact, instructive, lacking the focused meditative quality of the Nigg representation.[95] Coordinated as the remarkable pediment sculpture is with the ravishing elegance of the great cross design below it, the Nigg cross-slab deserves a place second to none in the history of Western medieval art.

The scene of SS Antony and Paul sharing the loaf sent from heaven is also represented on a cross-slab at St Vigean's [204]. The seated saints do not dominate or directly relate to the emblem of the cross but form part of the decoration at the right side of the shaft. They are seated on high backed chairs facing one another, and are in the very act of pulling the loaf apart. The eucharistic implication of the scene, made explicit at Nigg, is brought out at St Vigean's in a different but equally interesting original way. Below the seated saints is another scene, in which a goblin-like figure, a naked man with a big head and spiky hair, an emaciated body, swollen joints and stomach, is crouching in front of a horned ox or bull standing on a raised platform [205].[96] The man holds a knife to the throat of the animal and has already wounded it, since his projecting tongue curls up to lick its blood. In the Carolingian Stuttgart Psalter, at verse 31 of Psalm 68 is inserted a picture of an ox on a plinth, to which a crowd is bringing offerings, illustrating the text that the prayers and praise of the faithful please God better than the bloody sacrifice of an ox.[97] The resemblance of the Stuttgart and St Vigean's compositions might suggest a common pictorial model. But the St Vigean's image more specifically shows the sacrifice, and together with the saints above, sharing the bread, explores ideas set out in St Paul's Epistle to the Hebrews,

202 *Front of cross-slab, Nigg, Ross & Cromarty. Sandstone*

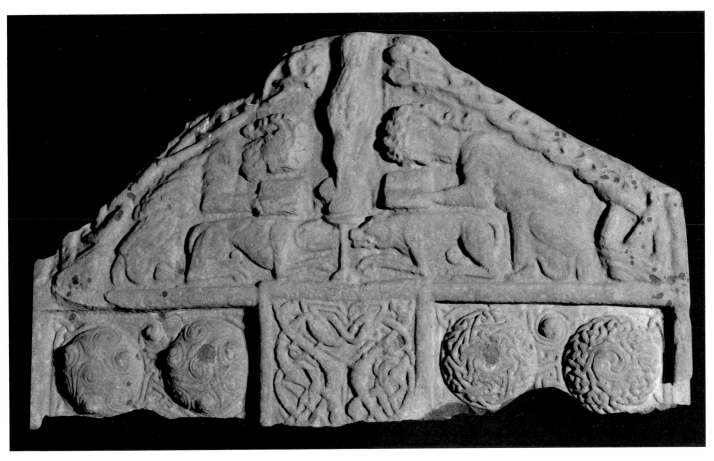

203 *Pediment at top of front of cross-slab, Nigg, Ross & Cromarty. Sandstone*

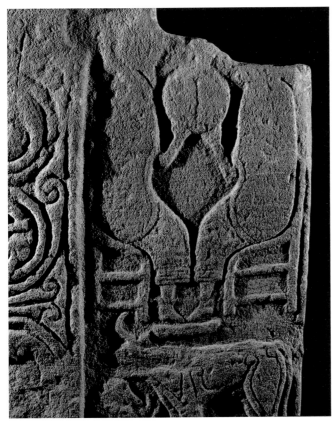

204 *Saints Paul and Antony, detail from cross-slab,*
St Vigean's, Angus, No. 7. Sandstone

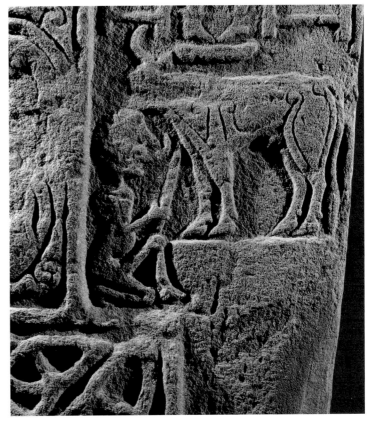

205 *Sacrifice scene, detail from cross-slab,*
St Vigean's, Angus, No. 7. Sandstone

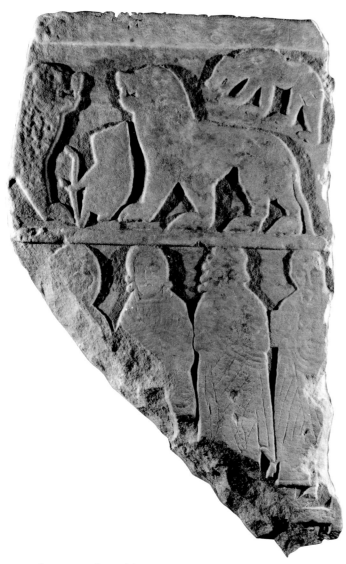

appears of *f.* 26v of the Old English Hexateuch, BL Cotton MS Claudius B.iv,[99] literally illustrating Genesis, 15, 9–11, where Abraham obeys God's command to make an offering of a heifer, a goat and a ram, dividing them 'per medium'. The significance of this division, obscure in the text of Genesis, is elaborated on in a densely legalistic passage in the Prophet Jeremiah, 34, 18–20, when the confirmation of God's covenant with his people hangs on the correct observation of a ritual involving a calf 'cut in twain': 'vitulum quem conciderunt in duas partes'. The princes of Judah and the princes of Jerusalem are threatened for failing to fulfil the covenant. It seems possible that the Tarbat scene is an attempt to express this difficult material, the lions representing the princes, since at least the lion of the Tribe of Judah is a familiar concept, for example in Revelation, 5, 5.[100] These same lions stand on either side of the cross on the Ulbster cross-slab [207],[101] doing honour to the sign of the New Covenant. At Tarbat, immediately below the lions' ground line, the sculptor has represented a row of standing bearded men, likely to be Apostles (as argued below), in which case the scheme of sculpture involves the juxtaposition of Old and New Testament themes, as at St Vigean's, and as at St Vigean's there is the sense of repudiation of the old ritual observances of the Jews. The Apostles are witnesses to the new dispensation brought about by Christ's death on the Cross. In chapter 3 of the Epistle to the Philippians, St Paul writes 'videte concisionem', the same word used by Jeremiah for the ritual division of the calf. Such images are not strictly typological, but are getting close.

According to Bede, the monastery at Jarrow possessed an extensive typological series, imported from Rome, in which an event in the New Testament, the antitype, was accompanied by its prefiguration or foreshadowing, the type, in the Old Testament.[102] Such a programme does not expressly occur in Pictish art, but a well known type of Christ's Entombment and Resurrection, the swallowing and disgorging of Jonah by the whale is represented in

206 *Fragment of cross-slab, with animal and figurative scenes, Tarbat, Ross & Cromarty. Sandstone*

10, where he contrasts the New Covenant of the Christians with the Old Covenant of the Jews: 'For it is not possible that the blood of bulls and of goats should take away sins...(whereas)...we are sanctified through the offering of the body of Jesus Christ once for all'. The gruesome appearance and actions of the St Vigean's crouching man suggest that the sculptor intended to repudiate not only the faith of the Jews but pagan sacrifices in general.

A specific aspect of Old Testament ritual may, however, be portrayed in the upper part of a fragmentary relief sculpture at Tarbat [206]. The composition seems originally to have been symmetrical, with two formidable lions standing confronted and appearing to snarl over the division of the prey that lies between them, a situation often moralized about in Aesop's Fables.[98] The apparent prey, however, consists of only the lower half of a hoofed beast, neatly truncated. Exactly the same straight cut, dividing the lower and upper halves of two animal carcasses,

the upper right corner of the cross-slab from Woodrae [*101*] and at the bottom left of the cross-slab at Dunfallandy [*49*],[103] the Pictish 'whale' being recognizably akin to the wolf-like, fishtailed *Ketos* of Late Antique representations of Jonah, as for example the 3rd-century marble group in the Cleveland Museum of Art.[104] As we have seen, Meigle No. 2 [*194*] may represent Daniel in the Lions' Den, another familiar type of the Entombment and Resurrection, and David, the type of Christ the Good Shepherd, often appears in Pictish sculpture. Surface damage and lesser craftsmanship make it uncertain if the figures at the top of the back of the cross-slab at Eassie [*208*][105] can be interpreted as the three men or angels of Genesis, 18, moving forward to meet Abraham at the oak tree of Mamre. With the same uncertainty, the dregs of a Samson cycle may perhaps be seen on the front and back of a cross-slab from Inchbrayock.[106]

On the back of the cross-slab at Aldbar [*193*] two stolid robed figures sit side by side on a bench-like throne equipped with posts, framing the figures, decorated with beast-head terminals, much like the throne of David in the Durham Cassiodorus, though at Aldbar the beast heads look outwards, not inwards.[107] The same type of throne, represented in rather more detail, is occupied by two taller figures on the back of the cross-slab at St Vigean's, No. 11 [*209*],[108] comfortably swathed in mantles whose bunched or rippling edges hang down below their arms nearly to the straight hem of their robes. They have bare feet, and both hold books and floriated rods. The figure at the left is placed a little higher than the other, and though strictly frontal they incline slightly towards one another as if exchanging comment. Immediately above their heads, where the slab is broken, are the remains of the feet and hemline of another, smaller figure. A crude version of the same composition is found on a relief carving from Lethendy [*210*].[109] Two figures with oversized heads sit close together, bolt upright, draped in pleated mantles with a broad decorated hem to their robes. They have bare feet, and the figure at the left holds a book, with one hand placed below it and one above. In the space over their heads is the figure of an angel with half-open wings. It seems probable that the top figure at St Vigean's was also an angel. The Holy Spirit is represented as an angel on the Anglo-Saxon Mortain reliquary,[110] and the combination of an angel with two dignified enthroned figures suggests the iconography of the Trinity. The *Codex Amiatinus*, from before 716 [*21*], proves that the anthropomorphic representation of God the Father was acceptable to the Insular world, at its most scholarly and critical.[111] David's famous prophecy in Psalm 109, quoted by Christ himself in Matthew, 22, 'The Lord said to my Lord, sit thou on my right hand, till I make thine enemies thy footstool', Christ's affirmation of status in Mark, 14, 62, and the vision of St Stephen recorded in Acts 7, lead naturally to the depiction of the Father and the Son, together, enthroned. That the Aldbar enthroned figures might

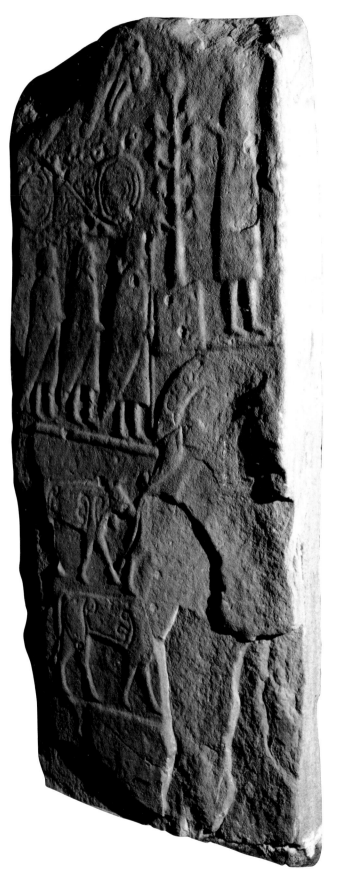

207 *Detail of front of cross-slab, Ulbster, Caithness. Sandstone*

208 *Back of cross-slab, Eassie, Angus. Sandstone*

illustrate Psalm 109 is supported by the representation in the lower part of the slab of David throttling the lion, while his harp and ram lie alongside, and also his club, upright as in the David and the lion scene in Cotton MS.Tiberius C.vi.[112] Below the seated figures at Lethendy, two men in elaborately pleated tunics stand playing pipes and a harp, so again evoking the Psalms and in a style which despite the poor craftsmanship hints at a good early pictorial model. An entirely different kind of subject is represented below the seated figures at St Vigean's. A profile man wearing a hooded cape and short trousers walks to the left leaning

on a thick staff. A fragment only remains of another figure also holding a thick staff, coming to meet him from the left. The hooded figure leaning on a staff is reminiscent of the two men who move away down the right half of the architectural arch from Forteviot [211].[113] These men, and the much larger figure who fills the left curve of the arch, are placed in a solemn context iconographically by the presence at the apex of the arch of a lamb, standing adjacent to a cross. A lamb beside a cross at the apex of an arch recalls the early Apocalypse imagery above the apse at SS. Cosmas and Damian in Rome, where the Holy Lamb lies in front

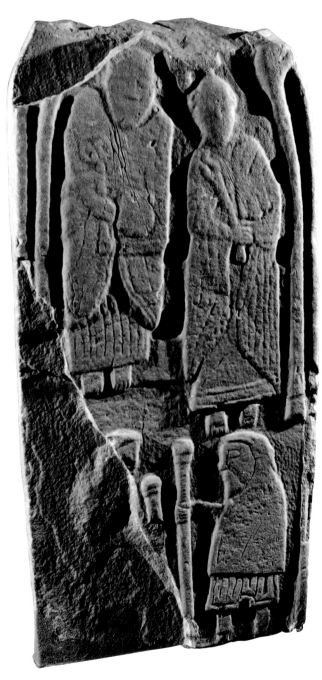

209 *Back of cross-slab, St Vigean's, Angus, No. 11. Sandstone*

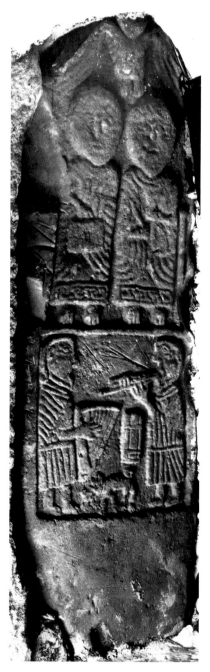

210 *Back of cross-slab, Lethendy, Perthshire. Sandstone*

of the cross, between the seven candlesticks, representing the one who 'was slain' and is 'alive for evermore' of Revelation, Chapters 1 and 5.[114] At Forteviot the muffled wayfarers shift the focus away, specifically, from the Apocalypse, so we are left with the lamb and cross as signifying Christ's death and Resurrection. Wayfarers could then represent the Apostles setting off on their universal mission,[115] or alternatively the two disciples returning from Emmaus after their encounter with the risen Christ, reported by Luke, 24. At least in the later Middle Ages the imagery and equipment of pilgrimage lay heavily over the Emmaus story.[116] The large figure at Forteviot would then represent Christ as Good Shepherd with a staff and a sheep at his feet. The mannered style of the Forteviot figures offers some parallels for that of BL Cotton MS Vitellius F.xi and the Southampton Psalter.[117] If the imagery at Forteviot does relate to the disciples' reaction to the Resurrection, some such connotation would also apply to the lower scene at St Vigean's.

The standard items of Christian iconography – for example, scenes of the Nativity, Baptism, Ministry and Passion of Christ – are rare in Pictish art, although they are not over plentiful in the whole span of Insular art, as it survives, compared with the very solid coverage of the same themes in Carolingian art.[118] The conventional excuse, of loss through iconoclasm, can reasonably be advanced, in Scotland more than in England. On the front of the cross-head of the free-standing cross at Camuston, the basic outline of the Crucifixion survives, with Stephaton and Longinus in skipping poses on either side of Christ's body. Beneath the scene, the first panel of the stem of the cross contains another threatening figure, a conflation of Centaurus and Sagittarius.[119] At Kingoldrum, the fragment of a crucified Christ, a head and one arm, outlined in crude style, does not necessarily belong to the Pictish period.[120] A relief-carved shaft at Monifieth is broken off at the waist of a figure of Christ crucified wearing a flared skirt-like loin cloth, below which his long straight legs hang down, flanked by two figures, from their position either the Virgin Mary and St John or Stephaton and Longinus, small in proportion to the figure of Christ, and also to the two pairs of figures in lower panels. Since David playing the harp completes the framed scenes at the bottom, a series of ancestors of Christ might be intended.[121] In a now-lost fragment of a Crucifixion at Strathmartine, the outstretched left arm only of Christ survived, together with the figure of Longinus and part of an attendant angel.[122] At Abernethy, Stephaton and Longinus thrust their lances upwards on either side of a skirted Christ [212], the monument again broken off at

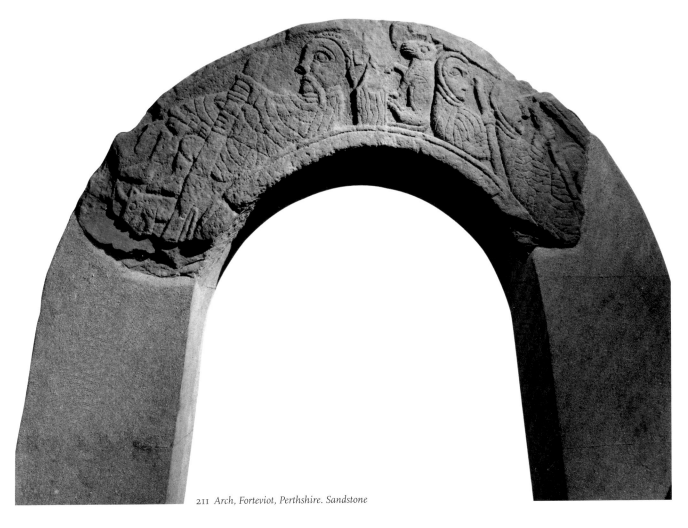

211 *Arch, Forteviot, Perthshire. Sandstone*

Christ's waist. Below his feet are three heavily cowled frontal faces, reasonably to be interpreted as the women present at the Cross or at the Resurrection.[123] The style is distinct from the majority of Pictish sculptures. On the Kirkcolm cross-slab Christ is represented in a segmented stylized manner, closely integrated with a relief-carved Tau-cross, again not easy to relate to the Pictish canon.[124] Most of these images of the Crucifixion have been vandalized.

Holy Men and Angels

On the great cross-slab at Nigg the figure of David, originally in high relief, has been systematically defaced, an odd choice for the Psalm-singing 'Men of Nigg' to molest, leaving the saintly Desert Fathers and the Mass in the pediment unscathed.[125] Presumably the total loss of literacy in respect of Christian imagery in post-Reformation Scotland saved them. Distinguished sculptures at Kinneddar and Tarbat are markedly smashed up, but the circumstances of their destruction are uncertain. The Tarbat fragment with the probable Old Covenant imagery at the top [213], contains in a lower section a row of three originally full-length bearded, frontal, robed figures, and part of the head of a fourth at the extreme left of the remaining portion of sculpture. Another

head, clearly from the same group, survives, its surface better preserved, detached from the rest.[126] Like the animal frieze above, these sculptures are essentially in two planes, the figures being clearly silhouetted against a flat recessed background. The Tarbat figures wear winnowing vertical draperies, the details of which are scratched shallowly on the surface and shaded with hatching, like an engraving. Nothing could be further from the deep plasticity of the pediment saints at Nigg, although the Crucifixion miniature in the Durham Gospels, which offers the best parallel for the curious layered bandage-like drapery of the Nigg figures, displays in the head of the crucified Christ the perfect model for the stylized design of the very low, curved triangular brows of the Tarbat figures.[127] The vigorous delineation of their heads is reminiscent of that of the Prophet Isaiah and the Patriarch Abraham (if so they be) in the *Christi autem* page of the Irish 'Garland of Howth'.[128] On the other hand, Christ's Apostles are frequently represented as a row of frontal figures, shoulder to shoulder, either accompanying Christ who stands in the centre as in the lost mosaic representing the Commission to the Apostles in the half dome of the Triclinium of Leo III in the Lateran,[129] or in an unbroken row, without Christ, as in the illustration to verse 4 of Psalm 18, 'in fines orbis terrae verba eorum', in the Stuttgart Psalter. In another illustration in the Psalter, to Psalm 88, verse 8, 'the assembly of the saints' consists of a seated Christ with only three standing Apostles, one on one

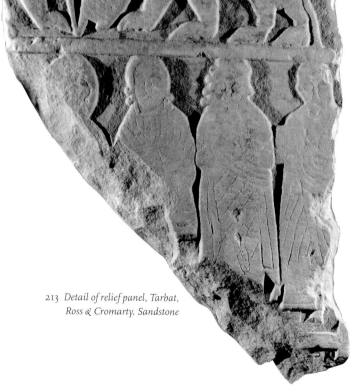

213 *Detail of relief panel, Tarbat, Ross & Cromarty. Sandstone*

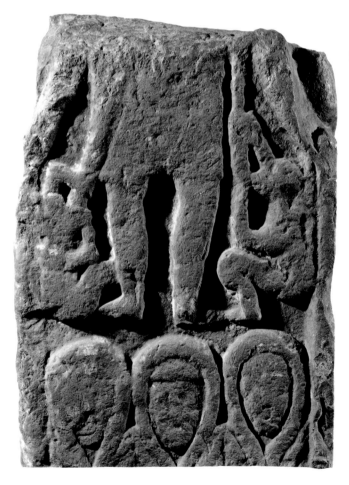

212 *Fragment of free-standing cross, Abernethy, Perthshire. Sandstone*

side, two on the other.[130] The fragmentary head on the left of the Tarbat group is markedly larger than the others and has a firm rounded contour. The line of the left shoulder (the viewer's right) of this figure is placed further down the picture space than the shoulders of the standing figures, which might suggest a seated figure. The rounded contour of its large head suggests a nimbus, lacking in the other figures, so the whole group would represent standing Apostles accompanying a seated Christ. But the inner surface of the apparent nimbus is segmented, as if representing hanks of hair, similar to the hair of the bust-length figure lodged in foliage in one of the fragments of sculpture at Reculver. The absence of a nimbus, let alone a cross nimbus, makes interpretation difficult.[131]

Within the limits of the space and style, the Tarbat figures are differentiated by the set of their heads, the size of their beards, and in three cases by the curled or spiky locks of hair which stick out around their heads, more locks showing at their right than at their left, recalling, though oddly misplaced, a spatial device used in the Apostles' heads incised on the wooden coffin of St Cuthbert.[132] The sculptor's interest in giving individual features to the Apostles (if so they be) connects Tarbat with texts such as *De Tonsura Apostolorum* preserved in the late 8th-century Irish 'Reference Bible', a brief description of the Apostles differentiating them by age and colouring, following the rules of Roman painting or of a specific example of such painting.[133] Pictures of the Apostles imported from Rome, are recorded by Bede at Wearmouth.[134] The figure second from the right at Tarbat has a more wild and rugged look than his companions. He is similar to the figure third from the left on the back of the Mercian Hedda Shrine in Peterborough Cathedral who has been identified as St Andrew, because in a 6th-century mosaic at Ravenna and elsewhere, St Andrew has heavy dishevelled hair.[135] In later medieval representations, the ascetic desert-dwelling St John the Baptist is also represented in this way.[136] Both at Tarbat and on the Hedda Shrine the categories of Christ's companions may be widening. Only one of the Tarbat figures certainly holds a book. He stands at the extreme right of the row, and is preserved very nearly full length. His small feet, sloping down in a perching pose towards the ground line, are reminiscent of the feet of relief-sculptured figures in the Midlands, at Castor and Fletton. The surface of both feet is now missing, but round the left ankle is a strap which at the ankle bone meets another strap descending from the hemline and which broadens into an oval disc, like a tiny 'belt of strength'. These thongs above and across the ankle are very specific and hard to parallel. We might expect Apostles to be barefooted in this period as they are, for example, in the Stuttgart Psalter, but in Early Christian art they are regularly represented wearing conventional sandals.[137]

At Dunkeld the back of the cross-slab, carved in a style similar to the Monifieth cross-shaft, represents two rows each of six frontal figures, big headed, in rectangular robes, their feet evidently turning in a little so that the figures appear to be forming themselves into a group [214]. They may have had attributes, but due to the present state of the sculpture it is difficult to be certain. They are identifiable as the Apostles essentially because of their number, the design with its emphatic roll call of six and six not so much less abstract than that of the twelve decorated bosses at the right of the Nigg cross-slab. A frontal figure on a much larger scale, probably nimbed, on the right side of the Dunkeld slab seems likely to represent Christ.[138] The upper part of the frontal figures of two Apostles appear on the fragmentary cross-slab in Brechin Cathedral [215].[139] The figure at

214 *Back of cross-slab, Dunkeld, Perthshire. Sandstone*

215 *Front of cross-slab, Brechin, Angus. Sandstone*

the left has a broad, squat, apparently beardless face. He has a nimbus, and smooth rounded hair, not tonsured, yet he is St Peter judging from the keys held up in his right hand. The head of the other nimbed figure is markedly longer and he is holding his right hand up, open in a gesture of acclaim. St Peter is most likely to have St Paul as his close companion.[140] Immediately above their heads, the centre of the short armed cross is filled by a large framed medallion, supported by stocky angels on either side. Inside the medallion sits the Virgin supporting the Christ child from above with her left hand and from below with her right. The child sprawls across her knees like a giant chrysalis, but lifts his head into the same upright frontal position as the Virgin's. They have a family likeness in that their hair is bunched far out over the ears and enclosed in a net or cap, oddly reminiscent of the unusual coiffure of the stone head of a Celtic Goddess surviving from the Roman fort at Birrens.[141]

The upper arm of the cross, directly over the head of the Virgin, frames a large eagle-like bird, walking sideways. The presence of the Holy Spirit, in the form of a dove, over the head of the Virgin is a precocious image, paralleling the dove perching on the Virgin's head in the famous pictorial exploration of Christian doctrine on *f.* 75v of the Winchester New Minster Offices, of the early 11th century, and the same image occurs among the sophisticated decoration of the Arenberg Gospels' canon-tables.[142] In the spaces under the cross-arms the Brechin cross-slab introduces another new theme, the symbols of the Evangelists, the

eagle of St John, the head only surviving, with a book at the level of its breast, and the head of the fierce snarling lion of St Mark who lifts up a book with his paw. The equivalent position above the cross-arms is occupied by two robed winged figures, human in outline, whose heads are gone. These would be expected to be the other two Evangelists, Matthew and Luke, though in a curious order of appearance whichever way round we read them. To match the Evangelist symbols below, these human figures would have required, in the case of Luke, the head of a calf or ox. Insular artists were well acquainted with zooanthropomorphic symbols. St John on the Brandon Plaque has a human body and hands, and an eagle's head. The Evangelist symbols on the first canon-table of the Barberini Gospels have human bodies but animals' feet and heads.[143] The Lion of St Mark at Brechin might be of the type used in the Barberini Gospels, but its thin upraised foreleg and the scale of its head much more suggest the silhouette of the rearing lion symbol in the cross-carpet page, *f.* 27v, of the Book of Kells. Nor is it apparent that either of the upper figures at Brechin have the necessary animal forelimbs. The two sets of figures are hard to reconcile, even given the visual mix that zooanthropomorphic images entail, and the upper figures should probably be interpreted as angels, accompanying the Holy Ghost, just as their colleagues below accompany the Virgin and Child.

An interesting variant of the iconography of the Evangelists occurs on the front of the Elgin cross-slab [216]. The upper part of the composition consists of an upright cross with small hollows

216 *Front of cross-slab, Elgin, Moray.*
Granite with heavy crystals of felspar

217 *The Book of Kells, Dublin, Trinity College MS 58*, f. 202v,
'The Temptation of Christ'

bearded head, more or less frontal, with a hunched left shoulder, above which his symbol projects, perhaps a winged calf with a small head as in the Kells canon-tables,[146] or perhaps an eagle. The packing together of the Evangelist and his symbol is a rare type of representation, found oddly enough when there is very little room for both of them, as on the flanks of the gold chalice made for Duke Tassilo of Bavaria in the 770s,[147] and also on the cross-arms (two only survive intact) of the Ruthwell Cross.[148]

If the two winged figures at the top of the Brechin slab were Evangelist symbols, they would of course hold their Gospel Books. The angel symbol of St Matthew regularly holds a book, as he does, for example, in the Lindisfarne Gospels. In Western art angels themselves, however, usually hold rods or sceptres, scrolls, rolled up or open, or have covered hands, but do not often hold books. Exceptions to this rule are found in the Book of Kells. It is indeed one of the idiosyncrasies of that manuscript. Angels carrying books occupy the spandrels in the top corners of the Temptation miniature on *f.* 202v, illustrating Luke 4, 9–12 [*217*]. Two other angels hover over Christ's head, their function being to guard Christ in accordance with the verse from Psalm 90 quoted by Satan to tempt Christ. Christ who holds a rolled-up scroll in his hand, confutes the Tempter with a text from Deuteronomy. It is possible to see in the elaborate composition of the miniature, especially in the crowds of attendant figures, an intention to illustrate a further passage in Luke, 4, namely verses 16–21, where Christ reads a text of Isaiah in the Synagogue in Nazareth and declares that the prophesies contained in it are now fulfilled, 'impleta est haec scriptura'.[149] Although prophesy would rather be thought of as contained in a scroll, and St Luke has 'revolvit' for Christ's opening the writings of Isaiah, the word 'Liber' would be visualized as a codex. That the books held by the angels in the spandrels contain prophetic writings is supported by the conspicuous presence of a book-holding angel in the initial to St Mark's Gospel, 15, verse 25, on *f.* 183, 'Erat autem hora tercia'.[150] The division of Christ's garments at verse 24, in fulfilment of the prophesy of Psalm 21 immediately precedes this initial on the opposite verso, and at verse 28 we read 'Et impleta est scriptura quae dicit: Et cum iniquis reputatus est', the prophesy of Isaiah 53, verse 12. Thus Kells's angels may be charged to bring to bear the witness of the Prophet, and the same explanation seems appropriate in the case of the angels who stand one on either side of the cross-stem of the Aberlemno roadside cross-slab [*218*], each holding out a book towards the cross, signifying prophecies of the Passion such as those contained in Psalm 21 and Isaiah 53. The angels may be meditating on these texts, but the eloquence of their pose, bending their necks forward and with their wings drooping like heavy plants left in a vase without water, clearly refers to the tradition that all God's creatures sympathized with the suffering Saviour. In Carolingian and later Anglo-Saxon art the sun and moon are literally darkened, and angels throw themselves down around the cross.[151] The angels at Aberlemno (really cherubim, as they have four wings each) are symmetrically placed

between the arms, and a decorative circular boss in the centre. On either side, above the cross-arms, figures with wings conjacent to their bodies are broken off halfway up, as they also are at Brechin, but where the Brechin figures are undoubtedly angels, the Elgin ones will have been Evangelists, each with his symbol beside him in the same small compartment. The sculpture is laid out like a cross-carpet page, with the only certainly identifiable Evangelist, St Matthew, at the bottom left. Given the extraordinary recalcitrance of the medium chosen by the sculptor, the St Matthew group is quite fully realized. The Evangelist himself is bust length with narrow shoulders and a large face, in three-quarter view, with close fringed hair, heavy features, bulging eyes and short, wide-nostrilled nose, pouting lips and round chin. The naturalism and projection of the face is similar to that of David on the St Andrews Sarcophagus [*189*].[144] His angel symbol, tucked behind him, is in profile, as in the Lindisfarne Gospels,[145] but has the extra Pictish detail of scrolled hair at the nape of his neck, like the leading warrior in the 'three warriors' frieze from Birsay [*78*]. Under the right cross-arm the Evangelist has a moustached

but by no means identical. The angel on the spectator's right [219] is in a turning pose and by a remarkable device his left heel slips out of the picture space, across the line of the frame on which his right foot is resting, giving an impressive thrust to his otherwise still and contemplative pose.[152] The Pictish composition, where the angels are stationed in the places conventionally reserved for the mourning Virgin and St John, shows a fine sensibility on the sculptor's part, but is not without precedents in early Christian art. In a 6th-century cut and engraved glass chalice at Dumbarton Oaks, angels evidently carrying books stand on either side of a cross, ceremonially represented within a curtained ciborium.[153] These book-carrying angels have been identified as symbolizing the role of deacons serving the priest and carrying and reading the Gospels, in the liturgy of the Mass. The *Gloria*, following the *Kyrie*, is particularly the angels' hymn, and suggests their mystical

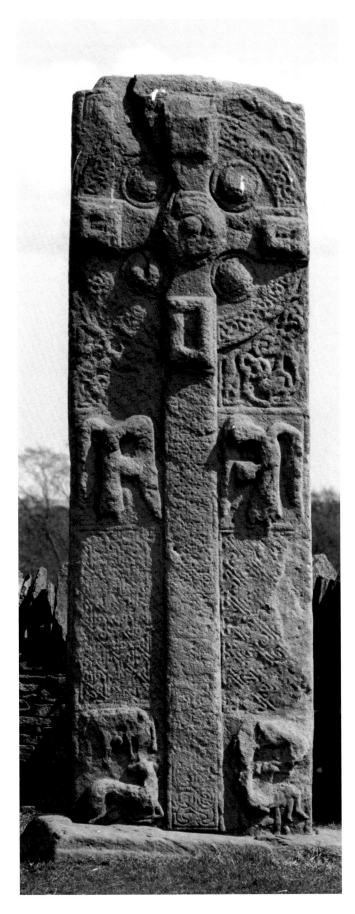

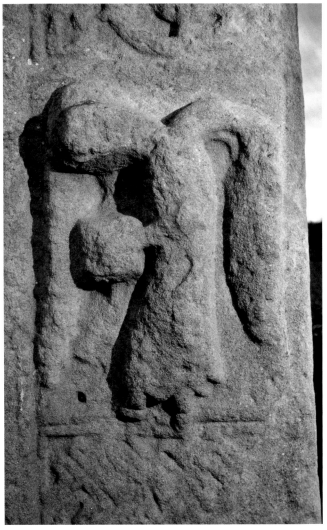

219 *Detail of angel on front of cross-slab, Aberlemno roadside, Angus. Sandstone*

218 *Front of cross-slab, Aberlemno roadside, Angus. Sandstone*

presence around the altar. The Aberlemno angels, therefore, might basically parallel the liturgical emphasis given to the Nigg cross-slab, with its overt imagery of host, chalice, and altar frontal.[154] In Book V, chapter 13 of his *Ecclesiastical History*, Bede vouches for the association of angels in the Insular period with another form of book, the record of a man's good deeds which will be shown up at the Judgment after his death.[155] If as the Tarbat inscription suggests, the sculptured crosses of the Picts have a commemorative and intercessionary intention, then the two Aberlemno angels might be holding up to the redemptive Cross the written evidence that the commemorated person, presumably

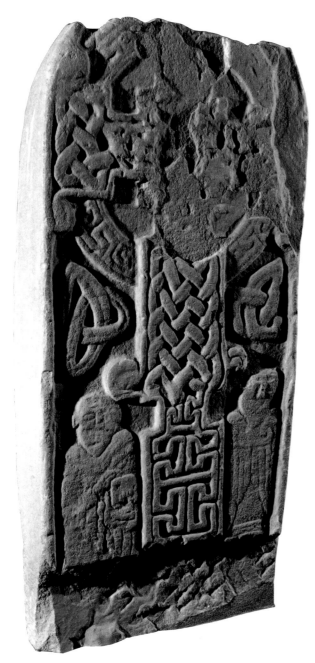

220 *Cross-slab, St Vigean's, Angus, No. 11*

the patron and donor of the great work, was fit to receive reward in heaven.

Angels commonly accompany the cross in Pictish art, but they are normally less iconographically charged than at Aberlemno, more witnesses than participants, although they doubtless share the function of the seraphim in the Crucifixion miniature in the Durham Gospels, revealing the cross as the fulfilment of the Ark of the Covenant of III Kings, 6.[156] At Kirriemuir, No. 2 [183], two angels kneel, one on either side of the upper arm of the cross, in a twisted pose similar to the angel in the *Hora autem tercia* initial in Kells. At Shandwick [200] cherubim stand below the arms of the cross, each in a little framed compartment, like a rustic garden plot. At Dunfallandy [49] the angels are one above the other, at the right of the cross-stem, simply as motifs along with eight variegated others. Even more desultory are the single angels on the cross-slabs at Glamis, No. 1 [34], and Rossie [86], though the latter is a carefully composed figure with wings closely encasing his body like classic versions of the Old Testament guardians of the Ark, such as those in the miniature of the Tabernacle in the *Codex Amiatinus*.[157] The same type of cherubim appear standing side by side, bolt upright, ending the sequence of subjects along the surviving sculptured face of the recumbent at Kincardine [297].[158] At Eassie [179] an angel with two pairs of wings and a flared skirt stands at the left side of the cross-head. But the fragmentary winged figure at the right is no angel. His feet are not human, but short, high, and rounded, like hooves, and he has dew-claws at his heels, a feature which he shares with the devil in the Temptation miniature in Kells [217]. The emblem of the Cross at Eassie is therefore surmounted by a curious duality, perhaps signifying judgment, or psychomachia.[159] At Invergowrie, the lower part of a single angel, and of two men, survive in a photograph of the reverse of a fragmentary cross-slab. The figures give off a sense of engagement in a narrative, such as that of Tobias and the angel, but too little remains to allow the subject to be identified.[160] A similarly tantalizing fragmentary sculpture came to light in the 2001 excavation of the site of the Hilton of Cadboll cross-slab, evidently from the hitherto unknown front. What may be the figure of an angel (only his legs and feet, the hem of his robe, and possibly wing tips remain) follows another figure, consisting only of naked legs, towards the left. Was this the Expulsion from Paradise? Much less hint of narrative action is given by the stationary frontal angel at the right of the stem of the cross on the front of St Vigean's, No. 11 [220].[161] He and the frontal vested cleric holding a book in the equivalent space at the left might simply be space-fillers, though of rather meaninglessly mixed categories. On the other hand, this very mixture, priest and angel, on either side of the block-like base of the cross recall the very start of St Luke's Gospel when Zacharias sees an angel 'standing on the right of the altar of incense'.[162] This interpretation is tempting, since we have tentatively suggested above that the base of the back of St Vigean's No. 11 might represent the Emmaus pilgrims in the last chapter of St Luke's Gospel [209].

Clerics and Images of the Judgment

God's servants on earth – clergy, ecclesiastics, unidentifiable saints – occupy positions similar to those of the angels in relation to the cross. Two frontal robed figures, each holding a book across his body, flank the cross-stem at Aldbar.[163] At Papil [228] two pairs of hooded clergy, holding crosiers, two of them with shrines or book satchels hanging on their chests, move towards the stem of a circular-headed cross.[164] On St Vigean's, No. 7, two tonsured figures, with cowls thrown back, wearing long, carefully delineated vestments and high-ankled shoes, and carrying staves, the one behind with a shrine or book satchel slung around his neck, move from the left towards the cross-stem [221].[165] Their heads frame the block on which the head of a naked inverted figure is placed in the upper compartment of the sculpture. Their evident indifference to that scene may be compared to that of the priest and the Levite in St Luke's story of the Good Samaritan.[166] Certainly their relationship to the upper scene is much less apparent than that of the pagan sacrifice to the Eucharist shared by SS Paul and Antony on the other side of the cross-stem.

Two similar clerics, with elaborate vestments, walk towards the plinth of the cross represented on the great cross-slab at Fowlis Wester [222].[167] Facing in towards the stem of the cross, on either side, above the level of the walking clergy, are two more clerics in wonderful textured robes, seated in the pose of Paul and Antony at St Vigean's but separate, both spatially and psychologically. They seem engrossed by their own hagiography, in the one case involving a tree similar to the one planted by the waters in Psalm 1, 3, up behind his head, and set before him a tall upright plant stem bearing nine short branches ending in leaves or fruit, two too many to be the gifts of the Holy Spirit. For his identification, we need a holy man who wrote nine homilies or founded nine churches.[168] The other cleric is accompanied by an angel, perhaps his companion and informant, in the manner of St Guthlac of Crowland.[169] If the pictorial imagery here is both suggestive and mysterious, so too is the close encroachment of Pictish symbols to the two figures seated facing one another on elaborate chairs on the back of the Dunfallandy cross-slab [77]. The ground lines on which the figures are sitting slope up and straighten to form the plinth of a small free standing cross which does not block their view of one another but looks more like a piece of household furniture, or topic of conversation. The intimacy of the figures' relationship with the cross, their proprietary air, bears some resemblance to the drawing in the New Minster *Liber Vitae* of the joint donation of an altar cross by Cnut and Aelfgyfu.[170] At Dunfallandy the figure at the left, smaller and lacking a hood, has been interpreted as a woman.[171] The scene might be interpreted as the Pictish equivalent to a memorial to the combined enterprise of Helena and Constantine to locate and glorify the True Cross. But it is not the nails of Christ that hang about the bridle[172] of the vested figure as he rides away in a lower compartment of the cross-slab but more of the cryptic Pictish symbols.

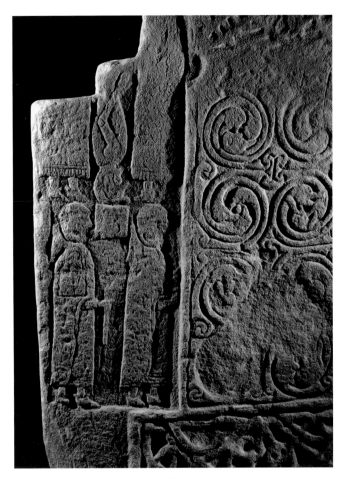

221 *Detail of robed clerics, cross-slab, St Vigean's, Angus, No. 7*

In the remaining space below the rider what appears to be the tools of a smith are strongly delineated, a pair of pincers, a hammer and an anvil.[173] A skilful craftsman, a smith, useful to the monastic community he served but personally sunk in sin, is the subject of an admonitory chapter in Book V of Bede's *Ecclesiastical History*. In a vision, he saw Hell open, and the fate of sinners such as Caiaphas 'who slew the Lord', and a place reserved for himself in the everlasting flames.[174] Bede's thinking on such matters was much influenced by the vivid anecdotal *Dialogues* of St Gregory. In one of Gregory's stories a young sinner, repenting too late, feels himself steadily drawn head first into the throat of a dragon.[175] Damnation imagery of that kind forms the frame of the back of the Dunfallandy cross-slab. A human head is caught, poised between the tongues or scorching breath of two dragons whose slender eel-like bodies end at the base of the panel with a last flick of their tails, the very same dragons which, on a different scale and very different context, form the edge of the 'Tara' brooch.[176] Many other forms of animal play their part in Pictish representations of death and damnation. At the very bottom of the back of the cross-slab at Fowlis Wester, a monster has hold of the back of a man's head, ready to devour him.[177] At Meigle, on the side of a recumbent monument, a gravemarker, No. 26, among other

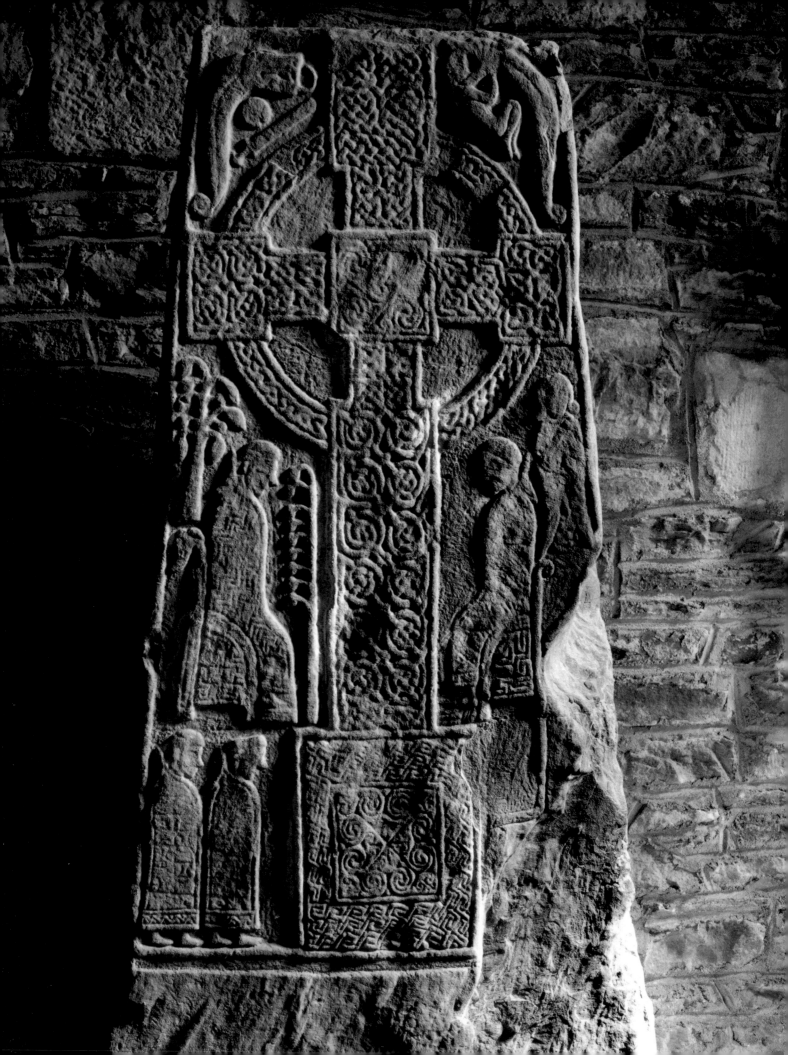

223 *Detail of left side of recumbent, Meigle, Perthshire, No. 26. Sandstone*

224 *Detail of end of recumbent, Meigle, Perthshire, No. 26. Sandstone*

225 *Fragment of relief sculpture, Rosemarkie, Ross & Cromarty, No. 3. Sandstone*

frightening prowling monsters, two bears or lions finish off between them the remains of a human body [223]. A leg protrudes from the mouth of one of them, and a little round profile human head, drafted in from a Roman coin, lies between their adjacent snouts. In a relief from Murthly one of the lions or bears has just caught up with the fleeing naked man, who casts a despairing glance back over his shoulder [182]. On the end of Meigle recumbent, No. 26, a similar pursuit involves a monster well equipped to follow a scent [224]. The claustrophobic encroachment of three beast heads, licking, sniffing, and on the verge of swallowing, in a fragmentary relief from Rosemarkie, looks more

like the torments of the damned, not just the imminence of damnation [225].[178]

The Picts share with other parts of the Insular world more conventional depictions of the damned. A naked figure, one of those who 'slew the Lord', or Satan himself in the depth of Hell, squats, tugging his beard and bitten by serpents on the genitals and around his head in the central column of the first canon-table in the Barberini Gospels. The very same figure is carved on the flat end of a fragmentary cross-arm from Strathmartine [226].[179] The figure is alone in his confined space, unthreatened. Confronted wrestling men on a panel from Pittensorn in Perthshire, probably

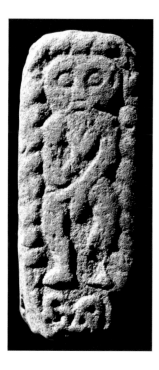

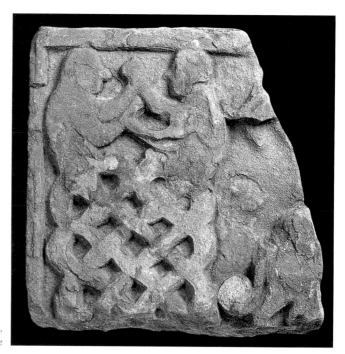

226 *End of cross-arm, fragment of free-standing cross, Strathmartine, Angus, No. 8. Sandstone*

227 *Fragment of panel, Pittensorn, Perthshire. Sandstone*

part of the Murthly shrine, have their genitals bitten by serpents [227].[180] Semi-naked figures in writing poses pull one anothers' beards in the *Quoniam* initial of the Book of Kells, the whole of the decoration of which can be interpreted as representing the fate of sinners, heretics and schismatics as well as various sensualists.[181] The back of a fragmentary cross-shaft on Canna represents a serpent evidently attached to the genitals of a man who stands with legs set wide apart. The man is clothed, so this image of the punishment is muted.[182]

An exhibitionist pose is adopted by a small frontal winged figure at the top of the Cross on the front of the beautifully carved cross-slab at St Vigean's, No. 1 [105]. He looks more like the Lincoln Imp than an angel.[183] Devils are much rarer in Pictish art than angels, but denizens of Hell would seem to be represented at the base of the cross-slab from Papil [228]. They wear tunics, carry axes, and are bird headed, and so are clearly related to the masked men of the incised symbol stones at Mail and Rhynie. The Papil figures have thin legs and claw feet, like Harpies, which no mummer's disguise would explain, and they should therefore probably be regarded as traditional images deliberately demoted to the role of devils, torturing a soul by pecking his head with their heron beaks.[184] The composition of the Papil sculpture may be read as a whole. We move from Hell at the bottom, up through the zone dominated by a possible latecomer to the collection of Pictish symbols, who here stand like Cerberus guarding the gate of Hell.[185] Above him again are the vowed servants of Christ, sheltering under the emblem of the cross. In the Epistle to the Hebrews, St Paul states that through Christ's sacrifice sins and iniquities are blotted out.[186] The cross as a refuge for the penitent is succinctly represented by the crouching man huddled in the space above the left cross-arm of the cross-slab, Meigle, No. 7 [229].[187] He holds on to the rim of the upper panel of the cross.

In the hands of the great master of Meigle No. 2, the battleground between redemption and damnation, the area of retrieval, Purgatory, is depicted with power and subtlety. On the front [199], the breadth of the stem of the great wheel-cross leaves only a narrow space beyond it on either side. Menacing coiled dragons have made their way up the flank of the cross on the right, and another is stretching up at the base of the stem at the left. Dangling and struggling in the shaft above him is a human figure, who is being hauled up by his arm by a helper, crouching on the curved ledge of the cross-stem. The prayer of St Perpetua for the soul of her young dead brother was able to bring him 'out of a dark place'.[188] In Bede's story of the smith, the members of his community were so convinced, out of his own mouth, that he was everlastingly lost, that no one ventured to say Masses or sing psalms or even pray for him.[189] The efficacy of all these things is being asserted in the programme of the great Meigle monument, the Daniel/Christ triumph over the lions on the back, the cross of the resurrection on the front, and the spirited rescue act being deftly conducted at its left-hand side, under the big studs on the bottom left curve of the ring cross which symbolized the wound in Christ's side whence the saving sacraments flowed.[190] The Pictish church which raised these spectacular monuments will have didactically pointed to their imagery as well as conducting the ritual of the Mass in sight of them.

In the Romanesque period, a favourite subject for artists and their patrons was the parable of Dives and Lazarus in Luke, 16. The poor leper, starved and neglected, is finally lifted into Abraham's bosom and the bliss of paradise, while the rich man for all his past feasting and purple clothes is doomed to eternal torment in the flames of Hell.[191] No sculpture of Dives and Lazarus survives in Pictland, or anywhere in the Insular world.[192] But with characteristic precocity the sculptor of a cross-slab at Meigle, No.

27, now mostly destroyed, represents a subject exactly comparable to that of Dives and Lazarus [230]. A semi-naked man crouches behind the tilted chair of a long-garmented figure sitting at what appears to be a table. Obviously a contrast in social status is implied by the different appearance and the relative positions of the figures. In the Catholic Epistle of St James, 2, the man with the gold ring and gay clothing is welcomed at the feast and given a good place at table, while the poor man in vile clothing is ordered to stand or to sit out of the way under the host's footstool. The point being made by the sculpture would be the message in James, 3, that 'if a brother or sister is left naked, and destitute of daily food...you that have showed no mercy will receive judgment without mercy'. In so far as the image is drawn from St James's Epistle, the Meigle sculpture extends the general Pictish contribution to the iconography of the Apostles, and is another example of their interest in literal illustration, like the visual quotation from St Jerome's *Life of St Paul the Hermit* at Nigg and the allusion to Jeremiah 34 at Tarbat. The little man crouching behind the chair at Meigle, a precious piece of evidence surviving by chance, indicates the range and sensitivity of the Pictish iconographic programmes which we know now only in part.

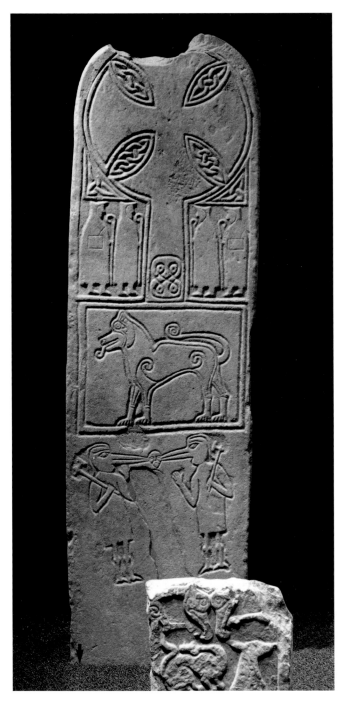

228 *Cross-slab, Papil, Isle of Burra, Shetland. Sandstone*

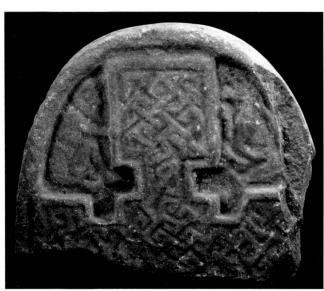

229 *Fragment of front of cross-slab, Meigle, Perthshire, No. 7. Sandstone*

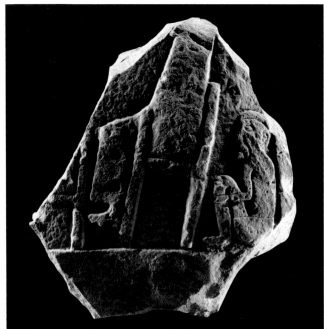

230 *Detail of back of fragmentary cross-slab, Meigle, Perthshire, No. 27. Sandstone*

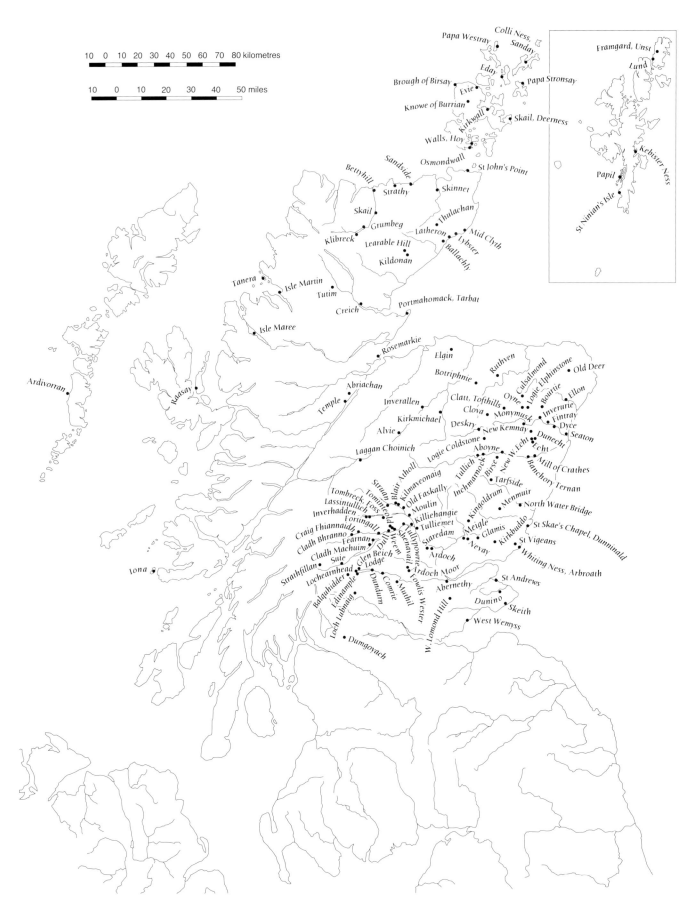

Map 5
Pictish sites with cross-marked stones

Form and Function of Pictish Sculpture: I

The Picts were presumably no different from any other cultural group in that they valued display. The testimony of documentary sources, such as are available for contemporary Ireland, is scarcely needed to appreciate that fine jewelry would be an accepted indicator of status.[1] As we have seen, some Picts in the 7th century were aware that to appear decked with a heavy silver neck chain [109, 111], whatever its origin, enhanced their standing in society.[2] Later, silver mountings for weaponry and silver tableware [150–66], all intricately ornamented, are evidence for a society that, when appropriate, raised military and communal activities into the realm of ceremony.

The patron of the Rogart brooch [138] added to the gleam of silver showy evidence of the prestige of consummate craftsmanship and design, polychrome effects of gilding, and coloured glass, and eye-catching birds' heads expressed in the round in high relief. The same combination of precious metals and polychrome mounts and inlay creates a shining and colourful container for the sacred contents of the Monymusk reliquary [167]. There is nothing muted about surviving Pictish metalwork, but the loss of liturgical vessels, together with the absence of book art, depresses a sense of the cultural strength, even identity, of the Pictish church. For this we must look at Pictish sculpture, its variety of forms, and its quality.

The origin of the forms of sculpture raised in the British Isles in the early medieval period is a long-standing problem. Roughly analogous Roman monuments such as the 'Jupiter columns' with their shaft-like shape and niched figures may have played a part, and contemporary Merovingian and Lombardic decorative sculpture in relief provides parallels, but no fully adequate explanation has been forthcoming.[3]

Although the predominant form of sculpture in Pictland is the cross-slab, Pictish sculpture is part of this wider Insular problem. Certainly there is nothing in Europe with which one can compare the Anglo-Saxon free-standing crosses at Ruthwell and Bewcastle, or the Irish crosses at Ahenny and Clonmacnois, but there is also nothing like the cross-slabs at Pictish Meigle [296] and Shandwick [200]. Nor can the nature and content of all these Insular monuments, in form or art, explain each other, one originating region being subsequently emulated by the others. In its enigmatic nature Insular sculpture is a single cultural phenomenon, dependent on a number of shared cultural and historical factors, but which, nevertheless, met with a distinctive response in each area. The differences might stem from yet-to-be-established historical links between the individual Insular regions and specific monumental traditions in France and Italy.

The Cross-marked Stones

The simplest form of Pictish monument is the cross-marked stone.[4] It originated, without doubt, in Irish missionary work among the Picts in the 6th and 7th centuries. Adomnán in his life of St Columba tells the story of how one of the earliest of these crosses, perhaps the first, was made by the Saint himself when he marked the gates of the hilltop fortress near Loch Ness, the northern base of the powerful pagan Pictish king Bridei, with 'the sign of the Lord's cross' in order to gain entry and secure his cooperation in allowing a start to be made in the conversion of his people.[5] The conformity in every respect with the cross-marked stones on Iona, and in the west of Scotland generally, is in itself evidence for the period at which Christianity began, literally, to make its mark on Pictland.

With the recent full description and illustration of the comparative material in the west of Scotland a much more confident approach to using the Pictish evidence is justifiable. The great diversity of forms of stone and types of cross being carved in the west is exactly matched in the Pictish corpus. We can imagine that the Irish missionaries selected from the Pictish terrain stones suitable for carving with crosses similar to those they used on their home ground. They were rarely fully shaped or dressed, but certain approximations of forms are favoured in both areas: the pillar, the kite shape, the heart shape, the oval and the roughly rectangular slab comprise an identifiable range of formats which are sufficiently consistent to define a monumental tradition datable to the 6th to 9th centuries.[6] This is true also of the range of techniques, which comprises incision, deep broad gouging, false relief, and true relief, the latter employed for simple Latin crosses in high relief on boulder-stones, and on plain relief crosses which are as technically competent as the crosses that define the symbol-bearing cross-slab carved in relief. The surfaces of the stones are sometimes left naturally rough, but often advantage has been taken of the split along a bedding plane to obtain a near dressed appearance.

Dressing of slabs bearing plain relief crosses seems relatively common. Technically, such slabs are likely to belong with those that can be dated by their ornament to the late 7th to the 9th century. Some stones, those marked on two broad faces, will have stood erect, others, of thinner section, will have been recumbent. Here one concludes that the function dictated the form; the recumbent slabs and flat-sided boulder-stones marking graves, while the erect pillars and slabs could serve a range of functions. This functional aspect of the study of cross-marked stones has yet

to be undertaken, as indeed has the study of the possible significance of the diversity of the cross-types displayed on monuments and on the walls of certain caves, which by association, were regarded as sacred. Again, however, it must be said, that the proportions of even the simplest linear cross and the nature of its terminals make it possible to identify Early Christian crosses with reasonable confidence.

Different types of Early Christian crosses carried different meanings and some of these were known about in the Insular world. It has been shown, for example, that elements associated with the bejewelled cross erected on a stepped base at Golgotha influenced the appearance of the Irish high crosses, with their spiral-boss ornament, stepped bases and canopies. Crosses in circles derive from the common Early Christian motif of a cross surrounded by a triumphal wreath. This kind of cross appears in

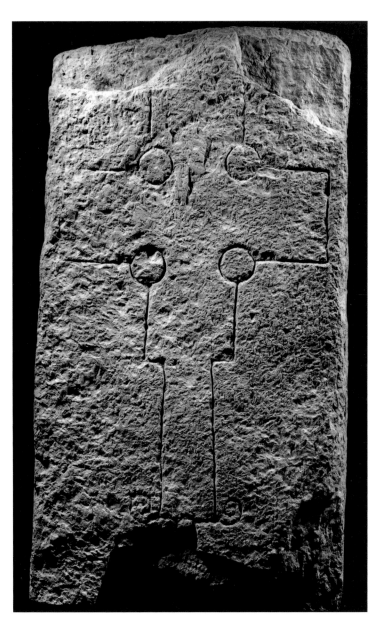

its simplest form on cross-marked stones but it may also have influenced the great ringed cross-heads of Ireland and Iona.[7] It would not be surprising if the diversity of cross-types used on stones in early medieval Scotland reflected knowledge of a set of venerable symbolic forms which were considered appropriate for use in certain circumstances. In time the specific meanings could have been blurred, taking on, possibly by minor elaboration, more generalized or localized significance. A striking example of diversity calling for explanation is the large slab on Iona bearing four differentiated types of Latin cross.[8] Were these types selected for mere elegant variation or did each carry a specific meaning eliciting different responses from those standing round the slab? Similarly, one wonders why two obviously contemporary medieval recumbent slabs on Isle Maree, sited within an Irish/Pictish border district in Ross & Cromarty, have identical distinctive shafts, with a base and tenon depicted, but are given different cross-heads, one a cross-of-arcs and the other a cross-head with straight arms and curved armpits.[9] If an intended specific meaning is attributable to the acknowledged diversity of the cross-types in the west and east of north Britain then they present a problem of interpretation quite as intractable as the repertoire of Pictish symbols.

It is tempting to think of the very simple linear crosses as primitive and early, and the more complex designs as a development, but it is safer to assume that the requirement for simple crosses persisted long past the missionary period. The more complex crosses, however, are more likely to belong to a period when the Picts had access to a range of models for cross elaboration, in metalwork and manuscript art, to which their own associations could be attached. Given the sparse archaeological traces of ecclesiastical sites, the low survival rate of Pictish liturgical metalwork, and the absence of manuscripts, the evidence present in the cross-marked stones for knowledge of these media should be exploited to the full. The outline Latin cross with hollowed armpits probably had its origin on Iona. Its occurrence in a Northumbrian context, in conjunction with a stepped base, incised on an inner board of the coffin-reliquary of St Cuthbert provides a late 7th-century date for the type, and permits the speculation that the design was chosen for the coffin as a conscious memento of the role played by Iona in the foundation of Lindisfarne. Cuthbert's personal association with the Columban tradition at Melrose and even his concern for the well being of the 7th-century Pictish church would have reinforced the appropriateness of the choice.[10] When the Pictish church used this type of outline cross on their incised cross-marked stones [231] and in relief on their cross-slabs it too may have had in mind the part Iona played in their conversion and the formative years when they were part of the Columban confederacy which included Northumbria.

231 *Incised cross, Walls, Isle of Hoy, Orkney. Sandstone*

232 *Fragment of incised cross, Ballachly, Caithness. Sandstone*

When the first Irish or British missionaries introduced to the Picts the idea of carving a cross on a stone they will also have explained how the Christian symbol should function in a Christian society. It would primarily be as the embodiment of the central belief of the church that Christ's sufferings on the cross and his subsequent Resurrection gave mankind the hope of eternal life. The cross was the basic aid for instruction and devotion. It could also mark as sacred the ground on which it stood, whether on a grave or within an enclosure. Displaying a cross could also afford protection; at the entrance of a building, at a landing-place for boats, on a remote mountain pass or for the area around a settlement in general. Displaying the cross was at the very least a token of the acceptance of the Christian faith and obedience to the Church. The presence of clusters of cross-marked stones, no doubt functioning in different ways, are evidence for thriving Christian communities. When they are associated with cross-slabs, gravemarkers and other church furniture – as, for example, at Tarbat and Rosemarkie – this assemblage of sculpture affords the best evidence we have for locating the monasteries that Irish and English sources record as having been established among the Picts in the 7th century. Some of these sites that have the full range of monumental types will be discussed in this and the following chapter.

It is useful to look more closely at this material first in two somewhat neglected areas – Caithness in the far north and Aberdeenshire north of the Grampian range – and then in Perthshire, the culturally sensitive district that was an important gateway to the west.

The Caithness stones are of special interest because of the complexity of their cross designs. For example, at Mid Clyth, between Lybster and Ulbster, there are two monuments incised with cross-types of unusual form.[11] One, in the graveyard, is basically a simple linear cross, but its top arm develops spiral terminals and its transverse arms end in circles with a central dot.

The other, now in private hands, displays an incised outline cross with circular terminals, an unusual type for the Pictish area. These terminals can be paralleled in the West Highlands, but the sculptors at Mid Clyth were sensitive to both of them. The recent find at Ballachly, Dunbeath, Caithness is even more remarkable [*232*].[12] Unless simply a preliminary sketch for some ambitious project, the slab is incomplete, with the lower arm missing. The control of the surviving incision is weak, making it difficult to be sure of the exact nature of the terminals. The cross-arms are splayed and the spiral-ended terminals have been described accurately as finials, forming, as it were, extensions from a band or collar. The left-hand terminal of the upper arm is rounded almost to a complete circle. This circular area is filled with either rays or a roughly executed equal-armed cross with a saltire cross superimposed. The left-hand terminal of the transverse arms is similarly, but more crudely treated. The right-hand terminal of the upper arm also turns into a circle but it is split by an inner curve to form a hook-like crescentic shape.

All these forms are strongly reminiscent of the treatment of initials in the earliest decorated Irish manuscripts, in particular, in the *Cathach* of St Columba, where similarly antennae-like spirals emerge from a collar attached to the body of a decorative letter. The splitting of the bowls of decorated letters in the *Cathach* also produce a crescentic shape.[13] Although the treatment of the rayed terminals of the Ballachly cross only vaguely suggests the monogram of Christ (the Chi-Rho), the fish within the upper right-hand quadrant is more certainly the Early Christian symbol for Christ, the Greek word for fish, *icthus*, being an anagram of Christ's name. The somewhat minnow-like Ballachly fish is much more like the Christological fish which swim through the decorated pages of the Book of Kells, than the full-bodied cock salmon used on incised Pictish stones [*76, 245*].[14] It seems, then, that the patrons of the cross at Ballachly knew at least one universal Christian symbol and possibly, the design of decorated letters of a type used in an early Columban manuscript. To add to the richness of this essentially calligraphic cross the top arm has a further curvilinear extension on its top. This might also be an echo of the explosion of spiral ornament which is a regular feature of the tops of decorated letters in Insular manuscripts. Whatever the status of this cross-marked stone there is no doubt that the complexities of its design belong with cross-art in other media and its discovery greatly increases the cultural expectations of the ecclesiastical site with which it is associated.

The large cross-marked stone standing within the cemetery of St Thomas's Chapel, Skinnet, by Halkirk, also in Caithness, suggests that its sculptor had access to similar sources [*233*].[15] The cross is very worn, but the design has been accurately preserved in a drawing. It consists of an encircled cross-of-arcs with the arms decorated with interlace. The slab is 150 centimetres high, 84 centimetres wide and 13 centimetres thick and the diameter of the circle fills the breadth of the slab. A circular element at the crossing point is suggestive of a rivet serving both to hold the

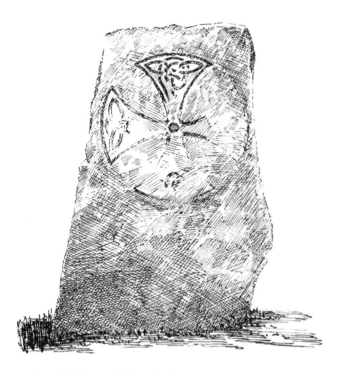

arms together and to attach the cross to a disc. Such a cross is very like a design for metalwork crosses used for pendants or fittings for ecclesiastical objects. For example, a mould for casting an equal-armed cross of similar design was found at the Northumbrian monastery at Hartlepool, and the suite of encircled crosses which were used for the bases of the silver bowls in the St Ninian's Isle treasure [150–55] contains many elements of the design.[16] The Skinnet cross, being carved in stone is, of course, very much larger, but even so the design manages to convey the delicacy of metalwork or indeed of drawing. The encircled cross-of-arcs with interlace-filled arms at the centre of f. 85 v of the Book of Durrow [8] is another close parallel.[17] The importance of this particular cross-marked stone is enhanced by there having been a very fine cross-slab, of equal sophistication, at the chapel site [47].[18] Although the exact significance of the Mid Clyth crosses will never be known, the treatment of their spiral and disc terminals can be related to those at Ballachly and suggest regional experimentation and taste. The cross-marked stones at all three sites hint at cultural resources in the area otherwise absent, and none are likely to be missionary crosses. Either they are copied from the repertoires of treasures belonging to a centre of excellence in their region or – a more ambitious speculation – they may function as durable representations of venerated art objects on

233 Cross-slab, Skinnet, Caithness. Sandstone.

234 Tullich, Aberdeenshire, churchyard from the air

their sites, which in the long term proved more vulnerable to theft and destruction.[19]

The cross-marked stones of Aberdeenshire are of particular interest because of the large numbers that have survived, in contrast to the survival rate of relief-carved cross-slabs. Almost every variety of cross-type is represented there including the linear cross, the simple outline cross of plank construction, and the more developed outline cross with hollow armpits. There is, however, a distinct regional preference for encircled equal-armed crosses exemplified by those at Monymusk, Toft Hills, Clatt, and Milton of Crathes [235]. Just as the hollow armpit cross has been associated with the Columban church it was suggested long ago that this type of cross reflected the missionary work of the Ninianic church among the Picts. The encircled Christogram is represented in Galloway at the Ninianic sites at Whithorn and Kirkmadrine, and Bede believed that the Picts to the south of the Grampians had been converted by Ninian. The simple, undatable, Aberdeenshire crosses cannot make a useful contribution to defining the role of Ninian in the conversion of the Picts but this undeniable regional preference calls for some explanation. The simple answer would be that the cross-type reflects some local ecclesiastical allegiance not necessarily Ninianic, not necessarily Columban, for this is not a common type on Iona or its vicinity.

Two sites in Aberdeenshire merit special attention, Tullich in upper Deeside near Ballater, and Dyce, near Aberdeen. Around fifteen cross-marked stones are preserved within the circular churchyard of the ruined medieval church at Tullich [234].[20] Although not all identical in form, a significant number display Latin crosses with proportionately broad transverse arms and a tapering shaft which ends in a rounded or angled point. [239, 240] Two large slabs are incised with outline crosses with hollowed armpits. A smaller ringed cross-head, with its shaft missing, also has hollows at the angles of the arms. This type of ringed cross is found at Banchory Ternan, an ecclesiastical site on Deeside with ancient associations [237].[21] A pillar-like stone at Tullich is carved with an equal-armed cross. A long narrow stone has three equal-armed crosses, of the type with heavy transverse arms.

In the gazetteer which forms the third part of the *Early Christian Monuments of Scotland*, Allen described, but did not illustrate, five of the Tullich stones including one 160 centimetres long, 40 centimetres wide and 21 centimetres thick, and another similar, only very slightly smaller, one.[22] He suggested that these large stones in the collection had been recumbent and that the smaller ones on the site were headstones [239, 240]. At 21 centimetres thick the large stones might well have stood erect, for that is the thickness of the largest of the relief-carved cross-slabs.

235 *Incised cross, Milton of Crathes, Aberdeenshire. Stone*

236 *Incised cross, Tullich, Aberdeenshire. Stone*

237 *Cross-slab, Banchory Ternan, Aberdeenshire. Stone*

238 *Incised cross, Muthill, Perthshire. Sandstone*

239 *Incised cross, Tullich, Aberdeenshire. Granite*

240 *Incised cross, Tullich, Aberdeenshire. Granite*

On the other hand recumbent cross-marked gravemarkers of this thickness could, as we shall see, belong with another genre of sculpture, unique to the Picts, the carved recumbent gravemarker. Allen notes in his description that the crosses on the large Tullich slabs both belong to his type 101A (a shafted cross with round hollows at the angles). A large number of Pictish cross-slabs carved in relief display this type of cross but these Tullich examples do not appear in his analytical lists or statistics. Allen was a cautious scholar and he obviously felt that their lack of either the symbols or datable Insular ornament excluded them from his scientifically based quantitative analyses. It is possible, of course, that these slabs are indeed not early medieval in date, but the association of this particular cross-type and the proportions and scale of these slabs are sufficient grounds to include them in any assessment of the monumental history of early medieval Christian Aberdeenshire, along with the many other examples at the indisputably ancient site. The Tullich slabs have recently been ascribed to Columban activity.[23] This is likely to be true but only perhaps in the sense that the Pictish church was Columban until the beginning of the 8th century. The first cross-marked stones to be erected at Tullich may well have belonged to the Irish missionary period (not all of which was Columban) but

the rest of the collection must be the products of the Columban Pictish church manned by local Pictish clergy. The incised cross-slabs at Dyce are different in format from those at Tullich, but some of their designs are particularly worthy of attention.[24] One has a square at the crossing of a simple linear cross with a dot within the square in each quadrant of the cross [241]. Dots in the quadrants are found on the stone at Milton of Crathes on Deeside in the east, and elsewhere in the west, but the square at the crossing is less common. However, this is a feature of the cross on *f.* 2 of the Book of Durrow.[25]

Another cross-marked stone at Dyce was described by Allen as having 'altogether a most unusual design' but again it was not included in his statistics [242]. The design consists of an equal-armed encircled cross with splayed arms that do not reach the perimeter of the ring. At the angles of the arms are round hollows that Allen compared, rather remotely, to the design of St Cuthbert's pectoral cross.[26] The enclosing circle is intersected by four smaller circles which create an equal-armed cruciform shape which becomes the background on which the central cross lies. The placing of four small circles outside a circle is discernable on the remarkable encircled design of superimposed crosses at Skeith in Fife [243] where the motif has been compared to the

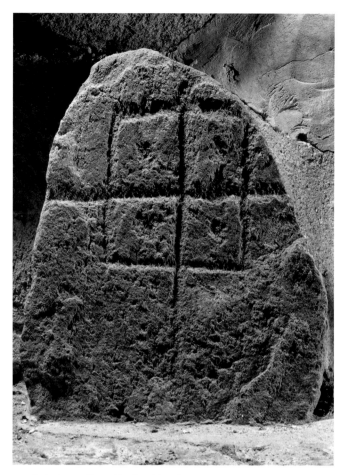

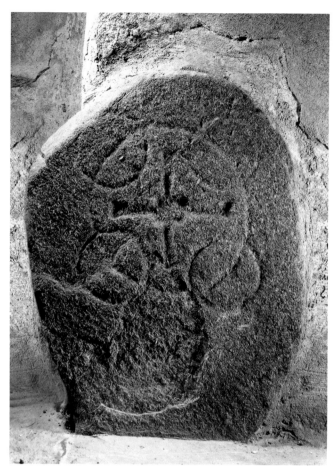

241 *Incised cross, Dyce, Aberdeenshire. Stone*

242 *Incised cross, Dyce, Aberdeenshire. Stone*

design of the frontispiece in an early 7th-century text of Orosius in the Irish foundation at Bobbio in north Italy.[27] In both cases the smaller circles do not intersect because they would interfere with the encircled cruciform shapes. The association of four circles with designs of superimposed crosses also appears on the surface of bowl no. 1 in the St Ninian's Isle hoard [156], discussed earlier. This motif is not easy to parallel. The roundel at the centre of the design on *f*. 192v of the Book of Durrow [9], where an encircled Maltese cross has three smaller roundels set around it on a bed of interlace, is constructed out of similar components, but the selection of three circles, no doubt for symbolic reasons, instead of four, makes the cross less effective in terms of design than that on the Dyce stone.[28]

The cross-marked stone at Logie Coldstone, in a burial ground near Dinnet, is an example of another recurring type. It is an irregular oval shape with maximum dimensions of 50 centimetres high by 30 centimetres wide. In a recessed background of a regular oval shape there lies a neatly carved relief Latin cross with hollows at the angle of the arms. The effect is cameo-like. Parallels in size and design for this sculpture are found on Iona where a stone with some of these characteristics is traditionally known as 'St Columba's pillow'.[29] There is a careful record of a similar stone

having been found on the Island of Inchmarnoch in the River Dee not far from Tullich. A very finely carved stone at Rosemarkie in Ross & Cromarty [312], to be discussed in the next chapter, can be added to this group.[30] It seems probable that this kind of stone had a function compatible with the consistent care with which it is carved, and its portable scale. It could belong with church furnishings or provide a devotional focus in an eremitic setting where there was no church. The examples in the east of Scotland are once again useful physical evidence for an active Pictish church and the role that sculpture played in its worship. While one would not wish to overstress the role of Iona (other Irish centres will undoubtedly have played their part in the conversion of the Picts) monuments on Iona will inevitably dominate art-historical analysis, for it is the centre with by far the largest collection of early Christian sculpture and the only one which has a claim to be instrumental in the dissemination of the Insular art style. Further study of cross-marked stones is likely to produce evidence to correct this monolithic view of the Pictish conversion.

The mapping of cross-marked stones of Perthshire was part of an authoritative survey by Charles Thomas of the Early Christian archaeology of north Britain. In this, a range of cross types in the west of Scotland were interpreted as tracking Irish missionary

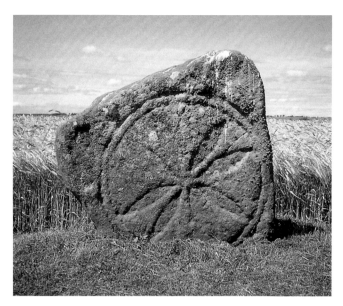

243 *Cross-slab, Skeith, Fife. Whinstone*

activities in the 7th and 8th centuries. Further work highlighting the presence of the variety of cross-marked stones throughout the Pictish territories, requires this view to be modified, particularly if it is agreed that many of these crosses cannot be regarded as solely due to missionary activity. In the present state of knowledge Early Christian cross-marked stones can be recognized as such, but more precise dating within this period is not yet possible. They can only be regarded as generalized evidence for the presence of Pictish Christians who used monuments for specific aspects of the practice of their faith. An example of the difficulties that can arise when using the cross-marked stones as evidence for historical events is the attempt to define more specifically the relationship with Iona. Recent work on the toponymy of Perthshire notes the preponderance of names there associated with Adomnán of Iona. Cross-marked stones are well represented in this area. If, as it has been argued, this amounts to further evidence that Adomnán 'worked' in Perthshire, it would have to have been before he became abbot of Iona in 679 when he arrived on the island, evidently as a newcomer.[31] Some connection in the mid-7th century between Iona and the church in Pictland is entirely likely, and if this was mediated in southern Pictland by Adomnán himself, a man of wide learning and intellectual range, the possibility of speedy assimilation of cultural resources of all kinds by the Picts is greatly enhanced, and would have considerable significance for the history of Pictish art. Although Adomnán says nothing in his Life of St Columba about his having been in contact personally with the developing Pictish church, it is nonetheless noteworthy that in the Life he is markedly sympathetic to the Picts and his firm assertion that the Picts had escaped the plague because of the protective power of the Columban monasteries in their territory would be consistent with a degree of personal acquaintance. Unfortunately, whatever the implied attitude to the

Picts in Adomnán's Life of the saint, the conjunction of the undatable cross-marked stones, the undatable associations in the place names of Perthshire with Adomnán, and the lack of historical evidence for the actual presence of Adomnán in Perthshire, while suggestive, does not substantiate this attractive avenue for the cultural enrichment of the Picts. In this book we are concerned not with ecclesiastical history, but with the evidence available in the visual forms, part of which is embedded in the cross-marked stones. Some traces of the influence of sophisticated products of Ionan art can, as we have seen, be detected in the north but sufficiently specific examples in Perthshire and the south generally have still to be found or recognized in sufficient numbers to contribute to understanding of the first century of Pictish Christianity. Three perhaps are worth noting: the design of the cross-of-arcs handsomely carved on the probably very early stone at Skeith in Fife [243], and, from Perthshire, a neatly formed Latin cross of slim outline (shown with a tenon) from Balquhidder and the sturdily proportioned incised Latin cross with expanded terminals at Muthill [238].[33] Otherwise, the majority of the cross-marked stones in Perthshire are of simple design whether linear or in outline, although they are often on a large scale.

A few examples in both the northern and southern regions have Latin crosses with ringed cross-heads and it might be said that these crosses and the hollow armpit crosses of north and south belong not to the missionary period but to the late 7th and early 8th centuries when the ornamented cross-slab carved in relief was already in production. There are at least six plain hollow-armpit crosses in Aberdeenshire and there are some fine examples in Caithness, Sutherland [244] and the Northern Isles. For example, the cross incised on the modest, metre-high slab found in the walls of St Colm's Chapel, Walls, on the Island of Hoy in Orkney, is a good example of an idiomatic cross design fully understood by the sculptor [231].[34] The making of such crosses corrects the implication of Allen's statistics that early medieval monumental history in the north is largely confined to stones bearing incised Pictish symbols.

While it is premature to draw firm conclusions from the cross-marked stones it does seem that there may turn out to be a difference in the forms of crosses in Perthshire compared with those north of the Grampians. While the northern group contains types of decorative linear crosses readily identifiable with those on Iona and in the west generally, those in Perthshire give an impression of being less calligraphic, more monumental, and less concerned with elaboration of the terminals. The parallels with manuscript art cited above for the northern cross designs, with the exception of the Skeith stone, cannot be so readily made in the south. Aspects of this difference, as we shall see, are certainly reflected in the more developed forms of cross-slabs in the two areas. Some of the cross- types on the simple cross-marked stones appear alongside Pictish symbols but before looking at this interface the characteristics of the simple symbol-marked stones must first be considered.

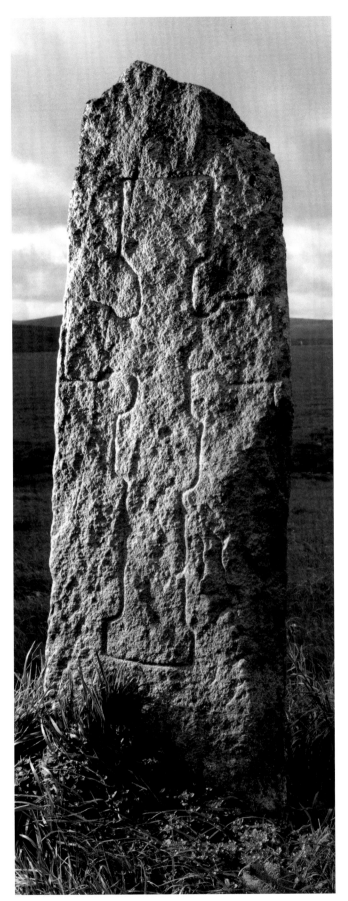

The Symbol Stones

The symbol-marked stones have a variety of forms far more diverse than the cross-marked stones. What was said of the cross-marked stones above, that although diverse, the range of formats was sufficiently consistent to define a monumental tradition cannot be said of the symbol stones: it is the symbol designs that make a stone a symbol stone.

In some circumstances the Picts were happy to use a pre-existing form of monument for the display of the symbols [245]. A significant number of symbol stones are reused prehistoric single standing stones with prehistoric cup-marks, or which may originally have been part of settings of prehistoric henges.[35] Other symbol stones are selected from the erratic boulders in the vicinity. Although very few are carved on both sides it can be said with confidence that symbol stones stood erect. The layout of the symbols – usually one beneath the other, regularly leaves a third or so of the length of the stone blank so that it can be interred without losing sight of the lowest symbol. There is some evidence of capacity to shape up stones for many are angled at the bottom, presumably artificially, to aid insertion of the slab into the earth.[36]

The form and location of symbol stones may give some indication of function. They were clearly meant to be seen for they are never miniature and the symbols occupy most of the field available for carving. Although the majority of symbol stones stand alone, which is one reason for the suggestion that they might mark boundaries, there are some clusters of symbol stones that indicate that something about the site was considered appropriate to the raising of symbol stones.[37] One interpretation would be that the site served a communal funerary purpose, and the fact that stones of similar form elsewhere in the British Isles mark graves is considered a strong argument for a similar function for the symbol stones. This view is further supported by the occurrence of a comparatively small number of symbol stones found associated with low-kerbed burial cairns.[39] This association was rightly regarded as a breakthrough in the 1980s, but the failure, in print at least, to add to the list of such associations is disappointing and one excavator has rejected claims for direct association between cairns and the symbol stones dispersed on his site. The absence of symbol stones from the excavation of an extensive Pictish period graveyard near St Andrews in Fife further suggests that some Picts did not include the erection of symbol stones as part of their burial rite.[40] On the other hand, the excavation in the Dairy Park, Dunrobin [246], provided one convincing instance of the association of a female grave of appropriately Pictish date, with a cairn and a symbol stone [71].[41] At present, unless substantially more evidence is forthcoming, archaeology does not present us with a 'fact' on which other hypotheses can be safely built. As for the 'normal' culturally

244 *Incised cross, Creich, Sutherland. Stone*

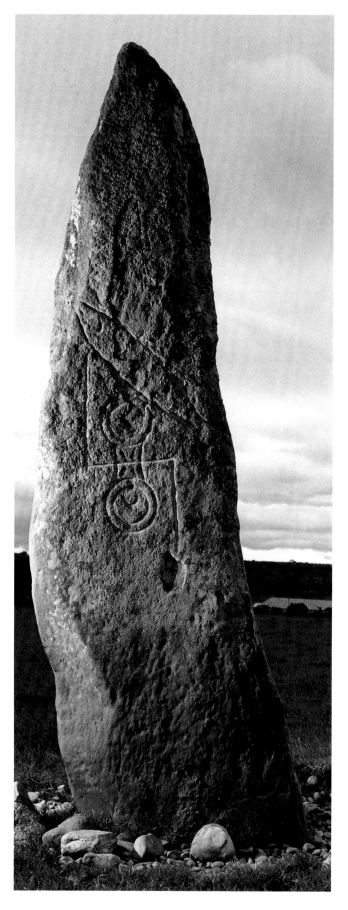

widespread practice of setting upright commemorative monuments over the dead, the Picts have two forms that could have functioned this way, the symbol stones, and the early cross-marked stones. The erection of symbol stones in the 7th century could be regarded as evidence for a localized persisting pre-Christian ritual but their existence is certainly not evidence in itself for a sinisterly late conversion.

Before addressing, briefly, the vexed question of the meaning of the symbols, the question has to be asked to what extent does the art of the symbols give indications as to their meaning? Some aspects of their decoration on the relief cross-slabs are, as we have seen, part of the Pictish assimilation of the repertoire of Insular art but the interior elaboration of the incised symbols supports the view of Charles Thomas that the shapes of the symbols can be related to the gear of the Caledonian warrior aristocracy of the late 1st century BC/early 1st century AD, such as armlets, collars, harness fittings, cauldrons and the like. This relationship with artefacts of that period can also explain an aspect of the incised animal art – the peculiarly Pictish convention of body marking on their otherwise naturalistically conceived profile animal designs. The lobes and scrolls, which raise these single portraits of a range of animals into a distinctive art style, are not joint scrolls, as is so often said, but very skilfully represent recessions which express

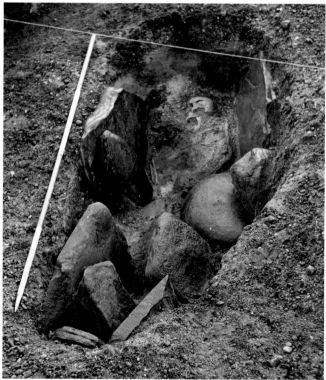

246 *Grave associated with symbol stone, Dairy Park, Dunrobin, Sutherland*

245 *Symbol stone, Edderton, Ross & Cromarty. Sandstone*

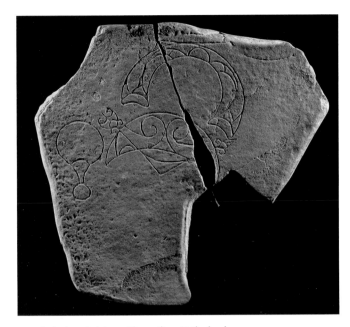

247 *Incised symbol stone, Clynemilton, Sutherland,*
No. 1. Sandstone

the volume of the animal, the swell of the belly and the rounding of the muscles of shoulder and haunch. Such recessions belong with the effects achievable in repoussé metalwork which we know to have been produced by the Caledonians.[42] Other unusual features of the art of the symbols can be similarly explained, for example, the apparently wandering cobwebs of lines which are spread over the 'horseshoe' symbol on Clynemilton No. 1 [247], are recognizably those of the keeled ridges of repoussé work, and the hatchings, scrolls, peltas, and other curvilinear forms have their place in both arts. Such traits strengthen the view that the symbols are, understandably enough, in some degree fossils of an earlier culture. In addition to the late Iron Age impedimenta recalled by the symbol shapes, one would want to add shield plaques, since decorative motifs and animals, in the form of metal cut-outs, were applied to shields from the Iron Age on through to the early historic period. Their fixed profile quadrupeds, birds, fishes and other ornaments agree with the appearance of the symbol designs. From the later period, the 7th-century Lombardic shield from Stabio, with its naturalistic hunting scene created in this scrapbook fashion has often been cited as comparable to Pictish art, and the pair of gilded fish on the 6th-century shield from the Anglo-Saxon site at Spong Hill [248, 249] provides a model for the way the prototypes of the Pictish symbols might have looked.[43] As we saw in an earlier chapter, there is some Pictish artefactual evidence that symbols were indeed cut out of sheets of metal. Some of the analogies in later art – for example, the decorative forms used in the 7th-century *Cathach*, mentioned above in connection with cross-types – themselves have origins in metalwork curvilinear art of the late Iron age. To this extent incised Pictish symbol designs and their interior decoration have a

shared background. Interlace, key-pattern and developed spirals are never used on the incised symbol stones. The interior decoration of the symbol shapes was fixed before the Insular art synthesis had taken place.

Art historians are frequently, and unfairly, said to ignore the question of how the symbols functioned within society, concerning themselves only with their art-historical context. Nobody exposed to the Pictish symbols is not haunted day and night by the problem of their meaning. If art historians have been reluctant to address this problem with the commitment and energy of scholars in other disciplines, an excuse might be that they stand closer to the actual phenomenon of the display and use of the symbols, in all its baffling diversity.[44] We have already shown that on the monuments there seems to be an overwhelming obsession to display the symbols coupled with what seems an entirely random method of doing so. As Anderson wrote when he reviewed the possibility of breaking the code of the symbol system, 'none of the conjectural hypotheses suggested by selected examples will stand the test of a general application'.[45] It is as if choice was exercised within a fairly limited repertoire, so that the same, or similar, or different, permutations occur at locations near one another. The different permutations do not affect the validity, and one might assume, efficacy, of the statement being made.

Anderson, who justifiably regarded himself as a scientific archaeologist, held firmly to the view that the only context for the use of symbols was their regular appearance on the same monument as the Christian cross [51, 200]. Students of the meaning of the symbols have tacitly accepted this constraint, and solutions tend towards being safely neutral as to Christian values. Indicators of rank and status, titles to land, names, writing systems, are reckoned to be transferable from a pagan past to a Christian present. Others are driven by the desire to make the symbolism conform to some known anthropological system. The logic of this latter view excludes the social importance in the combination of the symbols and the Christian cross on the slabs.

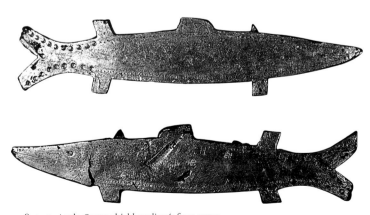

248, 249 *Anglo-Saxon shield appliqués from grave,*
Spong Hill, North Elmham, Norfolk. Bronze-gilt

Inscriptions should, of course, be the best guide as to function.[46] A few stones have ogham inscriptions adjacent to the symbols. The inscriptions appear to express personal names, so are the symbols also names, as has recently been powerfully argued? Or, rather than creating a bilingual monument, do the oghams provide additional information that the symbols are not expected to express? On the two surviving inscriptions in Latin letters on symbol-bearing cross-slabs one, at Fordoun in Kincardineshire is a single name, possibly of an ecclesiastic, and the other, St Vigean's No. 1 (the 'Drosten Stone') [87, 250], contains three names all of which are used in the Pictish king list.[47] Again,

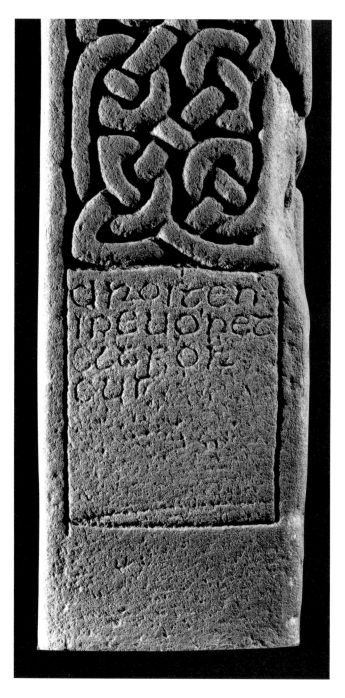

the question arises that if the symbols are the equivalent of names why should there be an inscription in addition to the symbol-names? Inscribed monuments should belong to the non-symbol-bearing class. Non-symbol-bearing monuments, mostly fragmentary, do have names, and one, the famous Tarbat inscription, in relief display majuscules [201], is clearly commemorative. We do not know, of course, whether or not the symbols appeared on the complete monument. The one complete monument with a name inscribed on it, the Dupplin Cross, has no symbols, but that cannot be said to prove that the inscription has taken their place, or indeed that free-standing crosses, all the rest of which are fragmentary, never displayed symbols.

The first thorough-going attempt in modern times to interpret the symbols, that of Thomas, who worked out in detail a way in which the symbols could display information about the rank and status of the deceased, still has many advocates.[48] The belief of Jackson, that the symbol stones recorded marriage alliances was respected as an entirely new idea, but the social context necessary for it to operate did not convince.[49] A currently favoured view is that of Samson, that the symbols represent bipartite names, in other words that individual symbols do not mean anything, but that paired combinations stand for names formed of two elements such as are familiar from Anglo-Saxon personal names. A development of this view by Forsyth sees the shapes of the symbols as conforming to the structure of a writing system.[50] Incidentally Forsyth gives a useful directive towards paying attention to the shapes of the symbols, free from regarding them as merely representational. Considered objectively, they look in their combinations, their pairing, and even sometimes in the format of a single symbol, like conscious exercises in the resolution of contrary visual formulae, meander or zigzag, square or round, open or closed, and so forth [31]. It is perhaps not an exaggeration to regard the symbols, from the purely visual point of view, as stabilizers, images of equity, and to allow that their physical construction was integral to their meaning and function.

An ambitious theoretical paper by Driscoll, based, reasonably, on the premise that it is possible to make deductions about how the symbol system 'worked' on the monuments without knowing the specific meaning of the symbols, has the merit of finding a role for the church in his interpretation.[51] The sculpture is seen as a means of control by those in society who had access to the cultural resources necessary for its production. However, in developing his interesting argument, he asserts that 'links' with the art of Northumbria and Ireland are more commonly found in southern Pictland, and that this cultural advantage was one of the ways in which the south came to control the north. This is not the case. Sculpture in both the north and south is equally an integral part of Insular art. This is obvious in the case of the monuments of Ross & Cromarty, but it can be demonstrated also for those in

250 Inscription on right side of cross-slab, St Vigean's, Angus, No. 1

251 Left *Incised bone, Broch of Burrian, Orkney*; right, above *Incised bone, Pool, Sanday, Orkney*; right, below *Incised bone pin, Pool, Sanday, Orkney*

Moray and the far north. Using the conventional terminology, Driscoll believes that the regional distinctiveness of 'Classes I and II' gave way to a 'variation of Insular art' in 'Class III'. This is only true if the symbols are the touchstone of distinctiveness, and his argument goes well beyond this simplistic position. From the point of view of the art, distinctiveness lies between 'Class I' and 'Class II', when restricted, 'fossilized' forms of interior decoration for the symbol shapes in incision give way to full participation in the Insular repertoire, employed both as interior decoration for the symbols and elsewhere on the cross-slabs. From the point of view of repertoire, 'Class II' and 'Class III', in so far as these terms have any meaning, are part of a continuum. In such matters art-historical study can help to refine discussions on the meaning of the symbols.

It may be useful here to state baldly the present writers' speculative impressions regarding the symbols, always with the proviso that the art and the experience in front of the art is leading the argument. If the 'fossilized' artefacts and their decoration is accepted as identifiable in the symbol designs as we know them then some relatable 'fossilized' significance might also be expected to be carried through to the historic period. The general forms of the symbols and their decoration were established in the pagan period. The practice of incising symbols on stone first took place in enclosed contexts such as caves, structures and comparatively remote locations. The plain undecorated symbols at

Pool, Sanday, Orkney, and some of the symbols in the caves at Covesea, Moray and Wemyss, Fife [*118*, *119*], and on the plaques from the Dunnicaer headland immediately to the south of the Pictish fortified site at Dunnottar, Kincardineshire, represent early forms of the basic shapes.[52] Their appearance on field monuments, sometimes on existing prehistoric monuments, followed [*245*]. Finally, as a result perhaps of the experience of cutting cross-marked stones, the symbol stones as we know them were produced. Shortly after the early field monument stage there was some substantial redesigning and standardization of the symbols, together with some new invention, in a style which exhibits exactly the same creative thrust as the very first 'Insular' metalwork and manuscript decoration. On the relief slabs the symbol shapes remained remarkably consistent but the attractions of the 'Insular' repertoire were such that, as we have seen, the choice of interior embellishment for the main symbols drew freely on it. In areas where symbol stones continued to be erected the earlier visual forms were maintained and the plain symbol shapes sufficed to mark playing pieces made out of cattle bones or the more shaped and worked stone discs found in the far north [*251*].[53]

One possible connection of style with meaning would involve the carrying over of meaning from the decorative and animal art associated with strength and guardianship on Iron Age military gear. The symbol stones could have been erected with concepts in

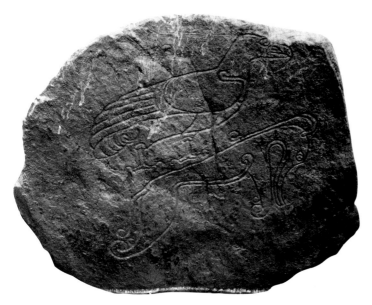

252 *Incised symbol stone, Tillytarmont, Aberdeenshire, No. 4. Granite*

mind similar to those emblazoned by the warrior on his weaponry; instead of marking personal equipment with significant signs, the ethos of those signs was transferred to conspicuous field monuments which in a landscape without maps would be the natural focus for communal transactions and ceremonies. In such spots, the social implications of the exercise of various kinds of authority could have wider application, protection guaranteed, pledges honoured, common and private rights over land, pasture, cattle, assessed and maintained, renders collected. Thus sublimated, lifted beyond the context of shields and weaponry, the symbols could take on apotropaic and prophylactic but also propitiatory significance. As such numinous tokens they would arguably be consonant in intention with the great consolatory protective sign of the cross; to which in the event they became aligned, the cross on the front, the symbols on the back, just as if they were the Pictish element in a 'typological' system, the kinds of propositions which they make being acceptable as anticipating or paralleling the full redemptive teachings of the Christian church. While *Realpolitik* no doubt played its part in public proclamations on the monuments, the secular and ecclesiastical authorities had to record their right to the wealth they derived from the land and with it the obligations to protect the inhabitants both from expansionist neighbours and the wiles of the devil. In a well-known grant of land by Aethelbald of Mercia (716–57) (a king who had dealings with the Picts) for the building of a monastery, the punishment for violation of its conditions is expressed not in terms of secular penalties but with the threat of the Last Judgment, the *ratio terribilis*. There are plenty of visualizations of the fate of violators and sinners on the Pictish cross-slabs [218] and this particular message could serve the purposes of state and Church alike. The visual expression of

power and protection are of course a main concern of much of the art of the period in all media and one can see how such a connotation for the symbols accommodates them on prestige metalwork, whether massive chains, or small, silver, votive-style plaques. What Anderson called the 'prevailing symbols' – the crescent, the double disc, the beast and the comb and mirror [72] – would carry the central ideas and the rest would have been dictated by a generalized random preference of signs that were locally recognizable. The way in which the Pictish symbols become more emphatic (it is a common misconception that they fade away) does give the impression that something intrinsic to the location was being made very clear. The decorative possibilities of the symbol system may itself have added to its length of life. It may even be that the later sculptors enjoyed the opportunities that the symbols gave to astonish by inventing variations on the well-known themes expressive of fundamental social contracts. Other methods of establishing title could have operated during the period of the symbol-bearing cross-slabs, and it could indeed be that the symbols latterly functioned more as a series of decorative traditional seals rather than as the embodiment of the actual contract. The wide diffusion of the symbols throughout the Pictish regions, even in districts early lost to the Irish from the west, seems to call for some Pictish equivalent of Luke 2, 1, a decree, able to have practical consequences.[54] That precocious political unity is implied by the geographical universality of the symbols is, however, nowadays vehemently denied by historians, since the intricate processes of state formation are at the heart of much current thinking about this period. One of the attractions of the name theory is that, as Forsyth puts it, there is 'no need to postulate a self-consciously shared cultural package, merely a common language'.[55] Others who find it difficult to set aside the widespread relevance of the symbolism suggest that the unity belongs to the 8th century, the period when something like a Pictish state could have been under way, with a consequent late date for the symbol stones. Art can contribute to the assessment of these views. The symbol-bearing cross-slabs in the north and south display a style of art dateable from the late 7th century to the end of the 9th century. A good many symbol stones were no doubt being erected before that period. The art of the cross-slabs is part of a common cultural package, imposed by the Christianity that brought it. A putative method of writing the language would surely have to be considered as part of such a package. The symbolism, however interpreted, is evidence for a common cultural understanding of specific signs, which need not necessarily bring along with them political cohesion. The fact remains that as far as the symbolism is concerned, the great cross-slab at Nigg, Ross & Cromarty [184, 202], with its exegesis on Jerome's Life of Paul the Hermit, and the symbol stone in the field at Tillytarmont, Aberdeenshire [252] reflect a shared cultural background. Again we must entertain the notion that an uncommonly significant role in society was played by the sculptors responsible for spreading the very same symbols

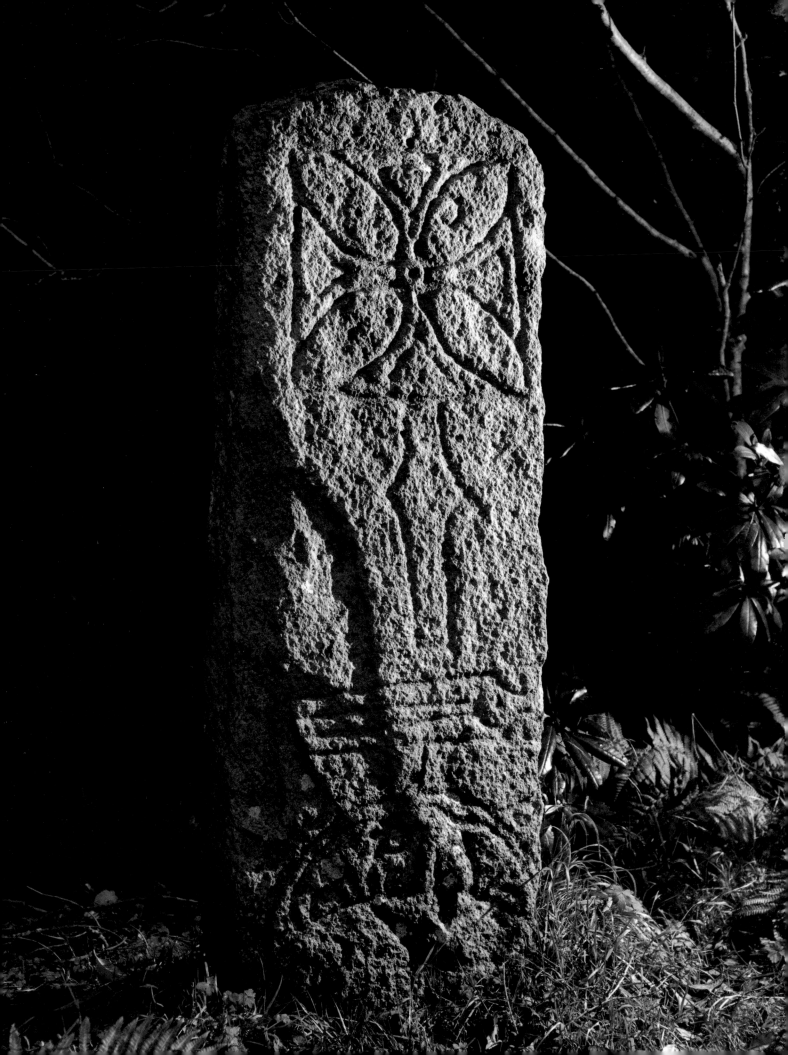

along the banks of the Urie and the Don as along the coast of Sutherland, especially since in the symbol designs at their best, repeated definitively, but also occasionally as experimental 'singletons', a mastermind is perceptible.

The earliest phase of the interface between cross and symbol is best exemplified by two carvings on the Isle of Raasay off Skye.[56] One consists of a cross only, carved on a rock face close to the pier. It comprises a well-formed cross-of-arcs set within a square frame with a curl on the upper right arm indicating that it is a Chi-Rho cross. The square frame is set on a pedestal. About 100 metres from this spot a rectangular granite slab of over 2 metres high was found during road-making. It is carved with a similar pedestalled Chi-Rho cross [253] but with the addition of a sub-triangular motif in each of the arms and a raised ring at the point of their crossing, in the manner of the cross-of-arcs at Skinnet

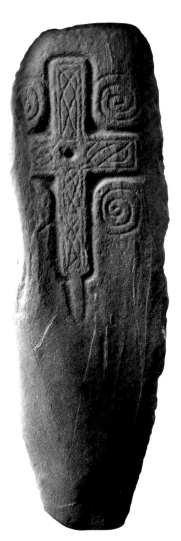

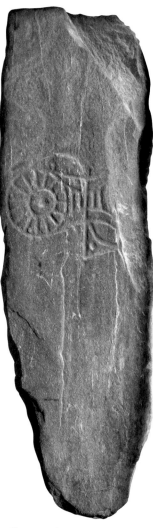

254 *Front of cross-slab, Alyth, Perthshire. Slate or gneiss*

255 *Back of cross-slab, Alyth, Perthshire. Slate or gneiss*

Chapel described earlier [233].[57] The cross is carved at the top of the slab, below is a 'tuning-fork' symbol and finally a 'crescent and V-rod'. There is no doubt that cross and symbols were carved at the same time and the arrangement of carving the upper two-thirds of the slab and leaving the remaining third as a tenon is typical of the form of the great majority of the symbol stones whose overall length is known. A similar type of cross is paralleled on Iona, No. 6, 22, a gravemarker which has an inscription in half-uncials reading 'lapis Echodi', 'the stone of Echoid', and on the central roundel of *f.* 85v of the Book of Durrow [9]. A related cross-type set on a pedestal is attached to initial letters in the *Cathach*.[58] That the Raasay cross-marked stone, bearing symbols, dates to the 7th century is probable.

The incised cross-marked stone from Seaton, Aberdeenshire, depicts an outline cross with a short spike-like tenon at the end of the shaft. One face of a slab at Alyth, Perthshire [254, 255], has the same shape of cross, but now decorated with a dot at the crossing, simple interlace on the arms and shaft, and spirals in the quadrants. The back is damaged but a portion of a 'double disc with Z-rod' symbol remains. The surviving disc is decorated with rays of different lengths centred on an asymmetrically placed circle with a dot in the centre. The inner portion of the junction is hatched and there is a dot in the angles of the rod. The style of carving, mostly in incision, and the primitive decoration of the symbol suggest that this is an early cross-slab now observing the convention of keeping the cross on one side and the symbols on the other.[59] Other incised outline crosses, as we have seen, for example, at Tullich and Banchory Ternan have the hollow-armpit shape typical of the relief slabs. It has often been pointed out that the depth of the incision of some of the symbols and animal designs on the symbol stones creates an effect of 'false' relief. The small group of crosses with roughly hacked-out crosses in comparatively high relief – which includes examples from Tarbat [256], Rosemarkie and St Vigean's – may be bolder early experiments with relief carving.[60] Behind the symbol-bearing cross-slabs lies a considerable monumental tradition which comprised two types of multi-functional monuments, both of which have to be taken into account when assessing their form and function.

The Cross-slabs

One of the better known traits of Pictish sculpture is its adherence to the slab format, although this, as we have seen, does not prevent the prevalent use of the term 'stone' for a Pictish cross-slab. It used to be thought that the development of Irish sculpture could be charted in terms of its formats, the slab with a cross gradually evolving into a free-standing cross. Whereas the Irish and the Anglo-Saxons outgrew the slab stage, the Picts did not. Another reason often given, which preserves the stereotype of the mysterious pagan symbols, is that Picts only carved symbol-

bearing monuments and that symbols were unsuitable for carving on a replica of the cross of Christ. The first argument can be ignored, for what has been called the 'Darwinian' evolution of Irish sculpture has been discredited. While not at all conceding that Pictish sculptors were only called on to exercise their skills when symbols had to be displayed, it is noteworthy that while a rider can on occasions be carved within the cross on a cross-slab, as at Fordoun, Kincardineshire and Rossie, Perthshire [86, 87], and Balluderon, Angus, there is no surviving example of symbol designs invading the cross-shape.[61] They can be carved on the same side as the cross and adjacent to its shaft but not within it. The implication of this for the meaning of the symbols has been discussed earlier. Here the emphasis is on the implications for the meaning of the cross. However it benefited the monument as a whole, to be marked with the Pictish symbols, Christ's own emblem did not need their ratification or direction.[62] The monuments, which belong essentially to the church, had an important role to play, and for 8th-century Pictish society Christian sculpture functioned best in the form of a slab. A slab format, typically around 2 metres high and 1 metre broad,

although frequently considerably larger, is certainly not to be thought of as a simpler solution for a public monument than the production of a column or free-standing cross. As we shall see, the Picts were well aware of alternative monument types, and if they had wanted free-standing crosses they would have raised them, as indeed they did on occasions. It is the exploitation of the scope for carving given by a slab which makes Pictish sculpture distinctive, just as the exploitation of the free-standing cross makes the Irish high crosses uniquely grand within that format. Ireland and Pictland, in comparison with Anglo-Saxon England, are fortunate in the number of complete monuments that have survived. Pictish sculpture, of course, did not escape destruction. It was broken up by acts of violence of all periods. It was neglected, or abused as building stone, grave-lining, paving or footbridges, but on the whole it survived well, and when left standing was perceived through the ages as a local landmark on the horizon rather than as a beacon of pre-Reformation Christianity.

At the time of the erection of the first cross-slabs there can be no doubt that their social impact lay in the bringing together of the native symbolism and the Christian cross of Salvation on one

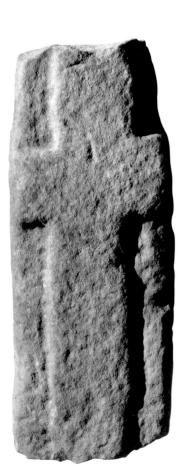
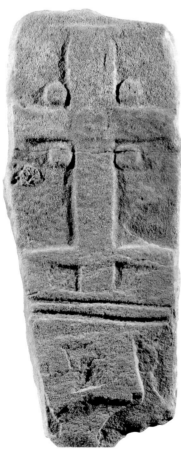

256 *Cross-slab, Tarbat, Ross & Cromarty. Sandstone*

257 *Cross-slab, Tarbat, Ross & Cromarty. Sandstone*

258 *Cross-slab, Tarbat, Ross & Cromarty. Sandstone*

monument. We cannot determine how such a radical break with tradition was viewed, particularly since in all likelihood the simpler discrete types, symbol stone and cross-marked stone, continued to be erected.

The inclusion of the symbols on the cosmopolitan slab will have ensured a degree of continuity in the monumental tradition. This can be seen in the retention of the artistic convention of using lobed scrolls to express animal musculature, a device that virtually defines the incised animal designs. It continued to be used in the most naturalistic contexts such as the pastoral cattle scene at Tarbat [96, 303] and in sculpture as mature as the Nigg cross-slab [184]. The symbol cutters carried over to the new format

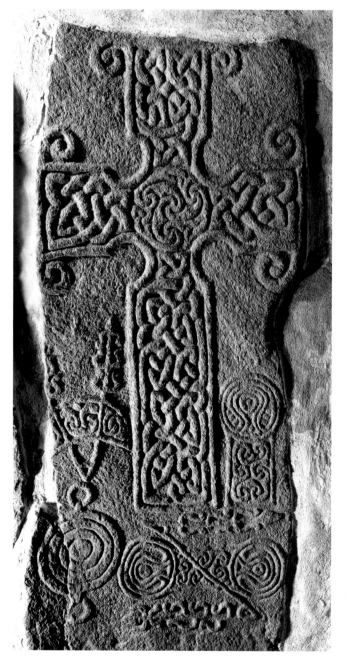

their skills in controlling a fluent line, a facility in curvilinear art, an awareness of the effectiveness of false relief and a preference for a layout based on the stacking and interlocking of imagery.[63]

The introduction of the cross-slab has long been attributed to the cultural experience of the Pictish legation, specifically to the monastery of Jarrow, but almost certainly also to the twin foundation of Wearmouth. Its business was primarily liturgical, to do with the arguments for adopting the Roman method of calculating the date of Easter. One way of publicizing the agreed change of obedience from St Columba of Iona to St Peter of Rome was to build, in the manner of the Romans, a church in stone. Northumbrian masons are said to have gone north to teach the Picts how to build in stone. The preparation of stone for masonry would have been equally applicable to the quarrying, cutting and dressing of slabs. Within the precincts of Jarrow and Wearmouth were examples of large slabs carved with standing crosses in relief. There were also panels of shallow-relief sculpture displaying, as we have seen, roundels of fine interlace and Germanic animal ornament, both of which feature on the early examples of Pictish cross-slabs. All this sculpture in form and decoration, along with the historical record that accounts for the transference of skills, provide an explanation for the appearance of the Pictish slabs. Nonetheless it is important to stress that this is a possibility, not a 'fact'.

A difficulty with the linking of the new monument type with the Jarrow initiative is that its production becomes inextricably tied to the Petrine symbolism of the stone church. We should expect that with the Roman Easter Tables and the church built in the Roman manner the new monument would not have been nativist to the extent of including the symbolism, but rather would have been carved with matter impeccably consistent with the art of Mediterranean Christendom. The syncretism of the Pictish symbol-bearing cross-slab would belong better to a period before this cultural change of direction.

We should not forget the strong cultural influence of Iona on the production of the cross-marked stones and slabs. Some of these, both on Iona and in Pictland, begin to take on a more regular format as a result of the depiction of the more developed forms of the outline cross.[64] The techniques employed have yet to be studied. However, the combined experience of crafting these slabs and the knowledge displayed in the selection of stones suitable for carving by the symbol cutters would have made it possible for the slab format to evolve within Pictland. To transfer an extended Insular repertoire on to a slab would initially have been work for an artist in another media, familiar with the conventions of the panelled decorative style. Slabs like those at Glamis [33] and Eassie [179] could well have been produced in this way, even Meigle No. 1, with its erratic composition and unequal workmanship.[65] It is only with the Aberlemno churchyard slab [36,

259 Cross-slab, Dyce, Aberdeenshire, No. 2. Granite

82] that one is confronted with what looks like architectural skills: its regularly cut pediment; its strong taper of 30 centimetres from bottom to top; the immense labour of the cutting back of the surface of the slab so that the hewn cross is allowed to project by 10 centimetres.[66] By then the bonding of symbolism and cross on one monument could have been fully established. The form and, to some extent, function of the symbol-bearing cross-slab could thus be part of an ongoing monumental development discernible in Dál Riata (Iona) and Pictland, strengthened and enriched by the new southern contacts of the early 8th century but not initiated by them.

The basic function of the symbol-bearing cross-slabs was to display the cross in a more emphatic way than had sufficed for the various functions of the cross-marked stones. The few, but instructive, examples of the dual-functioning monuments of Aberdeenshire confront us with the relationship between the symbols and the cross in its starkest terms, for there is rarely any other imagery. The monument type, an irregular slab or pillar stone, is conservative, as is the decorative treatment of the symbols. The sculptural technique is a mixture of incision and relief. The shapes of the crosses, for example at Dyce No. 2 *[259]*, Migvie *[260]* and Monymusk *[262]*, are distinctive and their decoration limited, but on analysis surprisingly complex in construction. Whether such monuments, which share many characteristics with those of Caithness, are to be regarded as transitional, provincial or late – and there is no compelling reason to adopt any of these labels – they demonstrate a relationship between the cross and the symbolism in which the symbols, grouped, like donors in later art, round the cross, are subordinate.[67] However, such a view is more difficult to sustain in front of the unique 'Maiden Stone' at Drumdurno, Aberdeenshire *[261]*. Over 3 metres high, it displays on the reverse *[80]* symbols in relief each around 60 centimetres high, occupying three-quarters of the back of the slab. On the front an equal-armed ringed cross is placed second from the top in a five-panel display, some of which are bravura displays of ornamental carving in granite. The raising of such a monument suggests a function rather different in intention from the other Aberdeenshire relief monuments. The two sides of the monument are in evident balance. What is being set out can scarcely be as straightforward as old pagan submitting to new Christian, or even a visualization of relations between the state, or an individual, and the Church. An unambiguously clear statement about specific rights, sealed as it were with the impress of the symbols and validated by the authority of the Church, seems more in question. The claim and its validation would be further underwritten by the grandeur of the scale and the brilliance of the sculpture.

From the sculptors' point of view the addition of the combined symbol/cross in the form of a slab must have been extremely liberating. Symbol cutters may have been aware that ancient metalworking ultimately lay behind some of their designs, but it now became possible to exploit contemporary

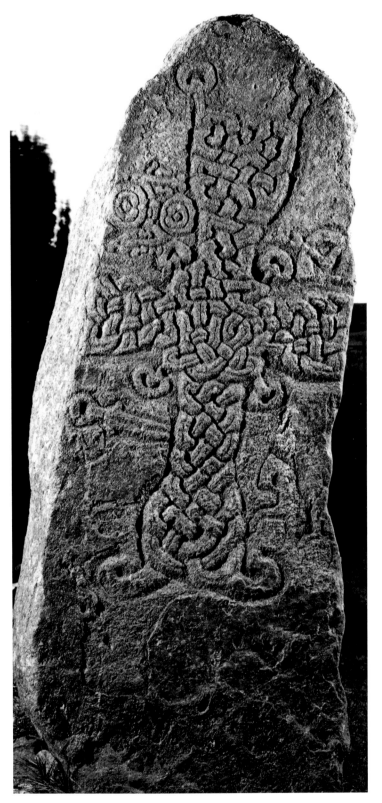

260 *Cross-slab, Migvie, Aberdeenshire. Gneiss*

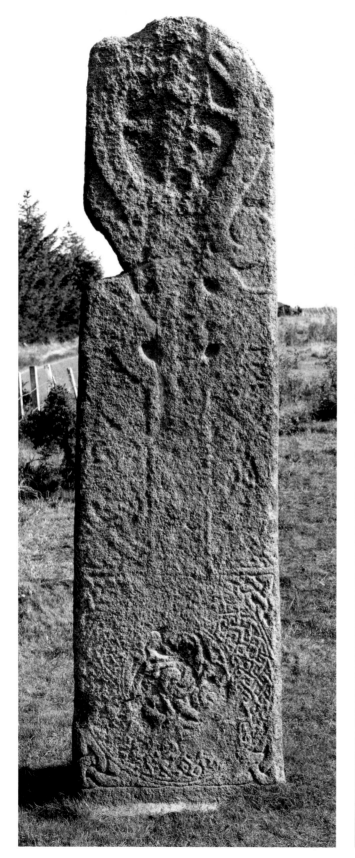

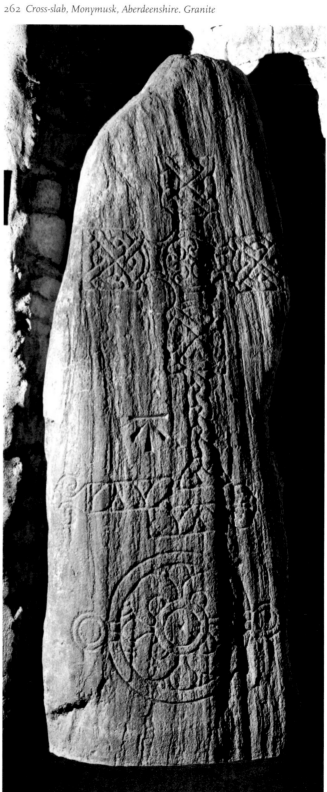

261 *Front of cross-slab, the 'Maiden Stone', Drumdurno, Aberdeenshire. Granite*

262 *Cross-slab, Monymusk, Aberdeenshire. Granite*

developments in metalwork and book art (both of which, no doubt, were already being participated in fully by Pictish artists). The greater part of Pictish art survives as sculpture, the last of the media to respond to the new synthetic style, and perceptions of it have suffered accordingly.

To the south of Aberdeenshire, in Perth, Angus and Fife, and to its immediate north in Moray and Ross & Cromarty, the carving of subject matter additional to the symbolism and the cross reflects extensions of function. As one would expect there is a pastoral and theological function in the depiction of salvation in the Old Testament, in the form of iconography of David, Daniel and Jonah, and in other less obvious themes identified in an earlier chapter. Other common themes are the hunt, military might, and animal imagery of a more developed kind than the incised animal designs.

Although hunt imagery is not unknown in early medieval art, the number of representations in Pictish sculpture is surprising and calls for explanation. It is hard to overestimate the importance of the hunt as an image in Late Antiquity. Hunting scenes were pervasive, on mosaic floors, precious metalwork, glass bowls, tapestries, sarcophagi and triumphal buildings. The hunt was regarded not simply as an elite activity but as symbolic of the good life, the hunters, energetic and virtuous. Success in hunting was a match for success in warfare, and the Picts display on their monuments both of these social arts. The classical hunters typify the virtues and responsibilities of good leadership, which, it was suggested, could lie behind the depiction of the principal symbols. Warriors, and their surrogates the hunters, could expect to reap their reward in heaven as model members of society. Somewhere the Picts had sight of this kind of image. We certainly do not know that a Pictish delegation went to Rome and between Church councils saw the hunting sarcophagi of the early Christian period, but that is the kind of stimulus required to account for the zest of their hunting imagery which found its apotheosis in the lion-hunt on the St Andrews Sarcophagus [189, 190].[68] These are ideal hunts, such as might be described in a literary text, not snapshots in stone of Pictish life, although the depiction of the hunt could certainly be symbolic of what has been called in a Carolingian context a 'ritual of the court', an affirmation of social cohesion that afforded opportunities of largesse from the leader in the form of the spoils of the chase.[69]

It has been said of the classical hunting sarcophagi that what had been an ostentatious aristocratic sport 'became in the end an eschatological dream, a hope of ultimate victory, soon to be found only through the Christian faith'.[70] The function of the hunting scenes on Pictish sculptures are perhaps to be thought of in these terms, terms which make the surrounding of David, the type of Christ, the Saviour, with the fierce struggle of the hunt on the Nigg cross-slab [184] entirely appropriate. In displaying the symbols in this context, often indeed as a kind of headline, it can be inferred that the idealization of the hunt must be as relevant to their meaning as it is to the symbol of the cross. The 'named' persons,

or the officials registered, or the conceptual acclamations, must be embodiments of the extended virtues of the hunt.

The same will apply to depictions of warfare and of single warriors. The warrior as 'symbol' is encapsulated in a fragment from Burghead showing a resolute soldier's head cut with the economy and assurance of the Stittenham wolf. There are three battle scenes, with the dead lying on the field, carved on cross-slabs. The assumption that such scenes represent actual events has been questioned in an earlier chapter. From the point of view of function, the inclusion of the symbols adjacent to one of them raises other questions. The prominent display of the symbols above the battle scene on the Aberlemno churchyard slab [82] was obviously integral to the depiction. The 'notched rectangle' is the same height as the individual riders and occupies almost the same area. Its decoration is not the standard curvilinear art of the incised versions of this symbol, but triple spirals, comparable to the spiral decoration of the circular panel at the centre of the head of the cross on the front. An accommodation is being made to the Insular repertoire so expertly carved on this front face. The identification of the Aberlemno battle scene as the Pictish victory over the Northumbrians in 685 at nearby Dunnichen is not a 'fact' any more than the claim that the cross-slab format originated in the Pictish visit to Jarrow a generation later is a 'fact'. The perceptible change in the art-style of the symbols is visual evidence which has to be taken into account in assessing the date and function of this display of military art.

Within the dense military iconography of 'Sueno's Stone' [195] it is possible to identify the leader, by scale, in the top panel, and by pose, the frontal figure in the top row of the second panel. A battle scene at Dunkeld similar in style to Forres, is too fragmentary to make such an identification.[71] If the rider in the bottom left corner of the Aberlemno scene is the Pictish king who in the battle killed the English leader – identified as the dead warrior in the bottom right-hand corner – one would expect that in some way he would have been identifiable as different from the rest of his army. It may be that the symbols, if personal names, celebrated him at the top of the monument. If names of offices, then Thomas's identification of the 'notched rectangle' symbol as 'war-leader' fits admirably.

However, many depictions of warfare in art simply celebrate a foregone conclusion. The Roman centurion on a slab who tramples and maims 'natives' does so because Rome is invincible, not because, on a specific, remembered, occasion he was particularly effective on the field. In these terms the symbols can be understood, as the present writers suggest, as images of effective authority, and the Aberlemno battle scene as generally celebrating the *Gloria Pictorum*, whoever the enemy. From the point of view of function such an interpretation takes us away from particularism to an expression of successful military might as a social virtue. The three armed warriors in ceremonial garments advancing in procession with the symbols flying above their heads like standards, on the slab from Brough of Birsay [78]

convey the same message. Did the cross-slabs, then, function as the public display of social ideals, as relevant and irrelevant to 'real life' as is a Law Code, something which properly belongs to art which by its selectivity, stylization, and repetition, can take on more general applications?

The hunter and the warrior are, of course, familiar as bearers of the values of a secular heroic idealism, but success or failure in warfare, as noted above in the theme of the hunt, from a Christian perspective is also bound up with the Last Things: Death, Judgment, Heaven and Hell, the fulfilment of God's rich promises or the exercise of his wrath. For the viewer of the 21st century the 'secular' themes function as a way into perceiving how the Picts lived and how the seculars and the churchmen were adjusting to each other's methods of controlling society. Interpreted in this way, much of Pictish sculpture falls apart, into a secular side and a Christian side. If the monuments are given the status of coherent works of art then it follows that their 'evidence' is that of an intellectual construct, closer to that of a Christian literary text than to a documentary record. No doubt seculars, on occasion, saw social advantage in being associated with such monuments, but as a 'source' they are essentially unhistorical and only in a very simplistic way to be regarded as tracking historical accommodations between church and state. The tension is there, but it is between the ethos of a heroic past being transferred into a Christian present within an art form.

The intellectual, literary character of Pictish sculpture has been emphasized in the earlier chapter on themes and programmes where reference was made to the analogous iconographies of the Northumbrian Franks Casket [23]. The Casket has been described as 'ostentatiously erudite', and the same could be said of much Pictish sculpture, with its flamboyant displays of the classical hybrids, the centaur, the hippocamp and the griffin.[72] These were well known to Insular artists in metalwork and sculpture but the Picts took them up and were able to integrate them stylistically and conceptually with their own ideas about animal force, and in particular with their own hybrid animal, the enduring 'beast' symbol, made up of parts of horned, tailed and marine creatures but with no core species [72, 97].

There is evidence also in the specificity of the Pictish depiction of monstrous animals for access to texts concerned with animal lore and confrontations with monsters.[73] Such texts in Anglo-Saxon contexts have recently been the subject of detailed critical analysis.[74] It has been convincingly demonstrated how such sensational subject matter was used to bring home the moral dangers implicit in some aspects of the heroic ideal, which was in the process of being deconstructed in Christian terms. The ancient, 'heroic' combats with monsters were a source of pride, that touchstone of the pagan hero, but for the Christian the most deadly sin, which caused Man's fall. The study of Irish texts has similarly shed light on monster types, and having to do with monsters, as a source of evil.[75] Monsters, then, have a significant role in helping society to redefine itself within Christianity.

The display of monsters on the front of the Rossie Priory cross-slab [102], each a well-defined motif, and the relationship between monsters, symbols and riders, is the Pictish equivalent of these Insular texts. An important aspect of the slabs, therefore, was this display of learning with its latent didactic import, calculated to catch the attention of society at all levels.

The Picts facility in animal art made it inevitable that it should continue to play an important part in the decoration of the slabs. Pictish flexibility of mind ensured an expansion of the genre, single portraits of naturalistic animals continued, alongside similar studies of monsters, and of course, the decorative animal art of the Insular repertoire was fully exploited. Nor were these styles kept apart, for they were literally brought together in virtuosic displays of animal combats, such as the naturalistic animal with a thick serpent knotted round its body while its tail is entangled with its own legs in the manner of decorative creatures in book art, on Meigle No. 4 [35], or the expressive tug and twist of the head of a domesticated animal in the jaws of a lunging dragon on Meigle No. 2 [194]. A role for animal art was also found in the popular texts known as *Physiologus*, well known in the contemporary Insular world, where the 'natures' of animals were used to form Christian allegories. From *Physiologus* comes the use of serpent imagery whose natures included sloughing of its skin, identifiable with the resurrection of Christ and the renewal and rebirth at baptism. Much of this animal art of the cross-slabs would be made available to the sculptor through contacts with churchmen who knew the texts.[76]

In looking for the function of the cross-slabs, subject matter is strongly on the side of them being directly related to the purposes of the Church. Recently the term 'prayer-cross' has been used to describe them.[77] Providing an incentive and location for regular personal prayer is indeed a function for crosses described in both Anglo-Saxon and Irish sources. But many other functions are cited also, and a prayer-station would scarcely justify the raising of a large, heavily carved cross-slab. Some of the great slabs could serve as mass-crosses, or indeed mark the spot where the sacraments in general could be dispensed.[78] Such slabs would attract burials and the cemetery might then itself be developed into a church. The great slab at Shandwick [200] would fit this model. It appears to be in its original position, standing in relation to a burial ground. It faces east with the rising sun playing on its spiral-encrusted cross set high on the slab. If, as in churches in Ireland, mass was said at dawn, the location would indeed have been an impressive one.[79] Ross & Cromarty sculpture poses a particular institutional problem, for it has four sites with large slabs only a few kilometres away from each other on the Tarbat peninsula. It has been suggested that this reflects a constellation of related sites, with a centre, and associated hermitages or cells.[80] One might want to modify this to a centre with associated burial grounds and chapels functioning in different ways, analogous to what has been described as the complex 'liturgical landscape' of Iona.[81]

It is not difficult to assign different roles to the monuments on the Tarbat peninsula, which the present writers regard as virtually contemporary productions. We have seen that Shandwick, with its bold use of the symbols and elevated cross, could be a public focus for the dispensing of the Sacraments. The Nigg slab with its frail intricacy [202], muted symbols [184], and unique visualization of the Mass [203], is admirably suited to stand in an Episcopal chapel (a role served by Nigg Church in its later history).[82] Tarbat with the display of literacy on a massive cross-slab identified by its inscription as a memorial, is presumably the monastic centre with its own range of churches within the immediate precinct. The Hilton cross-slab, associated with a chapel site, is now revealed not just as a slab of architectural proportions, displaying hunt iconography under somewhat mannered symbols framed by elegant vinescroll [50, 61], but as depicting on its front face a weighty cross set on a stepped base around which writhe animals designed in the latest fashion [43, 273].[83] Although it is too soon to assess the context of the Hilton cross-slab, an initial impression suggests that it may have stood adjacent to or within a private chapel. Such speculations apart, it is a fact that although all these Ross & Cromarty slabs share a format and decorative repertoire, they are planned to look different. The difference is likely to be due to difference in function rather than to competing patrons or the passage of time. There are many other slabs that could be singled out as belonging to this architectural, functionally designed class. Obvious candidates are Meigle No. 2 [194] (discussed below), Cossans [271], St Vigean's No. 7 [48], Rosemarkie [39], and Aberlemno Nos 2 [36] and 3 [218]. Other slabs, including those given over to an encyclopaedic display of learning discussed above, will have had a quite different role.

When the imagery is concentrated and the scale intimate then it is reasonable to assume a more personalized function. Meigle No. 5 [91, 92, 321] is a good example of this type of slab.[84] Although only 76 centimetres high, the cross-face is markedly sophisticated. The distinctive type of cross, based on metalwork, is presented within a decorated border. A selection from the range of animal imagery is carved in the background. The symbols are incised on a narrow side. The back is treated as one panel, displaying a single rider in classic Pictish style set upon a plain plinth, well-suited for an inscription. This slab is clearly not designed to serve as an official focus but is a personal monument of some distinction. The same discernment is at work on Kirriemuir No. 2 [183, 263], although the subject matter is resolutely traditional.[85] Only 7 centimetres higher than Meigle 5, its hunt scenes, on both sides of the slab, have both the dash and attention to detail of the Roman hunt sarcophagi. The pose of the main rider on the back seems in intentional contrast. With a single symbol by his shoulder and wearing a sword as well as carrying a spear, he has the stationary *gravitas* of a military leader about to address his troops.

These are choice monuments relatable in function if not in style to the warrior slabs at Benvie and Kirriemuir No. 3. In Angus, the profile rider as an image of 'the man on horseback

who rules' became less common. The sophisticated warrior ethos of Kirriemuir No. 2 is balanced exactly by the exclusively ecclesiastical nature of Kirriemuir No. 1 [314], with its range of hagiographical and devotional imagery, which includes on either side of the cross-shaft a frontal facing cleric.[86] The repetitive pairs of ecclesiastics shown frontally on these small slabs, enthroned or holding books and other liturgical impedimenta, have often been interpreted as Evangelists, the stereotype seated frontal figures of the Irish pocket Gospel Books, but a heightened and more complex iconography seems hinted at by, for example, the

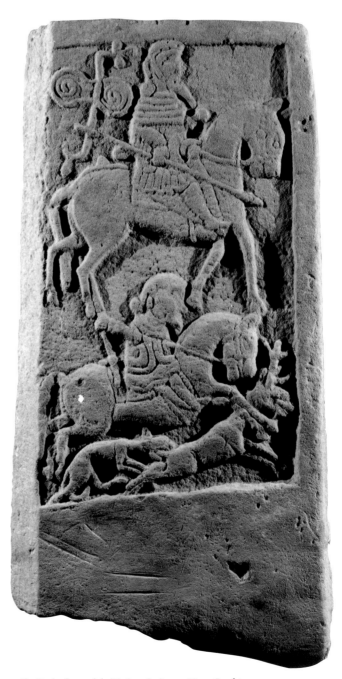

263 *Back of cross-slab, Kirriemuir, Angus, No. 2. Sandstone*

combination of David images with the pair of seated figures at Aldbar [193], and by St Vigean's No. 11 [209], as argued above.[87] The function of slabs carrying visible exegesis would more likely be devotional than commemorative, although the presence of the profile rider at Aldbar impressively links the scriptural material with the accessible icon of secular society.

These smaller slabs are important, and are only beginning to get the attention they deserve. They are not just poor relations of the larger slabs. The eventual elucidation of the role of the early church at Kirriemuir, which is now seen to have had a considerable sculptural output, will help to define their context.[88] The slabs at St Andrews also merit further study [264–267].[89] They comprise a large number of slabs found in the vicinity of the early churches of St Andrews that functioned without doubt as grave-slabs. Rather than being downgraded as rather mechanical productions, probably mass produced and so strikingly unlike the varied and virtuosic symbol-bearing slabs, they should be seen as a development from the cross-marked stones, a very seemly kind of gravemarker that does credit to the communities at St Andrews. Here and there one finds clear evidence – a vinescroll, the mingling of spirals and key-pattern, or an ambitious frontal figure – that, had more elaborate monuments been wanted for the function of gravemarking, the sculptors would have had no difficulty in producing them. Given the almost hectic profusion of imagery, figurative and animal, on the cross-slabs, the sobriety and efficiency of the St Andrews workshop almost inevitably seems tame. But this is a splendid collection of gravemarkers comparable to that of Iona and Clonmacnois, Hartlepool, and Lindisfarne. The dates of these collections and the individual monuments within them vary and it is probably because the St Andrews collection belongs to a comparatively short date-bracket that it is so uniform. The St Andrews gravemarkers rely basically on spiral and geometric repertoires set within a rigid framework to provide a background for the undecorated cross. Comparison with the rich imagery and decoration of the great Sarcophagus is inappropriate, since like is not being compared to like. As we shall see, the free-standing crosses at St Andrews provide the artistic bridge between the modest shallow-relief gravemarker and the virtually three-dimensional carving of exotic imagery on the shrine.

It is only because they give this superficial impression of mass production that the St Andrews slabs appear different from other Pictish sculpture. In fact many connections can be made between them and other monuments of similar scale in Angus and Perthshire. The accomplished complete slab at Invergowrie, Angus, has a geometrically laid out cross-face, with the cross ringed and with a markedly tall upper arm filled with grooved interlace. The background of the cross has discrete panels of key-pattern set into the corners of the slab.[90] All these features can be paralleled in the St Andrews collection. The same is true of the ringed cross-head on another fragmentary slab at Invergowrie. Interestingly, however, the figurative art on the fragment consists

of a rider and a narrative scene carved in a naturalistic plastic style, while on the reverse of the complete slab three figures, set above a formal panel of animal ornament, are carved in shallow relief, their garments expressed in rigidly parallel folds. This linear figure style is used for figures on the Lethendy, Perthshire, slab [210]. On both the Lethendy slab and the complete slab at Invergowrie [67] the designer has employed the convention of giving the important figures proportionately larger heads than the other figures on the slab. This device is used for figures in the Book of Kells and dominates the later Irish Gospel Books. The use of a conventional non-naturalistic style to convey meaning is a new development and not a sign of encroaching barbarization or Gaelicization. The linear style for figures was also used on sculpture at Fortingall, Perthshire, which has been shown in other respects to have connections with slab sculpture at St Andrews.[91]

A similar relationship is perceptible between slab production at St Andrews and sculpture in the far north. The most striking example is the slab at Farr, Sutherland [268].[92] Its dimensions – 2.3 metres high by 60 centimetres wide – are very different from those of the St Andrews slabs, but like many of them it is carved on one face only and its geometric layout and use of the decorative repertoire of interlace, key-pattern and spirals make the connection immediately apparent. Even the motif of the birds with linked necks that fills the base of the Farr cross-shape has a loose parallel on St Andrews No. 64, a slab that Hay Fleming rightly describes as 'strikingly beautiful'. Closer parallels for this motif, which is derived ultimately from the Early Christian motif of birds obtaining nourishment from a vine or Tree of Life, are found elsewhere in Insular art, for example, on *f.* 2 recto of the Book of Kells. A further link is the use by the Farr sculptor of the spiral pattern, Allen No. 1054, which occurs on at least five slabs at St Andrews.[93] These connections reflect the coming and going along the eastern seaboard, a cultural routeway already apparent in sculpture of a very different kind at St Andrews and the Tarbat peninsula. The community at Farr was clearly ambitious but kept within a chosen monumental genre.[94] It seems probable that all these small slabs had a private function, with scale and content tailored to the taste and circumstances of an individual or to a self-contained ecclesiastical community.

Free-standing Crosses

The majority of the crosses depicted on Pictish cross-slabs are long-shafted, although decoratively divided by panelling into an equal-armed cross-head set on a shaft attached to the lower arm [202]. Many have hollowed armpits made out of a section of a circumference of a circle. Sometimes the circle was completed so creating what has been called a quadrilobate ring, for example on the Aberlemno churchyard slab [36], but which nonetheless are ringed crosses. True rings also encircled cross-heads as on the

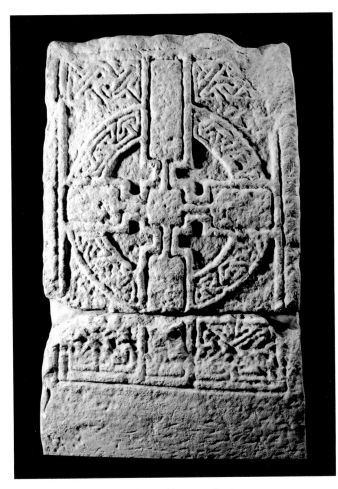

264 *Back of cross-slab, St Andrews, Fife, No. 21. Sandstone*

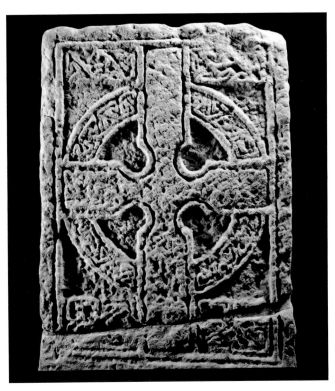

265 *Back of cross-slab, St Andrews, Fife, No. 22. Sandstone*

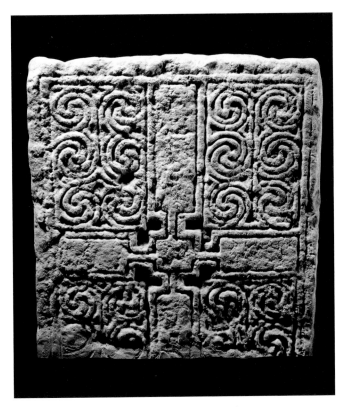

266 *Front of cross-slab, St Andrews, Fife, No. 24. Sandstone*

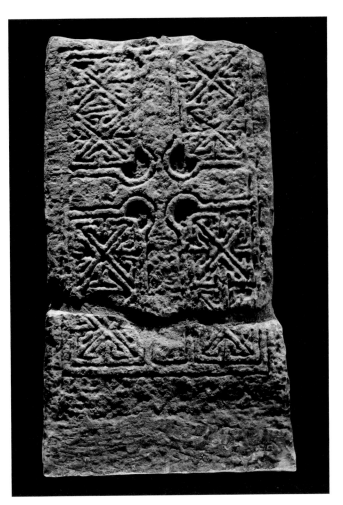

267 *Back of cross-slab, St Andrews, Fife, No. 23. Sandstone*

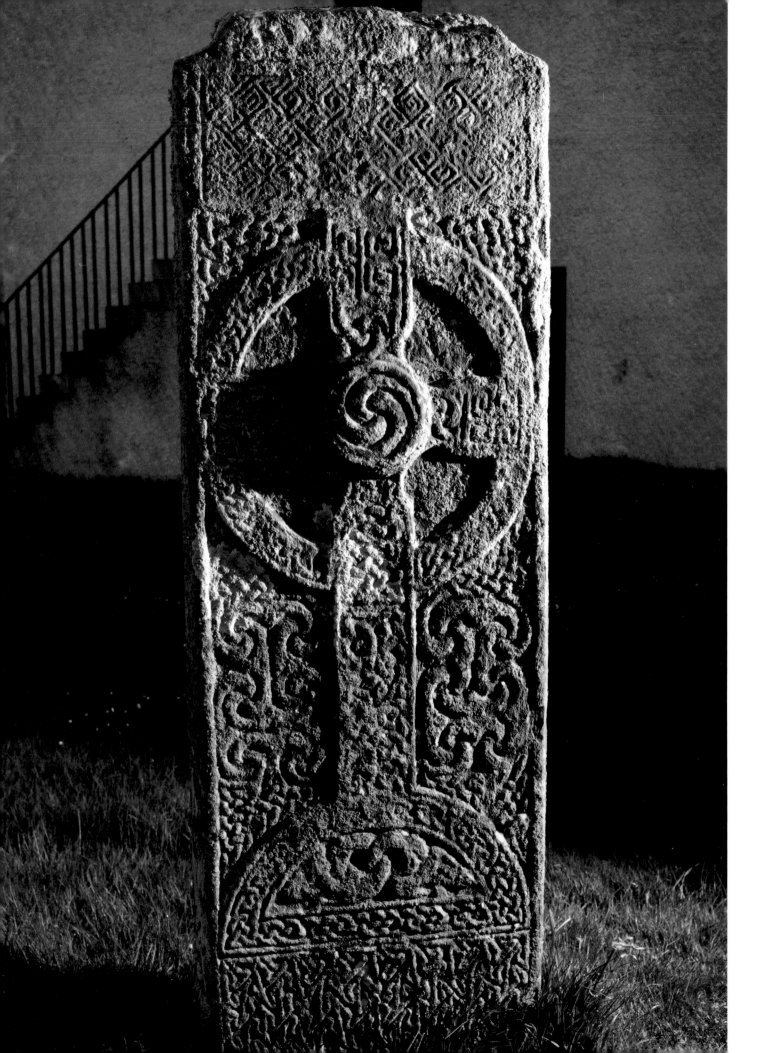

Aberlemno roadside slab [218]. As we have seen, encircled equal-armed crosses are common on the cross-marked stones. There is certainly no reason to suppose that the ringed crosses on slabs depended on Irish free-standing ringed crosses.[95] The bottoms of cross-slabs are often impaired, but many have the shaft ending with a decorative panel which reached the lower edge of the slab. Below that was a tenon which was set either in the earth or into a socket-stone. The cross-slab at Dunfallandy [49, 77] was probably earth-fast[96]; Aberlemno roadside appears to be set in its original socket-stone. The free-standing cross placed between enthroned figures depicted on the reverse of the Dunfallandy slab may be set on a plinth higher than ground level [77]. The free-standing cross which is the goal of the pilgrims on the Papil shrine panel is of similar proportions and stands on a substantial block base [301]. On the taller Pictish cross-slabs, the Latin cross sometimes ends before the lower edge, suspended as it were in the air, in the manner of the cross on Shandwick [200]. Others draw a base, as on the crosses on both sides of the Skinnet slab [47]. Some of the drawn bases are block-like, others are simply a plinth, as at Elgin [216] and Forres. The larger slab at Fowlis Wester [270] has an equal-armed cross-head set on a broader shaft rather in the manner of Northumbrian free-standing crosses. At over 3 metres high and with the arms projecting beyond the edges of the slab the visual effect is strongly that of a free-standing cross, but in this case, apparently without a 'drawn' base. This slab is symbol-bearing, as is Largo, another example of a depiction of a free-standing cross on a slab.[97] Here the ring is cut round at the top of the slab to form a rounded upper edge and the shaft sits firmly on a deep base. The slab at Cossans [271] has the soaring appearance of a free-standing cross with its long tapering shaft, complex cross-head and truncoidal base. The whole of the cross has a recessed border, though still in higher relief than the surface of the slab, a feature reminiscent of the free-standing cross on the Isle of Canna, which has other Pictish connections.[98] A symbol-bearing cross-slab like Cossans slips naturally into the format of the free-standing cross. The most impressive 'drawn' base of all is that recently recovered at the Hilton of Cadboll chapel site. The cross-face of the Hilton slab was chipped off in the 17th century and survives only as fragments. The lower portion of both sides of the slab [273] has survived virtually intact, although without its lower edge and the original tenon, which were lost after a fall in antiquity. The base of the cross is revealed as broad and two-stepped, flanked by two further panels which visually form a third step. These flanking panels, originally projecting from the edges of the slab, now form stopping blocks where the slab may have entered a supporting 'collar' stone. The base structure occupies the whole width of the slab (140 centimetres), its massiveness heightened by the severity of its key-pattern decoration, parts of which rise to form high-relief spiral bosses. This decorative treatment belongs with the panels of bossed ornament used on the shafts of the St Oran's and St John's crosses on Iona. Its use on a base whether drawn or part of a free-standing cross is

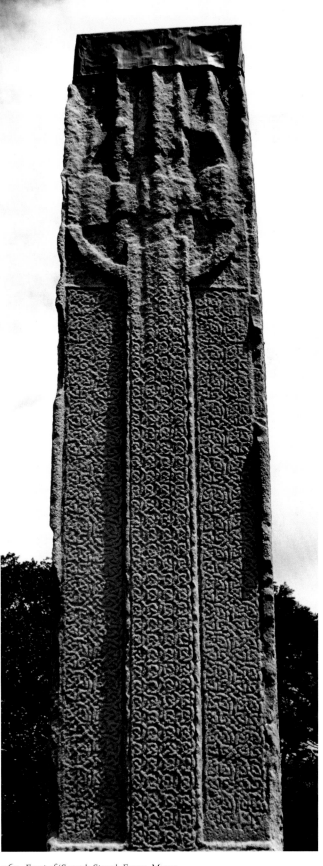

269 Front of 'Sueno's Stone', Forres, Moray

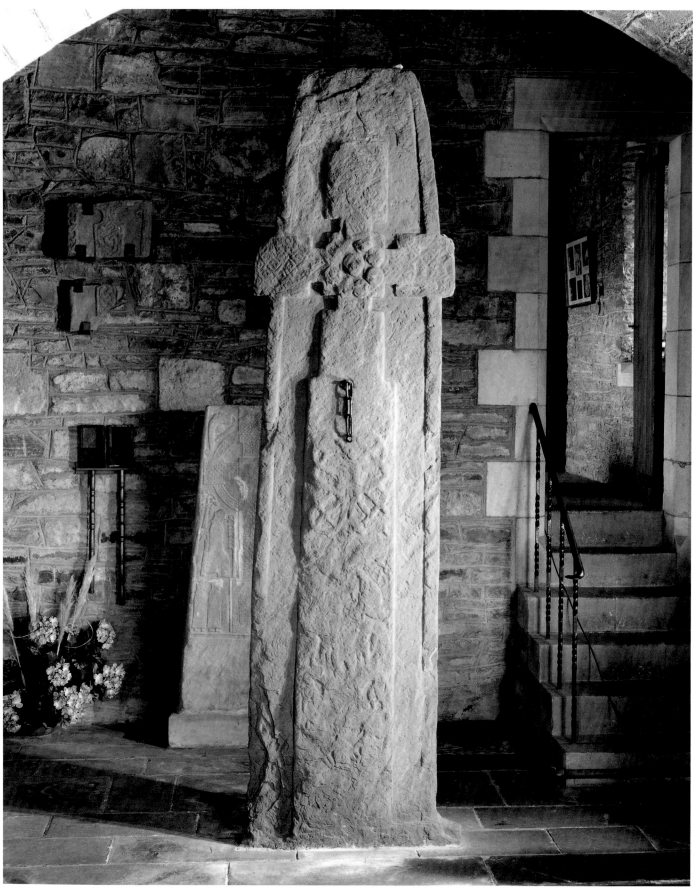

270 *Front of cross-slab, Fowlis Wester, Perthshire, No. 1*

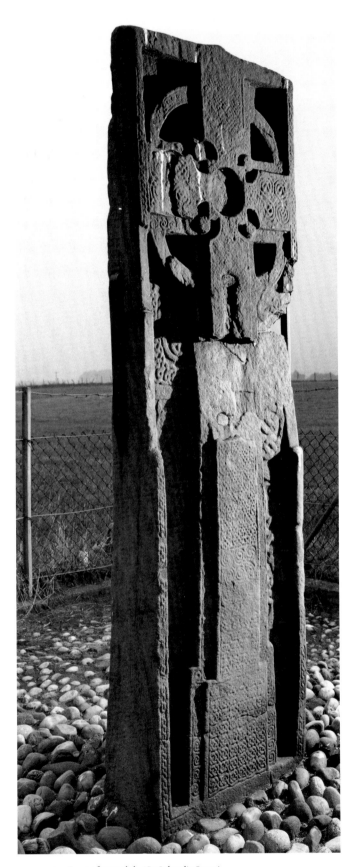

271 *Front of cross-slab, 'St Orland's Stone',*
Cossans, Angus. Sandstone

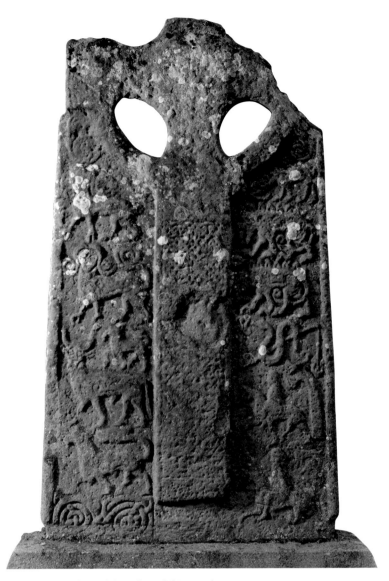

272 *Back of cross-slab, Gask, Perthshire. Sandstone*

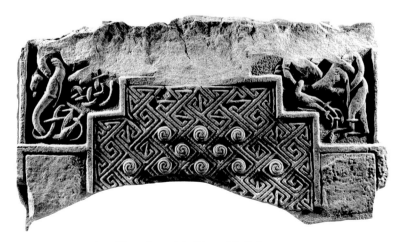

273 *Lower portion of front of cross-slab, Hilton of Cadboll,*
Ross & Cromarty. Sandstone

unparalleled in surviving Insular sculpture. When complete the cross-arms on the Hilton slab projected from the sides of the slab. These projections were removed probably in the 17th century, but traces of them are just visible on the edges of the surviving back of the slab. The original size and technical function of the lower projections is at present uncertain, but visually, like the arm projections, they give additional 'architectural' emphasis to the cross-shape.

Some Pictish cross-slabs have the armpits of the cross deeply recessed or even pierced. This piercing of the ring has been described as 'a distinctive blend of Irish and Pictish sculptural traditions' in discussion of a fragment of a cross-slab at Applecross, Ross & Cromarty.[99] Here a sturdy shaft is set on a base expressed as a decorated panel rather than as a piece of

architecture in the manner of the Hilton base. The piercing of the ring on the Applecross slab, which has more connections with Pictish sculpture than with Irish sculpture, may be a 'blend', but the other well-known example of pierced armpits, the slab at Gask, Perthshire [272], with its symbols, riders and learned animal imagery could scarcely be more Pictish. Some Pictish desire to make a less slab-like monument must be at work, and that desire may be rooted in awareness of the effect of a free-standing cross. So that the piercing 'works' for the carving on the back, the Gask sculptor carved crosses of the same shape on his front and back, thereby increasing the similarity of his design to that of a free-standing monument.

A fragment of a cross-slab from Carpow, near Abernethy, is another Perthshire example of a slab with identical ringed crosses

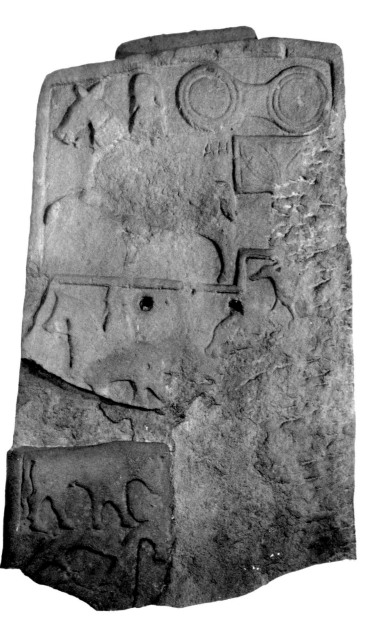

274 *Back of cross-slab, Woodrae, Angus. Sandstone*

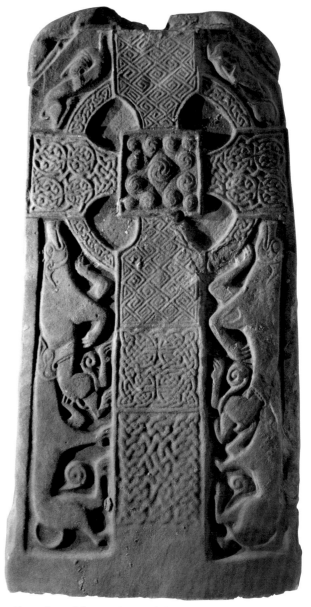

275 *Front of cross-slab, St Madoes, Perthshire*

on front and back with the armpits pierced.[100] The cross itself has a recessed border of the Cossans type. Not enough remains to identify its type further, although the use of body scrolls on a quadruped and a fine study of a stationary stag, looking back, show that it is not far removed from the mainstream Pictish monumental tradition.

The projection of the horizontal arms of the cross noted on Fowlis Wester and Hilton of Cadboll is paralleled on an Irish slab, Fahan Mura, County Donegal. A recent analysis of the development of the free-standing cross in Ireland dates Fahan Mura to the 8th century, but part of the argument depends on the conventional date for Pictish slabs of the Glamis type.[101] This type has no projection of the side arms but has many similarities with Fahan Mura, in its scale, its cross-type and its decoration. The urge to relieve the formlessness of the lateral edges of the rectangular slab has a counterpart on Meigle No. 2 [194, 199] which has pairs of prominences on each side unrelated to the structure of its cross.[102] Such prominences even on a slab with a rounded top defined by a true ring are unlikely to relate to any fundamental dissatisfaction with the slab format.

Meigle No. 2 is finished off with a pseudo-finial in the form of a spiral-ended narrow projection sitting, as it were, on the top arm. A similar projection, well-formed but apparently plain, tops the elaborately decorated cross-face of the symbol-bearing slab from Woodrae, Angus [274]. The most dynamic finish to a cross-slab is on the top edge of the cross-slab from St Madoes, Perthshire [275], where virtually three-dimensional lions crouch on either side of a damaged central feature. The eastern face of the finial of St John's Cross on Iona displays two confronted standing lions.[103] Much closer to the St Madoes pair is the single beast, also carved virtually in the round, which tops a cross-head at Mayo Abbey, County Mayo.[104] The lions on St Madoes are in the main in much better condition, so that one can appreciate such details as the shaping of the hindquarters and the pendulous hang of a tail [276]. In general, they have much more in common with what may be the ultimate source of this iconography, the Romano-British slabs topped with lions flanking a central motif, familiar from the Mother and Child tombstone from Murrell Hill, Cumberland.[105] Their appearance on the top of the St Madoes slab is therefore free of any direct influence from Irish free-standing crosses.

A monument at Mugdrum, Fife [277], which should have been central to the understanding of the relationship of slabs to free-standing crosses in the Pictish area has been rendered almost valueless by its (continuing) exposure to the elements. Allen records that the shaft and what remains of the head together measure 3.35 metres. With its base of 46 centimetres high it must have approached the height of 'Sueno's Stone', Forres. Its 168 centimetres long base is appropriate to this great height.[106]

What has survived of this great free-standing cross is of much interest, for it is entirely given over to the hunt theme. Four elegantly mounted horsemen disposed in three panels and moving to the left are carved above a panel displaying at least three

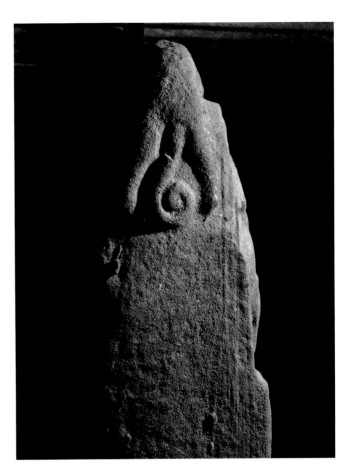

276 *Detail of top of right side of cross-slab,*
St Madoes, Perthshire

hounds bringing down an equal number of stags with their legs doubled up under them, either collapsed or in the classic stag-in-flight position. This is a very different spectacle from the battle lines of Forres and belongs unequivocally to the Pictish tradition. It shares with the Forres triumphal slab the use of inhabited vinescroll, just detectable on one edge. The riders and the hounds with their open-jawed, pug-dog pounce are in the style of the symbol-bearing slab, discussed above, Kirriemuir No. 2 [263]. We cannot tell what the rest of the sculpture on the Mugdrum free-standing cross looked like, but its sculptor evidently had no inhibitions in filling a free-standing cross shaft with hunt imagery.

Understanding of the role of the free-standing cross in Pictish sculpture was greatly advanced by the intensive study of the Dupplin Cross [196] prior to its removal from a hillside overlooking the Water of May towards the Pictish settlement site at Forteviot, Perthshire. The Dupplin Cross is the only surviving example of a complete free-standing cross in the Pictish area. Other examples, as we shall see, are fragmentary. The cross has always been associated with the Dalriadic dynasty of Cinaed mac Ailpín, famed in story for his takeover of the kingdom of the Picts. Extensive archaeological investigations in the nineteen-eighties filled out the sparse written records which, however, reported that

Cinaed had died 'in palacio Fothiurtabaicht' (Forteviot) in 858.[107] The front of the monument with its uncompromisingly military iconography of a single portrait of a mounted leader, set above a clean-shaven bodyguard moving to the left led by two moustached officers carved on the left edge, was well suited to the incoming Dalriadic victor thought to have put an end to the political existence of the Picts. The function of the cross, like that of the Forres slab was patently triumphalist. The decipherment of part of the inscription on the back of the monument disturbed this view,

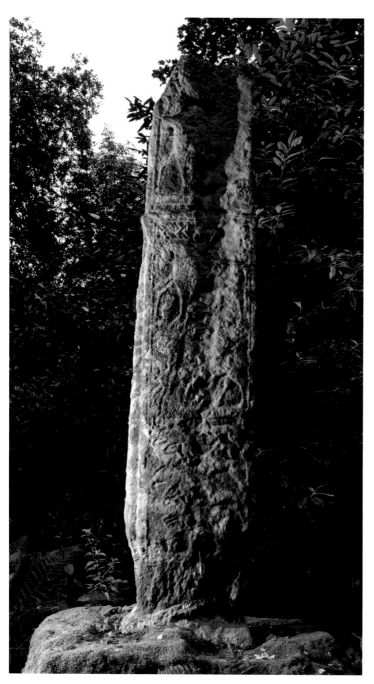

277 *Shaft of free-standing cross, Mugdrum, Fife. Sandstone*

for it displayed the name of a Pictish king, Constantin, son of Fergus, who died in 820 [*278*].[108] From the point of view of an art historian not committed to the interpretation of Pictish sculpture as a linear progression of subject matter and format, this association of a Pict with a free-standing cross was not surprising.[109] There is nothing strikingly like the Dupplin Cross to be found in Dál Riata, which includes Iona and its sculpture school. Much more obvious is a Northumbrian connection in the relationship between the cross-head and the shaft, and in the arrangement of vinescroll around a central boss on the front of the cross-head, although it should be noted that it is this location for vinescroll and not the motif itself which is new to Pictish sculpture. Vinescroll as an alternative to the snake-boss was already established in the Pictish repertoire, a move from the symbolism of Resurrection to the symbolism of the Eucharist. Much of the other ornament on the Dupplin Cross is directly relatable to the slab sculpture of Perthshire and Angus discussed above, the mainstays of which, on these smaller slabs, were triple spirals connected with C-scrolls, key-patterns, median-incised interlace and animal-headed interlace.

The change in figure style is more significant than the change in format. The profile portrait of the military leader on the front of the cross, immediately below the vinescroll, has the same stationary mount as the leading rider on Kirriemuir No. 2 described earlier but the naturalism of that figure's head is replaced on Dupplin by a seemingly disproportionately large stylized head, in the manner of the central, frontal ecclesiastic on the Invergowrie slab noted above [*67*]. This device with its bracteate-like stylization of the body proportions of the rider has a precedent and near parallel in the St Andrews Sarcophagus.[110] This more expressive approach to style is seen also in the rigid wall-like depiction of the four-strong bodyguard. Few modern viewers will prefer this style to the naturalistic supple grace of the Aberlemno churchyard warriors [*82*], but in a way such a signifier of importance would, as we have seen, have assisted the interpretation of the battle scene. The rest of the iconography of the Dupplin Cross is given over to Pictish Christian themes, such as David, as Psalmist, and David shown to be eligible as the protector of his people in his feat of saving his sheep from the lion's jaws. An interlace-filled roundel bordered by plump birds may be a 'coded' reference to St Columba, whose name means 'dove', and whose cult was promoted by King Constantin. The abbreviated hunt scene, of running hounds only, is in the Mugdrum style.[111]

This is not to say that in this predominantly Pictish monument there are not signs of the Insular exchange of ideas. The vinescroll disposed on the cross-head in the Northumbrian manner has been mentioned, and the facial type of a block nose and frontal eye can be exactly paralleled in the Irish cross at Moone, County Kildare.[112] Moone appears to have had Columban connections, which may explain this transmission of forms. The most significant Irish feature, not part of the repertoire of the Iona

school, is the finial-like extension of the upper arm of the cross that does not display lions, but is conceived of as a tiled roof, an indication of knowledge of the house-shaped finials on top of the Irish High Crosses. These finials, and a related domed variety, have been identified as representing the Holy Sepulchre.[113] The base of the Dupplin Cross is not stepped but it is perhaps sufficiently high to allow, when taken with its tegulated finial, the possibility that a king called Constantin had caused to be erected a cross which recalled that set up by his namesake on Golgotha Mount. We have seen that Pictish awareness of the appearance of that jeweled cross might well account for the spiral-studded Shandwick cross [200], and the dramatically stepped base of the cross on Hilton of Cadboll [273] suggests a similar visual reference. That Constantin wanted a cross seen against the sky might also have influenced the choice of format. The unparalleled delicately scalloped edging of the Dupplin cross-head is appropriate for metalwork and the Northumbrian vinescroll gives the head something of the look of the Living Tree, comparable to the wooden cross erected by Oswald before his great victory in 633 over the British King Cadwallon. It has been observed that Bede casts that story in terms that 'presented the king as an English version of Constantine, inspired to victory by a cross'.[114] The Constantin monument in Perthshire may have been intended to have the same resonances. Constantin became king after a victory in 789, and just as Constantine the Great and Oswald of Bernicia advanced the cause of Christianity, so Constantin appears to have led a revival of the veneration of St Columba. The art of the Pictish slabs shows a readiness for moving into the format of the free-standing cross but the erection of this particular prestigious monument must have been influential in promoting both the form and the repertoire displayed on it. The latter certainly influenced the small slabs of southern Pictland.

That the Picts moved in and out of the two formats is further demonstrated by the nearby Crieff slab [279].[115] In reverse of the fate of the Hilton of Cadboll cross-slab it had its back chipped off, a fact simply ignored by its critics. For all we know this may have been a symbol-bearing slab. The designer of its surviving cross-face was clearly aware of the Dupplin Cross but his ornament is based on developments in 8th-century Insular art not drawn upon by the Dupplin sculptor. Its dominant motif of animalized foliate ornament is closely parallel in Southumbrian manuscripts such as the St Petersburg Gospels. The treatment of the cross-head is different also. Whereas the Dupplin sculptor kept his ornament free of the central bosses, the Crieff sculptor attempted a more ambitious design whereby the ornament on the arms swirled into the centre to create the boss. The complete Dupplin monument declares its function as a means of promoting a saint and a king. The Crieff slab was similarly explicit in that it too had an inscription placed on the shaft, exactly as at Dupplin.[116] Intensive work on the slab's earlier history and topographical context has revealed that the promotion of a saint was also a motivating factor, but whether under the influence of a secular leader cannot now be determined.[117] The function of the two monuments was clearly broadly similar, and the recognition that the format could be either that of a slab or a free-standing cross helps to break down the ethnic stereotype applied to them. The cross-slab at St Vigean's with its inscription [250] consisting of three names might support the view that the recording of names had become a function of public monuments by the early 9th century. The slab is symbol-bearing, riderless and displays both finely drawn naturalistic animals and unusually deformed monsters. The slab provides a

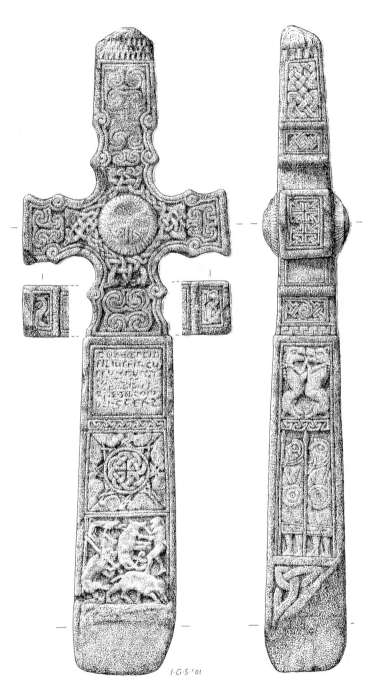

I·G·S·'01

278 Back and side of free-standing cross,
Dupplin, Perthshire, when removed from the base

useful restraint on over-categorizing the intentions of Pictish patrons and sculptors in this period.[118]

Another royal site, St Andrews, had at least two free-standing crosses and probably as many as four.[119] St Andrews No. 19 [280] survives as a shaft only, measuring around 2.44 metres high. Its proportions give it a section more slab-like than the Dupplin shaft. Mugdrum though large, shares the slab proportions. St Andrews No. 19 has a substantial amount of figure carving and forms a link between the Sarcophagus and the small slabs. Simple fleshy scrolls of vine undulate up both edges. On a broad face two similar stems are arranged in the middle section of the shaft to form a medallion scroll. Above is a cramped version of the scene of David killing the lion. Below, the foliate stems are given sucker-like heads that clamp on the crowns of two confronted profile men. The figure on the right holds the wrist of that on the left. Their free hands hold entangled serpents. Their bodies are elongated to form interlaced fishtails. Adjacent is a fish standing on its tail, a denizen of the depths of the sea. In conscious contrast the back of the shaft displays in the top panel two upstanding resolute profile

men who hold respectively a sword and a shield. Below the shield is a small contorted figure. The scene might represent the advice of St Paul to the Ephesians, in chapter 6, where he encourages them to take up the sword of the spirit and the shield of faith in order to withstand the assaults of Satan. Immediately below is another monstrous image. A single human head, fuses into the bodies of two beasts while its crown is attacked by two birds. All this iconography can be paralleled in mainstream Pictish sculpture. David iconography dominates the Sarcophagus [189]. The wrist-holding men whose lustful sins turn them into half monsters appear on the horizontal panel at Pittensorn [227], on one edge of the Forres slab and at Applecross, Ross & Cromarty. A similar figure with his hand on his genitals is on the edge of a fragment of an arm of a free-standing cross at Strathmartine [226].[120] The double beast-bodied man is depicted on the recumbent monument Meigle No. 9 [290] and on the back of the cross-slab, Meigle No. 23. The visualization of a New Testament directive for the conduct of the Christian life is paralleled on the back of the cross-slab, Meigle No. 27 [230].[121] The decoration of the

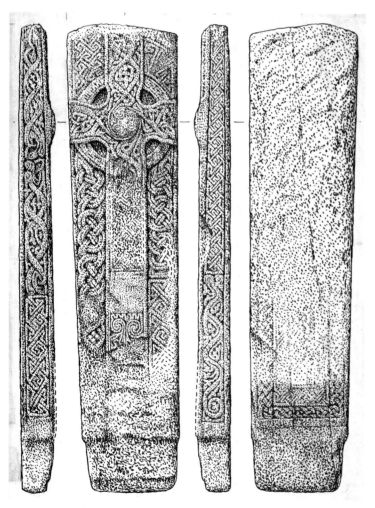

279 All four sides of the Crieff Cross, Perthshire. Sandstone

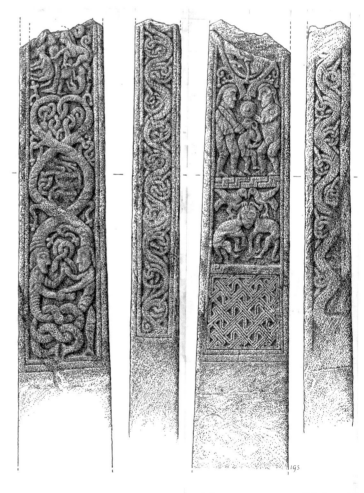

280 All four sides of cross-shaft, St Andrews, Fife, No. 19. Sandstone

281 *Fragment of cross-arm, St Andrews, Fife, No. 52. Sandstone*

front of this last slab, with its median-incised interlace and spirals joined with C-curves is markedly similar to the St Andrews slabs. Monuments at sites as far apart as Applecross, Forres, Meigle and St Andrews comprise a surprisingly coherent body of sculpture.

A second shaft at St Andrews, No. 14, is comparable in scale to No. 19, but is an essay in controlled abstract ornament, possibly in reaction to the more bizarre aspects of the iconography of No. 19.[122] Its repertoire of five types of median-incised interlace and four varieties of key-pattern does not suggest any flagging of effort or ingenuity. The large blank panel on a broad face and a smaller one on a narrow edge may have been used for a painted inscription. Here the free-standing cross is allowed to make its own physical message of the cross of Salvation.

There are two fragments of cross-heads at St Andrews. No. 6 measures 51 centimetres across the arms. Its square terminals and hollow armpits are an Anglian type but a peculiarity is the incomplete cutting away of the armpits, giving the arms a solid concave connection. The effect is unfinished, but the shape is clearly intended, for it appears again, although in a more usual disc-head form, at St Vigean's No. 15. The other fragment at St Andrews, No. 52 [*281*], must have been part of a large cross for the remaining arm is 51 centimetres across. It too is an Anglian type with a wide curve. One side is decorated with a bold key-pattern, the other is plain. Once again the arm is not cut entirely free of the surrounding stone. These cross-heads seem to have retained something of the slab form.

The boss at the centre of St Andrews No. 6 [*282*] is kept free of ornament in the manner of the bosses on both sides of the Dupplin Cross. The reverse of the cross-head [*283*] is flat with triple spirals on the arms running in to a larger triple spiral at the centre.[123] Very different is the arm and central boss of a free-standing cross found in the Old Churchyard at Edzell, Angus in 1952. The spread of the arms has been estimated as 53 centimetres, so it was not a large cross-head in spite of its carving

being in very high relief. One side is carved with a diagonal key-pattern very common in Pictish sculpture. The boss on that side is hemispherical and covered in a mesh of interlace. The other side is flatter but covered with spiral bosses of varying sizes, the centre made up of eight small bosses ranged round a larger boss. It has been argued, because of the similarity of the carving to Pictish sculpture of the quality of the Nigg cross-slab and the St Andrews Sarcophagus [*41, 42*], monuments themselves related to the Iona school of sculpture, that it is 'a fragment of probably the earliest known free-standing cross in the areas where Pictish cross-slabs predominated, and the only one in the style of their most elaborate monuments'.[124] Interestingly the cross-head shows physical signs of having been composite, the head set on a tenon in a manner comparable to the construction of the Iona crosses.[125] The bosses are very similar indeed to the bosses which cover the cross on the Shandwick slab and to the infilling of the 'double disc and Z-rod' symbol at Rosemarkie [*81*]. However, even more accomplished spiral bosses fill the same symbol on a fragment at St Vigean's, No. 6 [*55*]. The Edzell fragment is certainly an early and experimental effort, on a small scale, to produce a free-standing cross in the Iona fashion, but it lies outside the interest in the production of monolithic free-standing crosses visible in the slabs.

None of the free-standing crosses discussed so far was ringed, but there is evidence for this type of cross having been made at Forteviot.[126] Forteviot No. 3 is a fragment of the arm of a cross, 25 centimetres wide, with part of one of the quadrants of the ring still attached. The carving, on one broad face and on the edge of the terminal, is respectively broad triangular interlace interspersed with pellets, and median incised interlace. The outer edge of the surviving segment of the ring is decorated with key-pattern suggesting that this was an elaborately carved monument. The pellets are similar to those within the panels of key-pattern at Rosemarkie. The key-pattern on the ring is common on slabs in Perthshire, Angus, and Fife. The interlace is repeated on a

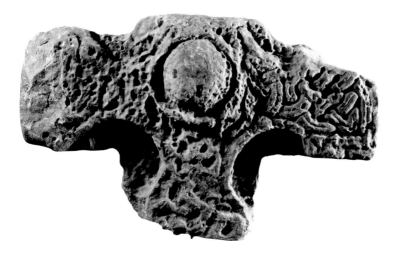

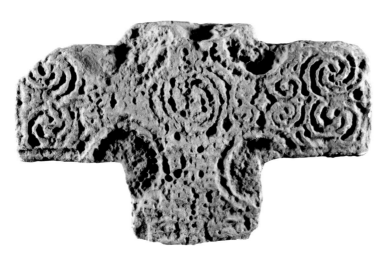

282 *Front of fragment of cross-head, St Andrews, Fife, No. 6. Sandstone*

283 *Back of fragment of cross-head, St Andrews, Fife, No. 6*

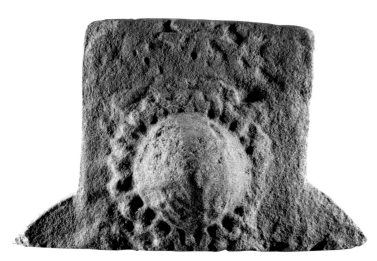

284 *Bossed cross-arm, St Vigean's, Angus, No. 9. Sandstone*

fragment with figurative art at Burghead, Moray. Close to Burghead is Kinneddar with its collection of sculpture (now in Elgin Museum) ranging from a symbol stone to a fragment of a ringed free-standing cross (No. 9). Another fragment (No. 10) is part of a cross-shaft.[127] Fragments of the shaft of a third free-standing cross survive in the vicinity of Forteviot at Invermay. It is carved with a distinctive median incised key-pattern used on the nearby Dupplin Cross.[128]

A more spectacular ringed cross survives as fragment No. 9 at St Vigean's [284].[129] It is a conical boss in very high relief, surrounded by animalized interlace and with a trace of a connecting ring on one edge. As reconstructed in a drawing in the St Vigean's Museum, the fragment, which is 33 centimetres wide and 56 centimetres high, has been interpreted as the top arm of a very large cross, similarly bossed on all four arms. The fragment originally had a boss on its reverse, presumably shallower, so that this must have been a major monument.

Although no unequivocal evidence for the erection of free-standing crosses north of the Moray Firth has yet been recovered, a case can be made for interpreting a pillar carved on all four faces from Reay, Caithness, as a refashioned shaft [285, 286]. As it survives, it is 23 centimetres square and 91 centimetres high. Its naturalistic animal art on one face, which includes two cows with conventional Pictish body-marking, is presumably the justification for its having been dated to the 8th century.[130] Other ornament, however, such as the cross filled with key-pattern, animal-headed interlace and fat running spirals would support a later date. A boss has been chiselled off one face and the top of the pillar has been reworked also. Either this is yet another format for stone sculpture or it is part of a free-standing cross with a bossed cross-head, the existing boss representing its lower arm. A difficulty is the presence of a second cross, but in other respects this pillar is not inconsistent with the art of the period of the introduction of the free-standing cross described above. Even its animal art could find a place in the context of the shaft at Monifieth, which locates an animal portrait at the bottom of its decorated shaft, but which belongs to a period later than the sculpture under consideration in this book.[131]

From the above survey it is evident that free-standing crosses were erected at sites which had other mainstream Pictish sculpture or had in themselves links with mainstream sculpture. Their erection probably signalled the period of the institutional amalgamation of the Picts and Irish from the west but they cannot be regarded as clear-cut evidence for a cultural ethnic takeover. Indeed the patently Pictish characteristics of the free-standing crosses, and other symbol-less monuments, are evidence for a continuing and developing Pictish cultural input through to at least the end of the 9th century. The greater vulnerability of the free-standing cross in post-Reformation Scotland no doubt accounts for the small number surviving even in a fragmentary state. How different St Andrews would have looked if its tall free-standing crosses had survived intact. The survey also shows

continuing monumental links between sculpture south of the Grampian range and the far north. Sophisticated relief sculpture does not stop at Ross & Cromarty. Underappreciated slab sculpture from Reay [285, 286], Ulbster [56], Skinnet [47] and Farr [268], along with the cross-marked stones and symbol stones of the region are equally part of the Pictish response to Insular art in all media. This sculpture, the sculpture of Aberdeenshire with its restrained monumental taste, and the small slabs in the south, must be assessed in their own terms and not simply as a falling away from productions in major centres which are mistakenly regarded as comprising a norm for the content, form and function of Pictish sculpture.

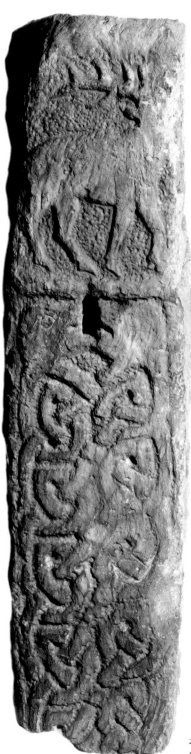

285 *Back of pillar, Reay, Caithness. Sandstone*

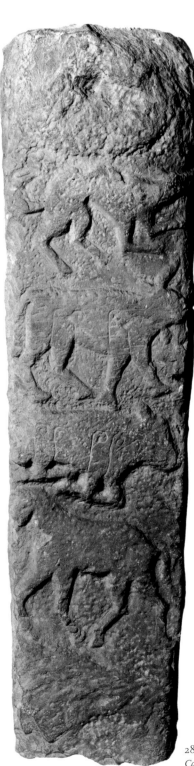

286 *Right side of pillar, Reay, Caithness. Sandstone*

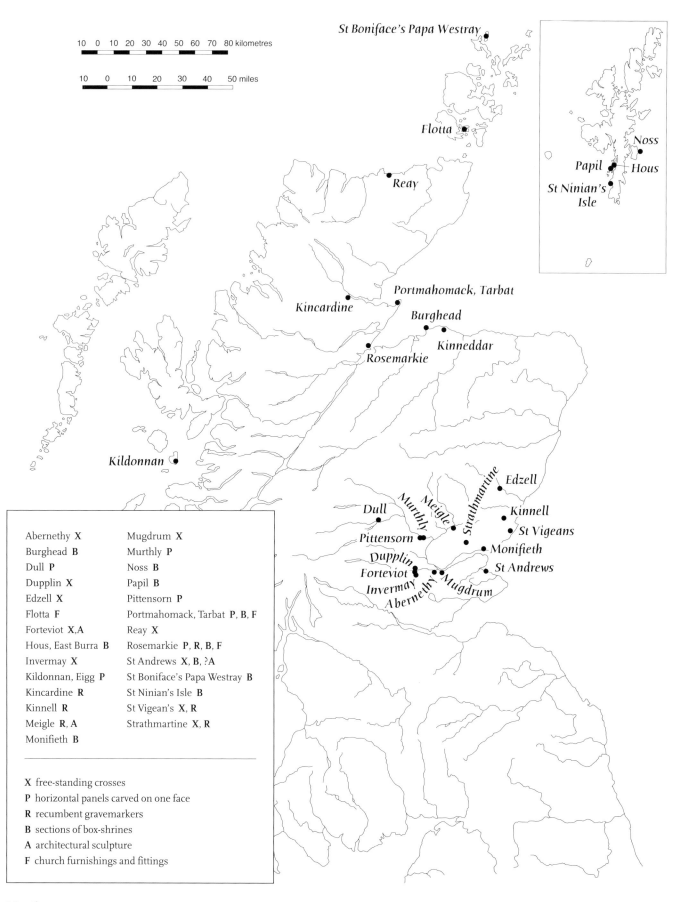

St Boniface's Papa Westray

Noss

Papil — Hous

St Ninian's
Isle

Flotta

Reay

Portmahomack, Tarbat

Kincardine

Burghead

Kinneddar

Rosemarkie

Kildonnan

Edzell

Strathmartine

Dull

Murthly

Meigle

Kinnell

St Vigeans

Pittensorn

Monifieth

Dupplin

St Andrews

Forteviot

Invermay

Mugdrum

Abernethy

10 0 10 20 30 40 50 60 70 80 kilometres

10 0 10 20 30 40 50 miles

Abernethy **X**	Mugdrum **X**
Burghead **B**	Murthly **P**
Dull **P**	Noss **B**
Dupplin **X**	Papil **B**
Edzell **X**	Pittensorn **P**
Flotta **F**	Portmahomack, Tarbat **P, B, F**
Forteviot **X,A**	Reay **X**
Hous, East Burra **B**	Rosemarkie **P, R, B, F**
Invermay **X**	St Andrews **X, B, ?A**
Kildonnan, Eigg **P**	St Boniface's Papa Westray **B**
Kincardine **R**	St Ninian's Isle **B**
Kinnell **R**	St Vigean's **X, R**
Meigle **R, A**	Strathmartine **X, R**
Monifieth **B**	

X free-standing crosses
P horizontal panels carved on one face
R recumbent gravemarkers
B sections of box-shrines
A architectural sculpture
F church furnishings and fittings

Map 6
Sites with relief-carved sculpture on monuments other than slabs.

7
Form and Function of Pictish Sculpture: II

Composite Monuments: Recumbent Grave Covers and Shrines

If archaeology has not yet been able to establish a firm or generally applicable association between Pictish burial practice and Pictish symbol-bearing monuments, non-symbol-bearing sculpture provides one form of monument which beyond doubt functioned as a gravestone. Only around a dozen or so of these recumbent bodystones have survived, but they include some of the most impressive examples of Pictish carving and the form they take is unique to the Picts. In profile they are wedge-shaped, higher at one end and with a taper in width towards the foot. The largest is Meigle No. 11 [287, 288], with a head height of 69 centimetres, which slopes to 48 centimetres at the bottom. Complete examples are of sufficient length to cover an adult grave. A rectangular recess is cut into the head end of the top surface.[1]

The origin of this distinctive funerary monument is not immediately obvious. In shape it is comparable to the so-called tomb of Bishop Agilbert in the crypt at Jouarre, near Paris, which itself reflects the sloping and tapering shape of Merovingian sarcophagi. Agilbert spent some time in England before returning to France to become Bishop of Paris in 669. The carvings, on two faces, of his tomb have often been associated with sculptural developments in Northumbria but for no very specific reasons.[2]

The solid nature of the recumbents compares better with the carved house-shaped Hedda Shrine at Peterborough and this form of monument is represented in the 'St Leonard's School shrine' at St Andrews. Apart from a cross cut in high relief at one end, which may be secondary, and the tegulated roof, the 'St Leonard's School shrine' is plain, certainly a contrast with the treatment of Pictish monuments in general, but the possibility that it reflects a Pictish type should not be discounted.[3]

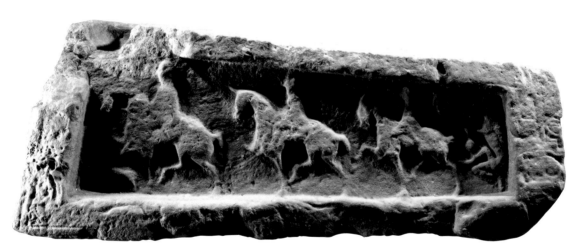

287 *Left side of recumbent, Meigle, Perthshire, No. 11*

288 *Right side of recumbent, Meigle, Perthshire, No. 11*

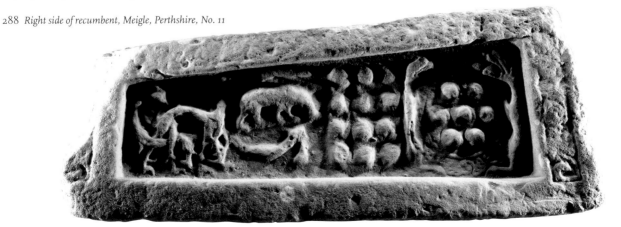

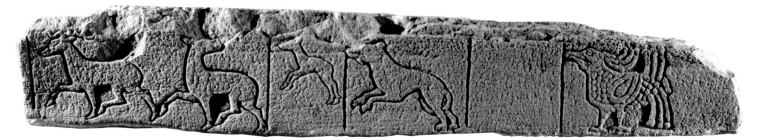

289 *Recumbent, St Vigean's, Angus, No. 8. Sandstone*

290 *Left side of recumbent, Meigle, Perthshire
No. 9. Sandstone*

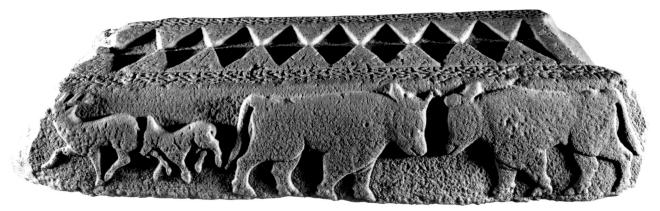

291 *Recumbent, Meigle, Perthshire, No. 12. Sandstone*

With its four examples of recumbent gravemarkers, Meigle, Perthshire, is regarded as the type site; the large collection of sculpture there includes a variant of the 'hogback' gravestone of northern England.[4] In form, this monument bears no relation to the Pictish recumbents but its presence on the site testifies to a degree of continuity of function – the covering of a grave with a massive carved stone.

The slot cut into the upper surface of the typical Pictish recumbent puts it into the category of a composite monument. Although, as will be suggested below, the recess may have been multi-functional, it almost certainly was primarily intended to hold an upright cross [292]. Small upright crosses placed at the ends of graveslabs, sometimes set into the slab themselves, are known in Ireland and northern England, but in Ireland the slabs cover stone-lined graves and the date of the English examples is uncertain.[5] Some of the Pictish cross-marked, but otherwise plain, slabs discussed in the previous chapter will have been recumbent, but there is no evidence for their association with lined graves, and no example slotted for a cross-shaft has yet been found.

Of more relevance to the physical appearance of the Pictish recumbents is the 7th-century string-course that decorates the wall above the western entrance to the church tower at Wearmouth.[6] Here the panelled single motifs of animals and human figures contained within a strip 24 centimetres deep is strikingly like, in disposition and themes, the long sides of the Pictish recumbents. Nevertheless, a string-course is not an adequate explanation for the form of a distinctive type of funerary monument.

Apart from the significant absence of symbols, the repertoire of ornament and imagery used on the recumbents is that of the symbol-bearing cross-slabs. The iconography of the living is present in the form of riders (Meigle Nos 11 and 26 [293]) ; the classical image of the devouring power of death, the griffin, is well represented (Meigle Nos 9 and 26); and what has been described as the Pictish vision of Hell, where naked human figures are pursued, snatched and consumed by fierce animals, is vividly represented (Meigle No. 26 [223] and St Vigean's No. 14).[7] This Hell imagery is carved on a number of cross-slabs including two at Meigle, and a possible variant on the recumbent Meigle No. 9 [290], where a bird bites into the neck of a man, is repeated also on the fragmentary cross-slab, Monifieth No. 3. The theme of confronted bulls, powerfully expressed on Meigle No. 12 [291] appears on the animal panel of the cross-slab at Shandwick, Ross & Cromarty [97].

These themes of violence are kept to the sides of the recumbents. The top surfaces conceal symbolic Christian themes easily overlooked, such as the serpent, an image of resurrection (Meigle No. 26 [292], Kinnell and Strathmartine No. 2) and the benign sea horses, which, reduced to S-dragons, become a standard symbol of guardianship and protection on a number of cross-slabs where they are frequently placed adjacent to the cross (Meigle No. 26, Skinnet [47], and the 'Maiden Stone' at Drumdurno) [261].[8]

Significant also are the seemingly perfunctory passages of ornament rarely commented on. On a side of Meigle No. 26 a portcullis-like square of fret-pattern fences off the predatory beasts from the galloping riders [293]. The bosses on the recumbents may have a richer symbolism. The number of studs on liturgical metalwork and roundels on manuscript pages reflects the pervasive interest in the symbolism of numbers shown by Early Christian writers. Like their Irish counterparts, Pictish sculptors were aware of the possibilities of selecting arrangements of bosses so as to enrich the intricacy of their patterns with spiritual reference. Thus the panel of twelve bosses on one of the sides of Meigle No. 11, rather than being a mere space-filler, could evoke the twelve Apostles and their role as judges in the Heavenly Jerusalem (Revelation 21) [288]. Between the protective sea horses and the coil of benign serpents on the top surface of Meigle No. 26 [292], a square is divided by two diagonals into triangles, each of which contains three raised bosses. The cruciform arrangement of triune bosses is surely intentional. Even at the numerical level

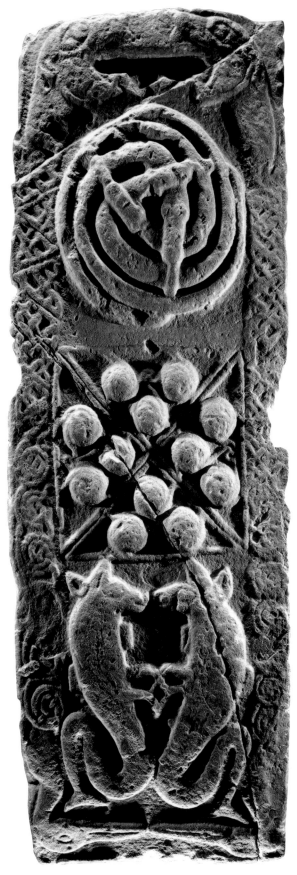

292 *Top of recumbent, Meigle, Perthshire, No. 26. Sandstone*

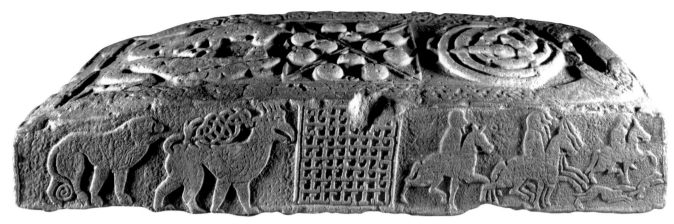

293 *Right side, recumbent, Meigle, Perthshire, No. 26*

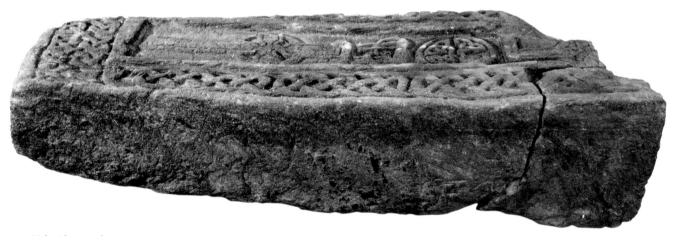

294 *Right side, recumbent, St Vigean's, Angus,*
No. 13. Sandstone

the number twelve, and its components and multiples, was expressive of perfection. The circle of bosses on Meigle No. 11, six arranged around a seventh, is frequently used for the centre of cross-heads in Irish and Pictish sculpture, perhaps in reference to the seven days of Creation or the seven gifts of the Holy Spirit, or as symbolic of the perfection of the Universal Church.[9]

The fragmentary recumbent at Rosemarkie, a tapering head end with a recessed panel on the top surface bordered by anthropomorphic ornament, has a raised square, similar to that on the top of Meigle No. 26, carved in the recession, but with triquetras in the triangles instead of triplets of bosses. The upper surface of St Vigean's No. 13, an incomplete recumbent, has a recessed panel like Rosemarkie on its top surface, here bordered by serpentine interlace [294]. However, within this panel ornamental symbolism has given way to the overt imagery of two Latin crosses.[10]

The repertoire carved on the recumbent monuments is therefore appropriate to their funerary function, both explicitly in their imagery and by symbolic implication in their ornament.

They are not so 'secular' as is often claimed. Nor of course should we forget that the slots or sockets at the head ends probably contained upright crosses. It has been argued that these miniature adjuncts were removable, so that on special occasions precious objects associated with the dead person could be laid, as it were, into the tomb. Other recesses in the recumbents – most notably the square one at the end of Meigle No. 11, set at an angle so that it presents a diamond shape to the spectator [295] – could have held a metal attachment to secure a venerable object to the surface of the slab. There were two such attachments on the west face of the St John's Cross on Iona.[11] The striking lozenge shape of the recesses along the top of Meigle No. 12 itself has a symbolic importance, for it is associated with Christ [319].[12] The animals that hold the contents of the recession on Meigle No. 26 protect them in the manner of the beasts that flank the panel with cruciform ornament on the roof-ridge of the Pictish Monymusk reliquary [167]. As we have seen, the influence of reliquary design also informs the unique cross-shaft on the cross-slab Meigle No. 5 [321]. That some of the recumbents functioned in a context where the

graves had an occasional secondary reliquary role by means of the recesses seems very likely.

The difference between Pictish cross-slabs and the recumbent monuments supporting a cross lies in form rather than in decoration and imagery, always excepting the absence of the symbols. If the symbol-bearing monuments were always, to some degree, indicative of territorial spheres of influence, then a natural explanation for the lack of symbols would be that the recumbents were designed for burials within churches, which themselves embodied ecclesiastical and secular affiliations. Those so buried needed no further definition of their earthly status and responsibilities.

The symbol-less cross-slab, Meigle No. 2, shares many design features with the recumbents [296]. In particular the proportions and decoration of its uniquely broad cross-shaft could be readily transferred to the upper surface of a recumbent. The lack of symbols on Meigle No. 2 does not reflect a creeping ethnic movement towards the culture of the Irish in the west (a popular view, but in any case unsustainable in terms of its art) but rather indicates something about the particular circumstances at Meigle, a locational and functional difference. The Meigle No. 2 cross-slab could have acted as the focus of a funerary chapel that contained graves over which the cross-bearing recumbents were placed. Its

295 End with recess, recumbent, Meigle, Perthshire, No. 11

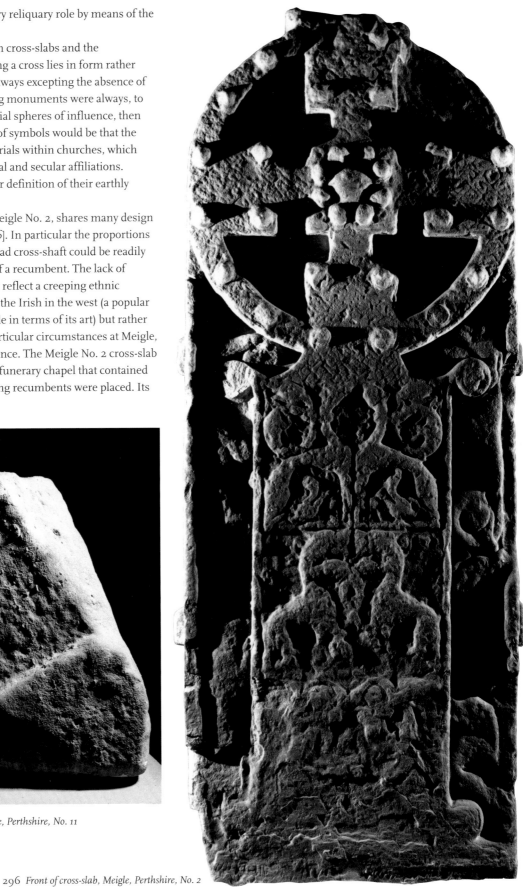

296 Front of cross-slab, Meigle, Perthshire, No. 2

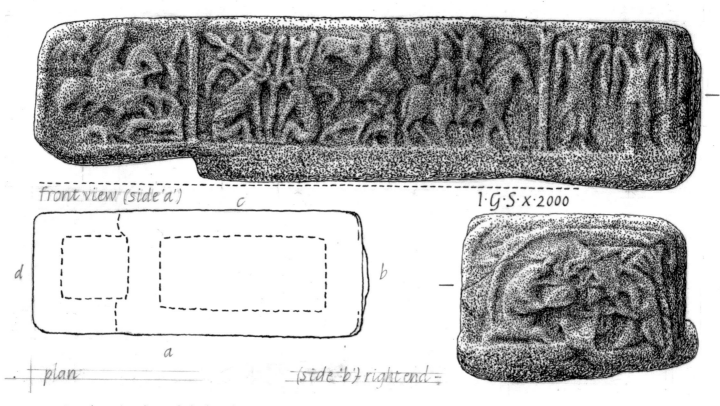

front view (side 'a')

plan

(side 'b') right end

I·G·S·x·2000

297 *Recumbent, Kincardine, Sutherland. Sandstone*

triumphant Redemption programme stands as solace amidst the darker penitential imagery of the recumbents. If, as has been proposed, the protuberances on its edges supported other panels, then the triptych-like structure so created would have formed a striking backdrop for a funerary chapel.

The recumbents themselves are ideally suited to meet the need for an 'intermediate' monument, proposed in a recent analysis of the more familiar Pictish form of monument known as a 'composite box-shrine'.[13] A carved recumbent could have covered the interred body prior to enshrinement. When complete, the box-shrine consisted of a lidded stone box made out of four panels flanged to fit into grooved corner pieces. The corner pieces could be slabs providing fields for elaborate decoration, or pillars roughly square in section. The painstaking assembly of the fragmentary evidence for the construction of such shrines reveals the extent to which this monument type figured in the material culture of the Pictish Church. Stone shrines of varying types were being made in Anglo-Saxon contexts at this time, but the number and wide distribution of those surviving in Pictland – six such shrines, for example at two sites in Shetland, Papil [301] and St Ninian's Isle – demonstrate that whatever its origin, the box-shrine was fully integrated into the Pictish monumental tradition.[14] The art of the shrines and the art of the recumbents reinforce the view that their respective functions could have worked together. Even the restrained iconography of the Shetland

shrines, with their protective confronted S-dragons, patterns of cruciform and tripartite construction and arrangements of spirals, is recognizably part of the Pictish repertoire used by the sculptors of the recumbents. The griffin imagery of the recumbents is used to effect on the main surviving panel of the grandest of the box-

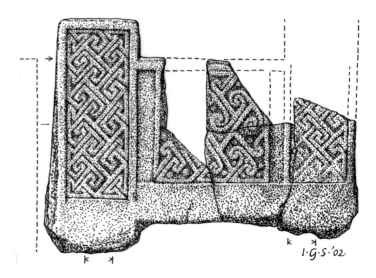

I·G·S·'02

298 *End slab of composite shrine, Kinneddar, Moray. Sandstone*

shrines, the St Andrews Sarcophagus [99]. There the griffin's victim, a little horse, is shown collapsed under its claws. The components of this image are on the recumbent, Meigle, No. 26 [95]. The exhausted little horse is tucked into the sloping end of one side, the griffin stands erect at the centre of the side opposite.

The possibility of a direct relationship between the recumbents and the box-shrines has been strengthened by the recent identification of a miniaturized version of the main theme of the St Andrews Sarcophagus panel (David rending the jaws of the lion), on a recumbent at Kincardine, Ross & Cromarty [297].[15] The layout of the carving on this northernmost recumbent, a long central panel flanked by two shorter panels, also recalls the layout of the St Andrews Sarcophagus, with its main panel and lateral slabs [189]. The David theme is unparalleled on other recumbents, but the Kincardine precedent underlines the need to reconsider the status of the David fragment from Kinneddar, Moray [191]. On the obvious analogy of the St Andrews Sarcophagus it has been taken to be part of a composite box-shrine, but at 18 centimetres the Kinneddar fragment is very deep for a shrine panel. It could more appropriately have been part of a cross-slab, but the hunched pose of David, which contrasts with his erect posture on the St Andrews Sarcophagus, and the horizontal stance of the lion, could be explained by the image being compressed into the shape of field available on a recumbent. If this were the case, the recumbent would have been a mighty one, some 6 centimetres higher at the top end than Meigle No. 11. However, there was at least one composite shrine at Kinneddar [298], which rather tends to tug the David fragment that other way.[16] There was also another composite shrine at nearby Burghead, presumably from a chapel associated with the fortified residence there. A grooved post has survived [299] and a flanged fragment of a panel carved with a vigorous depiction of a stag being brought down by hounds, a theme also represented on the Kincardine recumbent [300].[17]

Study of the iconography of the surviving long panel of the St Andrews Sarcophagus demonstrates the extent to which its visual impact depends not only on the sculptor's wide knowledge of the contemporary state of developments in Insular art but on his access to the contents of royal and ecclesiastical treasuries containing the models which informed his figural art and its 'landscape' setting.[18] To a degree all Pictish sculpture was dependent on locally available possessions, objects acquired at a high social level, valued for their association with the donor, their style and their antiquity. Intellectual effort, combined with consummate technical skills themselves expressive of meaning, were required if the box-shrine was to function as a royal monument, a category not evident elsewhere. The imagery of the Imperial lion hunter [190] and the grandeur of David, king and precursor of Christ the Saviour, is the result of the sculptor's

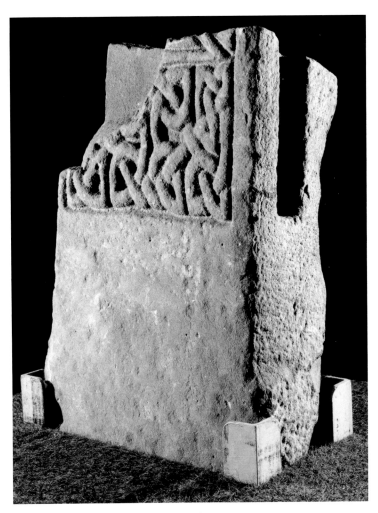

299 *Fragment of slotted corner slab, Burghead, Moray. Sandstone*

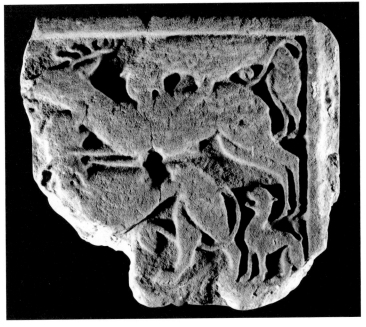

300 *Fragment of shrine panel, Burghead, Moray. Sandstone*

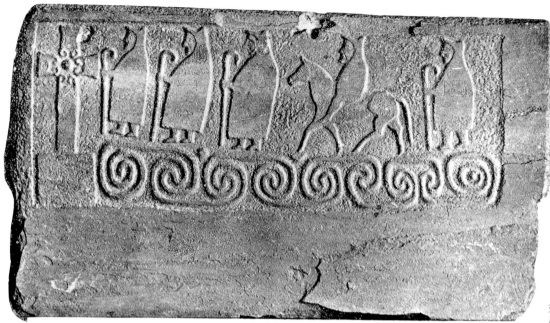

301 *Carved shrine panel,*
Papil, Shetland. Sandstone

capacity to use his models so as to heighten the otherwise familiar themes of the virtuous huntsman and the typological image of salvation from the Old Testament.

A much less ambitious theme, that of pilgrimage, is displayed on the carved shrine panel from Papil [301]. It shows cowled pilgrims, one riding and others on foot, each carrying a staff and one with a book-satchel hung round his neck. They approach a free-standing cross set on a base, or possibly in the slot of an end-on recumbent gravemarker. The sculpture is presumably self-referring, confirming its venerable reliquary function.[19]

A recent find, yet to be fully published, among the variety of forms of carving being recovered at Tarbat, provides evidence for what may be the first example of a Pictish shrine lid [302].[20] It was found in the fabric of the 12th-century church and is very compressed and damaged. In some respects it resembles the recumbents, for its single portraits of lively profile animals enclosed within panels that taper in size is very similar in presentation to recumbents at Meigle and St Vigean's. However, a rebate at the surviving end suggests that it was designed to be bedded down on an infrastructure. The slab, as it has survived, slopes, and a sloping lid with tapering decorative fields is suggestive of a lid for a stone 'coffin'-style monument comparable to the Govan Sarcophagus, whose carvings have frequently been compared to Pictish work.[21] It is possible therefore that the Picts had a second type of funerary monument additional to the recumbents. The depth of the Tarbat lid suggests that it closed over a very large monument, or possibly a grave lined with massive slabs. The carving of an equal-armed cross on the surviving end has its only parallel on an end panel of the St Andrews Sarcophagus [107].[22]

An important advance in the study of the composite stone shrines was the recognition that the construction technique of

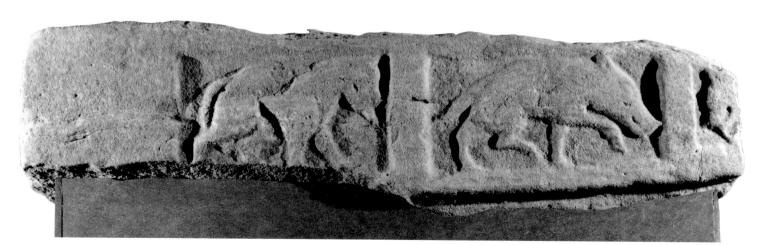

302 *Sarcophagus lid, Tarbat, Ross & Cromarty. Sandstone*

slotting panels into grooved posts had its origin not in carpentry techniques but in the screens used from Antiquity onwards to divide up space, indoors or outdoors.[23] The liturgical division of space within a church could be accomplished by the erection of stone screens decorated in a variety of ways. Although a bold suggestion has been made that a precedent for this kind of corner-piece and slab construction could be found in native burial customs, the possibility has not been developed.[24] We know that the Picts had to be taught how to build in stone by the Northumbrians, who themselves had had to receive instruction from Continental masons. It is a reasonable step to extend the transference of skills in building to the means of dividing up space. It has been argued above that although this technical advance in handling stone may also have included the cutting of slabs for relief carving, the Picts had already much relevant experience in carving stone and probably, knowledge of laying out of designs in other media, to bring to the production of the new monument. It is possible therefore that an explanation for the Picts' enthusiasm for composite stone shrines, even in the far north, stemmed ultimately from a familiarity with an ancient burial type which included supportive elements at the corners. The general notion of making a screen with panels, would, of course, have been part of simpler techniques involving wattle and free-stone constructions.

Carved Panels

Another issue is whether the growing corpus of carved Pictish panels belonged to shrines or screens or were perhaps cladding for the interiors and exteriors of the new stone buildings. For a panel to be part of a composite structure, with reasonable certainty, there has to be some physical evidence of the mechanism of juncture, that is, of the cutting of a flange, or tongue, for insertion into a groove. This is not always present on carved panels and the carved area itself may reach to the extreme edges of the slab. Any insertion would mean loss of sculpture.

A panel carved on one face only from Murthly, Perthshire [182], now in the Museum of Scotland, is representative of the type. Its dimensions, including the uncarved area, correspond closely to the Papil shrine panel. Here, the imagery consists of three boldly carved discrete motifs, confronted sea horses, flanked by masked men fighting (a scene of earthly folly), and the Hell theme of a naked man pursued by a beast. The carved area is enclosed by a frame on three sides with no hint of a flange on either of its lateral edges. A section of a panel from nearby Pittensorn [227], so similar in dimensions, technique, and imagery that it could be part of the same monument, has a frame on the surviving sections of the top and lateral edges, again with no flange. The Pittensorn fragment is incomplete on its lower edge, but both Papil and Murthly have a substantial uncarved area under their carved panels which must have been concealed in the earth or set within a supporting plinth.[25]

The very different imagery of interlocking figurative and animal motifs on the Tarbat panel known as the 'Calf Stone' has the same formal characteristics [303]. Like the Papil slab its top edge is carefully rounded. The finished nature of the carved panel is emphasized by the incision of four horizontal lines along the top edge, which give the effect of an emphatic moulding intended

303 'Calf Stone' panel, Tarbat, Ross & Cromarty. Sandstone

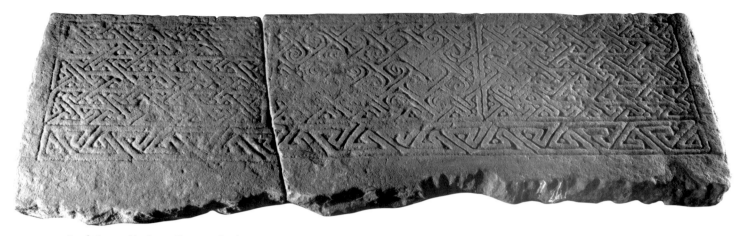

304 *Panel, Rosemarkie, Ross & Cromarty. Sandstone*

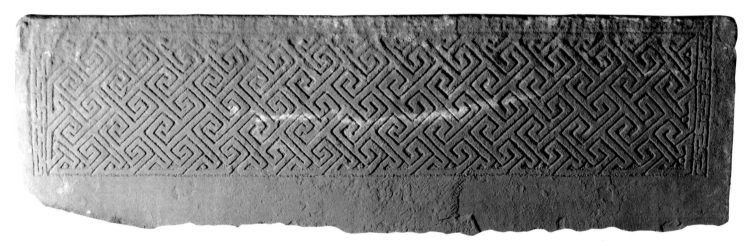

305 *Panel, Rosemarkie, Ross & Cromarty. Sandstone*

to be seen. The proportion of carved to uncarved area is similar
to that of Murthly and Papil, suggesting that whatever the
function of these slabs the methods of supporting them were
of the same nature.

The finds at Tarbat also included a section of a grooved post.
The grooves are on opposite faces, and so could have supported
the panels of a screen. However, one of the faces looks as if it has
been sheered off. This raises the possibility that the post was a
supporter for the side panels and dividing panel of a double-
chambered shrine of the type found at St Ninian's Isle.[26]

The subject matter of the Murthly, Pittensorn, and Tarbat
panels is carved in the visual language common to much Pictish
sculpture, consisting of discrete motifs each carrying their own
meaning. The martial scenes on the fragments of panels from
Dull and Kinneddar, and the hunt scene on the reused panel at
Kildonnan, Eigg, can also be accommodated in the common
repertoire. The question arises whether such imagery would have
been appropriate on panels for a shrine. Would they not have
been more suited to a memorial, didactic or decorative role in the form

of screens or wall decoration? On the other hand, the panels are
only fragments of monuments, their place in a total iconographic
scheme irrecoverable. There seems no reason, for example, to
reject the Burghead hunt fragment as belonging to a shrine, for
it is flanged and there is a grooved and carved corner piece on
the site.[27]

The panels in the collection of Pictish sculpture at
Rosemarkie, Ross & Cromarty, present different problems. Two
take the typical form of a horizontal slab carved on one face, with
an uncarved area beneath the panels of carving [304, 305].[28]
They are both considerably longer than the Murthly panel, 162
centimetres and 154 centimetres, compared with Murthly's 112
centimetres. The larger of the two has a narrow border of large-
scale key-pattern along the whole length of the lower edge of the
panel. Above are three panels, the central one filled with a
spiraliform version of diagonal key-pattern, its sides tapering
slightly towards the border below. Panels of identical size on either
side are filled with the most common of the key-patterns, Allen
No. 974, which has a similarly horizontal axis, interspersed with

loose pellets. It is clear that this ornament admirably reflects its function, a firm baseline and a central focus, such as would be appropriate for an altar frontal. The edge of the slab is recessed on the right-facing side, suggesting that it once formed part of a composite structure.

The smaller of the two panels shows a different, but in its way equally effective use of ornament to signal function. The regularity of the cutting of this single panel of diagonal key-pattern is astonishing, and the sharpness of the cutting suggests that the piece was always in an indoor setting. (The same is probably true of the location of the larger three-panelled piece in antiquity, but its secondary use as a modern grave slab has inevitably impaired its surface condition.) The smaller of the two panels is carved on the top and sides with a narrow border of a key-pattern made up of 'T'-shaped bars. At the top, the border lies along the edge of the slab, whereas at the sides an area is left uncarved between the carved panel and the original edges. This uncarved area, present also on the larger panel, would allow for insertion into a supporting device but there is no trace of a rebate on either edge. At 7 centimetres the thickness of the larger panel compares reasonably well with the Murthly panel (10 centimetres) and the Papil shrine slab (6 centimetres). The smaller Rosemarkie panel is significantly thinner at 3.5 centimetres. However, the back of this panel is naturally smooth, so its thinness could have been dictated by natural fracture.

In spite of minor differences it is difficult not to see these two panels as part of the same monument or of the same architectural scheme within a church. The layout of the carving of the larger panel is perhaps more suited to an altar than to a shrine, but, of course, the use of a shrine as an altar is perfectly possible. The plainer panel would suit admirably for the less visible side of the structure. If its smaller dimensions and fragility rule out its use in a structure requiring a degree of weight-bearing, then wall cladding is the alternative. There is mortar along its top edge and on the central section of the reverse of the slab but this may belong to secondary use. Two other roughly square-shaped panels at Rosemarkie could have been the short sides of composite monuments[29]. One is a fragment carved with a bush vinescroll [63], flanked by key-pattern edged with the kind of narrow geometric pattern of the smaller of the two long panels. It is not clear how far the key-pattern extended, but there are matching rebates behind it. Crouching animals nibble at a bush vinescroll on the Kincardine recumbent [297], forming another link between the repertoires of recumbents and composite monuments. Foliage is carved on the St Andrews Sarcophagus, but in the uniquely developed form of a tree inhabited by a variety of animals. The other square panel at Rosemarkie [306] is a very expertly dressed, slightly convex, fragment, carved in relief with an equal-armed ringed cross, its surviving arm clipped by spirals to the edge moulding and set in a tapering base. The back has a rough pebble-filled surface with a groove, 2.5 centimetres deep and 6 centimetres wide, lying behind the surviving arm of the cross.

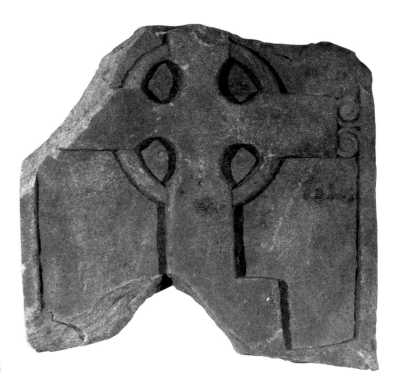

306 *Panel from composite monument, Rosemarkie, Ross & Cromarty. Sandstone*

These two possibly end panels of shrines are carved with the sobriety of the reverse of the symbol-bearing cross-slab at the site, and it would be a mistake to divorce the four panels in time from that monument. Expertise in the execution of key-pattern is fully demonstrated on the slab; the equal-armed crosses on both sides are complex refined designs, comparable to that of the panel cross, and above all, a delight in the possibilities of all-over patterns is as abundantly evident in the symbol-bearing cross-slab as it is on the horizontal panels.

Separating those panels designed for architectural use from those that are parts of monuments is probably premature, but a recognition of the qualities of both their form and art is suggestive of a multi-functional role for panels, which need not surprise us if the origin of the panel form is accepted as being in architecture. That sculpture was applied to plaques, panels, shrines and string-courses is attested in Anglo-Saxon contexts, though most amply, in terms of survival, in Mercia rather than in Northumbria. Mercian influences, or more accurately, shared tendencies in Mercian and Pictish art have often been remarked on, and the recent suggestion that the east coast connections of Pictland extended far south of the Tyne is convincing.[10] On the other hand an origin in Northumbria does seem the most likely for Pictish panels, and their use in composite panel and grooved corner-piece structures. The use of the latter device on Iona (here probably more directly under the influence of carpentry) in plain constructions for cross-bases, and for displaying large metalwork shrines, confirms its position as a widely used, serviceable,

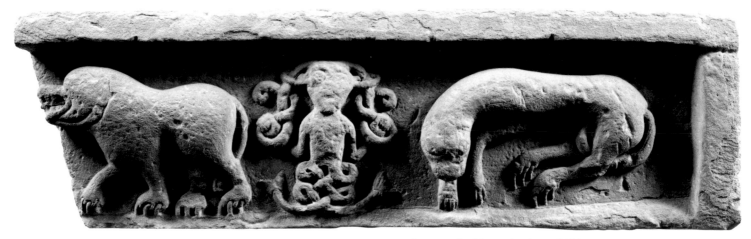

307 *Fragment of architectural sculpture, Meigle, Perthshire, No. 22. Sandstone*

Insular format in stone whatever its regional prototypes.[31] What certainly seems to be the case is that the Picts were uninhibited in their use of stone and that they readily adopted those forms which provided generous fields for carving.

Architectural Sculpture

The panel and the corner-post shrine belonged to an interior setting and they provide the best evidence to date for Pictish church building, complementing usefully the few traces of architectural forms. Identifying uncarved forms has been limited to the south door of Restenneth Priory, Angus. Few, if any, now accept this elevation as physical evidence for the first Pictish church built in stone, commissioned by King Naiton at the beginning of the 8th century. That that particular church was built somewhere in this district has to rely on the evidence of place names and the rapid appearance of quarried and dressed public monuments at this period.[32] The extent to which the Picts applied sculpture to buildings will only be discernible when all those fragments recorded by Allen as being carved on one face only and assigned to the catch-all 'Class III' are separated out and examined as a group. The handful of carvings readily recognizable as architectural include the idiosyncratic and the mainstream. Technically, the most impressive is the section of a lintel, Meigle No. 22 [307]. The carving is deeply cut into a solid block 25 centimetres high and 9 centimetres thick. A deep moulding runs along the top edge and down the surviving lateral edge. The format has been compared to the animal friezes of Northumbria, at Wearmouth and Hexham.[33] The two most closely comparable Hexham carvings, one with a cow, the other with a boar, are not *in situ* so that their function is not certain. In proportion they are narrower (17.8 centimetres) and deeper (29 centimetres and 14.2

308 *Narrow face of a slab, Dunblane, Perthshire. Sandstone*

centimetres), suggesting a more load-bearing function than Meigle No. 22. Nonetheless, the smooth-skinned profile animals in high relief are stylistically akin. The subject matter and its presentation are, however, significantly different. We can suppose that the Meigle composition when complete, allowed for an extension of the design scheme where a low-relief semi-figurative image was interspersed with high-relief animals. The surviving section gives undue importance to the figurative image that will have taken its place as an element in a sequence of imagery. This sophisticated design of alternating high and low relief is matched by the alternating poses of the panther that turns out into space, the frontal fish/man, and the profile carnivore. The subject matter, unlike the surviving Hexham animals, is exotic and learned. This kind of proto-Bestiary imagery is relatable to the earliest, pre-Romanesque 'random reliefs' which decorated the exterior and interiors of early medieval churches.[34]

In Insular sculpture the use of this kind of imagery for architectural sculpture is best paralleled in the centaurs and peacocks which are part of the repertoire of the extensive friezes at Breedon-on-the-Hill, carved possibly under Mercian royal patronage in the early 9th century. The style of the carving of the Mercian friezes is, however, quite different. The delicate ivory-like creatures at Breedon do not make their symbolic point with the bold, three-dimensional technique of the Meigle sculpture. Coincidentally perhaps, there is another Pictish parallel for the Mercian friezes, this time in terms of the purely ornamental repertoire. The carving on a narrow face of a worn cross-slab at Dunblane [308] provides the only surviving analogy in Insular sculpture for the ornamental juxtapositions at Breedon.[35] The Dunblane decorative strip, as at Breedon, places passages of median-incised interlace, key-pattern and animal interlace side by side, and may reflect frieze conventions. There is some documentation to support this slender sculptural evidence for a Pictish stone church at Dunblane and taken with Meigle No. 22 a case can reasonably be made for this form of architectural sculpture, quite free of the symbol-bearing function, being produced by the Picts.[36]

The iconography of the well-known Forteviot arch [211] has been discussed above.[37] The building in which it was set is wholly destroyed but its wider archaeological and topographical context has been fully explored.[38] There is no reason to doubt that the arch came from a royal site, Pictish in the 7th and 8th centuries, but by the second half of the 9th century associated with the Dalriadic Scots. There is nothing about the form or the carving of the arch to justify any marked change in cultural direction and the likelihood must be that the arch was erected and carved around the same time as the Dupplin Cross whose date, refined by the dates of the king memorialized in its inscription, must be in the first half of the 9th century.[39] It is not easy to point to any analogy in contemporary architecture in the British Isles for an arch carved with figurative subject matter. In discussing the format of the figurative art in the pediment of the Nigg cross-slab it was

argued that the architectural forms of manuscript painting may have been its inspiration. The same is likely to be true for the Forteviot arch. Human figures are squeezed into the arches and columns of the canon-tables in the Book of Kells in an exactly similar fashion as they are in the arch – compare the long-bodied profile men with their pipe-cleaner legs bent up in the columns of Canon I, ff. IV and 2 with the contortion of the Forteviot figures. The design of the calf-symbol in the canon-tables with its receding muzzle, wide ears and vestigial body scrolls is also comparable to the Forteviot lamb, even in its vertical position as in Canon II, f.3v.[40] Figures are tucked into all the architectural elements in the canon-tables, within the spandrels, in the overriding arches, and within the smaller arches that contain the textual correspondences. The carver of the Forteviot arch had plenty of solutions to his design problem within contemporary Gospel Book art.

The only possible hint that the carver was aware of contemporary architectural conventions lies in the interpretation of the imagery. If, as has been argued in Chapter 5, the figures represent the commission to the Apostles to go forth to preach to all the nations, then the carving of such a theme on an arch which met the viewers' gaze as they left the church would qualify as an example of the architectural symbolism recently detected in later Anglo-Saxon buildings.[41] Consciousness of the symbolism of entrances is already apparent in the carving of protective animals on the jambs of the entrance to the porch of the church at Wearmouth. The long-beaked dragons demark the safe but narrow gate into the sacred space where new life is made possible.[42] The symbolism of the 'architecture' of the form of the free-standing cross, discussed earlier, was certainly appreciated by the sculptor of the related Dupplin Cross [196, 278]. That an archway should be carved with a depiction of the Apostolic mission is therefore not so surprising. The sculptor of the Forteviot arch displays understanding of the way in which forms and imagery could work together with the symbolism inherent in the layout of a church. To use his knowledge of how book artists managed to introduce figures within architectural forms showed admirable intelligence and resourcefulness. His aim was ambitious and probably innovatory. The arch is a vestige of one very grand Pictish stone church.

Fittings and Furniture

Churches required fittings and furniture. Northumbrian churches had stone thrones and benches and a finely carved lectern was recovered at Jarrow. The most impressive survival of Pictish stonework belonging to this genre is the slab from the Island of Flotta, Orkney [309].[43] It is a large slab 165 centimetres long, 81 centimetres high and 10 centimetres thick. It is bordered on three sides, which have no rebates. The front face has a central panel containing an equal-armed cross with hollowed armpits. The

panel is slightly larger than a third of the length of the slab. The terminals are decorated with interlace which is more densely woven in the constrictions of the arms. The slab was part of a composite monument for it has two vertical grooves on the back, comparable to the grooves on the backs of the slabs at Rosemarkie described above. Allen thought that it had probably formed one side of an 'altar-tomb'. Clearly this is not part of a shrine with corner pieces. The tripartite division of the larger of the Rosemarkie long panels and its vertical groove does seem reminiscent of whatever form of monument relied on this 'house of cards' support system combined with an earth-fast lower edge. The Flotta slab is higher than the Rosemarkie panels, and its bold centralized cross set in an expanse of uncarved stone gives a stronger impression of being the natural focus of an altar frontal, an early example of an identifiable class of frontals with central crosses. The Flotta panel has something of the single purpose present in the back panel of the box-shaped altar commissioned by Ratchis, King of the Lombards (744–49) in memory of his father, now standing in the Museo Cristiano of the cathedral at Cividale del Friuli, with its simple scheme of crosses ranged round a recess. The stylization and emotional intensity of its carvings of Christ's Incarnation on earth, and Glory in Heaven on the other faces, can without exaggeration also be traced in the similarly stern, linear art used to express the Christological theme on the Forteviot arch.[44] The altar depicted on the arch is furnished with a cross and an altar cloth that hangs to the ground. The altar itself was presumably a table altar.[45]

The collection of sculpture at Rosemarkie contains two other pieces of sculpture that may be identified as church furnishings in stone [310, 311]. A very smoothly dressed fragment of a slab is decorated on its broader plain surface with a border filled with loosely knotted interlace carved in relief and edged on both sides with a moulding. The adjacent narrow edge, some 6 centimetres deep, is carved with a denser, median-incised interlace finished off with a moulding that forms a rolled lower edge to the slab. This refined piece of sculpture has the quality of technical execution and sensitivity to design appropriate to the mensal slab of an altar.[46]

A tiny portable stone altar, roughly 10 centimetres square was found off the coast of Wick, Caithness. It has the typical arrangement of crosses, one at each corner and a larger one at the centre. Portable altars would have been a practical need in a terrain where settlements were scattered. If, as suggested in the previous chapter, cross-slabs occasionally functioned as the backdrop for the 'mass in the field', then such an altar must have been a common, but in later times easily neglected, artefact.[47]

The second Rosemarkie piece is a boulder-stone carved with an equal-armed cross superimposed on a broad ring [312]. The spaces between the hollowed armpits and the ring are cut away. In many respects it resembles the boulder-stone crosses of Aberdeenshire discussed in the previous chapter but the deep recess at the centre of the cross-head and similar recesses on each arm suggest that it was a grander version, enhanced with inlays of precious materials. The depiction of a tenon on one arm confirms

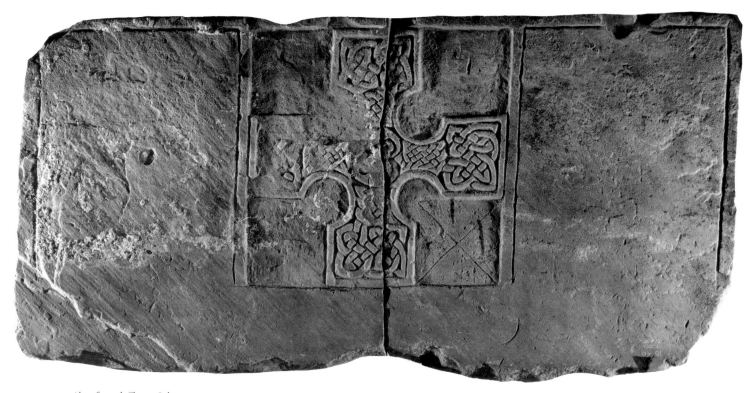

309 *Altar frontal, Flotta, Orkney*

310 *Fragment of top of altar slab, Rosemarkie, Ross & Cromarty. Sandstone*

311 *Enlarged detail of edge of decoration of altar slab*

that the designer had an altar cross in mind. The care with which the cross is laid out contrasts with the asymmetric irregularities of the edges of the boulder. If the piece had been attached to the wall above an altar as a reredos then the rough edges could have been concealed by adjoining masonry.

A recent find of a three-dimensional animal head at Tarbat [*313*] has yet to be fully assessed, but an initial impression suggests that it functioned as a finial to the back of a chair such as has been recovered from Wearmouth and other Anglo-Saxon ecclesiastical sites. Such chairs with animal heads are familiar on Pictish cross-slabs, for example, on the back of Kirriemuir No. 1 [*314*].[48]

Surviving liturgical metalwork can supplement this glimpse into the interior of Pictish churches. The principal items, the house-shaped reliquaries, have been discussed in Chapter 4. To these the small corpus of mounts from southern Pictland (to which can now be added another example from Tarbat) provide a scintilla of nonetheless significant evidence for precious metalworking in a Pictish ecclesiastical context. The identification of plain ironwork bells at sites nearly all of which have Pictish sculpture helps to fill out the picture.[49] Representation of liturgical impedimenta on sculpture, such as the vessel on to which the raven deposits St Paul's rations on the Nigg cross-slab [*203*], can less certainly be claimed to represent Pictish artefacts. However, aspects of the decoration of sculpture, such as the cross-head of the Aberlemno roadside cross-slab [*218*] and the crosses on both sides of the symbol-bearing slab at Rosemarkie [*316*], are clearly based on metalwork associated with reliquaries of various types.

312 *Reredos, Rosemarkie, Ross & Cromarty. Sandstone*

313 *Fragmentary stone finial, Tarbat, Ross & Cromarty. Sandstone*

The simple answer to the question of why the churches that produced the clusters of Pictish sculptures in a variety of forms, including funerary monuments, have not yet been located is that they are probably overlaid by later church buildings that are rarely accessible to archaeological investigation.[50] At Tarbat the foundations of Pictish stone buildings associated with the 8th-century monastery have been retrieved, but the church itself lies sealed under the east end of the fabrics of a succession of church buildings. Frequently, as at Tarbat, sculpture is found used as building stone either in the fabric of churches or in associated walling. Sometimes it just lay around to be broken up for grave-lining or other practical purposes. For example, the varied sculpture produced at Kinneddar suffered all these fates, and recently, no less than seventeen fragments of Pictish sculpture were recovered from the base of a probably 'pre-1787' stretch of wall round Kirriemuir Parish Church, adding significantly to the collection of sculpture from this site and to its probable ecclesiastical importance in the Pictish period.[51]

Short-lived, less thriving, church sites with associated sculpture are more likely to produce accessible evidence for actual fabric: sites such as St Martin's Chapel at Ulbster, St Thomas' Chapel at Skinnet, near Halkirk, and the Chapel Hill site at Ballachly, Dunbeath, where fragments of relief sculpture as well as the sophisticated cross-marked stone described earlier have been found in the walls of nearby outbuildings. The highly successful reconnaissance excavations of early historic fortifications had their richest results in southern Pictland. For the investigation of ecclesiastical sites, Abernethy and Fortingall, both with a variety of sculpture, are obvious choices for the south, but a campaign in the north is likely to be even more productive, as has recently been demonstrated by the excavations at Tarbat. Confirmation of the original position of the Hilton of Cadboll cross-slab at the west end of the chapel site at Hilton, a few miles from Tarbat, would raise another reasonable hope for the location of a Pictish stone church.[52]

The major centres for the production of sculpture might be expected to provide in their forms and their art evidence of ecclesiastical networks. The recognition of influential 'schools of sculpture' is at a very primitive stage in the study of Pictish sculpture. Aspects of 'Meigle' taste can easily be detected in, for example, the slabs from the neighbouring Perthshire sites of Murthly and Pittensorn, but that taste, in terms of subject matter, is equally present in Ross & Cromarty, at Shandwick and Tarbat. The far-flung analogous carving at Aberlemno and Hilton of Cadboll, and at St Vigean's and Applecross are well known, and it has been argued that the sculptor of the Nigg cross-slab could have been the sculptor of the St Andrews Sarcophagus, so close are the similarities between them. Only in this last example has there ever been any attempt to individualize a sculptor.

314 *Back of cross-slab, Kirriemuir, Angus, No. 1. Sandstone*

So far, it has not proved possible to perceive traits which could amount to a consistent 'house style'. Even the four rounded tops of slabs at Meigle are scarcely sufficient to give this feature the status of a defining trait comparable to the round-topped gravemarkers at Lindisfarne and the square-topped variety at Hartlepool. The only other round-topped slabs listed by Allen are at Kirriemuir No. 1 [314] and Papil [228], neither of which has any sign of being under the influence of each other or of a 'Meigle school'. There is no evidence yet detected that would allow such description as 'the Ahenny school' in southern Ireland or 'the Iona school', where the common traits in form and decoration are immediately apparent.

The Mechanism of Commissions

In recent groundbreaking research on the status of sculptors and the organization of their workshops in Ireland, a document-based picture emerges which gives grounds for speculation on these matters in a Pictish context.[53] The circumstances outlined for Ireland and Scottish Dál Riata (Iona) are not strictly applicable, for there the transition from the erection of free-standing wooden crosses to free-standing stone crosses is perceptible and the relevant Irish local tract on social status is concerned in its earliest, 8th-century, version only with craftsmen working with wood. Pictish composite stone structures, as we have seen, were based on existing technology in stone, although the desire for instruction in stone building expressed by King Naiton presupposes a tradition of building in wood.

The Irish sources examined are not explicit in this particular matter of commissioning, but some of the arrangements described in detail in later glosses of the early text could account for aspects of Pictish sculpture or at the very least present a possible scenario. The Irish sources imply that a master sculptor had free status when his contractual commission had been met. He was then able to enjoy some geographical mobility and the fact that Iona sculptors worked on sculpture at sites without Columban connections bears this out.[54]

This is something slightly different from the 'peripatetic' sculptors often invoked to account for the apparent lack of geographical specialization in Pictish sculpture. The model proposed would be for the creation of centres of sculptural expertise, including training, as a result of localized patronage. When work was completed the sculptor and his team were then free to enter a new contract in another location. The new location would bring with it access for the sculptor to a new range of what might be termed 'treasury' exemplars, to be filtered through his individual talent. Such a model provides for the initial introduction and dissemination of slab-cutting skills, the wide transmission of pictorial and decorative traits, and the local introduction of novel artistic resources. It would account, for example, for the appearance of decorative traits associated with

manuscript traditions south of the Humber on the Ulbster cross-slab. The link between that slab and the focal centre at Tarbat, in the shared adoring lion motif, completes the picture. That a sculptor from Tarbat worked in the far north is scarcely a surprising conclusion, but the Irish analysis gives us some notion of how the patron's overall control, the patron in this case being the Tarbat community, and the undertaking of an outlying commission might be reconciled. Skinnet, on the other hand, not far from Ulbster, with its cross-marked stone reminiscent of metalwork and its elaborate cross-slab, may have had some of its own 'treasury' exemplars to offer to the sculptor's gaze. To over-particularize such speculations is idle, but a model of this kind gives status and the necessary freedom of action to the sculptor to produce work drawing on past experience in other locations as well as on new sources of ideas. In any theoretical construct, we must allow for that element apparent in the most polished performances by Insular artists of invention within the intellectual as well as the formal content of the work. The Ezra page in the *Codex Amiatinus* does not merely reflect the input of a committee of wise exegetes but by its very form gives expression to their complex thought. The same is true of the Nigg cross-slab.

There can be no doubt that as Stuart Piggott, Edinburgh's Professor of Archaeology, wrote thirty years ago, 'Art is inextricably bound up with the structure of society and is indeed a social artifact'.[55] A difficulty in respect of the Picts is the fortuitous nature of our knowledge of Pictish society. There is always a danger of putting too much reliance on the sculpture, which like the sculpture of the Irish and the Anglo-Saxons is hard to date with precision, but which unlike Ireland and Anglo-Saxon England has not a body of historical and literary texts to provide a controlled framework for speculation. Pictish art is likely to contribute more usefully to regional studies where it can be scrutinized with the kind of individualized rigour applied to place names. In the wider context the unique usefulness of art is to demonstrate attitudes of mind, cultural resources, and foreign contacts. Pictish art is a constant reminder that the Picts were part of early medieval Europe. When Bede reports that King Naiton had hopes of making his people 'follow the customs of the holy Roman and apostolic church...remote though they were from the Roman language and people', he is describing an initiative which displays the reverse of Pictish remoteness. The issue was current, and the institution approached had the necessary knowledge and authority. Naiton's request stems from cultural inclusion, not segregation. After all, to have been part of the Columban church was not to be starved of cultural stimuli. Nevertheless the contact with Jarrow evidently brought with it a variety of new ideas about the uses of sculpture, monumental types, and techniques of construction to which, in the early 8th century, the already active and precocious Pictish artists responded with comprehension and enthusiasm. By the end of the 8th century these novel formats and methods had been thoroughly integrated into the Picts' own special contribution to the art of the Christian West.

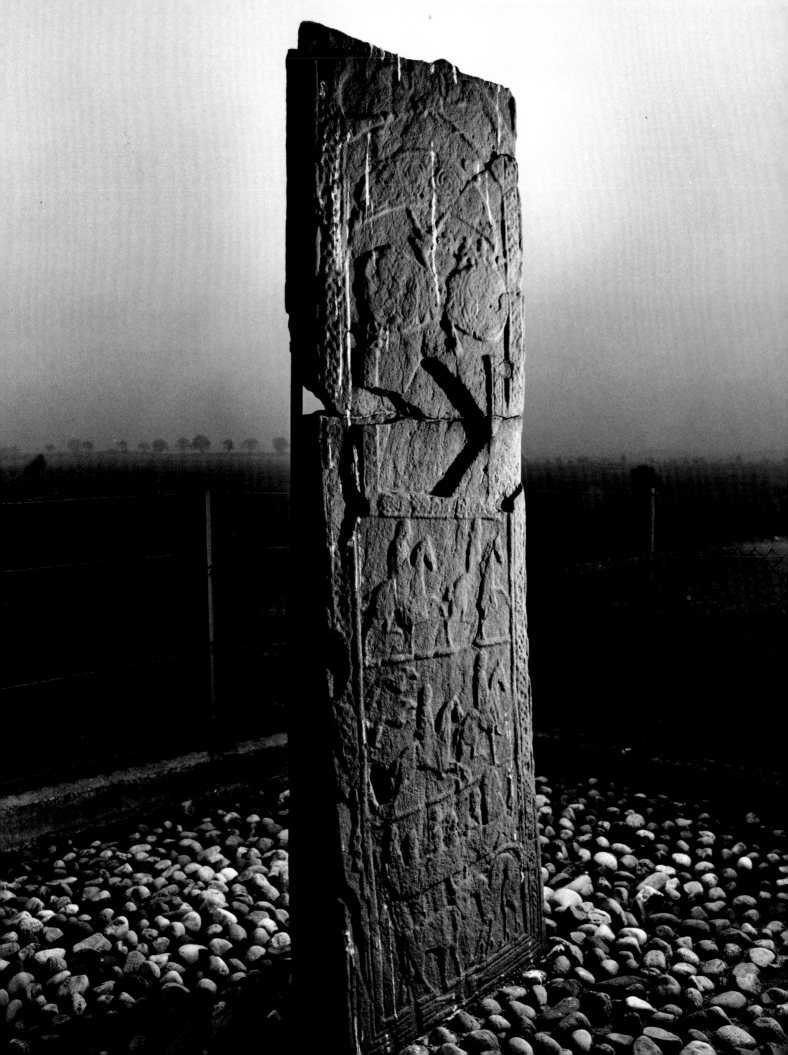

8

Losses

Books and Book Covers

In his *Orygynale Cronykil* the late 14th-century Androw of Wyntoun reports that an ancient (*avitus*) Gospel Book encased in a silver cover or book-shrine (*theca*) stood in his day at the north end of the high altar of St Andrews Cathedral Priory. The cover was made (*construxit*) by order of *Fodawch qui Scottis primus Episcopus est*, the name inscribed on the outside of it.[1] He was either Bishop Fothad I who died in 963, or Bishop Fothad II who died in 1093. Wyntoun, who was a canon regular of the cathedral, identified the donor as the earlier of the two.[2]

Today the broken slabs of the high altar stand under the open sky, in the ruins of the cathedral, wrecked and looted by the mob after an inflammatory address by John Knox on 11 June 1559 in the nearby parish church.[3] The 1560 Reformation in Scotland wiped out books and their associated furnishings much more thoroughly than the equivalent events in England. Among English cathedral libraries, those of Hereford, Worcester and Durham survive nearly intact and in place, and books from very many other houses have been preserved, but in the lists of surviving manuscripts compiled by N. R. Ker in his *Medieval Libraries of Great Britain*, 'No Scottish medieval library is represented by more than two or three manuscripts or printed books'.[4] Precious liturgical books, kept like relics on the altar, will have been particularly vulnerable. Since an entry in the Irish annals proves that there was a monastery ruled by an abbot at Kinrimund (*Cennrigmonaid*), as St Andrews was then called, in 747,[5] it is inconceivable that that monastery did not possess at least one copy of the Gospels. So a venerable Gospel Book could well have existed there in the 14th century, passed down from Pictish times to the post-Pictish 'Church of the Apostle'. Such an ancient Gospels would certainly have contained valuable linguistic and social evidence, as is proved by the existence of the Gaelic notes in the Book of Deer.[6] Among much else that was snuffed out with the destruction of the St Andrews Gospels, it is not inconceivable that we then lost a key to the meaning of the Pictish symbols. Early Gospel Books, especially when preserved on the altar, regularly had charters inserted or written into them for safe keeping,[7] and since the Pictish symbols have been interpreted as signalling status or property, some very early records of donations might have included some of them in an intelligible context.

Another thing that we have been robbed of is the Gospel Book at Banchory Ternan, recorded by the author of the Aberdeen Martyrology appended to Bishop William Elphinstone's Breviary, early in the 16th century.[8] It had a gold and silver cover, and was reputedly St Ternan's own copy of a single Gospel. St Ternan was believed to have died around 431. A saint's personal copy of a single Gospel has happily survived [19], in this case *secundum iohannem*, from the coffin and shrine of St Cuthbert at Durham. Its red leather binding is the earliest surviving European example, still covering the book for which it was made.[9]

The extent of our cultural loss with the disappearance of the St Andrews Gospels is indicated by the parallel history of the Book of Durrow, Trinity College, Dublin, MS.57. It also was given a silver cover, in Irish called a *cumdach*, in the 10th century, with the donor's name, Flann King of Ireland (died 916) likewise inscribed on the outside. It is reasonable to suppose that the St Andrews Gospels was, like the 7th-century Book of Durrow, much older than its *cumdach*. The Book of Durrow carries a colophon, tracing its origin directly or indirectly to an exemplar written by St Columba himself.[10] A hymn book written in St Columba's own hand on fine white parchment is reported by Adomnán to have been in the possession of a Pictish priest, by name Iógenán, probably in Ireland itself. Adomnán's account of St Columba's mission to the Picts, involving his personal journey to the Inverness area[11] and the possibility at least of permanent mission stations linking Pictland with Iona, added to the widespread scholarly agreement that the Book of Durrow is the product of a Columban centre, make it easy enough to understand that Pictish traits might appear in at least one of Durrow's Evangelist pictures, the lion on *f*. 191v [24],[12] given that the Picts were not merely receivers but also contributors to the formation of the visual style coming into existence in the 7th century to answer a new demand. So far as historical contacts are recorded, the Picts appear to have been well placed to digest and accommodate visual conventions, and themselves to make the right mix. Christianity was taught to them not only by Columban clergy. The partial control of Pictish territories by Northumbria in the period up to the death of King Ecgfrith in 685 put the spiritual welfare of the Picts into the hands of men like St Wilfrid and St Cuthbert, both of whom are likely to have been sensitive to the impact of visual images.[13] The Pictish Church was fully functioning and its traditional customs under review at the time of Ceolfrid's and Bede's formal correspondence with Naiton, King of the Picts, around 710.[14] Pictish clergy could not have existed without service-books, Gospels, Psalters and the like.

The group of closely related manuscripts, Echternach [27], Corpus 197B [14], and the Gospels in Durham, MS.A.II.17 [10], though with evident ties to the Lindisfarne scriptorium are perhaps earlier than the Lindisfarne Gospels or at any rate represent an older, independent tradition. These books have been

315 *Back of cross-slab, 'St Orland's Stone', Cossans, Angus. Sandstone*

Losses 215

thought to originate in one or other of the centres of religious observance and study – Mayo, in County Mayo, Rath Melsigi (perhaps Clonmelsh in County Carlow) and elsewhere – centres presided over by Egbert, a remarkable man of Anglo-Saxon birth whose achievements and sanctity were revered by Bede.[15] When Egbert was in his early twenties, around 664, he vowed to undertake ascetic voluntary exile as a pilgrim (peregrinus) from his homeland. For the last fifteen years of his life he lived on Iona and died there, aged ninety, on Easter Day, 729, immediately after celebrating 'a solemn mass'. During this long life he was a central figure in bringing about the unity of religious practice in the British Isles. Bede says that Egbert brought much blessing both to his own race and to those amongst whom he lived in exile, the Irish and the Picts.[16] In addition to this, from the 680s onwards Egbert masterminded a major missionary enterprise to the Low Countries, Frisia and the Lower Rhine, disciples of his preaching to the heathen and establishing new religious communities at Utrecht, Kaiserwerth on the Rhine near modern Düsseldorf, and Echternach, further south, near Trier, whose churches were equipped by Egbert with books and consecrated liturgical gear.[17] The Echternach Gospels survive from among such spiritual provision. Egbert's familiarity with the Picts, vouched for by Bede, might explain what look like Pictish elements, more idiomatically correct than those in the Book of Durrow, in the Evangelist symbols depicted in the manuscripts likely to have been produced in Egbert's scriptoria [27].

The closeness to Pictish conventions of the Corpus eagle [14] and the Echternach calf make it feasible that Evangelist symbols in a wholly unadulterated Pictish style were available for copying from the pages of a pre-existing Gospel Book belonging to one or other of the early church centres in Pictland. To envisage the other two Evangelist symbols in this proposed lost Pictish Gospels, the man and the lion, we can turn in the first place to f. 25v of the Lindisfarne Gospels.[18] Stevenson drew attention to the scroll articulating the angel's wing, merely to demote such scrolls as a manuscript commonplace.[19] In fact, since the angel stands in strict profile with a wide almond shaped eye like so many Pictish figures, the scroll on his wing might signal his identity as a specifically Pictish imago hominis, afterwards adopted by the artist of the Lindisfarne Gospels as an adjunct of his St Matthew author portrait. As one would expect, given the apparent deliberate tendency of the group of manuscripts to which it belongs to vary the images employed, the Echternach Gospels uses a quite different iconography, a frontal man without angelic attributes, in the tradition of Durrow.[20] Echternach's active lion of St Mark, which has moved very far away from the static badge-like lion of Durrow, might on the other hand fill out for us a Pictish series. It has good parallels in Pictish relief sculpture, in the leaping lions on the St Andrews Sarcophagus [189][21] and the related fragment from Kinneddar [191]. The flowing mane and fur of the Echternach lion are expressed as a regular series of close-knit lobes coursing along its sinuous body. These lobes are repeated in

the fleece of David's sheep on the back of the Nigg cross-slab [184]. Stevenson made a false dichotomy between the specific and the decorative when he stated that scrolls were 'little used otherwise [than as body markings] by the Picts'. At the level of artistry at which the Nigg sculptor, and his colleagues in the Shandwick, Hilton of Cadboll, Tarbat fraternity were working, one cannot doubt that ideas were constantly, and speedily, being exchanged between stone carving and manuscript painting, with metalwork as a bridge.

That cultural connections were maintained at the highest level in northern Pictland is evidenced by the Tarbat inscription [201] with its rare and specific invocations in nomine Iesu Christi and Crux Christi, and the forms of Insular display capitals which match accurately the script of the Lindisfarne and Lichfield Gospels. We may compare the diamond-shaped 'O', with transverse bars at the top and bottom, and the form of 'M' involving three verticals and a central cross-bar like a triple 'H', which occur at Tarbat and in the opening of the Novum opus text in Lindisfarne; and the hooked 'R' in the Tarbat inscription and in the Christi autem page of Lichfield which also uses the three stroke 'M'.[22] The Tarbat lettering keeps to the best Insular standard, well proportioned, firm but elegant. It is remarkable also, as Higgitt pointed out in 1982, for being in relief, thus paralleling relief inscriptions in Latin and Greek known to have been made for John VII who was Pope from 705 to 707.[23] Around that time, as Lapidge has shown, copies of the texts of papal epitaphs were brought back from Rome by an English traveller.[24] As well as their vocabulary, their appearance may have been noted. Evidently contacts were such that northern Pictland could respond to new ideas of this kind.

The Tarbat inscription reveals the common ground between book decoration and sculpture. Two cross-carpet pages in the Lindisfarne Gospels, f. 2v (where a rectilinear deeply indented cross floats against flickering panels of interlace) and f. 26v (where cross and background share the constant stir and coil of outstretched tangled animal bodies) set the agenda for the strongly articulated design on the front of the cross-slab at Nigg [202]. There the ideas are taken further and given the extra power of plasticity and projection. It is inconceivable that no other examples of cross-carpet designs, in the books themselves or as the metal covers to books, existed in Pictland when taste and technique have reached such a pitch of virtuosity as we see at Nigg. A cross-carpet page on f. 1v of Book of Durrow, encloses in a wide frame a rectangle containing a two-armed cross, a form associated with relics of the True Cross.[25] The ends of the horizontal and upright bars are composed of step or fret patterns. As Nordenfalk observed long ago, the Durrow leaf bears a striking resemblance to the central motif on the back of the great cross-slab at Rosemarkie [316].[26] Without books and book covers in the mind of its sculptor, the Rosemarkie cross-slab could not have been made. What is equally telling, he is not stuck at the Durrow stage of Insular ornament but pushes the modest fret pattern of

Durrow into far greater prominence, in keeping with a decorative
trend first clearly seen in the Lichfield Gospels.[27] The cross-carpet
page design at Rosemarkie is encased by a broad flat frame carved
with a scintillating fret pattern with eye-catching triangular
openings. The taste for fret patterns leads us significantly back to
the continental mission initiated by Egbert and continued by his
pupil Willibrord, Archbishop of Utrecht, who died in 739, ten
years after Egbert himself.[28] Due to their contacts throughout the
Insular world, works of art made for, or on, the continent make
strong use of Insular motifs. The fret pattern is seen for example
on a splendid ivory book cover now in Brussels, made under
Insular influence somewhere in north-western Europe.[29]

No carved ivory or illuminated manuscript survives from this
period in Pictland. But the visual evidence of liaison, of shared
practices and levels of patronage is preserved in the stone
sculpture. A square panel of fret is carved on the reverse of the
Shandwick cross-slab [51], on the right, near the base. By the deep
cutting of his design, exploiting light and shade, the sculptor
achieves the same visual effect as illuminators who shade in a
dark background behind the zigzag patterns on their pages. The
broad field employed for the repeat pattern at Shandwick, and the
emphatic vertical strands running through the design, have a
close parallel in the Augsburg Gospels [16], another of the Gospel
Books from Echternach, a fragment this time, dating early in the
700s. Ó Cróinín has suggested that the Augsburg Gospels were
not written at Echternach itself but was another of the books
provided for the Frisian mission by Egbert's scriptorium.[30]
Something very like the Augsburg Gospels cross-carpet page must
surely have also been before the eyes of the designer of the front of
the Rosemarkie cross-slab [59], where a cross is defined by inset
panels of richly variegated key or fret pattern. Considering the
kinship which exists between artistic expression in Ross &
Cromarty and the decoration of books made from the late 7th
century onward for, among other things, the book satchels and the
altars of the Frisian missionaries, it is not surprising, though no
less satisfactory, that the glebe field at Tarbat produced in the 1998
excavation an example of the so-called 'porcupine' type of early
penny, known from large hoards in East Frisia and the mouth of
the Rhine, and manufactured in the Low Countries in the period
715 to 735.[31] Someone on business from Egbert's continental
mission could have come to Tarbat with such a coin in his purse.

To look at Pictish sculpture for evidence of lost manuscripts is
not a parochial operation. The connections with Insular art as we
know it in other media, notably manuscripts, are so intimate, so
'in-house' that, as we indicated in a previous chapter, Pictish
sculpture helps to fill in the picture of Insular art as a whole,
including aspects of manuscript art not otherwise recorded. The
figure style of the hermit saints on the pediment of the Nigg cross-
slab is a case in point. The striped effect of their draperies, like
bandages, and the sidelong swoop of the figures aided by the
linear rhythm of their clothing have a striking parallel in the
banded undulating drapery of the crucified Christ in the Durham

316 *Lower half of back of cross-slab, Rosemarkie,
Ross & Cromarty, No. 1. Sandstone*

Gospels.[12] Other comparisons can be made with a somewhat later
manuscript, the Book of Kells. For example, the rolling hemline of
the saints' robes, as well as the general proportions of the figures
with very large heads and long arms but diminished lower limbs,
are paralleled in the figures in the so-called 'Arrest of Christ'
miniature [22]. The conformity of the figures at Nigg to the shape
of the pediment recalls the way figures are fitted into the arches
and spandrels of the canon-tables before the opening of the Kells
Gospel texts.[33] But the effect of the figures at Nigg is less
bombastic than Kells, more naturalistic, halfway between the
decorative mannerisms of Kells and the strict classicism of the
Barberini Gospels [20],[14] and so an authentic independent Insular
voice, which speaks from an unknown space sometime after the
period of the Durham Gospels.

Stone Sculpture

The front of the cross-slab at Elgin [216] is an important document in the discussion of lost manuscript material in Pictland since its choice of the difficult iconography of the Evangelists coupled with their symbols lodged above and below the arms of a cross[35] looks like replication of a prestigious book or book cover. But the back of the Elgin cross-slab [188] gives not only more evidence of the liaison between sculpture and book painting but is itself a monument part of which is lost. Allen's drawing of what remains at the top of the slab shows a central panel of spirals, and on either side a pair of broad hooked or claw like motifs.[36] These forms, so difficult to make out on the heavy granular texture of the slab, can be interpreted by means of other Pictish sculptures, and then, beyond the specifically Pictish canon, by other Insular works of art. Among the sculpture preserved at Meigle is the remarkable architectural frieze [307] which contains the curious figure of a merman clutching his own serpent-like hair. The St Andrews and Kinneddar figures of David [189, 191] have big strong hands with which they grip the lions' jaws. In the light of these sculptures, the ovals between Allen's claw-like motifs can be recognized as strong clenched fists, grasping snakes, or thick strands of some sort. The figure to whom these hands belonged must have continued upwards, and once must have had a head on top of the monument which some iconoclast has smashed off, perhaps under orders, like those who demolished St Triduana's shrine and statue at Restalrig in 1560,[37] or the Ruthwell Cross in 1642.[38] The spiral ornament between the hands seems likely to be some kind of breastplate, like that of Christ on the 8th-century Athlone plaque, an openwork book cover representing the Crucifixion.[39]

A parallel for sculpture on the upper surface of a cross-slab is seen, tentatively, in the ascending plant stems which clothe the pediment of the Nigg cross-slab [203], and more patently in the two lions which crouch on the top of the St Madoes cross-slab [275, 276] like guardians on a tomb or shrine.[40] The very top of the picture space on three other cross-slabs give hints towards the Elgin design. At Dunfallandy [77] two fishtailed dragons menace a centrally placed human head. On the pediment of the Aberlemno churchyard cross-slab [82], and at Cossans [315], two dragons whose bodies, as at Dunfallandy, form the frame up the sides of the monument, come face to face at the top.[41] At Elgin the missing figure is that of Christ who has taken charge of these menacing creatures and grapples with them, triumphing over evil, in the manner represented in the Book of Kells at the top of *f*. 2v where Christ grips and tames the tongues of two ferocious lions.[42] The original silhouette of the Elgin cross-slab will have been similar to that of the Temptation miniature in the Book of Kells [217], where the bust-length figure of Christ emerges from the top of the shrine-shaped Temple and dominates the entire composition. These Kells images help us to reconstruct, and perhaps also to date, the Elgin sculpture, an impressive manifestation of the Pictish religious imagination.[43]

In surveying the decorative and figurative programme of Pictish sculpture we have had to deal with many examples of fragments of which the whole format and context are lost. At Kinneddar the scale and shape of the monument from which the relief sculpture of David rending the lion's jaws is broken off can now only be guessed at; if, as suggested above,[44] it was a cross-slab, then the excellent trumpet spiral fragment also from Kinneddar might well have belonged to the same monument. The base of the Hilton of Cadboll cross-slab [273] has recently come to light, together with fragments and chippings from the front of the slab,[45] but from Tarbat the base and the efficient tenon of a similar design of monument [62] survives with nothing preserved above the first 60 centimetres of its decoration.[46] The base of the Nigg cross-slab [202], from which that wonderful monument was snapped off, reputedly in an early 18th-century gale,[47] is meantime buried and hidden at some unknown spot in the impressive island-like site of the Nigg churchyard. Occasionally fragments can be recognized as originally conjacent and able to be realigned, a notable example being at Tarbat[48] where the recently discovered slab [317] exhibiting the row of standing Apostles on the back [206], carries on the front the top left corner of a cross-head, the bottom right corner of which has long been known on the fragmentary slab on whose narrow side the Tarbat commemorative inscription in raised lettering [201] is carved. The space in between the two portions, depending on how many Apostles have been lost, is a matter of debate, but it is certain that the two surviving portions indicate a cross-head featuring cross bars of an unusual diagonal, saltire, disposition, with parallels on some of the pages of the Book of Kells and the Book of Deer.[49]

The retrieval rate of sculptural fragments, notably in north-eastern Scotland, has been high recently, but the overall picture must be one of absolute losses, of which we will never know the content. Unexpected or unique features often enough occur in the surviving monuments, for example the grotesque figure lusting after bulls' blood on the cross-slab at St Vigean's [205] and the figure squatting, clutching his knees, behind the chair, 'socially marginalized' on the fragmentary Meigle No. 27 [230].[50] Two outstanding lost monuments of which we have records hold similar surprises. One, at Newtyle, 3 kilometres (2 miles) south-east of Meigle in Perthshire, was described in 1569 by the then Dean of Glasgow[51] in measurements equivalent to 2.7 m. (8 ft 9 in.) high by 1.2 m. (4 ft) across, with a cross carved on both west and east faces. This feature connects the lost Newtyle slab with those at Rossie Priory [86], Gask [272], Edderton [93], and Ulbster [56], but all the figurative work appears to have been on the east face, which we would consider the back. The cross on the west face, the front, is described as 'curiouslie gravit', and so will have been an ornate cross, full length like those at Aberlemno roadside [218] or Meigle No. 2 [199]. The back of the slab displayed a shorter cross 'at the heid of it, and ane goddess next that in ane cairt, and two hors drawand hir, and horsmen under that, and fuitmen and dogges, halkis and serpentis...' The placing of the horsemen

317 *Fragment of cross-slab, Tarbat, Ross & Cromarty.*
Sandstone

below the level of the cross is like Edderton, and the presence of
men on foot recalls the composition on the back of Aberlemno
roadside. The hawks and serpents might have been symbols, or
the former might have been part of the hunting team as at Elgin
[*188*] and St Andrews [*190*], while the latter might have belonged to
the ornamental repertoire, as at Murroes [*58*]. It is not clear if the
cart group was 'next to' as opposed to 'under' the cross, that is in a
special eminence alongside the cross-stem or lodged beside one of
the cross-arms. Wherever it was, it sounds impressive enough.
It makes one think of Suetonius's report of Caligula instituting an
annual day of sacrifices, and games at the circus, in honour of his
mother, on which occasions a two-wheeled covered carriage, a
carpentum, was to draw her image in procession through Rome.[52]

A representation similar to that described at Newtyle was
preserved in a rectangular relief-carved panel at Meigle [*318*],
seen and drawn by or on behalf of various 18th- and 19th-century
antiquaries, but now lost.[53] The illustrations of this panel
published by Chalmers (1848) and Stuart (1856)[54] generally
coincide in showing a cart with a large twelve-spoke wheel and a
light framework and canopy occupied by two figures. The driver is
seated in front, holding on to reins that have a curious circular
feature halfway towards the horses' necks. A pair of horses draw
the cart set one above the other in relief, cameo fashion, as on
Meigle No. 2 and Hilton of Cadboll.[55] They pace forward, high
stepping in the typical Pictish manner. The Roman *carpentum*
was evidently usually drawn by mules and tended to have fewer
spokes, but there are innumerable Roman relief sculptures of
ceremonial or army and public transport carts drawn by two draft
animals, in silhouette, that give generally the impression of the
Meigle sculpture and a Roman model in some medium seems the
most likely source of the motif.[56] At Meigle it might play its part in
a continuous narrative. It moves off towards the left, its
passengers either indifferent to, or distancing themselves from,
the violent scene at the bottom right of the panel. The panel was
evidently cut short at the right. Below the cart is the familiar
crouching figure of the bowman, facing right, about to discharge
his bolt. We have ventured to suggest that this figure had a name
and circumstances known to Pictish viewers.[57] Here his quarry
may have been the slim wolf or lion immediately ahead of him,
but both man and beast might be coming to the aid of the man
on whom a huge bear is trampling, its open jaws around his
forehead.[58] The man, so imperiled, is supine, stretched out and
kicking his legs in typical Pictish fashion. Where the Stuart
version deviates from that of Chalmers and all earlier drawings is
in showing a knife in the man's right hand, which he thrusts into
the chest of the monster above him, as Sigurd thrusts his sword
from below into the dragon Fafnir.[59] A comparable image might be
the upright man, beset by two bears, who stabs his knife into the
midriff of one of them on the Scandinavian helmet ornament, the
Torslunda plaque.[60] At Meigle it is this hint at a heroic saga which
gives narrative cohesion to the panel. A comparable forgotten hero
may be represented by the man below the right cross-arm on the
front of the cross-slab, Meigle No. 4 [*104*], found broken in two
pieces in 1858, the middle section missing. With his right hand he
seizes the offside foreleg of a horse that rears up in front of him, a
sort of Pictish Eighth Labour of Hercules.[61] However the existence
of the knife in the iconography of the lost Meigle panel cannot
now be checked, and it is a fact that defenceless human victims
of predators are a regular Pictish theme, on other sculptures at
Meigle itself, and elsewhere.

The certainly uncommon element in the relief is the elegant
conveyance of the two shrouded figures in their grand wheeled
cart. Various Irish monuments represent wheeled vehicles,
though none with the specific features of the Meigle example.[62] If
the man and beast struggle belonged to the typical Pictish imagery

of Hell and Damnation, then the passengers in a cart with twelve conspicuous spokes on its wheel might signify the secure state and passage to heaven of those who followed the faith of the twelve Apostles. The distinct status which the image of the cart and passengers had on the Newtyle cross-slab, up above the common ruck of subjects placed below the cross, might support this interpretation, but the argument from twelve spokes is admittedly frail. A splendid early Celtic four-wheeled cart, with shafts for two animals, which survives from Dejbjerg, West Jutland, has no less than fourteen spokes to each wheel.[63]

The lost Meigle panel has a framing ridge along the bottom. It is part of a horizontal structure, such as a closure screen, like the so-called 'calf-stone' at Tarbat [303], which has a ledge at its top, and which, as it happens, is similarly ambivalent in its iconography, in Tarbat's case exhibiting examples of both solicitude and depredation in the animal kingdom. Tarbat is currently piecing together the shards and debris of the fabric of its erstwhile major ecclesiastical institution.[64] Within the monastic enclosure the 8th-century visitor would have seen gravemarkers inscribed with the cross [256] and larger recumbent monuments [302], and a stone church whose entrance may have been defined by a carved lintel and jambs. The interior of the church would have been divided by a post-and-panel screen into a nave and sanctuary. Adjacent to the altar would have stood the cross-slab [206, 213] with the group of Apostles and the unusual diagonally-set cross-bars, as reconstructed above, the name stone, in raised letters, of a revered abbot or patron. Other larger cross-slabs or crosses would have been placed scenically, outside the church. So much the imagination can today legitimately propose for the lost edifice and once-functioning ornaments and focuses of devotion

at Tarbat's monastery. The much more substantial collections of stone sculpture at Meigle, comprising many complete cross-slabs as well as fragments of others, gravemarkers and portions of architectural sculpture, were scooped up long ago by the literary and nationalistic imagination of Hector Boece, the first Principal of Aberdeen University, into a rather different cultural complex, namely the sepulchral monument of King Arthur's unfaithful Queen Guinevere, locally known as Vanora, and later Wanders. Like only too few Pictish sculptures, Vanora's name was 'writtin thairapon'.[65] A number of sculptured stones seem to have been boxed up together, with Meigle No. 2 [194, 199] as the centerpiece. 18th-century romantic and antiquarian opinions only added to the bizarre conflation, on which the poet Gray was able to feast his eyes in 1765.[66] This loss of perspective regarding the original meaning and value of the sculpture at Meigle entailed much relocating and trimming of individual pieces, and afterwards the supposed sepulchre or other stones were 'carried off or broken' by the local inhabitants, ending up with a scattering of material over a wide area and subsequent loss by fire and neglect.

The quantity of sculpture nonetheless still remaining in Meigle Museum signals the fact that a single Pictish site could have been famous at an early date for its monumental visual display. What is now available at Meigle by way of imagery does not tally with the report in the *Liber Floridus* of Lambert of St Omer, dating to 1120, that there was a 'palace of the soldier Arthur in Britain, in the country of the Picts, constructed with marvelous art and variety, in which may be seen sculptured all his deeds and wars'.[67] The 12th century, like the 16th, was fixed on the Arthurian explanation, as the 19th was fixed on the Danish. The identification of Lambert's *palatium* as the *furnus Arturi*, Arthur's

318 *Lost monument, Meigle, Perthshire, No. 10. Sandstone*

319 *Top of recumbent, Meigle, Perthshire, No. 12. Sandstone*

O'on, the Roman domed shrine formerly on the River Carron two miles north of Falkirk, has to dismiss as fiction the sculptured narrative scenes.[68] Military iconography is not particularly plentiful in the Pictish canon, but where it occurs it has considerable power and impact, in the parade of guards with their general on the front of the Dupplin Cross [196], in the battle scene in Aberlemno churchyard [82], and in the wide range of *gesta bellorum* on 'Sueno's Stone' [195].[69] Especially with this last, the predisposition to make war images on a large scale is apparent. We have remarked earlier on the evidence that there were formerly two such monuments at Forres, so it is possible that important examples of political visual propaganda, as well as Christian ones, have simply vanished from the Pictish landscape.

There is clear evidence that certain of the original Meigle monuments, like the later fantasy complex of Vanora's Grave, were themselves composite and additive. The evidence, discussed in the previous chapter,[70] lies in the facings and structure of the monuments, and signals losses of salient features of the decorative design. Considering the bold embossed all-over decoration of the sides of the recumbents, the vertical feature, set in the end slot, seems likely also to have been highly wrought, but perhaps was structurally lighter in some other material, wood or metal or a shaft of stone of another colour. That contrast of texture and colour was part of the Pictish aesthetic is suggested by the most curious feature of the Meigle recumbents, Nos 11 and 12. As we have seen, the whole length of the upper surface of Meigle No. 12 carries a row, point to point, of recessed lozenges, neat and sharp-edged, evidently awaiting the insertion of metal plaques, or polished stone panels to resemble the lozenge shaped insets of green and purple porphyry on Roman and Early Christian patterned stone floors [319].[71] Some form of precious attachment also now lost, conceivably the relic of a saint, seems implied by the carefully cut recess of an irregular four-sided shape, like a slanted axe blade, contained within a separate rectangular frame on the back of the cross-slab at Cossans, in the central zone, below the symbols and above the procession of horsemen [315].[72] A small square recess is inserted into the fragmentary relief sculpture, perhaps from a box shrine, at St Andrews, immediately below a pair of cupped hands which seem to hold reverentially with their fingertips a small square object. The precious object so held in the sculpture might have been actually enshrined in the recess.[73] One of the corner slabs of the St Andrews Sarcophagus is decorated with a recessed cruciform design of key-pattern, contrasting with the higher plane of interlace surrounding it.[74] Perhaps at Cossans and Meigle engraved metal plaques were nested in the stone blocks, engraved with devices, or with patterns which stood out conspicuously against those on the surrounding stone.

Metalwork

Metalwork provides a sadly large category of what we know we have lost of Pictish art: what we know of is doubtless only the tip of the iceberg. If we were to believe the rumours that were current or dormant in the twenty years after the looting in 1819 of the large Norrie's Law tumulus (and eventually, in 1839, reported by George Buist to the Fifeshire Literary and Antiquarian Society), the treasure ransacked included 'a rich coat of scale armour', made of silver, the accoutrements, we might suppose of a Pictish Lohengrin, an appropriate compatriot for Queen Vanora in a fantasy world of pseudo-history and romance.[75] In 1848 Patrick Chalmers repeated the story of 'a suit of Silver Armour, which, being too bulky for concealment, was broken up and conveyed piecemeal to the crucible'.[76] In our time James Graham-Campbell has been at pains to discover the truth about Norrie's Law, and other similar finds, and it is in the light of his careful assessment of the evidence that we are able to judge the nature of what was found, and how much is now missing.[77]

The bulk of the Norrie's Law hoard was dispersed by a peddler, in various lots locally but principally to two jewellers, one unnamed in Edinburgh and one called Robertson in Cupar. Subsequently some more pieces were retrieved from the site, and some important items rescued from the Cupar jeweller, who was also persuaded to recollect what he had long since melted down. The weight of silver originally found was calculated to have been 400 oz (12.5 kg), of which only 750 g survives today, that is 6 per cent of the whole. The extant items, notably the handsome handpins and the flat leaf-shaped plaques [112] engraved and enamelled with the 'double disc and Z-rod' and 'beast head' symbols are discussed in more detail in another chapter.[78] Part of the silver hoard was comprised of late-Roman material, as indicated by the recorded presence in it of a crushed 4th-century inscribed Roman spoon, and two 4th-century silver coins. The jeweler Robertson described what he took to be the remains of a shield, with 'rich carving', 'embossed', bearing ' the figure of a man on horseback'. It has been suggested that what he was handling may have been a late-antique figured plate, with a mounted emperor, or a Sassanian vessel representing a royal hunt. Graham-Campbell is clear that a fragment of a Viking silver arm ring now mixed in with the Norrie's Law hoard does not rightly belong with it, and is not definitive of the date when the hoard was hidden. The antique horseman plate, if so it was, was deposited too early, perhaps in the mid-7th century, to be the specific model of the royal rider on the St Andrews Sarcophagus [190], although the presence in Pictland, in Fife, of some such sumptuous imported artefact is confirmed by the exotic elements in the Sarcophagus front panel.[79] On the other hand, the jeweler Robertson does not seem to have described a substantial round platter. Much of the fabric was missing, but was nonetheless 'heart-shaped', 'a shield of old pointed shape', 'the design of the edge distinct'. Stuart criticized the reconstructed shape of the shield published by Buist as 'too modern', as indeed it is, short, broad, with a shallow curved bottom and a cusped top. The reported dimensions, sixteen by ten inches (40 x 25 centimetres), indicate a long narrow shape. Unlike surviving fragments of thin silver plate, some with repoussé ornament, which may well be parts of the covering of a circular parade shield, the structure of the panel or sheet with the image of the horseman specifically affirmed by Robertson does not tally with Pictish shields known in the sculptures, which are either round or square. The much smaller symbol-bearing plaques from Norrie's Law would appear shield-shaped if their tapering upper portion were missing, and the horseman might have been engraved on a larger scale Pictish ceremonial plaque. The evidence that much of the horseman panel or sheet was 'wanting' might mean that it was crushed out of recognition by the thieves, but assorts ill with the perfect condition of the surviving engraved symbol plaques. The Norrie's Law hoard sounds more like fine finished Pictish artefacts together with a miscellany of damaged Roman material, and the horseman probably belonged in the latter category rather than the former. Either way, the horseman would have illuminated the history of Pictish art, and its destruction for the gain of a few pounds sterling was a shameful act.

Robertson spoke of eight 'bodkins', or handpins of the type of which three and part of a fourth are preserved, and the original hoard may, tragically, have contained a dozen of these splendid objects with their combined Christian and native iconography. Robertson also thought that he had handled a crushed silver helmet, which may again have been either Roman or Pictish. A number of engraved silver bowls, set one within the other, were found in 1958 on St Ninian's Isle, Shetland [150–162].[80] Modern scholarship has transformed Robertson's silver sword hilt into the stem and base-plate of a drinking cup or tazza. More difficult of interpretation due to their loss are the 'very large number of scales or plates', some of which had hooks attached. These objects gave rise to the supposition that they had once clothed and protected an early hero, who, so kitted out, would have glittered like a salmon. The suspension tags and the scale- or leaf-shape format are certainly reminiscent of antique pendant necklaces.[81] On the other hand only 'some' had hooks attached, and two 'scales or plates' survive, the noble plaques with the Pictish symbol engraved on them, and with no inbuilt means of suspension. Robertson reported also 'a number of coins', which other eye witnesses said were decorated with symbols like those on the plaques. We have evidently, therefore, lost a large number of examples of fine Pictish metalwork, a cache of symbol-bearing plaques of both leaf and coin-like disc shape, the multiplicity and presumed repetitiousness of which must colour any interpretation of the function of the Pictish symbols. These precious, small, highly crafted tokens, especially because they were in multiple copies, in themselves represent the core of the problem. How they were used or mounted, what diplomatic or gaming table role they played, or whether for example they were the equivalent of Alfred's æstel,[82] can only be speculative. The loss of the objects themselves, both as works or art and as an archaeological benchmark, is a great catastrophe.

The treasure from the Broch of Burgar, Outer Evie, Orkney, was allegedly found in 1840 by the owner of the Outer Evie estate and was lost sight of in the course of the finder's petulant resistance to treasure trove claims by Her Majesty's Treasury. Like much of the Norrie's Law hoard, the silver articles from the Broch of Burgar are known or can be guessed at only from descriptions collected from eyewitnesses, nineteen years and more after their discovery.[83] The star item was a silver vase or beaker, perhaps one of a number set one inside the other, the outer vessel about the size of a half-gallon pot, with a narrow neck and base and a thick bulging waist, ornamented with many projecting bosses or knobs, the whole stamped or incised with various decorative designs. Stacked inside the vase or vases were reputedly two or three short stubby penannular brooches like those extant from St Ninian's Isle, pieces of silver chain consisting of three links interwoven, five or six short pins, evidently not the bigger handpins of Norrie's

Law, several silver combs with long rounded perforated backs, some with teeth as long as 15 centimetres, in profile perhaps something like the incised symbol combs from Clynemilton No. 2,[84] and a large number of amber beads, perforated for stringing, some as large in diameter as 7.5–10 centimetres, others much smaller. Three small amber beads are known from the Croy hoard, and amber was used to decorate small cells on the grand pseudo-penannular brooches from Hunterston [11], Dunbeath [137] and Westness [149], but the quantity of amber from Burgar is recognized by Graham-Campbell as more characteristic of Viking hoards than Pictish, whereas the silver, though some of it was unique in format, could all have come from an aristocratic Pictish household, the vase representing the taste for smooth decorated surfaces swelling into spiral and other bosses so prevalent in mature stone sculpture such as Dunfallandy [49], Shandwick [200], Hilton [273], and Rosemarkie [81]. Whereas the Norrie's Law hoard brings us close to a silversmith's own collection of raw materials and his own pristine artefacts, concealed perhaps to avoid them falling into alien hands in the years prior to the Northumbrian defeat at Nechtansmere in 685, the concealment of the Broch of Burgar silver might parallel that of St Ninian's Isle and date from the first advances of the Norsemen, the same marauders who disrupted the cultural and devotional life of Iona and Lindisfarne around 800. The putative existence of a treasure of silver objects in the Orkney Islands provides a useful bridge between the St Ninian's Isle hoard and hoards from the north of mainland Scotland.

These are found, only to be lost again, through the stupidity or greed of those who first had access to them. The character of the location of the Gaulcross hoard, from Ley, Fordyce in Banffshire was similar to that of Norrie's Law, inside the ring cairn of a recumbent stone circle, shortly before 1840.[85] A handpin of the same splendid type as from Norrie's Law, a fine multi-linked rope-like chain, and a smooth twist of beaten silver, a bracelet to match the Norrie's Law finger ring, are the sole survivors from a hoard [123] that contained many other pins and brooches, their appearance not recorded. A similar site, a sandpit adjoining a stone circle, at Waulkmill, near Tarland, Aberdeenshire, yielded 'a number of silver articles', of which nothing but the fact of their existence in 1899 is known. A few years earlier, in the 1870s, precious metalwork and glass and amber beads were found on different occasions partly scattered in a ploughed field at Croy, near Inverness. Among the survivors from this hoard are three silver penannular brooches [140],[86] but it is suspected that much more has been lost. A 19th-century photograph preserves the appearance of one of the Croy finds which has disappeared, a decorative mount.[87] An electrotype, now in the National Museum of Scotland, preserves the shape and detail of a lost brooch from Banchory, with raised birds' heads on the corners of its square terminals.[88] That brooch was one of a very specific design-pattern known from a fragment surviving from Freswick in Caithness [136], from two others found in Norwegian graves, and from a site

in Northern Ireland.[89] It is ironical that the examples stolen by Vikings long ago are preserved, and the ones that stayed in (former) Pictish soil until the 19th century are broken or secretly purloined. Of the great hoard found in 1868 at Rogart, during the construction of the railway, of eleven brooches, displaying high standing birds' heads, gilt silver with green glass eyes, set around amber studs, only the remains of six survive, together with fragments of the thin bronze fabric of a drinking vessel, perhaps analogous to the lost beaker from the Broch of Burgar.[90] The progress of modern industrial technology did not elevate human nature. The closure ring of a great Pictish silver chain, found while the Caledonian Canal was being constructed near Inverness, failed to reach Edinburgh Museum. A massive oxydized silver chain, discarded as useless by a blacksmith at Greenlaw, Berwickshire, was eventually recognized for what it was but subsequently disappeared.[91] Banffshire, which swallowed up the majority of the exquisitely crafted silver jewelry from Gaulcross, momentarily revealed at Forglen, 'in a moss', an entire Pictish silver chain, 'of great mass'. The eyewitness in 1853 to this other valuable corrective to the chance-distorted map of find-sites of the Pictish chains was none other than John Stuart, of *The Sculptured Stones of Scotland* fame, but even he was unable to redeem this particular treasure from subsequent oblivion.[92]

The church, a cell of Lindisfarne, celebrated in Aethelwulf's poem *De Abbatibus* written in the years around 810,[93] grew in the splendour of its furnishings over the hundred years since its foundation, equipped with a golden chalice and a silver paten, with books in gold covers, and an altar and ciborium covered with embossed silver reliefs representing the saints in heaven, all this precious metal made to gleam in the light shed by suspended lamps and bowls. The core of the church's first altar was a tablet consecrated and dedicated to St Peter by Bishop Egbert,[94] the same whom Bede reports brought blessing upon the Picts. Aethelwulf's church was only an aristocratic foundation. It seems reasonable to suppose that the stone church which King Naiton proposed to build in around 710 would have been amply beautified out of royal bounty. Its foundation is exactly contemporary with the church in Aethelwulf's poem, and its dedication likewise to St Peter[95] is something in which Bishop Egbert, in his care for the Picts, and as a key figure in the evolution and propagation of Insular art, might literally have had a hand. The sacred stores which must have accumulated on and around the altars of every major church throughout the Pictish territories in the 7th, 8th and 9th centuries, are lost, with the sole exception of some iron hand bells[96] and the two elegant house-shaped shrines, from Monymusk [167] and Bologna [320]. Exactly the style of decoration which these objects display is recognizable in the relief sculpture of the Pictish cross-slabs, and provides us, as it were, with our own eyewitness reports of the form and character of lost metalwork. The base of the relief cross on Meigle No. 5 [321] is shaped like a separate stand, supporting the equal-armed cross up above, its left and right corners extending in the form of the slim neck and head

of an animal, each turned to look towards the steep curved central panel of the stand. The roof ridge of the Monymusk shrine has the neck and head of a bird at each end, which curve round to look towards the central ornament of the roof ridge, a panel of interlace like the interlace which fills the necks of the birds themselves. The middle of the roof ridge of the Bologna shrine is marked by a small framed rectangular panel with an extra roof-like curved upper panel which breaks the line of the ridge. Crouching at either end of the roof ridge are two stylized animals that look back towards one another and at the central motif. Such guardian animals appear again in stone, perched on the top of the cross-slab from St Madoes [275, 276]. The body of the Bologna shrine carries round and rectangular jewels, recessed in massive projecting frames, and the very same thick boldly projecting frames around a rectangular recess form the terminals of the cross-arms of the great Aberlemno roadside cross-slab [218]. If house-shrines and reliquaries are echoed in the base and the arms of the cross at Aberlemno and Meigle No. 5, the huge ring around the cross-head at Meigle No. 2 [199], its wide flat surface studded with a measured procession of bosses, signals that the sculptor and his audience were familiar with patens with a flat rim set with jewels, like that

from Derrynaflan [18].[97] We have already observed that the central panel of the back of the great cross-slab at Rosemarkie [316] displays a complex framed cross design, which recalls the layout of the first carpet page in the Book of Durrow, but in its dynamic textured raised-relief form more resembles a metal book-shrine. Just such a book-shrine has recently come to light at Lough Kinale, County Longford.[98] At the start of this chapter we noted the former existence of a gold and silver cover on St Ternan's Gospel at Banchory Ternan, and the enshrined Gospel Book on the High Altar of St Andrews Cathedral. The sculptor at Rosemarkie, whose entire cross-slab, front, back, and sides [39, 81], gives the effect of cast and repoussé metalwork, offers us in another medium visual images which must surely have been realized contemporaneously in Pictland in metal itself, the central guiding and definitive medium of Insular art. It is an essential fact about Insular art that book painting, stone sculpture, and metalwork shared exactly the same design precepts and motifs, and that we can legitimately supplement gaps in the one from what we know of the others.

The images which the Rosemarkie sculptor conjures up lead us beyond lost liturgical gear to the similarly depleted world of representation of the Pictish symbols in metal. As we have seen in

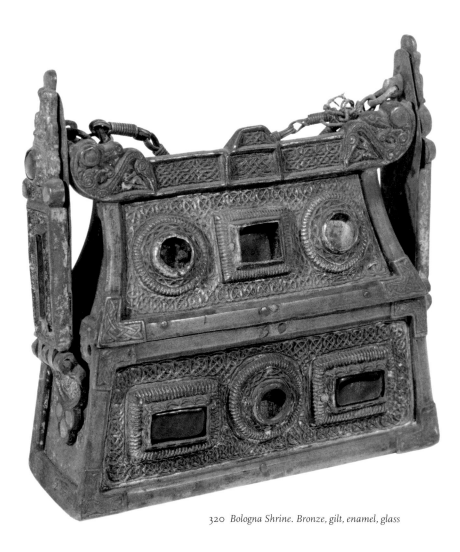

320 *Bologna Shrine. Bronze, gilt, enamel, glass*

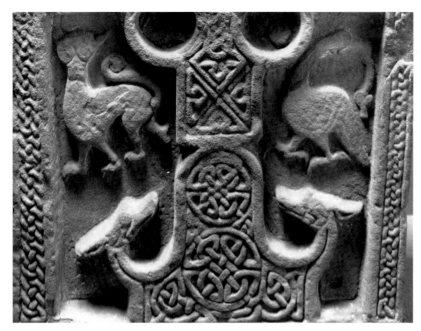

321 Detail of front of cross-slab, Meigle, Perthshire, No. 5. Sandstone

our survey of the location of the Pictish symbols on the cross-slabs, the great monument at Rosemarkie holds up to view an unusual array of three 'crescent and Z-rod' symbols and one 'double disc and Z-rod' symbol. The double discs are each filled with a bold ring of raised spiral bosses. The firm rim of the discs is continuous and bends like a hoop to contain the two groups of bosses. The object represented could be made of a thin sheet of metal, hammered and punched out from the back. The lowest of the 'crescent' symbols consists of an open shell ribbed by thick strands of interlace, again metallic in character. The contained energy of these crescents and discs is very similar to what pulsates within the stiff narrow 'D'-shape of the St Germain plaques [12].[99] The crescent above the 'double disc' symbol is flat, lightly scored with a diagonal key-pattern. The all-over treatment with key-pattern strikingly recalls the design of the crescent on the front of the lost Laws, Monifieth, bronze plate, recorded in a drawing made in 1796 [322, 323]. The back of the Monifieth plaque carries the same group of symbols, 'double disc and Z-rod' and 'beast head' which appears on the Norrie's Law silver leaf-shaped plaques. The Monifieth bronze plate, having symbols on both front and back, and being cut to a crescent shape itself, differs from the Norrie's Law examples, but is nonetheless a depiction of the symbols in metal, as a separate portable token or insignia. The Rosemarkie cross-slab gives all the appearance of setting up a display of a collection of stylish metal symbols, just as it also displays an elaborate depiction of the cross, appropriate to cover the sacred Gospels. The Rosemarkie cross-slab eloquently demonstrates the total integration of the imagery of the Christian faith and the system of Pictish symbols, and both these intimately allied visual traditions freely expressed themselves in the idiom of the Insular style. It may well be that we have lost as many examples of symbol-bearing metalwork as of objects made specifically in the service of the Church.

322 1796 drawing of back of lost Monifieth Plaque

323 1796 drawing of front of lost Monifieth Plaque

Epilogue

The Picts have caught the popular imagination as a safely remote ethnic group, the more 'ancient' the better, remembered for their prowess against 'fierce' enemies, Romans and Northumbrians, with whom it is satisfactory therefore to claim kinship and empathy. Their principal legacy, stone sculpture, exercises a peculiar appeal because of the tantalizing Pictish symbols. In the past century many a head has puzzled over their meaning, and nowadays they are a gift to the 'Heritage' industry (purveying that obligatory commodity, 'Fun for all the family'), the symbols being coupled with baseless and banal assertions about Pictish 'pagan' beliefs. Scottish regional authorities, also anxious to extend the scope of tourism, are promoting the so-called 'Pictish Trail', again essentially a journey into the labyrinth of the symbols, but with the good side effect of placing the monuments in the landscape and at least hinting at sequences and groups, if not positively defining form and function.

Meantime the Museum of Scotland in Edinburgh, in a fine new building,[1] has consciously chosen to disband the visual and cultural achievement of the Picts, dispersing the monuments as if at haphazard, identifying them by minute secretly disposed labels, inscrutable 'timelines', and tiny dots on maps, while larger more eye-catching notices consist of portentous phrases such as 'Gods of the frontier, God of the Book', or atmospheric prose-poems, recalling the musings of Hiawatha. Consequently no coherent picture of Pictish stone sculpture and metalwork, decorative and figurative art and epigraphy, can possibly be obtained by the casual or even determined visitor: on the one hand, the surviving back panel of the Hilton of Cadboll cross-slab stands, isolated from all and any relevant *comparanda*, in a huge showy space, intellectually void, while on the other hand a number of large incised symbol stones are given 'Heritage' treatment, as images from the primeval past, approached down a sloping passage and clustered together in a dim womb-like compartment.[2] Because they too display the symbols, some elegant silverware, the Norrie's Law plaques and a chain-terminal or two, are also exhibited in this spurious psychic cradle, on the doctrinaire principle of dispersion, strictly not allowed to appear alongside other similar artefacts, and the other forms of Pictish metalwork in the national collection which are elsewhere flashily captioned as 'Objects of desire'.[3]

Our book, no less than the Edinburgh Museum, is animated by theory. Indeed it shares with the Museum an avoidance of a rigid pseudo-chronological interpretation of Pictish sculpture. However, our thematic approach is firmly based on an appreciation of the art of the sculpture. This precious evidence for the inclusion of the Picts in the wider culture outside the Pictish region should have been exploited by the Museum, not suppressed for the imaginary benefit of visitors expected to wander about at will, informing themselves as they can.[4] On the positive side for such a scenario, one hopes that some of the visitors will notice that they are looking at historic works of art.

For the proper objective cumulative impact of Pictish sculpture, perhaps the most valid show-place is the old schoolhouse at Meigle. There, discretely backed by an efficient and sufficient descriptive catalogue,[5] the clarity of Pictish draftsmanship, the monumentality of their handling of relief, and

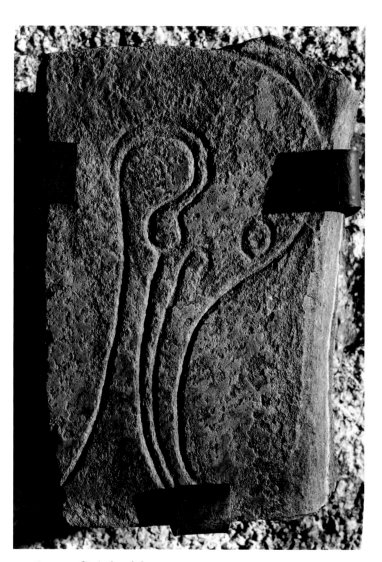

324 *Fragment of incised symbol stone, Inveravon, Banffshire, No. 3. Gneiss*

the sheer drama of their imagery, make a direct, life-enhancing, impression. The basis for presentations of artefacts of any period should be respect, and accurate historical understanding, not manipulation and profoundly inappropriate theory. Thus the collection of sculpture at Meigle quite naturally produces a sense of discovery, awe and wonder.

Outwith the museum context, the artistic quality of many Pictish monuments is often not comprehended or even noticed by those supposedly charged with responsibility for keeping them in existence. One masterly carving, the fragmentary 'Pictish beast' symbol at Inveravon, Moray [324], flawless in its linear grace, is clamped on the outside wall of the church, simply as a curiosity, with no concern for the fact that the end of the parallel curves of the creature's long sensitive mouth surely deserve to be seen. No one would entertain for a moment the idea of treating a Picasso or Matisse design in this jarring way. But at least at Inveravon four noble incised-carved monuments from, and still in, the same beautiful churchyard site are displayed side by side, wholly innocent of letter-press, and with no hidden agenda, simply inviting scrutiny and comparison one with the other, and inevitably stirring admiration for the purity of the abstract language of forms which they have in common.

The modern viewer has here an advantage over the readership to whom Allen and Anderson first presented *The Early Christian Monuments of Scotland*, in as much as abstract art has been fashionable in the past century and its aims and conventions are familiar. For Anderson, in his Rhind Lecture for 1892, carving in incision on a naturally shaped block was categorized as 'primitive', and said to exhibit 'few features that can be dealt with as art in the proper sense of the term',[6] whereas to our eyes the visual felicities and inventiveness of the linear and plastic design of a symbol stone like the wonderful one found in a garden at Kintore in 1974 [325] are self-evident. The Kintore slab bears a unique symbol, consisting of a thick-rimmed rectangle, at the top right and bottom left ballooning out in a lumpish swelling with two pellets nestling at its base, and at the top left and bottom right ballooning inwards with the same mushroom-like bulge, cutting out a shape inside the rectangle like a piece of a jigsaw puzzle.[7] This daringly asymmetrical and somehow 'alien' design, which equally implodes and explodes, keeping opposite impulses in equilibrium, is closely juxtaposed with the more familiar 'Pictish beast' and 'mirror' symbols, outlined in the same confident deeply trenched linear technique. That the symbols are now indecipherable as messages makes them all the more accessible and memorable as expressive shapes.

Anderson was a child of his own time in regarding figurative representation as a sign of 'advanced' art and exposition, so that the intense packaging of devotional intent in the image of the Cross in Insular art goes unremarked, except for its decorative effect. He was right, however, to search across a wide field of art to find parallels for Pictish subject-matter; for example he proposes a connection between Pictish hunting scenes and those on Early Christian sarcophagi, a connection which we have developed further in an earlier chapter, and is open-minded and exploratory in testing out the seated figures with the cross between them on the back of the Dunfallandy cross-slab against what he regarded as Early Christian imagery of the Trinity.[8] As we have suggested in our survey of 'Themes and Programmes', there indeed seems to be interesting early Trinity iconography in Pictland, if not specifically at Dunfallandy, and in many other respects Pictish artists were experimental and perspicacious in the selection and focus of their imagery, some of it of startling import for their literacy and learning.

It is ironical that when professional art historians, after more than a hundred years of the development of their discipline, really attempt to do justice to the intellectual vigour of Pictish sculpture, the literate audience for such an analysis, either written or in front of the works of art themselves, is fast diminishing. The public at large, when they go beyond the fastness of the Pictish incised symbols to the large-scale cross-slabs, may find the finely wrought complexities of the ornament quaint and attractive, but are diffident or bewildered, if not indifferent, in face of interpretations of sense and purpose. Christian education, of the sort Anderson could take for granted, having died the death, few or any tourists or followers of the 'Pictish Trail' now recognize the inhabited vinescroll on the borders and base of the Hilton of Cadboll cross-slab as a standard symbol of the Eucharist. But if told, they find that this enhances their appreciation of what they are looking at. Unaided 'imagination' cannot do this work, and a few intellectual guidelines are needed.[9]

Without informed input, the spiral bosses and even the interlace will go on for ever being called 'Celtic', and the image of the Cross itself, particularly if its arms are joined in a ring as at Aberlemno roadside, will continue to be assigned to the invasive influence of the 'Celtic Church', that fanciful concoction so long a mainstay of the 'historical' pretensions of the Anglican and Presbyterian establishments alike, now effectively debunked in academic circles[10] but still casting its lurid twilight over that part of the popular mind which is not wholly secularized. Since nothing in the monuments themselves directs one in any other way, it is the standpoint of our book that the great Pictish cross-slabs and equally the simpler cross-marked stones were erected by communities as fully and faithfully Catholic as any of their contemporaries in Armagh, Lichfield, Canterbury, or Rome. St Egbert did not labour in vain, either in his central role as shepherd of souls or as patron and promoter of the grand Insular art synthesis. So far as the Picts are concerned, the supreme masterpiece of Pictish art, the cross-slab at Nigg, makes a fitting memorial to his endeavours both spiritual and artistic, towards that vision of divinely-ordained concord which Bede credits him with: 'He saw it, and was glad'.[11]

325 Overleaf *Incised symbol stone, Kintore, Aberdeenshire, No. 4*

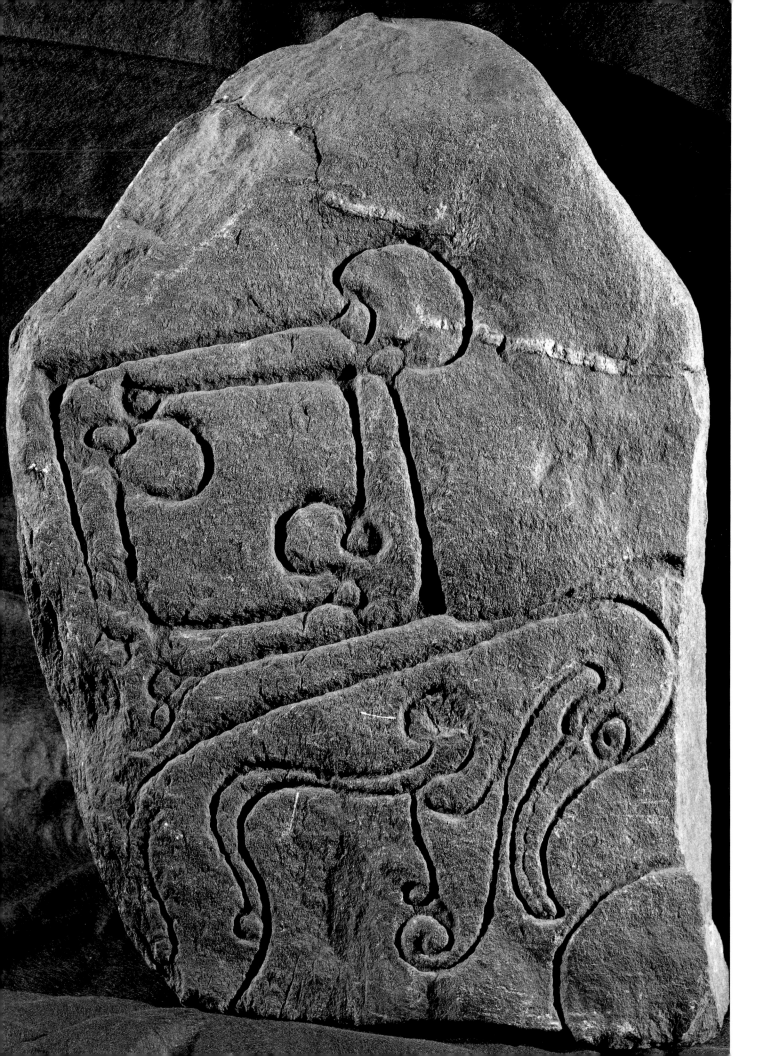

Appendix: The Old Scatness Bear

We are much indebted to Val Turner, Regional Archaeologist, Shetland, for providing the photograph of the Old Scatness bear reproduced here, together with the following note about its archaeological context:[1]

'The Old Scatness bear was discovered during the Shetland Amenity Trust/Bradford University excavations at Old Scatness, Dunrossness, Shetland. There was a strong Pictish presence in the Late Iron Age village that built up around the broch. One of the buildings in the village was a wheelhouse which still stands over 1.5 m. in height and which was in use up to the ninth century. The bear was discovered carved onto the underside of what appeared to have been a flag stone forming a late surface. The stone had been broken in antiquity, the break occurring across the top of the head and back of the animal.'

We supplement this note with a brief comment on the art historical significance of the excavators' discovery. The Old Scatness bear adds a new species to the core group of Pictish incised animals. Even more overtly feral than the stag, wolf or eagle [28, 29, 30], the bear emphatically tips the balance in favour of Pictish priority in the arguments concerning the relationship of Pictish art with the Gospels of Durrow, Corpus and Echternach [24, 14, 27]. There is no Gospel according to St Ursus or St Arctos from whose prefatory illustration the Old Scatness bear might conveniently derive its bulk and stealthily menacing pose. Formidably equipped with teeth and claws, bears like this were formerly exported from Scotland for the purposes of devouring criminals in the Roman arena.[2] No less than the animal itself, the artistic conventions employed in this image were native-born.

1 For the excavations up to 1998 see R. A. Nicholson and S. J. Dockrill (eds), *Old Scatness Broch, Shetland: Retrospect and Prospect* (Bradford 1998).
2 J. M. C. Toynbee, *Animals in Roman Life and Art* (London, 1973), p. 93, n. 52, and p. 362, n. 11.

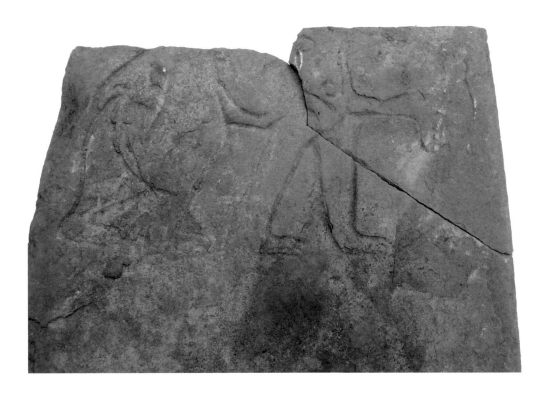

Glossary

Anthropomorphic
A decorative design with human attributes.

'Basket' hatching
Decoration consisting of engraved lines set at right angles to each other.

Canons
Regulations concerning morals and religious practices.

Canon tables
A numerical concordance of text references laid out in parallel vertical rows, often under decorative arches and separated by simulated architectural columns, placed as an adjunct to St Jerome's explanatory letter beginning *Novum opus*, before his standard edition of the four Gospels.

Cartouche
Tablet or panel placed as the central focus of a design.

Chape
Metal fitting to strengthen base of scabbard.

Chevron
A decorative V-shaped motif formed by the juncture of two bars.

Chi and Rho
The first letters of Christ's name in Greek, which together became a sacred formula, the *Christogram*. In Insular Gospel Books they are used in the display letters of St Matthew's Gospel 1, 18.

Christi autem
'Now, of Christ (the generation was as follows...)'; the first words of St Matthew's account of the miraculous birth of Christ, St Matthew's Gospel 1, 18.

Cloisonné cells
The small separate metalwork frames made to contain and visually organize a continuous pattern of inlaid garnets or glass.

Cross-slab
An approximately rectangular slab having a cross sculpted in relief on one or more faces.

Display letters
Handsome larger forms of script used to emphasize the start of a sacred text.

Escutcheon
Decorative metal mount on rim or base of hanging-bowl.

Evangelist symbols
The four 'living things' of Revelation 4 – lion, calf, man, eagle – traditionally associated in slightly varying permutations with the Evangelists, the writers of the four Gospels.

Explicit
'It ends'; the completion of a text.

Filigree
Fine work on gold, consisting of wires and beads.

Folio
Sheet of vellum or parchment, being the page of a book.

Gospel Book
Texts of the four Gospels, with various traditional introductory matter.

Greek Cross
Cross with equal arms.

Handpin
A pin of which the head is flat, like the palm of a hand, with projecting 'fingers'.

Hanging-Bowl
Bowl, usually of bronze, equipped with elaborate fitments for suspension (see Escutcheon). The function of such bowls is uncertain.

Incipit
'It begins'; the opening words of a text, for example, in St John's Gospel, 'In principio...'

Latin Cross
Cross with lower arm longer than the others.

Lentoid
(Ornament) of pointed oval shape.

Maltese Cross
Cross with arms becoming wider as they grow outwards, and with indented ends to the arms.

Millefiori
Minute transverse slices of multi-coloured bundles of glass rods, used as decorative inlays.

Niello
A black compound of metallic sulphide used for filling in engraved designs.

Pelta
Decorative motif consisting of one convex and two concave sides.

Penannular
Circular, but with a gap in the full circle.

Pointillé
Textured with dots.

Psalter
A separate volume containing the one hundred and fifty Old Testament Psalms, supposedly composed by King David, in a Latin version, together with a small group of similar texts.

Quoniam
The opening word of St Luke's Gospel.

Recumbents
Approximately rectangular monuments of different dimensions evidently intended to be laid horizontally over a grave.

Repoussé
Thin metal sheet, decorated by being pressed or beaten out from the back.

Reredos
An ornamental or pictorial screen attached to the wall above an altar.

Revelation, or the Apocalypse
The last book of the New Testament.

Skeuomorph
Formulaic representation of an originally functioning element in an artefact.

Symbol stone
A field monument incised with the characteristic Pictish symbols only.

Tabula ansata
Board, with handle-like projections at each end, for displaying an inscription.

Triquetra
Decorative motif, consisting of three arcs interlocked.

Zoomorphic
Decoration employing animal attributes.

Notes

When a source is frequently cited an abbreviated entry (author's name or, in the case of multi-author works and translations, short title) is given along with a reference to the full entry in the style 'cit. at n. chapter/ note', with chapter number in Roman numerals. Several abbreviations are used throughout, as listed below. Bible references are to the Douai version.

Abbreviations

General

RCAHMS Royal Commission on the Ancient and Historical Monuments of Scotland

EH Ecclesiastical History (Bede)

ECMS J. R. Allen and J. Anderson, *The Early Christian Monuments of Scotland* (Edinburgh, 1903 in 3 parts; reprinted with an introduction by Isabel Henderson, 2 vols, Balgavies, 1993). All references are to the 1993 edition.

Journals

Ant. J. The Antiquaries Journal

Arch. Archaeologia

Arch. J. Archaeological Journal

CMCS Cambridge Medieval Celtic Studies (later Cambrian Medieval Celtic Studies)

IR Innes Review

JBAA Journal of the British Archaeological Association

JRSAI Journal of the Royal Society of Antiquaries of Ireland

MA Medieval Archaeology

PSAS Proceedings of the Society of Antiquaries of Scotland

TFAJ Tayside and Fife Archaeological Journal

Introduction pp. 9–13

1 *The Ruthwell Cross*, Index of Christian Art, Occasional Papers I, ed. B. Cassidy (Princeton 1992).

2 RCAHMS, *Argyll: An Inventory of the Monuments*, vol. 4: *Iona* (Edinburgh, 1982).

3 *Govan and its Early Medieval Sculpture*, ed. A. Ritchie (Stroud, 1994).

4 For the sculpture of the Isle of Man, see P. M. C. Kermode, *Manx Crosses* (London, 1907), reprinted with an introduction by D. M. Wilson (Balgavies, 1994). The reprint contains up-to-date bibliography by Ross Trench-Jellicoe (Appendices, pp. 36–7). On the Welsh sculpture see V. E. Nash-Williams, *The Early Christian Monuments of Wales* (Cardiff, 1950). The compilation of a new corpus of early medieval sculpture in Wales is underway under the direction of Nancy Edwards. A new corpus of Manx sculpture by Ross Trench-Jellicoe is forthcoming. Both works will make it possible to integrate this material fully into the general history of Insular art.

5 For full discussion of the sources and derivation of the name 'Picti' see A. L. F. Rivet and C. Smith, *The Place-Names of Roman Britain* (London, 1979), pp. 438–40.

6 For these names see K. Jackson, 'The Pictish Language' in *The Problem of the Picts*, ed. F. T. Wainwright (Edinburgh, 1955), pp. 129–66, espec. pp. 158–9. For a recent critique of Jackson's views on the Pictish language, see K. Forsyth, *Language in Pictland*, Studia Hameliana 2 (Utrecht, 1997).

7 For a reassessment of the later medieval sources for the regional division of Pictland, see D. Broun, 'The Seven Kingdoms in *De Situ Albanie*: A Record of Pictish Political Geography or Imaginary Map of Ancient Alba?' in *Alba, Celtic Scotland in the Middle Ages*, ed. E. J. Cowan and R. A. McDonald (East Linton, 2000), pp. 24–42.

8 M. Herbert, 'Rí Éirenn, Rí Alban, Kingship and Identity in the Ninth and Tenth Centuries' in *Kings, Clerics and Chronicles in Scotland, 500–1297*, ed. S. Taylor (Dublin, 2000), pp. 62–72.

9 For a balanced discussion of the difficulties inherent in 'traditional' interdisciplinary studies see D. W. Harding, 'Changing Perspectives in the Atlantic Iron Age' in *Beyond the Brochs: Changing Perspectives on the Later Iron Age in Atlantic Scotland*, ed. I. Armit (Edinburgh, 1990), pp. 4–16, at p. 14.

10 C. Batey, 'Picts and Vikings in Caithness and Sutherland: a Résumé' in *Studies in Insular Art and Archaeology*, ed. C. Karkov and R. Farrell, American Early Medieval Studies I (Oxford, Ohio, 1991), pp. 49–58; D. Howlett, *Caledonian Craftsmanship: The Scottish Latin Tradition* (Dublin, 2000), p. 190.

11 A. P. Smyth, *Warlords and Holy Men: Scotland AD 80–1040* (London, 1984), pp. 76–8.

12 For the sculpture at one site, Tarbat, Ross & Cromarty, being attributed to the Irish (with erroneous 'historical' support) see F. Henry, *Irish Art in the Early Christian Period (to 800 AD)*, 3rd edn (London, 1965), p. 141. For the view that the Picts had no sculptors see A. Jackson, *Pictish Symbol Stones?*, The Association for Scottish Ethnography, Monograph No. 3 (Edinburgh, 1993), pp. 195–6.

13 *ECMS*.

14 *ECMS*, 1 (pt. I), pp. lxviii–ci. The investigations of metalwork analogies are concerned with origins, do not extend to later work and, obviously, could not include works then unknown. As with most writers Anderson's consideration of the metalwork is detached from the sculpture except when it happens to be symbol-bearing.

15 On the role of the classification scheme in *ECMS* see I. Henderson in the introduction to the 1993 reprint, page twenty-four.

16 See caption for the back of the Hilton of Cadboll slab in D. M. Wilson, *Anglo-Saxon Art from the Seventh Century to the Norman Conquest* (London, 1984), p. 116, as 'Pictish stone of Class II'; and M. Lynch, *Scotland a New History* (London, 1991) p. 13, who considers 'the standing stones of the Picts' as the 'best evidence' for the Picts, although his brief account of the nature of this evidence, p. 451, n. 5, shows unfamiliarity with even the basic facts relating to the sculpture and its study.

17 *ECMS*, 2 (pt. II), p. 4.

18 For example, the statement of Ian Smith that early sculpture at St. Andrews, Fife, reveals 'a strong Northumbrian influence on local native work' in 'The archaeology of the early Christian church in Scotland' in *Church Archaeology: Research Directions for the Future*, ed. J. Blair and C. Pyrah, CBA Research Report 104 (York, 1996), pp. 19–37, at p. 33. This assertion goes unreferenced to any relevant art-historical study. Smith makes telling use of the distribution of Pictish sculpture, but considers its 'decoration' and 'imagery' as providing 'scope' and 'a preoccupation' for art historians only, having no self-standing bearing on the concerns of other disciplines.

19 F. T. Wainwright, 'The Picts and the Problem' in *The Problem of the Picts* (cit. at n. Intro/6), pp. 1–53.

20 A. A. M. Duncan, *Scotland, the Making of the Kingdom*, The Edinburgh History of Scotland, vol. 1 (pbk edn Edinburgh, 1978), pp. 52–3, p. 71. Duncan invokes the evidence of 'Class I' and 'Class II' with due caution. However, like many others, he believes that the 'best examples' of 'Class II symbol stones' are found in southern Pictland. Awareness of the superlative symbol-bearing cross-slabs on both shores of the Moray Firth, and beyond, upsets attempts to equate the quality of sculpture with the political vicissitudes of the north and south.

21 *ECMS*, 2 (pt. III): 1 for Caithness, p. 36; 3 for Scotland, p. 54; 8 for Aberdeenshire, p. 196; 12 for Perthshire, pp. 341–3; 7 for Fife, pp. 373–4.

22 J. Anderson, *Scotland in Early Christian Times*, 2nd ser. (Edinburgh, 1881), pp. 94–5. See also I. Henderson, 'Early Christian Monuments of Scotland Displaying Crosses, but with no other Ornament' in *The Picts: A New Look at Old Problems*, ed. A. Small (Dundee, 1987, repr. 1996), pp. 45–68. Here the suggestion was made that the cross-marked stones should comprise a 'Class IV' in order to 'attach them more obviously to the Allen Corpus'. The term was adopted and heightened awareness of these monuments. The real aim, that the 'introduction of a Class IV', with its obvious dating difficulties, would underscore the chronological neutrality of the other three classes failed, and for this reason the term has not been used in this book.

23 Kathleen Hughes in her influential 1970 Jarrow Lecture, *Early Christianity in Pictland*, argued that the conversion of the Picts was delayed until the appearance of the cross on 'Class II' symbol stones in the early 8th century. Her analysis was effectively countered on historical grounds by D. P. Kirby, 'Bede and the Pictish Church', *IR* 24 (1973), 6–25, p. 12, n. 31. It is not common knowledge that as a consequence Dr Hughes modified her views in 'Where are the Writings of Early Scotland?' in *Celtic Britain in the Early Middle Ages*, ed. D. Dumville, *Studies in Celtic History* 2 (Woodbridge, 1980), 1–21, pp. 8–9. Studies of Pictish art cannot answer questions about the date of the conversion of the Picts except in the broadest terms. Art-historical interpretations can only point to the existence of certain types of Christian art in certain places that imply cultural contacts made at certain periods. The products of such contacts will, of course, be unaffected by fluctuating political relationships. See Smyth (cit. at n. Intro/11), n. 11, p. 78.

24 *ECMS*, 1 (pt. I), pp. lvi–lxv.

25 ibid., pp. lxxxi–lxxxii.

26 ibid., pp. xxxi–lv.

27 ibid., pp. xxxvi, xxxix. For the medieval Nativity scene see R. Mellinkoff, 'One is good, two are better: the Twice Appearing Ass in a Thirteenth-Century English Nativity' in *New Offerings, Ancient Treasures: Studies in Medieval Art for George Henderson*, ed. P. Binski and W. Noel (Stroud, 2001), pp. 325–42.

28 Most tendentious of all is the parallel he draws, *ECMS*, 1 (pt. I), p. xxxv, between the Pictish serpent and rod combination and the sacramental brazen serpent of St John's Gospel, 3, 15.

29 For a full discussion of this question see I. Henderson, *Pictish Monsters: Symbol, Text and*

Image, H. M. Chadwick Memorial Lectures,
7 (Cambridge, 1997), pp. 2–13.

30 *ECMS*, I (pt. I), pp. lii–liii.

31 G. Henderson, 'The Textual Basis of the Picture
Leaves' in *The Eadwine Psalter: Text, Image, and
Monastic Culture in Twelfth-Century Canterbury*, ed.
M. Gibson, T. A. Heslop and R. W. Pfaff (London
and University Park, Penn., 1992), p. 42.

32 This is not to discount the importance of work
on the artefacts as represented. There is a
considerable literature on the form of the harps
carved on Pictish sculpture. See, for example, with
references, A. Buckley, 'Music-related imagery on
early Christian insular sculpture: identification,
context, function', *Imago Musicae* 8 (1991),
pp. 135–99. On the general issue of clothing,
weaponry and horse gear depicted in sculpture
see I. Henderson, 'A note on the artefacts depicted
on the surviving side panel' in *The St Andrews
Sarcophagus: a Pictish Masterpiece and its
International Connections*, ed. S. M. Foster (Dublin,
1998), pp. 156–65. For an example of the dating
of a particular sword-type motivating the dating
of a monument see L. Laing, 'The Date of the
Aberlemno Churchyard Stone' in *Pattern
and Purpose in Insular Art*, ed. M. Redknap,
N. Edwards, S. Youngs, A. Lane, J. Knight,
Proceedings of the Fourth International
Conference on Insular Art (Oxford, 2001),
pp. 241–51.

33 R. N. Bailey, *England's Earliest Sculptors*,
Publications of the Dictionary of Old English,
5 (Toronto, 1996), pp. 17–18.

34 The conclusion of the useful chapter, 'Dating
Methods', R. Cramp, *Grammar of Anglo-Saxon
Ornament*. A general introduction to the *Corpus
of Anglo-Saxon Stone Sculpture* (Oxford, 1991),
pp. xlvii–xlviii (= *Corpus of Anglo-Saxon Stone
Sculpture: General Introduction* [Oxford, 1984]).

35 P. Harbison, *The High Crosses of Ireland*, 3 vols:
vol. 1, *Text*; vol. 2, *Photographic Survey*; vol. 3,
Illustrations of Comparative Iconography,
Römisch-Germanisches Zentralmuseum,
Forschungsinstitut für Vor-und Frühgeschichte,
Monographien 17 (Dublin and Bonn, 1992). For a
different chronology see R. Stalley, 'European Art
and the Irish High Crosses', *Proceedings of the
Royal Irish Academy*, Section C90 (1990),
pp. 135–58.

36 A. Lane and E. Campbell, *Dunadd: an Early
Dalriadic Capital*, Cardiff Studies in Archaeology
(Oxford, 2000).

37 E. Okasha, 'The Non-Ogam Inscriptions of
Pictland', *CMCS*, 9 (Cambridge, Summer 1985),
pp. 43–69; J. Higgitt, 'The Pictish Latin
inscription at Tarbat in Ross-shire', *PSAS* 112
(1982), pp. 300–21; K. Forsyth, 'The Inscriptions
on the Dupplin Cross' in *From the Isles of the
North: Early Medieval Art in Ireland and Britain*,
Proceedings of the Third International
Conference on Insular Art, 1994, ed. C. Bourke
(Belfast, 1995), pp. 237–44.

38 The major study, K. Forsyth, *The Ogham
Inscriptions of Scotland: An edited Corpus*, PhD
(Harvard: University Microfilms Inc., 1996), has
moved the study forward immeasurably. R. A. V.
Cox, *The Language of the Ogam Inscriptions of
Scotland. Contributions to the Study of Ogam,
Runic and Roman Alphabet Inscriptions in Scotland*,
Department of Celtic, University of Aberdeen
Scottish Gaelic Studies Monograph Series I
(Aberdeen, 1999) has the benefit of Dr Forsyth's
reading of the inscriptions and examines a
selection of Ogam inscriptions to support his
view that they are written in Old Norse and that
the *termini ante quem* of 'Class I and II stones'

extends to the 11th and 12th centuries. His
'traditional dating of the classified monuments'
(p. 169) ignores all modern studies of Pictish
sculpture. Cox's work on the language of the
inscriptions is under review.

39 J. Hunter, *A Persona for the Northern Picts*, Groam
House Museum Lecture (Rosemarkie, 1997),
p. 32 and pl. 4.

40 For the fort at Burghead, Moray, see I. Ralston and
J. Inglis, *Foul Hordes: the Picts in the North-East and
their background* (Aberdeen, 1984) pp. 23–24. For
the fort at Dunadd, Argyll, see Lane and Campbell
(cit. at n. Intro/36) p. 254. Both strongholds have
associated Pictish incised animal designs. For the
association between symbol stones and graves see
Chapter 6, pp. 167–8.

41 See *www.york.ac.uk/depts/arch/staff/sites/tarbat*

42 L. and E. A. Alcock, 'Reconnaissance excavations
on Early Historic fortifications and other royal
sites in Scotland, 1974–84'. Five reports published
in *PSAS*: 1. St Abb's Head, Berwickshire... vol. 116
(1986), pp. 255–79; 2. Dunollie Castle, Oban,
Argyll... vol. 117 (1987), pp. 119–47; 3. Dundurn,
Strathearn, Perthshire... vol. 119 (1989), pp.
189–226; 4. Alt Clut, Clyde Rock, Strathclyde...
vol 120 (1990), pp. 95–149; 5. A. Forteviot,
Perthshire... B. Urquhart Castle, Invernesshire...
C. Dunnottar, Kincardineshire... vol. 122 (1992),
pp. 215–87.

43 G. W. S. Barrow, 'The Childhood of Scottish
Christianity: a Note on Some Place-Name
Evidence', *Scottish Studies*, 27 (1983), 1–15;
S. Taylor, 'Place-Names and the Early Church in
Eastern Scotland' in *Scotland in Dark Age Britain*,
St John's House Papers, No. 6, ed. B. E. Crawford
(St Andrews, 1996), pp. 93–110; W. F. H.
Nicolaisen, *Scottish Place-Names* (London, 1976).

44 D. N. Dumville, 'The Chronicle of the Kings of
Alba' in *Kings, Clerics and Chronicles* (cit. at
n. Intro/8), pp. 73–86.

45 *Venerabilis Baedae Opera Historica*,
ed. C. Plummer, 2 vols. (Oxford, 1896);
Bede's Ecclesiastical History of the English People,
ed. B. Colgrave and R. A. B. Mynors (Oxford,
1969, oft. repr.); J. M. Wallace-Hadrill, *Bede's
'Ecclesiastical History of the English People':
a Historical Commentary* (Oxford, 1988).

46 The fundamental work on the historical sources
that contains editions of the king-lists, and their
co-relation to the Irish annal collections is M. O.
Anderson, *Kings and Kingship in Early Scotland*
(Edinburgh, 1973; rev. edn. 1980). See also
A. O. Anderson, *Early Sources of Scottish
History, A.D. 500 to 1286*, 2 vols (Edinburgh
1922, reprinted with preface, bibliographical
supplement and corrections by M. O. Anderson
(Stamford, 1990).

47 Cramp (cit. at n. Intro/34), p. xlviii.

48 The admirable practice of Mrs Anderson, the
leading source historian in the field, is to refer
to the work of specific art historians. For a rare
tribute to the usefulness of Pictish sculpture
see the concluding sentence of Dauvit Broun's
masterly analysis of a difficult stretch of the king-
lists, 'we may turn... away from the vagaries of
the written word and concentrate on the solid
evidence of Pictish sculpture, and not least the
St Andrews Sarcophagus itself'. D. Broun,
'Pictish Kings 761–839: Integration with Dál
Riata or Separate Development?' in *St Andrews
Sarcophagus* (cit. at n. Intro/32), pp. 71–83, at p. 83.

Chapter 1: Diagnostic Features pp. 15–29

1 See, for example, the old vexed question of the
priority of Rome or Assisi in the initiation of

the style primarily associated with Giotto; for
the present state of opinion see H. Belting,
Die Oberkirche von San Francesco in Assisi
(Berlin, 1977); *Assisi e Roma: Risultati, Problemi,
Prospettive, Roma anno 1300*, Atti della IV
settimana di studi di storia dell' arte medievale
dell' Università di Roma, 'La Sapienze' (Rome,
1980), pp. 93–101.

2 *A New Eusebius*, ed. J. Stevenson (London, 1968),
pp. 341, 343, 366–7, 369.

3 C. Bourke, *Patrick: The Archaeology of a Saint*
(Belfast, 1993), pp. 14–16; see also cover of *Isles
of the North* (cit. at n. Intro/37).

4 *Early Celtic Art*, Arts Council exhibition catalogue
(Edinburgh, 1970), no. 146a, opp. p. 32; J.
Brailsford, *Early Celtic Masterpieces from Britain in
the British Museum* (London, 1975), pl. VIII, p. 71.

5 Dublin, Royal Irish Academy MS.s.n; J. J. G.
Alexander, *Insular Manuscripts 6th to the 9th
Century* (London, 1978), no. 4, pp. 28–9, pls 2–5.

6 Exodus 31 and 35–37; III Kings, 7.

7 For hanging-bowls see R. Bruce-Mitford, 'Ireland
and the Hanging-Bowls – a Review' in *Ireland
and Insular Art AD 500–1200*, ed. M. Ryan
(Dublin, 1987), pp. 30–39; *'The Work of Angels':
Masterpieces of Celtic Metalwork, 6th–9th Centuries
AD*, ed. S. Youngs (London, 1989). The catalogue
of an exhibition on display 1989–90 in the British
Museum, the National Museums of Scotland
and the National Museum of Ireland; Lane and
Campbell (cit. at n. Intro/36), pp. 47–53; 154–5.

8 R. Bruce-Mitford, *The Sutton Hoo Ship-Burial*,
1 (London, 1975), 2 (London, 1978), 3, I and II,
ed. A. C. Evans (London, 1983); A. C. Evans,
The Sutton Hoo Ship Burial (2nd impr., London,
1989).

9 E. Kitzinger, *Byzantine Art in the Making: Main
Lines of Stylistic Development in Mediterranean Art
3rd–7th Century* (London, 1977), pl. 158. For the
Book of Durrow, f. 21v, see B. Meehan, *The Book
of Durrow: A Medieval Masterpiece at Trinity College
Dublin* (Dublin, 1996), pp. 34–5. For the Book of
Durrow see also n. 24, below.

10 R. Bruce-Mitford, 'The Hanging-Bowls' in Bruce-
Mitford (cit. at n. I/8), 3, I, pp. 206–244; Evans
(cit. at n. I/8), pls 57–60, pp. 72–4 and pl. II, p. 33.

11 G. Henderson, *Vision and Image in Early Christian
England* (Cambridge, 1999), pl. II after p. 126.

12 Bruce-Mitford (cit. at n. I/8), 2, pp. 460–5 and
figs. 327, 330.

13 Evans (cit. at n. I/8), pls 67–68, p. 81. For a full
appreciation of the function and manufacturing
technique of the chains, see V. H. Fenwick, 'The
Chainwork' in Bruce-Mitford (cit. at n. I/8), 3,
pp. 511–553.

14 Bruce-Mitford (cit. at n. I/8), 2, pp. 536–63 and
fig. 396.

15 G. Henderson (cit. at n. I/11), pl. 15.

16 Bruce-Mitford (cit. at n. I/8), 2, fig. 36, p. 49 and
fig. 384, p. 521; C. Lennox-Boyd, R. Dixon and
T. Clayton; *George Stubbs: the Complete Engraved
Works* (London, 1989), no. 81.

17 Evans (cit. at n. I/8), pls 34, 35, 37, pp. 53–5.

18 *Work of Angels* (cit. at n. I/7), no. 31, p. 101.

19 Cologne, Dombibliothek Cod. 213, f. 1;
Alexander (cit. at n. I/5), no. 13, pl. 60.

20 Bruce-Mitford (cit. at n. I/8), 2, pp. 523–35
and fig. 386, p. 524.

21 *EH*, Bk 1, Ch. XXIX, pp. 104–5; *Historia Abbatum
auctore Baeda*, ed. C. Plummer (Oxford, 1896,
often repr.), pp. 367–73 and 379–80.

22 *Cassiodori Senatoris Institutiones*, ed. R. A. B.
Mynors (Oxford, 1937), Bk I, XXX, 3, p. 77.

23 Bede, *De Tabernaculo*, Bk II, Corpus Christianorum
Series Latina, CXIXA, ed. D. Hurst (Turnhout,
1969), pp. 45–6; *The Life of Bishop Wilfrid by*

Eddius Stephanus, ed. B. Colgrave (Cambridge, 1927), ch. XVII, pp. 34–7.

24 A. A. Luce, G. O. Simms, P. Meyer and L. Bieler, *Evangeliorum Quattuor Codex Durmachensis*, 2 vols. (Olten, 1960); Alexander (cit. at n. I/5), no. 6, pp. 30–32; G. Henderson, *From Durrow to Kells: The Insular Gospel-books 650–800* (London, 1987), pp. 18–55; Meehan (cit. at n. I/9), pp. 10, 15, 18, 48, 58, 64, 79.

25 'quasi sit rota in medio rotae...Spritus enim vitae erat in rotis', The Prophecy of Ezechiel, 1, 16, 20.

26 The Apocalypse of St John the Apostle, 4–5.

27 Meehan (cit. at n. I/9), p. 65.

28 Durham, Cathedral Library MS.A.II.17, for which see *The Durham Gospels*, Early English Manuscripts in Facsimile, 20, ed. C. D. Verey, T. J. Brown and E. Coatsworth, with an Appendix by R. Powell (Copenhagen, 1980); Alexander (cit. at n. I/5), no. 10, pp. 40–42; G. Henderson (cit. at n. I/11), pl. VI after p. 126; G. Henderson (cit. at n. I/24), pls 79, 83, 85–86, pp. 64–67.

29 Bruce-Mitford, 'The Hanging Bowls' in Bruce-Mitford (cit. at n. I/8), 3, I, pp. 215, 220, 228–9; Evans (cit. at n. I/8), pl. II, opp. p. 33.

30 London, British Library Cotton MS. Nero D.iv; T. D. Kendrick, T. J. Brown, R. L. S. Bruce-Mitford, *Evangeliorum Quattuor Codex Lindisfarnensis*, 2 vols (Olten, 1960); Alexander (cit. at n. I/5), no. 9, pp. 35–40; J. Backhouse, *The Lindisfarne Gospels* (Oxford, 1981), pp. 34–7, 53, 56.

31 R. Cramp, *County Durham and Northumberland*, The British Academy Corpus of Anglo-Saxon Stone Sculpture, I (Oxford, 1984), pt. 2, pl. 265, 1432; Backhouse (cit. at n. I/30), detail of *f.* 139, pl. 47, p. 72.

32 ibid., pls 28, 40, pp. 48, 64.

33 *Work of Angels* (cit. at n. I/7), p. 77; P. Harbison, *The Golden Age of Irish Art: The Medieval Achievement 600–1200* (London, 1999), pls 39, 41.

34 *Work of Angels* (cit. at n. I/7), no. 69, p. 75 and pp. 91–2.

35 Alexander (cit. at n. I/5), no. 12, p. 44. G. Henderson (cit. at n. I/24), pl. 92, p. 69.

36 *Work of Angels* (cit. at n. I/7), no. 64, p. 68.

37 ibid., no. 63, p. 67.

38 D. H. Wright, *The Vespasian Psalter, British Museum Cotton MS. Vespasian A.i.* Early English Manuscripts in Facsimile, 14 (Copenhagen, 1967); Alexander (cit. at n. I/5), no. 29, pp. 55–6 and pl. 146.

39 Rome, Vatican, Biblioteca Apostolica MS. Barberini Lat. 570; Alexander (cit. at n. I/5), no. 36, pp. 61–2, pl. 170.

40 Dublin, Trinity College Library MS. 58; E. H. Alton, P. Meyer, *Evangeliorum Quattuor Codex Cenannensis*, 3 vols (Berne, 1950); Alexander (cit. at n. I/5), no. 52, pp. 71–6; B. Meehan, *The Book of Kells: An Illustrated Introduction to the Manuscript in Trinity College Dublin* (London, 1994), p. 27.

41 C. Bourke, 'Fine Metalwork from the River Blackwater', *Archaeology Ireland*, 45, vol. 12, 3 (Autumn 1998), pp. 30–31.

42 *Work of Angels* (cit. at n. I/7), no. 138a, b, pp. 145, 166; G. Henderson (cit. at n. I/24), pp. 170–171.

43 Meehan (cit. at n. I/40), pl. 51; I. Henderson, 'The Book of Kells and the Snake-Boss Motif on Pictish Cross-Slabs and the Iona Crosses' in *Ireland and Insular Art* (cit. at n. I/7), pp. 56–65).

44 Evans (cit. at n. I/8), pl. VI, opp. p. 81.

45 Meehan (cit. at n. I/9), p. 58.

46 Paris, Bibliothèque Nationale MS. Lat. 9389; Alexander (cit. at n. I/5), no. 11, pp. 42–3, pl. 53; G. Henderson (cit. at n. I/24), pl. 98, p. 72.

47 R. Bruce-Mitford and S. M. Youngs, 'Late Roman and Byzantine Silver' in Bruce-Mitford (cit. at n. I/8), 3, ed. Evans, pp. 15–17 and figs. 12, 14.

48 See mosaic floors at the Woodchester and Lullingstone villas in J. M. C. Toynbee, *Art in Roman Britain* (London, 1962), no. 186, pp. 198–9, pl. 222, and no. 192, p. 200, pl. 229; also the floor of the Courtyard of the Warehouse of Epagathus, Ostia, in A. Pellegrino, *Ostia e Porto: le zone archaeologiche e i musei: Guide pratiche* (Milan, 1989), p. 46.

49 Meehan (cit. at n. I/9), p. 15.

50 ibid., p. 10; also mount from the Oseberg Bucket, p. 35.

51 Backhouse (cit. at n. I/30), p. 52.

52 I. Henderson and E. Okasha, 'The Early Christian Inscribed and Carved Stones of Tullylease, Co Cork', *CMCS*, 24 (1992), pp. 1–36 and pls Ia, II.

53 First exploited in the corner extensions of the carpet page of *f.* 210v of the Lindisfarne Gospels: Backhouse (cit. at n. I/30), pl. 30; Alexander (cit. at n. I/5) For the Lichfield Gospels, Lichfield Cathedral Library, see Alexander (cit. at n. I/5), no. 21, pp. 48–50 and pls 78–82.

54 Augsburg, Universitätsbibliothek Cod. I. 2. 4°. 2 (formerly Schloss Harburg); Alexander (cit. at n. I/5), no. 24, pp. 51–2 and pl. 119; D. Ó Cróinín, 'Is the Augsburg Gospel Codex a Northumbrian Manuscript?' in *St Cuthbert, His Cult and His Community to AD 1200*, ed. G. Bonner, D. Rollason and C. Stancliffe (Woodbridge, 1989), pp. 189–201.

55 R. H. I. Jewell, 'The Anglo-Saxon Friezes at Breedon-on-the-Hill, Leicestershire', *Arch.*, 108 (1986), pp. 95–115, espec. p. 103, and pls XLVII, LI.

56 Meehan (cit. at n. I/40), pl. 54, p. 48; pl. 57, p. 53; pl. 62, p. 55; pl. 66, p. 58.

57 Alexander (cit. at n. I/5), no. 36, pls 169–78; no. 39, pls 188–95, and frontispiece.

58 M. Ryan, 'Some Aspects of Sequence and Style in the Metalwork of Eighth- and Ninth- Century Ireland' in *Ireland and Insular Art* (cit. at n. I/7), pp. 66–74.

59 Durham, Cathedral Library MS. B. II. 30, *f.* 81v; Alexander (cit. at n. I/5), no. 17, p. 46 and pl. 74.

60 London, British Library Cotton MS. Vespasian A.i, *ff.* 30v, 64v; Alexander (cit. at n. I/5), no. 29, pp. 55–6, pl. 146, and fig. 7, p. 17.

61 Berlin, Deutsche Staatsbibliothek MS. Hamilton 553, *f.* 48; Alexander (cit. at n. I/5), no. 14, pl. 63; Meehan (cit. at n. I/40), pl. 97, p. 74. For the subjects of these historiated initials see G. Henderson, 'The Barberini Gospels (Rome, Vatican, Biblioteca Apostolica Barberini Lat. 570) as a Paradigm of Insular Art' in *Pattern and Purpose* (cit. at n. Intro/32), p. 159.

62 Meehan (cit. at n. I/40), pp. 54, 75–84.

63 Evans (cit. at n. I/8), pl. VIII, opp. p. 97 and pls 27, 29.

64 *Work of Angels* (cit. at n. I/7), no. 51, p. 61.

65 Backhouse (cit. at n. I/30), p. 57, pl. 35, and p. 74, pl. 49.

66 Ryan (cit. at n. I/58), fig. 2, p. 73; see also *The Derrynaflan Hoard, I, A Preliminary Account*, ed. M. Ryan (Dublin, 1983).

67 *Work of Angels* (cit. at n. I/7), no. 91, p. 105.

68 Ryan (cit. at n. I/58), pl. II. 1. p. 69.

69 Meehan (cit. at n. I/40), pls 12, 13, p. 20.

70 G. Henderson (cit. at n. I/24), pp. 165–8; G. Henderson (cit. at n. I/61), p. 165.

71 G. Henderson (cit. at n. I/24), pls 190, 191, p. 132.

72 Cramp (cit. at n. I/31), pt. One, pp. 217–22, and pt. Two, pl. 215, 1224.

73 Wilson (cit. at n. Intro/16), pl. 33, pp. 44–5; For an analysis of development in animal ornament at this period of Anglo-Saxon art, see R. N. Bailey, 'The Gandersheim Casket and Anglo-Saxon Stone Sculpture', *Das Gandersheimer Runenkästchen*,

Internationales Kolloquium, Braunschweig, 24.–26. März 1999, ed. R. Marth (Braunschweig, 2000), pp. 43–51.

74 Stockholm, Royal Library MS.A.135, *f.* 11; Alexander (cit. at n. I/5), no. 30, pp. 56–7, pl. 152.

75 R. N. Bailey and R. Cramp, *Cumberland, Westmorland and Lancashire North-of-the-Sands*, The British Academy Corpus of Anglo-Saxon Stone Sculpture, II (Oxford, 1988), pls 682, 685, 686, 687.

76 Vienna, Nationalbibliothek Cod. 1224; Alexander (cit. at n. I/5), no. 37, pp. 62–3, pl. 182.

77 Alexander (cit. at n. I/5), pls 170, 172.

78 *The Making of England: Anglo-Saxon Art and Culture AD 600–900*, ed. L. Webster and J. Backhouse (London, 1991), no. 86, p. 121.

79 G. Henderson (cit. at n. I/24), pp. 122–4, and pl. 180.

80 St Petersburg, Public Library Cod. Q.V.I.18; Alexander (cit. at n. I/5), no. 19, pp. 47–8, pl. 83.

81 Cramp (cit. at n. I/31), pt. One, pp. 174–8; pt. Two, pls 167–75. Bailey and Cramp (cit. at n. I/75), pp. 61–72 and pls 91–3, 99, 100, 102, 107.

82 Alexander (cit. at n. I/5), pl. 178; Cramp (cit. at n. I/31), pt. Two, pl. 266, 1435.

83 Meehan (cit. at n. I/40), pls 27, 73, pp. 25, 61.

84 ibid., pl. 54, p. 49; pls 69, 70, pp. 60–1.

85 Toynbee (cit. at n. I/48), pl. 235; see also n. 48, above.

86 H. Gerstinger, *Dioscorides, Codex Vindobonensis Med. Gr. I der Österreichischen Nationalbibliothek*, Codices Selecti, phototypice impressi, facsimile 12 (Graz, 1970); *The Rabbula Gospels. Facsimile Edition of the Miniatures of the Syriac Manuscript Plut. I. 56 in the Medicean-Laurentian Library*, ed. C. Cecchelli, G. Furlani and M. Salmi (Olten and Lausanne, 1959); see also D. H. Wright, *The Roman Vergil and the Origins of Medieval Book Design* (London, 2001). A liking for plain, ridged, recessed frames might have been roused by sight of Late-Antique consular diptyches and the like, and especially from panelled stone furnishings of churches on the continent, altars, and closure-screens. Two of the rare surviving instances of Insular decorative motifs carved in stone, the early, Durrow-type, animal at Wearmouth and the later medley of motifs, trumpet spirals, key pattern, strap-work, and birds and dragons among leafy stems at South Kyme, Lincolnshire, were themselves displayed on closure-screens, altars, or perhaps box-shrines, since the fluent Insular ornaments are firmly bounded by rectilinear moulded frames; Cramp (cit. at n. I/31), I, pt. Two, pls 121, 656; P. Everson and D. Stocker, *Lincolnshire*, Corpus of Anglo-Saxon Stone Sculpture, V (Oxford, 1999), pls 339–44.

87 Meehan (cit. at n. I/9), pp. 42, 56, 62 and 48, 59, 64.

88 K. Corsano, 'The first quire of the Codex Amiatinus and the *Institutiones* of Cassiodorus', *Scriptorium*, 41 (1987), pp. 3–34.

89 R. L. S. Bruce-Mitford, 'The Art of the Codex Amiatinus', Jarrow Lecture 1967, *JBAA*, 3rd series, 32 (1969), pt. C, opp. p. 8, and pls IX, X.

90 Backhouse (cit. at n. I/30), pls 23, 27, 30, 33, pp. 40, 46, 50, 54.

91 *Work of Angels* (cit. at n. I/7), p. 77 and pp. 138–9 and 163–4.

92 Backhouse (cit. at n. I/30), p. 57.

93 Meehan (cit. at n. I/40), pls 26, 34, 37, pp. 26, 37, 39; Alexander (cit. at n. I/5), pls 322–8 and 337, 345.

94 Alexander (cit. at n. I/5), pls 174, 176–7.

95 *Making of England* (cit. at n. I/78), no. 66a, pp. 82–3.

96 Kitzinger (cit. at n. I/9), pls 81, 86.

97 Compare the Evangelist portraits in the Godescalc Gospel Lectionary, Paris, Bibliothèque Nationale MS. Nouv. acq. Lat. 1203; W. Koehler, *Die Karolingischen Miniaturen, II, Die Hofschule Karls des Grossen* (Berlin, 1958), pp. 22–9 and pls 1–12.

98 G. Henderson (cit. at n. I/61), p. 166.

99 Meehan (cit. at n. I/40), pl. 7, p. 12; for the antecedents and affiliations of the Kells Virgin and Child see E. Kitzinger, 'The Coffin Reliquary' in *The Relics of Saint Cuthbert*, ed. C. F. Battiscombe (Oxford, 1956), pp. 248–60.

100 Durham Gospels, *f.* 38v, for which see Wilson (cit. at n. Intro/16), pl. 27, p. 37.

101 G. Henderson (cit. at n. I/24), pp. 73–6 and pl. 102.

102 ibid., pp. 124–6, pl. 185; see also G. Henderson, 'Cassiodorus and Eadfrith Once Again' in *The Age of Migrating Ideas: Early Medieval Art in Northern Britain and Ireland*, ed. R. M. Spearman and J. Higgitt (Edinburgh and Stroud, 1993), pp. 87–8.

103 G. Henderson (cit. at n. I/24), pp. 122–4 and pl. 180.

104 Alexander (cit. at n. I/5), no. 44, pp. 66–7, pl. 203.

105 ibid., pls 204, 205.

106 London, Lambeth Palace MS.1370; Alexander (cit. at n. I/5), no. 70, pp. 86–7, pls 326–8, 354.

107 Cambridge, University Library MS.Ii.6.32; Alexander (cit. at n. I/5), no. 72, p. 87 and pls 335–7; I. Henderson, 'Understanding the Figurative Style and Decorative Programme of the Book of Deer' in *'This Splendid Little Book'*, ed. K. Forsyth (forthcoming, Dublin, 2004); D. Marner, 'The Sword of the Spirit, the Word of God and the Book of Deer', *MA*, 46 (2002), pp. 1–28.

108 Meehan (cit. at n. I/40), pl. 35, p. 37.

109 Backhouse (cit. at n. I/30), pl. 23, p. 40.

110 Meehan (cit. at n. I/40), pp. 11, 12, 23, 49, pls 6, 7, 22, 54.

111 B. Piotrovsky, L. Galanina, N. Grach, *Scythian Art* (Oxford, Leningrad, 1987), nos 126–9, 196–8; exhibition catalogue, *Splendeur des Sassanides*, text L. Van den Berghe and others, Museés royaux d'Art et d'Histoire (Brussels, 1993), nos 49–59.

112 Alexander (cit. at n. I/5), pl. 146.

113 G. Henderson (cit. at n. I/11), pls 53–5 and 59.

114 R. Cramp, *Early Northumbrian Sculpture*, Jarrow Lecture (Jarrow, 1965), p. 5.

115 M. Herity, 'The Antiquity of *an Turas* (the Pilgrimage Round) in Ireland', *Lateinische Kultur im VIII. Jahrhundert: Traube-Gedenkschrift*, hrsg. Von A. Lehner und W. Berschin (St. Ottilien, 1990), pp. 95–143, at 104–6, figs. 7, 8, 18.

116 M. Herity, 'Carpet pages and Chi-rhos: Some Depictions in Irish Early Christian Manuscripts and Stone Carvings', *Celtica*, 21 (1990), pp. 208–22, fig. 1.

117 For examples of book-size name-stones from Hartlepool see Cramp (cit. at n. I/31), pt. One, pp. 100–1; pt. Two, pl. 85. For discussion, and references to Insular and continental 'outline' crosses see I. Henderson and Okasha (cit. at n. I/52), pp. 24–6.

118 D. Kelly, 'Irish High Crosses: Some Evidence from the Plainer Examples', *JRSAI*, 116 (1986), pp. 51–67. J. Higgitt, 'The Dedication Inscription at Jarrow and its Context', *Ant. J.*, 59 (1979), pp. 343–74. R. N. Bailey, *England's Earliest Sculptors* (Toronto, 1996), pp. 50–1, fig. 27.

119 For the Ahenny Crosses see Harbison (cit. at n. Intro/35), vol. 2 Photographic Survey, figs. 15, 20. For St. John's Cross see RCAHMS, *Argyll, An Inventory of the Monuments*, 4, *Iona* (Edinburgh, 1982), p. 199.

120 For sculpture at South Kyme and Breedon see above at nn. 55 and 86. For the dating of the

Ahenny Group see Harbison (cit. at n. Intro/35), vol. 1: text, pp. 380–82; N. Edwards, 'An Early Group of Crosses from the Kingdom of Ossory', *JRSAI*, 103 (1983), pp. 5–46.

121 V. E. Nash-Williams, *The Early Christian Monuments of Wales* (Cardiff, 1950).

122 For the Monkwearmouth wall plaque carved with Durrowesque animal ornament see n. 86, above. For similar ornament at Hackness see J. Lang, *York and Eastern Yorkshire*, The British Academy Corpus of Anglo-Saxon Stone Sculpture, III (Oxford, 1991), p. 41 and ills 4–11.

123 For the dragon-headed creatures carved on the jambs of the Monkwearmouth porch see Cramp (cit. at n. I/31), pt. One, pp. 125–6, pt. Two, pls 112–115. For Bealin see F. Henry, *Irish Art in the Early Christian Period (to 800 AD)*, 3rd edn. (London, 1965), fig. 25d, p. 189 and pl. 88. For Lindisfarne see Cramp (cit. at I/31), pt. One, p. 95, pt. Two, p. 188, 1039.

124 Wilson (cit. at n. Intro/16), pp. 64–5, ills 58–60; *Making of England* (cit. at n. I/78), no. 207, p. 242.

125 R. Cramp, 'Mediterranean Elements in the Early Medieval Sculpture of England', Union Internationale des Sciences Préhistoriques et Protohistoriques, IXᵉ Congrès, Colloque XXX (1977), pp. 263–95.

126 Bailey and Cramp (cit. at n. I/75), pp. 115–17, ill. 359.

127 H. Richardson, 'Number and Symbol in Early Christian Irish Art', *JRSAI*, 114 (1984), pp. 28–47.

128 Cramp (cit. at n. I/31), pt. One, pp. 217–21, pt. Two, pls 211–15.

129 Harbison (cit. at n. Intro/35), vol. 2: Photographic Survey, fig. 258.

130 R. Cramp, 'The Insular Tradition: An Overview' in *The Insular Tradition*, ed. C. E. Karkov, R. T. Farrell and M. Ryan (New York, 1997), pp. 283–299, at p. 295.

Chapter 2: Pictish Participation pp. 31–57

1 R. B. K. Stevenson, 'Sculpture in Scotland in the 6th–8th Centuries AD' in *Kolloquium über Spätantike und Frühmittelalterliche Skulptur: 1970*, II, ed. V. Milojčić (Mainz, 1971), pp. 65–75; 'Further Thoughts on Some Well Known Problems', *Age of Migrating Ideas* (cit. at n. I/102), pp. 16–26.

2 Fish are more positively represented in the inverted S-curve joining the uprights of the initial 'N' of the early 7th-century Bobbio manuscript of St Jerome's *Commentary on Isaiah*, Milan, Biblioteca Ambrosiana MS.S.45. sup., p. 2, for which see Alexander (cit. at n. I/5), pl. 8. For the Sutton Hoo purse cover see Evans (cit. at n. I/8), pl. VIII opp. p. 97; for the fish, pp. 72–3 and pl. 58; for the stag, pp. 83–4 and pl. 73.

3 R. B. K. Stevenson, 'Further Thoughts on Some Well Known Problems', *Age of Migrating Ideas* (cit. at n. I/102), p. 19. For a Burghead Bull, the Grantown Stag, the Dores Boar, and the Echternach Calf see I. Henderson, *The Picts* (London, 1967), pls 32, 34, 36 and 33; for comparison of the Echternach calf with the Stittenham (Ardross) wolf see G. Henderson (cit. at n. I/24), pls 110, 111 on p. 78. Significantly, the Pictish menagerie of incised animals equipped with body scrolls now includes a bear, at Old Scatness, Shetland, reported in *The Shetland Times*, 9 August 2002 (personal communication, A. Mack). See Appendix, p. 229.

4 Backhouse (cit. at n. I/30), pl. 32, p. 53.

5 London, British Library Egerton MS. 1894 and Add. MS. 44949, for which see M. R. James,

Illustrations of the Book of Genesis, Roxburghe Club (Oxford 1921); E. G. Millar, 'The Egerton Genesis and the M. R. James Memorial Manuscript', *Arch.*, 87 (1938), pp. 1–5 and pls I–IV; also L. F. Sandler, *Gothic Manuscripts 1285–1385* (Oxford, 1986), II, no. 129, p. 143 and pls 340–1; no. 127, p. 141, pl. 337.

6 G. Henderson (cit. at n. I/24), pl. 109.

7 Meehan (cit. at n. I/9), p. 77.

8 G. Henderson (cit. at n. I/24), pl. 107; now in Tankerness House Museum, Kirkwall.

9 J. Milton, *Paradise Lost*, Bk IX, l.525.

10 G. Henderson (cit. at n. I/24), pls 86, 88; G. Henderson (cit. at n. I/11), pl. VI.

11 J. Higgitt, (cit. at n. I/118), pl. LXII a, b.

12 J. Close-Brooks, *Pictish Stones in Dunrobin Castle Museum* (Derby, 1989), pp. 4–7.

13 *ECMS*, 2 (pt. III), figs. 234A, B.

14 *ECMS*, pls 322A and 278. See ornamental design no. 786 in *ECMS*, 1 (pts I and II), p. 300.

15 The Gospel According to St Luke, 23, 43; B.C. Raw, *Anglo-Saxon Crucifixion Iconography and the Art of the Monastic Revival* (Cambridge, 1990), pls I–XVI.

16 *ff.* IV, 85v, 125v for which see Meehan (cit. at n. I/9), pp. 10, 48, 58.

17 *ff.* 94v, 138v for which see Backhouse (cit. at n. I/30), pls 28, 31, 51, pp. 48, 52, 76.

18 Evans (cit. at n. I/8), pl. VII, opp. p. 96.

19 A. Ritchie, *Picts* (HMSO, Edinburgh, 1989), p. 2.

20 ibid., for Meigle No. 4, p. 60, and Aberlemno churchyard, p. 23.

21 *ECMS*, 1 (pts I and II), pp. 202–307.

22 Ritchie (cit. at n. II/19), p. 11.

23 G. Henderson (cit. at n. I/24), pls 102, 103.

24 Alexander (cit. at n. I/5), pls 77.

25 *ff.* 26v, 94v, 138v, 210v for which see Backhouse (cit. at n. I/30), pls 24, 28, 31, 34, pp. 42, 48, 52, 56.

26 Ritchie (cit. at n. II/19), pl. inside front cover; *ECMS*, 2 (pt. III), fig. 313A, opp. p. 297, and p. 300; *ECMS*, 1 (pts I and II), p. 219.

27 Alexander (cit. at n. I/5), pl. 77.

28 ibid., pl. 76.

29 *Work of Angels* (cit. at n. I/7), no. 70, p. 92 and p. 78; For St Ninian's Isle see n. 45, below.

30 Meehan (cit. at n. I/9), p. 64.

31 Cramp (cit. at n. I/31), pt. One, no. 9, p. 126, and pt. Two, pl. 121.

32 ibid., pt. One, nos 8a, b, pp. 125–6, and pt. Two, pls 112–5.

33 Pellegrino (cit. at n. I/48), p. 16.

34 Excavated 1999 by Department of Archaeology, University of York, unpublished.

35 I. Henderson, '*Primus Inter Pares*: The St Andrews Sarcophagus and Pictish Sculpture' in *St Andrews Sarcophagus* (cit. at n. Intro/32), pl. 12, opp. p. 145.

36 Alexander (cit. at n. I/5), nos 14, 17, 30, and pls 63, 74, 152.

37 *ECMS*, 2 (pt. III), fig. 240A, opp. p. 228; p. 289 and fig. 306A.

38 I. Henderson, *The Art and Function of Rosemarkie's Pictish Monuments*, Groam House Lecture Series No. 1 (Rosemarkie, 1990), pp. 10, 14–16.

39 I. Henderson, 'The Cross-Slab at Nigg, Easter Ross' in *New Offerings* (cit. at n. Intro/27), pp. 129–34.

40 Wilson (cit. at n. Intro/16), pl. 33.

41 Alexander (cit. at n. I/5), no. 32, pls 162–4; no. 36, pls 171–2.

42 I. Henderson (cit. at n. II/35), pls 12 and 13; D. Mac Lean, 'The Northumbrian Perspective' in *St Andrews Sarcophagus* (cit. at n. Intro/32), fig. 59 (b), p. 194.

43 For the Durham Cassiodorus, Durham Cathedral Library MS.B.11.30, *f.* 81v, see Wilson (cit. at n. Intro/16), pl. 31; For Rothbury see Cramp (cit. at n.

I/31), pt. Two, pls 214, 1223; 215, 1224; for South
Kyme see P. Everson and D. Stocker, *Lincolnshire,
Corpus of Anglo-Saxon Stone Sculpture*, V
(Oxford, 1999), pls 339, 345; for Breedon
see Jewell (cit. at n. I/55), pl. LIc.

44 See plates and texts by various authors in *Das
Gandersheimer Runenkästchen*, (cit. at n. I/73).

45 A. Small, C. Thomas, D. M. Wilson, *St Ninian's
Isle and its Treasure* (Aberdeen, 1973), II. pls
XXVII.b; XXVIII.b; XXVI.d; XXVIII.a; fig. 21 and
pl. XVIII.

46 ibid., fig. 33 and pl. XXVII.c; Alexander (cit. at
n. I/5), no. 30 and pl. 147.

47 Bruce-Mitford (cit. at n. I/7), p. 37.

48 ibid., pl. I, d.

49 Meehan (cit. at n. I/9), p. 18.

50 *Work of Angels* (cit. at n. I/7), no. 47, p. 37.

51 Ritchie (cit. at n. II/19), p. 55.

52 See Chapters 4 and 8.

53 Lane and Campbell (cit. at n. Intro/36), p. 154
and pl. 19.

54 Bruce-Mitford (cit. at n. I/7), pl. I, i.

55 *ECMS*, 2 (pt. III), fig. 313A, opp. p. 297.

56 Close-Brooks, (cit. at n. II/12), p. 9.

57 *ECMS*, 2 (pt. III), figs. 51, 51A and 272A.

58 ibid., p. 134.

59 ibid., figs 29, 29A, 32.

60 I. Fisher, *Early Medieval Sculpture in the West
Highlands and Islands*, RCAHMS and Soc. Antiq.
Scot., Monograph Ser. I (Edinburgh, 2001), p. 89.

61 G. Henderson (cit. at n. I/24), pl. 79, p. 64.

62 Meehan (cit. at n. I/40), pp. 66–72.

63 Compare the Battersea Shield, for which see
Celtic Art, ed. B. Raftery (Unesco, 1990), p. 105.

64 *Work of Angels* (cit. at n. I/7), no. 63, p. 67.

65 *ECMS*, 2 (pt. III), fig. 66B, p. 70.

66 ibid., fig. 67, p. 71.

67 ibid., fig. 75, p. 78.

68 G. Vasari, *Vite de piu' eccellenti pittori, scultori ed
architetti* (Firenze, 1771), p. 156: 'Onde a gran
ragione se gli dà grado del primo, che mettesse
in buono uso l'invenzione delle storie ne'
bassirilievi....'

69 *ECMS*, 2 (pt. III), fig. 92, p. 92; fig. 91, p. 90;
fig. 93, p. 92.

70 ibid., pp. 91–3.

71 ibid., p. 144.

72 ibid., p. 242.

73 ibid., p. 66 and n. 1.

74 *ECMS*, I (pts I and II), nos 747, 749, pp. 291, 292.

75 Harbison (cit. at n. I/33), pl. 84.

76 *ECMS*, 2 (pt. III), pp. 69–70.

77 ibid., pp. 265–6 and fig. 276.

78 ibid., figs. 51, 51A, opp. p. 49.

79 ibid., no. 14, p. 141 and fig. 144.

80 ibid., p. 64, fig. 61; Alexander (cit. at n. I/5),
pl. 119.

81 Alexander (cit. at n. I/5), no. 70, pls 326–8.

82 M. Corner, *Kinneddar as an Early Christian
Settlement*. Unpublished typescript in the National
Monuments Record of Scotland, Edinburgh:
MS/131 n.d; I. Henderson (cit. at n. II/38), p. 20.

83 Jewell (cit. at n. I/55), p. 103, pls XLVII, LI.

84 Harbison (cit. at n. I/33), p. 89.

85 *ECMS*, 2 (pt. III), pp. 206–7, fig. 223.

86 *Treasures from Romania*, catalogue of British
Museum exhibition, January–March 1971
(London, 1971), no. 156, p. 51.

87 *ECMS*, 2 (pt. III), pp. 111–13, figs. 115, 116.

88 I. Henderson (cit. at n. II/3), pl. 43.

89 Wilson (cit. at n. Intro/16), pl. 35.

90 I. Henderson (cit. at n. II/35), fig. 24, p. 111 and
pl. 5.

91 Alexander (cit. at n. I/5), no. 65, pls 286, 289, 293,
294, 301.

92 Meehan (cit. at n. I/40), pls 54, 63, 68, 69, 70.

93 Wilson (cit. at n. Intro/16), pls 71, 73, 74, 78.

94 Alexander (cit. at n. I/5), pl. 172.

95 ibid., pl. 178.

96 *ECMS*, 2 (pt. III), pp. 73–5, fig. 71.

97 L. Southwick, *The so-called Sueno's Stone at Forres*
(Elgin, 1981), pp. 16–17 and pl. after p. 10.

98 *ECMS*, 2 (pt. III), fig. 252c, opp. p. 237.

99 ibid., pp. 362–3 and figs. 378c, 380 A, B.

100 I. Henderson, 'The Dupplin Cross: A Preliminary
Consideration of Its Art-Historical Context' in
Northumbria's Golden Age, ed. J. Hawkes and
S. Mills (Stroud, 1999), pp. 161–77, and
fig. 14.1, p. 162.

101 M. Hall et al., 'Of makings and meanings:
towards a cultural biography of the Crieff Burgh
Cross, Strathearn, Perthshire', *TFAJ*, 6 (2000),
pp. 154–88.

102 I. Henderson (cit. at n. II/38), p. 17; *Making of
England* (cit. at n. I/78), no. 86, p. 121.

103 I. Henderson, 'Pictish Art and the Book of Kells'
in *Ireland in Early Mediaeval Europe: Studies in
Memory of Kathleen Hughes*, ed. D. Whitelock,
D. Dumville and R. McKitterick (Cambridge,
1982), p. 95 and pls XII a and b; Meehan (cit. at
n. I/40), p. 7.

104 *ECMS*, 2 (pt. III), fig. 319, p. 304; Meehan (cit. at
n. I/40), pl. 56, p. 50 and p. 20, pls 12, 13, for disc
brooch from Togherstown. See also *Work of Angels*
(cit. at n. I/7), no. 57, p. 63; Harbison (cit. at n.
Intro/35), fig. 14.

105 Wilson (cit. at n. Intro/16), pls 49, 50, pp. 54–5.

106 Jewell (cit. at n. I/55), pls XLV, L.

107 Meehan (cit. at n. I/40), p. 6, and detail, p. 43.

108 G. Henderson (cit. at n. I/24), pls 194, 195,
pp. 134–5.

109 P. Brown, *The Book of Kells* (London, 1980), p. 20;
I. Henderson (cit. at n. II/38), p. 28.

110 *ECMS*, 2 (pt. III), p. 227 and figs. 239 A, B; *Insular
and Anglo-Saxon Illuminated Manuscripts: An
Iconographic Catalogue*, c. A.D. 625 to 1100,
ed. T. H. Ohlgren (New York and London, 1986),
pl. 2.

111 *ECMS*, 2 (pt. III), pp. 255–6 and fig. 266B,
opp. p. 243.

112 I. Fisher and F. A. Greenhill, 'Two unrecorded
carved stones at Tower of Lethendy, Perthshire',
PSAS, 104 (1971–2), pp. 238–41 and pl. 36a;
ECMS, 2 (pt. III), p. 340, fig. 355.

113 Alexander (cit. at n. I/5), pls 326–37 and 348–54.

114 ibid., pls 54, 74.

115 See n. 107, Chapter 1, above.

Chapter 3: The Pictishness of Pictish Art
pp. 59–85

1 A. Jackson, 'Pictish symbols: their meaning and
usage', *PSAS*, 115 (1985), p. 445.

2 *ECMS*, 2 (pt. III), fig. 163, p. 157; figs 184, 200,
pp. 171, 185.

3 C. L. Curle, 'The Chronology of the Early
Christian Monuments of Scotland', *PSAS*, LXXIV
(1939–40), pl. XXIa; *ECMS*, 2 (pt. III), fig. 187,
p. 174.

4 T. Blackie and C. Macaulay, *The Sculptured Stones
of Caithness: A Survey* (Balgavies, 1998), p. 7.

5 Curle (cit. at n. III/3), pl. XVIa; *ECMS*, 2 (pt. III),
figs 99, 99A, pp. 96–7. The description of this
unique symbol by A. Mack, *Field Guide to the
Pictish Symbol Stones* (Balgavies, 1997), p. 103 as
'like a double snap-hook' is appropriate. It might
also be described as a 'notched shield', since it
employs exactly the same pair of circular indents
on a short stalk as the 'notched rectangle' symbol
at, for example, Clynemilton.

6 Mack (cit. at n. III/5), p. 33.

7 Close-Brooks (cit. at n. II/12), p. 2.

8 *ECMS*, 2 (pt. III), pp. 182–4; see also Mireton,
pp. 167–8, fig. 178.

9 Curle (cit. at n. III/3), pl. XVa; *ECMS*, 2 (pt. III),
pp. 171, figs 185, 185A, 186, 186A.

10 Curle (cit. at n. III/3), pl. XVIIIc; for the cross
mounted on the 'Q' of *Qui habitat*, Psalm 90,
and in the 'V' of *Venite, exultemus*, Psalm 94 in
the Cathach, see Alexander (cit. at n. I/5), pl. 5,
and Meehan (cit. at n. I/9), p. 28; mounted on the
Christi autem and *In principio* initials of Durrow,
ibid., pp. 39, 65.

11 *ECMS*, 2 (pt. III), figs 233A, B, and 234A, B,
pp. 221–3.

12 I. Henderson (cit. at n. II/3), pl. 43.

13 Alexander (cit. at n. I/5), pls 16, 56, 29, 231.

14 At Glenferness, stylistically a later monument,
the 'Pictish beast' symbol again appears twice and
again faces in two different directions; *ECMS*, 2
(pt. III), fig. 120, opp. p. 97.

15 *ECMS*, 2 (pt. III), fig. 238B, p. 226.

16 ibid., fig. 258B, p. 244.

17 ibid., fig. 308B.

18 J. Close-Brooks and R. B. K. Stevenson, *Dark Age
Sculpture* (Edinburgh, 1982), cover and p. 30.

19 Meehan (cit. at n. I/9), p. 64.

20 ibid., p. 10.

21 I. Henderson (cit. at n. II/38), pp. 20–2.

22 *Age of Sprituality: Late Antique and Early Christian
Art, Third to Seventh Century*, ed. K. Weitzmann
(New York, 1979), no. 84, pp. 93–4.

23 *ECMS*, 2 (pt. III), fig. 306B, pp. 289–90; see also
n. 76, Chapter 5, below.

24 *ECMS*, 2 (pt. III), pp. 344–7 and figs 359A, B
and 360.

25 Close-Brooks, (cit. at n. II/12), p. 9.

26 *ECMS*, 2 (pt. III), pp. 296–7, figs 310A, B.

27 ibid., pp. 33–5, figs 31, 31A.

28 ibid., pp. 290–1, figs 307, 307A.

29 ibid., pp. 215–6, fig. 229.

30 ibid., pp. 201–3, figs 217A, B.

31 The centre of the cross on the back is square,
contrasting with the circular centre on the front.
The horizontal arms of the cross are partitioned,
symmetrical figurative (?) motifs framing
interlace. The lower arms of the cross have flatter
ribbon interlace, featuring beast head terminals,
as in the top arm of Glamis No. 2. The unusual
extent of subject scenes adjacent to the cross on
the front of St Vigean's No. 7 looks like a
development of the design of Glamis No. 2.

32 Blackie and Macaulay (cit. at n. III/4), no 10, p. 11.

33 S. Cruden, *The Early Christian and Pictish
Monuments of Scotland* (Edinburgh, 1964), pl. 34.

34 *ECMS*, 2 (pt. III), pp. 300–301.

35 *ECMS*, 2 (pt. III), pp. 73–5, figs 71, 71A.

36 Curle, 'The Chronology...', p. 64.

37 See Chapter 1, p. 16, above.

38 *ECMS*, 2 (pt. III), pp. 102–3, figs 106, 107. The
lines of Inverness No. 1 appear to have been
reworked, making its original quality difficult
to judge, but the design is squat and simple.

39 C. Hicks, 'The Pictish Class I Animals' in *Age of
Migrating Ideas* (cit. at n. I/102), fig. 24.2, p. 198.

40 *ECMS*, I (Parts I and II), pp. 72–8; see also Hicks
in previous note. The system is perpetuated and
aggrandized in Mack (cit. at n. III/5).

41 For definition and analysis of these principles
see I. Henderson (cit. at n. Intro/29).

42 D. Gordon, *Making & Meaning: The Wilton Diptych*
(London, 1993), pl. 1, p. 25.

43 The legs of the monstrous beast on the front of
the Apostles fragment at Tarbat buckle under it,
giving a look of defeat and capitulation, which
may well be the meaning of the image here, the
Old Serpent constrained and intimidated by
the Cross.

44 Job 41, 13: 'In collo ejus morabitur fortitudo'.

45 I. Henderson (cit. at n. Intro/29), pp. 39–42;
Piotrovsky et al. (cit. at n. I/3), nos 65, 82. For an
attempt to link ancient Nomadic art with later
European designs, see G. P. Greis and M. N.
Geselowitz, 'Sutton Hoo Art: Two Millennia of
History' in *Voyage to the Other World: The Legacy
of Sutton Hoo*, Medieval Studies at Minnesota, 5,
ed. C. B. Kendall and P. S. Wells (Minneapolis,
1992), pp. 29–44. For the incidence of animal-
headed tails in late Roman bronze mounts, see
N. Whitfield, 'Formal Conventions in the
Depiction of Animals on Celtic Metalwork' in
Isles of the North (cit. at n. Intro/37), p. 93, fig. 5c.

46 *ECMS*, 2 (pt. III), fig. 307A and p. 291.

47 I. Henderson (cit. at n. Intro/29), p. 19.

48 O. Pächt, 'The pre-Carolingian roots of early
Romanesque art' in *Romanesque and Gothic Art:
Studies in Western Art*, Acts of the Twentieth
International Congress on the History of Art, I,
ed. M. Meiss (Princeton, 1963), pp. 67–75.

49 G. C. Druce, 'Notes on the History of the Heraldic
Jall or Yale', *Arch. J.*, LXVIII (1911), pp. 173–99.

50 I. Henderson, 'The Insular and Continental
Context of the St Andrews Sarcophagus' in
Scotland in Dark Age Europe, ed. B. Crawford,
St John's House Papers No. 5 (St Andrews, 1994),
p. 80.

51 J. M. C. Toynbee, *Animals in Roman Life and Art*
(London, 1973), p. 57 and pl. 14.

52 I. Henderson (cit. at n. Intro/29), pp. 21–5.

53 *ECMS*, 2 (pt. III), pp. 128–9, fig. 134.

54 ibid., figs 30A, 31A; pp. 132–3, and fig. 136A,
opp. p. 127.

55 *The Bayeux Tapestry*, ed. Stenton; C. Hicks, 'The
Borders of the Bayeux Tapestry' in *England in the
Eleventh Century*, Harlaxton Medieval Studies, II,
ed. C. Hicks (Stamford, 1992), pp. 251–65.

56 R. Hahnloser, *Villard de Honnecourt-Kritische
Gesamtausgabe des Bauhüttenbuches, Ms. fr. 19093
der Pariser Nationalbibliotek* (Vienna, 1935); M. R.
James, 'An English Medieval Sketchbook. No.
1916 in the Pepysian Library, Magdalene College,
Cambridge', *Walpole Society*, XIII (1924–25).

57 I. Henderson (cit. at n. Intro/29), pp. 2–13.

Chapter 4: Reassessing Pictish Metalwork
pp. 87–121

1 The find circumstances of the chains, none in an
archaeological context, have been published at
various times in *PSAS*. For the references see
I. Henderson, 'The Silver Chain from
Whitecleugh, Shieldholm, Crawfordjohn,
Lanarkshire', *Transactions of the Dumfriesshire and
Galloway Natural History and Antiquarian Society*,
3rd ser., LIV (1979), pp. 20–1, at n. 1. To the ten
chains mapped in fig. 1 of that paper can be added
a 19th-century reference to the finding of a chain
near Banff. This information comes from the
draft of an unpublished lecture given in
Kalamazoo in 1991 entitled 'Pictish Silverwork' by
J. Graham-Campbell, the text of which was kindly
made available to the authors. An expanded and
updated version of this definitive survey is
imminently forthcoming but we have found the
lecture text an invaluable guide. References to it
should be regarded as subject to revision by the
author. Opinions vary as to the exact number
of chains due to confusion arising from the
changing names of administrative districts.
On the matter of origin the most significant
contribution is C. Thomas, 'The Artist and the
People, A Foray into Uncertain Semiotics' in *Isles
of the North* (cit. at n. Intro/37), pp. 1–7, at pp. 5–6.
See also, C. Cessford, 'Early Historic Chains of
Power', *Pictish Arts Society Journal*, 6 (1994),
pp. 19–26. (Cessford argues that the chains
were worn across the chest; A. Breeze, 'Pictish
chains and Welsh forgeries', *PSAS*, 128 (1998),
pp. 481–4. (Breeze points out that there is no
reliable evidence to support the view that early
medieval Welsh kings wore massive chains
instead of crowns.)

2 See below p. 90.

3 J. Graham-Campbell, 'Norrie's Law, Fife: on the
nature and dating of the silver hoard', *PSAS*, 121
(1991), pp. 241–60; L. Laing, 'The hoard of Pictish
silver from Norrie's Law, Fife', *Studia Celtica*, 28
(1994), pp. 11–38. Laing argues for a 5th-century
deposition date, Graham-Campbell for a 7th-
century one. The art-historical evidence supports
the later date.

4 See below, Chapter 8, p. 222.

5 See below, Chapter 6, p. 171.

6 It is possible that the drawing has failed to
reproduce the 'beast bust' symbol accurately, but
this could not explain the late characteristics of
the treatment of the other symbols. See J. C.
Roger, 'Notice of a drawing of a Bronze Crescent-
shaped Plate, which was dug up at Laws, Parish
of Monifieth, in 1796', *PSAS*, 14 (1879–80),
pp. 268–74.

7 C. Thomas, 'The Interpretation of the Pictish
Symbols', *Arch. J.*, 120 (1963), pp. 31–97, at
pp. 46–7, fig. 3.3.

8 L. Laing, *A Catalogue of Celtic Ornamental
Metalwork in the British Isles, c. AD 400–1200*,
Nottingham Monographs in Archaeology No. 5,
BAR Brit. Ser. 229 (Oxford, 1993), p. 105,
no. 240, pl. 25.

9 See below, Chapter 6, p. 169.

10 I. A. G. Shepherd, 'The Picts in Moray' in *Moray:
Province and People*, ed. W. D. H. Sellar
(Edinburgh, 1993), pp. 75–90.

11 I. Henderson, 'The Picts of Aberdeenshire
and their Monuments', *Arch. J.*, 129 (1971),
pp. 166–74, at p. 170, n. 19; I. A. G. Shepherd,
'Pictish Settlement Problems in N.E. Scotland'
in *Settlement in North Britain 1000 BC–AD 1000*,
ed. J. C. Chapman and H. C. Mytum, pp. 327–56,
at pp. 334–5; J. N. Graham Ritchie and J. N.
Stevenson, 'Pictish Cave Art at East Wemyss,
Fife' in *Age of Migrating Ideas* (cit. at n. I/102),
pp. 203–8.

12 Bruce-Mitford (cit. at n. I/7), pp. 30–9, at p. 33,
with a reference to the view of L. Alcock that
Picts need not have been involved, in 'A survey of
Pictish settlement archaeology' in *Pictish Studies*,
ed. J. G. P. Friell and W. G. Watson, BAR Brit. Ser.
125 (Oxford, 1984), pp. 7–41, at p. 27.

13 Bruce-Mitford (cit. at n. I/7)

14 *Work of Angels* (cit. at n. I/7), no. 38, p. 52 and ill.

15 op. cit. no. 37, p. 52, and ill. For the connection
between the find-spot, near St. Comgall's
monastery at Camus, and Columba see Adomnán
of Iona, *Life of St Columba*, trans. R. Sharpe
(Harmondsworth, 1995), Bk 1, ch. 49. On
Columba and the River Ness, see Bk 2, ch. 27.

16 Lane and Campbell (cit. at n. Intro/36). For the
flat enamelled disc (find 2123) and its relationship
to the hanging-bowl corpus, see pp. 154–5,
ills 4.58 and 4.59; pl. 19.

17 For the St Ninian's Isle, Shetland, hanging-bowl
see below. For the Castle Tioram and Tummel
Bridge, Perthshire, fragments see, H. E. Kilbride-
Jones, 'A Bronze Hanging-Bowl from Castle
Tioram, Moidart: and a suggested absolute
chronology for British Hanging-Bowls', *PSAS*, 71
(1936–37), pp. 206–247, figs. 1 and 2. Here it is
argued that there were good trade connections
between the North British production centre and
the North of Scotland (p. 244). (The paper, of
course, pre-dates the find at Craig Phadrig.) A
flat disc decorated with peltas found at Clatchard
Craig, Fife, is related to the escutcheons and discs
of hanging-bowls, but it is miniature (22 mm
diameter) and like the Dunadd disc could have
been part of other objects. See J. Close-Brooks,
'Excavations at Clatchard Craig, Fife', *PSAS*, 116
(1986), pp. 117–84, at pp. 168–9, and below.

18 L. Webster in *Work of Angels* (cit. at n. I/7), p. 28,
no. 10, and ill.

19 M. Ryan in *Work of Angels* (cit. at n. I/7), p. 29,
no. 11, and ill.

20 Ryan, op. cit., notes that there are two Irish
examples of disc-headed pins made of copper
alloy. Susan Youngs drew the attention of I. H. to
a copper alloy disc-headed pin from Broxbourne,
Herts., which has the characteristic triple pelta
design on the disc face and the nib-like
termination of the shank decoration. The solid
silver pair are unprovenanced.

21 The dating of disc-headed pins is problematic.
They could have been produced as early as the 6th
century or as late as the beginning of the 8th. See
for the earlier dating of particular examples the
entries in the *Work of Angels* catalogue cited above.
See for later dating, *The Illustrated Archaeology of
Ireland*, ed. M. Ryan (Dublin, 1994).

22 Graham-Campbell (cit at n. IV/3), pp 246–7, ill. 2.

23 *ECMS*, 1 (pt. I), pp. lxxxiv–v.

24 Graham-Campbell (cit. at n. IV/3), p. 253.

25 The 'double-disc and Z-rod' symbol is carved on a
fragmentary bone pin from Pool, Sanday, Orkney.
What has been regarded as a 'proto-Pictish'
double disc is engraved on a solid silver brooch
from Carn Liath, Sutherland. Laing (cit. at
n. IV/3), p. 29, fig. 6, is a good illustration. The
best account is in J. Curle 'An inventory of objects
of Roman and Provincial Roman origin found on
sites in Scotland...', *PSAS*, 66 (1931–32),
pp. 277–397, at p. 338. Curle points out that
although strongly influenced by Roman brooch-
types it 'stands alone'. On the basis of the saltire
decorating the arm (not, it seems, the presence
of conjoined discs on the stem) he saw a parallel
with items in the Norrie's Law hoard: 'It is
possible that we have here a frail link between
provincial Roman design and the symbols which
are characteristic of the sculptured stones of the
north and east of Scotland'.

26 *Work of Angels* (cit. at n. I/7), p. 63, no. 58,
col. ill. p. 39.

27 Graham-Campbell (cit. at n. IV/3), p. 252;
S. J. Plunkett, 'Some Recent Metalwork
Discoveries from the Area of the Gipping
Valley, and their Local Context' in *New Offerings*
(cit. at n. Intro/27), pp. 61–87, at p. 77, fig. 6f;
G. Henderson (cit. at n. I/11), p. 45, pl. 21.

28 R. B. K. Stevenson, 'The Earlier Metalwork of
Pictland' in *To Illustrate the Monuments. Essays on
Archaeology presented to Stuart Piggott*, ed. J. V. S.
Megaw (London, 1976), pp. 246–51, at p. 248, fig.
1, b–f; for the identification of the strips as saddle
mounts see R. Ó Floinn in *Work of Angels* (cit. at
n. I/7), p. 30, no. 13.

29 On the Norrie's Law bracelet terminals see
Graham-Campbell (cit. at n. IV/3), p. 247.
The Irish bronze analogies are discussed and
illustrated by Ó Floinn in *Work of Angels* (cit. at
n. I/7), pp. 44–5.

30 Laing (cit. at n. IV/3), pp. 24–5; J. Graham-
Campbell, 'National and Regional Identities: The
"Glittering Prizes"' in *Pattern and Purpose* (cit. at
n. Intro/32), pp. 27–38, at p. 33. For an illustration
see Graham-Campbell (cit. at n. IV/3), p. 247, ill. 2

31 Graham-Campbell (cit. at n. IV/30), pp. 33–6.

32 D. M. Wilson in *St Ninian's Isle and its Treasure* (cit. at n. II/45), vol. 1, pp. 82–3.

33 Wilson was aware that the number of brooches of this type that he had identified (thirty-one) was not sufficiently large for 'firm conclusions'. However the similarity of their distribution to that of Pictish symbol-bearing monuments and objects (and some shared artistic traits between the art of the hoard and the art of Pictish relief sculpture) he felt broadly justified the labelling of the brooch type as 'Pictish'. The underpinning of the Pictish symbols, as usual, was important for the attribution of Pictish manufacture. See *St Ninian's Isle and its Treasure* (cit. at n. II/45), vol. 1, pp. 88–90.

34 C. L. Curle, *Pictish and Norse Finds from the Brough of Birsay 1934–74*, Society of Antiquaries of Scotland Monograph 1 (Edinburgh, 1982), pp. 62–3, and ill. 15.

35 ibid., p. 27, ill. 14, a and b.

36 ibid., pp. 30–3, ill. 17; pp. 46–7 is a report of J. Hunter on the glass. He thinks that the garnet was included accidentally, being mistaken for glass. For a good illustration of the dog's head see J. Close-Brooks, *St Ninian's Isle Treasure* (Edinburgh, 1978), ill. 9a.

37 Curle (cit. at n. IV/34), pp. 48–9, ill. 30.

38 *St Ninian's Isle and its Treasure* (cit. at n. II/45), vol. 1, pp. 174–5.

39 *Work of Angels* (cit. at n. I/7), p. 110, no. 104, col. ill. p. 155.

40 Meehan (cit. at n. I/40), p. 49; the minute heads end the interlace in the border just under the cross-arms of the symbol-bearing side of the Rossie slab. See RCAHMS, *South-East Perth: and archaeological landscape* (Edinburgh, 1994), p. 103.

41 *Work of Angels* (cit. at n. I/7), p. 111, no. 105, col. ill. p. 155. For the Dunadd type see op. cit., p. 191, no. 181, a bird-headed brooch mould from a 7th-century deposit.

42 Wilson in *St Ninian's Isle and its Treasure* (cit. at n. II/45), vol. 1, p. 70. For a colour illustration see *Work of Angels* (cit. at n. I/7), p. 155.

43 *St Ninian's Isle and its Treasure* (cit. at n. II/45), vol. 2, pl. xxxii, b.

44 Wilson in *St Ninian's Isle and its Treasure* (cit. at n. II/45), vol. 1, p. 93.

45 *Work of Angels* (cit. at n. I/7), p. 57, no. 44, col. ill., p. 74.

46 *Work of Angels* (cit. at n. I/7), pp. 91–2, no. 69, col. ill. p. 75 (= Hunterston brooch); pp. 131–2, no. 125 a and b, col. ill. p. 162 (= Derrynaflan paten); col. ill. p. 77 (= 'Tara' brooch). For the quality of the Dunbeath 'hollow platform' technique see N. Whitfield, 'Motifs and Techniques of Celtic Filigree: are they original?' in *Ireland and Insular Art* (cit. at n. I/7), pp. 75–84, at p. 78.

47 For the dating of the Dunbeath brooch on technical grounds to the late 8th or 9th century see N. Whitfield, 'Filigree Animal Ornament from Ireland and Scotland of the Late-Seventh to Ninth Centuries' in *The Insular Tradition* (cit. at n. I/130), pp. 211–43, at pp. 231–2.

48 R. M. Spearman and M. Ryan in *Work of Angels* (cit. at n. I/7), p. 51, no. 44.

49 In addition to the fragment of a complex incised cross (see Chapter 6, p. 161, below), fragments of sculpture carved with well-formed, high-relief interlace have been found, reused as building material in structures adjacent to the site.

50 For an account of this type of animal art in sculpture and its relationship to metalwork, see I. Henderson (cit. at n. Intro/29), pp. 28–9. The examples used there are taken from monuments south of the Grampians. The style is equally present in sculpture in the north, for example, at Brodie, Moray, and Hilton of Cadboll and Shandwick, Ross & Cromarty.

51 For a summary list of the archaeological and monumental richness of the area see J. Close-Brooks, 'A Pictish pin from Golspie, Sutherland', *PSAS*, 106 (1974–5), pp. 208–10, at pp. 209–10. On the nature of the Rogart Hoard see Wilson in *St Ninian's Isle and its Treasure* (cit. at n. II/45), vol. 1, pp. 81–2.

52 Psalm 42 (Vulgate, Psalm 41).

53 *Work of Angels* (cit. at n. I/7), p. 97, no. 76, col. ill. p. 82.

54 The Croy hoard is described in Graham-Campbell (cit. at n. IV/1). On aspects of the coins, which may need revision, and references, see C. E. Blunt, 'The Date of the Croy Hoard', *PSAS*, 84 (1949–50), p. 217. The complete brooch and the two fragments are illustrated in *St Ninian's Isle and its Treasure* (cit. at n. II/45), vol. 2, pl. xxxviii.

55 F. Henry, *Studies in Early Christian and Medieval Irish Art*, Vol. 1, *Enamels and Metalwork* (London, 1983), item III, 'Irish Enamels of the Dark Ages and Their Relationship to the Cloisonné Techniques', pp. 93–114, at p. 114, and n. 53. IH is most grateful to Dr Susan Youngs of the British Museum for letting her see a copy of a draft description of the terminal fragment. For the gold and garnet stud at Dunadd (No. 777) see Lane and Campbell (cit. at n. Intro/36), pp. 150–1 where by implication it is linked with a Royal Bernician presence at Dunadd in the 7th century. On p. 153 the fact that the garnet used differs in composition to the garnets in the Sutton Hoo jewelry raises the possibility of its being a 'hybrid design' incorporating Celtic and Anglo-Saxon elements, and for an independent source for garnets.

56 For these assessments see S. Youngs in *Work of Angels* (cit. at n. I/7), pp. 94–5, no. 72, and ill.

57 R. B. K. Stevenson, 'The Pictish brooch from Aldclune, Blair Atholl, Perthshire', *PSAS*, 115 (1985), pp. 233–9.

58 *Work of Angels* (cit. at n. I/7), p. 114, no. 109, and ill.

59 *Work of Angels* (cit. at n. I/7), p. 115, no. 110, and ill.; Wilson in *St Ninian's Isle and its Treasure* (cit. at n. II/45), vol. 1, p. 89, n. 2, and p. 91; Stevenson (cit. at n. IV/57), p. 236.

60 *Work of Angels* (cit. at n. I/7), p. 77; *ECMS*, 2 (pt. III), pp. 286–9, fig. 305B.

61 *ECMS*, 2 (pt. III), fig. 308B, pp. 291–2.

62 Meehan (cit. at n. I/40), p. 65.

63 For the Insular mount see *Work of Angels* (cit. at n. I/7), pp. 145–6, no. 139, and ill.

64 These parallels with the decorative animal art of the Book of Kells have many counterparts in Pictish sculpture. See I. Henderson (cit. at n. II/103), pp. 79–105.

65 For the fragment see R. M. Spearman, 'The Mounts from Crieff, Perthshire, and their Wider Context' in *Age of Migrating Ideas* (cit. at n. I/102), pp. 135–42, at p. 135, fig. 16.5

66 Close-Brooks (cit. at n. IV/17), pp. 117–84, at pp. 162–4. Ill. 25 compares the design of the Clunie terminals with a tentative reconstruction of the appearance of the brooch from Clatchard Craig. See also ill. 22 for the surviving mould fragments.

67 Close-Brooks (cit. at n. IV/17), p. 149. For the silver ingot see ill. 28.121, p. 168.

68 The mould is artefact No. 1636. See Lane and Campbell (cit. at n. Intro/36), pp. 115–16 and ill. 4.19 and 4.20. A schematic reconstruction of the mould as if it were for a pseudo-penannular is on p. 247, ill. 7.11. A drawing reconstructing it as penannular with comparisons is ill. 7.8.

69 The comparison between the Dunadd and Clatchard Craig moulds (as reconstructed), the larger Clunie brooch and the large decorated Hunterston Brooch is made in Lane and Campbell (cit. at n. Intro/36), p. 245, ill. 7.8; the suggestion that the Clatchard Craig mould could date to the 7th century and that the Clunie brooch is an early, inferior copy of Anglo-Saxon metalwork is also on p. 245. If the Clatchard Craig and Dunadd moulds date to the 7th century then it follows that the Hunterston brooch and the Tara brooch would cease to be regarded as prototypes for the larger decorated brooches, and the whole sequence would be much earlier.

70 Described as 'strange stylized tube-like animals' by M. Ryan in *Work of Angels* (cit. at n. I/7), pp. 98–9, no. 79, col. ill. p. 84.

71 Stevenson (cit. at n. IV/57), p. 236.

72 *Work of Angels* (cit. at n. I/7), p. 92, no. 70, col. ill. p. 78.

73 R. B. K. Stevenson, 'The Celtic brooch from Westness, Orkney, and hinged-pins', *PSAS*, 119 (1989), pp. 239–69, at 255–6. Stevenson suggests that the head derives from the classical *ketos* used for Jonah's whale. The Picts certainly knew the classical *ketos* for it is depicted very accurately in the image of Jonah on the Dunfallandy cross-slab but the derivation of the truly vulpine head on the Westness brooch-pin from such a source seems unlikely. Stevenson rejects the view that the wolf is a local reinvention prompted by the rings at the necks of the hanging-bowl escutcheons. Naturalistic heads cast in high relief are an intrinsic part of brooch design of the 8th to 9th century, and the head is surely a natural variant of this tradition.

74 Whitfield (cit. at n. IV/47), p. 228; Laing opts for a Dalriadic origin; see his *Catalogue of Ornamental Metalwork* (cit. at n. IV/8), p. 73, no. 103, and pl. 12 which shows the wolf clearly.

75 Wilson in *St Ninian's Isle and its Treasure* (cit. at n. II/45), vol. 1, pp. 106–7, vol. II, pls xvii–xxiii. The Sutton Hoo bowls are fully discussed in Bruce-Mitford (cit. at n. I/8), 3, pp. 69–113, with references to the St Ninian's Isle bowls at pp. 111–13. See for illustrations of the interiors of two of the Sutton Hoo bowls, Evans (cit. at n. I/8), pp. 60–1, ills 44 and 45. At the time when Wilson published the St Ninian's Isle treasure, analysis of the silver used for the bowls was not possible.

76 Bruce-Mitford (cit. at n. I/89), pp. 1–25, pl. XII.

77 The appearance of the bowls when shelved is well-conveyed in Close-Brooks (cit. at n. IV/36), ills 4–6.

78 *St Ninian's Isle and its Treasure* (cit. at n. II/45), vol. 2, pl. xxi.

79 Wilson in *St Ninian's Isle and its Treasure* (cit. at n. II/45), vol. 1, pp. 47–51, 106–7, 125–31; vol. 2, pls xviii and xxix.

80 Wilson, citing the views of Bruce-Mitford, in *St Ninian's Isle and its Treasure* (cit. at n. II/45), vol. 1, p. 130.

81 Meehan (cit. at n. I/40). For an example of an animal with a foliate tail, ill. 62. For linked animals in the frame of the Virgin and Child miniature, ill. 7.

82 R. M. Spearman in *Work of Angels* (cit. at n. I/7), p. 108, no. 97, col. ill. p. 153.

83 *St Ninian's Isle and its Treasure* (cit. at n. II/45), vol. 1, pp. 55–7, 108–12, 134–7; vol. 2, pls xxiv and xxv, figs. 23 and 38.

84 *St Ninian's Isle and its Treasure* (cit. at n. II/45), vol. 2, pl. xxv, b and c (the external mount); pl. xxiv and fig. 38 (the internal mount) with analogous animal type in the Book of Durrow.

85 Cramp (cit. at n. I/31), pt. One, p. 126, pt. Two, pl. 121, 656.

86 Evans (cit. at n. I/8), pl. VII. See also the drawing in *St Ninian's Isle and its Treasure* (cit. at n. II/45), vol. 2, fig. 38. The fragment of bronze sheet stamped with a Germanic animal found at Dunadd is only distantly related to the procession of creatures on the internal mount of the St Ninian's Isle bowl. Instead of the characteristic pear-shaped foreshoulders and hips the Dunadd creature has 'hip spirals'. These are said by the excavators to be a feature of Pictish art 'occasionally assimilated into Insular manuscript art, for example in the Book of Durrow symbol of the lion'. Lane and Campbell (cit. at n. Intro/36), pp. 152–3, ill. 4.57. In fact it is the muscle-defining scrolls used on Pictish animals that can be related to the lion symbol that is placed at the beginning of the Gospel of St John in the Book of Durrow. However, coiled spirals are used to decorate the joints of the otherwise naturalistic calf symbol of St Luke in that manuscript. Such spiral joints are not characteristic of Pictish art but are a feature of later Insular art animal styles. The St Ninian's Isle crouching creatures belong to an earlier phase.

87 S. Youngs, 'The Steeple Bumpstead Boss' in *Age of Migrating Ideas* (cit. at n. I/102), pp. 143–150, figs. 17.1 and 17.5.

88 L. Webster in *Making of England* (cit. at n. I/78). The chapes are discussed on pp. 223–4. No. 178 (a, b), ill. on p. 224, where they are said to be 'Pictish or? Anglo-Saxon, late 8th century'. The sword-pommel, similarly attributed, is no. 177, ill. on p. 223. In *Work of Angels* (cit. at n. I/7), chapes and pommel are described as 'Pictish, 8th century'.

89 *Making of England* (cit. at n. I/78), nos 175, 176 and 181.

90 Wilson in *St Ninian's Isle and its Treasure* (cit. at n. II/45), vol. 1, pp. 137–40, at p. 138.

91 Webster (cit. at n. I/78), p. 223, in the discussion of the pommel.

92 Wilson, on the treasure as an entity in *St Ninian's Isle and its Treasure* (cit. at n. II/45), vol. 1, pp. 91, 93, 133 and p. 146.

93 For an analysis of the similarities between the art of these monuments and the art of these artefacts see I. Henderson, 'Variations on an Old Theme: Panelled zoomorphic ornament on Pictish sculpture at Nigg, Easter Ross and St Andrews, Fife, and in the Book of Kells' in *The Insular Tradition* (cit. at n. I/130), pp. 143–66, at pp. 160–1.

94 For the Lindisfarne Gospels *f.* 95, the beginning of St Mark's Gospel see Alexander (cit. at n. I/5), pl. 46. For the use of stipple to set off curvilinear ornament, see an engraved plaque which was part of the Donore, Co. Meath, hoard of church fitments in *Work of Angels* (cit. at n. I/7), p. 69, no. 65, col. ill. p. 40.

95 For the house-shaped reliquary shrines generally see *Work of Angels* (cit. at n. I/7), pp. 134–40, nos 128–32. The Monymusk reliquary is discussed on pp. 134–5, no. 129. No Welsh metalwork was on show in the *Work of Angels* exhibition, but fragments of a similar shrine have been found in Wales. See L. Butler and J. Graham-Campbell, 'A lost reliquary casket from Gwytherin, North Wales', *Ant. J.*, 70 (1990), pp. 40–48. The authors write on p. 46, 'The one thing that is certain is that we are ignorant of the full range of Insular reliquaries of 8th/9th-century date – more so in England than in Ireland, but completely so in Wales'. Their conclusions differ; for Graham-Campbell the Gwytherin casket is of English workmanship, for Butler it was 'manufactured in Wales under Irish influence'. Such discrepant assessments are only too familiar to the student of Pictish art. The existence of Pictish reliquaries is not even

remarked. The subsequent finding of a fragment of the wooden core of the casket extended the discussion, see N. Edwards and T. Gray Hulse, 'A fragment of a reliquary casket from Gwytherin, North Wales', *Ant. J.*, 72 (1992), pp. 91–101. The paper includes a list of the small corpus of early Christian artefacts associated with Wales, surviving, or known from antiquarian sources.

96 For a drawing of the ornament see *St Ninian's Isle and its Treasure* (cit. at n. II/45), vol. 2, fig. 41.

97 M. Blindheim, 'A House-shaped Irish-Scots Reliquary in Bologna, and its place among the other Reliquaries', *Acta Archaeologica*, 55 (1984), pp. 1–53. The paper illustrates comparisons with Pictish sculpture. *Work of Angels* (cit. at n. I/7), no. 132, col. ill. p. 164.

98 For drawings of this device on disc 2 of the Donore, Co. Meath, hoard see M. Ryan, 'The Decoration of the Donore Discs' in *Isles of the North* (cit. at n. Intro/37), pp. 27–35, at pp. 30–1, figs. 5 and 6.

99 See below p. 224.

100 *Work of Angels* (cit. at n. I/7), pp. 138–9, no. 131. For comparison of the treatment of the back of the Copenhagen shrine to that of the Bologna shrine, see ills on pp. 164 and 139.

101 R. M. Spearman in *Work of Angels* (cit. at n. I/7), p. 119–20, no. 117a and b, and ill. where they are described as 'Irish style, 8th century'. R. M. Spearman, 'The Mounts from Crieff, Perthshire, and their Wider Context', *Age of Migrating Ideas* (cit. at n. I/102), pp. 135–42. For the Cumbrian plaque, related Insular mounts, and the Dupplin comparison, see S. Youngs, 'A Northumbrian Plaque from Asby Winderwath, Cumbria' in *Northumbria's Golden Age* (cit. at n. II/100), pp. 281–95, at pp. 284–5 and p. 292.

102 For the Skjeggenes fragment see C. Bourke, T. Fanning and N. Whitfield, 'An Insular Brooch-Fragment from Norway', *Ant. J.*, 68 (1988), pp. 90–8. The Kilmainham brooch is in *Work of Angels* (cit. at n. I/7), pp. 95–6, no. 74, col. ill. p. 81. The large brooch from Rogart, Sutherland, also has red glass settings.

103 Laing (cit. at n. IV/8), p. 92, no. 179, and well illustrated on pl. 14. Laing identifies the animal as a wolf. R. B. K. Stevenson, surely correctly for an animal with its tail between its legs and a well-defined mane, calls it a 'Celtic-looking "lion"'. See R. B. K. Stevenson, 'The Brooch from Westness, Orkney' in *The Fifth Viking Congress in Tórshavn, July 1965*, ed. B. Niclasen (Tórshavn, 1968), pp. 25–31, at p. 26.

104 J. Close-Brooks (cit. at n. IV/51), pp. 208–10. For the Rosemarkie pin see R. B. K. Stevenson, 'Pins and the Chronology of the Brochs', *Proceedings of the Prehistoric Society*, 21 (1955), pp. 282–94, at p. 284.

105 C. Bourke and J. Close-Brooks, 'Five Insular enamelled ornaments', *PSAS*, 119 (1989), pp. 227–37. The Aberdour fragment is discussed on pp. 228–9, with analysis of its materials on p. 235. On the complexities of the Aberdour disc, its use of millefiori in the cross design and the ribbon interlace see S. Youngs, 'Medium and Motif: Polychrome Enamelling and Early Manuscript Decoration in Insular Art' in *Isles of the North* (cit. at n. Intro/37), pp. 37–47, at pp. 41, 43 and 44, fig. 5l. The millefiori inlay was published in 1989, p. 235, as being enamel. This was corrected in S. Youngs, Exhibits at Ballots: 2. A medieval Irish enamel. *Ant. J.*, 72 (1992), 188–91, at p. 189, with a further reference to its design context on p. 190.

106 For the St. Andrews and Freswick enamels see 'Five Insular enamelled ornaments', pp. 228–30,

with materials' analysis on p. 235. The Freswick brooch is discussed above on p. 99.

107 For the Dalmeny fragment see L. Alcock, *The Neighbours of the Picts: Angles, Britons and Scots at War and at Home* (Rosemarkie, 1993 = Groam House Museum Annual Academic Lecture), fig. 15. For the Cramond disc see 'Five Insular enamelled ornaments', pp. 230–2, with materials analysis on p. 235. On the Cramond millefiori see J. Carroll, 'Millefiori in the Development of Early Irish Enamelling' in *Isles of the North* (cit. at n. Intro/37), pp. 49–57, at p. 55, where it helps to date what is called the Irish style of millefiori, defined as 'Class 3'. The Class 3 style is called 'Irish' because the find places of examples are predominantly Irish. 'Therefore' according to the writer 'the great many Scandinavian finds of Class 3 millefiori-decorated enamels can be deemed to be Irish.' This assumption is questionable.

108 For the Tarbat finds: *www.york.ac.uk/depts/arch/staff/sites/tarbat*

109 Close-Brooks (cit. at n. IV/17), pp. 168–9, ills 28 and 29, with description, material analysis and discussion of the design.

110 M. Ryan in *Work of Angels* (cit. at n. I/7), p. 101, no. 83. The back is illustrated on p. 101, a colour illustration of the front is on p. 87. The present writers record with gratitude the gift of copies of drawings of the brooch from Michael Ryan that enhanced their appreciation of this superlative piece.

111 R. Ó Floinn in 'Secular Metalwork in the eighth and ninth centuries', pp. 72–91 of *Work of Angels* (cit. at n. I/7), at p. 90.

112 Youngs (cit. at n. IV/87), concluding sentence on p. 150.

113 For pertinent discussion of these issues see O. Owen and R. Welander, 'A traveller's end? – an associated group of early historic artefacts from Carronbridge, Dumfries and Galloway', *PSAS*, 125 (1995), pp. 753–70. Although the penannular brooch from Carronbridge meets the design specifications for Wilson's 'Pictish' penannulars, the authors prefer to follow the modern trend of 'abandoning such ethnic labels in favour of less subjective terminology' and so prefer to describe the brooch as 'Insular Celtic' (pp. 763 and 766–7). One would applaud this if it led to more openmindedness as to origins. On the other hand if indeed the Picts can claim some significant role in the development of the penannular of this type, one would not wish to deprive them of this contribution in the interests of theoretical 'correctness'. The present writers are aware that they are advocating a degree of positive discrimination for the Picts in this matter. For a critique of the paper by Owen and Welander and a discussion of terminology see Graham-Campbell (cit. at n. IV/30), pp. 27–38, at pp. 33–6.

114 J. Graham-Campbell, 'Western Penannular Brooches and their Viking Age Copies in Norway: a new classification', *Proceedings of the Tenth Viking Congress, Larkollen, Norway, 1985*, Universitetets Oldsaksamlings Skrifter, Ny rekke, 9 (Oslo, 1987), pp. 231–46, at p. 237, figs. 6–8, and p. 244. For the Hatteberg brooch and the related brooch mould, No. 300, from Birsay, see Curle (cit. at n. IV/34), p. 101 and ill. 60.

115 Stevenson (cit. at n. IV/57), at p. 235. See the careful use of terminology in C. Paterson, 'Insular Belt-fittings from the Pagan Norse Graves of Scotland...' in *Pattern and Purpose* (cit. at n. Intro/32), pp. 125–32.

116 On the Skei bucket, see Graham-Campbell, (cit. at IV/30), pp. 30–1. On the Birka bucket, see Wilson

in *Reflections on the St Ninian's Isle Treasure*, Jarrow Lecture for 1969 (Jarrow, 1970), p. 9.

117 L. Webster in *Work of Angels* (cit. at n. I/7), pp. 121–2, no. 120, and ill.; 'the vine-scroll decoration of the bucket clearly suggests a Northumbrian origin'.

118 R. Cramp, *The Monastic Arts of Northumbria*, Arts Council of Great Britain Exhibition Catalogue (London, 1967), no. 37, pp. 17–18, and ills.

119 R. Ó Floinn, in *Work of Angels* (cit. at n. I/7), p. 121, no. 119, col. ill. p. 159.

120 Graham-Campbell (cit. at n. IV/30), pp. 30–1, fig. 3.3

121 To the examples listed in I. Henderson, 'Pictish Vine-Scroll Ornament' in *From the Stone Age to the 'Forty-Five'. Studies presented to R. B. K. Stevenson*, ed. A. O'Connor and D. V. Clarke (Edinburgh, 1983), pp. 243–68, must be added the unique lower edge of what can now be seen to be a three-sided vine-scroll frame for the panelled carvings on the back of the Hilton of Cadboll symbol-bearing cross-slab, correcting the speculative view, at p. 244, that there were two independent side panels of vine-scroll.

122 For the Orkney mount see *ECMS*, 1 (pt. I), p. xcii, fig. 22, where Anderson notes the trumpet-shaped endings to the spiral junction of the wings to the body, and the similarity of the border ornament, alternating crescents and almond-shapes, to the design on the Crieff mounts. See also S. Foster, 'Decorated Bronze and Gold Pieces' in 'Excavations at Warebeth (Stromness Cemetery) Broch, Orkney', *PSAS*, 119 (1989), pp. 101–31 at pp. 127–8, ill. 12, with full description, and the interesting observation that there are three impressed indentations on the top edge, suggestive of a clasp attachment. The author, on the basis of the vine-scroll, believes that there is no reason to attribute the mount to the Picts, in spite of its being 'a popular Pictish motif'.

123 Graham-Campbell (cit. at n. IV/30), p. 30.

124 J. N. G. Ritchie, 'Excavations at Machrins, Colonsay', *PSAS*, 111 (1981), pp. 263–81, pl. 15a.

125 S. Youngs, 'Insular Metalwork from Flixborough, Lincolnshire', *MA*, 45 (2001), pp. 210–20.

126 Wilson in *St Ninian's Isle and its Treasure* (cit. at n. II/45), vol. 1, pp. 63–4.

Chapter 5: Themes and Programmes
pp. 123–157

1 See Chapter 6, pp. 167–74.

2 G. Henderson (cit. at n. I/24), pp. 50–1.

3 *EH*, p. 130.

4 Jerome, *Vita S Pauli Primi Eremitae*, in J. P. Migne, *Patrologiae Cursus Completus...Series Latina* (Paris, 1845) [hereafter *PL*], 23, cols 18–27, espec. col. 22: 'hominem equo mixtum, cui opinio poetarum Hippocentauro vocabulum indidit...et frangans potius verba quam proloquens, inter horrentia ora setis...'.

5 *EH*, Bk IV, ch. 3, pp. 338–9, '...simplici tantum habitu indutus et securim atque asciam in manu ferens...'.

6 *ECMS*, 2 (pt. III), p. 95 and n. 1, for Kilmorack, misnamed Balblair. For Strathmartine, Balblair and Rhynie No. 3 see I. A. G. Shepherd and A. N. Shepherd, 'An Incised Pictish figure and a new symbol stone from Barflat, Rhynie, Gordon District', *PSAS*, 109 (1977–8), pp. 211–22, espec. pp. 214–16.

7 *ECMS*, 2 (pt. III), pp. 48–50; see also Close-Brooks (cit. at n. II/12), p. 16.

8 Oxford, Bodleian Library MS. Junius 11, p. 82; see also Abraham between two buildings, p. 87.

9 I. Gollancz, *The Caedmon Manuscript of Anglo-Saxon Biblical Poetry* (Oxford, 1927).

9 For example, London, British Library Cotton MS. Nero C. iv, f. 3; F. Wormald, *The Winchester Psalter* (London, 1973), pl. 6; Leiden, Bibliotheek der Rijksuniversiteit MS. Lat. 76A, f. 10v; H. Omont, *Miniatures du Psautier de S. Louis* (Leyden, 1902), pl. IV.

10 In the large main gallery with procession of gods and goddesses; see H. Frankfort, *The Art and Architecture of the Ancient Orient* (Harmondsworth, rev. edn 1970), pp. 225–31 and pl. 261.

11 Toynbee (cit. at n. I/48), pl. 41. For other images of Juno Regina, Juno Dolichena and Jupiter Dolichenus standing on the backs of beasts, see H. Schutz, *The Romans in Central Europe* (New Haven and London, 1985), pls 68–71. These classical deities stand frontally while their beasts are set sideways. The ancient Hittite deities, like the Pictish man, are in profile, facing the same way as their mounts.

12 Oxford, Ashmolean; E. Panofsky, 'The Early History of Man in a Cycle of Paintings by Piero di Cosimo, *Journal of the Warburg and Courtauld Institutes*, I (1937), pp. 12–39, and pl. C. opp. p. 24. The base of the East face of the North Cross at Ahenny, Co. Tipperary, looks like a weak imitation of the Shandwick type of composition. For interpretation of the subject at Ahenny, see Harbison (cit. at n. Intro/35), I, p. 11 and II, fig. 10.

13 *ECMS*, 2 (pt. III), pp. 305–6 and fig. 321. For a parallel convention of warriors with beast attributes, see K. Hauck, 'Der Missionsauftrag Christi und das Kaisertum Ludwigs des Frommen' in *Charlemagne's Heir: New Perspectives on the Reign of Louis the Pious (814–840)*, ed. P. Godman and R. Collins (Oxford, 1990), pls 15, 19, after p. 738.

14 I. Henderson (cit. at n. II/3), pl. 50.

15 H. C. Whaite, *St Christopher in Medieval English Wall-Painting* (London, 1929); J. Salmon, 'St Christopher in English Medieval Art and Life', *JBAA*, New Series 41 (1936), pp. 76–115.

16 Kirriemuir No. 2, *ECMS*, 2 (pt. III), pp. 227–8 and fig. 240 A, B.

17 I. Henderson (cit. at n. II/39), p. 138.

18 L. W. Jones and C. R. Morey, *The Miniatures of the Manuscripts of Terence prior to the thirteenth century* (Princeton, n.d.); K. Weitzmann, *The Joshua Roll: A Work of the Macedonian Renaissance*. Studies in Manuscript Illumination III (Princeton, 1948). The merits at least of verbal constructions in Terence's *Andria* were known to Insular readers from Cassiodorus's citations in his *Institutiones* Bk II, 15; *Cassiodori Senatoris Institutiones* (cit. at I/22), pp. 125–7.

19 *The Bayeux Tapestry*, ed. F. Stenton (London, 1957), pls 1–2 and II.

20 *ECMS*, 2 (pt. III), pp. 83–4 and figs. 82, 82A. Here the back is wrongly called the front, and vice versa.

21 ibid., pp. 300–1.

22 ibid., pp. 299–300. Compare Cambridge University Library MS. Ee. 3. 59, f. 32v; M. R. James, *La Estoire de Seint Aedward Le Rei* (Oxford, 1920).

23 J. D. Beazley, *The Development of Attic Black-Figure* (Berkeley, 1951), pls 11, 1, 13,1, 16.

24 M. R. James, *Illustrations to the Life of St Alban in Trin. Coll. Dublin MS.E.1.40* (Oxford, 1924), pl. (39), f. 55v, 'Merciorum Rex Offa' setting out on his expedition. (The trumpeters here are in front of the King.) The trumpeters in the sculpture also bring to mind a scriptural text, Numbers 10, 2, which ordains the use of two silver trumpets to signal assemblies and journeys.

25 *EH*, p. 174: '...speculum argenteum et pectine(m) eboreum inauratum...'

26 E. Oxenstierna, *The World of the Norsemen* (London, 1957), pl. 27; K. Hauck, 'Der Missionsauftrag Christi und das Kaisertum Ludwigs des Frommen' in *Charlemagne's Heir* (cit. at n. V/13), pl. 5 after p. 738, and pp. 278–9.

27 *Aeneid*, Bk IV, l.159, 'aut fulvum descendere monte leonem'.

28 I. Henderson (cit. at n. II/35), pp. 134–40.

29 ibid., p. 111, fig. 24; Alexander (cit. at n. I/5), pls 171–2; *Making of England* (cit. at n. I/78), no. 160, p. 207.

30 Alexander (cit. at n. I/5), pls 31, 74.

31 I. Henderson (cit. at n. II/35), pp. 119–34.

32 The back hoofs of the lamb, and the forepaws of a hound, remain on the edge of the fragment, at the right. The depth of the fragment, from the surface of David's hands on the front to its rather humped back, is 18 cm. The St Andrews Sarcophagus main panel, at its deepest, is 12 cm; see I. Henderson, 'Descriptive Catalogue of the Surviving Parts', *St Andrews Sarcophagus* (cit. at n. Intro/32), p. 20. It seems probable that the back of the Kinneddar fragment was once also carved.

33 I. Henderson (cit. at n. II/39), pp. 139–41.

34 London, British Library Cotton MS. Tiberius C.vi, f. 8; F. Wormald, 'An English Eleventh-Century Psalter with Pictures', *The Walpole Society*, 38 (1962), pp. 1–13.

35 The list of musical instruments with which God is praised in Psalm 150 ends with cymbals: 'Laudate eum in cymbalis bene sonantibus: laudate eum in cymbalis jubilationis'. In the Stuttgart Psalter illustration of Psalm 150, cymbals are evidently represented as two small conjacent discs, like clappers, held upright on a pair of jointed stems. Apparently the same instrument, but seen side-on and looking like toasting forks, is represented in the Vivian Bible. In the Utrecht Psalter the cymbal player may be the figure in a tense cross-legged pose at the right of the scene, elegantly holding up two more substantial discs, both at the same level. The dancing or swaying figure at the top right of the Psalter preface in Charles the Bald's Psalter looks to be holding a pair of round-headed chime bells, rather than instruments to be struck one upon the other. For illustrations of these, see *The Utrecht Psalter in Medieval Art: Picturing the Psalms of David*, ed. K. van der Horst, W. Noel, and W. C. M. Wüstefeld ('t Goy-Houten, 1996), fig. 6, p. 6, and figs. 5, 7, p. 88. For the Utrecht Psalter, see E. T. deWald, *The Illustrations of the Utrecht Psalter* (Princeton, New Jersey, 1933). The Nigg cymbalist, and the trumpeters at nearby Hilton of Cadboll, might have had an admonitory purpose as distinct from simply narrative, and allude to the 'sounding trumpet' and 'clashing cymbal' of I Corinthians, 13, I.

36 Leiden, Universiteitsbibliotheek Voss. Lat. Q.79, for which see W. Koehler and F. Mütherich, *Karolingischen Miniaturen, IV, Einzelhandschriften aus Lotharingien* (Berlin, 1971), pp. 108–16, pls 75–96; *Aratea: Faksimile Ausgabe des Leidener Aratus mit Kommentarband* (Lucerne, 1989).

37 *The Oxford History of Classical Art*, ed. J. Boardman (Oxford, 1993), no. 84, pp. 94–6. On the figure at Nigg, see I. Henderson (cit. at n. II/39), pp. 138–9.

38 *Age of Spirituality* (cit. at n. III/22), no. 85, pp. 94–5.

39 Just as triangular and shallow curved pediments alternate over the windows on Antique revival villa facades by Palladio, for example Palazzo Thiene, Vicenza, for which see J. S. Ackerman, *Palladio*, The Architect and Society Series

(Harmondsworth, 1966), pls 46, 48, pp. 95, 97. The gabled ciborium sheltering the *crux gemmata* in the Dumbarton Oaks glass chalice has a markedly low-slung arch topped by a triangular pediment: see no. 545 in *Age of Spirituality* (cit. at n. III/22), and p. 151 below.

40 Ritchie (cit. at n. II/19), p. 43.

41 Stevenson, 'Further Thoughts on Some Well Known Problems', *Age of Migrating Ideas* (cit. at n. I/102), p. 24; see Chiron with a plant over his shoulder on a black-figure cup in Palermo in Beazley (cit. at n. V/23), pl. 20, 2.

42 *f.* 12 in London, British Library Harley MS. 647, for which see Koehler and Mütherich (cit. at n. V/36), IV, pls 62–74.

43 *Statistical Account of Scotland* (Edinburgh, 1791–9), I, pp. 506–7.

44 Dublin, Trinity College MS.58, *ff.* 28v, 32v.

45 Bruce-Mitford (cit. at n. I/8), 2, *Arms, Armour and Regalia* (London, 1978), pp. 487–522, and figs. 377, p. 513, 385, p. 522.

46 G. Henderson (cit. at n. I/24), pl. 45, p. 44.

47 ibid., p. 233, p. 163; see also J. Stevenson, *The Catacombs: Rediscovered Monuments of Early Christianity* (London, 1978), pp. 63–84.

48 Alexander (cit. at n. I/5), pl. 202.

49 Harbison (cit. at n. I/33), pl. 89.

50 G. Henderson (cit. at n. I/61), pp. 158–9.

51 See n. 4, above.

52 M. Lapidge, 'The New Learning', *Making of England* (cit. at n. I/78), pp. 71–3; D Ó Corráin, 'The Historical and Cultural Background of the Book of Kells' in *The Book of Kells: Proceedings of a Conference at Trinity College Dublin, 6–9 September, 1992*, ed. F. O'Mahony (Aldershot, 1994), pp. 1–32.

53 For the range of interpretations roused by the Aberlemno Churchyard battle scene, see for example G. D. R. Cruickshank, *The Battle of Dunnichen* (Balgavies, 1991), and C. Cessford, 'A Lost Pictish Poem?', *Scottish Literary Journal*, 23, No. 2 (November, 1996), p. 7.

54 Alexander (cit. at n. I/5), pl. 349.

55 G. Henderson (cit. at n. I/11), pp. 105–21.

56 R. N. Bailey, *Viking Age Sculpture* (London, 1980), pp. 162–70, and pl. 48; G. Henderson, *Bede and the Visual Arts*, Jarrow Lecture (1980), pp. 12–13.

57 L. Wüthrich, *Wandgemälde von Müstair bis Hodler: Katalog der Sammlung des Schweizerischen Landesmuseums Zürich* (Zürich, 1980), pp. 26–41; J. S. Cwi, 'A Study in Carolingian Theology: The David Cycle at St John, Müstair' in *Riforma religiosa e arti nell' epoca Carolingia*, ed. A. A. Schmid (Bologna, 1983), pp. 117–27.

58 F. Wormald, 'Style and Design' in *The Bayeux Tapestry* (cit. at n. V/19), p. 29, and nn. 21, 22, p. 35.

59 H. Miller, *Scenes and Legends of the North of Scotland*, 2nd edn (Edinburgh, 1860), pp. 39–44.

60 *ECMS*, 2 (pt. III), fig. 386, and p. 367.

61 I. Henderson (cit. at n. II/100), pp. 161–77 and fig. 14.1, p. 162.

62 *ECMS*, 2 (pt. III), pp. 149–51, figs. 156, 156A. For two monuments, see P. J. McCullagh, 'Excavations at Sueno's Stone, Forres, Moray', *PSAS*, 125 (1995), pp. 697–718, espec. pp. 701–2.

63 For the columns of Trajan and Marcus Aurelius as major features of medieval Rome, see references in R. Krautheimer, *Rome, Profile of a City 312–1308* (New Jersey, 1980).

64 For the construction of the illustrations in the Vatican Virgil see T. B. Stevenson, *Miniature Decoration in the Vatican Virgil: A Study in Late Antique Iconography* (Tübingen, 1983); D. H. Wright, *The Vatican Vergil, a Masterpiece of Late Antique Art* (Berkeley, 1993).

65 G. Henderson (cit. at n. I/11), pp. 24–30.

66 *Cassiodori Senatoris Institutiones* (cit. at I/22), Bk II, pp. 89–172, espec. section 15, pp. 125–27 for citations of Virgil.

67 Painted wall plaster showing a fragmentary figure with a spear, from Otford, Kent, probably 4th century, preserved in the British Museum; the scene has a caption written between ruled lines taken from either *Aeneid* Bk I, l. 313 or Bk XII, l. 165. For this see Toynbee (cit. at n. I/48), p. 205 and n. 1. See also pp. 203–5 and pl. 235 for the 4th-century mosaic from the Roman Villa at Low Ham, Somerset, showing scenes from the story of Dido and Aeneas. The scene of the hunt is depicted merely like a horse race, and Dido does not ride side-saddle.

68 *EH*, Bk IV, 26, pp. 428–9, 'fluere ac petro sublapsa referri', Aeneid, Bk II, l. 169.

69 ibid., Bk II, 12, pp. 178–9, 'et caeco carperetur igni'; *cf. Aeneid*, Bk IV, l. 2, 'et caeco carpitur igni'. The same device of colouring the narrative by Virgilian allusion is used by Jerome in his Life of the hermit St Paul, for which see nn. 4 and 51 above. The account of the first encounter of the aged saints is aptly solemnized by two lines taken from different books of the *Aeneid*, both concerned with the 'age-worn' Anchises, one about his stubborn refusal to quit Troy, and the other in connection with the earnest search for him in the Elysian Fields.

70 *EH*, Bk V, 21, pp. 534–5 and 540–41; *cf. Aeneid*, Bk III, ll. 681–2. For other examples of knowledge of Virgil in Anglo-Saxon England in this period, see A. Orchard, *The Poetic Art of Aldhelm* (Cambridge, 1994), pp. 130–35 and A. Orchard, *Pride and Prodigies. Studies in the Monsters of the* Beowulf-Manuscript (Cambridge, 1995), pp. 99–103.

71 *Aeneid*, Bk IV, l. 139, 'aurea purpuream subnectit fibula vestem'. Alexander Duff, or his executors, wholly or partly responsible for the desecration of the Hilton of Cadboll cross-slab and its reemployment as a personal memorial dated 1676 with an inscription complacently citing 'Solomon the Wise', might conceivably have read the images on the back as an illustration of III Kings, 10, 13, when after the Queen of Sheba has paid tribute to the wisdom of Solomon, 'so she turned and went to her own country, she and her servants'. Another crumb of Solomon's wisdom might have stayed their vandal hands, Proverbs, 22, 28, 'Remove not the ancient landmark which thy fathers have set'.

72 G. Henderson (cit. at n. I/11), pp. 94–6, and 105; L. E. Webster, 'Stylistic Aspects of the Franks Casket' in *The Vikings*, ed. R. T. Farrell (Chichester, 1982), pp. 20–31.

73 G. Henderson (cit. at n. I/11), pp. 118–21.

74 For Glenferness see *ECMS*, 2 (pt. III), figs. 119, 120, opp. p. 97.

75 ibid., fig. 230B, opp. p. 216.

76 ibid., pp. 289–90 and fig. 306B. Under the feet of the soldiers at the bottom of the slab, a lion-like animal has grabbed a man by the back of his head. See I. Henderson (cit. at n. Intro/29), pl. VII(b) and p. 46. To some extent these images are paralleled in the Apocryphal Acts of St Andrew, the text of which was known in the West from the epitome by Gregory of Tours. The saint is exposed to, and unharmed by, a bull led in by thirty soldiers and incited by two hunters, and is also unharmed by a fierce leopard, which instead seizes and strangles the son of the proconsul who has ordered the saint's execution. See M. R. James, *The Apocryphal New Testament* (Oxford, 1924), p. 343.

77 Cramp (cit. at n. I/31), pt. One, no. 20, p. 115; Wilson (cit. at n. Intro/16), pl. 50, p. 55.

78 Harbison (cit. at n. Intro/35), I, p. 12 and II, fig. 11.

79 H. Mayr-Harting, *The Coming of Christianity to Anglo-Saxon England* (London, 1972), pp. 224–5 and p. 316, nn. 13, 14.

80 Dublin, Trinity College MS.55, *f.* 149v; Alexander (cit. at n. I/5), pl. 1.

81 G. Henderson (cit. at n. I/11), p. 79.

82 Isaiah, 6, 1; Malachi, 3, 1.

83 Exodus, 36, 35 and 37, 9; Matthew 27, 51; Hebrews, 9, 1–11.

84 *The Dream of the Rood* in *The Vercelli Book*, ed. G. P. Krapp (London and New York), pp. 61–5; S. A. J. Bradley, *Anglo-Saxon Poetry* (London, Melbourne and Toronto, 1982), pp. 160–3.

85 Kitzinger (cit. at n. I/9), pp. 41–4, and pl. 80; J. Osborne and A. Claridge, *Early Christian and Medieval Antiquities*, I, *Mosaics and Wallpaintings in Roman Churches*: The Paper Museum of Cassiano dal Pozzo, Series A, pt. II (London, 1996), p. 307.

86 See Chapter 8, pp. 214–25.

87 J. Higgitt, 'The Pictish Latin inscription at Tarbat in Ross-shire', *PSAS*, 112 (1982), pp. 300–21, espec. 308.

88 The closest analogy in manuscript painting to the format of the Nigg cross is the cross-carpet page on *f.* 2v of the Lindisfarne Gospels, introducing the splendidly decorated *incipit* of St Jerome's letter to Pope Damasus. The words *Novum opus ... ex veteri*, in the artistically transcendental form given to them in Lindisfarne (and presumably also by a later generation in Kells, now lost; see G. Henderson (cit. at n. I/24), p. 131) reverberate with more than a reference to an editorial process, however important. So it is reasonable to see in the Nigg Cross, lineal descendant of *f.* 2v of Lindisfarne, a symbolic intent to connect the Old and New Testaments. For the relationship of the 'old' and 'new' Testaments, see St Paul, The Epistle to the Hebrews, 8, 8–9 and espec. 13. For number symbolism see W. Berschin, '*Opus deliberatum ac perfectum*. Why did the venerable Bede write a second prose life of St Cuthbert?' in *St Cuthbert, Cult and Community* (cit. at n. I/54), pp. 95–102, espec. 98–101.

89 G. Henderson (cit. at n. I/24), p. 159.

90 For a full account of the iconography of the pediment see I. Henderson (cit. at n. II/39), pp. 120–9.

91 See Chapter 8, p. 218.

92 R. Deshman, *The Benedictional of Æthelwold*: Studies in Manuscript Illumination, 9 (Princeton, 1995), pl. 19.

93 *The Golden Age of Anglo-Saxon Art 966–1066*, ed. J. Backhouse, D. H. Turner and L. Webster (London, 1984), no. 112, pp. 113–14.

94 G. Henderson (cit. at n. I/11), p. 6; H. Rubeus, *Historiarum Ravennatum Libri Decem* (Venice, 1572), p. 85.

95 R. E. Reynolds, 'A Visual Epitome of the Eucharistic 'Ordo' from the Era of Charles the Bald: The Ivory Mass Cover of the Drogo Sacramentary' in *Charles the Bald: Court and Kingdom*, ed. M. T. Gibson and J. L. Nelson (2nd, rev., edn, Aldershot, 1990), pp. 241–60.

96 cf. the seated ascetics in two terracotta plaques, from Kashmir, Harwan, 4th century, nos 59, 131, 132 in the Department of Indian Antiquities, The Cleveland Museum of Art; *The Cleveland Museum of Art Handbook* (Cleveland, 1978), p. 292.

97 Stuttgart, Württembergische Landesbibliothek, Biblia Fol. 23, *f.* 81; J. Eschweiler and F. Mütherich, *Der Stuttgarter-Bilderpsalter* (Stuttgart 1965–6).

98 *Fables of Aesop*, trans. S. A. Handford (Harmondsworth, 1954, often repr.), pp. 14, 15, 23.

99 C. R. Dodwell and P. Clemoes, *The Old English Illustrated Hexateuch*, Early English Manuscripts in Facsimile, XVIII (Copenhagen, 1974).

100 For two lions, both identified as the Lion of Judah, crouching at either side of the Torah Ark, see bottom of 4th-century gold glass cup, no. 347 in *Age of Spirituality* (cit. at n. III/22).

101 *ECMS*, 2 (pt. III), pp. 33–5 and figs. 31, 31A.

102 *Historia Abbatum auctore Baeda*, ed. C. Plummer (Oxford, 1896, repr. 1956), p. 373; see also G. Henderson (cit. at n. V/56), p. 16. For typology see G. Henderson (cit. at n. I/11), pp. 12–17.

103 I. Henderson (cit. at n. Intro/29), p. 25. For Woodrae and Dunfallandy, see *ECMS*, 2 (pt. III), p. 243, fig. 258A, and p. 288, figs. 305A, C.

104 *Age of Spirituality* (cit. at n. III/22), no. 366, pp. 406–9.

105 I. Henderson (cit. at n. II/3), pl. 43.

106 ibid., pp. 145–7; *ECMS*, 2 (pt. III), p. 224, figs. 235A, B.

107 ibid., p. 246, fig. 259B. See also Ritchie (cit. at n. II/19), p. 43. For the Durham Cassiodorus, see Alexander (cit. at n. I/5), pl. 74.

108 Cruden (cit. at n. III/33), no. 11, p. 26, and pl. 45.

109 I. Fisher and F. A. Greenhill, 'Two Unrecorded Carved Stones at Tower of Lethendy, Perthshire', *PSAS*, 104 (1971–2), pp. 238–41, and pl. 36a.

110 *Making of England* (cit. at n. I/78), no. 137, pp. 175–6.

111 G. Henderson, 'Cassiodorus and Eadfrith Once Again', *Age of Migrating Ideas* (cit. at n. I/102), p. 84; Bruce-Mitford (cit. at n. I/89), pl. XI (1).

112 See n. 34, above.

113 *ECMS*, 2 (pt. III), fig. 336, opp. p. 315; L. and E. A. Alcock (cit. at n. Intro/42), pp. 223–7.

114 Osborne and Claridge (cit. at n. V/85), pp. 94–5, no. 15.

115 Gospel According to St Mark, 16, 15–18. For the division of the Apostles, the festival of which is celebrated on 15 July, see Eusebius, *Ecclesiastical History*, ed. and trans. K. Lake and J. E. L. Oulton, Loeb Series (1926–32), Bk III, ch. 10. See also para. 1 of the 'First Act of the Apostle Thomas' in M. R. James, *The Apocryphal New Testament* (Oxford, 1924), p. 365. A reasonable parallel for such a treatment of the subject occurs on the base of the North Cross at Ahenny, where the group of figures with shepherds' crooks and 'wearing cloaks with hoods, the costume of the traveller', were identified by Françoise Henry, following Helen Roe, as the Mission of the Apostles; see F. Henry, *Irish Art in the Early Christian Period (to 800 AD)*, 3rd edn (London, 1965), p. 151 and pl. 79.

116 O. Pächt, C. R. Dodwell and F. Wormald, *The St Albans Psalter (Albani Psalter)* (London, 1960), pp. 74–5.

117 Alexander (cit. at n. I/5), nos 73, 74, pls 348–52.

118 G. Henderson, 'Emulation and Invention in Carolingian Art' in *Carolingian Culture: Emulation and Innovation*, ed. R. McKitterick (Cambridge, 1994), pp. 248–73. The Irish High Crosses, which have been deemed to respond to contemporary Carolingian stimulus, belong stylistically more to the Ottonian than to the Carolingian period, *pace* P. Harbison. 'The Carolingian Contribution to Irish Sculpture' in *Ireland and Insular Art* (cit. at n. I/7), pp. 105–10.

119 *ECMS*, 2 (pt. III), pp. 252–4 and figs. 263A, B.

120 ibid., p. 258, fig. 268.

121 ibid., p. 265, and fig. 275A.

122 ibid., p. 267. For an illustration, see J. Stuart, *Sculptured Stones of Scotland*, II (Edinburgh, 1867), pl. 101, no. 1.

123 *ECMS*, 2 (pt. III), p. 310, and fig. 325, p. 311. For another interpretation, as male clerics, see E.

Proudfoot, 'Abernethy and Mugdrum: towards reassessment' in *The Worm, the Germ and the Thorn: Pictish and related studies presented to Isabel Henderson*, ed. D. Henry (Balgavies, 1997), pp. 49–50.

124 *ECMS*, 2 (pt. III), pp. 482–3, and fig. 514A.

125 Miller (cit. at n. V/59), pp. 149–50.

126 Press report, *The Press & Journal*, Wednesday, September 1, 1999, p. 3.

127 Wilson (cit. at n. Intro/16), pl. 27, opp. p. 36.

128 Alexander (cit. at n. I/5), no. 59, and pl. 274.

129 Krautheimer (cit. at n. V/63), pp. 115–16, pls 88, 89; C. Davis Weyer, *Early Medieval Art 300–1150*, Medieval Academy Reprints for Teaching, 17 (Toronto, 1986), pp. 88–92.

130 Stuttgart Psalter, *ff.* 22v, 103v, in Eschweiler and Mütherich (cit. at n. V/97).

131 Wilson (cit. at n. Intro/16), pl. 66, p. 70; see also the hair of St Andrew on the St Andrew Auckland Cross in G. Henderson (cit. at n. I/11), pl. 69. The problem of interpretation of the Tarbat scene is exacerbated by the fact that the extant design on the front of the slab, to be balanced symmetrically, indicates a width of the original monument which does not place the seated figure in the Apostles' group at the centre of a company of three, and three, standing figures, but is too much to the right. The centre of such a proposed composition requires a second figure to extend the central area – a second seated figure! Christ seated at the right hand of God the Father would not have standing Apostles as companions. The Virgin Mary stands at Christ's right on the Hedda Shrine, but could hardly sit with him at such a comparatively early date in the history of Christian art: see 'The Coronation of the Virgin on a Capital from Reading Abbey' in G. Zarnecki, *Studies in Romanesque Sculpture* (London, 1979), pp. VI–12. A duplication of the figure of Christ Himself is not wholly out of the question, if the designer of the Tarbat cross-slab knew a composition like the one which lies behind the Communion of the Apostles represented on the Stuma and Riha patens, for which see *Age of Spirituality* (cit. at n. III/22), p. 593, fig. 82 and no. 547, pp. 611–2. The subject of the Communion of the Apostles would give particular aptness to the Old Testament covenant ritual alluded to in the upper part of the panel. Apostles do not stand alongside seated prophets, although the general resemblance of the Tarbat figures to the probable Isaiah, Abraham pair seated in the initial to St Mark's Gospel in the Garland of Howth makes this a tempting solution. Perhaps future excavation on the site will produce more data.

132 *Relics of St Cuthbert* (cit. at n. I/99), pls V, VIII.

133 D. Ó Cróinín, 'Cummianus Longus and the Iconography of Christ and the Apostles in Early Irish Literature' in *Sages, Saints and Storytellers: Celtic Studies in Honour of Professor James Carney*, Maynooth Monographs 2, ed. D. Ó Corráin, L. Breatnach and K. McCone (Maynooth, 1989), pp. 268–79.

134 *Historia Abbatum auctore Baeda*, ed. Plummer, p. 369. For these paintings see G. Henderson (cit. at n. V/56), pp. 15–16. For Bede's celebration in verse of the twelve Apostles, designed as an inscription in a chapel dedicated to the Apostles, see M. Lapidge, *Bede the Poet*, Jarrow Lecture (1993), pp. 2–3.

135 R. N. Bailey (cit. at n. Intro/33), fig. 5, p. 10, and pp. 58–9.

136 The solidity of the Tarbat figure recalls that of John the Baptist on the Ruthwell Cross. For unkempt locks as an attribute of later images of John the Baptist, see *Byzantium: Treasures of*

Byzantine Art and Culture from British Collections, ed. D. Buckton (London, 1994), nos 206, 223, 230, 231.

137 Kitzinger (cit. at n. I/9), pls *passim*.

138 *ECMS*, 2 (pt. III), pp. 317–19 and figs. 332 B, C.

139 A. Ritchie and D. J. Breeze, *Invaders of Scotland*, Historic Buildings and Monuments pamphlet (Edinburgh, n.d.), p. 53; I. Henderson, 'Sculpture North of the Forth After the Take-Over by the Scots' in *Anglo-Saxon and Viking Age Sculpture*, ed. J. Lang, BAR British Series, 49 (1978), p. 58. J. Higgitt 'The Iconography of St Peter in Anglo-Saxon England, and St Cuthbert's Coffin' in *St Cuthbert, Cult and Community* (cit. at n. I/54), p. 282.

140 See St Peter combined with St Paul in Early Christian gold glass 'medallions', in Osborne and Claridge (cit. at n. V/85), pp. 202–10.

141 Toynbee (cit. at n. I/48), no. 45, p. 147 and pl. 48. For a similar headdress see the figure of a woman carved in relief on the cross-slab, Monifieth 2, *ECMS*, 2 (pt. III), p. 229, fig. 242 B.

142 E. Temple, *Anglo-Saxon Manuscripts 900–1066* (London, 1976), no. 77 and pl. 245; no. 56, pl. 167.

143 *Making of England* (cit. at n. I/78), no. 66 (a), pp. 82–3; Alexander (cit. at n. I/5), pl. 173.

144 I. Henderson (cit. at n. II/35), pp. 124, 134, and fig. 30.

145 London, British Library Cotton MS. Nero D. iv, *f.* 25v, Backhouse (cit. at n. I/30), pl. 23, p. 40.

146 G. Henderson (cit. at n. I/24), pl. 192, p. 133.

147 *Making of England* (cit. at n. I/78), no. 131, p. 168; N. Netzer, 'Observations on the Influence of Northumbrian Art on Continental Manuscripts of the 8th Century', *Age of Migrating Ideas* (cit. at n. I/102), pp. 48–9 and fig. 5.9.

148 R. T. Farrell, 'The Archer and Associated Figures on the Ruthwell Cross – A Reconsideration' in *Bede and Anglo-Saxon England*, ed. R. T. Farrell, British Archaeological Reports, 46 (1978), p. 96 and pls VIII, IX.

149 G. Henderson (cit. at n. I/24), pl. 242 and pp. 168–74.

150 Brown (cit. at n. II/109), cover illustration, and pl. 30.

151 See, for example, the front cover of the Lindau Gospels, New York, Pierpont Morgan Library, in P. Lasko, *Ars Sacra 800–1200* (Harmondsworth, 1972), pl. 59.

152 For this use (or abuse) of the delimiting frame as an emotional launching-pad, compare the crucifixion miniature in the Judith of Flanders Gospels, New York, Pierpont Morgan Library MS. 709, *f.* 1v, for which see Temple (cit. at n. V/142), pl. 289.

153 *Age of Spirituality* (cit. at n. III/22), no. 545, pp. 609–10.

154 For angels' ceremonial and spiritual relationship to the Cross see also J. O'Reilly, 'Early Medieval Text and Image: The Wounded and Exalted Christ', *Peritia*, 6–7 (1987–88), pp. 72–118, espec. 110–11.

155 *EH*, pp. 498–503.

156 G. Henderson (cit. at n. I/11), p. 144.

157 Bruce-Mitford (cit. at n. I/89), p. 16 and pl. VII.

158 See R. Trench-Jellicoe, 'Pictish and Related Harps: their form and decoration' in *The Worm, the Germ and the Thorn* (cit. at n. V/123), pl. 5, p. 169.

159 Allen misreads this imagery as 'two angels or cherubim': *ECMS*, 2 (pt. III), pp. 218–9.

160 ibid., fig. 266B, opp. p. 243.

161 ibid., pp. 271–2 and fig. 282 A.

162 This subject is quite often illustrated in this period. See G. Henderson, *Losses and Lacunae in Early Insular Art*, University of York Monograph Series, 3 (1982), p. 26.

163 *ECMS*, 2 (pt. III), pp. 246–7 and fig. 259 A.

164 ibid., p. 12, fig. 7.

165 ibid., pp. 268–9 and fig. 278, opp. p. 265.

166 *Gospel According to St Luke*, 16, 19–31.

167 See I. Henderson (cit. at n. II/3), pl. 44, and p. 148 where the identification of the figures as SS. Paul and Anthony is argued.

168 Or St Donevald or Donald, to whom the Aberdeen Breviary attributes nine daughters. For children as plants see Psalm 127, 3.

169 See *Felix's Life of Saint Guthlac*, ed. B. Colgrave (Cambridge, 1956), ch. L, pp. 156–7.

170 *ECMS*, 2 (pt. III), pp. 286–9 and fig. 305B. For the drawing in the New Minster *Liber Vitae*, London, British Library Stowe MS. 944, *f.* 6, see Temple (cit. at n. V/142), pl. 244.

171 N. M. Robertson, personal communication; cf. N. M. Robertson 'Reading the Stones, I, Women in Pictish Sculpture', *Pictish Arts Society Newsletter*, 8 (Summer, 1991), pp. 5–17.

172 For Constantine's reputed use of the nails in this way see *Elene*, ll. 1167–1200, in *The Vercelli Book*, ed. Krapp, pp. 98–9; Bradley, *Anglo-Saxon Poetry*, pp. 193–4.

173 Or crucible; a similar set of instruments is represented on an incised slab at Abernethy, *ECMS*, 2 (pt. III), p. 282, fig. 299.

174 *EH*, Bk V, ch. 14, pp. 502–5, '...faber iste tenebrosae mentis et actionis...'

175 Gregory, *Dialogues*; Liber IV, c.XXXVIII in *PL*, 77, Col. 392: 'ecce draconi ad devorandum datus sum...Caput meum iam in suo ore absorbuit...'

176 Harbison (cit. at n. I/33), pl. 41.

177 See n. 76, above.

178 I. Henderson (cit. at n. II/38), p. 18.

179 Alexander (cit. at n. I/5), pl. 173; I. Henderson (cit. at n. Intro/29), pl. VII(a).

180 M. A. Hall, I. Henderson and S. Taylor, 'A sculptured fragment from Pittensorn Farm, Gellyburn, Perthshire', *TFAJ*, 4 (1998), pp. 129–44.

181 G. Henderson (cit. at n. I/24), pp. 165–8; G. Henderson (cit. at n. I/61), p. 159.

182 *ECMS*, 2 (pt. III), p. 109, fig. 112.

183 ibid., fig. 252A, opp. p. 237.

184 Alexander (cit. at n. I/5), fig. 8, p. 21.

185 This animal, which looks curiously like the Wolf of Stittenham reversed and stylized after the manner of the Lion of St John in the Book of Durrow, makes a bid for the status of a Pictish symbol on the back of the Golspie Cross-Slab. Allen classified it as a symbol: see *ECMS*, 1 (Parts I and II), p. 74. For Cerberus see Virgil, *Aeneid*, Bk VI, ll. 417–24. Cerberus is memorably depicted on a 6th-century BC Laconian cup, his body seething with snakes, and his tail in the form of a snake (a device later adopted by Pictish artists): see A. Johnston, 'Pre-Classical Greece' in *The Oxford History of Classical Art*, ed. Boardman, no. 72, pp. 74, 76.

186 *Epistle to the Hebrews*, X, 12–18.

187 *ECMS*, 2 (pt. III), p. 303, fig. 316A.

188 *Vita S Perpetuae* in *Acta Sanctorum, Martii* (Antwerp, 1668), I, p. 635.

189 See n. 174, above.

190 For the wheel cross of Meigle No. 2 compared to the Derrynaflan paten, see Chapter 8, p. 224. The Host represented in the pediment of the Nigg Cross-Slab has a portion cut away in the equivalent position of the spear wound in Christ's right side.

191 See for example G. Zarnecki, *Romanesque Lincoln: The Sculpture of the Cathedral* (Lincoln, 1988), pp. 59–63; also New York, Pierpont Morgan Library MS. 521, in C. M. Kauffman, *Romanesque Manuscripts 1066–1190* (London, 1975), no. 66 and pl. 177.

192 However, a fragment of the disassembled front of the Hilton of Cadboll Cross-Slab lifted from the ground on 7 September 2001 represents the haunch and tail of a shaggy beast closely adjacent to the lower part of a frontally-placed human figure whose long, bare (?) legs and feet survive on separate fragments, broken off just below the hem line of a widely-flared robe, preserved from the flounced drapery at the waist downwards and astonishing for the raised arabesque of scrolls, representing sumptuous embroidery, with which the whole skirt is decorated. Insular ornaments on drapery occur on the hem and braids of the figure of Christ on the Athlone plaque and in a more stylized form on the bodies of the Evangelist symbols in the Macdurnan Gospels and the cover of the Soiscel Molaise, for which see Harbison (cit. at n. I/33), pls 89, 131, 141, but these examples do not match Hilton's appearance of a real embroidered textile. The extreme rarity of such decoration on represented drapery in Insular manuscripts suggests that the purpose here is iconographic – that the figure is luxuriously clad. The close proximity of the beast makes it unlikely that *Salomon in omni gloria sua* is intended. A possible candidate is *Dives* in the parable, Luke 16, 19, described as 'induebatur purpura et bysso'. The figure is being assailed by one of the fierce beasts that inhabit the spaces at the sides of the cross, in Hell imagery similar to that of Meigle No. 2.

Chapter 6: Form and Function I pp. 159–195

1 M. R. Nieke, 'Penannular and Related Brooches: Secular Ornament or Symbol in Action?', *Age of Migrating Ideas* (cit. at n. I/102), pp. 128–34.

2 See above p. 87.

3 R. Kozodoy, 'The Reculver Cross', *Arch.* 108 (1986), pp. 67–94, at pp. 88–90, with reference to Jupiter Columns in n. 149, p. 94; See most recently, J. Mitchell, 'The High Cross and Monastic Strategies in Eighth-Century Northumbria' in *New Offerings* (cit. at n. Intro/27), pp. 88–114, at pp. 88–95 with useful discussion and references to the classical and Lombardic comparanda.

4 See above pp. 10–11. Study of the cross-marked stones was inspired by the work of C. Thomas, *The Early Christian Archaeology of North Britain* (Oxford, 1971), pp. 124–5, with a distribution map and range of cross-types. This was developed by I. Henderson, 'Early Christian Monuments of Scotland Displaying Crosses but no other Ornament' in *The Picts: A New Look at Old Problems* (cit. at n. Intro/22), pp. 45–58, which included references to the work in Aberdeenshire of W. Douglas Simpson. The paper included a literature search which was subsequently significantly expanded by N. M. Robertson of Perth through his knowledge of local publications and systematic fieldwork. See also 'Pictish, and related Dalriadic, cross-marked stones', a distribution map in *Atlas of Scottish History to 1707*, ed. P. G. B. McNeill and H. I. Macqueen (Edinburgh: the Scottish Medievalists and Department of Geography, University of Edinburgh, 1996), p. 56.

5 *Adomnán's Life of Columba*, ed. and trans. A. O. Anderson and M. O. Anderson (Edinburgh, 1961; 2nd edn, Oxford, 1991), Bk 2, ch. 35, pp. 408–9. While we need not assume that all of Adomnán's accounts of Columba's dealings with the Picts are historical, all the incidents he cites are replete with scriptural allusions that testify to the importance with which his activity as a saviour of souls was regarded in 7th-century Iona.

6 Fisher (cit. at n. II/60). Figs 1–13 display measured drawings of the incised crosses by I. G. Scott, set out for comparative study. For a selection of characteristic slab shapes see p. 127, A–C. A similar publication for eastern and northern Scotland must now be a priority. Mr Fisher has made available to N. M. Robertson and I. Henderson some of his preliminary survey work on incised crosses in Aberdeenshire and Caithness. The eventual creation of distribution maps for the various types of cross should contribute to the understanding of their function and significance.

7 For distinctive types of cross carrying different meanings see C. D. Sheppard, 'Byzantine Carved Marble Slabs', *Art Bulletin* 51 (1969), pp. 65–71. For the influence of some of these on Irish free-standing crosses see H. Richardson, 'The Jewelled Cross and its Canopy' in *Isles of the North* (cit. at n. Intro/37), pp. 177–86. See also Fisher (cit. at n. II/60), pp. 8–9.

8 RCAHMS, *Argyll*, 4, *Iona* (cit. at n. Intro/2), no. 6, 26. The slab is 205 cm (6 ft 8½ in.) long and 98 cm (3 ft 2½)wide.

9 Fisher (cit. at n. II/60), no. 19, p. 90, ills B and C.

10 I. Henderson, 'The Shape and Decoration of the Cross on Pictish Cross-Slabs Carved in Relief' in *Age of Migrating Ideas* (cit. at n. I/102), pp. 209–18, at p. 209 with references to the date of the board in the coffin. See also Bailey (cit. at n. Intro/33), p. 51. The coffin cross has a stepped base and if this indeed represents the Golgotha cross then the choice of a cross-type symbolic of Christ's redeeming suffering would have had a theological significance transcending, though not obliterating, the historical association of the cross-head with Iona. On literary links between the hagiography of Cuthbert and Columba see A. Thacker, 'Lindisfarne and the Origins of the Cult of St Cuthbert' in *St Cuthbert, His Cult and his Community to AD 1200* (cit. at n. I/54), pp. 103–22, at p. 112.

11 For the Mid Clyth slabs see Blackie and Macaulay (cit. at n. III/4), nos 16 and 17, figs. 19 and 20.

12 Illustrated on the front cover of Blackie and Macaulay (cit. at n. III/4). We are deeply indebted to George and Nan Bethune of Ballachly, who gave us the benefit of access to the slab and to their perceptions of it. The slab will be the subject of a forthcoming study by I. Fisher.

13 Alexander (cit. at n. I/5), ills 2 and 3.

14 For example, see Meehan (cit. at n. I/40), ill. 55.

15 Blackie and Macaulay (cit. at n. III/4), no. 13, fig. 16.

16 For the Hartlepool mould see *Making of England* (cit. at n. I/78), no. 106a, pp. 140–41.

17 G. Henderson (cit. at n. I/24), ill. 11, on p. 23.

18 On the shocking story of the breaking into six pieces of this 7½ foot tall slab sometime in the 1860s see *ECMS*, 2 (pt. III), p. 31. The slab is now in Thurso Museum.

19 See for this suggestion in connection with other Pictish sculpture with forms based on metalwork, I. Henderson in *Age of Migrating Ideas* (cit. at n. I/102), p. 216.

20 On Tullich and its association with 'St Nathalan' see W. D. Simpson, *The Origins of Christianity in Aberdeenshire* (Aberdeen, 1925), pp. 27–30.

21 See below p. 215.

22 *ECMS*, 2 (pt. III), pp. 196–8.

23 Fisher (cit. at n. II/60), p. 13.

24 *ECMS*, 2 (pt. III), p. 196; Simpson (cit. at n. VI/20), p. 55, fig. 24; Fisher (cit. at n. II/60), p. 169, G–J, and M.

25 G. Henderson (cit. at n. I/24), p. 42, ill. 42.

26 ibid., p. 120, ill. 174.

27 R. Trench-Jellicoe, 'The Skeith Stone, Upper Kilrenny, Fife, in its Context', *PSAS*, 128 (1998), pp. 495–513, ill. 5.

28 G. Henderson (cit. at n. I/24), p. 41, ill. 41.

29 For Logie Coldstone see Simpson (cit. at n. VI/20), p. 27, n. 1, and fig. 36. For Columba's 'pillow' see RCAHMS, *Argyll*, 4, *Iona* (cit. at n. Intro/2), p. 188–9, no. 6, 60.

30 For Inchmarnoch see Simpson (cit. at n. VI/20). Simpson cites as his informant, F. C. Diack. Notes on the island site by F. C. Eeles are preserved in RCAHMS, MS/716/11. Here the slab is said to have been removed to a local rockery and subsequently lent to 'the Glasgow Exhibition' of 1911. No trace of it now exists. Mr Eeles describes it carefully and recognized that it was a 'very uncommon type' making the comparisons with both 'St Columba's Pillow' and the Logie Coldstone slab mentioned here. At the time of his writing there were 'traces of an ancient chapel' on the island. Mr Eeles's notes were brought to our attention by I. Fisher of the Royal Commission. For the Rosemarkie stone see below, p. 210.

31 See the fundamental paper, S. Taylor, 'Place-names and the early Church in Scotland', *Scottish Church History Society Records*, 28 (1998), pp. 1–22; S. Taylor, 'Seventh-century Iona abbots in Scottish place-names', *IR*, 48 (1997), pp. 45–72; N. M. Robertson, 'Dominicae crucis signum: simple cross-marked stones as an index of the Christianization of the Picts', part 2, Perthshire. (Unpublished lecture given at a conference to mark the 1,400th anniversary of Columcille's death, Magee College, University of Ulster, 1997).

32 See Trench-Jellicoe (cit. at n. VI/27) who argues, in a fully researched paper that the Skeith stone, with its complex encircled Chi-Rho cross, reflects the expansion of the Ninianic Church.

33 With eight slabs of an early type, Balquhidder has one of the largest concentrations in Scotland. In addition to the slab described, the collection includes linear crosses and a 'sunken cross' of a type found on Iona. Described by Robertson in the lecture cited in n. 31. The name involves the potentially early element *both*. See Taylor (cit. at n. Intro/43), pp. 93–110, at pp. 96–8, 104. Muthill was a 'Culdee' community. For its possible appearance in an early compilation in chronicle form, see E. J. Cowan, 'The Scottish Chronicle in the Poppleton Manuscript', *IR*, 32 (1981), pp. 3–21, at pp. 9–10.

34 For Walls on the Island of Hoy see *ECMS*, 2 (pt. III), p. 25. In Aberdeenshire there are only seven sites in the valleys of the Rivers Dee and Don having symbol-bearing cross-slabs. If the cross-marked stones are taken into account there are more than twenty sites with monuments displaying crosses.

35 For example, Edderton (p. 57), Roskeen (p. 60), Newton House (p. 178), Aberlemno No. 1 (p. 205). All page references to *ECMS*, 2 (pt. III). Associations with prehistoric vestiges are briefly but conveniently indicated in the 'findspot' column of Mack (cit. at n. III/5). Mack's lists and information are up-to-date, and his accompanying discussion always valuable. Allen in *ECMS*, 2 (pt. III), 1903, has the benefit of his acute and trenchant observations, his descriptions of the non-symbol-bearing relief monuments and the analyses of the decorative patterns. For other useful listings see the Select Reference Bibliography, p. 248.

36 For example, Clynekirkton (p. 38), Tillyarmont (p. 186), Newbigging Leslie (pp. 177–8), all in *ECMS*, 2 (pt. III). Study of the contours of the lower edges

of Pictish slabs, even where available, have yet to be undertaken.

37 For example, there are clusters of four or more symbol stones recorded by Allen, in *ECMS*, 2 (pt. III), at Kintradwell (p. 43), Little Ferry Links (p. 45), Inveravon (p. 152), Inverurie (p. 168), Kintore (p. 171), Rhynie (p. 182) and Tillyarmont (p. 186), and Mack (cit. at n. III/5), nos 223–7. The most southerly cluster was on the headland of Dunnicaer, Kincardineshire, nos 62–6.

38 P. J. Ashmore, 'Low cairns, long cists and symbol stones', *PSAS*, 110 (1978–80), pp. 346–55.

39 L. and E. A. Alcock (cit. at n. Intro/42), pp. 242–87, at p. 264.

40 E. Proudfoot, 'Excavations at the long cist cemetery on the Hallow Hill, St Andrews, Fife', *PSAS*, 126 (1996), pp. 387–454.

41 J. Close-Brooks, 'Excavations in the Dairy Park, Dunrobin, Sutherland, 1977', *PSAS*, 110 (1978–80), pp. 328–45. The skeletal remains in the grave gave a radiocarbon date bracket of AD 653–782, a date-span as Alcock (cit. at n. Intro/42) rightly observes 'is fully consistent with a Christian burial'.

42 I. Henderson (cit. at n. Intro/29), pp. 13–14. For Caledonian metalwork, see M. Macgregor, *Early Celtic Art in North Britain*, 2 vols (Leicester, 1976).

43 For the Stabio shield mounts see *I Longobardi*, ed. G. C. Menis (Milan, new edn, 1992), pp. 182–3. For the Spong Hill shield appliqués see C. Hills, 'Chamber Grave from Spong Hill, North Elmham, Norfolk', *MA*, 21 (1977), pp. 167–76, at pp. 173–5, fig. 64. The fish were positioned on the shield on either side of its boss, each attached by two bronze rivets extending from their backs. The shape of the fish is naturalistic, with anatomical resemblances to the, then exotic, zander, and the native pike. The excavator remarks that either fish 'would be a suitable warrior emblem, both being aggressive carnivores'.

44 A select bibliography for the meaning of the symbols will be found in the Select Reference Bibliography, p. 248.

45 *ECMS*, 1 (pt. I), p. xxxix.

46 The discussion following does not take into account the current debate on the nature of the evidence of the oghams on Pictish sculpture. See above p. 12. For an authoritative account of Pictish oghams see K. Forsyth, 'Literacy in Pictland' in *Literacy in Medieval Celtic Societies*, ed. H. Price (Cambridge, 1998), pp. 39–61.

47 E. Okasha, 'The Non-Ogam Inscriptions of Pictland', *CMCS*, 9 (1985), pp. 43–69. Fordoun, pp. 51–2 (*ECMS*, 2 (pt. III), figs. 217A and B). St Vigean's No. 1, pp. 59–61, pl. V. The recent discovery of a section of an ogham inscription on the side of a fragment carved with a 'double-disc' symbol decorated with high-relief developed spirals shows that the two alphabets were used at the same site.

48 Thomas (cit. at n. IV/7), pp. 31–97; 'The Pictish Class 1 Symbol Stones' in Pictish Studies: Settlement, Burial and Art in Dark Age Northern Britain, BAR British Ser., 125 (Oxford, 1984), pp. 169–88.

49 A. Jackson, *The Symbol Stones of Scotland. A Social Anthropological Resolution of the Problem of the Picts* (Kirkwall, 1984).

50 R. Samson, 'The Reinterpretation of the Pictish Symbols', *JBAA*, CXLV (1992), 29–65. K. Forsyth, 'Some thoughts on Pictish symbols as a formal Writing System' in *The Worm, the Germ and the Thorn* (cit. at n. V/123), pp. 85–98.

51 S. T. Driscoll, 'Power and authority in Early Historic Scotland: Pictish symbol stones and other documents' in *State and Society: the*

Emergence and Development of Social Hierarchy and Political Centralization, ed. J. Gledhill, B. Bender and M. Larson (London, 1988), pp. 215–36.

52 For Pool, see RCAHMS, *Pictish Symbol Stones. An Illustrated Gazetteer* (Edinburgh, 1999), no. 171, p. 37; for Dunnicaer, Alcock and Alcock, 'Reconnaissance excavations.....C, Excavations at Dunnottar, Kincardineshire, 1984, *PSAS*, 122 (1992), pp. 267–82; with drawings of the five symbol-bearing plaques, ill. 36. There is a photograph of four of the plaques in F. C. Diack, *The Inscriptions of Pictland*, ed. W. M. Alexander and J. Macdonald (Aberdeen, 1944). Plain symbols are found, most commonly, north of this cluster. For the forms of symbols appearing in cave-art see Thomas (cit. at n. IV/7), p. 44, fig. 2.

53 For relevant 'art-mobilier', including the stone discs, see the definitive account in Thomas (cit. at n. IV/7), pp. 44–8. For the northern material see A. Ritchie, 'The Picts in Shetland' in *The Worm, the Germ and the Thorn* (cit. at n. V/123), pp. 35–46.

54 '... there went out a decree from Caesar Augustus that the whole world should be enrolled'.

55 Forsyth (cit. at n. VI/50), p. 93.

56 For both carvings see Fisher (cit. at n. II/60), no. 34, pp. 102–3.

57 See above, p. 162.

58 RCAHMS, *Argyll*, 4, *Iona* (cit. at n. Intro/2), no. 6, 22, pp. 182–3. Alexander (cit. at n. I/5), ill. 20 (Book of Durrow) and ill. 5 (Cathach).

59 For Seaton, now in St Machar's Cathedral, Old Aberdeen, see Simpson (cit. at n. VI/20), fig. 25. For Alyth see *ECMS*, 2 (pt. III), p. 286, figs. 304A and B; RCAHMS, *South-East Perth, an archaeological landscape* (Edinburgh, 1994), p. 96.

60 *Tarbat Discovery Programme*, University of York, Bulletin No. 3 (1997), Appendix 2, TR 19. Rosemarkie, listed for SCRAN, ROMGH 1996.4. The Rosemarkie example is miniature, but has the additional interest of using the contrasting white geological veins in the micaceous granulitic gneiss to set off the roughly shaped relief cross. Such use of geological coloration has a parallel on a small 9th-century slab at Hoddom, Dumfriesshire where the stone is 'dressed back to leave a white cross in relief against a red background'. D. Craig, 'The Sculptured Stones from Hoddom, 1991', Appendix 1, in C. A. Lowe, 'New Light on the Anglian Minster at Hoddom', *Trans. of the Dumfriesshire and Galloway Natural History and Antiquarian Society*, LXVI (1991), pp. 27–9. fig. 11. Small relief crosses, of a generally similar type are found in the west. See Fisher (cit. at n. II/60), ill. 14. The date of such carvings is uncertain but the occurrence of examples of the type at these particular Pictish sites, whose assemblage of sculpture is very similar, increases the likelihood that they belong to an early period.

61 *ECMS*, 2 (pt. III), pp. 201–3, figs. 217A and B (Fordoun); pp. 306–8, fig. 32B (Rossie); pp. 215–16, fig. 229 (Balluderon).

62 The typological relationship proposed above (p. 172) does not contradict 1 Corinthians, XIII, 12; 'We see now through a glass in a dark manner: but then face to face'.

63 I. Henderson (cit. at n. II/3), pp. 128–9. The laborious smoothing of the incised line, such as is evident on the Brandsbutt, Aberdeenshire symbol stone, *ECMS*, 2 (pt. III), pp. 506–7, fig. 551, would cease to be necessary, but the pecked, and even V-shaped, incision would remain useful for laying out the design. That different stone types called for different techniques, and possibly tools, would have prepared the way for the change to relief carving. On the design principles governing much

Pictish sculpture see I. Henderson (cit. at n. II/35), pp. 103–4.

64 RCAHMS, *Argyll*, 4, *Iona* (cit. at n. Intro/2), pp. 183, 185–6.

65 I. Henderson, 'The Shape and Decoration of the Cross on Pictish Cross-Slabs Carved in Relief' in *Age of Migrating Ideas* (cit. at n. I/102), pp. 209–18, at p. 216. *ECMS*, 2 (pt. III): pp. 221–3, figs 233A and B, 234A and B (Glamis Nos 1 and 2); pp. 218–19, figs 231A and B (Eassie); pp. 296–7, figs. 310A and B (Meigle No. 1).

66 The planning skills necessary for carving elements in a design in a range of differing heights of relief, so common in Pictish sculpture, would have called for extensive retraining of sculptors. The passing on of new technical skills is one way in which subject matter and repertoire could have been disseminated.

67 *ECMS*, 2 (pt. III): pp. 189–90, fig. 206 (Dyce No. 2); pp. 191–2, fig. 208 (Migvie); pp. 192–3, fig. 209 (Monymusk).

68 *Age of Spirituality* (cit. at n. III/22), p. 65, fig. 14. Much of the discussion which follows is inspired by the account by R. Brilliant of scenic representations, in Section I of the catalogue, 'The Imperial Realm'.

69 J. L. Nelson, 'The Lord's anointed and the people's choice: Carolingian royal ritual' in *Rituals of Royalty. Power and Ceremonial in Traditional Societies*, ed. D. Cannadine and S. Price (Cambridge, pbk edn 1992). On how the Pictish representation of hunts might reflect such rituals, see I. Henderson 'The Picts: Written Records and Pictorial Images' in *Stones, Symbols and Stories. Aspects of Pictish Studies. Proceedings from the Conferences of the Pictish Arts Society, 1992*, ed. J. R. F. Burt, E. O. Bowman and N. M. Robertson (Edinburgh, 1994), pp. 44–57, at pp. 51–3.

70 *Age of Spirituality* (cit. at n. III/22), p. 64.

71 The fragmentary but massive slab at Dunkeld (*ECMS*, 2 (pt. III), pp. 317–19; better illustrated in RCAHMS, *South-East Perth*, pp. 89 and 96–7) and 'Sueno's Stone', the very tall slab at the edge of Forres, Moray, are frequently attributed to influences from the incoming Irish from the west of Scotland in the 9th century, in spite of the fact that there are no monuments in that region which can account for such sculpture. These monuments and many others in eastern Scotland, however dated, are a natural extension of the Pictish monumental tradition, whatever opportunities for cultural interaction have contributed to the inner development of their style. Both these monuments combine warfare with the representation of sanctity (the haloed large-scale figure on a narrow edge at Dunkeld), and ceremonial (the enigmatic figurative scene carved under the cross at Forres).

72 L. Webster in the entry for the Franks Casket, *Making of England* (cit. at n. I/78), no. 70, pp. 101–3, at p. 103.

73 For classical hybrids, animal lore and monstrous animals in Pictish sculpture see I. Henderson (cit. at n. Intro/29).

74 Orchard (cit. at n. V/70).

75 J. Borsje, *From Chaos to Enemy: Encounters with Monsters in Early Irish Texts. An Investigation Related to the Process of Christianization and the Concept of Evil, Instrumenta Patristica*, 29 (Turnhout, 1996).

76 For *Physiologus* and Pictish sculpture see I. Henderson (cit. at n. Intro/29), pp. 2–13. Note, in particular, at p. 3, '*Physiologus* was essentially a pastoral text for moral instruction… the basic philosophical position is that every aspect of God's creation reflects an aspect of God'.

77 For example, in the succinct and well-balanced account of the Pictish cross-slabs in Ritchie (cit. at n. II/19), pp. 29–37, at p. 31.

78 'Even at the end of the eighth century [in England] many Christian communities of long standing were still unprovided with any form of church. Archbishop Theodore [archbishop for the English 668–690] had allowed priests to say mass "in the field"', F. M. Stenton, *Anglo-Saxon England* (Oxford, 1943, repr. many times) p. 150.

79 J. Stevenson, in F. E. Warren, *The Liturgy and Ritual of the Celtic Church* (Oxford, 1881); repr. with Introduction by J. Stevenson, *Studies in Celtic History*, 9 (Woodbridge, 1987), pp. lx–lxi. Even today in its worn condition and protected by a glass shelter the Shandwick cross-face looks dazzling in full sunlight.

80 J. Harden in a lecture given in the History of Art Department, University of Cambridge, 1994. See also J. Harden, 'A Potential Archaeological Context for the Early Christian Sculptured Stones from Tarbat, Easter Ross' in *Isles of the North* (cit. at n. Intro/37), pp. 221–7. The ditch at Tarbat, and its associated bank, are now considered to be datable to the Christian period, and so may form the boundary for a monastic site.

81 J. O'Sullivan, 'Excavation of an early church and a women's cemetery at St Ronan's medieval parish church, Iona', *PSAS*, 124 (1994), pp. 327–65 at p. 361.

82 G. Stell, 'Architecture and Society in Easter Ross before 1707' in *Firthlands of Ross and Sutherland*, ed. J. R. Baldwin (Edinburgh, 1986), pp. 110–11.

83 For a striking picture of the base still in the ground see *Historic Scotland*, Winter, 2001, p. 18.

84 *ECMS*, 2 (pt. III), pp. 300–1, figs. 314A, B and C.

85 *ECMS*, 2 (pt. III), pp. 227–8, figs. 240A and B.

86 *ECMS*, 2 (pt. III), pp. 226–7, figs. 239A and B.

87 p. 143.

88 p. 212.

89 *ECMS*, 2 (pt. III), pp. 350–63, 373, 510–13; D. Hay Fleming, *St Andrews Cathedral Museum* (Edinburgh, 1931). The early sculpture is numbered and described on pp. 1–52; I. Henderson (with drawings by I. G. Scott), 'Towards defining the function of sculpture in Alba: the evidence of St Andrews, Brechin and Rosemarkie' in *Kings, Clerics and Chronicles* (cit. at n. Intro/8), pp. 35–46.

90 *ECMS*, 2 (pt. III), pp. 255–6, figs. 266A and B (= Invergowrie No. 1 facing page 243).

91 N. M. Robertson, with photographs by Tom E. Gray, 'The Early Medieval Carved Stones of Fortingall' in *The Worm, the Germ and the Thorn* (cit. at n. V/123), pp. 133–48.

92 *ECMS*, 2 (pt. III), pp. 53–4, figs. 51 and 51A.

93 *ECMS*, 1 (pt. II), p. 389.

94 See above p. 51.

95 As suggested by L. de Paor in his wide-ranging paper, 'The High Crosses of Tech Theille (Tihilly), Kinnitty, and Related Sculpture' in *Figures from the Past: Studies on Figurative Art in Christian Ireland in honour of Helen M. Roe*, ed. E. Rynne (Dublin, 1987), pp. 131–58, at p. 150. The notion of a ringed cross was present in manuscript art by the time of the Lindisfarne Gospels. Pictish responses to manuscript art of this period are demonstrated above, p. 35. It is probable that an encircled equal-armed cross was one of the earliest types appearing on Pictish cross-marked stones.

96 For a good record of the section of the Dunfallandy cross-slab intended to be concealed in the earth see the frontispiece to vol. 2 of the 1993 reprint of *ECMS*.

97 *ECMS*, 2 (pt. III), pp. 344–7, figs. 359A and B.

98 For the Canna cross see Fisher (cit. at n. II/60), pp. 98–9. For the Pictish connections see p. 16.

The format of the Canna cross can be seen as a hybrid free-standing/slab, comparable to the virtually hybrid formats discussed above.

99 Fisher (cit. at n. II/60), pp. 88–9.

100 For Carpow see E. Proudfoot (with photographs by Tom E. Gray), 'Abernethy and Mugdrum: towards reassessment' in *The Worm, the Germ and the Thorn* (cit. at n. V/123), pp. 53–4; *ECMS*, 2 (pt. III), pp. 311–13, figs. 327A and B.

101 N. Edwards, 'The Origins of the Free-standing Cross in Ireland: Imitation or Innovation?' *Bulletin of the Board of Celtic Studies*, XXXII (1983), pp. 392–410, at pp. 395–6, pl. IIIA and B.

102 See below p. 201.

103 RCAHMS, *Argyll*, 4, *Iona* (cit. at n. Intro/2), p. 198.

104 J. Hawkes, 'An Iconography of Identity? The Cross-Head from Mayo Abbey' in *From Ireland Coming. Irish Art from the Early Christian to the Late Gothic Period and its European Context*, ed. C. Hourihane (Princeton, 2001), pp. 261–75.

105 Toynbee (cit. at n. I/48), no. 82, pp. 157–8, pl. 87 (Tombstone for a cavalryman, Gloucester); no. 89, p. 161, pl. 86 (Mother and Child grave relief from Murrell Hill, Cumberland).

106 E. Proudfoot in *The Worm, the Germ and the Thorn* (cit. at n. V/123), pp. 54–6.

107 L. and E. A. Alcock (cit. at n. Intro/42), pp. 215–42.

108 K. Forsyth, 'The Inscriptions on the Dupplin Cross' in *Isles of the North*, ed. Bourke, pp. 237–44. For the 'Pictishness' of Constantin see D. Broun, 'Pictish Kings 761–839: Integration with the Dál Riata or Separate Development?' in *St Andrews Sarcophagus* (cit. at n. Intro/32), pp. 71–83, at p. 80.

109 I. Henderson (cit. at n. II/100), pp. 161–77.

110 For a juxtaposition of the surviving long panel of the St Andrews Sarcophagus and the front of the Dupplin Cross see *The Transformation of the Roman World AD 400–900*, ed. L Webster and M. Brown (London, 1997), pls 65 and 67. Plate 57 op. cit. shows the most extreme stylization of this convention.

111 In 2002 prior to the removal of the Dupplin Cross from Edinburgh to its permanent home in the church at Dunning, Perthshire, Ian G. Scott drew the entire monument. The description of the carving given in I. Henderson (cit. at n. II/100), is correct, with the exception of the motif in the left corner of the lowest panel on the back. This is not as stated on p. 174 a human figure wielding a stick, but an animal set vertically with a weapon passing under its nearside foreleg and behind or through its neck, and is presumably part of a generalized hunting scene.

112 I. Henderson (cit. at n. II/100), p. 173, fig. 14.7.

113 H. Richardson, 'The Concept of the High Cross' in *Ireland and Europe*, ed. P. Ní Chatháin and M. Richter (Stuttgart, 1984), pp. 127–34.

114 R. Bailey (cit. at n. Intro/33), p. 50.

115 I. Henderson, in M. Hall et al., 'Of makings and meanings: towards a cultural biography of the Crieff Burgh Cross, Strathearn, Perthshire', *TFAJ*, 6 (2000), pp. 154–88, at pp. 154–66.

116 K. Forsyth and R. Trench-Jellicoe, in Hall et al. (cit. at n. VI/115), pp. 166–8.

117 M. Hall and A. Watson, in Hall et al. (cit. at n. VI/115), pp. 168–83.

118 On the St Vigean's inscription see E. Okasha, 'The Early Christian Carved and Inscribed Stones of South-west Britain' in *Scotland in Dark Age Britain* (cit. at n. Intro/43), pp. 21–32. Also, T. O. Clancy, 'The Drosten Stone: a new reading', *PSAS*, 123 (1993), pp. 345–53. The new reading is based on a tentative suggestion made by Okasha in 'The Non-

Ogam Inscriptions of Pictland' (cit. at n. VI/47) and the dating formula it provides is therefore not strong enough to support, independently, an absolute chronology. For the art of the slab see I. Henderson in Okasha's 1985 paper at pp. 60–1, and I. Henderson (cit. at n. Intro/29), pp. 42–4.

119 For St Andrews No. 19 see I. Henderson in *Kings, Clerics and Chronicles* (cit. at n. Intro/8), pp. 38–40.

120 Henderson in M. Hall, I. Henderson and S. Taylor, 'A Sculptured fragment from Pittensorn Farm, Gellyburn, Perthshire', *TFAJ*, 4 (1998), pp. 129–44, at pp. 129–36.

121 *ECMS*, 2 (pt. III): pp. 330–1, fig. 343B (Meigle No. 9); pp. 337–8, fig. 351B (Meigle No. 23); p. 339, fig. 353A (Meigle No. 27).

122 I. Henderson in *Kings, Clerics and Chronicles* (cit. at n. Intro/8), p. 39. Illustrated in Hay Fleming (cit. at n. VI/89), figs 19–22.

123 Hay Fleming (cit. at n. VI/89), p. 14, figs 8 and 9 (no. 6); p. 45, figs 68–9 (no. 52).

124 R. B. K. Stevenson, 'The Inchyra Stone and some other unpublished Early Christian monuments', *PSAS*, 92 (1958–59), pp. 33–55, at p. 42, pl. VI. For 'only' one would wish to substitute 'only surviving'. For example, the nature of the no doubt impressive cross-head of the shaft at Mugdrum, Fife, is wholly lost to us.

125 For the placing of the cross-head within the tradition of composite free-standing crosses on Iona and in Ireland see D. Mac Lean, 'Technique and Contact: Carpentry-constructed Insular Stone Crosses' in *Isles of the North* (cit. at n. Intro/37), pp. 167–75, at p. 171. Mac Lean questions perceptively the suitability of a 'linear progression' model for the understanding of developments in Insular sculpture (pp. 173–4).

126 Forteviot No. 3, Alcock and Alcock, 1992, p. 224, ill. 5; *ECMS*, 2 (pt. III), p. 326, figs 337A and B. The Alcocks comment: 'Forteviot No. 3...is a fragment from the arm of a free-standing ringed cross, and is therefore of Irish, Scottish (Ionan), or (unlikely) Anglo-Saxon inspiration, rather than Pictish'. Such ethnic rigidity in respect of form cannot be justified.

127 For the key-pattern on the ring see JRA No. 887, *ECMS*, 1 (pt. II), p. 331; for the interlace pattern on the edge. JRA No. 773, p. 288 (*recte* Burghead No. 8). For Kinneddar, *ECMS*, 2 (pt. III), p. 146, figs 151A and B (ringed cross-head fragment); p. 147, figs 152A and B (cross-shaft).

128 *ECMS*, 2 (pt. III), p. 328, figs 340 and 341.

129 *ECMS*, 2 (pt. III), pp. 269–70, fig. 280.

130 R. B. K. Stevenson, 'Pictish Sculpture from Reay', *PSAS*, 84 (1949–50), p. 218; Blackie and Macaulay (cit. at n. III/4), p. 19, fig. 24.

131 *ECMS*, 2 (pt. III), p. 265, figs 257, A–D.

Chapter 7: Form and Function II pp. 197–213

1 *ECMS*, 1 (Parts I and II), pp. 32–4.

2 For the tomb sculpture at Jouarre see E. James, 'The Continental Context' in *St Andrews Sarcophagus* (cit. at n. Intro/32), pp. 240–9, at p. 247.

3 For the Hedda Stone see Wilson (cit. at n. Intro/16), pl. 83. The foreshortening of the 'St Leonard's School Shrine' in *St Andrews Sarcophagus* (cit. at n. Intro/32), p. 167, fig. 49, gives a false impression of the degree of similarity. It is approximately the same height (50 cm) along its length. The shrine has yet to be studied. It may be that sculpture has been removed from both sides.

4 The recumbents at Meigle are described and illustrated in *ECMS*, 2 (pt. III): No. 26, pp. 303–5; No. 9, pp. 330–1; No. 11, pp. 331–3; No. 12, pp. 333–4; No. 25 (the hogback), pp. 338–9. See also the excellent guide, A. Ritchie, *Meigle Museum,*

Pictish Carved Stones (Edinburgh, 1997). For an important contextual study of the Meigle sculpture see A. Ritchie, 'Meigle and lay patronage in Tayside in the 9th and 10th century AD', *TFAJ*, 1 (1995), pp. 1–10.

5 P. Lionard, 'Early Irish Grave-slabs', *Proceedings of the Royal Irish Academy* 61C (1961) pp. 95–169, at p. 150; H. M. Taylor and J. Taylor, *Anglo-Saxon Architecture* (pbk edn Cambridge, 1980), vol. 1, pp. 314–15.

6 R. Cramp (cit. at n. I/31), pt. Two, pl. 117, 621–5 = Monkwearmouth No. 12.

7 For Hell imagery see above p. 155. The best illustration of the motif on St Vigean's No. 14 is in Cruden (cit. at n. III/33), pl. 51.

8 *ECMS*, 2 (pt. III): Kinnell, pp. 225–6; Strathmartine No. 2, p. 231; Skinnet No. 1, pp. 30–3; Drumdurno (The Maiden Stone) pp. 190–1. For an illustration of the cross-face of Drumdurno see Ritchie (cit. at n. II/19), p. 62.

9 On St Augustine's view on the value of 'the theory of number' and, in particular, the significance of the numbers 7 and 12 see *City of God*, trans. H. Bettenson (London, 1972, repr. London [Penguin Classics], 1984): XI, 30 and 31; XV, 20; XIX.5. There seems little doubt that *City of God* was read on Iona. See the brief account of Iona's library in T. O. Clancy and G. Márkus, *Iona. The Earliest Poetry of a Celtic Monastery* (Edinburgh, 1995) p. 215.

10 For the Rosemarkie recumbent see I. Henderson (cit. at n. II/38), p. 28; For St Vigean's No. 13, *ECMS*, 2 (pt. III), pp. 272–3.

11 I. Henderson, 'The Insular and Continental Context of the St Andrews Sarcophagus', *Scotland in Dark Age Europe* (cit. at n. III/50), pp. 71–97, at pp. 91–2 and n.3 on p. 96, with references to similar cavities in Anglo-Saxon sculpture. On relic-cavities in altars see Thomas (cit. at n. VI/4), pp. 178–81. For other cavities in Pictish sculpture see below p. 221. For the attachments on the St John's Cross, see RCAHMS, *Argyll*, 4, *Iona* (cit. at n. Intro/2), p. 203.

12 H. Richardson, 'Lozenge and Logos', *Archaeology Ireland*, 36 (1996), pp. 24–5.

13 C. Thomas, 'Form and Function' in *St Andrews Sarcophagus* (cit. at n. Intro/32), pp. 84–96, at pp. 87–9.

14 On the shrines see Thomas (cit. at n. VI/4), pp. 150–7; *St Ninian's Isle and its Treasure* (cit. at n. II/45), vol 1, pp. 14–28; pp. 33–5 with refs to figures and plates in vol 2; 'The double shrine 'A' from St Ninian's Isle, Shetland' in *From the Stone Age to the 'Forty-Five'. Studies Presented to R. B. K. Stevenson*, ed. A. O'Connor and D. V. Clarke (Edinburgh, 1983), pp. 285–92.

15 R. Trench-Jellicoe, 'Pictish and Related Harps: Their form and decoration' in *The Worm, the Germ and the Thorn* (cit. at n. V/123), pp. 159–72, at pp. 168–70, ill. 5. A decorated fragment at St Andrews, No. 36, Hay Fleming, p. 33, currently reconstructed as a slotted cross-base, might in fact be part of a recumbent gravemarker.

16 On the pose of the Kinneddar David see I. Henderson (cit. at n. II/35), pp. 97–167, at pp. 130–1 and n.17. For the collection of sculpture from Kinneddar, now in Elgin Museum, see P. Dransart, 'Two Shrine Fragments from Kinneddar, Moray' in *Pattern and Purpose* (cit. at n. Intro/32), pp. 233–40.

17 J. Macdonald, 'Historical notices of "The Broch", on Burghead, in Moray, with an account of its antiquities', *PSAS*, 4 (1860–2), pp. 321–69.

18 I. Henderson (cit. at n. II/35), at pp. 118–46.

19 P. Moar and J. Stewart, 'Newly discovered stones from Papil, Shetland', *PSAS*, LXXVIII (1943–44),

pp. 91–9, pl. VI. Thomas (cit. at n. VI/4), p. 156, interprets the Papil panel as a memorial to the arrival of missionaries in Shetland from across the sea – the sea represented by the strip of vigorous spiral work below the figures. Such a theme would be equally suitable for a reliquary monument attracting pilgrimage.

20 *Tarbat Discovery Programme*, Bulletin No. 3 (1997). Appendix 2. Illustrated catalogue of sculptural fragments found at Tarbat to April 1998. The sarcophagus lid is TR 22. With drawings of the carved faces by I. G. Scott.

21 R. M. Spearman, 'The Govan sarcophagus: an enigmatic monument' in *Govan and its Early Medieval Sculpture*, ed. A. Ritchie (Stroud, 1994), pp. 33–45.

22 *St Andrews Sarcophagus* (cit. at n. Intro/32), pl. 3.

23 Thomas (cit. at n. VI/4), pp. 159–63.

24 P. J. Ashmore, 'Low cairns, long cists and symbol stones', *PSAS*, 110 (1978–80), pp. 346–55, at p. 353. I. Henderson (cit. at n.VII/11), p. 90.

25 M. Hall, I. Henderson and S. Taylor, 'A sculptured fragment from Pittensorn Farm, Gellyburn, Perthshire', *TFAJ*, 4 (1998), pp. 129–44. M. Hall, I. Henderson and I. G. Scott, 'The sculptures from Gellyburn, Murthly and Pittensorn, Perthshire: a second look at their context and function in Early Medieval Scotland' (forthcoming). A photograph of the Murthly panel taken when it had temporarily been removed from display suggests that it is slightly convex. This is certainly true of the main surviving panel of the St Andrews Sarcophagus.

26 *Tarbat Discovery Programme*, Bulletin No. 3 (1997). With drawings of all faces of the grooved post (TR 27) by I. G. Scott. Bulletin No. 4 (1998), fig. 6, a drawing of the 'Calf Stone' (conjoining fragments TR 28 and TR 35) by E. Hooper. *St Ninian's Isle and its Treasure* (cit. at n. II/45), vol 2, figs. 9 and 11.

27 For the panels from Dull and Kinneddar see *ECMS*, 2 (pt. III), p. 315, fig. 329 and p. 148, fig. 329. For a photograph of Kinneddar see Ralston and Inglis (cit. at n. Intro/40), p. 54. For Kildonnan see Fisher (cit. at n. II/60), pp. 93–4, with a photograph, and a drawing by I. G. Scott. Fisher implies that the hunting-scene, which runs vertically was carved at the same time as the cross on the other face. It seems altogether more likely that the cross-slab was manufactured from a panel, particularly since an incised Latin cross is inserted vertically within the scene, presumably to neutralize what was regarded as the secular subject-matter. See, D. Mac Lean, 'Maelrubai, Applecross and the Late Pictish Contribution West of Druimalban' in *The Worm, the Germ and the Thorn* (cit. at n. V/123), pp. 173–87, at p. 181 and n. 94.

28 A diagram of the larger panel is shown in *ECMS*, 2 (pt. III), pp. 85–6, fig. 83. A section of the sharply cut key-pattern carved on the smaller panel is illustrated in I. Henderson (cit. at n. II/38), p. 21. Many carved slabs have been found since the publication of *ECMS*. The whole collection was examined in 1996 by S. Seright, I. G. Scott and I. Henderson in order to make it available on the *Scottish Cultural Resources Access Network*. For a brief account of its scope see I. Henderson (with drawings by I. G. Scott), 'Towards defining the function of sculpture in Alba: the evidence of St Andrews, Brechin and Rosemarkie' in *Kings, Clerics and Chronicles* (cit. at n. Intro/8), pp. 35–46, at p. 43.

29 I. Henderson (cit. at n. II/38), p. 17 and p. 28.

30 S. J. Plunkett, 'The Mercian Perspective' in *St Andrews Sarcophagus* (cit. at n. Intro/32), pp. 202–26.

31 The evidence for composite stone structures on Iona is fully described in RCAHMS, *Argyll*, 4, *Iona* (cit. at n. Intro/2). See also the measured comparative drawings by I. G. Scott in Fisher (cit. at n. II/60), figs 29 and 30, Cross-bases and Socket-stones; and fig. 34, Shrine-posts, Architectural Fragments and Hogback Grave-cover.

32 Restenneth Tower, which had been compared to Northumbrian work of the 7th and 8th centuries, is now thought to date to some point in the 11th century. See most recently, N. Cameron, 'St Rule's Church, St Andrews, and early stone-built churches in Scotland', *PSAS*, 124 (1994), pp. 367–78, at p. 375; R. Fawcett, *Scottish Abbeys and Priories* (London, 1994), pp. 19–20 and ill. 8, p. 138. For the place-name evidence for a Pictish church dedicated to St Peter that might have been Naiton's foundation, see Barrow (cit. at n. Intro/43), pp. 1–15.

33 For the Monkwearmouth animal frieze see Cramp (cit. at n. I/31), pt. 2, pl. 117, 621–5. For sections of animal friezes at Hexham: No. 20 (fish); No. 33 (cow); No. 34 (boar); No. 35 (? lion); No. 39 (coiled serpent). pl. 184, 1007–11 and pl. 185, 1012–15, 1027.

34 M. Schmitt, '"Random" Reliefs and "Primitive" friezes: Reused sources of Romanesque Sculpture?' *Viator* 11 (1980), pp. 124–45.

35 *ECMS*, 2 (pt. III), p. 317; Jewell (cit. at n. I/55), pp. 95–115. The Dunblane analogy is on p. 111.

36 For a reference to Dunblane in a source which might be as early as the 10th century, Cowan (cit. at n. VI/33), pp. 3–21, at p. 12.

37 p. 145.

38 L. and E. A. Alcock (cit. at n. Intro/42), pp. 218–42, with a well-illustrated survey of the sculpture, pp. 222–7. The context of the nearby Dupplin Cross is discussed on pp. 238–42.

39 K. Forsyth, 'The inscription on the Dupplin Cross' in *Isles of the North* (cit. at n. Intro/37), pp. 237–44.

40 For folio 2, Meehan (cit. at n. I/40), col. ill. p. 6. For folio IV see G. Henderson (cit. at n. I/24), p. 132, pl. 190. For the vertical calf, p. 134, pl. 194.

41 R. Gameson and F. Gameson, 'The Anglo-Saxon inscription at St Mary's church, Breamore, Hampshire' in *Anglo-Saxon Studies in Archaeology and History*, VI (1993), ed. W. Filmer-Sankey, pp. 1–10.

42 E. Kitzinger, 'Interlace and Icons: Form and Function in Early Insular Art', *Age of Migrating Ideas* (cit. at n. I/102), pp. 3–15, at pp. 4–6.

43 *ECMS*, 2 (pt. III), p. 23. Thomas (cit. at n. VI/4), ch. 6, 'The Altar', at pp. 186–8.

44 G. C. Menis, *Longobardi d'Italia* (Udine, 1990), pls 92–5.

45 On altar cloths see Thomas (cit. at n. VI/4), p. 183.

46 *ECMS*, 2 (pt. III), pp. 87–8.

47 Thomas (cit. at n. VI/4), pp. 194–5. Blackie and Macaulay (cit. at n. III/4), p. 20, fig. 26. For discussion of a similar, though larger, altar slab from St Nicholas's Chapel, Papa Stronsay, Orkney, see C. E. Lowe, 'The *Papar* and Papa Stronsay: 8th-century Reality or 12th-century Myth?' in *The Papar in the North Atlantic: Environment and History*, ed. B. Crawford (St Andrews, 2002), pp. 88–90.

48 *ECMS*, 2 (pt. III), p. 227, fig. 239B.

49 C. Bourke, 'The hand-bells of the early Scottish Church', *PSAS* 113 (1983), pp. 464–8.

50 See Alcock and Alcock (cit. at n. VII/38) for discussion of this issue.

51 *Pictish Arts Society Journal*, 8 (1995), p. 46. [Information supplied by N. Atkinson.]

52 H. F. James, GUARD Report (Glasgow, 2001).

53 D. Mac Lean, 'The status of the sculptor in Old-Irish law and the evidence of the crosses', *Peritia*, 9 (1995), pp. 125–55.

54 ibid., pp. 151–2.

55 S. Piggott in the introduction to the catalogue of *Early Celtic Art*, an Arts Council of Great Britain exhibition held in the Royal Scottish Museum, Edinburgh, and The Hayward Gallery, London, in 1970 (Chatham, 1970).

Chapter 8: Losses pp. 215–225

1 *The Orygynale Cronykil of Scotland – by Androw of Wyntoun*, ed. D. Laing, II (Edinburgh, 1872), Bk VI, X, pp. 91–2. An Augustinian canon who between 1144 and 1153 wrote an account of St Andrews reads the name on the inscription slightly differently, *Fothet qui Scotis Summus Episcopus est*; see 'The Legend of St Andrew' in *Chronicles of the Picts, Chronicles of the Scots, and other Early Memorials of Scottish History*, ed. W. F. Skene (Edinburgh, 1867), p. 190.

2 For the dates of Fothad I and Fothad II see A. O. Anderson, *Early Sources of Scottish History AD 500 to 1286* (Edinburgh, 1922), I, p. 471; II, p. 49. Also M. O. Anderson, 'St Andrews before Alexander I' in *The Scottish Tradition. Essays in Honour of R. G. Cant*, ed. G. W. S. Barrow (Edinburgh, 1974), p. 4.

3 D. McRoberts, 'Material Destruction caused by the Scottish Reformation', *IR*, 10 (1959), pp. 126–72, espec. 142; see also J. Boswell, *The Journal of a Tour to the Hebrides with Samuel Johnson, LL.D.*, ed. P. Levi (Harmondsworth, 1984), p. 189 '...he was affected with a strong indignation, while he beheld the ruins of religious magnificence...'; the Australian poet Les Murray pungently calls St Andrews 'that Reformation bombsite', in a specially commissioned poem entitled 'Robert Fergusson Night, St Andrews University AD 2000', see: *www.st-andrews.ac.uk/~www_se/fergusson/homecorrect.html*

4 J. Higgitt 'Manuscripts and Libraries in the Diocese of Glasgow before the Reformation' in *Medieval Art and Architecture in the Diocese of Glasgow*, ed. R. Fawcett, *British Archaeological Association Conference Transactions* (Leeds, 1999), pp. 102–10.

5 For the antiquity of St Andrews, see M. O. Anderson, 'The Celtic Church in Kinrimund', *IR*, 25 (1974), pp. 67–76.

6 K. Jackson, *The Gaelic Notes in the Book of Deer* (Cambridge, 1972).

7 For example, records of endowments to St Augustine's Abbey, Canterbury, were placed for safety in the 6th-century Italian Gospel Book, now MS. 286 in the Parker Library of Corpus Christi College Cambridge, for which see M. R. James, *A Descriptive Catalogue of the Manuscripts in the Library of Corpus Christi College, Cambridge*, II (Cambridge, 1912), pp. 52–6. See also P. Sims-Williams, 'The uses of writing in early medieval Wales' in *Literacy in Medieval Celtic Societies*, ed. H. Pryce (Cambridge, 1998), pp. 15–38, espec. 19–20.

8 W. D. Simpson, *The Province of Mar*, The Rhind Lectures in Archaeology, 1941 (Aberdeen, 1943), p. 86; see also W. J. Watson, *The History of the Celtic Place-Names of Scotland*, The Rhind Lectures in Archeology, 1916 (Edinburgh, 1926), pp. 300, 337.

9 Stonyhurst College, Lancashire, Gospel of St John (Stonyhurst Gospel), on loan to the British Library; see *Making of England* (cit. at n. I/78), no. 86, p. 121, and pl. 86. For the binding see R. Powell 'The Stonyhurst Gospel: the Binding', *Relics of St Cuthbert* (cit. at n. I/99), pp. 362–74.

10 A. A. Luce, 'Editor's Introduction', in A. A. Luce, G. O. Simms, P. Meyer and L. Bieler, *Evangeliorum*

Quattuor Codex Durmachensis, 2 vols (Olten, 1960), p. 31; G. Henderson (cit. at n. I/24), p. 193; also pp. 54–5 and pl. 162; Meehan (cit. at n. I/9), pp. 26–8.

11 *Adomnán's Life of Columba*, ed. and trans. A. O. Anderson and M. O. Anderson (Oxford, 1991) Bk ii.9, pp. 106–7; also Bk ii.27, pp. 132–5, and Bk ii.32–5, pp. 138–47.

12 See Chapter 3, p. 31; also G. Henderson (cit. at n. I/24), pp. 52–4.

13 D. P. Kirby, 'Bede and the Pictish Church', *IR*, XXIV (1973), pp. 6–25. For Cuthbert's and Wilfrid's taste in the visual arts, see R. L. S. Bruce-Mitford, 'The Pectoral Cross', *Relics of St Cuthbert* (cit. at n. I/99), pp. 308–25; G. Henderson (cit. at n. I/24), pp. 119–20; G. Henderson (cit. at n. I/11), pp. 179–81, 192–3.

14 *EH*, Bk V, ch. 21, pp. 532–53.

15 ibid., Bk III, ch. 27, pp. 312–5; D. Ó Cróinín, 'Pride and Prejudice', *Peritia*, I (1982), pp. 352–62; G. Henderson (cit. at n. I/24), pp. 57–97; C. D. Verey, 'Lindisfarne or Rath Maelsigi? The Evidence of the Texts' in *Northumbria's Golden Age* (cit. at n. II/100), pp. 327–35.

16 *EH*, Bk V, ch. 22, pp. 552–5; Bk III. ch. 27, pp. 314–15.

17 *EH*, Bk V, chs. 9–10, pp. 474–81; Ó Cróinín, 'Is the Augsburg Gospel Codex a Northumbrian Manuscript?' in *St Cuthbert, Cult and Community* (cit. at n. I/54), pp. 189–201; N. Netzer, 'Willibrord's Scriptorium at Echternach and its Relationship to Ireland and Lindisfarne' in *St Cuthbert, Cult and Community* (cit. at n. I/54), pp. 203–12.

18 Alexander (cit. at n. I/5), pl. 28.

19 Stevenson, 'Further Thoughts on Some Well Known Problems' in *Age of Migrating Ideas* (cit. at n. I/102), p. 19.

20 Alexander (cit. at n. I/5), pl. 54.

21 I. Henderson (cit. at n. II/35), fig. 35, p. 130, and pl. 5, after p. 144.

22 Alexander (cit. at n. I/5), pls 36, 76.

23 Higgitt (cit. at n. V/87), pp. 300–21.

24 Lapidge (cit. at n. V/134), p. 6.

25 M .Werner, 'The Cross-Carpet Page in the Book of Durrow: The Cult of the True Cross, Adomnan, and Iona', *Art Bulletin*, LXXII, 2 (1990), pp. 174–223.

26 C. Nordenfalk, 'An Illustrated Diatessaron', *Art Bulletin*, L (1968), p. 124.

27 Alexander (cit. at n. I/5), pls 77–82.

28 For Willibrord see I. Wood, *The Merovingian Kingdoms 450–751* (London, 1994), pp. 317–21; D. Parsons, Willibrord's 'Frisian' Mission and the Early Churches in Utrecht' in *Northumbria's Golden Age* (cit. at n. II/100), pp. 136–49.

29 *Making of England* (cit. at n. I/78), no. 141, pp. 180–83.

30 See note 17, above; Alexander (cit. at n. I/5), pl. 119; G. Henderson (cit. at n. I/24), pl. 131, p. 91.

31 M. Blackburn, 'An Eighth-Century Coin from the Glebe Field', *Tarbat Discovery Programme*, Bulletin No. 4 (1998), pp. 15–17.

32 G. Henderson (cit. at n. I/24), pl. 114, p. 81.

33 ibid., pls 231, 190–3, pp. 162, 132–3.

34 Alexander (cit. at n. I/5), pls 174–8.

35 I. Henderson, 'The Insular and Continental Context of the St Andrews Sarcophagus', *Scotland in Dark Age Europe* (cit. at n. III/50), p. 82.

36 *ECMS*, 2 (pt. III), p. 134.

37 McRoberts (cit. at n. VIII/3), p. 151; n. 115, p. 151.

38 B. Cassidy, 'The Later Life of the Cross' in *The Ruthwell Cross* (cit. at n. Intro/1), p. 4 and n. 2, p. 4.

39 G. Henderson (cit. at n. I/24), pl. 116, pp. 82–4.

40 Compare the placing of lions at the top of the 9th-century Enger reliquary, for which see P. Lasko, *Ars Sacra 800–1200* (Harmondsworth, 1972), pls 7, 8.

41 *ECMS*, 2 (pt. III), figs. 228B, 230B, 305B.
42 G. Henderson (cit. at n. I/24), pl. 192, p. 133.
43 For the authors' first appraisal of this monument, and a reconstruction of it, see I. Henderson, 'The Social Function of Pictish Sculpture at Elgin and Kinneddar (Moray) and Portmahomack (Tarbat, Easter Ross)' in *Pictish Art*, A Record of the Conference held by Elgin Museum and The Moray Society, August 1998, ed. S. Bennett (Elgin, 1999), pp. 11–15 and figs. 2, 3, pp. 14–15.
44 See Chapter 5, n. 32, above.
45 Report in *The Times*, 11 September 2001, News Section, p. 5.
46 *ECMS*, 2 (pt. III), pp. 73–5, figs. 71, 71A, B. This fragmentary cross-slab is now in the National Museum of Scotland, Edinburgh.
47 I. Henderson (cit. at n. II/39), p. 135.
48 As displayed in the Tarbat Discovery Centre, Portmahomack, Ross & Cromarty, placing in one showcase the new fragment and a replica of the inscribed fragment, now in Edinburgh.
49 Alexander (cit. at n. I/5), pls 248, 250, 253, 332.
50 See above, p. 157
51 See P. Chalmers, *The Ancient Sculptured Monuments of the County of Angus* (Edinburgh, 1848), p. 9 and note 9; also Ritchie (cit. at n. VII/4), p. 2 and note 1, p. 9.
52 Suetonius, *Vitae Duodecim Caesarum*, in *Opera*, ed. F. A. Wolfius (Lipsiae, 1802) I, Bk IV,15, p. 342; Toynbee (cit. at n. III/51), p. 186.
53 J. N. G. Ritchie 'Recording Early Christian Monuments in Scotland' in *The Worm, the Germ and the Thorn* (cit. at n. V/123), pp. 119–28, pls 1a, b, 2a, b, c, pp. 120–1.
54 Chalmers's plate XVIII, No. 1, is captioned 'Within the church of Meigle'. Stuart reports it (the upper part of his plate LXXVI) as 'placed on a mound in the churchyard'.
55 Stuart's plate, but not Chalmers's, shows the horses' tails plaited, a marked feature of the tail of the horse in the upper part of the back of Meigle No. 4.
56 Toynbee (cit. at n. III/51), pls 85, 89–91, 95–6; H. Schutz (cit. at n. V/11), pl. 150, p. 136.
57 Chapter 5 above, p. 137.
58 A beast of similarly bloated appearance, but more swine than bear, stands over a similarly supine figure, in this case a slender animal, below the compartment containing the seraph at the left of the embossed cross at Shandwick. This image has been interpreted as beneficent, related to the lion in the Bestiary breathing life into its cub. See *ECMS*, 2 (pt. III), pp. 69–70, fig. 66B; also I. Henderson (cit. at n. Intro/29), p. 9.
59 G. Henderson, *Early Medieval* (Harmondsworth, 1972), and Medieval Academy Reprints for Teaching (Toronto, 1993), pl. 43, p. 80.
60 D. M. Wilson and O. Klindt-Jensen, *Viking Art* (London, 2nd edn, 1980), pl. III (a); K. Hauck, 'Der Missionsauftrag Christi und das Kaisertum Ludwigs des Frommen' in *Charlemagne's Heir* (cit. at n. V/13), pl. 14 after p. 738, and p. 284.
61 *ECMS*, 2 (pt. III), fig. 313A, opp. p. 297.
62 J. N. G. Ritchie, 'Recording Early Christian Monuments in Scotland' in *The Worm, the Germ and the Thorn* (cit. at n. V/123), p. 127.
63 E. Oxenstierna, *The World of the Norsemen* (London, 1957), pl. 9.
64 I. Henderson, 'Monasteries and Sculpture in the Insular Pre-Viking Age: The Pictish Evidence' in *Monasteries and Society in Medieval Britain*, Harlaxton Medieval Studies, VI, ed. B. Thompson (Stamford, 1999), pp. 75–96, espec. pp. 85–6, 94, 96; *Tarbat Discovery Programme*, Bulletin No. 4 (1998).

65 Chalmers (cit. at n. VIII/51), p. 9; R. S. Loomis, 'Scotland and the Arthurian Legend', *PSAS*, 89 (1955–56), pp. 1–21, espec. p. 18; Ritchie (cit. at n. VII/4), pp. 2–3.
66 *Correspondence of Thomas Gray*, ed. P. Toynbee and L. Whibley (Oxford, 1935), II, p. 891: '...passed through Megill, where is the tomb of Queen Wanders, that was riven to dethe by staned-horses for nae gude that she did, so the women there told me, I'm sure.' Legend evidently assigned her the fate actually suffered by the Merovingian Queen Brunhild.
67 O. J. Padel, 'The Nature of Arthur', *CMCS*, ed. P. Sims-Williams, 27 (Summer, 1994), pp. 1–31, espec. p. 6 and notes 18–20.
68 K. A. Steer, 'Arthur's O'on: A Lost Shrine of Roman Britain', *Arch. J.*, 115 (1958), pp. 99–110.
69 See Chapter 5, pp. 134–6.
70 See Chapter 7, pp. 200–1.
71 A fragment of green porphyry, smooth on one side, was found at Keiss, Caithness, and is now in the National Museum of Scotland, No. 9, case Y18. See also C. J. Lynn, 'Some Fragments of Exotic Porphyry found in Ireland', *Journal of Irish Archaeology*, 2 (1984), pp. 19–32. For a handlist of *porfido verde antico* finds in Scotland, see Lowe (cit. at n. VII/47), p. 93.
72 *ECMS*, 2 (pt. III), fig. 230B, p. 218, and n. 2, p. 218.
73 I. Henderson, 'The Insular and Continental Context of the St Andrews Sarcophagus' in *Scotland in Dark Age Europe* (cit. at n. III/50), pp. 90–4 and figs. 5, 10, 11.
74 *St Andrews Sarcophagus* (cit. at n. Intro/32), pl. 14, opp. p. 145.
75 'Wie glänzt sein Waffenschmuck!'; see W. Ruland, *Legends of the Rhine* (Köln, 1906), p. 276: 'a little barge... drawn by a snow-white swan. In the middle of the vessel stood a knight in shining silver armour'. See also S. McHardy, 'The Wee Dark Fowk o' Scotland: The Role of Oral Transmission in Pictish Studies' in *The Worm, the Germ and the Thorn* (cit. at n. V/123), p. 109.
76 Chalmers (cit. at n. VIII/51), pp. 15–16, and Postscript, opp. p. 16.
77 Graham-Campbell (cit. at n. IV/3), pp. 241–60.
78 See Chapter 4, pp. 87–8.
79 I. Henderson (cit. at n. II/35), pp. 134–40 and fig. 40.
80 *St Ninian's Isle and its Treasure* (cit. at n. II/45).
81 *Wealth of the Roman World AD 300–700*, ed. J. P. C. Kent and K. S. Painter (London, 1977), no. 190, pp. 113–14.
82 *Making of England* (cit. at n. I/78), p. 283.
83 J. Graham-Campbell, 'A lost Pictish treasure (and two Viking-age gold arm-rings) from the Broch of Burgar, Orkney', *PSAS*, 115 .), pp. 241–61.
84 *ECMS*, 2 (pt. III), fig. 37, p. 40.
85 *Work of Angels* (cit. at n. I/7), p. 26, col. ill. p. 33.
86 See Chapter 4, pp 102–3.
87 Society of Antiquaries of Scotland, MS. 307 (19).
88 *St Ninian's Isle and its Treasure* (cit. at n. II/45), pl. XL.a.
89 ibid., pl. XL.b; *Work of Angels* (cit. at n. I/7), pl. 85.
90 Graham-Campbell (cit. at n. IV/1). See Chapter 4, n. 1.
91 J. A. Smith, 'Notice of a silver chain or girdle, the property of Thomas Simson, of Blainslie, Esq., Berwickshire; another in the possession of the University of Aberdeen, and of other ancient Scottish silver chains', *PSAS*, X (1873), pp. 321–47, espec. 328–30 and 327–8.
92 From an unpublished letter of 10 February 1853, quoted by Graham-Campbell (cit. at n. IV/1).
93 *Aethelwulf: De Abbatibus*, ed. A. Campbell (Oxford, 1967).
94 ibid., VI, pp. 10–15.

95 *EH*, Bk V. ch. 21, pp. 532–3.
96 Bourke (cit. at n. VII/49), pp. 464–8.
97 Ryan (cit. at n. I/58), pp. 66–74 and pl. Ia; Harbison (cit. at n. I/33), pl. 49.
98 E. P. Kelly, 'The Lough Kinale Book-Shrine', *Age of Migrating Ideas* (cit. at n. I/102), pp. 168–74.
99 G. Henderson (cit. at n. I/24), pls 246, 248, and pp. 170–1.

Epilogue pp. 226–228
1 Opened in November, 1998; see D. V. Clarke, 'New things set in many landscapes: aspects of the Museum of Scotland', *PSAS*, 128 (1998), pp. 1–12.
2 Among the monuments thus 'stonehenged', is the precious fragment of one of the classic Pictish incised animals, the Dores boar, so heftily reconstituted as a whole animal that the quality of the original carving can no longer be seen.
3 On the same principle, the visitor to the National Museums will not find the inscription in raised lettering from Tarbat within sight of any of the other portions of the monument from which it quite probably comes or of any other sculpture from Tarbat. Cultural context is banned.
4 See Clarke (cit. at n. Epi/1), p. 10.
5 Ritchie (cit. at n. VII/4).
6 *ECMS*, 1 (pt. I), p. lv.
7 The 'rectangle' symbol from Grantown, which has a spiral projection at the top right and bottom left corner, may have some relationship to the Kintore design. The 'notched rectangle' symbol at Clynemilton, Birnie and Tyrie look like the result of similar thinking, producing a different solution. See also for cognate forms the rectangle scored across diagonally by a pair of small drum stick-like motifs, cut on the wall of a Fife cave, and the four pelta pattern on a small steatite disc from Gletness, Shetland, for which see Thomas (cit. at n. IV/7), fig. 2, 28, p. 44 and figs. 3, 4, p. 46.
8 *ECMS*, 1 (pt. I), p. xxxviii and n. 2.
9 Cp. Clarke (cit. at n. Epi/1), p. 6.
10 K. Hughes, 'The Celtic Church. Is This a Valid Concept?', *CMCS*, 1 (Summer, 1981), pp. 1–20; W. Davies, 'The Myth of the Celtic Church' in *The Early Church in Wales and the West*, ed. N. Edwards and A. Lane (Oxford, 1992), pp. 12–21. With the passing of time, the debunking exercise has unfortunately now become an over-personalized indulgence, on a popular 'Digest' level: see I. Bradley, *Celtic Christianity* (Edinburgh, 1999) and D. E. Meek, *The Quest for Celtic Christianity* (Edinburgh and Boat of Garten, 2000).
11 *EH*, V, 22, p. 554, 'vidit, et gavisus est', quoting St John's Gospel, 8, 56.

Select Reference Bibliography

1 Guides and Gazetteers

Mack, A., *Field Guide to the Pictish Symbol Stones* (Balgavies, 1997)

McNeill, P., and R. Nicholson (eds), *An Historical Atlas of Scotland c. 400–1600* (St Andrews, 1975)

McNeill, P. G. B., and H. L. MacQueen (eds), *Atlas of Scottish History to 1707* (Edinburgh, 1996)

Nicoll, E. H. (ed.), J. R. F. Burt (Bibliography), *A Pictish Panorama: The Story of the Picts and A Pictish Bibliography* (Balgavies, 1995)

Ritchie, A., *Picts* (Edinburgh, 1989)

—— (ed.), Royal Commission on the Ancient and Historic Monuments of Scotland [RCAHMS] series, *Exploring Scotland's Heritage: Fife and Tayside; Grampian; The Highlands; Orkney and Shetland* (2nd edns, Edinburgh, 1995)

RCAHMS, *Pictish Symbol Stones: An illustrated Gazetteer* (Edinburgh, 1999)

2 Sources

Anderson, A. O., and M. O. Anderson (eds and trans.), rev. M. O. Anderson, *Adomnán's Life of Columba* (Oxford, 1991)

Sharpe, R. (trans.), *Adomnán of Iona, Life of St Columba* (Harmondsworth, 1995)

Plummer, C. (ed.), *Venerabilis Baedae Opera Historica* (Oxford, 1896, many times reprinted)

Colgrave, B. and R. A. B. Mynors (eds), *Bede: Ecclesiastical History of the English People* (Oxford, 1969, many times reprinted)

3 General Studies

Crawford, B. (ed.), St Andrews Conferences on Dark Age Scotland: (1) *Scotland in Dark Age Europe* (St Andrews, 1994); (2) *Scotland in Dark Age Britain* (1996); (3) *Conversion and Christianity in the North Sea World* (1998)

Foster, S. M., *Picts, Gaels and Scots. Early Historic Scotland* (London, 1997, rev. edn forthcoming)

Groam House Museum Academic Lectures, Rosemarkie: I. Henderson, *The Art and Function of Rosemarkie's Pictish Monuments* (1989); A. MacDonald, *Curadan, Boniface and the Early Church of Rosemarkie* (1992); L. Alcock, *The Neighbours of the Picts: Angles, Britons & Scots at War and at Home* (1993); J. Hunter, *A Persona for the Northern Picts* (1997); J. N. Graham Ritchie, *Recording Early Christian Monuments in Scotland* (1998)

Harbison, P., *The Golden Age of Irish Art: The Medieval Achievement 600–1200* (London, 1999)

Hawkes, J., and S. Mills (eds), *Northumbria's Golden Age* (Stroud, 1999)

Karkov, C. E., R. T. Farrell and M. Ryan (eds), *The Insular Tradition* (New York, 1997).

Lane, A., and E. Campbell, *Dunadd: An Early Dalriadic Capital* (Oxford, 2000)

Proceedings of the International Conferences on Insular Art: (1) *Ireland and Insular Art: A.D. 500–1200*, ed. M. Ryan (Dublin, 1987); (2) *The Age of Migrating Ideas: Early Medieval Art in Northern Britain and Ireland*, ed. R. M. Spearman and J. Higgitt (Edinburgh/Stroud, 1993); (3) *From the Isles of the North: Early Medieval Art in Ireland and Britain*, ed. C. Bourke (Belfast, 1995); (4) *Pattern and Purpose in Insular Art*, ed. M. Redknap, N. Edwards, S. Youngs, A. Lane and J. Knight (Oxford, 2001)

Webster, L., and J. Backhouse (eds), *The Making of England: Anglo-Saxon Art and Culture AD 600–900* (London, 1991)

Wilson, D. M., *Anglo-Saxon Art from the Seventh Century to the Norman Conquest* (London, 1984)

4 Inscriptions

Cox, R. A. V., *The Language of the Ogam Inscriptions of Scotland* (Aberdeen, 1999)

Forsyth, K., *Language in Pictland: The Case against 'Non-Indo-European' Pictish* (Utrecht, 1997)

Higgitt, J., 'The Dedication Inscription at Jarrow and its Context', *The Antiquaries Journal*, 59 (1979), pp. 343–74

——, 'The Pictish Latin Inscription at Tarbat in Ross-shire', *Proceedings of the Society of Antiquaries of Scotland* [PSAS], 112 (1982), pp. 300–21

Okasha, E., 'The Non-Ogam Inscriptions of Pictland', *Cambridge Medieval Celtic Studies*, 9 (Summer, 1985), pp. 43–69

5 Sculpture

Allen, J. R., and J. Anderson, *The Early Christian Monuments of Scotland* [ECMS] (Edinburgh, 1903 in 3 parts; reprinted, with an introduction by I. Henderson, 2 vols, Balgavies, 1993)

Bailey, R. N., *England's Earliest Sculptors* (Toronto, 1996)

The British Academy Corpus of Anglo-Saxon Stone Sculpture in England: I, Parts 1, 2, R. Cramp, *County Durham and Northumberland* (Oxford, 1984). II, R. N. Bailey and R. Cramp, *Cumberland, Westmorland and Lancashire North-of-the-Sands* (Oxford, 1988)

Fisher, I., *Early Medieval Sculpture in the West Highlands and Islands* (Edinburgh, 2001)

Harbison, P., *The High Crosses of Ireland: An Iconographical and Photographic Survey*, 3 vols, Römisch-Germanisches Zentralmuseum Forschungsinstitut für Vor-und Frühgeschichte, Monographien, 17 (Bonn, 1992)

RCAHMS, *Argyll. An Inventory of the Monuments*: 4, *Iona* (Edinburgh, 1982); 5, *Islay, Jura, Colonsay and Oronsay* (Edinburgh, 1984); *North-East Perth: An Archaeological Landscape* (Edinburgh, 1990); *South-East Perth: an Archaeological Landscape* (Edinburgh, 1994)

The St Andrews Sarcophagus: A Pictish Masterpiece and its International Connections, ed. S.M. Foster (Dublin, 1998)

6 Metalwork

Bruce-Mitford, R., *The Sutton Hoo Ship-Burial*, 1 (London, 1975), 2 (1978), 3, I and II, ed. A. C. Evans (1983)

Curle, C. L., *Pictish and Norse Finds from the Brough of Birsay 1934–74* (Edinburgh, 1982)

Evans, A. C., *The Sutton Hoo Ship Burial* (2nd impression, London, 1989)

Laing, L., *A Catalogue of Celtic Ornamental Metalwork in the British Isles c.AD 400–1200*, BAR British Series 229 (1993)

Ryan, M., 'The Derrynaflan Hoard and Early Irish Art', *Speculum*, 72 (1997), pp. 995–1017

Small, A., C. Thomas and D. M. Wilson, *St Ninian's Isle and its Treasure*, 2 vols (Aberdeen, 1973)

'*The Work of Angels': Masterpieces of Celtic Metalwork, 6th–9th centuries AD*, ed. S. Youngs (London, 1989)

7 Manuscripts

Alexander, J. J. G., *Insular Manuscripts – 6th to the 9th Century* (London, 1978)

Backhouse, J., *The Lindisfarne Gospels* (Oxford, 1981)

Brown, P., *The Book of Kells: 48 Pages and Details in Colour from the Manuscript in Trinity College Dublin* (London, 1980)

Henderson, G., *From Durrow to Kells: The Insular Gospel-books 650–800* (London, 1987)

Henry, F., *The Book of Kells: Reproductions from the Manuscript in Trinity College Dublin* (London, 1974, repr. 1976)

Meehan, B., *The Book of Durrow: A Medieval Masterpiece at Trinity College Dublin* (Dublin, 1996)

——, *The Book of Kells: An Illustrated Introduction to the Manuscript in Trinity College Dublin* (London, 1994)

Select Bibliography on the Meaning of the Pictish Symbols

Titles are arranged in order of publication.

Anderson, J., 'The Symbolism of the Monuments', in *ECMS*, I (pt. I), pp. xxxi–lv

Diack, F. C., *The Inscriptions of Pictland*, ed. W. M. Alexander and J. Macdonald (Aberdeen, 1944)

Thomas, A. C., 'The Animal Art of the Scottish Iron Age and its Origins', *Archaeological Journal*, 118 (1961), pp. 14–64

——, 'The Interpretation of the Pictish Symbols', *Archaeological Journal*, 120 (1963), pp. 31–97

Gordon, C. A., 'The Pictish Animals Observed', *PSAS*, 98 (1966), pp. 215–24

Henderson, I. B., 'The Meaning of the Pictish Symbol Stones' in *The Dark Ages in the Highlands*, ed. E. Meldrum (Inverness, 1971), pp. 53–67

Jackson, A., *The Symbol Stones of Scotland: A Social Anthropological Resolution of the Problem of the Picts* (Stromness, 1984)

——, 'Pictish Symbols: Their Meaning and Usage', *PSAS*, 115 (1985), pp. 445–7

Driscoll, S. T., 'Power and Authority in Early Historic Scotland: Pictish Stones and Other Documents', *PSAS*, 116 (1986), p. 589

——, 'Symbol Stones and Pictish Ethnography'. Review of *The Symbol Stones of Scotland*, *Scottish Archaeological Review*, 4 (1986), pp. 59–64

——, 'Power and Authority in early Historic Scotland: Pictish Symbol Stones and Other Documens' in *State and Society: The Emergence and Development of Social Hierarchy and Political Centralization*, ed. J. Gledhill, B. Bender and M. T. Larsen (London, 1988), pp. 215–35

Jackson, A., 'Pictish Animal Symbols' in *Signifying Animals*, ed. R. G. Willis (London, 1990), pp. 103–18

Samson, R., 'The Reinterpretation of the Pictish Symbols', *Journal of the British Archaeological Association*, 145 (1992), pp. 29–65

Jackson, A., *Pictish Symbol Stones*, Association for Scottish Ethnography, Monograph No. 3 (Edinburgh, 1993)

Hicks, C., 'The Pictish Class I Animals' in *The Age of Migrating Ideas*, ed. R. M. Spearman and J. Higgitt (Edinburgh and Stroud, 1993), pp. 196–202

Alcock, L., 'Ur-Symbols in the Pictographic-System of the Picts', *Pictish Art Society Journal*, 9 (1996), pp. 2–6

Forsyth, K., 'Some Thoughts on Pictish Symbols as a Formal Writing System' in *The Worm, the Germ and the Thorn: Pictish and Related Studies Presented to Isabel Henderson*, ed. D. Henry (Balgavies, 1997), pp. 85–98

List of Maps

Map 1 [p. 8] Regional names used in the text.

Map 2 [p. 30] An Insular network: a selection of sites in Ireland and Britain associated with works of art which share specific aspects of the Insular repertoire.

Map 3 [p. 58] Sustained activity and ambitious commissions: locations of major collections of Pictish

sculpture (for which also see Map 2), and findspots of apparently single monuments of particular art-historical significance.

Map 4 [p. 86] Insular metalwork and moulds found at Pictish sites.

Map 5 [p. 158] Pictish sites with cross-marked stones.

Map 6 [p. 196] Sites with relief-carved sculpture on monuments other than slabs.

All maps © The Pinkfoot Press

List of Illustrations

Note: Measurements in the main are based on those given in published sources, and are provided simply as a general indication of scale. Information on materials is similar in nature. All measurements are given height x width x depth, unless otherwise stated.

Abbreviations used
RCAHMS: Royal Commission on the Ancient Historical Monuments of Scotland
NMS: National Museums of Scotland

1 Detail of front of cross-slab, Nigg, Ross & Cromarty. Sandstone. For dimensions see 41, below. Crown copyright: RCAHMS.
2 The Book of Kells, Dublin, Trinity College MS 58, f. 34, *Christi autem* initial. 33 x 25 cm (13 x 9⁷⁄₈ in.). Courtesy The Board of Trinity College Dublin.
3 Shrine, Clonmore, County Armagh. Tinned bronze. 8 x 8 x 3 cm (3¹⁄₈ x 3¹⁄₈ x 1¹⁄₈ in.). Photo Michael McKeown. Copyright Trustees of the Museums and Galleries of Northern Ireland.
4 Buckle, Sutton Hoo Ship Burial. Gold with niello inlay. 13.2 cm x 5.8 cm (5¹⁄₈ x 2 in.) © Copyright The British Museum.
5 Penannular brooch, Loughan, Co. Derry. Gold. Pin 10 cm (4 in.) long; width of terminals 5.2 cm (2 in.) Copyright National Museum of Ireland.
6, 7 Pair of hinged shoulder clasps. Sutton Hoo Burial. Gold, garnets and millefiori. 11.3 x 5.4 cm (4¹⁄₄ x 2¹⁄₈ in.). © Copyright The British Museum.
8 Carpet page, the Book of Durrow, Dublin, Trinity College MS 57, f. 85v. 24.5 x 14.5 cm (9⁵⁄₈ x 5¹⁄₄ in.). Courtesy The Board of Trinity College Dublin.
9 The Book of Durrow, Dublin, Trinity College MS 57, f. 192v, 24.5 x 14.5 cm (9⁵⁄₈ x 5¹⁄₄ in.) Courtesy The Board of Trinity College Dublin.
10 Durham Gospels, Durham Cathedral Library MS A.II.17, f. 2, *In principio* initial, 34.4 x 26.5 cm (13 x 10¹⁄₈ in.) Courtesy of the Dean and Chapter, Durham Cathedral.
11 Annular brooch, Hunterston, Ayrshire. Silver, gold, amber. Hoop diameter 12.2 cm (4¹⁄₄ in.); pin originally 15 cm (6 in.) long. © The Trustees of the NMS.
12 Detail of surviving roof finial from lost house-shaped shrine, St Germain-en-Laye, Musée des Antiquités Nationales. Gilt bronze. 20 x 7.5 cm (7⁷⁄₈ x 3 in.). Photo © RMN, Paris.
13 Cassiodorus, *Commentary on the Psalms*, Durham Cathedral Library MS B.II.30, f. 172v. 42 x 49.5 cm (16 x 11 in.). Courtesy of the Dean and Chapter, Durham Cathedral.

14 Corpus Gospels, Cambridge, Corpus Christi College MS 197B, f. 1, *Imago aquilae*, detail. Whole page 28.5 x 21.2 cm (11 x 8³⁄₈ in.). Courtesy of The Master and Fellows of Corpus Christi College, Cambridge. Photo The Conway Library, Courtauld Institute of Art, London.
15 Cross-slab, Tullylease, Co. Cork. Stone 95 x 63 x 7 cm (3 ft 2 in. x 2 ft 1 in. x 2 in.). © John Higgitt.
16 Augsburg Gospels, Augsburg Universitätsbibliothek Cod. 1.2.4.2, f. 126v, cross-carpet page. 24.5 x 18 cm (9⁵⁄₈ x 7¹⁄₈ in.). Copyright Universitätsbibliothek Augsburg.
17 Filigree panels, detail of rim of paten, Derrynaflan, County Tipperary. Silver, gilt bronze, gold wire, enamel. For dimensions of paten, see following illustration.
18 Paten, Derrynaflan, County Tipperary. Maximum diameter, 35.6–36.8 cm (14¹⁄₄–14¹⁄₄ in.). Copyright National Museum of Ireland.
19 Front cover of the Stonyhurst Gospel. Leather, moulded over string. 13.8 x 9.2 cm (5 x 3⁵⁄₈ in.). Courtesy of the English Province of the Society of Jesus (on loan to The British Library).
20 The Evangelist St Matthew, Barberini Gospels, Vatican, Biblioteca Apostolica MS Barberini Lat. 570, f. 11v. 34 x 25 cm (13¹⁄₈ x 9⁷⁄₈ in.). © Biblioteca Apostolica Vaticana (Vatican).
21 Framed lists of books of the Bible, the *Codex Amiatinus*, Florence, Biblioteca Medicea Laurenziana MS Amiatinus 1, f. VII. 50.5 x 34 cm (19⁷⁄₈ x 13¹⁄₈ in.). Photo: by kind permission of the Ministero per i Beni Culturali e Ambientali.
22 'The Arrest of Christ', the Book of Kells, Dublin, Trinity College MS 58, f. 114. 33 x 25 cm (13 x 9⁷⁄₈ in.). Courtesy The Board of Trinity College Dublin.
23 Romulus and Remus panel, left side of the Franks Casket. Whalebone. 23 x 13 cm (9 x 5¹⁄₈ in.). © Copyright The British Museum.
24 Lion symbol, the Book of Durrow, Dublin, Trinity College MS 57, f. 191v. 24.5 x 14.5 cm (9⁵⁄₈ x 5¹⁄₄ in.). Courtesy The Board of Trinity College Dublin.
25 Incised sculpture of bull from Burghead, Moray. Sandstone. 40 x 53 x 18 cm (21 x 16 x 7 in.). © Tom and Sybil Gray Collection.
26 Incised symbol of boar (fragment) from Dores, Inverness. Diorite. 56 x 42 x 20 cm (22 x 16 x 7 in.). © The Trustees of the NMS.
27 Calf symbol of St Luke, Echternach Gospels, Paris, Bibliothèque nationale MS lat. 9389, f. 115v. 33.5 x 25.5 cm (13¹⁄₈ x 10 in.). Cliché Bibliothèque nationale de France, Paris.

28 Incised sculpture of stag and 'rectangle' symbol from Grantown, Moray. Mica schist. 120 x 25 x 23 cm (4 ft x 10 in. x 9 in.). © The Trustees of the NMS.
29 Incised sculpture of wolf from Stittenham, Ross & Cromarty. Sandstone. 32 x 51 x 8 cm (1 ft¹⁄₄ in. x 1 ft 8¹⁄₄ in. x 3¹⁄₈ in.). Crown copyright: RCAHMS.
30 Incised sculpture of eagle, Knowe of Burrian, Birsay, Orkney. Sandstone. Whole monument 114 x 56 x 9 cm (3 ft 9¹⁄₂ in. x 1 ft 2 in. x 3¹⁄₂ in.). Photo J. W. Sinclair, Kirkwall, courtesy of N. F. Sinclair.
31 Incised sculpture of serpent and 'notched double-disc symbol', Newton, Aberdeenshire. Gneiss. 206 x 61 x 40 cm (6 ft 9 in. x 2 ft x 1 ft 4 in.). © Tom and Sybil Gray Collection.
32 Incised symbols on back of cross-slab. Glamis No. 2, Angus. Sandstone. Whole monument 276 x 150 x 24 cm (8 ft 9 in. x 5 ft 6 in. x 9 in.). © Tom and Sybil Gray Collection.
33 Front of cross-slab, Glamis No. 2, Angus. Sandstone. 276 x 150 x 24 cm (8 ft 9 in. x 5 ft 6 in. x 9 in.). © Tom and Sybil Gray Collection.
34 Front of cross-slab, Glamis No. 1, Angus. Sandstone. 150 x 72 x 14 cm (5 ft x 2 ft x 5¹⁄₂ in.). © Tom and Sybil Gray Collection.
35 Back of cross-slab, Meigle No. 4, Perthshire. Sandstone. 152 x 89 x 15 cm (5 ft x 2 ft 11 in. x 6 in.). Crown copyright: RCAHMS.
36 Front of churchyard cross-slab, Aberlemno, Angus. Sandstone. 198 x 127 x 29 cm (7 ft 6 in. x 4 ft 2 in. x 11¹⁄₂ in.). Crown copyright: RCAHMS.
37 Detail of animal ornament, front of Aberlemno churchyard cross-slab. © Crown copyright. Reproduced courtesy of Historic Scotland.
38 Fragment of relief sculpture from Tarbat, Ross & Cromarty. Sandstone. 30 x 27.5 cm (1 ft x 11 in.). © Martin Carver and University of York.
39 Back and right side of cross-slab at Rosemarkie, Ross & Cromarty. Sandstone. 258 x 77 x 19 cm (8 ft 6 in. x 2 ft 6¹⁄₂ in. x 7 in.). Crown copyright: RCAHMS.
40 Front of cross-slab. Nigg, Ross & Cromarty. For dimensions see 41, following. Crown copyright: RCAHMS, drawn by Ian G. Scott.
41 Detail of front of cross-slab, Nigg, Ross & Cromarty. Sandstone. Whole monument 210 x 104 x 13 cm (7 ft 3 in. x 3 ft 5 in. x 5 in.). Crown copyright: RCAHMS.
42 Corner slab of St Andrews Sarcophagus, Fife. For dimensions see 189 below. Crown copyright: RCAHMS, drawn by Ian G. Scott.

110 Incised symbol stone, Drimmies, Aberdeenshire. Granite. 101 x 63 x 33 cm (4 ft 1 in. x 1 ft 3 in. x 11 in.). © Tom and Sybil Gray Collection.

111 Terminal ring, Whitecleugh, Lanarkshire. Silver, enamel. Diameter 5.3 cm (2 in.). © The Trustees of the NMS.

112 Selection of objects from Norrie's Law Hoard, Fife, including leaf-shaped plaques. Silver, enamel. Leaf-shaped plaques 9.1 x 3.2 cm (3½ x 1¼ in.). Handpins, 17 cm (6¼ in.). © The Trustees of the NMS.

113–16 Pictish incised discs. Sandstone. Jarlshof, Shetland. Comparative scale: bottom left, diameter 6 cm (2¼ in.). © The Trustees of the NMS.

117 Pictish incised disc, Ness of Burgi, Scat Ness, Shetland. Sandstone. © The Trustees of the NMS.

118 Carvings of walls of Court Cave, East Wemyss, Fife. Drawing J. N. Stevenson. Crown copyright: RCAHMS.

119 'Salmon' and 'crescent and V-rod' symbols on east side of entrance. Covesea Cave, Moray, incised design 50 x 37 cm (20 x 14¾ in.). © Aberdeenshire Archaeological Service.

120 Escutcheon mould, Craig Phadrig, Inverness. Baked clay. Diameter 6.6 cm (2½ in.). © The Trustees of the NMS.

121 Rim and escutcheon of hanging-bowl. Castle Tioram, Argyll. Bronze. Bowl diameter 16.5 cm (6½ in.). Escutcheon, height 6 cm (2 in.), width 3.5 cm (1½ in.). Courtesy West Highland Museum, Fort William. Photo © The Trustees of the NMS.

122 Upper half of 'Londesborough Pin'. Silver, enamel. Complete length 32.4 cm (1 ft 1 in.). © Copyright The British Museum.

123 Objects from the Gaulcross hoard, Ley, Banffshire. Silver, enamel. Bracelet diameter 6.4 cm (2½ in.). Length of chain 27.9 cm (11 in.). Length of handpin 14.3 cm (5½ in.). © The Trustees of the NMS.

124, 125 Front, back and side views of the heads of the two pins from Norrie's Law, Fife. Silver, enamel. Width of heads 1.9 cm (¾ in.). © The Trustees of the NMS.

126, 127 Front and back of the 'Erchless Pendant', Breakachy, by Beauly, Inverness-shire. Shale. 6.9 x 3.7 x .6.5 cm (2½ in. x 1½ in. x ¼ in.). Copyright, Inverness Museum and Art Gallery.

128 Sheet of repoussé bosses, Norrie's Law, Fife. Silver. 11.5 x 12.5 cm (4½ in. x 5 in.). © The Trustees of the NMS.

129 Fragments of binding strips, Norrie's Law, Fife. Silver. Width 1.6 cm (¾ in.). © The Trustees of the NMS.

130 Penannular brooch, Tummel Bridge, Perthshire. Silver. Hoop diameter 7.8 cm (3¼ in.). © The Trustees of the NMS.

131 Penannular brooch, St Ninian's Isle, Shetland, No. 20. Silver-gilt. Hoop diameter 7.9 cm (3¼ in.). © The Trustees of the NMS.

132 Brooch moulds, the Brough of Birsay, Orkney. Baked clay. Comparative scale, central mould 5.5 x 4.8 cm (2¼ in. x 2 in.). © The Trustees of the NMS.

133 Decorated disc, the Brough of Birsay, Orkney. Lead. Diameter 5 cm (2 in.). © The Trustees of the NMS.

134 Penannular brooch, St Ninian's Isle, Shetland, No. 17. Silver-gilt. Diameter 10.8 cm (4¼ in.). © The Trustees of the NMS.

135 Terminal of brooch, St Ninian's Isle, Shetland, No. 28. Silver. Diameter of complete brooch 7.1 cm (2¾ in.). Drawing © Ian G. Scott.

136 Fragment of penannular brooch, Freswick, Caithness. Bronze. When complete, diameter 6.9 cm (2¾ in.). © The Trustees of the NMS.

137 Fragment of penannular brooch, Achavrole, Dunbeath, Caithness. Silver, gilt, gold filigree, amber. Surviving length 7.2 cm (2¾ in.). © The Trustees of the NMS.

138 Penannular brooch, the Rogart hoard, Sutherland. Silver, gilt, glass. Diameter 12 cm (4¾ in.). © The Trustees of the NMS.

139 Detail of ornament on hoop of Rogart brooch. © The Trustees of the NMS.

140 Left terminal of a penannular brooch, Croy hoard, Inverness-shire. Silver-gilt, gold filigree, garnet. Width of terminal 3 cm (1¼ in.). © The Trustees of the NMS.

141 Right terminal fragment of penannular brooch, gift of Max Rosenheim to The British Museum. Silver-gilt, gold wire, garnet. Length 1.9 cm (¾ in.) width 1.3 cm (½ in.). Cut down for re-use from broad terminal of Croy type. © Copyright The British Museum.

142 Annular brooch, Ardagh, Co. Limerick. Silver, gilt, glass. Diameter 13.1 cm (5¼ in.). Copyright National Museum of Ireland.

143 Penannular brooch, Breadalbane Collection, The British Museum. Silver, gilt, gold, glass. Diameter 9.8 cm (3¾ in.). © Copyright The British Museum.

144 Penannular brooch, Aldclune, Blair Atholl, Perthshire. Silver, gilt, glass. Diameter 6.5 cm (2½ in.). © The Trustees of the NMS.

145 Two penannular brooches and terminal fragment, Clunie, Perthshire. Left: cast silver. Diameter 11.6 cm (4½ in.); Right: silver, gilt, gold filigree. Diameter 8.2 cm (3¼ in.); Fragment: silver, gold filigree. 2.9 x 1.5 cm (1¼ in. x ¾ in.). © The Trustees of the NMS.

146 Loch of Clunie, Perthshire, island site. Crown copyright: RCAHMS.

147 Fragments of mould for a penannular brooch, Clatchard Craig, Fife. Baked clay. Below: width across terminal 7.5 cm (3 in.). Above, left and right: width of hoop 1.1 cm (½ in.). © The Trustees of the NMS.

148 Schematic reconstruction of casting of large brooch, Dunadd, Argyll, mould No. 1636. Dimensions of surviving mould, for terminal section. 6.5 x 7.5 cm (2¾ x 3 in.); width of terminal when cast 3.9 cm (1¾ in.) max. © The Trustees of the NMS.

149 Brooch-pin, Westness, Rousay, Orkney. Silver, gilt, amber, glass. Diameter 6.3 cm (2½ in.). Length of pin 17.5 cm (7 in.). © The Trustees of the NMS.

150–155 Designs on bases of six silver bowls, St Ninian's Isle, Shetland. Drawing, © Ian G. Scott.

156 Multiple cruciform design on spherical silver bowl, St Ninian's Isle, Shetland, No. 1. Drawing © Ian G. Scott.

157 Bowl, St Ninian's Isle, Shetland, No. 4. Silver. Diameter 14.5 cm (5¼ in.); height 4 cm (1½ in.). © The Trustees of the NMS.

158, 159 Animal ornament on bowls, St Ninian's Isle, Shetland, Nos 2 and 3. Drawing © Ian G. Scott.

160 Silver, gilt, bronze, enamel, internal mount on bowl, St Ninian's Isle, Shetland, No. 6. Drawing © Ian G. Scott.

161 Exterior view of hanging-bowl, St Ninian's Isle, Shetland. Silver. Diameter 14 cm (5½ in.). © The Trustees of the NMS.

162 Interior view of hanging-bowl, St Ninian's Isle, Shetland. © The Trustees of the NMS.

163 Chapes, St Ninian's Isle: Chape No. 15, front and detail of back. Silver-gilt. Actual dimension, width 8.1 cm (3¼ in.). Chape No. 16, detail of front. Silver. Actual dimension, width 8.2 cm (3¼ in.). Drawing © Ian G. Scott.

164 Pommel, St Ninian's Isle, Shetland, No. 11. Silver-gilt. Actual dimensions, height 3.1 cm (1¼ in.), length at base 5.5 cm (2¼ in.). Analytical drawing of central panel and front view. Drawing © Ian G. Scott.

165 Conical mounts from St Ninian's Isle, Shetland, Nos 14, 12, 13. Silver-gilt. Left: height 3.8 cm (1½ in.); Centre: height 4.3 cm (1¾ in.); Right: height 3.8 cm (1½ in.). © The Trustees of the NMS.

166 Analytical drawing of animal ornament on conical mount, St Ninian's Isle, Shetland, No. 12. Drawing © Ian G. Scott

167 The Monymusk reliquary. Silver, enamel, bronze, wood. Length 10.8 cm (4¼ in.); height 9.8 cm (3¾ in.); width 5.1 cm (2 in.). © The Trustees of the NMS.

168 Carved fragment with recessed crosses, Tarbat, Ross & Cromarty. Sandstone. 35 x 42.5 x 7.5 cm (14 in. x 17 in. x 3 in.). © The Trustees of the NMS.

169 Larger mount, Crieff, Perthshire. Bronze, gilt, rock crystal, glass. Height 5.8 cm (2¼ in.). © The Trustees of the NMS.

170 Smaller mount, Crieff, Perthshire. Bronze, gilt. Height 4.3 cm (1¾ in.). © The Trustees of the NMS.

171 Penannular Brooch, Kilmainham, Co. Dublin. Silver, gold, glass. Diameter 9.7 cm (3¾ in.). Copyright National Museum of Ireland.

172 Pin, Golspie, Sutherland. Bronze-gilt. Surviving length 5.5 cm (2¼ in.). © The Trustees of the NMS.

173 Pin, Rosemarkie, Ross & Cromarty. Bone, amber. 3.8 cm (1¾ in.). © The Trustees of the NMS.

174 Top left: fragment of disc, Aberdour, Fife. Bronze, enamel, silver wire, millefiori. Diameter when complete 4.5 cm (1¾ in.); top centre: stud, St Andrews, Fife. Copper, enamel. 2.2 cm (¾ in.) square; top right: stud, Freswick Links, Caithness. Copper, enamel. 1.37 cm (½ in.) square; bottom left: circular mount, Cramond, Midlothian. Bronze, enamel, millefiori. Diameter 3 cm (1¼ in.); bottom right: pyramidal mount, Dalmeny, West Lothian. Gold, garnet. St Andrews stud © Fife Council Museums *East*; all others © The Trustees of the NMS.

175 Front of penannular brooch, Loughan, Co. Derry. Gold. Maximum width of terminals 5.2 cm (2¼ in.). Copyright National Museum of Ireland.

176 Bucket, Skei, Steinkjer, Nord-Trøndelag, Norway. Bronze, wood. Height 16.5 cm (6½ in.). Copyright Per E. Fredriksen, NTNU Vitenskapsmuseet, on loan from Trondheim.

177 Fragment of mount, Stromness, Orkney. Bronze-gilt. Length 4 cm (1½ in.). Height 2.5 cm (1 in.). © The Trustees of the NMS.

178 Engraved sheet bronze fragments and associated boss, Machrins, Colonsay. Dimensions of largest fragment 4 cm x 3.2 cm (1½ in. x 1¼ in.). Diameter of boss 1.3 cm (½ in.). © The Trustees of the NMS.

179 Front of cross-slab, Eassie, Angus. Sandstone. 202 x 101 x 23 cm (6 ft 8 in. x 3 ft 4 in. x 9 in.). Crown copyright: RCAHMS.

180 Incised sculpture of monstrous man, Rhynie, Aberdeenshire. Gabbro. 178 x 70 cm (70 x 27½ in.). © T. E. Gray.

181 Incised sculpture of animal-headed figure, Mail, Cunningsburgh, Shetland. Sandstone. 60.5 x 42 x 3.5 (3 ft x 1 ft 4½ in. x 1½ in.). Copyright Shetland Amenity Trust.

182 Relief panel, Murthly, Perthshire. Sandstone. 101.5 x 57.5 x 10 cm (3 ft 4½ in. x 1 ft 10½ in. x 4 in.). © T. E. Gray.

256 Cross-slab, Tarbat, Ross & Cromarty. Sandstone. 34 x 12.6 x 8 cm (1 ft 1½ in. x 5¼ in. x 3¼ in.). © Tom and Sybil Gray Collection.

257 Cross-slab, Tarbat, Ross & Cromarty. Sandstone. 52.4 x 21.2 x 5.6 cm (1 ft 5 in. x 8½ in. x 2¼ in.). © Tom and Sybil Gray Collection.

258 Cross-slab, Tarbat, Ross & Cromarty. Sandstone. 32.5 x 32.5 cm (1 ft 1 in. x 1 ft 1 in.). © Tom and Sybil Gray Collection.

259 Cross-slab, Dyce, Aberdeenshire, No. 2. Granite. 135 x 60 cm (4 ft 6 in. x 2 ft). Crown copyright: RCAHMS.

260 Cross-slab, Migvie, Aberdeenshire. Gneiss. 180 x 70 x 38 cm (6 ft 2 ft 5 in. x 1 ft 1 in.). © Tom and Sybil Gray Collection.

261 Front of cross-slab, the 'Maiden Stone', Drumdurno, Aberdeenshire. Granite. For dimensions see 80, above. Crown copyright: RCAHMS.

262 Cross-slab, Monymusk, Aberdeenshire. Granite. 217 x 76 x 51 cm (7 ft x 2 ft 6 in. x 1 ft 8¼ in.). © Tom and Sybil Gray Collection.

263 Back of cross-slab, Kirriemuir, Angus, No. 2. Sandstone. 114 x 59 x 11 cm (2 ft 9 in. x 1 ft 9 in. x 4 in.). © Tom and Sybil Gray Collection.

264 Back of cross-slab, St Andrews, Fife, No. 21. Sandstone. 126.5 x 52 x 13 cm (4 ft 2½ in. x 1 ft 8¼ in. x 5 in.). © Crown copyright. Reproduced courtesy of Historic Scotland.

265 Back of cross-slab, St Andrews, Fife, No. 22. Sandstone. 90 x 53 x 16 cm (3 ft 1 ft 9 in. x 6¼ in.). © Crown copyright. Reproduced courtesy of Historic Scotland.

266 Front of cross-slab, St Andrews, Fife, No. 24. Sandstone. 60 x 53 x 13 cm (2 ft x 1 ft 9 in. x 5 in.). © Crown copyright. Reproduced courtesy of Historic Scotland.

267 Back of cross-slab, St Andrews, Fife, No. 23. Sandstone. 124 x 44 x 13 cm (4 ft 1¼ in. x 1 ft 5½ in. x 5 in.). © Crown copyright. Reproduced courtesy of Historic Scotland.

268 Cross-slab, Farr, Sutherland. Slate. 225 x 60 x 23 cm (7 ft 6 in. x 2 ft 9 in.). © Tom and Sybil Gray Collection.

269 Front of 'Sueno's Stone', Forres, Moray. For dimensions see 195, above. © Tom and Sybil Gray Collection.

270 Front of cross-slab, Fowlis Wester, Perthshire, No. 1. For dimensions see 198, above. Courtesy of Perth Museum and Art Gallery, Perth and Kinross Council.

271 Front of cross-slab, Cossans, Angus, 'St Orland's Stone'. Sandstone. 236 x 71 x 25 cm (7 ft 9 in. x 2 ft 4 in. x 10 in.). © Tom and Sybil Gray Collection.

272 Back of cross-slab, Gask, Perthshire. Sandstone. 184 x 109 x 23 cm (6 ft 4 in. x 4 ft 1 in. x 9 in.). © T. E. Gray.

273 Lower portion of front of cross-slab, Hilton of Cadboll. Sandstone. For dimensions see 61, above. © Crown copyright. Reproduced courtesy of Historic Scotland.

274 Back of cross-slab, Woodrae. Sandstone. 175 x 101 x 13 cm (5 ft 9 in. x 3 ft 4 in. x 5 in.). © The Trustees of the NMS.

275 Front of cross-slab, St Madoes, Perthshire. For dimensions see 79, above. © Tom and Sybil Gray Collection.

276 Detail of top of right side of cross-slab, St Madoes, Perthshire. Crown copyright: RCAHMS.

277 Shaft of free-standing cross, Mugdrum, Fife. Sandstone. Shaft 335 x 73 x 40 cm (11 ft 2 ft 5 in. x 1 ft 4 in.). Base above ground 167 x 122 x 46 (5 ft 7 in. x 4 ft 1 in. x 1 ft 7 in.). © T. E. Gray.

278 Back and side of free-standing cross, Dupplin, Perthshire. For dimensions see 196, above.

© Crown copyright. Reproduced courtesy of Historic Scotland, drawing by Ian G. Scott.

279 All four sides of the Crieff Cross. Sandstone. Carved area 250 x 60 x 20 cm (8 ft 2 in. x 2 ft x 8 in.). Crown copyright: RCAHMS, drawing by Ian G. Scott.

280 All four sides of cross-shaft, St Andrews, Fife, No. 19. Sandstone. 240 x 50 x 25 cm (8 ft x 1 ft 8 in. x 10 in.). Crown copyright: RCAHMS, drawing by Ian G. Scott.

281 Fragment of cross-arm, St Andrews, Fife, No. 52. Sandstone. 50 x 28 x 22 cm (1 ft 8 in. x 11 in. x 8½ in.). © GH.

282 Front of fragment of cross-head, St Andrews, Fife, No. 6. Sandstone. 30 x 50 x 15 cm (1 ft 1 ft 8 in. x 6 in.). © Crown copyright. Reproduced courtesy of Historic Scotland.

283 Back of fragment of cross-head, St Andrews, Fife, No. 6. Dimensions as above. © Crown copyright. Reproduced courtesy of Historic Scotland.

284 Bossed cross-arm, St Vigean's, Angus, No. 9. Sandstone. 33 x 55.9 cm (1 ft 1 in. x 1 ft 10 in.). Crown copyright: RCAHMS.

285 Back of pillar, Reay, Caithness. Sandstone. 91 x 23 x 23 cm (3 ft x 9 in. x 9 in.). © The Trustees of the NMS.

286 Right side of pillar, Reay, Caithness. Sandstone. Dimensions as above. © The Trustees of the NMS.

287 Left side of recumbent, Meigle, Perthshire, No. 11. Whole monument 170 x 67.5 x 48 cm (5 ft 8 in. x 2 ft 3 in. x 1 ft 7 in.), tapering to top. Crown copyright: RCAHMS.

288 Right side of recumbent, Meigle, Perthshire, No. 11. Crown copyright: RCAHMS.

289 Recumbent, St Vigean's, Angus, No. 8. Sandstone. 165 x 25 cm (5 ft 6 in. x 10 in.). © Tom and Sybil Gray Collection.

290 Left side of recumbent, Meigle, Perthshire No. 9. Sandstone. 178 x 30 x 33 cm (5 ft 11 in. x 1 ft x 1 ft 1 in.). Crown copyright: RCAHMS.

291 Recumbent, Meigle, Perthshire, No. 12. Sandstone. 143 x 48 x 28 cm (4 ft 9 in. x 1 ft 7 in. x 11 in.). Crown copyright: RCAHMS.

292 Top of recumbent, Meigle, Perthshire, No. 26. Sandstone. 150 x 48 x 23 cm (5 ft x 1 ft 7 in. x 9 in.). Crown copyright: RCAHMS.

293 Right side, recumbent, Meigle, Perthshire, No. 26. Crown copyright: RCAHMS.

294 Right side, recumbent, St Vigean's, Angus, No. 13. Sandstone. 105 x 37.5 cm (3 ft 6 in. x 1 ft 3 in.). © Crown copyright. Reproduced courtesy of Historic Scotland.

295 End with recess, recumbent, Meigle, Perthshire, No. 11. Crown copyright: RCAHMS.

296 Front of cross-slab, Meigle, Perthshire, No. 2. For dimensions see 45, above. © T. E. Gray.

297 Recumbent, Kincardine, Sutherland. Sandstone. 150 x 35 x 50 cm (5 ft x 1 ft 2 in. x 1 ft 8 in.). Crown copyright: RCAHMS, drawing by Ian G. Scott.

298 End slab of composite shrine, Kinneddar, Moray. Sandstone. 89 x 65 x 9 cm (3ft x 2 ft 2 in. x 3½ in.). Crown copyright: RCAHMS, drawing by Ian G. Scott.

299 Fragment of slotted corner slab, Burghead, Moray. Sandstone. 65 x 35 x 20 cm (2 ft 2 in. x 1 ft 2 in. x 8 in.). Crown copyright: RCAHMS.

300 Fragment of panel of shrine, Burghead, Moray. Sandstone. 53 x 45 x 10 cm (1 ft 9 in. x 1 ft 6 in. x 4 in.). Crown copyright: RCAHMS.

301 Carved shrine panel, Papil, Shetland. Sandstone. 100 x 55.5 cm (3 ft 4 in. x 1 ft 10 in. x 2 in.). Copyright Shetland Museum.

302 Sarcophagus lid, Tarbat, Ross & Cromarty. Sandstone. 106.5 x 46 x 23 cm (3 ft 6½ in. x 1 ft 6¼ in. x 9 in.). © Tom and Sybil Gray Collection.

303 'Calf Stone' panel, Tarbat, Ross & Cromarty. Sandstone. 77.5 x 48 x 10 cm (2 ft 7 in. x 1 ft 7¼ in. x 4 in.). © T. E. Gray.

304 Panel, Rosemarkie, Ross & Cromarty. Sandstone. 163 x 56 6.7 cm (5 ft 6 in. x 1 ft 10 in. x 3 in.). Copyright Groam House Museum.

305 Panel, Rosemarkie, Ross & Cromarty. Sandstone. 154 x 46.4 x 3.5 cm (5 ft 1¼ in. x 1 ft 7 in. x 1¼ in.). Copyright Groam House Museum.

306 Panel from composite monument, Rosemarkie, Ross & Cromarty. Sandstone. 49.2 x 51.8 x 8 cm (1 ft 7½ in. x 1 ft 8¼ in. x 3¼ in.). © Tom and Sybil Gray Collection.

307 Fragment of architectural sculpture, Meigle, Perthshire, No. 22. Sandstone. 81 x 25 x 9 cm (2 ft 8 in. x 10 in. x 3½ in.). Crown copyright: RCAHMS.

308 Slab, Dunblane, Perthshire. Sandstone. 84 x 51 x 20 cm (2 ft 9 in. x 1 ft 8 in. x 8 in.). © Paul Adair.

309 Altar frontal, Flotta, Orkney. 165 x 81 x 10 cm (5 ft 5 in. x 2 ft 8 in. x 4 in.). © The Trustees of the NMS.

310 Fragment of top of altar slab, Rosemarkie, Ross & Cromarty. Sandstone. 42 x 37.5 x 6 cm (1 ft 4½ in. x 1 ft 3 in. x 2½ in.). © The Trustees of the NMS.

311 Enlarged detail of edge of decoration of altar slab. 6 cm (2¼ in.). © The Trustees of the NMS.

312 Reredos, Rosemarkie, Ross & Cromarty. Sandstone. 29 x 36 x 10 cm (11½ in. x 1 ft 2½ in. x 4 in.). © The Trustees of the NMS.

313 Fragmentary stone finial, Tarbat, Ross & Cromarty. Sandstone. Height 9.5 cm (3¼ in.). © Martin Carver and University of York.

314 Back of cross-slab, Kirriemuir, Angus, No. 1. Sandstone. 58 x 46 x 10 cm (1ft 11 in. x 1 ft 6 in. x 4 in.). © Tom and Sybil Gray Collection.

315 Back of cross-slab, 'St Orland's Stone', Cossans, Angus. Sandstone. For dimensions see 271, above. © Tom and Sybil Gray Collection.

316 Lower half of back of cross-slab, Rosemarkie, Ross & Cromarty, No. 1. Sandstone. For dimensions see 39, above. Crown copyright: RCAHMS.

317 Fragment of cross-slab, Tarbat, Ross & Cromarty. Sandstone. For dimensions see 206, above. © Tom and Sybil Gray Collection.

318 Lost monument, Meigle, Perthshire, No. 10. Sandstone (?) 90 x 45 cm (3 ft x 1 ft 6 in.). Reproduced from J. Stuart, *The Sculptured Stones of Scotland*, 1856. Crown copyright: RCAHMS.

319 Top of recumbent, Meigle, Perthshire, No. 12. Sandstone. For dimensions see 291, above. Crown copyright: RCAHMS.

320 Bologna Shrine. Bronze, gilt, enamel, glass. 12 x 11.7 x 4. 2 cm (4¾ in. x 4½ in. x 1½ in.). Courtesy Museo Civico Medievale, Bologna. Photo Archivio Fotografico, Musei Civici D'Arte Antica, Bologna.

321 Front of cross-slab, Meigle, Perthshire, No. 5. Sandstone. 76 x 53 (tapering to 48) x 16 cm (2 ft 6 in. x 1 ft 9 in. [tapering to 1 ft 7 in.] x 6½ in.). Crown copyright: RCAHMS.

322 1796 drawing of back of lost Monifieth Plaque. Drawing reproduced scale 1:2. © The Trustees of the NMS.

323 1796 drawing of front of lost Monifieth Plaque. Drawing reproduced scale 1:2. © The Trustees of the NMS.

324 Fragment of incised symbol stone, Inveravon, Banffshire, No. 3. Gneiss. 33 x 20 x 15 cm (1 ft 1 in. x 7 in. x 6 in.). © Tom and Sybil Gray Collection.

325 Incised symbol stone, Kintore, Aberdeenshire, No. 4. Stone. 68 x 50 x 17 cm (2 ft 3¼ in. x 1 ft 8 in. x 6¼ in.). © Tom and Sybil Gray Collection.

326 The Old Scatness Bear, Dunrossness, Shetland (before conservation). Maximum width 36 cm (14 in.). © Val Turner, Shetland Amenity Trust.

Index

Illustrations are indexed by illustration number, indicated by *italic*.